# Lecture Notes in Computer Science 5915

Commenced Publication in 1973
Founding and Former Series Editors:
Gerhard Goos, Juris Hartmanis, and Jan van Leeuwen

Ido A. Iurgel   Nelson Zagalo   Paolo Petta (Eds.)

# Interactive Storytelling

Second Joint International Conference
on Interactive Digital Storytelling, ICIDS 2009
Guimarães, Portugal, December 9-11, 2009
Proceedings

 Springer

Volume Editors

Ido A. Iurgel
Universidade do Minho
DSI - Departamento de Sistemas de Informação
Campus de Azurém, 4800-058 Guimarães, Portugal
E-mail: ido.iurgel@dsi.uminho.pt

Nelson Zagalo
Universidade do Minho
Departamento de Ciências da Comunicação
Campus de Gualtar, 4710-057 Braga, Portugal
E-mail: nzagalo@ics.uminho.pt

Paolo Petta
Austrian Research Institute for Artificial Intelligence
Freyung 6/6, A 1010 Vienna, Austria
E-mail: paolo.petta@ofai.at

Library of Congress Control Number: 2009939506

CR Subject Classification (1998): J.5, H.3.1, I.2.1, K.8, K.3, J.4, I.7

LNCS Sublibrary: SL 3 – Information Systems and Application, incl. Internet/Web and HCI

ISSN        0302-9743
ISBN-10     3-642-10642-0 Springer Berlin Heidelberg New York
ISBN-13     978-3-642-10642-2 Springer Berlin Heidelberg New York

springer.com

© Springer-Verlag Berlin Heidelberg 2009
Printed in Germany

Typesetting: Camera-ready by author, data conversion by Scientific Publishing Services, Chennai, India
Printed on acid-free paper        SPIN: 12804450        06/3180        5 4 3 2 1 0

# Preface

The rich programme of ICIDS 2009, comprising invited talks, technical presentations and posters, demonstrations, and co-located post-conference workshops clearly underscores the event's status as premier international meeting in the domain. It thereby confirms the decision taken by the Constituting Committee of the conference series to take the step forward: out of the national cocoons of its precursors, ICVS and TIDSE, and towards an itinerant platform reflecting its global constituency. This move reflects the desire and the will to take on the challenge to stay on the lookout, critically reflect upon and integrate views and ideas, findings and experiences, and to promote interdisciplinary exchange, while ensuring overall coherence and maintaining a sense of direction.

This is a significant enterprise: The challenges sought are multifarious and must be addressed consistently at all levels. The desire to involve all research communities and stakeholders must be matched by acknowledging the differences in established practises and by providing suitable means of guidance and introduction, exposition and direct interaction at the event itself and of lasting (and increasingly: living) documentation, of which the present proceedings are but an important part. To illustrate: for the scientific constituency, this implies solving the issue of how to achieve high impact (factors) for different disciplines with differing understandings of the role of conferences and conference publications; for artists, to accommodate their presentations to technology-oriented expectations; for the editors, this requires preparedness and availability to put up with the broader range of quirks typical of the different authoring communities, and to invest work on adjusting form (compliance with specific layouts) and ensuring quality of content (e.g., fighting the particular disease of all too frequent issues with correctness and completeness of documentation of the embedding of the original work presented that *still* marks the original manuscripts of the more recent scientific and engineering disciplines).

At first sight, all of this could be misinterpreted as adding up to a disproportionate amount of trouble. But in fact these are the tangible and lively signs of an example of how to do away with balkanisations and divisions into two (or however many) cultures.

The recognition of the role of ICIDS is reflected in the number of submissions received: almost double the number over the already very successful first edition, and with some spread across areas (if still with room for future improvement). Clearly, this did not make the work of the Programme Committee any easier, and we want to thank each of the members, as well as the auxiliary reviewers, for their diligent work: this includes the noteworthy additional effort invested in discussions and further rounds of inspection of contributions that could be accepted only conditionally at first, and in support of an open mindset. The final decisions of acceptance and of the format assigned to each contribution

were thus based on close examination of all reviews and commentary received (as well as the inevitable influence of the logistic givens).

Out of 89 paper and poster submissions, the final programme comprised 19 full and 11 short paper presentations. Together with five accepted posters, this adds up to an overall acceptance rate of 39% that reflects well the aspired balance between the aims for inclusiveness and quality. Six demonstrations and four invited presentations provided further complementary samples of the interactive digital storytelling domain. In addition, a number of post-conference workshops offered the opportunity for more in-depth discussions, informed also by hands-on sessions, about selected topics. Out of the 108 co-authors of contributions to the main conference programme, 58 come from Europe, 31 from North America, ten from the Far East, four each from the Near East (Israel) and South America (Brazil), and one from Australia—with a noteworthy number of cross-continental collaborations.

In closing, we also wish to thank: all of the members of the ICIDS community who submitted; all the supporters of the ICIDS 2009 project and the sponsoring organisations; and in particular Uli Spierling and Nicolas Szilas, the organisers of the first ICIDS, for making our life easier in so many ways by not just handing over the torch, but providing continuous helpful commentary and suggestions; and, last but not least, the Constituting Committee for entrusting us with this important task.

October 2009

Paolo Petta
Nelson Zagalo
Ido A. Iurgel

# Organisation

## Conference Chairs

Ido A. Iurgel — University of Minho and Computer Graphics Centre (CCG), Guimarães, Portugal
Nelson Zagalo — University of Minho, Braga, Portugal
Paolo Petta — Austrian Research Institute for Artificial Intelligence (OFAI), Vienna, Austria

## Programme Committee

Elisabeth André — University of Augsburg, Germany
Ruth Aylett — Heriot-Watt University, Edinburgh, UK
Byung-Chull Bae — Samsung Advanced Institute of Technology, South Korea
Ana Boa-Ventura — University of Texas, Austin, USA
Jay David Bolter — Georgia Institute of Technology, Atlanta, USA
Brunhild Bushoff — Sagasnet, Munich, Germany
Marc Cavazza — University of Teesside, Middlesbrough, UK
Ronan Champagnat — L3i, IUT de La Rochelle, France
Yun-Gyung Cheong — Samsung Advanced Institute of Technology, South Korea
Nuno Correia — Universidade Nova de Lisbon, Portugal
Chris Crawford — Storytron.com, Jacksonville, USA
Stéphane Donikian — IRISA / INRIA, Rennes, France
Clive Fencott — University of Teesside, Middlesbrough, UK
Stefan Göbel — Technische Universität Darmstadt, Germany
Andrew Gordon — University of Southern California, Marina del Rey, USA
Paul Grimm — Erfurt University of Applied Sciences, Erfurt, Germany
Knut Hartmann — Flensburg University of Applied Sciences, Germany
Katherine Isbister — New York University's Polytechnic Institute in Brooklyn, USA
Klaus P. Jantke — Fraunhofer IDMT, Ilmenau, Germany
Lucia Leão — Pontifical Catholic University of São Paulo, Brazil
Craig Lindley — Blekinge Institute of Technology, Sweden
Brian Magerko — Georgia Institute of Technology, Atlanta, USA
Don Marinelli — Carnegie Mellon University, Pittsburgh, USA
Chico Marinho — Universidade Federal de Minas Gerais, Belo Horizonte, Brazil
Stacy Marsella — University of Southern California, Marina del Rey, USA

| | |
|---|---|
| Maic Masuch | University of Duisburg-Essen, Germany |
| Wolfgang Müller | University of Education, Weingarten, Germany |
| Janet H. Murray | Georgia Institute of Technology, Atlanta, USA |
| Frank Nack | University of Amsterdam, The Netherlands |
| Arturo Nakasone | National Institute of Informatics, Tokyo, Japan |
| Ryohei Nakatsu | National University of Singapore, Singapore |
| Stephane Natkin | Cédric, Paris, France |
| Michael Nitsche | Georgia Institute of Technology, Atlanta, USA |
| Ana Paiva | INESC-ID, Lisbon, Portugal |
| Zhigeng Pan | Zhejiang University, Hangzhou, China |
| Catherine Pelachaud | CNRS LTCI, TELECOM ParisTech, Paris, France |
| Yusuf Pisan | University of Technology, Sydney, Australia |
| Rui Prada | Instituto Superior Técnico and INESC-ID, Lisbon, Portugal |
| Stefan Rank | Austrian Research Institute for Artificial Intelligence, Vienna, Austria |
| Jean-Hugues Réty | University of Paris 8, Saint-Denis, France |
| Mark Riedl | Georgia Institute of Technology, Atlanta, USA |
| Maria Roussou | makebelieve design & consulting, Athens, Greece |
| Marie-Laure Ryan | University of Colorado, Boulder, USA |
| Oliver Schneider | IGDV, University of Applied Sciences, Darmstadt, Germany |
| Magy Seif El-Nasr | Simon Fraser University, Surrey, Canada |
| Ulrike Spierling | University of Applied Sciences, Erfurt, Germany |
| Andrew Stern | Procedural Arts, LLC, Portland, USA |
| Wen-Poh Su | Griffith University, Nathan, Australia |
| Kaoru Sumi | National Institute of Information & Communications Technology, Kyoto, Japan |
| Nicolas Szilas | TECFA, University of Geneva, Switzerland |
| Richard Wages | Cologne University of Applied Sciences, Germany |
| R. Michael Young | North Carolina State University, Raleigh, USA |

## Auxiliary Reviewers

Alissa Antle, Carla Coscarelli, Florian Berger, Mei Si, Mei Yii Lim, Michael Kriegel, Rebecca Rouse, Sebastian Weiss

## Local Organisation

| | |
|---|---|
| Pedro Branco | University of Minho, Guimarães, Portugal |
| Rogério E. da Silva | University of Minho, Guimarães, Portugal, and Santa Catarina State University (UDESC), Joinville, Brazil |

# Constituting Committee of the Joint Interactive Storytelling Conference Series

Olivier Balet, Marc Cavazza, Ronan Champagnat, Stéphane Donikian, Stefan Göbel, Ido Iurgel, Ulrike Spierling, Nicolas Szilas.

## Organisational Support

The Second International Conference on Interactive Digital Storytelling (ICIDS 2009) was organised in Guimarães, Portugal, by the Computer Graphics Centre (CCG), the Algoritmi Centre and the Centre for Communication and Society Studies of the University of Minho, jointly with the Austrian Research Institute for Artificial Intelligence (OFAI) of the Austrian Society for Cybernetic Studies (OSGK). The ABREU Conference Organisation services collaborated with these institutions in the local organisation. Special thanks are due to the City of Guimarães for the generosity of allowing to use the Centro Cultural Vila Flor (CCVF) as venue free of charge; to the CCVF, for their assistance and many services; and to Maria da Graça Guedes (University of Minho) and the initiative Agenda Design, for enabling and providing the framework for this. The conference could only be realised thanks to the efforts and dedication of the members of the CCG. The website and visual design of ICIDS 2009 were contributed by TECField Design Team. Further sponsors and supporters are listed on the conference website.

## Websites

ICIDS 2009: http://www.icids2009.ccg.pt
    ICIDS: http://www.icids.org

## Main Sponsors

IRIS FP7 Network of Excellence
Integrating Research in Interactive
Storytelling (FP7-ICT-231824)

Zon Multimedia

# Further Sponsors

TECField Design Team
http://www.tecfield.com

Câmara Municipal de Guimarães—City of Guimarães
http://www.cm-guimaraes.pt

# Supporters

Austrian Research Institute for Artificial Intelligence (OFAI)
http://www.ofai.at

Universidade do Minho
http://www.uminho.pt

Centro de Computação Gráfica / Computer Graphics Centre (CCG)
http://www.ccg.pt

Agenda Design — Universidade do Minho / Câmara Municipal de Guimarães

# Table of Contents

## Games and Story

## Theoretical Perspectives

## Tools, Applications and Frameworks

## Narrative Control and Drama Management

## Approaching Novel Perspectives and Experiences

## Posters

## Demonstrations

# Workshops

# Supporting Storytelling in a Programming Environment for Middle School Children

Caitlin Kelleher

Washington University in St. Louis, Computer Science Department, 1 Brookings Dr.,
St. Louis, MO 63112
ckelleher@cse.wustl.edu

**Abstract.** Storytelling Alice and Looking Glass are programming environments that are designed to motivate middle school students, particularly girls, to learn basic computer programming. Rather than presenting programming as an end in and of itself, both systems present computer programming as a means to the end of creating animated stories. In this talk, I will share some lessons learned about how to support middle school students in finding and realizing their story ideas.

**Keywords:** programming environments, storytelling, children.

## 1  Introduction

Student interest in computer science dropped by 50% between 2000 and 2005 and shows little sign of recovery [5]. Further, the gap between male and female participation in Computer Science is widening [6]. Providing middle school students with exposure to and a positive experience with basic programming will help to open the field of computer science up to a broader cross-section of students, including female students. This is particularly important today. The need for computer science skills extends beyond the field of computer science. In addition to the need to fill expected jobs, computer science is playing an increasingly important role in enabling progress in fields ranging from basic science to medicine and communications. If we starve computer science, we may also risk progress in many problems important to today's society such the discovery of new medications for cancer and HIV and the understanding of climate change and how to address it. Further, some research estimates that up to 30% of our computer-using workforce will be required to do some computer programming as part of their job [4].Thus, the ability to write and understand basic computer programs could become a basic skill for many students. And, a large population of students with basic computer programming skills could help to bolster fields like medicine and basic science which rely on computing to make substantial progress.

For the last several years, I and my colleagues have been developing programming environments for middle school students: Storytelling Alice and more recently Looking Glass. To potentially increase diversity within computer science, we have placed special emphasis on creating environments that are motivating to girls. In early user testing with middle school girls, we found that the programming system needed to both make learning to program approachable and provide a compelling reason that

I.A. Iurgel, N. Zagalo, and P. Petta (Eds.): ICIDS 2009, LNCS 5915, pp. 1–4, 2009.

girls would want to learn to program [2]. In developing Storytelling Alice and Looking Glass, we have chosen to present programming as a means to the end of creating animated stories. We chose to focus on storytelling because it 1) provides a gradual entry into programming, 2) enables users to get positive feedback and encouragement from non-programming friends and family members, and 3) can enable users to experiment with different roles, an important identity-formation activity for middle school children.

In this talk, I will describe lessons we learned about how to support storytelling in a programming environment and our current work on enabling users to explore and learn from stories created by their peers.

## 2 Using Storyboards to Guide API Design

We initially began to explore how to engage middle school students using Alice 2, a drag and drop based programming environment which enables students to use basic 3D graphics transformations [1]. In user testing Alice 2 with middle school students, we found it difficult to get middle school students, and particularly girls to engage. Although many users were interested in the activity of creating an animated story, the difficulty of animating characters proved to be a significant barrier. Often after a question or two about how to program a character to perform a high level task such as slamming a door, users would lose interest. It was clear that users were coming to Alice 2 with goals. But, it was difficult to capture these goals while users were interacting with Alice 2. Once users began to get a sense of what Alice 2 could do, they either adapted their goals to be more in line with their perceptions of the system's capabilities or gave up altogether. To capture the kinds of stories that kids envision telling, we developed a three step storyboarding process in which kids 1) write a 3-4 sentence summary of their story, 2) break the story into scenes and describe the action in each scene, and 3) draw a series of frames showing the actions for each scene [2]. We asked users to complete their storyboards before interacting with the system to avoid having their impressions of the system influence their goals for what they wanted to create.

Based on an analysis of the storyboards, we developed an API focused on human characters and social interactions. Characters in Storytelling Alice can walk around their settings, sit on furniture, kneel down, and talk to other characters. In essence, the API enables a user to easily build the basic actions that occur in his or her story. By supporting basic actions, we free users to focus on creating custom animations that are particularly important to their story. We found that providing users with two simple inverse kinematics based animations: touch and keep touching enabled them to create a wide range of the custom animations they envisioned.

## 3 Helping Users Find Story Ideas

A compelling story idea is one of the key factors that can help to keep kids engaged with programming in Storytelling Alice. While some users can easily generate an idea for a story that they want to tell, other users need more help. Through user testing, we

found two techniques that were particularly valuable in helping users to find story ideas that they wanted to pursue: 1) adult and non-human characters with clear roles and 2) animations that require explanation in the story.

In our studies, we found that middle school aged users often create stories in which the protagonists are children. The adult and non-human characters often play the role of a story catalyst. For example, an evil scientist character might kidnap a child, providing a problem to resolve. Characters with clear roles can help to suggest a story direction. For example, a lunch lady character is nearly always used as an authority figure which can lead users to think of ways for their protagonists to miss-behave.

Storytelling Alice includes a robot character Harold T. Wireton that has an animation entitled "Crazy go nuts." To explain why Harold went crazy, users constructed a wide range of stories ranging from romantic difficulties, to failing a test in school, to being grounded by his parents. Through further testing, we observed that the crucial attribute of "Crazy go nuts" is that it implicitly asks the author of the story to explain why Harold is going crazy [2]. In the gallery of characters that comes with Storytelling Alice, each character includes at least four unique custom animations. Many of these animations are designed to ask a story author to explain the behavior of the character.

## 4 Providing a Learning Path

Storytelling Alice is successful in getting middle school girls to engage with programming. In a formal study comparing Storytelling Alice and Generic Alice (a version of Alice focusing on 3D graphics), we found that girls who used Storytelling Alice spent 42% more of their time with the system programming [3]. Further they were more than 3 times as like as users of Generic Alice to sneak time to continue programming: 51% of Storytelling Alice users snuck extra time to program vs. 16% of Generic Alice users [3]. However, this study examined users' first few hours programming. To give users a solid grounding in programming necessarily requires more than a few hours. Further, it requires learning support that enables users to gradually learn new skills. Yet, computer science classes are rarely offered at the middle school level.

We are currently building Looking Glass, the next version of Storytelling Alice. We are particularly interested in developing software tools that enable kids with little to no programming experience and no access to anyone with programming experience to learn new skills from programs written by other Looking Glass users. We are currently building tools that enable users to capture the behavior of a program as it executes and then navigate through what happened during execution to identify the portions that they would like to reuse. The navigation process provides an opportunity for users to gain some familiarity with different methods and programming constructs. Then, when users have identified a piece of the functionality that they would like to reuse, they can automatically generate a tutorial that will guide them through building that motion in their own program. Suppose that a new user browsing through programs written by other Looking Glass users finds a story in which a kid is throwing a ball against a wall in boredom. The motion is similar to one that she wants to create in which a young boy accidentally throws a ball through the window of a

haunted house. Our software tools will enable users to identify functionality like the ball throwing motion and then automatically generate a tutorial that will guide them through building that functionality in their own program. Initial formative user testing with the code identification and repurposing tools suggests that middle school kids with no prior programming experience can use them to adapt functionality and learn new programming concepts.

Middle school girls often write stories that include issues from their own lives; many focus on relationships with friends and family. The ability to think through relevant issues or write a story to connect with a friend may be a strong component of what draws users to Storytelling Alice. By supporting users in reusing and adapting code written by other Looking Glass users, we provide a pathway that can support learning but allow users to pursue the stories they find the most compelling. As of September 2009, Storytelling Alice has been downloaded more than 285,000 times. We believe that by combining the appeal of storytelling with tools for independent learning, Looking Glass should have the ability to provide a rich and supportive introduction to computer programming for a broad range of middle school aged students.

# References

1. Kelleher, C., et al.: Alice2: Programming Without Syntax Errors. In: 15th ACM Symposium on User Interface Software and Technology. ACM Press, New York (2002)
2. Kelleher, C., Pausch, R.: Lessons Learned from Designing a Programming System to Support Middle School Girls Creating Animated Stories. In: Grundy, J., And Howse, J. (eds.) 23rd IEEE Symposium on Visual Languages and Human-Centric Computing, pp. 165–172. IEEE Press, New York (2006)
3. Kelleher, C., Pausch, R., Kiesler, S.: Storytelling Alice Motivates Middle School Girls to Learn Computer Programming. In: Begole, B., Payne, S., Churchill, E., Amant, S., Gilmore, R., Rosson, M. B. (eds.) 25th ACM Conference on Human Factors in Computing Systems, pp. 1455–1464. ACM Press, New York (2007)
4. Scaffidi, C., Shaw, M., Myers, B.: Estimating the Numbers of End Users and End User Programmers. In: Erwig, M., Schurr, A. (eds.) 22nd IEEE Symposium on Visual Languages and Human-Centric Computing, pp. 207–214. IEEE Press, New York (2005)
5. Vegso, J.: Enrollments and Degree Production at US CS Departments Drop Further in 2006/2007, http://www.cra.org/wp/index.php?p=139
6. Vegso, J.: Taulbee Trends: Female Students & Faculty, http://www.cra.org/info/taulbee/women.html

# Purple Rose of Cairo in Reverse

António Câmara

YDreams, Edifício YDreams, Madan Parque - Sul,
P-2829-149 Caparica, Portugal
antonio.camara@ydreams.com

**Abstract.** In Woody Allen's Purple Rose of Cairo, an actor could leave the film and become real. There are virtual reality (VR) technologies that may enable to achieve the reverse: a spectator entering the movie and interacting with people and objects. But in VR, one needs to develop costly synthetic worlds that are not real. With augmented reality (AR), one superimposes synthetic over real images. It is less expensive and more realistic.

YDreams Simvideo is an AR approach that facilitates the insertion and control of virtual characters in real scenes. In short, Simvideo enables an interactive Roger Rabbitt, by using real time occlusion, collision detection and shadow casting techniques. Illustrative applications of Simvideo in gaming, advertising, television and cinema are presented. They show Simvideo's current capabilities and limitations in story telling.

A blueprint for a future version of Simvideo is also an anticipation of interactive stories that one day will populate those media: a visual blur between reality and fiction, where artificial intelligence repairs the broken narrative of augmented worlds. The story of an augmented visit to Lisbon is used for illustrative purposes.

**Keywords:** virtual reality, interaction technologies, spectator engagement.

I.A. Iurgel, N. Zagalo, and P. Petta (Eds.): ICIDS 2009, LNCS 5915, p. 5, 2009.
© Springer-Verlag Berlin Heidelberg 2009

# The World Is My Oyster – Mobility as a Challenge for Interactive Storytelling

Frank Nack

Human-Computer Studies Group (HCS), Institute for Informatics, University of Amsterdam,
Science Park 107, 1098 XG Amsterdam, The Netherlands
nack@uva.nl

"...places (and, indeed, particular spatial orientations and vistas) are so central to the telling of stories that their names may become proxies for the stories themselves. It is not just that stories are about places, then, but that stories are about being in places."

Brewer & Dourish [1]

**Abstract.** A place is a shrine of stories and with every visit we try to understand it better. Not every visit has the same reason though. Visiting a place might mean that we wish to perform a journey into our own past by walking through those then well-known locations or landscapes from which we hope that they still provide enough triggers to stimulate the stories that bring us back in time. Visiting a place might mean to explore unknown territory either through a comparison between what we perceive with what we know or through the encounter of stories that tell us about the experiences other people had at this location some time in the past. Visiting a place might mean to re-create it through the interaction with people who populate it at the same time. In all cases the exploration is based on experiences that are infinitely personal, and shaped and filtered by emotional and cultural memories, which constantly change as we experience them over and over again.

Until recently we could access a location's memory mainly through media surrogates, such as books, drawings, film or audio files, or through face-to-face encounters with people who were able to knit us into the rich but hidden experience fabric of a place. The integration of low-cost pervasive and personal technology in the form of mobile devices and augmented reality into our everyday life starts to change our expectations about how to perceive the world around us. We are now able to leave traces of our emotional or intellectual experience as virtual attachments to any location. As a result we expect that any place, indoors or outdoors, reveals itself to us by confronting us with connection, context, and uncommon perspectives.

Yet, any exploration is in itself an experience and so we desire that the revelation is compelling and enjoyable on an individual level, which includes the connection to experiences already made in the current context or at other places or during other events. In short, we expect to experience the world around us as a continuous, flexible, and networked exchange of ideas that are routed in

I.A. Iurgel, N. Zagalo, and P. Petta (Eds.): ICIDS 2009, LNCS 5915, pp. 6–7, 2009.
© Springer-Verlag Berlin Heidelberg 2009

where and who we are and how these intrinsic facets of our experience are connected to those of others [2].

This interwoven play between the internal and external, the implicit and explicit, the static and dynamic, the real and the virtual, challenges digital storytelling with problems that need to be solved. As the real world is rather chaotic and does not provide us with a story space according to our likings [3,4,5], it is required to revisit questions that the methods and technologies we became so fond of do not cover any longer.

Where do the stories come from in such an open and endless space of dusted items? Where do these stories go to? How long do they accompany us – or do we accompany them? How does a story respond if I jump into it only because it attracted me while glimpsing at it as it bypasses me in a public space? What are the particles those stories are made out of? Their substance of expression [6] might be produced for purposes and reasons not much is known about, and yet, they will be used to form fluffs of meaning that twirl around with the drafts of the spectator's movements and disappear with him – and nobody knows them any longer? Are these stories real or mere fiction and is this distinction important? Will these stories challenge the individual assumptions and perspectives or do they comfort the spectator/participant with a view on the world she cherishes?

This presentation will be an explorative journey into these type of mobile and interactive environments not yet known but it aims to show that whatever is generated in them will ultimately alter the world.

# References

1. Brewer, J., Dourish, P.: Storied Spaces: Cultural Accounts of Mobility, Technology, and Environmental Knowing. International Journal of Human-Computer Studies 66(12), 963–976 (2008)
2. Nack, F.: Capturing experience – a matter of contextualising events. In: Proceedings of the 1st ACM MM WS on Experiential Telepresence (ETP 2003), Berkeley, CA, USA, November 7, pp. 53–64 (2003)
3. Aylett, R.S., Louchart, S., Dias, J., Paiva, A., Vala, M.: FearNot! - an experiment in emergent narrative. In: Panayiotopoulos, T., Gratch, J., Aylett, R.S., Ballin, D., Olivier, P., Rist, T. (eds.) IVA 2005. LNCS (LNAI), vol. 3661, pp. 305–316. Springer, Heidelberg (2005)
4. Mehta, M., Dow, S., Mateas, M., MacIntyre, B.: Evaluating a Conversation-Centered Interactive Drama. In: Proceedings of the Sixth International Joint Conference on Autonomous Agents and Multiagent Systems (AAMAS), Honolulu, Hawaii, USA (2007)
5. Damiano, R., Gena, C., Lombardo, V., Nunnari, F., Pizzo, A.: A stroll with Carletto: adaptation in drama-based tours with virtual characters. User Modeling and User-Adapted Interaction 18(5), 417–453 (2008)
6. Chatman, S.B.: Story and discourse: Narrative structure in fiction and film. Cornell University Press (1980)

# The IRIS Network of Excellence:
# Future Directions in Interactive Storytelling

Marc Cavazza, Ronan Champagnat, Riccardo Leonardi, and the IRIS Consortium[*]

School of Computing, University of Teesside, Middlesbrough, TS1 3BA, United Kingdom
m.o.cavazza@tees.ac.uk

**Abstract.** The IRIS Network of Excellence started its work in January 2009. In this paper we highlight some new research directions developing within the network: one is revisiting narrative formalisation through the use of Linear Logic and the other is challenging the conventional framework of basing Interactive Storytelling on computer graphics to explore the content-based recombination of video sequences.

**Keywords:** Narrative formalisms, planning, linear logic, video summarization, hidden Markov models, interactive storytelling, interactive narrative.

## 1 Interactive Storytelling: Where Are We Going?

The IRIS (Integrating Research in Interactive Storytelling) Network of Excellence (NoE) started its work in January 2009, as a new EC-funded initiative (under FP7's *Intelligent Content and Semantics*). It brings together 10 partners, most of which have been prominent actors of the Interactive Storytelling community since this Conference series started in 2001. The new structure for NoEs in FP7 makes them more focussed, but also smaller in size: as such, they can no longer aim at structuring an entire community, and their relationship to the community as a whole has to be revisited. IRIS' researchers cover most of traditional areas of Interactive Storytelling (IS). They also approach IS from different theoretical perspectives, and debates within the consortium can reflect, and perhaps progress, those taking place within the IS community at large. Finally, IRIS can also be a laboratory for new ideas not simply in progressing topics on which there is consensus in the community, but in identifying radically different directions, and questioning accepted wisdom. IRIS' partners are contributing to a broad range of topics as can be seen by the IRIS papers presented at this conference [1-8]. This paper highlights some current activities of the NoE, with an emphasis on some of its most original aspects.

## 2 Non-standard Narrative Formalisms: The Linear Logic of Madame Bovary

One of the major issues of IS is the development of formalisms supporting narratives' descriptions. Ideally these formalisms should also be computational or support a

---

[*] See the *Acknowledgements* section for the list of NoE members.

I.A. Iurgel, N. Zagalo, and P. Petta (Eds.): ICIDS 2009, LNCS 5915, pp. 8–13, 2009.

translation to traditional computational formalisms. Logical descriptions have not been a popular formalism since the early work of Grasbon and Braun [9], who resorted to logical description and logic programming. There is however a case for exploring non-standard logics, in particular when they embed concepts of high relevance to storytelling, such as causality. Linear Logic is precisely one such formalism. Linear logic has been introduced by J.-Y. Girard as a restriction of classical logic [10]. Unlike classical logic, linear logic is not used to determine whether an assertion is true or not but rather the validity of how formulas are used (and then consumed) when proving an assertion. It has, also, been introduced as a logic of resources [11]. Finally, linear logic is well suited to derive a computational model to partially ordered problems with resource sharing.

Greimas [12, 13] was the first to develop narrative formalisms as an abstract formula to represent an action. He proposed to define an action as a transition from one state to another state where the subject gains or loses an object (conjunctive or disjunctive narrative program). Greimas proposed to analyse a story as a sequence of actions, and we have proposed to use linear logic as a computational model to "compute" the story and to perform an analysis on the possible stories. The underlying model will stand in three points: the states of character and of the narrative, the story actions, and the story itself. Our example narrative is drawn from Madame Bovary, which is also studied by other activities in IRIS. We will also base part of our model on the characters' feelings, following [14].

We will focus on two characters from the novel (Emma and Rodolphe) and consider that Emma's state is given by two sub-states: one for her general mood (depressed ($E_d$), happy ($E_h$), in love ($E_a$)) and one for her feelings towards Rodolphe (Emma not acknowledging her love for Rodolphe ($E_{rR}$), Emma seduced by Rodolphe ($E_{sR}$), Emma in love with Rodolphe ($E_{aR}$)). As for Rodolphe, he may want to seduce Emma ($R_v$), be in love with her ($R_a$), or see his feelings for her waning ($R_w$). A state is modelled by an atom of linear logic.

We also model the novel's plot as a set of states: conversation while Emma and Rodolphe attend the *comices agricoles* (agricultural show) ($D_c$); in the council room ($D_s$); delay (T); at the Bovary's home ($D_b$); horseback riding (P); conversation at Rodolphe's home ($D_r$). Six actions have been considered through the story: going to the agricultural show ($A_1$); listening to the speech in the council room ($A_2$); waiting before meeting again ($A_3$); Rodolphe visits Emma ($A_4$); horseback riding ($A_5$); Emma visits Rodolphe ($A_6$). Each action is modelled by a formula of linear logic with a linear implication. The atoms on the left side of the linear implication connector correspond to the states required to perform the action. The ones on the right side are the ones derived by the action. For instance the action "listening discourse at the council room" requires the narrative to have the state $D_s$ available as well as Rodolphe state $R_v$ and $E_h$ and $E_{sR}$ for Emma, and will produce the following states: Rodolphe in love with Emma ($R_a$) and Emma happy ($E_h$) and seduced by Rodolphe ($E_{sR}$).

The story can thus be modelled by the following sequent:

$$D_c \otimes D_s \otimes T \otimes D_b \otimes P \otimes D_r \otimes R_v \otimes E_h \otimes E_{s_R} \otimes A_1 \otimes A_2 \otimes A_3 \otimes A_4 \otimes A_5 \otimes A_6 \vdash R_w \otimes E_{a_R} \otimes E_a$$

in which the formulas modelling actions have been replaced by their name $A_x$.

Proving the sequent consists in rewriting the sequent by making q substitutions of the formulas in order to have an initial sequent. The proof tree of the story is given by

$$A_1 : D_c \otimes R_v \otimes E_h \otimes E_{s_R} \multimap R_v \otimes E_h \otimes E_{s_R}$$
$$A_2 : D_s \otimes R_v \otimes E_h \otimes E_{s_R} \multimap R_a \otimes E_h \otimes E_{s_R}$$
$$A_3 : T \otimes E_h \otimes E_{s_R} \otimes R_a \multimap E_{r_R} \otimes E_d \otimes R_a$$
$$A_4 : D_b \otimes R_a \otimes E_d \otimes E_{r_R} \multimap R_a \otimes E_d \otimes E_{r_R}$$
$$A_5 : P \otimes E_d \otimes E_{r_R} \otimes R_a \multimap E_a \otimes E_{a_R} \otimes R_a$$
$$A_6 : D_r \otimes E_a \otimes E_{a_R} \otimes R_a \multimap R_w \otimes E_a \otimes E_{a_R}$$

**Fig. 1.** Representation of actions in Linear Logic

$$\frac{\dfrac{\overline{D_c \vdash D_c}\ id \quad \overline{R_v \vdash R_v}\ id \quad \overline{E_h \vdash E_h}\ id \quad \overline{E_{s_R} \vdash E_{s_R}}\ id}{D_c, R_v, E_h, E_{s_R} \vdash D_c \otimes R_v \otimes E_h \otimes E_{s_R}}\ \otimes R \quad \dfrac{R_v, E_h, E_{s_R}, D_s, T, D_b, P, D_r, A_2, A_3, A_4, A_5, A_6 \vdash R_w \otimes E_{a_R} \otimes E_a}{R_v \otimes E_h \otimes E_{s_R}, D_s, T, D_b, P, D_r, A_2, A_3, A_4, A_5, A_6 \vdash R_w \otimes E_{a_R} \otimes E_a}\ \otimes R}{\dfrac{D_c, D_s, T, D_b, P, D_r, R_v, E_h, E_{s_R}, A_1, A_2, A_3, A_4, A_5, A_6 \vdash R_w \otimes E_{a_R} \otimes E_a}{D_c \otimes D_s \otimes T \otimes D_b \otimes P \otimes D_r \otimes R_v \otimes E_h \otimes E_{s_R} \otimes A_1 \otimes A_2 \otimes A_3 \otimes A_4 \otimes A_5 \otimes A_6 \vdash R_w \otimes E_{a_R} \otimes E_a}\ \otimes L}\ \multimap L$$

**Fig. 2.** Proof of the sequent corresponding to an excerpt of Madame Bovary

Fig 2 (bottom-up reading). The linear implication corresponds to an action of the story, and this proof gives a manner to order the actions of the story.

The derived proof tree is very linear, which corresponds to the default course of action in Madame Bovary. However it can also provide alternative stories (in this specific case the actions that can be suppressed).

## 3   Interactive Storytelling with Video?

One of the basic dogmas of contemporary IS research has been that the generative nature of IS required similarly generative visual content, which could only be achieved through the use of computer graphics. The use of video was perceived as incompatible with the most recent AI-based narrative techniques and only compatible with various forms of branching techniques whose drawback was an explosion of pre-recorded content.

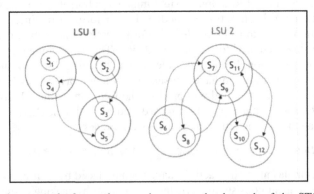

**Fig. 3.** After the removal of *cut-edges*, each connected sub-graph of the STG represents a Logical Story Unit (LSU)

## 3.1 Modelling Feature Films Scenes Using HMM

Yeung and Yeo [15] have shown that in a Scene Transition Graph (STG), after the removal of cut-edges, each connected subgraph well represents a Logical Story Unit (LSU), i.e., "a sequence of contiguous and interconnected shots sharing a common semantic thread", which is the best computable approximation to semantic scene [16]. In particular sub-graph nodes are clusters of visually similar and temporally close shots, while edges between nodes give the temporal flow inside the LSU (Fig 3).

Starting from the STG representation, each LSU can be equivalently modelled by a Hidden Markov Model (HMM). This is a discrete state-space stochastic model which works quite well for temporally correlated data streams, and where the observations are a probabilistic function of a hidden state [16]. Such a modelling choice is supported by the following considerations (see [17]): i) Video structure can be described as a discrete state-space, where each state is a conveyed event (e.g., "man A talking") and each state-transition is given by a change of event; ii) The observations of events are stochastic since video segments seldom have identical raw features even if they represent the same event (e.g., more shots showing the same "man A talking" from slightly different angles); iii) The sequence of events is highly correlated in time, especially for scripted-content videos (movies, etc.) due to the presence of editing effects and typical shot patterns inside scenes to model higher level of abstraction concepts (i.e., dialogues, progressive scenes, etc.).

For the purpose proposed here, while HMM states representing events correspond to distinct clusters of visually similar shots; on the contrary state transition probability distributions capture the shot pattern structure of the LSU. The original shots from which the HMM can be inferred constitute a possible observation set that has been produced by such stochastic model.

## 3.2 Using Feature Films' Scenes HMM Models for Interactive "Movietelling"

Each LSU can be attached a specific semantics, which is conveyed/narrated through the underlying sequence of shots. It can be hypothesized that a mapping can be established between the semantic message and the inner states of the LSU representative HMM.

From each LSU, it can then be foreseen that innovative combinations and sequences of previously recorded shots can be constructed to convey variations of the original semantic message, thus paving the way for interactive movietelling.

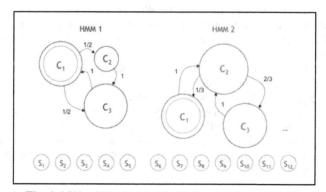

**Fig. 4.** *LSUs* of Fig. 3 are equivalently modelled by HMMs

HMMs are used to instantiate possible alternative variations, by producing a likely chain of observations from already existing recorded material. This may be considered ambitious but the idea has already been proposed in the context of skim generation for feature films without significantly reducing the informativeness and enjoyability of the entertainment, as described in [18].

## 4 Conclusions

IRIS' research programme aims at balancing progress on well-recognised key IS problems (such as authoring) and the ability to explore new avenues, such as video-based IS. The new directions we have presented are more connected to traditional IS problems than may be apparent at first glance, and in their own way lead to revisiting the notions of narrative action, causality, or the notion of scene and temporal unit.

To progress, the NoE also needs to envision various levels of integration. In the longer term, we should revisit key problems from an integrated perspective, such as the definition of narrative actions in-between narrative formalisms ("content") and AI formalisms ("form").

**Acknowledgements.** The IRIS Network of Excellence is funded by the European Commission (FP7-ICT-231824). IRIS members include Fred Charles, Julie Porteous (School of Computing, University of Teesside, UK); Stéphane Donikian, Marc Christie, Nicolas Pépin (IRISA/INRIA, FR); Ulrike Spierling, Steve Hoffmann (FH Erfurt, University of Applied Sciences, DE); Nicolas Szilas, Monica Axelrad, Urs Richle (TECFA, University of Geneva, CH); Peter Vorderer, Christian Roth, Ivar Vermeulen, Christoph Klimmt (CAMeRA, VU University Amsterdam, NL); Elisabeth André, Nikolaus Bee, Birgit Endrass, Katja Kurdyukova, Karin Leichtenstern (Institute of Computer Science, University of Augsburg, DE); Ronan Champagnat (University of La Rochelle, FR); Paolo Petta, Stefan Rank (Austrian Research Institute for Artificial Intelligence, AT); Patrick Olivier, Guy Schofield and Dan Jackson (Culture Lab, Newcastle University, UK), Riccardo Leonardi (University of Brescia, IT).

## References

1. Endrass, B., Boegler, M., Bee, N., André, E.: What Would You Do in their Shoes? Experiencing Different Perspectives in an Interactive Drama for Multiple Users. In: Iurgel, I., Zagalo, N., Petta, P. (eds.) ICIDS 2009. LNCS, vol. 5915, pp. 258–268. Springer, Heidelberg (2009)
2. Porteous, J., Cavazza, M.: Controlling Narrative Generation with Planning Trajectories: the Role of Constraints. In: Iurgel, I., Zagalo, N., Petta, P. (eds.) ICIDS 2009. LNCS, vol. 5915, pp. 234–245. Springer, Heidelberg (2009)
3. Spierling, U., Szilas, N.: Authoring Issues beyond Tools. In: Iurgel, I., Zagalo, N., Petta, P. (eds.) ICIDS 2009. LNCS, vol. 5915, pp. 50–61. Springer, Heidelberg (2009)
4. Szilas, N., Axelrad, M.: To be or not to be: Towards Stateless Interactive Drama. In: Iurgel, I., Zagalo, N., Petta, P. (eds.) ICIDS 2009. LNCS, vol. 5915, pp. 280–291. Springer, Heidelberg (2009)

5. Delmas, G., Champagnat, R., Augeraud, M.: From tabletop RPG to interactive storytelling: definition of a story manager for videogames. In: Iurgel, I., Zagalo, N., Petta, P. (eds.) ICIDS 2009. LNCS, vol. 5915, pp. 121–126. Springer, Heidelberg (2009)

6. Kurdyukova, E., André, E., Leichtenstern, K.: Introducing Multiple Interaction Devices to Interactive Storytelling: Experiences from Practice. In: Iurgel, I., Zagalo, N., Petta, P. (eds.) ICIDS 2009. LNCS, pp. 134–139. Springer, Heidelberg (2009)

7. Roth, C., Vorderer, P., Klimmt, C.: The motivational appeal of interactive storytelling: Towards a dimensional model of the user experience. In: Iurgel, I., Zagalo, N., Petta, P. (eds.) ICIDS 2009. LNCS, vol. 5915, pp. 38–43. Springer, Heidelberg (2009)

8. Spierling, U.: Conceiving Interactive Story Events. In: Iurgel, I., Zagalo, N., Petta, P. (eds.) ICIDS 2009. LNCS, vol. 5915, pp. 292–297. Springer, Heidelberg (2009)

9. Grasbon, D., Braun, N.: A morphological approach to interactive storytelling. In: Proceedings of Cast01 // living in mixed realities, netzspannung.org/journal, special issue, FhG–ZPS, Schloss Birlinghoven, Germany, pp. 337–340 (2001)

10. Girard, J.-Y.: Linear Logic. Theoretical Computer Science 50(1), 1–101 (1987)

11. Lafont, Y.: Introduction to Linear Logic. In: Lecture notes from TEMPUS Summer School on Algebraic and Categorical Methods in Computer Science, Brno, Czech Republic (1993)

12. Greimas, A.J.: Sémantique structurale, Larousse (1966) (in French)

13. Greimas, A.J.: Du Sens. Essais sémiotiques. Le Seuil (1970) (in French)

14. Pizzi, D., Charles, F., Lugrin, J.-L., Cavazza, M.: Interactive Storytelling with Literary Feelings. In: Paiva, A., Prada, R., Picard, R.W. (eds.) ACII 2007. LNCS, vol. 4738, pp. 630–641. Springer, Heidelberg (2007)

15. Yeung, M.M., Yeo, B.-L.: Time-constrained clustering for segmentation of video into story units. In: Proceedings of International Conference on Pattern Recognition, vol. 7276(3), p. 375. IEEE Press, Washington (1996)

16. Rabiner, L.R.: A tutorial on hidden Markov models and selected applications in speech recognition. In: Waibel, A., Lee, K. (eds.) Readings in Speech Recognition, pp. 267–296. Morgan Kaufmann Publishers, San Francisco (1990)

17. Xie, L., Xu, P., Chang, S., Divakaran, A., Sun, H.: Structure analysis of soccer video with domain knowledge and hidden Markov models. Pattern Recognition Letters 25(7), 767–775 (2004)

18. Benini, S., Migliorati, P., Leonardi, R.: A statistical framework for video skimming based on logical story units and motion activity. In: Proceedings of the International Workshop on Content-Based Multimedia Indexing, pp. 25–27. IEEE Press, Washington (2007)

# Digital Storytelling as a Whole-Class Learning Activity: Lessons from a Three-Years Project

Nicoletta Di Blas[1], Franca Garzotto[1], Paolo Paolini[1,2], and Amalia Sabiescu[2]

[1] HOC-LAB, Politecnico di Milano, Italy
{nicoletta.diblas,franca.garzotto,paolo.paolini}@polimi.it
[2] TEC-LAB, Università della Svizzera Italiana, Lugano, Switzerland
{paolinip,sabiesca}@usi.ch

**Abstract.** This paper introduces PoliCultura, a project created by Politecnico di Milano for the Italian schools, which has just completed three years of deployment. Participating classes (with pupils aged between 4 and 18 years) are required to create their own multimedia story, using an authoring-delivery environment (1001stories) provided by Politecnico di Milano. PoliCultura has offered us the opportunity to investigate the *prolonged* use of digital storytelling authoring tools as a whole-class educational activity in a *wide number* of real educational settings: approximately 7,620 pupils from 381 classes have been involved in this project since its birth in 2006. From the overall PoliCultura experience and from the wide amount of qualitative and quantitative data collected from participants though online surveys, focus groups, interviews and contextual inquiry activities, we have learned a number of lessons that we discuss in the paper.

**Keywords:** Multimedia Storytelling, e-learning, education, adoption, educational benefits, case-study.

## 1 Introduction

From preschool to high school, storytelling is a very common educational experience that teachers propose to their students, in order to develop a variety of skills, e.g., communication capability, search, or (collaborative) tasks completion. Interactive multimedia technologies provide new means to support story authoring that in principle facilitate the work of teachers and pupils, limiting some drawbacks of working with physical tangible tools like pen and paper, and foster new forms of creativity, increasing engagement through interactivity. Still, the adoption of tools for digital storytelling in conventional educational settings is currently limited; most reported educational projects based on these systems are largely based on episodic, short-term experiences involving a limited number of teachers and students for a short period of time. In this respect, the PoliCultura project discussed in this paper represents an exception. Since the birth of PoliCultura in 2006, its storytelling tool has been used by over 7,620 students - from pre-schools to high schools - in our country, for whole class activities in the conventional school context spanning along several months and oftentimes repeated year after year by the same class.

I.A. Iurgel, N. Zagalo, and P. Petta (Eds.): ICIDS 2009, LNCS 5915, pp. 14–25, 2009.

The paper presents PoliCultura and discusses the most relevant lessons learnt after the three years of life of this project. They pinpoint that that the conditions for adoption of a digital storytelling tool go beyond the design characteristics of technology per se, and highlight that even a relatively simple tool can promote students' creativity and achieve significant educational benefits.

## 2   PoliCultura and the 1001stories Storytelling Tool

PoliCultura is shaped as a competition for Italian schools requiring classes to complete a "multimedia narrative" on different subjects either proposed by organizers or freely selected by participants. The multimedia story has to be created using "1001stories" [1, 2], a streamlined authoring environment developed by HOC-LAB at Politecnico di Milano. The narrative format is based on a two levels structure: (1) a *short* story, consisting of a number of topics (from 4 to 7 are suggested); (2) a *long* story, consisting of the topics plus their sub-topics (from 3 to 5 suggested – Fig. 1). In the educational version of 1001stories, each topic or subtopic is composed by an audio, its text transcript, and a slideshow of images with their captions which are displayed in sequence and synchronized (automatically) with the audio track. The professional version supports also other types of media such as Flash animations and videos. The user can explore topics and subtopics at her own pace; alternatively, she can enjoy the story passively, while the system automatically presents either the short or the long version of the narrative.

**Fig. 1.** "Milan during the Roman Empire Age" (primary school). The screenshot shows how the final story looks: on the *left*, there is the list of sub-topics of the topic on display (the "Roman Thermae of Milan" – as the title on top of the image reads). In the *middle*, a short slideshow of images runs (1 minute approximately) and eventually on the *right* there are the images' captions and the transcript of the audio comment.

The main characteristics of the authoring environment which made it a success in wide-scale educational use are its accessibility, simplicity, and multichannel delivery. The tool is web-based. It supports a very natural way of defining and updating the narrative structure, allows very easy content upload of media units – mp3 files, jpeg images, and text, and is very intuitive to master: the average learning time is 20 minutes, measured in primary schools. Once the narrative is completed a delivery engine (managed by Politecnico di Milano), generates at once *several versions of the same narrative, for different delivery platforms*: a web-site, a podcast version, an off-line version on CD-ROM (which can be distributed to students and families) and also a cellular phone version or a standard phone version (including interactive audio only). In the process of generation, the images are coupled together and synchronized with audio to generate *video* files. All the different interactive widgets are also generated, customized for each channel.

In the first year (2006/07) the competition targeted *senior high schools* only, since we deemed that the multimedia story task was too difficult for younger students; one *primary school*, however, made a "voluntary submission" that proved successful. In the year 2007/08 the competition was therefore opened to junior high schools and primary schools too. But again, one *pre-school* made a "voluntary submission". In the year 2008/09 all undergraduate school types were admitted. Table 1 shows the numbers of participating classes (corresponding to approximately 17,100 students). Of the participants initially registered, 75% completed the work and 50% approximately submitted it to the competition (the evaluation process took almost 2 months).

**Table 1.** Participation to PoliCultura in 2006-2009 by school type. The columns on the *right* refer to the number of classes which accomplished and submitted the narrative, out of those initially registered.

| Year | Classes registered | | | | | Classes that submitted the narrative | | | | |
|---|---|---|---|---|---|---|---|---|---|---|
| | Total | Pre-school | Primary school | Junior-high school | High school | Total | Pre-school | Primary school | Junior-high school | High school |
| 2008/09 | **414** | 38 | 173 | 113 | 90 | **190** | 18 | 79 | 53 | 40 |
| 2007/08 | **338** | – | 149 | 98 | 91 | **135** | – | 57 | 38 | 40 |
| 2006/07 | **103** | – | – | – | 103 | **56** | – | – | – | 56 |

The rest of this paper discusses some key lessons learnt after three years of deployment. Each lesson is first introduced by a general statement and then supported through data and examples from PoliCultura. Our discussion is based upon the wide amount of qualitative and quantitative data collected during the whole project using different protocols: our team's analysis of the multimedia stories, *online surveys* to teachers (approximately 60% of teachers involved every year); *focus groups* and *semi-structured interviews*, involving respectively 10% and 5% of the set of participating teachers; *contextual inquiry* in a local primary school for over three months, with members of our team observing and working with 24 children aged 10-11 and their three teachers in the class or in the school computer laboratory.

# 3  Lessons Learnt

## 3.1  Conditions for Successful Adoption of Digital Storytelling in Schools

*In order to introduce an ICT-based activity such as digital storytelling in a class the basic ingredient is a committed teacher, open to innovation. The engagement of a teacher is in its turn facilitated by an effective tool, a good organization setting, and an adequate methodological support.*

An excellent teacher can obtain great results even with a difficult class while excellent students cannot overcome the underperformance of a teacher. We ask each class to create *one* story, therefore the organization of the groups, the task assignment, and motivation, are crucial ingredients that the teacher only can obtain from a class. A teacher's effective participation is encouraged by some *facilitating* elements, some of which are related to the tool that has to be used. In our case, the use of 1001stories has proved an easy job (see previous section). At the same time, the result is a kind of "magical" for teachers, pupils, and families [3]: with a single effort, a website, a CD-ROM, a podcast, and a version for cellular phone are produced. This makes the experience highly rewarding and builds confidence with the use of technology.

When facing a complex activity like creating a digital story, a good organization setting is crucial: in our experience with PoliCultura, the main reason (detected via online surveys) for dropping out is *underestimation of the work needed*. The other motivation is *conflict of schedule with curricular activities*. Both these reasons do not concern the storytelling activity *per se* but rather the *organizational context* in which it should take place. Another critical organizational factor is the principal's approval, for permission to take time from other curricular activities, or for using the computer laboratories, etc.

Eventually, though PoliCultura participants have shown a high degree of autonomy over the years, a good *support* both in terms of precise guidelines and examples to look at is important. We have collected and made available online a sizable library of the works done by the classes [4]: this provides a strong drive for *imitation*. In some cases works done by a class had been used in another to introduce a curricular topic, e.g., "Milan during the Roman Empire Age" – see Fig. 1, was adopted to discuss Roman civilization in the classroom.

*The overall lesson is: innovative activities in schools should give a pivotal role to teachers. They are the ones that can transform any idea in a real teaching and learning project.*

## 3.2  Anchoring Stories to a Shared, Real-Life Context

*Collective storytelling activities can be more motivating and engaging for students if their subject is anchored to a whole class, shared, real-life experience. This choice does not affect creativity (most stories, especially for younger pupils, go far beyond the mere realistic description of the experience) nor does it prevent the introduction of fictional elements in the narrative.*

Most of the stories generated by schools (at all levels) in PoliCultura are rooted in a real-life experience undertaken by the entire class, e.g., a trip, a visit to a museum, a research,  or a science experiment. As an example, one of the PoliCultura finalist stories (primary school) in the year 2008/09 was based upon a class trip in a forest region. Around this *real-life* experience students built a *fictional* tale of magic

encounters with mysterious creatures. In this case, the real-life experience created a strong context for the whole narrative. Additional examples are discussed below. In our opinion, there are two possible reasons that motivate participants to choose a real-life context for building a narrative: (1) PoliCultura competition asks for a *collective* narrative (rather than a collection of individual pupil's stories) and this strongly calls for reference to a shared *common ground* [5]; (2) as situated learning theory explains [6], a learning process is a function of the activity, context and culture in which it occurs: selecting a real life experience, teachers obtain two advantages: (a) more interest for the activity itself (e.g., a visit to a museum); (b) a long lasting effect of the experience being reinterpreted by the storytelling activity.

**Example 1. Anchor: Visiting Cultural Heritage Settings (Primary School).** For creating "Milan during the Roman Empire Age" (Fig. 1), a class of 10-11 years old pupils visited the local Archaeological Museum and some relevant spots in the city of Milan, took pictures, made drawings and gave their own interpretation of the city's Roman historical past [7]. Motivated by the storytelling activity, children involved families to visit the museum again. Among other educational benefits [7], this storytelling experience had a long lasting effect: interviews with parents, pupils and teachers two years later highlighted that they remember almost everything about it!

**Example 2. Anchor: A Research on Local History (Junior High School).** A class of junior high school children from a small town in Sicily, in the mafia's territory, anchored their narrative to a socially difficult context. They told us about those who fought *against* mafia, provocatively calling them "men of honour" (the way mafia people call themselves) and built a powerful, brave story based on a wide class research activity (Fig. 2, left). The storytelling activity generated motivation for the research and, at the same time, it helped students to "interiorize" the main themes of it, and fostered in youngsters a deep reflections on their feelings about mafia.

**Example 3. Anchor: A School Lab Activity (Pre-school).** The story of an elf teaching kids how to transform stones into beautiful artefacts frames the application

**Fig. 2.** On the *left*, one of the images of the application "Men of honour" about those people who bravely fought Italian mafia (junior high-school). The line reads: "… their ideas walk on our legs". On the *right*, recording audio for "Stones, pebbles and rocks" (pre-school).

"Stones, pebbles and rocks" that reports on an art-lab done in class (Fig. 2, right). The results of this project show that even very young children (aged 5) can be involved in a digital storytelling activity [3], in relationship with a meaningful and shared class activity. Interviews with teachers detected that one of the pupils, with minor personality problems and often not involved in class activities, specifically asked for a role in the storytelling and made some of the most touching recordings.

### 3.3  Narrative Paradigms are Multiple

*An "effective" story-telling tool must strike a balance between being easy to use (lesson 1) and not hindering the users' creativity. Student can bend to their communication needs even a tool with a limited set of functionalities and narrative formats, and make it support a number of different and unexpected storytelling paradigms.*

We have seen in Sect. 2 that 1001stories is apparently quite "rigid": the information architecture is fixed (a set of topics and sub-topics) and the kind of content that users can insert is limited (text, images, and audio). In addition, all users are provided with the same set of guidelines that distil our own experience in using the tool. Still, the submissions we receive display a surprising array of different "interpretations" of the format that show how "even with just a black and white pencil you can create a masterpiece" (quote from European architect Mario Botta).

**Example 1. "Rules Breaking": The Circus (Primary School).** "The Circus", based on a one-year school activity, "breaks" our guidelines in a number of ways: (a) audios are extremely short – they all last less than 10 seconds, while the recommended length is one minute or more; (b) in the audio, students do not read a narrative but play the characters' parts like "experienced actors"; (c) for each topic of the narrative there is only one image, instead of the 4-6 images recommended by our guidelines. Therefore the rhythm of the narrative is really fast-paced. The result, however, is an engaging set of lively stories in comic-style, animated by characters invented by the children.

**Example 2. "Rules Bending": Montevecchio (Primary School).** The application "Montevecchio and its surroundings" skilfully blends two literary genres: the "short story" (the set of main topics) is a fiction about two kids learning from talking animals how to care about the environment. The "details" (i.e., the sub-topics) illustrate various natural-science issues from a more objective perspective.

**Example 3. "Unexpected Content": Together with You, Grandpa (Junior High School).** The narrative "Together with you, Grandpa" is grounded on a school project for helping elderly people who are left alone in specialized communities. If most of the narrative is quite traditional, the end of the narrative introduces some "audio letters" from the elderly to the children who paid them a visit. The result of this unexpected content is engaging and touching (Fig. 3).

*Dear children,*
*I am Armando and I was very happy to meet you.*
*That morning I felt really good. I wanted to tell*
*you that I worked hard in my life for my 6 sons*
*and 5 grandchildren, whom I love very much.*
*When you told me I am the most beautiful*
*grandpa in the world – it made me smile. But I'm*
*so proud of it. I eagerly wait for you. Thank you*
*for keeping me company and for your letters.*

*Armando, the most beautiful grandpa in the*
*world*

**Fig. 3.** Two pieces of content from the narrative "Together with you, Grandpa" (Junior High School): A picture (left) and the transcript of an audio-letter to the kids, recorded by "grandpa" Armando

### 3.4 Learning Benefits

*The introduction of well supported digital storytelling in schools can be an extraordinary facilitator for a wide range of substantial educational benefits, e.g., acquisition and consolidation of knowledge and skills, heightened engagement, motivation towards learning activities, and also acquisition of digital literacy skills.*

The learning experience provided by PoliCultura is multifaceted: building a narrative implies a number of activities ranging from focusing the idea, organizing group work, designing the plot, writing the texts, recording the audios, selecting/adjusting the images. From our experience, pupils approach the subject matter of the narrative in a way that enables a structured view of the theme and its components, and fosters interest, higher retention rate, and deep understanding of the story subject. At the same time, students improve their teamwork capabilities: the thick social interaction engages students, including those with special needs, more than normal school activities do.

In PoliCultura, we performed a *specific* research on educational benefits every year, in the context of the wider study discussed in Sect. 2. The learning impact was measured on two macro-dimensions: the cognitive level (which involves knowledge and intellectual skills) and the affective level (referring to the way learners relate to things and activities emotionally - feelings, values, motivation, and attitude) [8].

Along the three years of PoliCultura, 318 adult educators overall participated in this study: 55 educators in the first year, 110 in the second and 153 in the third year, from pre-school, primary, junior high school and high school. Since lack of space prevents us from providing a detailed analysis of the whole study, we discuss here the results from the online questionnaire on learning outcomes submitted to teachers at the end of the storytelling experience in the 3rd project year.

We identified a list of educational benefits and asked respondents to i) assess the achievement of *each* benefit in the PoliCultura project against the achievement of the same benefit as it results in "normal" school activities, at a comparable effort on a comparable matter, and ii) compare the *overall* educational impact. Items were scored on a 5-point Likert scale (1: much lower; 5: much higher). The same questionnaire

also collected free comments that were then classified according to their pertinence to the different benefits and coded for analytical purposes.

The *overall learning impact* was evaluated *optimal* (with respect to comparable traditional activities) by *76.5%* of the teachers and *good* by *22.2%*. As Table 2 shows, *77.6%* of the teachers think that PoliCultura *engages* children *significantly more* than normal school activities. A teacher said: "I believe the educational benefits are obtained much more effectively than with usual frontal lessons. Students are well engaged because they get to use computers, which they are very fond of." *67.3 %* of the teachers think that the storytelling activity generates higher *interest in the subject matter*. *62.1%* underline that pupils develop a better *understanding of the logical connections* and relations among various themes addressed by their stories.

**Table 2.** Excerpt of learning benefits evaluation of the PoliCultura experience as compared to regular didactic activities (from questionnaires administered in 2008/09 to 153 educators)

| Educational benefit | Achievement with respect to regular teaching activities | | | | |
| --- | --- | --- | --- | --- | --- |
| | 1 [much lower] | 2 [lower] | 3 [equal] | 4 [better] | 5 [much better] |
| Deep understanding | 0.00% | 0.70% | 4.60% | **54.60%** | 40.50% |
| Content organization skills | 0.00% | 0.70% | 9.20% | **62.10%** | 28.10% |
| Retention | 0.00% | 0.70% | 5.90% | 39.50% | **54.20%** |
| Interest in a subject matter | 0.00% | 0.70% | 3.30% | 28.90% | **67.30%** |
| Engagement | 0.00% | 0.00% | 2.60% | 20.30% | **77.60%** |
| Technical abilities | 0.00% | 1.30% | 8.50% | 35.90% | **54.60%** |
| Communication abilities | 0.00% | 0.00% | 7.90% | **51.00%** | 41.40% |
| Teamwork capacities | 0.00% | 0.00% | 6.60% | 38.20% | **54.90%** |

In addition, all the teachers (67% rating 5, and 33% rating 4) found that using 1001stories had been a powerful tool for achieving *"media literacy"*, i.e. the ability "to effectively create, use and communicate information" using new technologies [9]. A teacher said: "The children had the chance to use the computer skills they were already in command of to *communicate* their experience". Some teachers underlined the effectiveness of storytelling for involving children with *mental or physical difficulties*, or *children isolated from the group*. A teacher mentioned: "In my class there is a dyslexic kid. He tried to record his part some 15, even 20 times and he did not want to give up. The whole class stood around him cheering and in the end he made it". A teacher reported that their project was also an occasion *to know her students better*, "especially some kids who proved invaluable in this work, whereas in regular school activity they do not usually stand out". One teacher even declared his intention to use the Policultura experience "to make other teachers understand that using multimedia can make interesting those topics which are usually found boring".

## 3  Related Work

Equipping children with storytelling skills starting from early childhood is proven to support their development, by helping them express and assign meaning to the world [10], [11], or for developing specific abilities such as tasks-completion and problem-solving [12-13]. The value brought by technology in supporting children storytelling and story authoring has been demonstrated by a series of studies [10], [14] and applied in the development of a very rich array of authoring tools, both commercial and resulting from academic research. When it comes to actual usage, however, the application area of digital story authoring tools remains in most cases small-scale.

In the following, we look at a series of projects involving the use of story authoring tools with a potential – not yet exploited – for wide integration in pre-school or school curricula, focusing on aspects of collaboration in the authoring experience. For a comparative look, we will also present one example of large adoption of an online digital story authoring environment supported by a broadcasting corporation. Finally, we will refer to widely employed solutions for implementing digital storytelling in the classroom, by using off-the-shelf technology and software.

The authoring process can be integrated in the scholarly activities on-site, or can involve collaboration of children at a distance. KidPad [15-16] is a tool involving children in synchronous co-presence collaborative story authoring, by using drawing, typing and hyperlinking functionalities optimized for synchronous collaborative input (e.g., multiple mice) on a 2-dimensional zoomable space. Further research has added tangible interface and gesture recognition technology to KidPad [17], resulting in a "magic carpet" which can support collaboration in larger groups, story retelling and reenactment as complementary to story creation. Playful collaboration in the creation of stories using the playground metaphor is also explored in the projects StoryMat [14], [18] and POGO [10]. Synchronous distance-based collaboration for authoring stories in 2D and 3D virtual environments has been exploited in projects such as FaTe2 [19], MOOSE crossing [20] or MyStoryMaker (work in progress) [21]. PUP-PET [22] is an example of a virtual environment used for teaching basics of drama production and enactment to children. An approach to narrative development which shifts the boundaries between author and user is Emergent Narrative (EN) [23], referring to stories in which the advancement of the narrative is determined by the interaction between characters, controlled by the user's choices. The active role taken by users in EN has been exploited for educational purposes through the introduction of role-play elements, allowing children to become aware of the consequences of their actions by acknowledging the response triggered in the virtual characters with which they interact. [24].

Most of the projects listed above and many similar others with potential of enriching educational experiences have a limited adoption rate. In trying to tap the possibilities as well as obstacles of extending the range of coverage of such projects, let us look, apart from our experience, at the successful implementation of one project in which a story authoring tool has been used by tens of thousands of children.

StoryBuilder [25], produced by CBC4Kids (Canadian Broadcasting Corporation) is a web-based tool which enables children to create multimedia commix-style stories in three modalities: contribute to an on-going story by adding the next page; use pre-existing elements to create a story from scratch; collaborative page-by-page creation

of a story among friends by editing and sending it by email. The project encountered wide success, with over 150,000 visits to the site and 2,200 submissions during the four months pilot phase. In this project, wide adoption was facilitated by a series of factors ranging from the simplicity of the tool (balancing the aim to leave space for creativity and the constraints of using ready-made story elements), easy access (log-in was required only after a submission was created), an easy-to-appropriate storytelling style based on comic-books conventions, flexibility, as well as the existence of various modes of contribution and various types of collaboration.

While success projects of wide adoption of authoring tools such as StoryBuilder are still few, digital storytelling found its way in the curriculum of many schools without making use of custom-made story authoring tools. By using regular video-editing software (from Windows MovieMaker to Apple Final Cut Pro) and sets of guidelines for creating compelling stories, teachers have engaged students in telling digital stories across a wide range of disciplines. These initiatives (e.g. [26-29]) prove that the motivation and the interest to integrate digital storytelling in the curriculum exist, and also pinpoint that low costs, simplicity and wide availability of authoring tools are essential aspects for its integration.

## 4 Conclusions

Few existing research investigate a massive, long term use of digital storytelling tools for educational purposes in real scholarly contexts. This paper has discussed the lessons learnt from a wide study carried on in the context of a three-years project – PoliCultura – during which we could explore how a multimedia storytelling tool has been used by around 7,620 students – in a wide number of Italian educational institutions of all grades - from pre-schools to high schools, from 2006 to 2009.

Current research on digital storytelling has been largely focused on developing and evaluating new systems and new forms of user experiences [10], [14-16], [18-19]. They oftentimes involve a sophisticated integration of different technologies and ad hoc devices, and are typically adopted for a relatively short time in real school contexts before being definitively abandoned. Indeed, such "high-tech" solutions require the availability of high budget and ICT specialists, and are seldom affordable by a typical educational context and sustainable in the medium-long term.

Our study has pinpointed some fundamental factors for large-scale, prolonged, and repeated use of storytelling authoring systems in schools: the pivotal role of teachers as drivers for adoption, low-cost, low-tech, simplicity of the tools, and availability of methodological support to the development process.

Our study has also highlighted that easy-to-understand, built-in narrative formats constrain some design aspects of a digital story but indeed simplify the use of an authoring tool, and foster its adoption without preventing students to express their creativity and to invent original narrative forms. A simple (albeit powerful) system as "1001stories" has an apparent rigidity (the predefined two-level structure of the story), but our studies have shown that creative teachers and pupils can circumvent such constraints and use the tool in original and effective ways: The variety of solutions developed by PoliCultura participants (in terms of rhetoric arrangement and

styles) is amazing and very interesting, and we have started a research project to systematically analyze them.

Finally, we have pinpointed various types of measurable benefits derived from a non episodic engagement of learners with digital storytelling activities at *collective* level, i.e., when the full class is involved as a whole. Collective storytelling is quite different from individual story-telling, where an individual (even if part of a community) is called to express his/her own narrative. In a collective storytelling activity, educational benefits are global for the participants, measurable at the levels of acquisition of knowledge and skills, but also at the level of shared expression forms and facilitated social interaction.

# References

1. Di Blas, N., Bolchini, D., Paolini, P.: Instant Multimedia: A New Challenge for Cultural Heritage. In: Bearman, D., Trant, J. (eds.) Museums and the Web (2007), http://www.archimuse.com/mw2007/papers/diBlas/diBlas.html (accessed July 7, 2009)
2. Di Blas, N., Garzotto, F., Poggi, C., Torrebruno, A.: Instant Multimedia for Educational Setting: A Success Story. In: ED-MEDIA 2008, pp. 538–544. AACE, Chesapeake (2008)
3. Di Blas, N., Boretti, B.: Interactive storytelling in pre-school: a case-study. In: 8th International Conference on Interaction Design and Children, pp. 44–51. ACM, New York (2009)
4. Library of storytelling examples produced by schools as part of the PoliCultura Project, http://www.policultura.it/background (accessed September 16, 2009)
5. Clark, H.H.: Using Language. Cambridge University Press, Cambridge (1996)
6. Brown, J.S., Collins, A., Duguid, P.: Situated cognition and the culture of learning. Educational Researcher 18(1), 32–42 (1989)
7. Garzotto, F., Paolini, P.: Bringing Cultural Heritage into Primary School Classrooms through Web technology: The "Milano Romana Tecnologica" Case-Study. In: Bearman, D., Trant, J. (eds.) Museums and the Web 2008, pp. 103–115. Archives & Museum Informatics, Montreal (2008)
8. Krathwohl, D.R., Bloom, B.S., Masia, B.B.: Taxonomy of Educational Objectives: The Classification of Educational Goals. In: Handbook II: Affective Domain. David McKay Co., Inc., New York (1964)
9. US National Commission on Library and Information Science: The Prague Declaration: Towards an Information Literate Society (2003), http://www.infolit.org/international_conference_2003/PragueDeclaration.pdf (accessed July 7, 2009)
10. Decortis, F., Rizzo, A.: New active tools for supporting narrative structures. Personal and Ubiquitous Computing 6(5-6), 416–429 (2002)
11. Madej, K.: Towards digital narrative for children: from education to entertainment, a historical perspective. Computers in Entertainment 1(1), 1–17 (2003)
12. Kritzenberger, H.: Architectures for constructive multimedia learning environments: challenges for narrative teaching models. In: ED-MEDIA 2004, pp. 88–95. AACE, Chesapeake (2004)
13. Richard, C., Williams, D., Ma, Y.: Implications of Narrative and Interactive Narrative for the Design of Problem-based Learning Environments. In: ED-MEDIA 2006, pp. 2410–2414. AACE, Chesapeake (2006)

14. Cassell, J., Ryokai, K.: Making Space for Voice: Technologies to Support Children's Fantasy and Storytelling. Personal Ubiquitous Computing 5(3), 169–190 (2001)
15. Druin, A., Stewart, J., Proft, D., Bederson, B., Hollan, J.: KidPad: a design collaboration between children, technologists, and educators. In: CHI 1997, pp. 463–470. ACM, New York (1997)
16. Hourcade, J.P., Bederson, B.B., Druin, A., Taxén, G.: KidPad: collaborative storytelling for children. In: CHI 2002 Extended Abstracts, pp. 500–501. ACM, New York (2002)
17. Stanton, D., Bayon, V., Neale, H., Ghali, A., Benford, S., Cobb, S., Ingram, R., O'Malley, C., Wilson, J., Pridmore, T.: Classroom collaboration in the design of tangible interfaces for storytelling. In: CHI 2001, pp. 482–489. ACM, New York (2001)
18. Ryokai, K., Cassell, J.: StoryMat: a play space for collaborative storytelling. In: CHI 1999 Extended Abstracts, pp. 272–273. ACM, New York (1999)
19. Garzotto, F., Forfori, M.: FaTe2: storytelling edutainment experiences in 2D and 3D collaborative spaces. In: 5th International Conference on Interaction Design and Children, pp. 113–116. ACM, New York (2006)
20. Bruckman, A.: MOOSE Crossing: Construction, Community and Learning in a Networked Virtual World for Kids. Ph.D. thesis. MIT, Cambridge (1997)
21. McKinley, B., Lee, Y.: Mystorymaker. In: CHI 2008 Extended Abstracts, pp. 3219–3224. ACM, New York (2008)
22. Marshall, P., Rogers, Y., Scaife, M.: PUPPET: a Virtual Environment for Children to Act and Direct Interactive narratives. In: 2nd Workshop on Narrative and Interactive Learning Environments, Edinburgh, UK (2002)
23. Aylett, R.: Narrative in Virtual Environments - Towards Emergent Narrative. In: Mateas, M., Sengers, P. (eds.) Narrative Intelligence. Papers from the 1999 Fall Symposium. Technical Report FS-99-01, pp. 83–86. AAAI Press, Menlo Park (1999)
24. Figueiredo, R., Brisson, A., Aylett, R., Paiva, A.: Emergent stories facilitated. In: Spierling, U., Szilas, N. (eds.) ICIDS 2008. LNCS, vol. 5334, pp. 218–229. Springer, Heidelberg (2008)
25. Antle, A.: Case study: the design of CBC4Kids' StoryBuilder. In: 2nd Int. Conf. on Interaction Design and Children, pp. 59–68. ACM, New York (2003)
26. Feher, P.: Towards effective student-centered, constructivist learning: Build Your Own Digital Story! In: ED-MEDIA 2008, pp. 2364–2367. AACE, Chesapeake (2008)
27. Oliveira, A., Roso, M., Miranda, R.: Construction of Collective Imagetic Narratives: Challenges in Teaching and Learning Processes within the Digital Culture. In: ED-MEDIA 2008, pp. 2998–3006. AACE, Chesapeake (2008)
28. Susono, H., Shimomura, T., Kagami, A., Ono, E.: Creating Digital Stories by College Students in Project Based Learning. In: ED-MEDIA 2008, pp. 2730–2734. AACE, Chesapeake (2008)
29. Pierre, F.: Krik Krak: Eyewitness to My Heritage, a Digital Storytelling Tale. In: Proc. ED-MEDIA 2006, p. 2602. AACE, Chesapeake (2006)

# Comparing Effects of Different Cinematic Visualization Strategies on Viewer Comprehension

Arnav Jhala[1] and R. Michael Young[2]

[1] University of California, Santa Cruz, CA - 95064
jhala@cs.ucsc.edu
[2] North Carolina State University, Raleigh, NC - 27606
young@csc.ncsu.edu

**Abstract.** Computational storytelling systems have mainly focused on the construction and evaluation of textual discourse for communicating stories. Few intelligent camera systems have been built in 3D environments for effective visual communication of stories. The evaluation of effectiveness of these systems, if any, has focused mainly on the run-time performance of the camera placement algorithms. The purpose of this paper is to present a systematic cognitive-based evaluation methodology to compare effects of different cinematic visualization strategies on viewer comprehension of stories. In particular, an evaluation of automatically generated visualizations from Darshak, a cinematic planning system, against different hand-generated visualization strategies is presented. The methodology used in the empirical evaluation is based on QUEST, a cognitive framework for question-answering in the context of stories, that provides validated predictors for measuring story coherence in readers. Data collected from viewers, who watch the same story renedered with three different visualization strategies, is compared with QUEST's predictor metrics. Initial data analysis establishes significant effect on choice of visualization strategy on story comprehension. It further shows a significant effect of visualization strategy selected by Darshak on viewers' measured story coherence.

**Keywords:** Intelligent Camera Control, Computational Models of Narrative, Discourse Comprehension, Visual Discourse.

## 1 Introduction

The automatic generation and communication of narrative are long-standing research areas within Artificial Intelligence [15,11,13,4]. To date, much of the research on story generation has focused either on computational models of plot and the construction of story events or on the communication of a given story with text. Problems central to the work on textual communication of a narrative have much in common with challenges found in the generation of other genres of natural language discourse, including the critical issues of content determination (what propositions should appear in the text) and ordering (how should the propositions describing a story be ordered so as to present a coherent story to a reader).

Text-based storytelling systems (e.g., [4]) typically build upon computational models of discourse generation in order to produce coherent narratives. While these text-based

I.A. Iurgel, N. Zagalo, and P. Petta (Eds.): ICIDS 2009, LNCS 5915, pp. 26–37, 2009.

systems have been successful within the text medium, less attention has been focused on techniques for the creation of effective *cinematic* discourse – the creation of narrative told using a virtual camera operating within a 3D environment. As we know from our experiences as film-watchers, cinema is a powerful and effective medium for communicating narratives. In this paper, we describe an evaluation of computational techniques for constructing cinematic discourse, i.e. communication of stories through the visual medium. We evaluate the coherence of the story through indirect measurement obtained from viewers' judgements about the goodness of answers provided to question-answer pairs pertaining to stories viewed as cinematic sequences.

We present an evaluation of cinematic discourse generated by Darshak, an existing visual discourse planning system, with our novel experimental design. In Darshak [10,9] the cinematic conventions developed by film-makers are represented as action operators within a planning framework. These operators are used by a specialized planning algorithm that constructs visual discourse plans containing cinematic actions. Camera shots are represented as primitive operators that manipulate the beliefs of viewers about the state of the story world. Abstract operators are used to define patterns of storytelling and impose constraints on lower-level shots and shot sequences.

To evaluate the coherence of the cinematic discourse produced by Darshak, we present a detailed user evaluation that exploits techniques first used to evaluate QUEST [8], a cognitive model of question-answering in the context of stories. Results from our initial experiments show that choice of visualization strategy significantly affects viewer comprehension, and that cinematics generated by the system using an intentional model of communication result in improved comprehension over naive approaches. Our experimental design itself is a significant contribution toward cognition-based evaluation of cinematic narrative discourse generation systems.

A bipartite representation of narrative proposed by Chatman [14] is employed, describing narrative as containing both story and discourse. The story level includes the story world with all its content, characters, actions, events, and settings. The discourse level involves the telling of the narrative – the ordering of the events in the story chosen for recounting,and the lingiustic communicative actions used to tell the story. In this paper, the focus is on the evaluation of automatically generated discourse level content, specifically narrative discourse that is communicated visually through the use of cinematic conventions.

One central problem in automatic generation of cinematic narrative discourse is the selection of viewpoints in 3D space that follows cinematic conventions and communicates the elements of the narrative unfolding the in 3D environment. Previous work on intelligent camera control has focused mainly on the graphical placement of the camera to satisfy given cinematic constraints [3,12,6]. Less attention has been paid on informing the placement of the camera based on the context of the story events [1,9]. Evaluation of these camera systems have either been based on runtime performance [7], or the efficacy of user-modeling based on specific interaction models in interactive scenarios [2]. Unlike other camera control systems, the Darshak system [9,10] incorporates an explicit representation of the story elements and constructs camera plans using plan operators that encode cinematic conventions. This paper presents an evaluation of the

output of the Darshak system with specific focus on measuring the coherence of the stories perceived by viewers on watching the movie clips automatically generated by the system.

## 2   Effective Cinematic Narrative Discourse

Within the context of our work, *cinematic narrative discourse* is a recounting of events occurring in a 3D graphical story world using a virtual camera. In this regard, events – and the world-state transitions that they prompt – are central to the notion of narrative. Linked to these events and state transitions are story world elements like settings, objects, characters and their internal beliefs, desires, plans, and goals. Film directors and master storytellers take advantage of these properties of stories and exploit them to craft interesting recountings or telling for these stories. Cinematics crafted by experts through manipulation of these properties are effective when viewers find the stories communicated by them coherent and the visualizations aesthetically pleasing. In order to produce a system that generates effective cinematics, we define three properties of the narrative, specifically saliency, coherence, and temporal consistency. We have designed a cinematic discourse generation algorithm to produce cinematics that demonstrate these properties in the narratives it produces. While these properties have not been explicitly addressed in previous approaches to the automatic generation of story visualizations, we claim that these properties are central to the comprehension of cinematic narrative.

*Selection of salient elements:* Salient elements in a cinematic discourse are elements from the story (e.g., events, char- acters, objects, the relationships between them) that are relevant to inferences needed for comprehension. When stories are narrated through any medium, it is the narrator's responsibility to utilize the properties of the medium to maintain the engagement of the audience by providing them with the relevant information at the right times during the story's telling. It is important for effective narrative discourse to maintain the focus of the audience on these salient story elements. Inclusion of extraneous elements that are not part of the causal chain of the story or leaving out necessary details of the story can interfere with the audience's comprehension process and prevent them from enjoying the narrative experience. Choices made by a narrative generator regarding the content from the story to include in its telling directly affect salience and thus comprehension.

*Plot coherence:* Plot coherence can be described as the perception by the audience that the main events of a story are causally relevant to the outcome of the story. This definition of plot coherence is taken from the *Fabulist* story generation system [13].

In our work, plot coherence relates specifically to the the perceived understanding of the causal relationships between events that a viewer constructs during narrative comprehension. If events narrated to an audience seem unrelated to the story's final outcome, then the audience may make incorrect inferences about the narrative and the narrative discourse may fail to achieve the author's communicative goals.

*Temporal consistency:* In this work, temporal consistency refers to the consistency in the timing of the changes in a camera's position and its movement in relation to the

events that are being filmed in the virtual world. Temporal consistency is important, as it is closely linked to the established conventions of cinematography readily identified by viewers. Any inconsistencies in the timing or placement of a camera affects the communicative meaning of the shot perceived by the audience. For example, moving the camera off its subject too early while filming an action leaves the viewer confused about the completion of the action and may introduce an unintended infer- ence in the mind of the viewer. Viewers have grown familiar with many cinematic idioms that are routinely used to indicate directors' specific communicative intentions. It is thus important for a visual discourse generation system to be able to reason about appropriate temporal relationships between camera movement and story events executing in a 3D environment.

## 3   Visual Discourse Generation

Our approach for generating visual discourse is based on the Darshak system developed by Jhala and Young [9,10]. [1] In this approach, cinematic discourse is generated by a hierarchical partial order causal link planner. The system takes as input an operator library, a representation of a story to be told, and a set of communicative goals relating to the story's telling. The operator library contains a collection of action operators that represent camera placement actions, transitions, abstract cinematic idioms and narrative patterns. Camera placement and transition actions, represented as primitive operators, have preconditions that encode continuity rules in cinematography and effects that alter a viewer's focus of attention. Operators representing abstract cinematic idioms and narrative patterns encode recipes for sequencing primitive or abstract operators and have effects that change the beliefs of a viewer about the story world and the actions in it.. The story to be told is input as a plan data structure that contains the description of the inital state of the story world, a set of story goals, and a totally ordered sequence of actions composing the story and the causal relationships between them. The input story plan is added to the knowledge base for the discourse planner in a declarative form using first-order predicates that describe the elements of the data structure, allowing the discourse-level plan operators to refer to story-level elements. The communicative goals are given to the system as a set of beliefs to be achieved in the mental state of the viewer.

The cinematic discourse planning algorithm performs both causal planning and temporal scheduling. To build a discourse plan, it selects camera operators from the operator library and adds them to the plan in order to satisfy specific communicative goals or preconditions of other communicative actions already in the plan. The algorithm binds variables in the camera operators, like a shot's start-time and end-time, linking them to corresponding actions in the story plan.

The output of the planning algorithm is a plan data structure containing a temporally ordered hierarchical structure of camera operators with all operator variables bound. This camera plan is combined with the story plan and is sent to an execution manager running on a game engine. The execution manager dispatches both story and camera

---

[1] Space limitations prevent a full description of the Darshak system. Readers are encouraged to see [9,10] for more detail.

actions on the game engine through objects that represent code for performing the action in the engine. In the game engine, story action function calls affect the physical state of the 3D world, such as movement of characters. Camera actions impose viewing constraints on the game world's virtual camera. A constraint-solving algorithm constantly checks the viewing constraints and maintains the camera's parameters (location and orientation) such that the constraints set by the camera actions are satisfied.

## 4   Empirical Evaluation

Evaluation of intelligent camera control systems is a challenging problem [7], primarily because there are several dimensions across which camera systems can be measured. Most current camera systems are evaluated based on their performance in terms of speed of calculating camera positions rather than their effectiveness at telling stories. While it is difficult to evaluate stylistic capabilities of such systems, it is possible to evaluate their efficacy in communicating the underlying narrative content. In this paper, we introduce an experimental design useful for comparing the effectiveness of different visualization strategies in communicating a story. Our approach is based on established cognitive models of story understanding [8] that have been successfully used to evaluate plan-based computational models of narrative [5,13].

To evaluate the efficacy of different visualization strategies, we prepared three visualizations of the same story, one with a fixed camera position within the setting, one with an over-the-shoulder camera following the protagonist, and one driven by a camera plan automatically generated by Darshak, a discourse planning algorithm [10]. Our purpose for running these experiments was two-fold: First, we want to investigate whether visualization strategies do indeed affect comprehension. Second, we sought to evaluate the quality of visualization generated by Darshak using a representation of camera shots as communicative actions. That is, we sought to determine whether visualizations generated by Darshak are coherent (as measured by viewers' perceptions of the attributes of the underlying stories). Empirical evaluation of such a subjective metric is challenging because a) viewers rarely share a common definition of coherence and so cannot be asked directly to give judgement on coherence, b) viewers differ in the relative magnitudes of values used to judge coherence, so the values they report cannot be directly mapped to a uniform scale across subjects, c) coherence is a property of both the cinematic discourse and the fabula plan itself, making the evaluation of the discourse difficult to separate from effects created by the underlying story. Any evaluation of the communicative elements must take into account this inherent coherence in the fabula itself, and d) it is difficult to control for the subjective opinions of subjects regarding coherence that are significantly influenced by extraneous factors such as the quality of character dialog or 3D animations.

In order to evaluate the effectiveness of various cinematic visualization techniques, we sought to measure how effective these techniques were at conveying the story structure that lies beneath the cinematic discourse. Because the underlying story elements in our system were defined as plan data structures themselves, we made use of previous work [5,13] relating these data structures to the mental models that users form during comprehension. To do this, we employ Christian and Young's mapping from plan data

structures onto a subset of the conceptual graph structures that model narrative defined by Graesser, et al, in their work on QUEST, a psychological model of question answering [8].

In the QUEST model [8] stories are represented as conceptual graph structures containing concept nodes and connective arcs. These graphs are called QUEST Knowledge Structures (or QKSs). They describe the reader's conception of narrative events and the relationships between them. Nodes and arcs in a QKS structure are based on their purpose in the narrative. For instance, if nodes A and B are two events in a story such that A causes or enables B, then A and B are represented by nodes in the QKS graph and are connected by a Consequence type of arc.

Techniques used by Graesser et. al. to validate the QUEST model were based on goodness-of-answer (GOA) ratings for question-answer pairs about the story shown to readers. In this approach, subjects read a short story, then were presented with a set of question-answer pairs relating to events in the story. For each pair, subjects were asked to provide a rating that measured how good the subject felt that the answer was an appropriate and accurate response to the question. GOA ratings obtained from their subjects were compared to ratings predicted by the QUEST model (QUEST supports questions of types why, how, when, enablement, and consequence). Graesser, et al's intent was to validate the QUEST algorithm as a model of human question-answering in the context of stories – the more closely QUEST's GOA ratings were to human subjects' responses over a large group of question-answer pairs, the more evidence was provided that QUEST's underlying question-naswering model matched human performance. We make use of QUEST and its well-supported validation to gauge the mental models build by viewers as they watch cinematics, seeking to determine if these models capture specific relationships between events in a story.

Within the QUEST model, each event and goal is represented as a node in the QKS structure. The links in a QKS structure represent the different types of relationships between events and character goals within a story. Consequence(C), : The terminal event node is a consequence of the initiating event node. Reason(R), : The initiating goal node is the reason for the terminating event node. Initiate(I), : The initiating event node indicates a terminal goal node. Outcome(O), and : The terminal event node is the outcome of the initiating goal node. Implies(Im) are the types of relationship arcs between event and goal nodes in a QKS structure. : The initiating event node implies the terminal event node.

The algorithm for converting a POCL plan data structure to the corresponding QKS structure is shown in Figure 1. In our experiments, we first convert our story, represented as a plan data structure, into a corresponding QKS structure. Predictor variables proposed in the QUEST model can be used to calculate predictions for the goodness of answer (GOA) ratings - the measure of good- ness of answer for a question/answer pair related to the events in the story. These GOA ratings are compared against data collected from participants who watch a video of the story filmed using static master-shots. The experiments measured the effectiveness of the QKS generated from a plan structure in predicting the Goodness of Answer (GOA) ratings given by the viewers.

GOA ratings in the models proposed by Graesser et.al. are determined through QUEST's predictor variables. The three predictors that are correlated to the GOA

Let n be the number of top-level goals of plan P and let m be the number of steps in P.

1. Create a total ordering o for the m steps in P that is consistent with the ordering constraints of P.
2. For each goal $g_i$ of plan P for i=1, ..., n, convert $g_i$ into a goal node $G_i$.
3. For each plan step $s_j$ for j=1, ..., m starting wiht the last step in o.
   a. Convert $s_j$ into a goal node $G_j$ and an event node $E_j$
   b. Link $G_j$ to $E_j$ with an outcome arc.
4. For each causal link in P connecting two steps $s_1$ and $s_2$ with condition c, connect the event node $E_1$ to the event node $E_2$ with a consequence arc.
5. For each causal link $<s_1,p,q,s_2>$ in P connecting two steps $s_1$ and $s_2$, connect $G_1$ to $G_2$ with a reason arc.

**Fig. 1.** Algorithm for converting a POCL plan data structure to corresponding QKS

ratings are arc search, constraint satisfaction, and structural distance. Users who participated in our experiments were shown a video of a story through fixed viewpoints in a virtual world. They were then given question/answer pairs from the story and were asked to rate the quality of answers. These results were compared to the GOA ratings predicted by the QKS structure based on the underlying DPOCL plan. 15 participants were randomly assigned to three groups with different categories of questions of the forms: how, why and what enabled.

## 4.1  Method

**Design.** Two stories (S1 and S2) and three visualization strategies were used for each story (V1-fixed camera, V2-over-the-shoulder camera angle, and V3-Darshak driven camera) yielding 6 treatments. Here treatments are identified by labels with story label as prefix followed by the label of the visualization. For instance, S2V1 treatment refers to a visualization of the second story(S2) with fixed camera angle strategy (V1) Participants were randomly assigned to one of 6 groups (G1 to G6). Each participant was first shown a video and then asked to rate question-answer pairs of three forms of how, why and what enabled. The process was repeated for each subject with a second video.

For this experiment, 30 subjects were divided into Youden squares experimental design. Accordingly 6 subject groups of 5 subjects each were distributed across 6 treatments. This design was chosen in order both to account for the inherent coherence in the fabula and to account for the effects of watching several videos in order. Assuming a continuous response variable, the experimental design, known as a Youden square, combines Latin Squares with balanced, incomplete block design(BIBD). The Latin Square design is used to block on two sources of variation in complete blocks. Youden squares are used to block on two sources of variation - in this case, story and group - but cannot set up the complete blocks for latin squares designs. Each row (story) is a complete block for the visualisations, and the columns (groups) form a BIBDs. Since both group and visualisation appears only once for each story, tests involving the effects of visualisation are orthogonal for those testing the effects of the story type; The Youden square design isolates the effect of the visual perspective from the story effect. The stories for this experiment consisted of 15 steps corresponding to 70 QKS state/event-goal nodes. These numbers were chosen in order to keep the story lengths comparable to those used

**Table 1.** 2x3 Youden squares design for the experiment. G1 through G6 represent 6 groups of participants with 5 members in each group. They are arranged so that each story and visualization pair has a common group for other visualizations.

| Viz | Master Shot | Over The Shoulder | Darshak |
|-----|-------------|-------------------|---------|
| S1  | G1,G4       | G2,G5             | G3,G6   |
| S2  | G5,G3       | G6,G1             | G4,G2   |

in earlier experiments [5,13]. The algorithm for converting plan data structures to QKS graphs is identical to that used in Christian and Young [5] and is shown for reference in Figure 1. The QKS graph of one of the stories used in the experiment is shown in Figure 2. Each story used in the experiment had 70 QKS nodes. Of the 70 QKS nodes, 10 and 12 questions were generated from randomly selected and converted to one of the three question types supported by QUEST: how, why, and what enabled. For each of the 10 questions, approximately 15 answer nodes were be selected from nodes that were within a structural distance of 3 in the QKS graph generated from the story data structure. These numbers were chosen to have similar magnitude to the previous experiments, for better comparison. Each story used in the experiment had 70 QKS nodes. Of the 70 QKS nodes, 10 questions were generated from randomly selected QKS elements and converted to one of the three question types supported by QUEST: how, why, and what enabled. For each of the 10 questions, approximately 15 answer nodes were selected from nodes that were within a structural distance of 3 in the QKS graph generated from the story data structure. These numbers were chosen to have similar magnitude to Christian and Young's previous experiments, for better comparison.

**Procedure.** Each participant went through three stages during the experiment. The entire experiment was carried out in a single session for each participant. Total time for a single participant was between 30 and 45 minutes. Initially, each participant was briefed on the experimental procedure and was asked to sign the consent form. They were then asked to read the instructions for participating in the study. After briefing, they watched a video of one story with a particular visualization according to the group assignment (Table 1). For each video, users provided GOA ratings for the question-answer pairs related to the story in the video. Participants were asked to rate the pairs along a four point scale (good, somewhat good, somewhat bad, bad). This procedure is consistent with earlier experiments [5,8] Next, they watched a second video with a different story and visualization followed by a questionnaire about the second story. The videos were shown in different orders to common groups in order to account for discrepancies arising from the order in which participants were shown the two videos.

## 5   Results

The mean overall GOA ratings recorded for the two stories are shown in Table 2 along with the standard deviations. These distributions of GOA scores do not present any problem for multiple regression analyses as the means do not show ceiling or floor

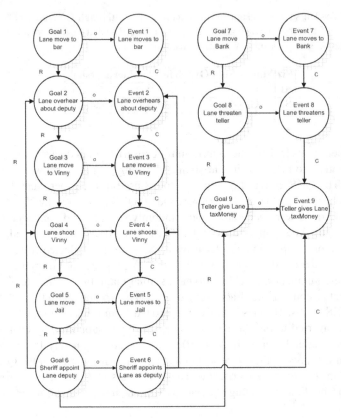

**Fig. 2.** QKS structure for one of the stories from the experiment. Goal and Event nodes from the story are represented by circles. Relationships between nodes is indicated by arrows which are labeled respectively as Reason(R), Consequence(C), and Outcome(O).

effects. The standard deviations are high enough to rule out the potential problem of there being a restricted range of ratings.

The GOA numbers shown in Table 2 indicate on preliminary observation that the GOA ratings for V1(Master Shot) and V3(Darhsak) are significantly closer than V2(Over-the-Shoulder shots). The standard deviations for V3 are lower than the other treatments in both stories. This indicates that participants converge better on rating questions in Darshak generated visualization. An interesting observation for V2 is that in story 2 the mean GOA ratings are significantly lower than the other two treatments with a significantly high standard deviation. These figures support the intuition that participants form their own interpretation of events in the story while looking at shots that are over-the-shoulder leading to the wide disparity in ratings in going from story 1 to story 2. While mean ratings provide an overall idea of the participant's responses, it is interesting to observe disparity in GOA ratings for individual questions across different visualizations. Figure 3 summarizes mean GOA ratings for individual questions related to story 1 for the three visualization treatments. Question numbers 1, 8, and 10

**Table 2.** Mean GOA ratings and standard deviations from the experiment

| GOA(stddev) | V1 | V2 | V3 |
|---|---|---|---|
| S1 | 1.69 (0.91) | 1.74 (0.82) | 1.70 (0.79) |
| S2 | 1.76 (0.59) | 1.51 (0.67) | 1.78 (0.59) |

are particularly interesting as there is a significant difference in the GOA ratings for the master shot visualiztion and the other two treatments, which have quite similar ratings. The question-answer pairs in discussion here are presented below: Why did Lane challenge Vinny? A. Because he wanted to kill Vinny. Why did Lane challenge Vinny? A. Because Lane wanted to steal tax money. Why did Lane meet Sheriff Bob? A. Becaue Lane needed a job. In Q1 and Q10 the ratings for V1 are significantly lower. This could be explained by examining the relationships between the question-answer nodes. In all three cases, the question answer nodes are two or more arcs away in distance along the causal chain of events. In case of the arc-search and structural distance predictors from QUEST these are good answers as they do lie on a causal chain of events leading to the question. The necessity and sufficiency constraints in the constraint satisfaction predictor reduce the strength of the answer. In Q1, for example, it is not necessary for Lane to challenge Vinny. He could just shoot him right away. This is an interesting case where users who were familiar with the gunfight setting chose to label the challenge as being an important step in killing Vinny. In a master-shot the gunfight sequence was not even recognized as a gunfight by most participants. Figure 4 shows the average ratings for each question for the second story. The interesting responses are the ones that have a significant difference in mean ratings across different visualizations. In this story, unlike story 1, the differences between ratings were relatively smaller. The interesting observations, however, were the ones where one of the treatments rated the answer as a 'bad' answer (rating $< 1.5$) and the other treatments rated the answer as a 'good' answer (rating $> 1.5$).

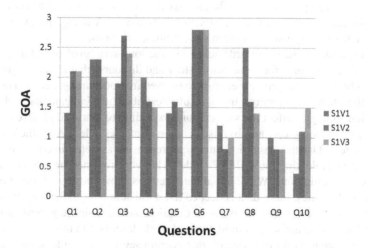

**Fig. 3.** GOA ratings for Story 1 across the three visualization strategies

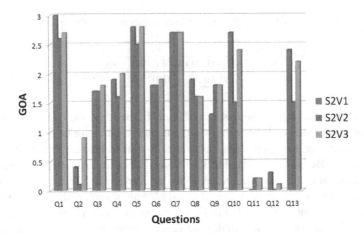

**Fig. 4.** GOA ratings for Story 2 across the three visualization strategies

## 6   Conclusion and Future Work

Camera shots can be seen as intentional communicative actions used to manipulate the beliefs of viewers. In this paper we briefly described a representation of narrative patterns and cinematic idioms as plan operators and a reasoning algorithm for constructing visual narrative discourse. Further, we presented a novel evaluation technique to measure effectiveness of intelligent camera control systems to communicate a story and an experiment that used the methodology to evaluate our cinematic discourse generator. The evaluation is based on an established cognitive model of story comprehension. We also presented an experimental design to compare several different visualization strategies. Our initial results are encouraging. We found significant differences between GOA ratings obtained from participants viewing different visualizations of the same stories in support of our hypothesis that different visualization strategies did affect comprehension. We also found significant correlation between GOA ratings predicted by the QUEST predictors and two of the three visualization strategies.

These experiments serve towards achieving the long-term goal of defining cognitively plausible structures for representing story and discourse that a) can be generated automatically and b) is expressive enough to be used in procedural generation of narratives in rich virtual environments. Initial results described here indicate that a) different visualization strategies affect the viewer's understanding of stories that have the same underlying fabula structure, and b) Visualization strategies selected by the discourse planning system, Darshak result in better comprehension as determined by the experiments used in evaluating the QUEST model. The work reported here is preliminary and has several limitations. While initial data analysis shows positive correlation with predicted GOA ratings, more data is needed to establish how visualization strategy affects comprehension for specific types of question-answer pairs (e.g. why, how, and what enabled). There are several limitations of work described in this paper. First, it is difficult to get subjects for experiments that contain several long videos and questionnaires. For this reason, the stories used for the experiments were short and the GOA

ratings were only solicited for a subset of question-answer pairs. Second, while there was consistency across the visualizations measure here, the effect of parameters like the visual appeal of the graphical engine, facial expressions and animations of characters, etc. needs to be studied further. This work does not include all the elements of the QUEST model as there is no direct mapping from plan structure to certain elements. Richer representation of story elements is needed for incorporating all the elements in the cognitive model. Future work will extend the plan representation to account for elements of the QUEST structure that do not feature in the current conversion algorithm. Further experiments are needed to isolate specific effects of presentation strategies on on viewer comprehension.

# References

1. Amerson, D., Kime, S., Young, R.M.: Real-time Cinematic Camera Control for Interactive Narratives. In: ACM ACE, Valencia, Spain, p. 369 (2005)
2. Bares, W., Lester, J.: Cinematographic User Models for Automated Realtime Camera Control in Dynamic 3D Environments. In: User Modeling, Vienna, Austria, pp. 215–226 (1997)
3. Bares, W., McDermott, S., Boudreaux, C., Thainimit, S.: Virtual 3D Camera Composition from Frame Constraints. In: ACM Multimedia, Los Angeles, USA, pp. 177–186 (2000)
4. Callaway, C.: Narrative Prose Generation. Artificial Intelligence 139, 213–252 (2002)
5. Christian, D., Young, R.M.: Comparing Cognitive and Computational Models of Narrative Structure. In: AAAI, San Jose, USA, pp. 385–390 (2004)
6. Christianson, D., Anderson, S., He, L., Salesin, D., Weld, D., Cohen, M.: Declarative Camera Control for Automatic Cinematography. In: AAAI/IAAI, Portland, USA, pp. 148–155 (1996)
7. Christie, M., Machap, R., Normand, J.-M., Olivier, P., Pickering, J.: Virtual Camera Planning: A Survey. In: Smart Graphics, Munich, Germany, pp. 40–52 (2005)
8. Graesser, A.C., Lang, K.L., Roberts, R.M.: Question Answering in the Context of Stories. Journal of Experimental Psychology: General 120(3), 254–277 (1991)
9. Jhala, A., Young, R.M.: A Discourse Planning Approach to Cinematic Camera Control for Narratives in Virtual Environments. In: AAAI, Pittsburgh, USA, pp. 307–312 (2005)
10. Jhala, A., Young, R.M.: Representational Requirements for a Plan-Based Approach to Virtual Cinematography. In: AIIDE, Marina Del Rey, USA, pp. 36–41 (2006)
11. Meehan, J.R.: Tale-Spin, An Interactive Program that Writes Stories. In: IJCAI, Cambridge, USA, pp. 91–98 (1977)
12. Halper, N., Helbing, S., Strothotte, T.: A Camera Engine for Computer Games: Managing the Trade-off Between Constraint Satisfaction and Frame Coherence. In: Eurographics, Manchester, UK, vol. 20, pp. 174–183 (2001)
13. Riedl, M.O., Young, R.M.: An Intent-Driven Planner for Multi-Agent Story Generation. In: AAMAS, New York (2004)
14. Chatman, S.: Story and Discourse: Narrative Structure in Fiction and Film. Cornell University Press, Ithaca (1980)
15. Schank, R.C., Abelson, R.P.: Scripts, Plans, Goals and Understanding: an Inquiry into Human Knowledge Structures. L. Erlbaum, Hillsdale (1977)

# The Motivational Appeal of Interactive Storytelling: Towards a Dimensional Model of the User Experience

Christian Roth[1], Peter Vorderer[1], and Christoph Klimmt[2]

[1] Center for Advanced Media Research Amsterdam (CAMeRA), VU University Amsterdam, De Boelelaan 1105, 1081 HV Amsterdam, The Netherlands
[2] Department of Communication, Johannes Gutenberg University of Mainz, Kleinmann-Weg 2, 55099 Mainz, Germany
pch.roth@fsw.vu.nl, p.vorderer@fsw.vu.nl, klimmt@uni-mainz.de

**Abstract.** A conceptual account to the quality of the user experience that interactive storytelling intends to facilitate is introduced. Building on social-scientific research from 'old' entertainment media, the experiential qualities of curiosity, suspense, aesthetic pleasantness, self-enhancement, and optimal task engagement ("flow") are proposed as key elements of a theory of user experience in interactive storytelling. Perspectives for the evolution of the model, research and application are briefly discussed.

**Keywords:** Interactive storytelling, user experience, enjoyment, entertainment.

## 1 Introduction

Interactive Storytelling applications strive for the intelligent synthesis of diverse computing technologies with inspiring narrative content [1]. By offering the opportunity to participate in, or even co-narrate a story, interactive storytelling applications promise radically new modes of user experiences. But how exactly does it feel to participate in an interactive story? Why should it be enjoyable? So far, very few studies have explored users' experiential qualities in specific interactive storytelling settings (e.g., "Façade": [2], or adventure video games: [3]). The present paper mines entertainment theories from communication science in order to develop conceptual foundations for expanding research on the user experience in interactive storytelling. We thus reflect on the similarities and differences between interactive storytelling environments and 'old entertainment media'. Such a theoretical analysis shall enrich designers' conceptual knowledge on how their applications should function from a user perspective. Moreover, explicating the dimensions of the user experience at the theoretical level is the base for user-centered evaluations of prototypes and for comparing different approaches to interactive storytelling in a systematic, empirical way.

## 2 Conceptual Building Blocks from Past Entertainment Media

Research on the 'past' generations of media entertainment such as literature, film, and video games, is useful to generate conceptual insight for interactive storytelling,

I.A. Iurgel, N. Zagalo, and P. Petta (Eds.): ICIDS 2009, LNCS 5915, pp. 38–43, 2009.

because interactive storytelling combines different ingredients of conventional entertainment, such as cinematics, character development, and user agency (e.g., [1]). We briefly refer to five experiential dimensions that have been found central in research on old entertainment use, most of which have also been discussed already – implicitly or explicitly – with regard to interactive storytelling.

## 2.1 Curiosity

"What will happen next?" This question runs through the mind of users of conventional media entertainment very frequently. Reading a novel, for instance, generates knowledge on characters and situations, which allows readers to conclude about what may happen next, what should happen next, and what is likely to happen next. Good writers attract readers' interest (e.g., [4]), which includes the motivation to learn about what will happen next. Being curious is thus common for users of conventional entertainment, and curiosity occurs in various modes. For instance, in video games, curiosity may refer to the progress of the story, but also to the action possibilities that players can try out ("What will happen if I do this?"). During movie consumption, curiosity may also refer to artistic or formal issues rather than the faith of the characters (e.g., "How will the director visualize this?").

Because various genres of media entertainment build on curiosity so frequently, it is likely that curiosity is pleasant in itself and thus contributes to overall appreciation. Several theorists argue for a psychophysiological base of the pleasantness of curiosity [5] [6]. When curiosity occurs, users (viewers, players etc.) first perceive a state of uncertainty, which comes along with increased physiological activation. To the extent that this uncertainty is not too strong, most users seem to enjoy such (temporary) activation [5]. When uncertainty is reduced (e.g., readers turn the page and find out what actually happens next), users experience a sense of closure or completion, which renders the increased physiological activation a positive, pleasant experience. If the state of curiosity is followed by a surprise (i.e., something unexpected happens), these affective user responses often turn into exhilaration [7]. Entertainment media that generate circles of increased curiosity and resolved curiosity thus create a chain of pleasant affective dynamics.

Such curiosity experiences are important for many interactive storytelling systems [8]. Users can be curious about multiple dimensions, including pre-scripted story progress ("What will happen next?"), interactive story progress ("What will happen if I decide this way?"), system response ("How will this agent respond if I start cursing?") or technological capacity of the system ("How will the system visualize my view into this tunnel?"). Because interactive storytelling systems unite elements from diverse conventional media, they may combine different mechanisms of curiosity, which should result in a high frequency and intensity of curiosity-based affective dynamics.

## 2.2 Suspense

"Will they survive?" For some types of entertainment media, this question occurs in users very frequently, such as in thriller novels, action movies, and shooter games. Because users are left in a state of uncertainty, the related user experience is similar to the (rather pleasant) curiosity process. However, the experiential state typically

referred to as "suspense" is also fueled by aversive emotional components, such as anxiety or empathic concern (e.g., a viewer fearing the defeat of a movie protagonist) [9]. Suspense thus differs from curiosity in the sense that users experiencing suspense have a strong interest in a specific outcome of a story episode, such as "My character must win the fight". In contrast to curiosity, suspense is rooted in emotional involvement with characters. This emotional interest makes users long for specific outcomes and generates the concern that these specific outcomes may not occur. Therefore, suspense is a rather stressful mode of entertainment. However, if the desired outcomes occur, strong experiences of relief and satisfaction occur in most cases ("happy end"; [6]). Research in media psychology suggests that both the aversive stage of suspense and the rewarding relief contribute to user enjoyment (e.g., [9]).

Suspense has been found to occur both in linear entertainment such as novels and in interactive media such as video games [10]. Therefore, interactive storytelling systems are likely to facilitate suspense as well. More precisely, interactive storytelling applications can establish emotional involvement with characters and situations [11], and they may simultaneously generate a perception of personal challenge in users. For example, an interactive crime drama may situate the user in the role of a police detective who is facing the climax confrontation with the villain. At this moment, suspense should be high for narrative reasons (as stakes are high in terms of plot development) and for interactivity reasons (as the user must make the "right" decisions to succeed in the confrontation). Therefore, interactive storytelling systems may also generate unique user experiences because they may facilitate high levels of cyclic suspense and relief experiences.

## 2.3  Aesthetic Pleasantness

"Beautiful!" is another typical user response to different content elements in conventional entertainment media. Such positive evaluations may relate to the physical appearance of characters, landscape imagery, or romantic episodes, for instance; they may also relate to attributes that constitute a media application as a piece of art. For example, movie experts may find the cinematic implementation of a special scene "beautiful". In Oatley's [12] terms, aesthetic pleasantness may thus occur in users "entering the world of the story" and in users who remain "outside of the story" (and rather analyze it as a piece of art). Aesthetic enjoyment has been found to depend on individual preconditions, such as expertise and absorption tendencies [13].

Given the importance of aesthetics in conventional entertainment [14], it is likely that interactive storytelling systems can have profound aesthetic impact on their users. The quality of this aesthetic experience may differ across applications: Some prototypes may facilitate affective responses through 'beautiful' imagery (e.g., digital landscapes). Other applications may address users aesthetic perception with creative plot development, character attributes, dialogue evolution, or puzzle tasks (e.g., as in the "Myst"™ video games). Aesthetic pleasantness shares physiological roots with curiosity and suspense ([5]), yet it is shaped to a stronger degree by individual factors (biography, sense of taste, social status) and is not necessarily bound to uncertainty reduction. In many cases, aesthetic appreciation is linked to users recognizing citations (e.g., a melody from a famous old movie being cited in a contemporary movie).

Consequently, there are many routes that interactive storytelling systems may take to generate aesthetic pleasantness in their users. Especially interactivity and sensory immersion may add to this capacity [1].

## 2.4  Self-enhancement

"We are great!" – Entertainment media of various kinds have been shown to affect users' self-perception and self-worth. Video games have been argued to increase players' self-esteem by providing experiences of success [15] and reward [16]. Another mode of video games affecting player self-perception is identification [17]: Identifying with a game character allows to feel like somebody one desires to be, such as a hero, a rock musician, or a powerful decision maker. Fulfilling desires of being like one wants to be generates positive emotions, and this response of reduced self-discrepancy has been linked to video game enjoyment.

To the extent that interactive storytelling systems facilitate identification with characters and/or provide experiences of competence and success, they are also likely to lift users' self-esteem. The sense of active participation is a plausible mechanism that renders users' self-enhancement an important dimension of the user experience in interactive storytelling: Because users are directly involved (or at least believe to be directly involved) in what happens in the story, they can attribute positive events to themselves (e.g., they make the hero save the world, [2]). Interactivity thus opens the pathway to users' self-enhancement. If users leave an interactive story with the impression "I have achieved something great!", their experience rests on competence and success.

## 2.5  Optimal Task Engagement ("Flow")

"Don't disturb me!" – many video game players can be found strongly engaged in their activity and trying to block out any external input that could distract them. Such players are commonly described as being in the state of 'flow' [18]. Users in the state of flow find themselves resolving a sequence of tasks that is exactly as difficult as they can handle if they work with full dedication, and this experiential state (in the middle between boredom and anxiety) is found highly pleasant in many situations.

Participating in an interactive story by making decisions and pushing a plot line forward can be construed as a task-type of activity, especially since most interactive storytelling applications set rules and limits to what users can decide on and do. Shaping a storyline while complying to such limitations may feel like resolving tasks – just as playing adventure games requires users to solve puzzles to move the story forward. If the timing and difficulty of users' participation in the development of the story is 'right', users may 'get lost' in the activity of giving input, or, more generally speaking, in co-narrating the story. Flow (or similar concepts such as immersion) may thus turn out as an experiential dimension important to users of sophisticated well-structured interactive storytelling systems that provide reasonable challenges and defined tasks to their audience [2] [3].

# 3 Conclusions and Research Outlook

The synopsis of potentially relevant theoretical accounts has revealed a broad range of experiential qualities that interactive storytelling can facilitate. Our approach that is based on entertainment theory converges nicely with the existing case studies on user responses in interactive storytelling that found qualitative evidence for diverse experiential dimensions [2] [3]. The reviewed concepts may turn out useful in further theorizing of what the envisioned synthesis of interactive user agency and (pre-structured) narrative actually could mean (e.g. [1]). It seems already clear that user appreciation of interactive storytelling systems is a multi-level phenomenon: Users are likely to respond to story content (e.g., characters, events), artistic features (e.g., cinematographic aesthetics) and technological features (e.g., curiosity when trying out the interface) alike, either simultaneously or sequentially, which will result in a complex, multifactor explication of what users experience when they engage in an interactive storytelling system.

Expert interviews and experiments with prototype systems for interactive storytelling are now needed to find out whether all of the reviewed five conceptual approaches are relevant and whether there are additional sources of user experience that should be elaborated on the way to a more elaborate model. This way, an advanced theoretical understanding of interactive storytelling from a user perspective will emerge that can support system designers in planning and optimizing their applications and system evaluators in comparing different systems. Standardized measures such as self-report scales should be developed (or adapted from entertainment studies) and tested in order to provide the methodological tools required for assessing the impact of (future) interactive storytelling systems on their users. For this endeavor, social-scientific research must be linked to technological work on prototypes. The present paper marks an attempt to build such disciplinary bridges and provide insight into the social science of media entertainment as a new starting point for user-centered research on interactive storytelling.

**Acknowledgments.** This research was funded by the European Commission (Network of Excellence "IRIS – Integrating Research on Interactive Storytelling" – Project ID 231824). We thankfully acknowledge the Commission's support.

# References

1. Cavazza, M., Lugrin, J.L., Pizzi, D., Charles, F.: Madame Bovary on the Holodeck: Immersive Interactive Storytelling. ACM Multimedia 2007, 651–660 (2007)
2. Milam, D., Seif El-Nasr, M., Wakkary, R.: A Study of Interactive Narrative from User's perspective. In: Furht, D.B. (ed.) Handbook of Digital Media in Entertainment and Arts. Springer, Heidelberg (forthcoming)
3. Mallon, B., Webb, B.: Stand Up and Take Your Place: Identifying Narrative Elements in Narrative Adventure and Role-Play Games. Computers in Entertainment (CIE), Article 6b, 3(1) (2005)
4. Krapp, A.: The Construct of Interest. Characteristics of Individual Interests and Interest-related Actions from the Perspective of a Person-object Theory (Studies in Educational Psychology No. 4). University of the German Armed Forces, Munich (1993)

5. Berlyne, D.E.: Conflict, Arousal, and Curiosity. McGraw-Hill, New York (1960)
6. Zillmann, D.: Sequential Dependencies in Emotional Experience and Behavior. In: Kavanaugh, R.D., Zimmerberg, B., Fein, S. (eds.) Emotion: Interdisciplinary Perspectives, pp. 243–272. Lawrence Erlbaum Associates, Mahwah (1996)
7. Zillmann, D.: Humor and Comedy. In: Zillmann, D., Vorderer, P. (eds.) Media Entertainment: The Psychology of its Appeal, pp. 37–58. Lawrence Erlbaum Associates, Mahwah (2000)
8. Malone, T.W.: Heuristics for Designing Enjoyable User Interfaces: Lessons from Computer Games. In: Thomas, J.C., Schneider, M.L. (eds.) Human Factors in Computer Systems, pp. 1–12. Ablex, Norwood (1984)
9. Vorderer, P., Wulff, H.J., Friedrichsen, M. (eds.): Suspense: Conceptualizations, Theoretical Analyses, and Empirical Explorations. Lawrence Erlbaum Associates, Mahwah (1996)
10. Klimmt, C., Rizzo, A., Vorderer, P., Koch, J., Fischer, T.: Experimental Evidence for Suspense as Determinant of Video Game Enjoyment. Cyberpsychology and Behavior 12(1), 29–31 (2009)
11. Paiva, A., Dias, J., Sobral, D., Aylett, R., Sobreperez, P., Woods, S., Zoll, C., Hall, L.: Caring for Agents and Agents that Care: Building Empathic Relations with Synthetic Agents. In: Proceedings of the Third International Joint Conference on Autonomous Agents and Multiagent Systems, vol. 1, pp. 194–201 (2004)
12. Oatley, K.: A Taxonomy of the Emotions of Literary Response and a Theory of Identification in Fictional Narrative. Poetics 23, 53–74 (1994)
13. Wild, T.C., Kuiken, D., Schopflocher, D.: The Role of Absorption in Experiential Involvement. Journal of Personality and Social Psychology 69(3), 569–579 (1995)
14. Cupchik, G.C., Kemp, S.: The Aesthetics of Media Fare. In: Zillmann, D., Vorderer, P. (eds.) Media Entertainment: The Psychology of its Appeal, pp. 249–265. Lawrence Erlbaum Associates, Mahwah (2000)
15. Vorderer, P., Hartmann, T., Klimmt, C.: Explaining the Enjoyment of Playing Video Games: The Role of Competition. In: Marinelli, D. (ed.) ICEC Conference Proceedings 2003: Essays on the Future of Interactive Entertainment, pp. 107–120. Carnegie Mellon University Press, Pittsburgh (2006)
16. Bateman, C., Boon, R.: 21st Century Game Design. Charles River Media, California (2005)
17. Klimmt, C., Hefner, D., Vorderer, P.: The Video Game Experience as 'True' Identification: A Theory of Enjoyable Alterations of Players' Self-perception. Communication Theory (in press)
18. Csikszentmihalyi, M.: Flow: The Psychology of Optimal Experience. Harper Row, New York (1990)

# Turbulence – A User Study of a Hypernarrative Interactive Movie

Noam Knoller[1] and Udi Ben Arie[2]

[1] Amsterdam School of Cultural Analysis, University of Amsterdam, The Netherlands
knoller@uva.nl
[2] Department of Film and TV, Tel Aviv University, Israel
udiben@post.tau.ac.il

**Abstract.** The goal of this study was to gain insight into the user experience of a recent hypernarrative interactive movie. Turbulence is a feature-length interactive narrative video and emphasising low frequency interaction, simultaneous optional plotlines and seemingly counter-agency moves. Eight participants took part in a phenomenological study of their experience, from which several directions for further study emerge.

**Keywords:** User study, interactive hypernarrative, video.

## 1 Introduction

Within the design space of interactive audio-visual storytelling, long interactive hypernarrative movies are not an overpopulated area. But they do have the longest history within the art form [1]. In 1967, long before the Holodeck, Radúz Činčera presented Kinoautomat - *A Man and His House* at the Montreal Expo. This unique experiment was not followed by a second one for some time, but alongside computer scientific experimentation, artists and film makers have also been coming up with their own interactive movies, such as Tender Loving Care [2], Artificial Changelings [3], Late Fragment [4], and others. This study attempts to gain insight into the user experience of Turbulence [5], a recent feature-length interactive hypernarrative video[1], based on the director's theoretical model, presented in [6].

## 2 Turbulence

Turbulence tells the story of three friends who meet again more than 20 years after they were busted by Israeli police and made to sign incriminating confessions against one another. A love story between two of them is rekindled, disrupting their families. Love or family – which will triumph? The user may try and influence the plot either way. For a full outline of the story and other materials related to this study see [7].

---

[1] We are indebted to Nitzan Ben-Shaul for his generosity and collaboration in studying this work. To order a copy of Turbulence, please contact turbulenceltd@gmail.com

I.A. Iurgel, N. Zagalo, and P. Petta (Eds.): ICIDS 2009, LNCS 5915, pp. 44–49, 2009.

Turbulence's is presented on a PC with a touch screen. Players may press or drag objects within the storyworld, which are shown in close up and highlighted with a glow, while the soundtrack loops for a few seconds. If the user does not interact within a few seconds, action continues. In terms of subject positioning, the player of Turbulence and his/her action remain extra-diegetic, imperceptible to other characters.

There are 15 intervention points (hotspots), although each user during one viewing will typically encounter only some of them.

There are four types of intervention in relation to the story's temporal structure:

1. **User training:** the first 3 hotspots do not affect plot structure and are just a means to explore, learn to recognise the hotspots and feel a degree of local agency [8]
2. **Plot intervention:** at 3 hotspots the user can affect the plot at the story's present.
3. **Alternate plot:** at 4 points the user can branch away to explore alternate, "what if…" plotlines. This is a navigational device.
4. **Retrospective plot intervention:** within the alternate plot lines, the user can intervene to change the course of events, but this time with the knowledge that the story's present has in fact not taken this different course.

## 3   Previous Research

To the best of our knowledge, very little research has been done on user experiences of feature-length interactive hypernarrative video. Nonetheless, some recent studies proved useful to our own work. Friess [9] presents a very controlled study of three versions of a short interactive video, created particularly for the study. The versions differ in rather small details of interface design that nevertheless yield significant changes in the experience, based on the responses of relatively a large pool of respondents (~40 per version) to a standard questionnaire. Milam et al.[10] conducted a phenomenological study of the user experience of 11 players of *Façade*. Their study was qualitative and gave rise to user generated descriptions, which the researchers then interpreted and organised to produce 16 themes.

## 4   Study Design

Turbulence was not created for this study, so a controlled experiment such as [9] was not possible. Considering the time it takes to play Turbulence through (65-85 mins.) we were concerned that a lengthy questionnaire to fill in would be very tedious. We were also concerned that such a questionnaire might frame the subjects' responses so that they fall in line with our preconceptions. In such an exploratory study of a new type of experience, we thought that semi-structured interviews were more appropriate. A template questionnaire (see [7]) ensured a common frame, but it was used by the researchers during the interviews as a script, allowing more in-depth exploration of emerging issues. This methodology was inspired by the phenomenological methodology used in [10]. Similarly to that study, we did not set out to test strong hypotheses, but rather to identify potential hypotheses for further research.

Eight participants took part in the study. The participants were a diverse group, ranging in age between 25-49, 2 women and 6 men. All of them had academic

degrees, which ensured that they had a sufficient knowledge of English (the language of the film. The interviews were held in Hebrew). Four of the participants had some practical and/or theoretical background in cinema, and three of those were also gamers (but only one of them was more than a casual gamer). The others had no special background in film, and of those, only one was an occasional gamer.

Participants were invited individually to a computer lab where Turbulence was already installed. The study included four phases:

1. A face-to-face conversation. Participants were asked some questions about themselves, their background in cinema, gaming and interactive cinema (5 mins).
2. Introduction of Turbulence's genre and interaction model. The first 30 seconds of the screening, showing the interaction model, are also part of this stage (3 mins).
3. Turbulence was played. During this phase, one of the researchers observed the participant's actions, and noted whether they have or haven't interacted in the designated hotspots or outside them, and how they interacted (65-80 mins). Right after hotspot 9 a bug occurred, causing the movie to hang. The researcher had to manually skip to the next segment (full details are available on [7]).
4. Semi-structured interviews, immediately after the screening (20-30 mins).

## 5  Analysis and Key Findings

The interviews were videotaped and then transcribed and translated into English. This produced several hundred statements, which were then read several times and interpreted, following the methodology suggested in [10]. We organised the interpreted statements into 15 themes. These themes emerged as salient from the semi-structured interviews, and are grouped here according to the analytical categories that we used in preparing the questionnaire (actual statements often touched upon more than one theme):

**Expectations:** Genre expectations; Medium expectations (Cinema vs. video games and digital media); Cultural and personal values.

**Content:** Comprehension (story information, gaps, backstory, recollection); Plausibility and believability, Empathy and identification.

**Form:** Optionality, closure, replayability, and coherence; Interaction model and usability; Flow – pacing, frequency of interaction.

**Performance and Experience:** Player Motivations, strategy and goals; Local vs. Global agency, control; Agency, surprise and dramatic engagement.

**Meaning:** Subject positioning; Meta-narrative reflection/awareness; Authorial presence and trust

The scope of this presentation does not allow us to discuss in detail all the themes that emerged from the interviews. We will focus here on those factors that seemed to most affect the participants' experience and the meaning they attributed to it.

**Expectations.** Medium expectations were difficult to pin point given the small sample. While all participants were acquainted with digital media, most of them had not had significant gaming experience. One participant, however, was an experienced

interactive fiction and adventure game player. Expectations he developed during that time led him, according to his own statements, to early frustration. The cultural background of our participants was uniform (they were all Hebrew speaking Israeli academics). Values played a role in forming an attitude towards the main conflict and its resolution, but, as will be shown later, that did not influence players' strategy.

**Content.** Participants had divergent perceptions of who the protagonists were and what their conflict was. Some participants mentioned not fully understanding what had happened, or "how one thing led to another". One participant's belief that the story had an open end can be attributable to the bug reported above (see 4). Four of the participants felt that aspects of the film were contrived. One felt that there was in fact no conflict for the character he identified as the main protagonist (Sol), while another said the exact opposite. Participants had very divergent levels of empathy towards the protagonists. One attributed her "moderate" level of empathy to moral indignation: "their case didn't sweep me off my feet...there's a story of infidelity there." This may correlate with the perception that Sol was not in any moral dilemma.

**Form: Optionality, Closure, Replayability.** The interaction model of Turbulence allows the player to explore plot alternatives without having to start a new session. Participants made varying use of these navigational opportunities. Three participants made no use of the "alternate plot" options. Of those, one – the experienced gamer - did so intentionally. Another participant who made no use of the alternate plot hotspots disengaged because the movie "didn't interest him all that much". The third participant was nonetheless curious to see alternate options, as did most of the other subjects who did exploit the alternate plot device. Of those, however, one stated that he was pleased with the version of the story he watched and didn't want to spoil it with an ending he didn't like. This strong sense of closure is probably not due to the particular plotline he followed. That was shared by another participant, who was morally opposed to its ending and was curious to "play through" the other options.

**Form: Usability, pacing and frequency of interaction.** Several usability issues arose. Participants had trouble recognising where there was or wasn't a hotspot. This was especially apparent with the "training" hotspots, which most participants missed. Although one of those concluded that there were "just enough" opportunities to intervene, most participants thought there were too few hotspots. Observation showed that during the first half hour of the film most participants did indeed attempt to intervene often, also where no hotspots existed. Curiously, one participant, a film editor, was so immersed in the audio-visual flow that he regretted his early attempts to interact. He did, however, interact as much as the others did.

**Performance and Experience.** We asked our participants several questions designed to understand what motivated their behaviours and choices and whether they had formulated goals and strategies to pursue them. We expected that they would be somewhat immersed in the drama and act upon that. This was usually not the case.

We asked participants whether they had a preferred resolution to the dramatic conflict they had identified. Five did. Those who had no clear preference had no plot-related goals. One was motivated by medium exploration, perhaps with a ludic focus, because he didn't find the drama engaging. But even most of those who did formulate a preference, still didn't act upon it. One participant said he was engaged in the

dramatic conflict, but still wanted to see what happened "if things didn't go my way". One completely lost interest because he felt a lack of agency. Another said that her exploratory, ludic and drama enhancement motivations were due to the drama not being gripping enough, and more determining than her moral indignation. In one case, a subject intentionally refrained from action to maintain and relish the level of action, although the plot proceeded against her dramatic resolution preference.

Local agency – the feeling created by immediate feedback [8] - was of paramount importance to most participants. Only one identified the first "user training" hotspot, remarking: "I felt [it] would have happened anyway... this interfered with my feeling of control". Another remarked "I felt some control at the moment of interaction, but not over the entire plot" – an indication that he felt no global agency.

But lack of global agency in itself was not always a problem. We examined in detail our participants' behaviours and responses to a plot intervention hotspot in which the plot outcome was designed to go against the players' intentions. None of them seemed to mind: "it wasn't what I expected but it was like Borges, you accept that there are different options", and "I began feeling an active part of the plot, implicated. And the story felt tighter." Ultimately, participants were split as to whether interaction increased or decreased their engagement. One undecided participant said: "it forced me to think practically...I'd like to just watch, without the responsibility... but I also enjoyed the control I got ... you can act out your frustration and see 'what if', and I experienced the power and fun of changing things".

**Meaning.** Several participants mentioned their self-implication in the events of the story. One participant even reported, when asked what she would have done if faced with a similar conflict: "I did think about it. I did experience the conflict I was in myself, and I was thinking about my own situation in comparison".

Participants sometimes reported a feeling of being very much aware and critical of authorial choices while they were watching them. One participant said: "Interactivity implies the ability to direct the film, but I know it's a film, so it's interesting to compare my reflections...and those the director chose". Some of our subjects described a feeling that the film had betrayed them (or not). One subject had both in the same viewing. When events in the story's present turned against her expectations, dramatic curiosity motivated her, against her personal moral values, to accept the plot twist as a legitimate and welcome complication. Conversely, she experienced a *retrospective* plot intervention as "cheating". This may stem from a "tense confusion" (as discussed in [11], and often repeated by ludologists), resulting in a breakdown of trust, a feeling that she was being conned by being offered an opportunity to intervene that would make no difference to the story's present.

## 6  Conclusion and Future Work

What is it that drives, guides or impedes participants' interaction with an interactive hyper-narrative movie? Subjects mentioned several motivators for their behaviour:

1. Ludic, interface-driven (responding mechanically to cues, for instance).
2. Exploration of the medium
3. Exploration of the story space
4. Maintaining story flow

5. Dramatic enhancement (encouraging situations with dramatic potential)
6. Discursive (wanting to explore or challenge the author's choices)
7. Dramatic-narrative engagement

Some of these motivations are common also to linear films. Adding interactivity introduces the possibly competing schemata associated with digital artefacts such as software applications and specifically video games. To understand the effect of the high-frequency agency culture of games referred to in [12] requires further, more controlled studies with larger samples of both gamers and non-gamers, as well as heavy and light users of other digital media.

Drama enhancement was the most prevalent motivation mentioned by the participants, sometimes but not always because they evaluated the drama as not so engaging. It would be interesting to compare the level of engagement reported by a larger sample of players and viewers of linear versions of Turbulence. Such a study may also serve as a benchmark to answer questions about the effect of interactivity on comprehension, empathy, self-implication and other dimensions.

**Acknowledgments.** We thank our study participants and Giulia Gelmini for her help and wisdom.

# References

1. Hales, C.: Cinematic interaction: From kinoautomat to cause and effect. Digital Creativity 16(1), 54–64 (2005)
2. Wheeler, D.: Tender Loving Care, USA (1997)
3. Dove, T.: Artificial Changelings, USA (1998)
4. Cloran, D., Doron, A., Guez, M.: Late Fragment, Canada (2007)
5. Ben-Shaul, N., Cohen Ben-Shaul, D.: Turbulence, Israel (2008)
6. Ben-Shaul, N.: Hyper-Narrative Interactive Cinema: Problems and Solutions. Rodopi, Amsterdam (2008)
7. Turbulence – a User Study of a Hypernarrative Interactive Movie,
   http://www.knoller.com/papers/turbulence2009/ (accessed: 09-24-2009)
8. Mateas, M., Stern, A.: Structuring Content in the Façade Interactive Drama Architecture. In: Young, R.M., Laird, J.E. (eds.) Proceedings of Artificial Intelligence and Interactive Digital Entertainment (AIIDE 2005), pp. 93–98. AAAI Press, Menlo Park (2005)
9. Friess, R.: Play and Narration as Patterns of Meaning Construction: Theoretical Foundation and Empirical Evaluation of the User Experience of Interactive Films. In: Spierling, U., Szilas, N. (eds.) ICIDS 2008. LNCS, vol. 5334, pp. 108–113. Springer, Heidelberg (2008)
10. Milam, D., Seif El-Nasr, M., Wakkary, R.: Looking at the Interactive Narrative Experience through the Eyes of the Participants. In: Spierling, U., Szilas, N. (eds.) ICIDS 2008. LNCS, vol. 5334, pp. 96–107. Springer, Heidelberg (2008)
11. Cameron, A., Barbrook, R.: Dissimulations (1998),
    http://www.daimi.au.dk/~sbrand/mmp2/Dissimulations.html (accessed: 18-03-2004)
12. Tanenbaum, J., Tanenbaum, K.: Improvisation and Performance as Models for Interacting with Stories. In: Spierling, U., Szilas, N. (eds.) ICIDS 2008. LNCS, vol. 5334, pp. 250–263. Springer, Heidelberg (2008)

# Authoring Issues beyond Tools

Ulrike Spierling[1] and Nicolas Szilas[2]

[1] FH Erfurt, University of Applied Sciences, Altonaer Str. 25, 99085 Erfurt, Germany
[2] TECFA, FPSE, University of Geneva, CH 1211 Genève 4, Switzerland
spierling@fh-erfurt.de, Nicolas.Szilas@unige.ch

**Abstract.** Authoring is still considered a bottleneck in successful Interactive Storytelling and Drama. The claim for intuitive authoring tools is high, especially for tools that allow storytellers and artists to define dynamic content that can be run with an AI-based story engine. We explored two concrete authoring processes in depth, using various Interactive Storytelling prototypes, and have provided feedback from the practical steps. The result is a presentation of general issues in authoring Interactive Storytelling, rather than of particular problems with a specific system that could be overcome by 'simply' designing the right interface. Priorities for future developments are also outlined.

**Keywords:** interactive storytelling, interactive drama, authoring, creation process.

## 1 Introduction

Creating an Interactive Storytelling experience is considered a difficult endeavour. It is aimed at an experience of an artifact that requires the execution of software constituting a dynamic story engine, which controls the unfolding of drama. This rather technical perspective is one of the main challenges that have recently been discussed at Interactive Storytelling conferences [14]. Dynamic story engines are complex software, equipped with Artificial Intelligence algorithms capable of reacting meaningfully to an interacting user, while maintaining a storyline model incorporated within the system.

Recent discussions about the issue of authoring suggest that it is hard to clearly define what steps of creation fall within the scope of authoring, and where the boundaries of so-called authoring tools are located. This is because on one hand we assign a co-creation role to the user regarding the resulting story experience, and on the other hand we cannot precisely distinguish between authoring a dynamic storyworld and programming the engine. There are also differences inherent to several approaches, resulting in genre-like interpretations of what Interactive Storytelling actually is.

Therefore, it is necessary that we first define the subject of this paper: "Authoring". After defining the term and discussing where its boundaries lie, we will explore the state of the art of authoring for current story engines, from a practical point of view. We focus our search on general issues that are most likely "here to stay", because of their independence from the (potential) lack of usability of some graphical user interface.

I.A. Iurgel, N. Zagalo, and P. Petta (Eds.): ICIDS 2009, LNCS 5915, pp. 50–61, 2009.

## 1.1 The Case of the Authoring Problem within Interactive Storytelling

We are discussing types of Interactive Storytelling (IS), in which a user (or users) experiences a narrative by interacting with a digital system of agents during the unfolding of said narrative[1]. Such a system of digital agents is considered to be the created Interactive Storytelling (IS) artifact. It consists of

    a) an IS storyworld, running on
    b) an IS runtime engine.

    The IS runtime engine enables the performance of agents' autonomous or semi-autonomous behaviour, which means that agents act independently of the author after the actual authoring phase is finished. This engine is a software architecture including specific IS platform components (e.g., story structure manager, planning, interaction/dialogue manager, representation managers, other agents ...).

    The IS storyworld constitutes the actual "content". It is created by a creator or author (or a team of creators / authors), and uses the agent functionality of the IS engine. For example, authors need to define the storyworld's specific characters as instances of the engine's generic agents. As a special difficulty, the user is as well an active agent (maybe a character) of the storyworld; the creator has to consider this when making up the storyworld. As well as containing components and assets, the content is also made up of rules and conditions that determine the occurrence and actions involving those entities, as well as their effects on the storyworld. As such, the created content ends up being code running on the IS engine.

    Examples for such IS artifacts are Façade [15] and FearNot! [1], which are IS projects with integrated storyworlds and agent engines. Other IS research projects have built story engines that allow for various storyworlds to be authored. Examples are: 'Storytron' [16] which can run several storyworlds such as *Balance of Power*, or the two examples that will be discussed in the next section, IDtension (running the story *The Mutiny*) and Scenejo (with the *Killer Phrase Game*). In each case, there is an end-user who interactively experiences the storyworld by playing a role in it.

    Authoring means delivering content for somebody else's (an end-user) experience. It is different from the potential kind of co-creation that can take place when end-users interact with a storyworld. However, there is a blurry borderline between authoring a storyworld as a delivered artifact, and the end-user's co-creation during the "runtime" experience. In Fig. 1, this blurry line is symbolized between the "Interaction" level and the "Storyworld" level as part of the IS artifact. Another blurry line is drawn between the runtime engine and the storyworld. This refers to the circumstance that an IS storyworld can only work in co-existence with a runtime engine, which (historically) was developed by a team of computer scientists.

    We assume that the developers in this model are computer scientists and that authors are from creative media fields, for example writers, designers etc. Recent discussions about authoring addressed developing authoring tools that allow creative media experts to create a dynamic storyworld without programming know-how. The goal of this paper is to present an overview of general problems that currently exist in the authoring process between the two levels: development and authoring.

---

[1] We are aware that this is a rather technical definition. It is necessary to distinguish from other ("branching") phenomena that might be grouped under the term "Interactive Storytelling".

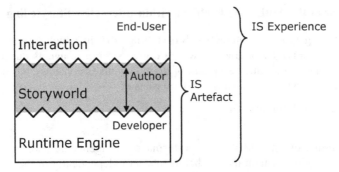

**Fig. 1.** Definition of the boundaries of authoring. There are blurry lines on the border of developing a runtime engine, as well as on the border of interacting with the content.

## 1.2 Related Work

Recent discussions on authoring have been followed up in workshops [14], and publications at conferences on that topic, e.g. [13]. However, there was less work on dealing with general authoring problems than with the suggestion of new authoring tools, which often provide GUI representations for specific engine functionalities. There have been few attempts to propose general authoring principles or tool classifications and outlines. For example, Pizzi [8] divided authoring tools according to the generative abilities of the underlying engine and the visibility of the engines' storyworld structure, while focusing on the aspect of visualizing and debugging plan structures. Louchart et al. [4] proposed a metaphorical landscape as a visualisation for emerging plotlines. Medler and Magerko [6] defined rather general requirements such as usability, debugging, control of pacing/timing and generality. A similar problem to the one presented here was the basis for Mateas and Stern's article on procedural authorship [5], with the conclusion that "authors must programme". While we agree that authors must have some level of procedural literacy, we think it's important to develop better tools that educate authors in what they need to do. Further, we believe that programming skills and authoring tools alone do not solve the problem, and that there are a number of general issues that have to be considered.

The goal of this paper is to give an illustration of "real" problems that are present in current content development for IS. It is the first step of an effort to bridge a perceived gap between creative authors and obscure technology by analyzing the affordances of current tools for creation.

## 2   Feedback from Real Authoring Exercises

In the following, *general* authoring problems are outlined that were observed during the practical creation of storyworlds, which run on interactive narrative engines. We take examples of our own systems and authoring tools to illustrate these problems: IDtension [17, 18], an interactive drama system that generates actions based on narrative principles, Scenejo [12], a character-centric conversational storytelling system based on conversing chatbots, and Rencontre [10], a fragment-based writing / reading

system with dynamically generated hyperlinks. To complement the data, we also present feedback found in literature, since the goal is not to blame one specific tool but to generalize the issues.

The most significant interactive storyworlds we created with IDtension [19] and Scenejo [13] are (for online descriptions of the architectures and stories see idtension.com, scenejo.org, and redcap.interactive-storytelling.de):

- "The Mutiny"; synopsis: *As a sailor jailed in a 17th century galleon, your goal is to take the leadership by preparing a small riot.* IDtension grants the player diversified and combinable action possibilities by a text interface.
- "The Killer Phrase Game"; synopsis: *As the moderator of a public debate on an airport extension, you must control the fairness level, otherwise the dispute escalates.* Scenejo allows users to text-chat along with 2 virtual characters.

## 2.1 Story Ideas That Do Not Fit into the Engine's Approach

### 2.1.1 Finding Authors

The initial phase in starting a project in IS is to find authors. This initial phase was skipped in many recent research projects, where the author and system designer were the same person, the best example being Façade [5]. But in the general case, and for the sake of disseminating interactive narrative, a specific author must be found to create new stories that run on a system. This initial phase often turned out to be less easy than expected. Of course, because the IS systems we are working with are research-based prototypes, we did not expect to find authors who 'a priori' understand the authoring framework. However, approaching authors always implied having to explain operational principles of the system in detail. The outcome of such explanations appeared to be unpredictable.

With IDtension, we went through the experience of spending two hours explaining the system in detail to a potential author, who later produced a first document completely out of scope with the engine. In another case, the author produced a document that was not incompatible with the system, but she preferred to remain at a general level of a synopsis, leaving the fine detail of content specification to the system designer. This was the same experience as in the design of the *Killer Phrase Game* for the conversational platform Scenejo. There, we assumed the underlying chatbot principle to pose technical challenges of implementation of the dialogues. But more than that, it also constituted a mental model of questions and answers that was hard to grasp for developing story structures at all, even if at first just "on paper".

A typical situation we encountered in these early stages of looking for authors was that authors were simply reluctant to the idea of reducing human affairs into logical models.

### 2.1.2 Abstraction

Given their generative nature, IS systems require authors to write at the level of story-related abstract structures. For example, many systems represent stories in terms of characters' or stories' goals [2, 18, 21], using the notion of generic/instantiated data. Such abstract concepts, with which Artificial Intelligence practitioners are well accustomed, remain distinct from usual creative ways of thinking. The author who wrote

*The Mutiny*, the scenario used to demo the IDtension system, reported that this way of writing was quite remote from his usual writing activity [17].

When working with Rencontre [10], a system that could be considered less abstract, since narrative fragments are not generated (only their sequencing is), authors also reported difficulties in grasping the abstract concept of hypersections. More remarkably, the designer and programmer of the previous system "IDtension" also found it difficult to write at the particular level of required abstraction. This observation shows that this authoring difficulty cannot be reduced to a general lack of programming skills or procedural literacy of the author.

As with Rencontre, Scenejo's 'generative' features do not go far beyond slightly restructuring ordering for predefined utterances, and offering to get interrupted by user's actions and respond accordingly. However, dialogue states can be tracked by the system, such as an increased stress level. Therefore it was necessary for authors to not only write utterances in direct speech, but to model a dynamic system of influences and meanings of abstract speech acts. Experiences showed that computer science students, capable of programming in general, but not with AI, had no advantage in modeling the dialogues. Specific creative knowledge of dialogue abstraction and design was necessary.

### 2.1.3 Formatted and Constrained Writing

Current IS systems require filling in several precise data structures. For creative authors, this may be perceived as "filling a form", a typical non-creative activity close to using templates that abridge creativity.

With IDtension, surface text had to be written in a spreadsheet file that was then processed by the runtime engine. The author did not comply with this constraint, and spontaneously chose a word processor, to be able to freely phrase sentences. As a consequence, the produced sentences were partly incompatible with the engine's text generator, and some rewriting by the system designer was required. In this case, the creativity of the author was limited by the interactive narrative formalism used within the engine.

For Scenejo, an authoring tool was provided that enabled – and forced – authors to directly write in the chatbot's terms of patterns and templates [12], where a pattern is a precondition that has to become true before an utterance is made, or in other words, the pattern provides the stimulus for each uttered response of a character. The whole dialogue between two characters had to be written separately for each actor, in order to work according to the character-centric approach taken in Scenejo.

Although these are issues that could be partially enhanced with better GUI support through a better authoring tool, the GUI often only replaces typing by clicking, and does not avoid the formality of the implementation that is simply necessary with given formalisms in story engines.

### 2.1.4 Algorithm-Centered Story Design

Given the constraints just mentioned, a strategy often adopted consists in first looking closely at the computational model and its limitations, in order to then find a story that best suits the model.

For the engine IDtension for example, we deliberately chose a story (*The Mutiny*) with 8 characters, because it fully expresses the richness of the model [19]. But when

applying IDtension to an existing training context with fewer characters and less in-ter-character interaction, the resulting global story was less interesting [11]. The pedagogical content, extracted from linear cases, consisted mainly in procedures to be applied by the main character. This context did not leave much room for possibilities such as influencing other characters to perform actions or getting helped by another character of your choice.

All the same, the idea for the *Killer Phrase Game* that runs on Scenejo was highly dependent on the potential that Scenejo offers to an end-user: Joining in a discussion between two or more chatbots (quite similar to the interaction paradigm in Façade). Starting out with the bot platform in mind, the creative task was to develop situations with real reasons to interrupt an ongoing dialogue between two or more characters, and the objective of moderating a debate suited that paradigm of the platform.

According to Marie-Laure Ryan [9], Façade's story [15] is chosen according to the limitations of the engine itself: *"As the conversation turns into a domestic fight, it is not too surprising that Grace and Trip increasingly ignore the visitor. With its theme of marital feud, Façade is very successful at minimizing the limitations of its AI mod-ule."* It is difficult to judge if algorithm-centered story design is a good or bad thing. It certainly characterizes the emerging field of Interactive Storytelling from the au-thoring point of view. For Laura Mixon, who has authored stories for the Erasmatron [7], one should not look too closely at the algorithm when designing: *"The first and among the biggest of my mistakes was to try to use every single, pea-pickin' one of the Erasmatron's wide array of features. If there was a button or menu item, I wanted to bring it into play."*

### 2.1.5 Potential of Engines Underused

Since it appears difficult to grasp the specifics of an engine, and therefore to ground any story design around the underlying computational models, some authors tended to use only a subpart of the engine's features. As a typical experience in first authoring attempts with each of our engines, an author would naturally try to reduce the func-tionality to a linear or branching structure, which is more intuitive.

For example, the first story that was written with Rencontre by an author external to the project did not use fuzzy hypersections, which constitute one of the distinctive features of this engine. Similarly, IDtension implements a system of ethical values which, has not yet been exploited enough in existing stories. Authoring seminars with students have shown that with Scenejo, first attempts to come up with story adapta-tions resulted in ideas for quiz game-like, question-answer structures. First, these are more akin to the well-known classical chatbot interactions than to the potential of having more characters debating with each other, and second, a quiz comes with a built-in branching structure of right and wrong answers. In other words, the result was far from conversational storytelling. It rather resembled well-known structures of cas-ual or adventure games.

This simply told us that because the field of Interactive Storytelling still lacks in-spiring examples, the effort for imagining novel ideas beyond known structures from known domains is high. This was the case for example with students of media infor-matics who found it easy to use the abstract tools, but on the other hand had few ideas. At the same time, it was hard for creative authors to arrive at conceptual models for creation that fit the engine's underlying drama or interaction models.

### 2.1.6  When Authoring and Programming Intersect

Theoretically, an often assumed modus operandi has been that runtime engines should be built first, after which storyworlds can be written based on the runtime engines. Practically, things tended to happen differently. It has not been uncommon that while writing content for IS, the engine designer modifies the engine with new a functionality to accommodate a specific story with new features. In such cases, authoring and programming were performed simultaneously, blurring the line between the storyworld and the engine (see Fig. 1).

For example, when adapting *The Little Riding Hood* to IDtension, we significantly improved the management of locations that *The Mutiny* did not use. Motivated through the development of the *Killer Phrase Game*, Scenejo has been equipped with better functionalities for managing the turn taking between the digital bots and the user.

This kind of intersection between writing and programming can definitely be associated to a certain immaturity of the medium of Interactive Storytelling (compared to cinema for example). However, we also presume that there are some aspects of it that are here to stay, because they are inherent to the digital nature of the medium. Given the flexibility of the computer, it must be accepted that such instability is not only unavoidable, but certainly desirable, because it allows to constantly improve the technology instead of freezing it.

### 2.2  Painful Process of Storyworld Implementation

In this section, we grouped the feedback from authors related to the process of story making. It concerns the day to day work with runtime engines and authoring tools while creating an interactive storyworld.

### 2.2.1  The Time-Consuming Task of Entering Content

Generally speaking, we still lack usable enough authoring tools to enter content, despite the previous work tackling this issue [6, 12, 16]. Currently, entering content – at first sight – closely resembles programming activities, because at least partially, data structures must be directly entered in text files (such as XML structures). Even with graphical templates that help create the correct syntax, entering data takes time and prevents from quickly seeing the result of the created content.

Typical problems that slowed down the processes in our examples include the lack of usable graphical interfaces supporting different perspectives on the content, the lack of control mechanism preventing authors from entering erroneous content, and the existence of several distinct files that are needed for running one storyworld, such as configuration files for various modularized elements, characters, dialogues etc.

With IDtension, we ended up writing narrative structures twice: an initial schema is established in a simple graphical software, which provides a clean overview of the narrative structure but is not connected to the XML effectively needed by the engine. The author has to write the schemas and then enter them into the system. These two files are hard to maintain and keep synchronized.

As already mentioned in section 2.1.3, what made entering content in Scenejo a tedious task was that dialogue parts and rules had to be written for each character separately, following a character-centric approach. There was a lack of visualizing

potential inter-character conversation results of these rules, so that authors of the *Killer Phrase Game* kept separate Excel files and external drawings to maintain an overview of the planned dialogue sub-lines.

At this point, future work in graphical authoring tools is worthwhile to speed up these processes. More than just providing templates for data input, different perspectives, on the same data, are necessary, as well as possibilities for simulating the outcome.

### 2.2.2  Understanding What Is Going on under the Hood

In our examples, after data for a conceived storyworld was entered, the first attempt was rarely conform to the author's expectations. A process of play-back, testing and tuning took place, as is quite common for linear media as well. But in the case of Interactive Storytelling, modifying the content is much harder, due to both the complexity of the models and the unfinished nature of runtime engines (see 2.1.6). Typically, in our own experience, when perceiving unwanted behaviour of the storyworld during its tested experience, three hypotheses were repeatedly made:

1. The storyworld was not implemented properly by the author. The content including its elements and rules must be tuned accordingly.
2. The runtime engine has a "bug", in other words, according to the logics of the model, it should behave differently from the way it actually does. The engine must be repaired (debugged) by the developer.
3. The underlying model does not allow performing what the author expected. In this case, either the runtime engine must be extended and enhanced accordingly, or authors need to develop a better conceptual model of the engine's potential and underlying dramatic model.

During our own experience with IDtension, we found that it was not easy to establish which of the three cases occurred. Finally, only the engine designer was able to tell. The adding of debugging/monitoring interfaces, allowing the visualisation of internal structures during execution (such as a list of all possible actions and their multifactor rating by the system) helped to better understand what was happening during execution.

In the implementation phase of the *Killer Phrase Game* on Scenejo, discussions were regularly needed between the designers/authors of the conversations and the engine programmers, to find out which of the above three possible interpretations of an error applied. This communication process slowed down the implementation significantly.

The conclusion to this aspect is that although there is great potential for improvements through better debugging tools, we believe that this issue is something inherent in Interactive Storytelling production in the near future, because engines constantly under development denote moving targets for authors. Similar experiences were had in the beginnings of the 3D animation production area, when graphic designers started using complex shaders and renderers that require many parameters to be tuned. Experienced designers usually get a good grip on intuitively finding "work-arounds" with given technical constraints. In the case of Interactive Storytelling, however, we have to deal with an even larger complexity.

## 2.3  Deliberating the End-User Experience

As motivated in section 1.1, the authoring process in IS aims at creating a storyworld that together with a runtime engine forms an artifact to be delivered to end-users. Not until end-users interact with this artifact does Interactive Storytelling occur as an activity and experience. Depending on the design of the engine model as well as the particular storyworld, the end-user plays a certain role within the storyworld, which is associated with particular possible actions and influences on the outcome.

This experience, which has often been discussed in relation to the notion of "the interactive narrative paradox" is actually something that the author has to conceive. In our view, it is an important – if not the most important – part of the authoring responsibility to care about the whole IS end-user's experience.

Within recent conferences and published literature, IS research has focused more on algorithms for interactive narrative management than on end-user experience, which has consequences in terms of authoring.

### 2.3.1  Foreseeing the End Result of the Storyworld Possibilities

While entering data for the storyworld, authors might have difficulties getting an idea of the final result of the interactive narrative. With IDtension for example, the author needs to enter a significant amount of data before getting an idea of the interestingness of the resulting interactive narrative. While testing the story, if no specific surface text is entered, the sentences appear in a crude form, which prevents a proper vision of the final product.

In Scenejo, dialogue pieces could be entered piece by piece and changes could be directly experienced after starting the play mode. This resulted in hearable and readable utterances, spoken by talking heads through a text-to-speech (TTS) converter. Preparations for this realistic playback included that the scene with modeled characters was built in advance and that TTS was connected and set up. Unfortunately it was not possible to change content "on-the-fly". This meant that there was a long design cycle, because it was necessary to stop the engine, go back to the authoring tool, make changes, and restart the engine from the beginning. With the prototype of Scenejo used in the authoring project, it was hard to focus on a specific situation that occurred late after some playback time, because it was only possible to initiate at the start, but not at a later plot point with given init values at this advanced state.

Through the feedback of the authors who really wanted to achieve a usable storyworld, more suggestions for changes in the authoring tools have been gathered. They concerned the possibility of on-the-fly changes as well as the possibility to scale down parts of the engine, because it also was perceived as a burden of always having to start the 3D world, even when only text occurrences within a dialogue had to be tuned.

### 2.3.2  Interaction Design

Only after a significant period of authoring effort, first real "play" tests were possible, which here means that end-users other than the authors themselves were called in to interact with the content. At this point, the next problem occurred in the experience that end-users would not know what to do and how to interact with the storyworld.

For example, in the conversational story of Scenejo, the interaction paradigm and style is quite obvious: End-users can type any text to phrase utterances directed at the

two bots of the *Killer Phrase Game*. However, similar to Façade (but rather worse, since we only developed a fractional amount of content in comparison), only a few of the users' utterances could potentially lead to perceivable changes in the dialogic turns of the bots. In the limited prototype built, this was addressed by reducing the game to a narrow task assignment for the user of moderating by reacting to killer phrases. We also built in visualizations of the state changes, to give end-users the possibility to perceive effects of their actions if they influence state values.

We were aware that with these adaptations, we moved the original plan of having a free dialogue towards more narrow task assignment-like game features. On the other hand, this raised the issue that interaction design has to be an immanent job part for authors of a storyworld.

In IDtension, after temporarily using a basic end-user interface, the interaction mode eventually used – the history-based interface [20] – came late into the project, two years after writing *The Mutiny* began. Preliminary end-user feedback informed us that this interface has a huge impact on the experience. As with the *Killer Phrase Game*, end-users interacting with *The Mutiny* did not necessarily know what to do, and their behaviour sometimes consisted in clicking everywhere rather than trying to interact with characters in a meaningful way, as expected by the author. Adding a help section within the interface helped in the first instance.

As a consequence, we conclude that an important task in authoring an interactive storyworld is the design of possibilities for interaction and role-adoption for end-users, as well as of interfaces with suitable perspectives on the action and the storyworld state. These are actual parts of the artifact, which are to be provided with a designed shape by creators who aim at offering an integrated, 'holistic' experience to end-users. Ironically, the affordances of the fragmented and abstract creation processes seem to be contrary to this goal. In recent discussions on authoring, this issue of integration has been mostly ignored.

## 3  Conclusion for Overcoming Authoring Issues

In this article, we presented feedback coming from the collaboration of authors and developers in real Interactive Storytelling projects. Not all of the reported issues are to be overcome by simply building the next generation of usable GUI for the immature tools (although a substantial number of proposals for this immediately filled the to-do lists). We argue that the current state of the art in creation is far from what is needed to fully embrace the procedural potential offered by future IS engines.

Quite naturally, there are two general ways to overcome the gap between current complex systems and more sustainable access for authors:

- Listen to authors: Make tools that better match the concepts and practices of media designers and content creators
- Educate potential authors: Make procedural principles of Interactive Storytelling understandable

We believe it is necessary that both lines develop in co-evolution. There is a vicious circle at the beginning of this co-evolution, as there are mutual dependencies between the two actions. As was revealed between the lines of some sections (2.1.1, 2.1.5, 2.2.2), we cannot expect that newcomers as authors in Interactive Storytelling provide us with

proper specifications of their needs, when they still cannot grasp the potential offered by engines and by the medium. Authors need prior design experience with the medium. However, designers and other non-AI-practitioners will require tools to get this first design experience, since they will not be able to program the engines directly.

In order to educate authors, procedural principles of Interactive Storytelling – grounded in Artificial Intelligence – have to be generalized to understandable conceptual models and metaphors. Further, design cycles need to be shortened, i.e. authoring tools need a direct connection to runtime engines in order to support these conceptual models, by letting authors experience the interactive quality of their decisions.

## Ackowledgements

This work has been funded (in part) by the European Commission under grant agreement IRIS (FP7-ICT-231824). [3]

## References

1. Aylett, R., Louchart, S., Dias, J., Paiva, A., Vala, M., Woods, S.: Unscripted narrative for affectively driven characters. IEEE Computer Graphics and Applications 26(3), 42–52 (2006)
2. Cavazza, M., Charles, F., Mead, S.J.: Characters in Search of an author: AI-based Virtual Storytelling. In: Balet, O., Subsol, G., Torguet, P. (eds.) ICVS 2001. LNCS, vol. 2197, pp. 145–154. Springer, Heidelberg (2001)
3. Cavazza, M., Donikian, S., Christie, M., Spierling, U., Szilas, N., Vorderer, P., Hartmann, T., Klimmt, C., André, E., Champagnat, R., Petta, P., Olivier, P.: The IRIS Network of Excellence: Integrating Research in Interactive Storytelling. In: Spierling, U., Szilas, N. (eds.) ICIDS 2008. LNCS, vol. 5334, pp. 14–19. Springer, Heidelberg (2008)
4. Louchart, S., Swartjes, I., Kriegel, M., Aylett, R.: Purposeful Authoring for Emergent Narrative. In: Spierling, U., Szilas, N. (eds.) ICIDS 2008. LNCS, vol. 5334, pp. 273–284. Springer, Heidelberg (2008)
5. Mateas, M., Stern, A.: Procedural Authorship: A Case-Study of the Interactive Drama Façade. In: Digital Arts and Culture, DAC (2005)
6. Medler, B., Magerko, B.: Scribe: A Tool for Authoring Event Driven Interactive Drama. In: Göbel, S., Malkewitz, R., Iurgel, I. (eds.) TIDSE 2006. LNCS, vol. 4326, pp. 139–150. Springer, Heidelberg (2006)
7. Mixon, L.J.: I can't believe I did that: A Reflection on Some of My Biggest Shattertown Blunders, http://www.erasmatazz.com/library/StS_Blunders.html (accessed July 2009)
8. Pizzi, D., Cavazza, M.: From Debugging to Authoring: Adapting Productivity Tools to Narrative Content Description. In: Spierling, U., Szilas, N. (eds.) ICIDS 2008. LNCS, vol. 5334, pp. 285–296. Springer, Heidelberg (2008)
9. Ryan, M.L.: Peeling the Onion: Layers of Interactivity in Digital Narrative Texts (2005), http://users.frii.com/mlryan/onion.htm (accessed September 2009)
10. Rety, J.-H., Szilas, N., Clément, J., Bouchardon, S.: Authoring Interactive Narrative with Hypersections. In: Proc. of 3rd ACM International Conference on Digital Interactive Media in Entertainment and Arts (DIMEA 2008), Athens, Greece, pp. 393–400. ACM, New York (2008)

11. Richards, D., Szilas, N., Kavakli, M., Dras, M.: Impacts of Visualisation, Interaction and Immersion on Learning Using an Agent-Based Training Simulation. International Transactions on Systems Science and Applications 4(1), 43–60 (2008)
12. Spierling, U., Weiß, S., Müller, W.: Towards Accessible Authoring Tools for Interactive Storytelling. In: Göbel, S., Malkewitz, R., Iurgel, I. (eds.) TIDSE 2006. LNCS, vol. 4326, pp. 169–180. Springer, Heidelberg (2006)
13. Spierling, U.: Adding Aspects of "Implicit Creation" to the Authoring Process in Interactive Storytelling. In: Cavazza, M., Donikian, S. (eds.) ICVS-VirtStory 2007. LNCS, vol. 4871, pp. 13–25. Springer, Heidelberg (2007)
14. Spierling, U., Iurgel, I.: Pre-Conference Demo Workshop "Little Red Cap": The Authoring Process in Interactive Storytelling. In: Göbel, S., Malkewitz, R., Iurgel, I. (eds.) TIDSE 2006. LNCS, vol. 4326, pp. 193–194. Springer, Heidelberg (2006)
15. Stern, A., Mateas, M.: Integrating Plot, Character and Natural Language Processing in the Interactive Drama Faç. In: Göbel, S., Braun, N., Spierling, U., Dechau, J., Diener, H. (eds.) Proceedings TIDSE 2003, Darmstadt, pp. 139–151. Fraunhofer IRB, Stuttgart (2003)
16. Storytron, http://www.storytron.com (accessed July 2009)
17. Szilas, N., Marty, O., Rety, J.-H.: Authoring Highly Generative Interactive Drama. In: Balet, O., Subsol, G., Torguet, P. (eds.) ICVS 2003. LNCS, vol. 2897, pp. 37–46. Springer, Heidelberg (2003)
18. Szilas, N.: A Computational Model of an Intelligent Narrator for Interactive Narratives. Applied Artificial Intelligence 21(8), 753–801 (2007)
19. Szilas, N.: IDtension – Highly Interactive Drama (Demonstration). In: Proc. of the 4th Conference on Artificial Intelligence and Interactive Digital Entertainment (AIIDE 2008), pp. 224–225. AAAI Press, Menlo Park (2008)
20. Szilas, N., Kavakli, M.: PastMaster@Storytelling: A Controlled Interface for Interactive Drama. In: Proceedings of the International Conference on Intelligent User interfaces - IUI 2006, Sydney, pp. 288–290. ACM Press, New York (2006)
21. Young, R.M., Riedl, M.O., Branly, M., Jhala, A., Martin, R.J., Saretto, C.J.: An architecture for integrating plan-based behavior generation with interactive game environments. Journal of Game Development 1(1), 51–70 (2004)

# Iterative Authoring Using Story Generation Feedback: Debugging or Co-creation?

Ivo Swartjes and Mariët Theune

Human Media Interaction group, Twente University
{swartjes,theune}@ewi.utwente.nl

**Abstract.** We explore the role that story generation feedback may play within the creative process of interactive story authoring. While such feedback is often used as 'debugging' information, we explore here a 'co-creation' view, in which the outcome of the story generator influences authorial intent. We illustrate an iterative authoring approach in which each iteration consists of idea generation, implementation and simulation. We find that the tension between authorial intent and the partially uncontrollable story generation outcome may be relieved by taking such a co-creation approach.

**Keywords:** Interactive storytelling, authoring, methodology, co-creation.

## 1 Introduction

Creating virtual worlds that are rich in dramatic content and afford users to have a story-like experience within such worlds has proven to be a technically and conceptually challenging goal. Branching narrative techniques are still the state-of-the-art in computer games [1], but are limited in the sense that the combinatorial explosion of possible stories makes it unfeasible to allow more than a few choice points. Tools have been developed that support the authoring of branching narrative [2,3], but for interactive stories that offer true agency to the player, it is unlikely that such tools will be enough to author the huge amount of story content that needs to be available. The approach often pursued in interactive storytelling research to reduce the amount of authoring required, is to use story generation techniques that automatically generate parts of the space of possible story lines.

Using story generation techniques within an interactive storytelling system significantly changes the way that authors can craft their work [4]. It requires a reconception of what the system affords authors to author (which is now no longer the full branching narrative) and of how the content they author relates to the overall space of possible stories (the authorial and interpretive affordances of the system, [5]). It is likely that such an authoring process of *implicit creation* [4] benefits from story generation feedback during authoring. Several authoring tools explicitly provide support for such feedback [4,6,7,8,9][1]. For instance, the

---

[1] For an overview of authoring tools and their relationship to story generation, see [8].

I.A. Iurgel, N. Zagalo, and P. Petta (Eds.): ICIDS 2009, LNCS 5915, pp. 62–73, 2009.

authoring toolset for the *Madame Bovary* system of Pizzi and Cavazza [8] provides step-by-step plan simulation to allow the author to visualize and modify the space of possible plans that the system generates.

Such feedback may also affect the *creative* process of the author. We identify two views on the relationship between story generation and the creative process. We can view story generation purely as a way to take some of the less creative aspects of authoring out of the hands of the author. We may also ascribe creativity to the story generator, where it is expected to contribute novelty to the story domain. The first view suggests a process that we may call *debugging*: authors adapt the story content or the story generator in such a way that the resulting space of stories matches their unchanging authorial intent. The second view suggests a process of *co-creation*: authors embrace the (sometimes unpredictable and surprising) output of the story generator as a contribution to the space of possible stories, letting it change their initial authorial intent and accepting that the possibilities and limits of these processes take a fundamental part in shaping and constraining the story space. Such a co-creation process can be justified in many cases because – as also noted by [7] – the fictional nature of story worlds allows for approaches in which authoring not only means constructing the domain representation but also the domain itself.

In this paper, we illustrate how a co-creation attitude can reduce tensions between authorial intent and the partially uncontrollable outcome of story generation. The context of our exploration is The Virtual Storyteller, a story generation system based on the emergent narrative concept [10]. Exploring the co-creation view, we describe the authoring process of two small story domains, following an iterative authoring cycle in which feedback was crucial to the conception of the domains. First, we illustrate the attitudes of debugging and co-creation, based on the story generator TALE-SPIN [11]. Then, we show how we incorporate the co-creation approach in an iterative authoring cycle, using our experiences with the two story domains as examples. Finally, we round off the discussion by providing conclusions and future work.

## 2   Mis-spun Tales or Opportunities for Un-told Tales?

To illustrate attitudes of debugging and co-creation, we revisit and discuss in this section two tales generated by one of the first story generation systems, TALE-SPIN by James Meehan [11]. TALE-SPIN is relevant here because its character-centric approach is also the approach of The Virtual Storyteller.

The two tales of Fig. 1 were classified by Meehan as 'mis-spun'. The first story was mis-spun because Bill did not see Henry Ant. To fix this domain under-representation, Meehan took the debugging approach by introducing 'noticing' inferences in TALE-SPIN. The second story had a different reason to be classified as 'mis-spun': the authorial intent was to reproduce the Aesop fable "The Fox and the Crow". Meehan wanted the fox to trick the vain crow into dropping the cheese. From this viewpoint, the hungry crow eating the cheese himself is not only unexpected but also unwanted, as it takes away the opportunity for a

**Story 1**

HENRY ANT WAS THIRSTY. HE WALKED OVER TO THE RIVER BANK WHERE HIS
GOOD FRIEND BILL WAS SITTING. HENRY SLIPPED AND FELL IN THE RIVER. HE
WAS UNABLE TO CALL FOR HELP. HE DROWNED.

**Story 2**

ONCE UPON A TIME THERE WAS A DISHONEST FOX AND A VAIN CROW. ONE
DAY THE CROW WAS SITTING IN HIS TREE HOLDING THE PIECE OF CHEESE. HE
BECAME HUNGRY AND SWALLOWED THE CHEESE. THE FOX WALKED OVER TO
THE CROW. THE END.

**Fig. 1.** Two 'mis-spun' tales generated by Meehan's story generator TALE-SPIN

story about deception by the fox. Meehan again took the debugging approach:
he changed the setup to match his authorial intent by making sure that the crow
was not hungry, so that the actual Aesop fable would emerge.

We can imagine though, that only taking the debugging approach is a rather
brittle way to author content for a story generation concept such as that of
TALE-SPIN. The more content is authored, the more likely it becomes that the
emergence of the deception story is disrupted due to unexpected interactions.
In contrast, taking the co-creation approach would mean that possible varia-
tions, resulting from a nondeterministic simulation of characters, are accepted
as opportunities. Story content is authored for the continuation or improvement
of these variations. Noticing that it is possible for the crow to eat the cheese
because he is hungry, Meehan could have embraced this unexpected possibility,
letting it inspire subsequent authoring. For instance, he might have made the
cheese actually belong to the fox. He could then have authored the possibility
for the fox to become angry with the crow eating his cheese, leading to a revenge
plan. Such a co-creation approach, in which authorial intent is affected by the
outcome of the story generator, is the focus of our exploration of authoring for
The Virtual Storyteller. The following sections describe and illustrate how we
incorporate this approach in an iterative authoring process.

## 3   Authoring with the Virtual Storyteller

The Virtual Storyteller is a multi-agent story generation framework based on the
*emergent narrative* approach [12] which has much in common with TALE-SPIN
in the sense that stories emerge from character behaviour.

At run time, the roles of characters in the story world are played by agents
using a BDI-like mental model to govern action selection. Actions of one char-
acter may affect other characters, resulting in the production of a network of
temporally and causally related story elements. These story elements are story
world setting facts, character goals, actions of characters, outcomes of goal pur-
suit, perceptions, cognitive states (beliefs, emotions, etc.) and (unintentional or
external) events. This formalism, based on story comprehension theory, is de-
scribed in [13]. The outcomes of the cognitive processes of the virtual characters

are stored as causal links. For instance, a planning algorithm determines how character goals motivate actions (stored as "goal A motivates action B" causal links), and a goal management process determines how cognitive states cause the adoption of new goals (stored as "emotion X psychologically causes goal Y" causal links). These causal links yield a network of causally related elements, forming a representation of the fabula of a story to be narrated afterwards.

The Virtual Storyteller aims to avoid the global coherence problem that TALE-SPIN suffered from by giving the characters a certain actor-awareness. As actors of their own stories, the agents use out-of-character processes such as *late commitment*, which means that they fill in relevant details of the story world at simulation time using *framing operators* [14], and *event planning*, which means that they play god by selecting events to happen. These processes give the characters flexibility to control the emerging event sequence, by further defining and influencing the story world, aiming for more causal connectedness of the emerging event sequence. For instance, as actors they can actively satisfy the preconditions of a goal, controlling when it is adopted. We call this process *goal justification*. An example from a pirates story domain: a goal to refill the water supply of a ship might have the preconditions that the ship has a water supply, that this water supply is exhausted, and that the character adopting the goal is the captain of the ship. Framing operators with the meaning "Let's pretend the ship has a water supply" and "Let's pretend I am the captain of this ship", and an external event with the meaning "The water supply became exhausted" can satisfy any of these preconditions if they were not fulfilled yet.

### 3.1   An Authorial Impasse

We consider the causal network formalism to be independent of any particular story domain, and inherent to the Virtual Storyteller system. The author of a story domain is concerned with the questions: (1) which instances of story elements are there in the domain: which actions, goals, etc. may occur? (2) how do they causally connect: when do these element instances occur, in causal relation to others? For instance, how will a pirate captain select his actions based on his internal state? How does a little girl respond emotionally to a scary wolf? And a grandmother? It might be useful to think of these two authoring concerns as *content authoring* and *process authoring*, respectively, although the distinction is somewhat artificial. It means that authors using this concept are required to also have cognitive modelling and programming skills. Content and process authoring constitute the implementation of a 'landscape of possible stories' when the system is run (the *story landscape*, [15]). Our focus here is not on the specific technical solutions for content and process authoring that were found for The Virtual Storyteller, but on the creative process by which one may develop such a story landscape.

The task of constructing a story landscape presents the author with a certain impasse. There is no direct architectural support for story lines in The Virtual Storyteller, as these are generated at run time as an effect of content and process authoring. On the one hand, the TALE-SPIN example illustrated that having a strong concern for the emergence of specific story lines leads to an approach in which content and process authoring are done in such a way that the intended

stories are produced. This is not only difficult, as it requires making predictions of the interaction of the behaviours of the character models and settings, but is also bound to result in a frustrating mismatch between what story lines one wants and what story lines emerge. On the other hand, we found that having *no* concern for desired story lines is also problematic, because it leads to a style of authoring in which arbitrary choices must be made in content and process authoring[2]. The authorial impasse is that writing characters also means considering the role they play in the emergence of story lines.

## 3.2   An Iterative Authoring Cycle

We found that a good way to resolve this impasse is to develop virtual characters and the story lines they take part in simultaneously, thereby authoring the story landscape in an iterative authoring cycle, as also suggested by [16, pp.154-157]. Here we elaborate on the authoring cycle by incorporating the notion of co-creation. See Fig. 2. An initial bootstrap design of a story world forms the start of an authoring process in which the author's intent for the story world is meant to be still vague or absent, but becomes clearer as authoring progresses:

1. **Idea generation.** The story landscape, laid out by the content and processes authored so far, inspires authorial ideas for how it can be extended. These ideas might be directly implementable as story world content (content authoring), or might require extending the cognitive processes of the characters (process authoring). The simulation may also have displayed undesired behaviour (e.g., the lack of 'noticing' inferences in TALE-SPIN), which must be diagnosed (is it a domain underrepresentation? A flaw in the AI? Or simply an uninspiring development?) and treated. The choice between these two approaches (co-creation or debugging) is up to the author.

2. **Implementation.** Based on the new ideas, story content is added to the system (content authoring), and new cognitive processes are implemented (process authoring). Based on the observation of undesired behaviour of the simulation, flaws in the representation are repaired, or the domain is further constrained. The authored content and processes may expand and change the story landscape in several ways, some of which were not directly intended by the author or even surprising, due to the complex interaction of the authored material.

3. **Simulation.** Running simulations of the story world under development give the author a feel for the current shape of the story landscape, and a feel for what the system can do with the authored material so far. It also exposes unintended and surprising effects of the authored material, which may inspire the author in a subsequent cycle.

---

[2] In early development phases of The Virtual Storyteller, we attempted to build 'a general purpose knowledge representation for story worlds'. We found that we often justified choices based on vague, general notions of authorial intent. For instance, we chose to include a character's health, because in many stories, characters become sick. Without the context of a specific story world, such a choice is arbitrary.

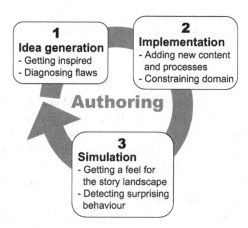

**Fig. 2.** Iterative authoring cycle for emergent narrative. A story landscape is formed iteratively, each iteration consisting of three consecutive phases: (1) idea generation, (2) implementation, and (3) simulation.

Within this authoring cycle, choices between debugging and co-creation must be made continuously. For example, we once modelled a goal for a pirate character to shoot an enemy ship, and two actions: to load a cannon and to fire at the ship. This had an unexpected effect on the story landscape: a pirate fired himself from the cannon to get to a nearby island. This was certainly not intended, but is it "wrong"? We should realize that this is an authorial choice. If we take the debugging approach (saying it does not match our authorial intent), then the action to fire something from a cannon must be further constrained to specify that only cannon balls can be fired. If we take the co-creation approach (adapting our authorial intent), then we incorporate this behaviour into the story domain. We proceed, for instance, by modelling that shooting oneself from a cannon hurts, and that a pirate, as a consequence, will use the cannon only in emergency situations (e.g., to escape from a fight), and with reluctance.

The latter approach builds on the idea in improvisational theatre that there is no "wrong" direction to an improvised story; anything can serve as a basis to further the story if properly incorporated. Improv actors start a scene with a trivial beginning, without knowing where it will take them, and then use association and knowledge of story progression to make authorial choices in context of what emerges. In the case of the proposed authoring cycle, it is the author who makes authorial choices 'in the moment', by simulating the system, deciding what might happen in certain situations, and implementing such decisions.

## 4 Two Case Studies

This section discusses two small story domains that were authored with The Virtual Storyteller: a domain about pirates, and a domain based on the "Little Red Riding Hood" story. Note that these domains are discussed with a focus on

the authoring process, rather than on the precise formalisations that underlie the authored material, which are detailed elsewhere [10].

## 4.1  Pirates

The Pirates story domain PLUNDER[3] is the main domain that the Virtual Storyteller project is focusing its efforts on. Pirates portray stereotypical behaviour that is somewhat easier to model than, say, the behaviour of characters in psychological thrillers. This property is shared with the domain of fairy tales, but unlike fairy tales, we believe that pirate tales evoke less expectations of story structure for the reader (e.g., adherence to Propp's morphology).

Rather than a fully generated plot, PLUNDER has an overarching storyline (a crew of pirates going on a treasure hunt) that forms the theme for several story subdomains. We brainstormed about the following questions: (1) what are some subdomains that we can conceive of to start building simulations around? (2) what are typical roles of pirates in such subdomains? (e.g., captain, boatswain) (3) what do pirates want and do there? (e.g., drink rum, commit mutiny) (4) what are typical objects associated with these subdomains? (e.g., ship, treasure map, pirate flag). We considered subdomains in which simple stories would take place: in a bar where a crew is assembled, on a ship underway to a treasure island, and on the island where the treasure is buried.

Our initial, naive authoring approach was to enforce a co-creation process by creating a 'big bag of domain content' to bootstrap the authoring iterations, and to see if we could use it as a basis for subsequent iterations. For the process authoring side of the domain, we reused domain-independent components developed earlier, such as a partial-order planner that allows characters to select actions based on their goals. The first subdomain we aimed to develop was called *on the ship*. We created two pirate characters: Anne Bonney and Billy Bones. We implemented a few goals that these pirates might have aboard a ship, and added some actions that allowed the characters to construct goal plans. For goal justification, we also added some events and framing operators. See Table 1.

*Cycle 1.* In an example simulation run, Anne Bonney used a framing operator to endow herself to be the ship's captain, and selected an event that the water supply became exhausted. This matched the preconditions of the goal to replenish it, that she subsequently adopted. Billy Bones selected an event to become thirsty for some rum, and used a framing operator to establish the fact that there was rum available in the hold of the ship. This justified the adoption of the goal to drink rum. Anne Bonney sailed to a nearby island, went ashore and started replenishing the water supply, whilst Billy Bones opened the hatch to the hold, went to the hold, picked up a bottle of rum and got himself drunk. After this, Billy Bones framed himself to hate Anne Bonney and adopted the goal to kill her. Planning how to do this, he endowed himself with a rapier and went ashore to find and stab Anne.

---

[3] Pirates Looming in Unscripted Narrative: towards Dramatic Emergent Roleplay.

We observed a certain incoherence in the event sequences. The causal network theory of story comprehension, on which we base our fabula formalism, relates narrative coherence directly to the causal connectedness of the events [17]. It follows that coherence would be improved if the events were better causally connected, e.g., when actions of one goal lead up to the adoption of another goal, or cause a conflict between goals and attitudes. Yet, Billy Bones' goal to kill Anne Bonney had no such causal connection to earlier story elements, including his own goal of getting drunk. We diagnosed this as a flaw in the AI, which we solved by further constraining the goal adoption process of the characters, so that they would only adopt goals that are a result of earlier events. After this debugging step, we took the co-creation view, adding more content to allow for more causal connections whilst building on the goals already present. So far, drinking rum, replenishing the water supply and killing a fellow pirate had little to do with each other. So, we ended up somewhat artificially adding possibilities for causal connections. For instance, we made it possible for a character to hate drunken pirates (not very pirate-like!), leading to murder. Another somewhat artificial addition for causal connection between goals was to add a goal to drink from the water supply (rather than to drink rum), so it would become exhausted.

*Cycle 2.* The newly added content resulted in the expected causal connections. For instance, Anne Bonney got drunk, after which Billy Bones saw her drunk, hated her, and decided to pick a fight. In another run, Billy Bones drunk the last of the water supply so that the goal to go and refill it was triggered for the pirate captain Anne.

Although we were on track towards the emergence of more coherent narratives, we felt that the initial arbitrary choices in story content required nontrivial work in order to embed the content within a larger causal context. It seems

**Table 1.** Operators for bootstrapping the Pirates subdomain *on the ship* (informal representation)

| Goal | Actions | Framing operators | Events |
|------|---------|-------------------|--------|
| **Drink rum** | – Open hatch<br>– Go to hold<br>– Pick up rum | – Rum bottle is in hold | – Become thirsty |
| **Refill water supply** | – Sail to island<br>– Go ashore<br>– Replenish water supply | – Pirate is the captain<br>– Ship has a water supply | – Water supply becomes exhausted |
| **Kill a fellow pirate** | – Go to pirate<br>– Draw rapier<br>– Stab pirate | – Pirate hates someone<br>– Pirate has a rapier | |

that this issue was at least partially caused by the 'big bag of domain content' approach. We concluded that a process of co-creation might benefit from a tighter integration of authoring and feedback, bootstrapping the authoring process from minimal content.

## 4.2   Little Red Riding Hood

The story domain RED (Red's Emergent Drama) was developed for participation in the *Little Red Riding Hood Panel: The Authoring Process in Interactive Storytelling* at the ICIDS 2008 conference. The co-creation view meant that we immediately let go of the goal to reproduce the original Little Red Riding Hood story, using it only as inspiration for the characters and their interactions.

We used three character agents playing the roles of Little Red Riding Hood (Red), Grandma, and Wolf. To enable a tighter feedback loop between authoring and story generation, we did not bootstrap the authoring process with a 'big bag of domain content' this time. Rather, we started with a simple and minimal design of a story world (e.g., one goal, actions that can achieve it, and a planner that turns these actions into a goal plan). In the case of the RED story world, this meant that the initial setup of the story world contained the goal (and accompanying actions) to bring a cake to Grandma. To enable the expression of this goal, a small story world geography was authored (a path from Red's house to the forest, and from the forest to Grandma's house) along with some actions (to skip from one location to another, and to give something to someone). With these initial ideas and their implementation, we started the iterative authoring cycle of Fig. 2.

*Cycle 1.* A predictable story 'emerged' during simulation: Red skipped to the forest, then to Grandma's house, and gave her the cake. We chose a continuation in which Grandma would eat the cake, and also wanted to enable Wolf to eat the cake, by stealing it. So we added a goal to eat something, and an action to take something from someone else. To enable goal justification, we added an event to become hungry.

*Cycle 2.* In the simulation, both Grandma and Wolf could not adopt any goals: for them, the preconditions for available goals did not match the initial state of the story world. So they attempted to justify goals (out-of-character) by selecting the event to become hungry. On her way to Grandma, Red met Wolf, who had adopted the goal to eat something and took the cake from Red. However, since Red still wanted to bring the cake to Grandma, she took back the cake from Wolf. Wolf still wanted to eat the cake, so again took the cake from Red. This 'cake fight' continued until Red skipped to Grandma's house before Wolf managed to take the cake from her. Then, a similar situation occurred with Grandma who did not know that Red was going to give her the cake. Because she was hungry, Grandma took the cake from Red. This also happened to solve Reds goal that Grandma had the cake. Now Red had no more goals to adopt, so she selected

the event to become hungry and adopted the goal to eat something. This caused Red to take back the cake from Grandma, and eat it herself.

Some of this behaviour was expected, some was surprising and inspiring (e.g., Red could be an assertive girl), and some was undesired, resulting from a domain underspecification: only mean persons take something from someone when it does not belong to them; nice people ask. Furthermore, if the cake can be taken away from Red without the possibility of taking it back (e.g., if Red is not mean), a response is needed to this event. We chose to have Red cry as a plausible dramatic response for little girls.

So in the implementation phase, we added a framing operator that can endow a character to be mean; only one character in the story world can be mean (authorial choice). We added a cry reactive action, triggered by someone taking something from a character without the character's consent. Preemptively, we constrained the crying reactive action trigger so that it is only applicable to little girls (authorial choice).

*Cycle 3.* In the simulation, Wolf framed himself to be mean (out-of-character, using the framing operator), so that he could plan to take away the cake from Red. After this mean action from Wolf, Red started crying. This was as expected. As authors, we considered how the simulation might continue at this point. Red might go to Grandma to seek support. In revenge, Grandma might poison a cake and feed it to Wolf. We considered how this might open up possibilities in the simulation for the cake to be poisoned by Red in an attempt to poison Grandma in case *Red* happens to be the mean one (an idea was to add a goal specifying that mean characters try to poison others). Wolf might be allowed to satisfy his hunger by eating Grandma, or by following Red and eating them both. Red might be given the option to be distrustful and avoid interaction with Wolf. We only implemented one of these ideas. We added a goal to seek support and added speech actions for Red to tell Grandma what happened, and to ask her what to do. We also added a goal for Grandma to avenge her granddaughter by poisoning the wrongdoer, and actions that allowed a goal plan.

By authoring like this, authorial choices are always made in a larger story context, avoiding problems of ending up with incoherent story content. Still, to avoid authoring a linear story, we found it necessary to actively consider the ways in which authored material might also be used in different simulation runs (e.g., poisoning as an act of meanness). This is a way to increase density of the story landscape, as discussed in [15].

## 5   Conclusions and Future Work

Using story generation within an interactive storytelling system may reduce the amount of story content that needs to be authored explicitly, but raises the question what the role of story generation is within the creative process of the author. A distinction between a process of debugging (author with an unchanging authorial intent) and co-creation (letting story generation and authorial intent

influence each other) was found useful in order to describe two different ways that story generation feedback during authoring may serve an author.

One important consequence of using the co-creation view for building interactive storytelling systems is that it moves away from the idea of having totally pre-meditated authorial control over the end result. This makes an iterative authoring process essential and is likely to have further consequences for the requirements of authoring tools for such systems. The benefit is that the tension between authorial control and the sometimes unpredictable or uncontrollable story generation outcome is lessened. Another benefit of the co-creation view is that it is suitable for multi-party authoring approaches. A recent example is the massively collaborative authoring approach of [9], in which intelligent story characters can be taught in a rehearsal mode how (not) to act and why.

For The Virtual Storyteller, we found that taking the co-creation view using an iterative authoring cycle allows for a flexible incremental approach to story world authoring. Such an approach reduces the authorial impasse that the author of an emergent narrative faces. We have first used the iterative authoring cycle for one of the subdomains of PLUNDER, and used a further refined approach in the RED domain. We found that bootstrapping the authoring cycle with minimal story world content, followed by small authoring cycles, helps in achieving coherence and density of the story landscape. Based on this refined version, we aim to develop more subdomains of the PLUNDER domain.

So far, the developed domains have been rather small in scale. An open question is how the authoring approach proposed here scales up. We foresee two factors that may complicate upscaling. First, since the simulation is nondeterministic, there is no systematic way to explore all possible simulation runs and the unexpected effects that result from any implementation step. Second, the authoring approach is meant to be additive, but might in practice require revisiting earlier choices. Since process and content authoring at any point in the authoring process affect the outcome of the simulation in fundamental ways, it may be possible that authoring choices made early in the authoring process can be undermined in subsequent authoring iterations, especially where these cannot be detected from the logical representation. These are issues that need further exploration.

**Acknowledgements.** This research has been supported by the GATE project, funded by the Netherlands Organization for Scientific Research (NWO) and the Netherlands ICT Research and Innovation Authority (ICT Regie).

# References

1. Costikyan, G.: Games, storytelling, and breaking the string. In: Harrigan, P., Wardrip-Fruin, N. (eds.) Second Person: Roleplaying and Story in Playable Media, pp. 5–14. MIT University Press, Cambridge (2007)
2. Silverman, B., Johns, M., Weaver, R., Mosley, J.: Authoring Edutainment Stories for Online Players (AESOP): Introducing Gameplay into Interactive Dramas. In: Balet, O., Subsol, G., Torguet, P. (eds.) ICVS 2003. LNCS, vol. 2897, pp. 65–73. Springer, Heidelberg (2003)

3. Sauer, S., Osswald, K., Wielemans, X., Stifter, M.: U-Create: Creative Authoring Tools for Edutainment Applications. In: Göbel, S., Malkewitz, R., Iurgel, I. (eds.) TIDSE 2006. LNCS, vol. 4326, pp. 163–168. Springer, Heidelberg (2006)
4. Spierling, U.: Adding Aspects of "Implicit Creation" to the Authoring Process in Interactive Storytelling. In: Cavazza, M., Donikian, S. (eds.) ICVS-VirtStory 2007. LNCS, vol. 4871, pp. 13–25. Springer, Heidelberg (2007)
5. Mateas, M.: Expressive AI. Leonardo: Journal of the International Society for Arts, Sciences, and Technology 34(2), 147–153 (2001)
6. Carbonaro, M., Cutumisu, M., McNaughton, M., Onuczko, C., Roy, T., Schaeffer, J., Szafron, D., Gillis, S., Kratchmer, S.: Interactive Story Writing in the Classroom: Using Computer Games. In: Proceedings of DiGRA 2005 Conference: Changing Views – Worlds in Play, pp. 323–338 (2005)
7. Thomas, J.M., Young, M.R.: Author in the Loop: Using Mixed-Initiative Planning to Improve Interactive Narrative. In: Proceedings of the ICAPS 2006 Workshop on AI Planning for Computer Games and Synthetic Characters (2006)
8. Pizzi, D., Cavazza, M.: From Debugging to Authoring: Adapting Productivity Tools to Narrative Content Description. In: Spierling, U., Szilas, N. (eds.) ICIDS 2008. LNCS, vol. 5334, pp. 285–296. Springer, Heidelberg (2008)
9. Kriegel, M., Aylett, R.: Emergent Narrative as a Novel Framework for Massively Collaborative Authoring. In: Prendinger, H., Lester, J.C., Ishizuka, M. (eds.) IVA 2008. LNCS (LNAI), vol. 5208, pp. 73–80. Springer, Heidelberg (2008)
10. Swartjes, I., Theune, M.: The Virtual Storyteller: Story Generation by Simulation. In: Nijholt, A., Pantic, M., Poel, M., Hondorp, H. (eds.) BNAIC 2008, Proceedings 20th Belgian-Netherlands Conference on Artificial Intelligence, pp. 257–264. University of Twente, Enschede (2008)
11. Meehan, J.: TALE-SPIN. In: Schank, R.C., Riesbeck, C.K. (eds.) Inside Computer Understanding: Five Programs Plus Miniatures, pp. 197–226. Lawrence Erlbaum Associates, Hillsdale (1981)
12. Aylett, R.: Emergent Narrative, Social Immersion and "Storification". In: Proceedings of the 1st International Workshop on Narrative Interaction for Learning Environments (NILE), Edinburgh (2000)
13. Swartjes, I., Theune, M.: A Fabula Model for Emergent Narrative. In: Göbel, S., Malkewitz, R., Iurgel, I. (eds.) TIDSE 2006. LNCS, vol. 4326, pp. 49–60. Springer, Heidelberg (2006)
14. Swartjes, I., Kruizinga, E., Theune, M.: Let's Pretend I Had a Sword: Late Commitment in Emergent Narrative. In: Spierling, U., Szilas, N. (eds.) ICIDS 2008. LNCS, vol. 5334, pp. 264–267. Springer, Heidelberg (2008)
15. Louchart, S., Swartjes, I., Kriegel, M., Aylett, R.: Purposeful Authoring for Emergent Narrative. In: Spierling, U., Szilas, N. (eds.) ICIDS 2008. LNCS, vol. 5334, pp. 273–284. Springer, Heidelberg (2008)
16. Louchart, S.: Emergent Narrative - Towards a Narrative Theory of Virtual Reality. Ph.D. thesis, University of Salford, Salford, UK (2007)
17. Trabasso, T., Secco, T., van den Broek, P.: Causal Cohesion and Story Coherence. In: Learning and Comprehension of Text, pp. 83–111. Lawrence Erlbaum Associates, Hillsdale (1982)

# Interactive Storytelling System Using Recycle-Based Story Knowledge

Kaoru Sumi[1,2]

[1] Hitotsubashi University,
2-1 Naka, Kunitachi-shi, Tokyo 186-8601, Japan
[2] National Institute of Information and Communications Technology,
3-5 Hikaridai, Seika-cho, Soraku-gun, Kyoto 619-0289, Japan
Kaoru.sumi@acm.org

**Abstract.** This paper describes an animation story generation system called WordsAnime, which uses recycle-based story knowledge. WordsAnime uses the animation database provided by animation consumer-generated media. A user generates a story by repeating the steps of in-putting scenarios and viewing animations. WordsAnime extracts the story knowledge automatically while the user is operating the system. The system presents manual, semi-automatic, and fully automatic modes of creating scenarios using the story knowledge. This paper introduces recycle-based story knowledge and its current state through several trials involving a number of users.

## 1 Introduction

WordsAnime [1][2] is a system for animation story generation using a three-dimensional animation that is created by a user inputting or selecting a simple scenario. The animation is created by combining animation sections corresponding to the words of a scenario. The user generates the story by repeating the steps of inputting scenarios and viewing animations. Data on animation sections in an animation database called Animebase correspond to words provided by the animation consumer generated media (CGM): Anime de Blog [3]. Anime de Blog can collect 3D animation and image data corresponding to the words. Users have indicated the need for a more appealing way of creating animation in blogs. In this system, animation or image data are searched for and selected from a shared consumer generated database by using simple words. Users share animation data and easily create new data by using an animation editor on the Web and uploading the data.

Drawing from scratch is the traditional way of generating animation. For example, animation can be created in this fashion by using professional three-dimensional computer graphics (3DCG) tools. It requires great effort to master professional 3DCG tools, and because they are expensive they are not for novice users. This limits creativity because novice users need easier trial and error practice and learning to create content.

By providing animation data corresponding to the natural language, we can enable novice users to create content. This is highly significant because of its potential for wide application.

I.A. Iurgel, N. Zagalo, and P. Petta (Eds.): ICIDS 2009, LNCS 5915, pp. 74–85, 2009.

WordsAnime extracts the story knowledge automatically while the user is operating the system. WordsAnime reuses the story knowledge for manual, semi-automatic, and fully automatic modes of creating scenarios. WordsAnime is a prototype recycle-based story knowledge learning method that extracts and shares information from users while they are using the system.

## 2   Related Work

WordsAnime has a story knowledge base for automatic scenario generation, which can extract knowledge automatically when the user is accessing the system.

Cyc [4] is an artificial intelligence project that attempts to assemble a comprehensive ontology and database of everyday common sense knowledge, with the goal of enabling AI applications to perform human-like reasoning. Cyc needs an elaborate logical language that precisely specifies the meaning. Our system does not need description of strict knowledge or even the operation of describing knowledge by users. Simply creating stories (or describing easy rules) will collect story knowledge. StoryNet [5] is a very large narrative-based knowledge database of story scripts that can be used for common sense reasoning. ComicKit [6] is an interface for acquiring a StoryNet script over the Internet. ComicKit can also extract scenario rules automatically when the user is creating comics using arranged graphics.

The main characteristic of our system is that it has both a 3D animation consumer-generated database based on words, and a story knowledge database based on simple subject, predicate, and object, etc. These databases based on words are not limited but flexible and can be expanded by users.

## 3   Animation Consumer Generated Media

WordsAnime uses the animation data from Anime de Blog. Figure 1 shows the operation flow of Anime de Blog. The user creates a blog and registers animation and image data on the Anime de Blog server. The animation database Animebase includes character data, animation-part data for each character, keywords, background images, and user information.

The animation parts are composited at the user's request. The character data is managed by an administrator because the character output format should conform to a particular hierarchical structure, number of joint parts, and balance of part lengths. This system was developed for the Japanese language.

Figure 2 is a snapshot of Anime de Blog. When a user inputs a subject and predicate as a scenario, and selects 'search', the system searches Animebase for animations matching the subject and predicate according to the frequency of usage. Similarly, when the user inputs a human object and selects 'search', the system searches Animebase for animations matching the human object and the subject's passive mode action of predicate according to the frequency of usage. When the user inputs an item object and selects 'search', the system searches Animebase for animations based on this object according to the frequency of usage. When the user inputs a background and selects 'search', the system searches Animebase for images by referring to this background according to the frequency of usage. The system then displays lists of animations or images as the search result.

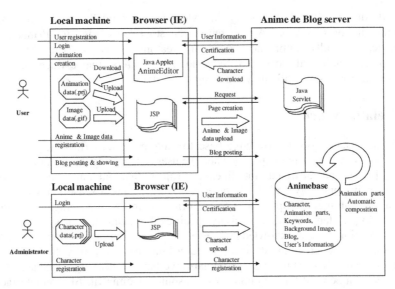

**Fig. 1.** Framework of Anime de Blog

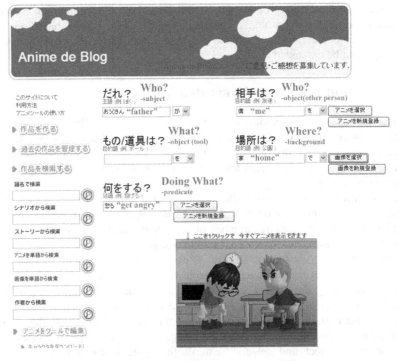

**Fig. 2.** Snapshot of "Create a new blog"

If users cannot find appropriate animations in Animebase, they can edit and register animation data in Animebase by using an animation editing system called the AnimeEditor Java applet using Java3D. They can also upload image data to create backgrounds. Regardless of their level of experience, users can easily use Anime Editor on a Web page. As they upload both new animation data created using this system and scenarios written in natural language, batch processing automatically occurs at predetermined times. The system creates more animations from the newly uploaded animation motion data and natural language expressions (subjects, predicates, or objects) by applying them to the motions of other characters, and it stores all of these new data in Animebase.

Even novice users can intuitively create animations by using the spatial keyframing method [7] in AnimeEditor. This method uses animation data to record the user's mouse operations in real time. The user sets the key poses for a character by placing the yellow balls as a spatial keyframe. By changing the position of the pink ball in the special area, the user can easily create an animation.

The user can then save the animation as a local project file which can be uploaded later to Anime de Blog. The project file includes settings (camera parameters and software version), background property (background setting), base (initial pose of the model), cursor (cursor trajectory), key (poses of the model, corresponding to key-frames), model (virtual reality modeling language (VRML) data of the character model), properties (character model information), texture (texture file), ground property (background setting).

(1) Character role configuration

AnimeEditor imports several characters and objects. These characters have to specify roles so as to increase the variety patterns of animations for reuse purposes. The roles include "main," "other," and "etc." "Main" means the central character of the predicate corresponding to the motion created by the user. "Other" means another character, corresponding to the character performing the passive motion of the predicate. "Etc." includes characters or items, and it indicates an accessory that is not changed for reuse in the animation register of Animebase. In other words, the role of "main" corresponds to the subject, "other" corresponds to the object (other person), and "etc." corresponds to the object (item).

For example, if the predicate is "play baseball" or "throw the ball", we set the throwing character as "main," the receiving character as "other," and the ball as "etc." The project is saved as "baseball.prj."

(2) Motion retargeting to other characters

The system can import a particular motion from the project file of an animation of a certain character, apply the motion to another character, and show the other character executing that same motion.

Copying from the basic model of the motion data (VRML) to another model can retarget the motion of the first model. Motion retargeting [8] is done by setting the cursor value (cursor trajectory), key (poses of the model corresponding to keyframes), model (VRML data of the character model), and properties (the character model information) to those of the other character.

When the user clicks the "Upload the animation" button or "Upload the image" button, the animation project file made by AnimeEditor or a GIF image file, respectively, is uploaded to the Anime de Blog site. For example, the baseball project is uploaded for the predicate "play baseball," the main character "pig," the other character "rabbit," and "etc." role "ball." Several keywords can be input to each input area by separating the keywords with a comma (,).

Once the animation is uploaded, motion retargeting is run as a background process. In this process, the system changes the "main" character to all the other characters of the same type in turn, and does the same for the "other" character. Then, it generates combinations of these animation files.

First, the system creates each project file by setting the value of the cursor to that of the original project file, setting the key to the calculated rotation value by using the value from the original project file, and setting the model and properties to those of the other character. Then, it creates a GIF animation for display on the blog page using Java3D rendering and the original VRML motion file.

Once this is done, if the user searches for "bear" as a subject, "dog" as an object (other person), and "play baseball" as a predicate, the system returns animations of a bear throwing a ball and a dog catching the ball, which are created by the background process.

The initial test installation of Animebase has 31 simple cartoon characters: seven kinds of animals (bear, dog, cat, panda, pig, rabbit, and mouse), six different male adults, six female adults, three male children, three female children, three elderly males, and three elderly females. These characters have relatively few joints, but over the course of the test, we have been uploading more realistic characters with many more joints. Thus far, the system has bipedal human or animal characters. Each type has the same hierarchical structure, the same number of joint parts, and the same balance of body part lengths; therefore, the motion data can be shared among the same character types. Motion data can be shared even when new character types are added. Animebase has about 200 registered verbs for its cartoon-type characters. These are high-frequency verbs extracted from fairy tales and elementary school textbooks. The initial animation data for Animebase were created by animators visualizing these verbs. The initial data yielded a total of 9500 possibilities (31 cartoon-type characters × 200 predicates + other animations).

Anime de Blog has begun its trial operation as the world's first animation CGM application. It gathers animation and image data corresponding to natural language information and stores them in a shared database called Animebase. During our first four-month trial operation of Anime de Blog, a total of 1033 users registered with the system. There was an average of 963 accesses per day (maximum of 7424). The number of stored animations increased from 9500 to 28464 and it is still increasing. These figures show that the users were very interested in animation con-tent creation.

# 4    Interactive Storytelling System: WordsAnime

WordsAnime prompts users to input a storyline through the method of paragraph writing. If a user inputs a scenario, an animation corresponding to the scenario appears on the display using the animation database (Animebase) collected by Anime de Blog. WordsAnime displays GIF animation data to display on the screen from Animebase, stored on the Anime de Blog server. WordsAnime includes functions for story generation support, automatic scenario generation using rules, rule extraction, and story browsing. It is based on Servlet/JSP and Ajax (JavaScript) and requires Windows XP and Internet Explorer 6.0 SP2 or Firefox 2.0.0.9.

## 4.1    Scenario Inputting

The user generates the complete story by repeating the steps of inputting scenarios and viewing animations. WordsAnime uses a method of paragraph writing derived from a Finnish method [9] enabling users to easily create stories. The system prompts a user to create scenes for "Introduction", "Problems", "Challenges", "Problem Resolution" and "Conclusion". The sequences from "Problems" to "Problem Resolution" and from "Problems" to "Challenges" are repeatable .

To create the complete story, the user accesses the WordsAnime URL, and the system shows the scene for "Introduction" on the scenario input page (Figure 3).

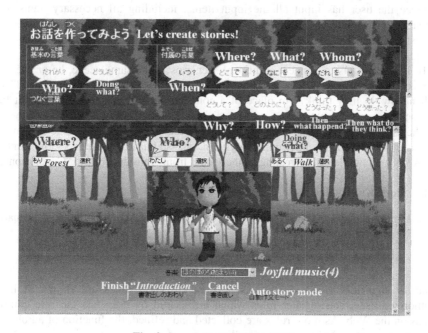

**Fig. 3.** Snapshot of "Introduction"

For each scene, the system prompts users to input "Who?" and "Doing what?" as necessary input items. All the input items can be selected by clicking alternatives in the scrolling list or by typing the user's own words. As optional items, the system provides "When?", "Where?", "What?", and "Whom?" "When?" and "Where?" correspond to the background image, "What?" corresponds to an item, and "Whom?" corresponds to a character as an object of a sentence. These optional items can be chosen by clicking the balloons in the menu, and they can be removed by re-clicking the balloons.

If the user types the "Who?" text or chooses from the scrolling list, the system shows the information dialogue window of the character, along with its thumbnail. In this window, the user can choose the kind of character, the height (tall/short), weight (heavy/light), strength (strong/weak), and mood (happy/gloomy). If the characters or background images include more than one data file, the system shows the choices in a new window and prompts the user to select one.

After the user selects the character, if the motions of the character corresponding to "Doing what?" include more than one data file, the system also shows the motion choices in a new window and prompts the user to make a selection. These choices are sorted by frequency of usage in Anime de Blog.

Next, if the characters corresponding to "Whom?" include more than one data file, the system again shows the choices in a new window and prompts the user to make a selection. Here, note that the character for "Whom" is performing the passive mode action of "Doing what?" because it is an object of the scenario.

Once the user has input all the input items, including all necessary items, the scenario is complete and it corresponds to one sentence. When the user clicks the "Finish the sentence" button, the animation appears with overlapping animations and images according to the scenario.

If the user wants to connect additional scenarios in the same scene, he or she can connect the sentences by clicking "Why?", "How?", "Then what happened?" or "Then how do they think?" in place of a conjunction. Then, the user can input the next scenario in the same scene.

The user can choose suitable music or sound effects in every scenario. The system has dozens of sounds, such as busy music, joyful music, sad music, footsteps, snoring, and so on. A story is completed by creating all the scenes from "Introduction" to "Conclusion".

### 4.2 Story Knowledge

WordsAnime has story knowledge described as rules for automatic scenario generation as follows.

Rule 19: IF   Who   "?a"   Whom or What   "?b"      Doing what   "call"
THEN   Who   "?b"   Doing what   "come"

Rule 19 signifies "If a calls b, then b comes". These rules are shown as lists. Authorized users can register rules which are shared by users via the rule control pages on the Web. As more rules are collected and refined, the function of automatic scenario generation becomes more intelligent.

These users can describe rules by writing IF and THEN sentences directly. An IF sentence represents the condition of the scene. A THEN sentence represents the condition of the next scene. These users can select scenes for rules, including

"Introduction-Problem", "Problem-Challenges", "Challenges-Problem resolution", and "Problem resolution-Conclusion". "Introduction-Problem" signifies that the condition of the IF sentence occurs in the Introduction scene, and the condition of the THEN sentence occurs in the Problem scene. The user can also input the character's features in a rule's condition, for example height, weight, strength, and mood, Each rule has a weight for conflict resolution, indicating how much the rule has been used. Rule candidates are shown sorted by their weights.

When the user creates a scenario and clicks the button "Finish the scene", then some scenario candidates appear as hints for the user. The user can select one of the candidates or create his or her own scenario when creating a scene. If the user selects one scenario, then the corresponding animation appears. There are semi-automatic and fully automatic modes.

The system then automatically extracts the IF–THEN rules containing the sentence of the scenario in the before scene (the IF rule) and the sentence of the scenario in the after scene (the THEN rule), which were stored in the knowledge base at the user's request. When the rule is extracted for the first time, the weight value is set to the default. If the extracted rule is the same as the rule in the rule base, the weight increases by one.

## 5   Experiment

The story generation system—WordsAnime—was evaluated by conducting three children's workshops then asking the participants to complete a questionnaire which was later analyzed.

The first workshop was held for an Open house at Keihanna research center of National Institute of Information & Communications Technology (NICT) located in Kyoto, Japan. The total number of attendees was 72 and the examinees included 39 family and children groups including children from 5 to 14 years old.

The second workshop was held for "CANVAS workshop collection" at Mita campus of Keio University located in Tokyo, Japan, co-organized by Keio University and CANVAS, which is a non-profit organization for children's workshops. The total number of attendees was 120 and the examinees included 68 family and children groups including children from 5 to 14 years old.

The third workshop was held at NICT Tsukuba research center located in Tsukuba, Japan, co-organized by Tsukuba city and NICT. The total number of attendees was 103 and the examinees included 39 family and children groups including children from 8 to 12 years old.

One group used one notebook PC. Because some of these children might have been using a PC for the first time, the adults assisted them with inputting if necessary. First, the experimenters asked the examinees to think about the characters and continuity of the story, then they started using the system. After they had finished making the story, their work was displayed on the front screen (Figure 4). Finally, they completed the questionnaires. The examinees scored the questions on a five-level scale.

A total of 54 stories were made in the first workshop, a total of 78 stories were made in the second workshop, and a total of 50 stories were made in the third work-shop.

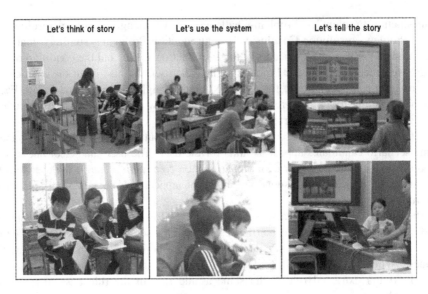

**Fig. 4.** Snapshot of a workshop

**Table 1.** A result of the questionnaire

| Questions | 1st | 2nd | 3rd |
|---|---|---|---|
| I enjoyed. | 92.3% | 98.5% | 100.0% |
| I would like to another story. | 89.7% | 81.5% | 89.7% |
| Making animation stories by words is easy. | 66.7% | 41.5% | 46.1% |
| Making animation stories by words is difficult. | 30.8% | 56.9% | 53.8% |
| Introducing continuity in the story is easy. | 64.1% | 67.7% | 64.1% |
| Introducing continuity in the story is difficult. | 33.3% | 29.2% | 35.9% |
| The animation generated & I imagined are similar. | 43.6% | 51.6% | 49.0% |
| Children can use this system without problems. | 87.2% | 83.1% | 87.2% |
| Elderly can use this system without problems. | 87.2% | 61.5% | 87.2% |

| Age | Average | S.D. |
|---|---|---|
| 1st | 8.94 | 2.38 |
| 2nd | 9.23 | 1.73 |
| 3rd | 9.98 | 1.04 |

Table 1 is a result of the questionnaire. Almost all of the children enjoyed the experience and said they would love to make another story. Further, almost half felt that making animation stories with words was easy. However, some did not always like using this method to make animation stories because they felt it was difficult. The users pointed out that some animations corresponding to their words were not always provided by the system. It was considered that the users input the word through a trial and error process because the operations allowed only inputting or selecting words and they were not taught how to make animations using AnimeEditor. More than half felt that introducing continuity in the story was easy, but some felt it was difficult. From this we concluded that introducing continuity in the story required training even

when using the paragraph writing method. According to their comments, there were some children that did not need alternative scenarios as hints by the system, whereas some children did need hints. This depended on the child. The assessment of how closely the rendered animation matched what they had imagined before using the system also depended on the child. We think that increasing the number of characters, motions, and background pictures could help achieve animations similar to those imagined by the user. Most of the respondents answered that children could use this system without problems. Most of the respondents also answered that elderly people could use this system without problems.

We received comments such as "I'd love to create another one. I can create better than I expected" and "It is easier than expected, and it is useful to make the imagination come true."

The most common predicates were "eat," "play," "go," "hear," "come," "think," "laugh," "say," "look," and "run" in order of usage frequency. Words that indicate behavior encountered often by children in their daily lives were ranked higher. Words indicating emotions such as "laugh," "angry," and "cry" and playing such as "play ball," "play football" and "dance" were also selected by the users.

Accordingly, the 32 rules set as the default increased to 199 rules in the first workshop, then rose to 207 rules in the second workshop, and then increased to 967 rules in the third workshop.

The rules that were frequently used were: IF someone A and someone B "play" THEN someone A and someone B "laugh" (Rule105), IF someone "get exercise" THEN someone "be tired" (Rule2), IF someone "play" THEN someone "get rest" (Rule31), IF someone "eat" THEN someone "eat" (Rule46), IF someone "play" THEN someone "play" (Rule70), IF someone "go" THEN someone "go" (Rule75). For refinement of the rule bases, more user trials and better quality stories would be needed. However, the system automatically stores and learns scenarios and rules as story knowledge according to their usage. Since the rules of popular sequences are weighted and refined, these rules will be useful for story creation.

## 6    Discussion

We have introduced a story generation system called WordsAnime as an applica-tion of Animebase, enabling even children to create animation content by selecting words. We have shown that users can create animation by combining keywords to create animation from predetermined system options.

WordsAnime is a prototype recycle-based story knowledge learning method that extracts and shares information from users while they are using the system. WordsAnime acquires story knowledge when a user is creating stories, and the user is unaware of it. Then, WordsAnime reuses the story knowledge as alternative scenarios for hints and for automatic scenario creation.

According to the workshops, almost every user enjoyed the application and wanted to use it more. It is significant that WordsAnime collects story knowledge while users are enjoying themselves, because this means they are not hampered by the operation

of the system. At this time, the system recognizes simple story input; however, as a next step, we will investigate the knowledge required for more complicated tasks.

It is more difficult for children of this age to create a story than it is for adults [10]. However, half of the users created animations easily using words. Some had problems with inputting. Some users pointed out that some animations corresponding to their words were not always provided by the system. Therefore, the system needs more data enhancement, for example for characters, motions, background pictures, and knowledge rules, and an easier interface.

The mental images that people have when they create something vary from person to person. In our system, users can select parts of animation content and revise them through the reuse function. Although they cannot always create content that precisely matches their own imagination, they can come close by using our approach and by accessing the large animation databases.

Through the workshops, we realized that the ability to create a story depends on the individual user. WordsAnime has the potential to be used as a tool for training people in this ability. Also, through using WordsAnime, we can easily try making animation as pseudo-creators.

For future work, we will investigate further the framework for recycle-based knowledge, and promotion of utilization of content creation.

## 7    Conclusion

We have introduced a story generation system, WordsAnime and its recycle-based story knowledge. This paper reports the attempt to collect rules of story knowledge via WordsAnime through three workshops. The system collects story knowledge while users are enjoying themselves and they are not hampered by the operation of the system.

## References

1. Sumi, K.: Animation-based Interactive Storytelling System. In: Spierling, U., Szilas, N. (eds.) ICIDS 2008. LNCS, vol. 5334, pp. 48–50. Springer, Heidelberg (2008)
2. Sumi, K.: Capturing Common Sense Knowledge via Story Generation. In: Common Sense and Intelligent User Interfaces 2009: Story Understanding and Generation for Context-Aware Interface Design, 2009 International Conference on Intelligent User Interfaces (IUI 2009), SIGCHI. ACM, New York (2009)
3. Sumi, K.: Anime Blog for collecting Animation Data. In: Cavazza, M., Donikian, S. (eds.) ICVS-VirtStory 2007. LNCS, vol. 4871, pp. 139–149. Springer, Heidelberg (2007)
4. Lenat, D.B.: CYC: A Large-Scale Investment in Knowledge Infrastructure. Communications of the ACM 38(11) (1995)
5. Singh, P., Barry, B., Liu, H.: Teaching Machines about Everyday Life. BT Technology J. 22(4), 227–240 (2004)
6. Williams, R., Barry, B., Singh, P.: Comickit: acquiring story scripts using common sense feedback. In: 10th international conference on Intelligent user interfaces, pp. 302–304 (2005)

7. Igarashi, T., Moscovich, T., Hughes, J.F.: Spatial Keyframing for Performance-driven Animation. In: ACM SIGGRAPH/ Eurographics Symposium on Computer Animation (2005)
8. Gleicher, M.: Retargetting Motion to New Characters. In: Proc. of SIGGRAPH 1998, pp. 33–42 (1998)
9. Koskipää, R., Töllinen, M., Wäre, M.: Uusi salainen kerho 3. WSOY, Finland (2004)
10. Tajima, K.: Development of Storytelling Ability (Monogatari noryoku no hattatu). In: Proc. of Japanese Society of Personality Psychology, 70–71 (2003) (in Japanese)

# Emohawk: Searching for a "Good" Emergent Narrative

Cyril Brom, Michal Bída, Jakub Gemrot, Rudolf Kadlec, and Tomáš Plch

Charles University in Prague, Faculty of Mathematics and Physics
Malostranské nám. 2/25, Prague, Czech Republic

**Abstract.** We report on the progress we have achieved in development of Emohawk, a 3D virtual reality application with an emergent narrative for teaching high-school students and undergraduates the basics of virtual characters control, emotion modelling, and narrative generation. Besides, we present a new methodology, used in Emohawk, for purposeful authoring of emergent narratives of Façade's complexity. The methodology is based on massive automatic search for stories that are appealing to the audience whilst forbidding the unappealing ones *during* the design phase.

## 1 Introduction

Despite rapid progress in the fields of virtual storytelling (VS) and virtual characters (VC) over the last decade, educational issues remain largely unaddressed in these disciplines [1]. The lack of tools supporting education of beginners is an issue of high priority. In particular, while tools for authoring 3D graphics that can be used for education exist, tools for teaching programming of *behaviour* for VC are almost missing. Many VS authoring toolkits emerged recently [see 2], but they tend to provide very limited or no support for teachers and learners. Many of them are poorly documented and some are not downloadable. To our knowledge, there are only three tools concerned with programming behaviour for VC explicitly supporting education: Netlogo [3], Alice [4], and Pogamut [5]. Netlogo is an entry-level tool for building simple agents and running social simulations, but it does not allow for creation of VCs and possesses no complex 3D environment. Alice's main goal is to introduce basic programming concepts like conditional and loop primitives. The complexity of the built-in 3D world is not comparable to current game engines; the 3D world is "only" a mean to achieve Alice's educational goal. Pogamut is our own toolkit based on Unreal Tournament 2004 (UT) [6]. It has been successfully used in undergraduate as well as high-school education [1], but it is primarily focused on gaming AI audience, with limited use for general VS/VC courses [1].

To address this gap, we have started to develop an educational toolkit Emohawk on top of Pogamut and the UT game. Our premise is that a good introduction into the world of VS/VC is to immerse students in an interesting 3D virtual narrative, which they can co-construct by interaction and *examine its underlying mechanisms at the same time*. Emohawk should assist in teaching: a) basics of 3D VC control, e.g. steering and reactive planning, b) appraisal-driven architectures, c) coordination of multiple characters; i.e. unfolding "atomic bits" of a story, d) composing a story from these "atomic bits". The target audience is students and teachers of general computer

I.A. Iurgel, N. Zagalo, and P. Petta (Eds.): ICIDS 2009, LNCS 5915, pp. 86–91, 2009.
© Springer-Verlag Berlin Heidelberg 2009

sciences, social sciences, computer games and new media and art. Emohawk is intended for both the high school and university courses, and for both boys and girls. The teaching methodology capitalises on our incremental method presented in [1].

Emohawk features a narrative scenario with three characters controlled by an appraisal-driven architecture. The narrative is partly emergent due to this architecture and also due to natural non-determinism and user interaction. At the same time, it is also partly scripted, for it evolves around some predetermined plot points. Some options are available for authoring such scenarios [e.g. 7, 8]; however, they seem either to be time-consuming during the design phase [8] or to be limiting interaction of the user below the limit acceptable for Emohawk [7]. Thus, we have designed a new authoring method. On a general level, it addresses the issue of integration of emergent narrative (EN) and story-based approach. The main idea is to perform massive automatic search through the story-space *during the design phase* to find subspaces where the EN system may produce appealing stories while forbidding places where the EN system would perform poorly. We employ this strategy due to the unpredictable behavior of EN systems that often produce unappealing stories. The forbidding is realized by the designer by creating constraints layered upon the EN system. In real-time, the provided constrains help to structure the story being unfolded so that the unappealing story arcs are avoided.

The goal of this paper is twofold. First, we present Emohawk; its current state is described in Sec. 2. Second, we overview our authoring method in Sec. 3.

## 2   Project Emohawk

The Emohawk's content has been being built according to the following principles:

1.  the scenario must be interactive and spectator-based at the same time,
2.  the scenario must be interesting both for girls and boys,
3.  the scenario must feature a story (i.e. a simple narrative arc must be present),
4.  the scenario must be short and of Façade's [8] complexity (i.e. tailored to school lessons, with a few characters),
5.  the characters must exhibit emotions,
6.  there can be a natural language interaction, but all communication has to be handled symbolically, i.e. by body language and emoticons,
7.  the setting should be "almost normal", i.e. no "hard core" sci-fi space-ships etc.

The final scenario is as follows: *There is a small city with about thousand inhabitants. At the edge of the city, an emohawk farm lays. An emohawk is a kind of pet having the ability to suck emotions from people and spit (transfer) them on other people. From time to time, an emohawk escapes from the farm.*

*There lives Thomas, age 16-19, in the town. Thomas has a girlfriend Barbara and... well... yet another girlfriend, Natalie. The girls naturally don't know about each other. Thomas has just been with Barbara in the cinema. Now, he has to walk her home quickly, since Natalie is waiting for him to be taken to the next movie. Besides, there is an emohawk roaming around.*

Now, several things may happen based on whether Thomas and Barbara meet the emohawk or not, and based on their attitudes towards the pet. For example, Barbara

may start to enthuse over the cute emohawk, annoying Thomas and causing Natalie to start searching for Thomas and eventually find him with Barbara. Now, Natalie may start to enthuse over the emohawk as well, or get mad, or something else might happen. Essentially, the author has created the plot as a branching one.

Two modes of interaction with the emohawk's world are being designed. The first is oriented on beginners and the second on advanced students. The first is a game in which a student is a spectator and influences the course of the story by interactions; e.g. switching on/off individual appraisal rules of certain characters or putting some objects into the world, e.g. a cute teddy bear next to Barbara (the object may attract her attention, delaying the normal course of events and changing the story outcome later on). The second mode is programming: students will have a code of a character that they can change easily and run immediately. They will start with making simple concrete changes and gradually proceed to abstract complex assignments.

Technically, Emohawk is being developed as an extension of our Pogamut toolkit [5], which has been already released. Pogamut differs from other projects using UT in featuring a full-fledged integrated development environment and auxiliary libraries facilitating development of characters' control mechanisms.

The prototype of the scenario is already implemented [8]. The characters' action selection is BDI-based. We use ALMA [9], which is based on the OCC theory [10] as the characters emotion model. Our instantiation of ALMA features several complementary pairs of *emotions* and *attitudes* towards other characters/objects. Both the action selection mechanism as well as the emotion model can be influenced by a story manager featuring reactive rules. Emotions are expressed by different animations and the most salient emotion/attitude is represented by coloured bubbles close to a character's head (see [11]).

## 3  Story Design in Emohawk

User interaction, random fluctuations and the appraisal-driven architecture of characters in Emohawk makes behaviour of the whole application non-deterministic; basically, we have an EN system. At the same time, we have a plot, which should be unfolded. It can and should be unfolded a bit differently each time, but nevertheless constrain what would be otherwise a pure emergent narrative. How to author this hybrid? Louchart et al. [12] suggest that the solution to EN authoring may be for the author to stop thinking "in terms of plots" and to start thinking in terms of "goals, actions and emotions there are, and under which conditions they occur" [12]. This could possibly lead to emergence of interesting episodes of local interactions among VCs and/or the user. Connecting these episodes into an interesting story is then, to a large extent, a responsibility of the user. In our opinion, this approach does not guarantee that a) local interactions are interesting (the result may be a quite accurate computational model of social interaction, which nevertheless features no appealing narrative), b) the user will be able to proceed from one episode to another despite his/her wishes (e.g. the couple will never meet the emohawk for the pet's appraisal-driven architecture will always lead the pet elsewhere, precluding the user to enter a large part of the story).

We reason differently. In every instant, the application *affords* the user a set of actions through which s/he can influence the world. The user anticipates outcomes of these actions and selects from them just one that appeals to him/her most at the given moment. Our opinion is that the author should think in terms of these *possible action outcomes*. The challenge is to afford to the user *appealing* action outcomes for a reasonably large number of contexts the user might encounter. It does not matter whether an outcome pushes the story forward or just colours the current episode in an interesting way (e.g. a user may push Thomas to offer a frog to Natalie); the only important thing is that the outcome is appealing in some way. Here, we actually need both "plot-oriented thinking" as well as "goals & emotions-oriented thinking"; these are unified in our framework. Note that although the whole story can be appealing to the user who co-created it, it may not be appealing to an external observer.

This vague idea materializes in the authoring method having been used in Emohawk as follows. The designer comes up with (a) an ideal of a branching narrative, and (b) with an EN system that produces a space of possible story unfoldments that may or may not be appealing to the audience. Let us call this space $S$. Now, the designer carves a smaller space of acceptable story unfoldments from $S$, so that each acceptable unfoldment approaches the desired ideal, i.e. she/he prunes away a large part of $S$ and extends the rest a bit, producing a new space $R$. In other words, the purpose of the EN system is to automatically afford as many actions to the user as possible. The purpose of the reduction $R$ is i) to make it impossible to execute actions with uninteresting outcome, and ii) to afford appealing action outcomes in situations in which the EN component does not afford anything interesting.

More precisely, we need the notion of a *dramatic situation* and a *corridor*. The former is a situation that affords naturally multiple interesting action outcomes, either outcomes just colouring the situation or pushing the story forward, e.g. "Barbara and Thomas meet the emohawk". The latter connects two dramatic situations and affords only a few interesting action outcomes. The author should organise the plot around these dramatic situations and corridors, i.e. to create a branching graph. The notion of a branching graph is not new, but we tend to look at it in a new way. We conceive every path of the graph as a representation of an optimal story evolution as foreseen by the author under the assumption of no user interaction. However, due to user actions and natural non-determinism, characters can depart from these optimal paths. Many of these "deviations" can be anticipated by the author, but some of them may be missed. Still, many of these unanticipated "deviating" stories can be interesting. To describe these stories, we need the notion of an *enabled corridor*. An enabled corridor represents situations that do not differ significantly from either a dramatic situation or a corridor (Fig. 1a) and still afford reasonable number of interesting action outcomes.

Now, with the branching graph in hands and with the idea of an EN system (which includes the idea of VCs' architecture, initial goals and parameters), we setup the virtual world, put our VCs into the initial settings, and let the story to evolve deterministically. We tweak the parameters of the VCs to produce a story that accords, at least approximately, with one of the possible paths in the branching graph. Now, we need to define the enabled corridors. Running the scenario multiple times, we investigate what happens when user actions and random fluctuations are taken into account, forbidding stories to evolve into situations with uninteresting action outcomes. Assume we can somehow detect these situations. If such situation is encountered due to a user interaction, we should forbid this interaction *in the design phase* (e.g. there will be no

teddy bear in the simulation). Otherwise, we can implement (in the design phase) a new reactive rule for the story manager that influences (during run-time) the story a moment before the situation is encountered so that the situation is avoided "naturally" (e.g. the emotional state of a character is altered unknown to the user—Fig. 1a). Additionally, an entirely new corridor leading to a new dramatic scene unforeseen by the author can be detected (Fig. 1c).

The problem is that detecting uninteresting situations, in general, is intractable; we can apply only a heuristic approach. Our heuristic was following: we formalised what it means that the story is interesting, based on states and changes of states in VCs' affective variables. This is inspired by Façade [8]. Then, we run the scenario over 300 times (these runs evolved non-deterministically), picked automatically runs that violated the definition of interestingness (around 30% of them) and inspected these runs manually by the designer for uninteresting situations or errors. The whole process cannot be explained here for brevity; it is fully detailed in [11]. Obviously, this approach can be only as good as the formalization is. For instance, there might be scalability problems for larger narratives or narratives that are not affective based.

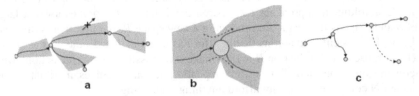

**Fig. 1.** a) The branching graph with enabled corridors (in grey) and rules forbidding the story to leave an enabled corridor. b) Either the story can follow one of the branches automatically due to the EN component, or the story manager can enforce the story to follow a specific branch. c) During the design phase, a new branch can be discovered (dashed line).

## 4  Discussion and Conclusion

We presented Emohawk: a 3D virtual storytelling application for teaching basics of the fields of virtual characters and virtual storytelling. The project is an on-going work. The main contribution so far is the new authoring approach we used to create a prototype of the Emohawk's scenario, as detailed in [11]. The approach is based on combining emergent narrative with scripting: the scripted part influences the emergent component by means of reactive rules that are created during the design phase based on the results of multiple runs of the scenario and automated detection of situations that should be avoided during a story evolution. Thus, the problem of combinatorial branching of possible stories is tackled by an off-line search.

Generally, our approach complements other methods of authoring 3D virtual narratives of this complexity, such as [7, 8]. Similarly to these methods, it is not without limitations. First, it seems that it can be scaled only for relatively small narratives with "interestingness" that can be formalised. Second, even for "the right" narratives and even after an extensive search, some uninteresting scenes are likely to be kept and it may happen that a user escapes to a terra incognita by an unpredicted sequence of actions. However, as the problem is intractable, we can not hope for a 100% correct solution: we will *always* have only a heuristic based solution. In our case, the

approach produced both novel dramatic scenes unforeseen by the author and helped to detect uninteresting evolutions of the narrative. This is clearly an improvement comparing both to a pure EN system as well as to a pure scripting.

In general, this paper showed that massive off-line search for appealing stories can be added to the portfolio of authoring approaches used in digital storytelling, though caution is needed.

**Acknowledgments.** This work was partially supported by the project CZ.2.17/3.1.00/ 31162 financed by the European Social Fund, the Budget of the Czech Republic and the Municipality of Prague, by Program "Information Society" (under project 1ET100300517, and by the research project MSM0021620838 of the Ministry of Education of the Czech Republic. The name "Emohawk" is inspired by Emohawk: Polymorph II, an episode of Red Dward VI (BBC).

# References

1. Brom, C., Gemrot, J., Burkert, O., Kadlec, R., Bída, M.: 3D Immersion in Virtual Agents Education. In: Spierling, U., Szilas, N. (eds.) ICIDS 2008. LNCS, vol. 5334, pp. 59–70. Springer, Heidelberg (2008)
2. Pizzi, D., Cavazza, M.: From Debugging to Authoring: Adapting Productivity Tools to Narrative Content Description. In: Spierling, U., Szilas, N. (eds.) ICIDS 2008. LNCS, vol. 5334, pp. 285–296. Springer, Heidelberg (2008)
3. Wilensky, U.: NetLogo. Center for Connected Learning and Computer-Based Modeling, Northwestern University (1999), http://ccl.northwestern.edu/netlogo/ (26.6.2009)
4. Carnegie Mellon University: Alice (1999-2009), http://www.alice.org/ (10.9.2009)
5. Kadlec, R., Gemrot, J., Burkert, O., Bída, M., Havlíček, J., Brom, C.: Pogamut 2 – A Platform for Fast Development of Virtual Agents' Behaviour. In: CGAMES 2007, pp. 1–5. Univ. La Rochelle (2007), http://artemis.ms.mff.cuni.cz/pogamut (26.6.2009)
6. Epic Megagames: UT 2004, http://www.unrealtournament.com/ (26.6.2009)
7. Aylett, R.S., Louchart, S., Dias, J., Paiva, A., Vala, M.: FearNot! – An Experiment in Emergent Narrative. In: Panayiotopoulos, T., Gratch, J., Aylett, R.S., Ballin, D., Olivier, P., Rist, T. (eds.) IVA 2005. LNCS (LNAI), vol. 3661, pp. 305–316. Springer, Heidelberg (2005)
8. Mateas, M.: Interactive Drama, Art and Artificial Intelligence. PhD thesis. Department of Computer Science. Carnegie Mellon University (2002)
9. Gebhard, P.: ALMA - A Layered Model of Affect. In: Dignum, F., Dignum, V., Koenig, S., Kraus, S., et al. (eds.) AAMAS 2005, pp. 29–36. ACM, New York (2005)
10. Ortony, A., Clore, G.L., Collins, A.: The Cognitive Structure of Emotions. Cambridge University Press, Cambridge (1988)
11. Bída, M.: Artificial emotions in computer games. Master thesis. Charles University in Prague, Czech Republic (2009), http://artemis.ms.mff.cuni.cz/emohawk (10.9.2009)
12. Louchart, S., Swartjes, I., Kriegel, M., Aylett, R.: Purposeful authoring for emergent narrative. In: Spierling, U., Szilas, N. (eds.) ICIDS 2008. LNCS, vol. 5334, pp. 273–284. Springer, Heidelberg (2008)

# Exploring Narrative Presentation for Large Multimodal Lifelog Collections through Card Sorting

Daragh Byrne[1,2] and Gareth J.F. Jones[1]

[1] Centre for Digital Video Processing, Dublin City University, Glasnevin, Dublin 9, Ireland
[2] CLARITY: Centre for Sensor Web Technologies
{daragh.byrne,gareth.jones}@computing.dcu.ie

**Abstract.** Using lifelogging tools, personal digital artifacts are collected continuously and passively throughout each day. The wealth of information such an archive contains on our life history provides novel opportunities for the creation of digital life narratives. However, the complexity, volume and multimodal nature of such collections create barriers to achieving this. Nine participants engaged in a card-sorting activity designed to explore practices of content reduction and presentation for narrative composition. We found the visual modalities to be most fluent in communicating experience with other modalities serving to support them and that the users employed the salient themes of the story to organise, arrange and facilitate filtering of the content.

**Keywords:** Lifelog, SenseCam, storytelling, digital narrative, media selection, narrative presentation, card-sorting, montage.

## 1 Introduction and Background

Lifelogging, or the capture of rich personal life histories through digital technologies, opens up wholly new opportunities for construction of highly personal biographical computation narratives [5,6]. Lifelogs may contain huge volumes of data from complimentary modalities including: visual diaries captured using the SenseCam; access to and the content of mobile and desktop documents; geo-location and people present using contextual sampling; explicitly captured photos or videos; and online social media, such as Twitter [5,10]. Given that a lifelog contains a wealth of content and context from a range of modalities, we must carefully consider how to select the most appropriate content to the story and how to integrate this multimodal content into a coherent, aesthetically pleasing presentation. This is particularly challenging.

Tomai and Forbus [13] note narrative presentation '*serves to extract and highlight those events, outcomes and conclusions which the presenter and observer find "interesting."*' As Barthes observes, not all of these events will be of the same importance to the plot and will contain both *cardinal* units, which can be seen as the core moments in narrative on which the plot is hinged, and *catalysers* or the surrounding relevant moments which fill the space between them [4]. However, it should not just recount a sequence of events, moments or happenings from the author's past, but should attempt to also communicate elements of the experience [2].

I.A. Iurgel, N. Zagalo, and P. Petta (Eds.): ICIDS 2009, LNCS 5915, pp. 92–97, 2009.

While some researchers have already explored narrative presentation in lifelog collections, these existing studies do not employ or offer computational models or strategies for narrative generation, and are been relatively small-scale or cursory [10,11]. For example, Harper et al. [11] explored the manual composition of stories from SenseCam footage but emphasis was placed on reporting their utility in reflection rather than narrative construction. Brooks offers one model for computational narrative [3], however, Appan et al. [2] demonstrate that this and other such approaches might not translate effectively to personal storytelling, finding narratives generated with such computational models to be *"disjoint and not very meaningful."* As such within lifelogs, coherence is a paramount consideration for computational approaches. Rhetorical Structure Theory (RST) offers a framework for the explanation and analysis of coherence through the composition and relations between nuclear and satellite elements. While originally designed for text, RST has been adapted both to the analysis and summarisation of multimedia collections [12]. Additionally, Cheong et al. [7] offer a narrative framework for game logs which makes provision for coherency checking.

Christian and Young note that there has been little effort to verify that the computational approaches for narrative generation align with the expectations of audience and their mental models [8]. This motivates our work. In this paper we investigate how multimodal lifelog archives containing photo, text, and context data can be brought together to best enable storytelling by observing the practices and methods employed by users during the composition of personal narratives.

## 2  Experiment Outline

In order to gain an understanding as to how multimodal narration of a lifelog might be achieved, we asked 9 individuals in our research group (7 male, 2 female; age range 20-50) to engage in a card sorting activity [9] in which they arranged, selected and reduced physical representations of 'artifacts' from an extended lifelog collection to produce a multimodal story (see [6] for full details).

Prior to the experiment, participants selected up to five stories relating to an interesting activity from their SenseCam collections. Examples included: attending and presenting at conferences; personal holiday or site-seeing; and socialising with friends/colleagues. Participants were requested to provide their SenseCam images, and any related digital content created, reviewed or accessed e.g. web page(s) related to a conference they attended; digital photos captured; etc. On average 1687.5 images were provided to author each story, which were temporally skimmed to between 75 and 150 images. Only 6 stories had digital photo content (on average 37 photos per story.) Most stories had some digital document content available, mainly emails, this was in low volumes (average 6 emails per story.) The investigator printed and assembled this digital material into card format [9]. To fully simulate an extended lifelog, contextual, emotional and thematic information, were provided through an oral retelling of the experience by the participant. Participants were presented with the artifacts as a set of small lightweight cards. They were instructed to use them to create a multimodal representation of their chosen story by first reducing the content to the 50 items following which they iteratively reduced the content from 50 to 25, 25 to 10, 10

to 5 and 5 to one single item. Participants were also asked to 'think-aloud' [14], paying particular attention to their reasons for including or removing items, thereby providing insight into their decision-making and content reduction practices.

## 3 Results and Discussion

We now present the findings from the card-sorting activity. Prior work contains full details on collections employed [6].

**General Observations:** The composition of the story can be broadly defined by the types of artifact chosen and the aspects of that story that an artifact communicates. Table 1 illustrates this for a subset of the stories, while Tables 2 and 3 provide further breakdowns. As the author's intended meaning and the nature of the story will have a huge impact on its final representation, both the selected artifacts and the aspects of the story embodied by them vary widely. For example, user 5's story 1 pertains to a party and so the chosen artifacts predominantly embody people present, while user 8's story 1 is of a site-seeing trip, large reflecting those places visited. While the end representation may vary, we found that the strategies and methods users employed in assembling a multimodal story from lifelog content tended to be highly consistent.

**Table 1.** Example of lifelog artifacts selected by users to embody a chosen story within 5 items

| User | Story | Item 1 | Item 2 | Item 3 | Item 4 | Item 5 |
|------|-------|--------|--------|--------|--------|--------|
| 1 | 1 | Twitter | SenseCam | SenseCam | SenseCam | IM Transcript |
| | | *Exposition* | *Place* | *Place* | *Person* | *Exposition* |
| 3 | 1 | Photo | SenseCam | Photo | SenseCam | Document |
| | | *Person* | *Person/Place* | *Person* | *Action* | *Exposition/Place* |
| 4 | 2 | Photo | SenseCam | SenseCam | Theme | Theme |
| | | *People/Place/* | *People/Action* | *People* | *Object/Place* | *Object* |
| | | *Object* | | | | |
| 4 | 4 | Photo | SenseCam | SenseCam | Photo | Theme |
| | | *People/Object* | *People/Action* | *Action* | *Object* | *Time* |
| 5 | 1 | Photo | Photo | SenseCam | SenseCam | Photo |
| | | *Person* | *Object* | *Action/Person* | *Action/Person* | *Person* |
| 5 | 2 | Photo | Photo | SenseCam | SenseCam | SenseCam |
| | | *People/Place* | *Place* | *Action* | *Action* | *Action/Place* |
| 7 | 2 | Photo | Photo | Theme | Theme | Theme |
| | | *Place/Object* | *Person* | *Emotion* | *Place/Object* | *Person* |
| 8 | 1 | Email | Sensecam | Sensecam | Sensecam | Sensecam |
| | | *Exposition* | *Place* | *Place* | *Place* | *Place/Object* |

**Content Fluency:** The range of available multimedia content required the participant to contemplate the affordances of each of the media modalities in communicating the story or its *fluency* and how this might impact on the end retelling. Tables 1 and 3 illustrate that users employed different modalities to communicate specific aspects of the story, suggesting that the modalities may have very different fluencies within the retelling. Almost 50% of a typical story is composed from SenseCam images (see Table 2.) making it the dominant modality. However, this is more likely to be a result of the volume available. In the 6 stories with digital photos, this photo media becomes the preferred modality. While preferred, users repeatedly expressed that it was

desirable to include SenseCam content to support the photo-media, to provide a secondary viewpoint on that moment or to narrate something not otherwise captured by the available photos. As capture is often 'staged', the explicitly captured photos tend not to embody a particular *action*, however the SenseCam provides 'in the moment' capture of activities such as walking, presenting, eating, etc. Text-based or document content was less frequently employed and typically in an expository capacity. For example, user 1 employed Twitter messages succinctly summarising their site seeing; and users 3, 5, and 8 included an agenda, itinerary or programme.

**Table 2.** Summary of Content Types Employed (displays average number in the Top 10 media artifacts selected to embody a story)

| Media Type | Totals | Stories with available photos | Stories with available text media |
|---|---|---|---|
| SenseCam | 4.63 | 3.33 | 4.62 |
| Photo | 1.08 | 4.33 | 0.77 |
| Theme | 3.38 | 2.00 | 2.92 |
| Document | 0.08 | 0.17 | 0.15 |
| Email | 0.54 | 0.17 | 1.00 |
| Web | 0.17 | 0.00 | 0.31 |
| Other | 0.17 | 0.00 | 0.31 |
| Number of Stories | 24 | 6 | 13 |

**Table 3.** The aspects of a story embodied by the modalities a percentage of the total items (note that a single artifact may embody one or more aspect of the story, e.g. it might simultaneously represent a person and an action).

| Aspect | All | Photo | Document | Context/Themes |
|---|---|---|---|---|
| Person | 0.47 | 0.62 | 0.04 | 0.36 |
| Place | 0.19 | 0.38 | 0.04 | 0.19 |
| Time | 0.03 | 0.00 | 0.00 | 0.10 |
| Action | 0.32 | 0.08 | 0.04 | 0.06 |
| Object | 0.25 | 0.23 | 0.22 | 0.26 |
| Emotion | 0.03 | 0.00 | 0.00 | 0.08 |
| Exposition | 0.07 | 0.00 | 0.65 | 0.03 |
| Other | 0.00 | 0.00 | 0.00 | 0.01 |
| Number of Items | 240 | 26 | 23 | 78 |

*Thematic Coherence & Clustering:* The participants' initial action with the cards was to identify the salient themes and elements of their story. By reviewing these cards, the participant quickly identified which of the themes (and by consequence) aspects of the story are important to its plot. Once a user had identified the focal aspects of the story, they then cycled through the remaining content, iteratively associating relevant content to related theme (see [6], Fig 1a.) By doing so, they confirm that there is appropriate content to support representation of each aspect of the story, establish sufficient coverage of the plot as a whole and ensure the story's coherence to its themes. A story consisted on average of 3.38 explicitly mentioned thematic or contextual elements (see Table 2), highlighting their importance to lifelog-based storytelling. The most central components were people present and actions undertaken, e.g. giving a presentation, etc. (see Table 3.) Only in a minority of cases was specific reference to time information made. While often mentioned during the oral retelling,

emotional/mental reactions were not typically utilized. In one case, weather (it being cold) was also mentioned.

***Core and Anecdotal Elements:*** In creating a story it was anticipated that the participants would emphasise the selection of artifacts core to communicating the overall activity, however, often elements which expressed peripheral or anecdotal encounters were preserved. These moments while not core to the plot, were noted by the users to be important to the overall experience. By preserving such elements, the narrative becomes more personal, exemplifying the unique experience of the individual. This aligns well with Barthes's *cardinal* and *catalysing* narrative units [4].

***Content Reduction, Filtering and Removal:*** Users were presented with a large number of multimodal content (minimum 75 items) which they iteratively reduced. The processes by which the available content was reduced were largely consistent across all users. Users first conducted a quick review of the stack of cards, from which they identified the key themes and/or artifacts. After which, they sampled the available cards categorizing the content based on utility in retelling their desired story. Items that were relevant but redundant, due to repetition, were typically removed unless they provided an alternative or salient viewpoint on the activity e.g. a SenseCam image which might compliment an explicitly captured photo. Finally, poor quality or irrelevant content was immediately discarded.

Content retained from this review was clustered around the major themes of the story ensuring that they were appropriately covered by the available content. Content was then reduced to meet the upper-bound in one of two ways: by removing an entire cluster or by examining the artifact clusters and removing relevant but overlapping content e.g. visually similar photos, or items made redundant by another artifact. This content reduction process was consistently applied across the iterative reductions. Expositional content – the artifacts used to explain or provide context to the story - was most likely to be removed as the upper-bound was lowered. Participants stated that these factors were implicit based on the presence of other content and could consequently be assumed or inferred. For example, explicit labeling of a person's presence would not be required if it was obvious from a photo that they were present.

***Layout and Presentation:*** Two major arrangements of the content were observed during the card sorting activity. In a minority of cases, where the stories could be considered more 'habitual', content was arranged as a chronological account. This was seen in particular with user's 4, 8 and 9. Within the experiment typically participants employed a theme-oriented montage-style layout in which items were placed concentrically around the most important items (see [6], Fig 1b.) This has parallels with the work of Ames & Manguy [1] and Appan et al. [2], and as such is a sensible visual presentational to pursue within lifelog-based digital narratives.

## 4 Conclusions and Future Work

While the richness of a lifelog opens new opportunities in the creation of personal digital narratives, its volume and multimodal nature pose significant challenges. We have explored narrative selection and presentation of lifelog content through a card-sorting

activity. The observed practices were largely consistently across users. Participants identified the core themes from the content, removing low-salience or quality content, and clustering content around the central themes and reduced the content based on repetition and redundancy. The presentation took a montage or thematic layout. It is possible that observed consistencies could be due to the candidate population, and so we plan to conduct investigations to with a broader population to further validate the results. We also plan to conduct a more detailed quantitative analysis and explore the relations between chosen story elements using a framework such as RST [12]. It is anticipated that this will allow appropriate computational models for narrative generation within multimodal lifelog collections to be uncovered and implemented.

**Acknowledgements.** This work is supported by the Irish Research Council for Science Engineering and Technology and by Science Foundation Ireland under grant 07/CE/I1147. We would like to extend our thanks to the participants who took part in these experiments.

# References

1. Ames, M., Manguy, L.: PhotoArcs: a tool for creating and sharing photo-narratives. In: Extended Abstracts CHI 2006, pp. 466–471. ACM, New York (2006)
2. Appan, P., Sundaram, H., Birchfield, D.: Communicating Everyday Experiences. In: Proc. SRMC 2004, pp. 17–24. ACM, New York (2004)
3. Brooks, K.: Do Story Agents Use Rocking Chairs? The Theory and Implementation of One Model for Computational Narrative. In: Proc. Multimedia 1996, pp. 317–328. ACM, New York (1997)
4. Barthes, R.: Introduction to the structural analysis of narratives. Image, music, text; essays selected and translated by Stephen Heath. Hill and Wang, New York (1977)
5. Byrne, D., Jones, G.J.F.: Towards Computational Autobiographical Narratives through Human Digital Memories. In: Proc. SRMC 2008, pp. 9–12. ACM, New York (2008)
6. Byrne, D., Jones, G.J.F.: Creating Stories for Reflection from Multimodal Lifelog Content: An Initial Investigation. In: CHI 2009 Workshop on Designing for Reflection on Experience (2009)
7. Cheong, Y., Jhala, A., Bae, B.C., Young, M.R.: Automatically Generating Summary Visualizations from Game Logs. In: Proc. AIIDE 2008. AAAI, Menlo Park (2008)
8. Christian, D., Young, R.M.: Comparing Cognitive and Computational Models of Narrative Structure. In: Proc. AAAI 2004, pp. 385–390. AAAI Press, Menlo Park (2004)
9. Fincher, S., Tenenberg, J.: Making sense of card sorting data. Expert Systems 22(3), 89–93 (2005)
10. Gemmell, J., Aris, A., Lueder, R.: Telling Stories with MyLifeBits. In: Proc. of ICME 2005, pp. 1536–1539. IEEE Press, Washington (2005)
11. Harper, R., Randall, D., Smyth, N., Evans, C., Heledd, L., Moore, R.: Thanks for the Memory. In: Proc. BCS HCI 2007, vol. 2, pp. 39–42. BCS, Swinton (2007)
12. Taboada, M., Mann, W.C.: Applications of Rhetorical Structure Theory. Discourse Studies 8(4), 567–588 (2006)
13. Tomai, E., Forbus, K.D.: Narrative Presentation and Meaning. In: AAAI 2007 Fall Symposium on Intelligent Narrative Technologies, pp. 162–165. AAAI, Menlo Park (2007)
14. van Someren, M.W., Barnard, Y.F., Sandberg, J.A.C.: The Think Aloud Method: A Practical Guide to Modeling Cognitive Processes. Academic Press, London (1994)

# Designing Storytelling Games That Encourage *Narrative* Play

Alex Mitchell and Kevin McGee

Communications and New Media Programme,
National University of Singapore
Singapore
{alexm,mckevin}@nus.edu.sg

**Abstract.** Storytelling games are a form of competitive storytelling framed in the context of gameplay. However, most existing storytelling games emphasize competitive gameplay and winning at the expense of competitive *narrative* play; they tend to be storytelling *games* rather than *storytelling* games. This paper explores issues related to the design of storytelling games that are won through *narrative* play and proposes a number of design rules for this. These design rules not only help in the design of storytelling games with a stronger element of narrative play, they also have implications for the design of computational storytelling systems.

**Keywords:** storytelling games, interactive storytelling, cooperative storytelling.

## 1 Introduction

Much of the research in interactive narrative is on problems related to the design of systems that allow player-readers to experience interesting, system-generated narratives, no matter what the player-readers choose to do. Research involves such things as how to generate stories based on goals and agents [1], how to control the revelation of story fragments through the use of constraints [2], how to develop drama managers that balance between player-reader choices and the requirements of a predefined story arc [3], and so on. However, there is another kind of interactive narrative, where the emphasis is less upon the stories that can arise via interaction between systems and players, but rather upon stories that can arise via interactions between players and other players (*via* the system). The development of such *collaborative storytelling* systems raises a number of issues about narrative interactivity – issues quite distinct from those usually addressed in interactive narrative research.

Collaborative storytelling has a long history and includes such things as role-playing games (*Dungeons & Dragons*), MMORPGs (*World of Warcraft*), hypertext- and wiki-based stories (*A Million Penguins* [4], *One Million Monkeys Typing*), MUDS (*Castle Marrach*), and multiplayer simulation environments

I.A. Iurgel, N. Zagalo, and P. Petta (Eds.): ICIDS 2009, LNCS 5915, pp. 98–108, 2009.

(*Second Life*). Obviously, some of these systems emphasize the collective enactment of group experiences rather than the collective 'narration' of stories to be read or heard, but the main point is that such systems tend to be appealing to the degree that the resulting group creation (adventure or story) is interesting – as opposed to the degree to which the system's automatically generated/shaped narrative is interesting.

One particularly interesting form of collaborative storytelling is the *storytelling game*, such as *Never Ending Stories*, *Once Upon a Time* (or *OUaT*), *TaleCraft*, *Dark Cults*, *The Extraordinary Adventures of Baron Munchausen*, *Pantheon*, or the *Into the D. . . C. . .* series. Such games typically consist of pieces (or cards) with different images upon them (e.g., images of characters, events, locations, objects). Typically, players take turns placing these pieces, with the placement constrained in different ways. As players place their pieces they invent/tell a continuation of the story to this point – and this must be somehow related to the piece they are placing. The winner is the first player to discard all pieces/cards while meeting the placement requirements.

Storytelling games are interactive in the sense that structures are put in place to enable and facilitate good person-to-person interaction (in the process of co-creating a story). In other words, similar to other forms of interactive narrative, the rules and structures support the actions of player-reader/tellers, which we will refer to as *playtellers*. But unlike other forms of interactive narrative, the reactions do not come from the system (whether in the form of traditional physical materials or computer-based networked frameworks), but rather from the actions of the other playtellers. A major concern when designing storytelling games is the creation of the rules/structures so that storytelling actions and interactions result in the ongoing invention of stories by the participants. Such structures, if well designed, encourage players to 'provoke' each other to invent/tell stories that engage the playtellers. This model of interactivity differs significantly from those that involve, say, systems that can adapt/respond to the choices/inputs of players-as-sleuths or players-as-choosers. Instead, a crucial characteristic of collaborative storytelling is – or should be – players-as-narrative-*elaborators*.

Of course, these games differ in a variety of ways. James Wallis, for example, distinguishes between 'rudimentary' or 'sequence-of-cards' games, such as *Story-Blocks* and *Never Ending Stories*, and games that use, in his words, "a mechanic or device to create the structure that would turn [a narrative into a story]" [5]. But even acknowledging such distinctions, there is a curious characteristic of most of these games: they tend to be storytelling *games* rather than *storytelling* games. In other words, they are usually much better at facilitating game play than they are at facilitating story-telling, or *narrative*, play.

For example, in many storytelling games, players win the game by discarding all their cards/pieces before the other players. As a consequence, it is possible for players to concentrate entirely on getting rid of their pieces as quickly as possible – as opposed to *winning in narrative terms*. If anything, most existing storytelling games present playtellers with a stark choice: play to win (by the rules) or enter into the (storytelling) spirit of the game. If playtellers focus on

the latter, they are often enjoined to 'play in the spirit of fun' (i.e., play without identifying winners) – or to use some form of voting to determine the winner (e.g., vote on the best story). Neither of these options is particularly satisfying for players who are interested in having competitive, game-like mechanisms and criteria that emphasize *storytelling*.

This may seem like the standard story/game debate about how (or whether) to reconcile an author's or system's ability to generate a satisfying story and the player-reader's ability and desire to choose freely (e.g., [6,7]). But the problem of balancing game and story in storytelling games is different: it involves the tension between the player's game-related goals and objectives – and the player-as-storyteller's *narrative* goals. So, whereas gameplay involves choices with the intent of winning the game, *narrative play* involves choices with the intent of winning *in narrative terms*[1].

And this is why the design of storytelling games is both similar to and different from the design thinking that goes into games, cooperative work environments, narratives, or even other kinds of interactive narratives. For example, similar to the process of designing games, the designer of a storytelling game is not thinking in terms of creating a specific story, but of a universe of rules and constraints in which playtellers repeatedly create and experience different stories. However, unlike the design of most games, the design of storytelling games involves the creation of rules and materials to facilitate *storytelling* rather than only (or even primarily) games that players can win strategically by, say, successfully discarding all their pieces before their opponents.

What, then, has been accomplished in terms of designing storytelling games that are won through narrative play?

## 2   Related Work

Although there are a number of successful storytelling games, virtually all of them either allow players to win by non-narrative means or simply emphasize collective storytelling without winners. In terms of research on this topic, there is broadly relevant related work about the design of game mechanics that increase the dramatic dimension of game play [8] and about creating and running competitive and narratively engaging role-playing games (RPGs) [9]. Otherwise, the issue of what we call narrative play seems to have been most extensively considered by Will Hindmarch, designer of the *Vampire* series of paper-based role-playing game, and James Wallis, designer of such storytelling games as *Once Upon a Time* and *The Extraordinary Adventures of Baron Munchausen*. Hindmarch has concluded that the way to balance game and story in storytelling games is to accept that the *"process* is the point, not the *output"* [10] (emphasis added). Wallis, on the other hand, has written about his goal of creating storytelling games "in which the story created and the gameplay used to create it are

---

[1] Narrative play can, of course, also encompass cooperative play that is competitive against some third entity. However, for the sake of simplicity, we here focus on purely competitive situations.

equal, which is both fun and creates a satisfying story" [5], so he seems at least open to the possibility of designs that support both. He has articulated a number of relevant theoretical ideas with his "four cornerstones that underlie any successful game or system that allows players to actively manipulate a story": clearly articulated genre, structure, rules, and story/game balance [5]. However, in his published work he has had the least to say about what he calls 'story and game balance.'

## 3   Problem Statement

In this paper, we examine one way that designers of storytelling games can shift the interactive fulcrum, so to speak, so that the storytelling process is one of being engaged in narrative play – and so that winning is the result of superior narrative play as opposed to superior game play. The specific technique we will describe is this: a player's narrative 'moves' create narrative problems that the other players must address in their narrative moves.

To be clear, this paper is not an attempt to solve the problem of designing a game that results in 'interesting' or 'good' stories. Rather, the goal is to show how the use of this technique (and a number of design rules that follow from it) can lead to storytelling games in which it is only possible to *win* the game via narrative play. These design rules not only help in the design of storytelling games with a stronger element of narrative play, they also have implications for the design of computational storytelling systems.

## 4   Designing for Narrative Play

In our research, we have come to believe that the main requirement in the design of a good storytelling game is to ensure that playtellers succeed or fail to the degree their *narrative* contributions succeed or fail. Designers need to ensure that *all* narrative choices have strategic/gameplay consequences – and that all strategic/game decisions have narrative impact.

This requirement impacts a number of different aspects of a storytelling game, but perhaps the most challenging consequence is the problem of designing suitable winning conditions. It is not enough, of course, to simply specify winning conditions – these need to be closely related to move-by-move success. Below we identify some strategies for accomplishing this.

### 4.1   Only Narrative Moves

Most important, we believe, is that all storytelling game moves be *only* narrative moves. Virtually all the storytelling games involve, to varying degrees, narrative play. In *OUaT*, for example, players cannot discard their cards unless they can tell a piece of the ongoing narrative in a way that meets various constraints. In *Baron Munchausen*, the structure of narrative play is quite ingenious, with players attempting to create the most elaborate 'tall tales' while incorporating

the ridiculous objections of their opponents. However, in each case, there is always an alternative to making a purely narrative move. In the case of *OUaT*, the constraints can be satisfied with minimal attention to story; in the case of *Baron Munchausen*, players can raise objections with the sole purpose of strategically getting rid of their betting (voting) coins.

## 4.2    Narrative Advancing/Blocking Possibilities

Each narrative move should advance the player relative to the other players – and also provide the player with the opportunity to thwart the narrative play of the other players. A very nice example of this is the 'stump the opponent' mechanic in Wallis's *Baron Munchausen*, where players create "a succession of new difficulties and dangers that the protagonist – who in *Baron Munchausen* is also the storyteller, all stories in the game being told in the first person – must overcome to reach his goal and succeed. The game wouldn't work at all without the interruptions: they function on both a gameplay level and a structural narrative level" [5].

## 4.3    Advantages/Disadvantages of Interrupting

If a game does not involve turn-taking, but rather makes use of some mechanism for players keeping or wresting storytelling control, there should be both advantages and disadvantages to attempting to take control. In the case of *OUaT*, where this mechanic is central, interrupting is only advantageous. And, as a result of the way the interruption mechanic works, in practice the threat of being interrupted can result in a fast, tersely-told story.

## 4.4    Narrative Moves towards Narrative Winning

Each narrative move should not only advance a player relative to the other players, it should clearly advance the player towards winning the game in terms of a narrative goal. Of course, for storytelling games where ultimate success is (at least partly) measured in terms of discarding all cards/pieces, then it is trivially true that 'success' during a turn (discarding a card/piece) involves progress towards successfully completing the game. Howerever, this design strategy is intended to result in game rules that ensure that players 'close the narrative distance' between the current state of the story and their desired Story Goal.

## 4.5    Narrative Winning Conditions

And finally, winning the game must be done in purely narrative terms. In some ways, this is the weakest point of all existing storytelling games.

Most storytelling games invoke one of two solutions for determining the winner: game-play (as opposed to narrative) events – or the use of voting related mechanisms to determine the winning story. A typical example of the former approach is the case where the player who successfully places the last piece/card

is the winner (e.g., *Never Ending Stories*, *OUaT*); the main problem with this is that the emphasis tilts in favor of gameplay rather than narrative play. A typical example of the latter is when players vote on the best story created by the different players (e.g., *NanoFictionary*, *Baron Munchausen*); the main problem with this is that players typically find such decisions too subjective.

The notion that the winning condition should connect directly to ongoing success throughout the storytelling game can be seen as analogous to winning in traditional board games such as chess or *Othello*. The player who makes the last move in chess is the winner because *the winning move ends the game*– but in most cases, *being able to make that last move* requires 'good play' throughout (most of) the game. In *Othello*, there is less emphasis on the actual last move, but the principle still holds. Thus, in these and other games, the overall, ongoing quality of play directly correlates with overall quality (i.e., winning). Similarly, in a storytelling game, good storytelling during each turn/play should determine whether a player is the winner of the storytelling game. In other words, if the connection between core gameplay mechanic and storytelling can be carried through to the winning condition, then the means of winning the game will be equivalent to telling the best story.

It is interesting to note that very few storytelling games allow for the possibility of winning/losing *at any moment*. Unlike, say, chess, typically there are a certain number of cards to discard or a certain amount of time to play. One of the few exceptions is the game *Dark Cults*, in which different players take on the role of "Life" and "Death" and compete to determine whether a character lives or dies at the end of the game. There is, in fact, an active *narrative* struggle each turn to win (or, at least, not lose).

## 5  Case Study: *Suspend Me*

In order to better understand narrative play, we have been designing and testing different storytelling games. We now describe one that embodies the principles described earlier. It is a variation of *Once Upon a Time*, intended to test whether certain modifications can eliminate or reduce the possibility of winning through non-narrative means.

In *OUaT*, players are dealt random hands that include cards for Characters, Aspects, Events, Places, and Items. Each player also receives a single Ending card. The first player begins to tell a story, connecting it to the cards he places. He continues placing until he is either interrupted or he discards all his cards (in which case, he has won). Players can interrupt if they hold a card that corresponds to some aspect of the story the narrating player mentions.

From the perspective of narrative play, there are two weaknesses in *OUaT*. First, the player who has narrative control can tell a mad dash of a story and successfully win (as long as the story is reasonably coherent). Second, interruptions are too decoupled from narrative: players are prevented from interrupting if they do not have a card that allows them to do so – and once they are able to interrupt, there are minimal constraints on the narrative coherence of their interruptions.

In our variation, *Suspend Me*, players compete to control a story in which they create and maintain suspense by constantly creating danger for their story characters – and by saving the other characters from danger. A player wins if he successfully attains his personal Story Goal in such a way that all the characters *except the player's character* are left in danger. In other words, the winner is the player who is able to resolve the situation as required, while also maintaining narrative tension.

*Suspend Me* begins with a randomly chosen Location card placed face up – along with a Character and Aspect card for each player (also face up). Thus, at the start of the game, all players know the location, the characters, and something about the characters. Players are dealt Item and Event cards which they use to play the game (much as they do in *OUaT*). *OUaT*'s Ending cards are not used at all; instead, players created their own Story Goal cards (based on a narrative goal that involves their character and the character's Aspect).

Each time a player lays down a card the portion of the story told must have all the following characteristics: must connect the Item or Event on the card in a reasonable way to the characters and the story so far; *and* must *save* his own character from that specific danger; *and* must create *suspense* by placing *all* of the other characters in danger *from* his character; *and* must either a) prevent own character from knowing how he is putting them in danger, or b) prevent the other characters from knowing how they are being put in danger; *and*, finally, must not create story events in which any player characters die.

Players must do *all* of these things each time they place a card. If they do not do all of these things, they are eliminated from the game. There are no 'turns' in this game. A player keeps playing cards until he hands off, is interrupted, wins, or is eliminated.

As in *OUaT*, players may interrupt and take storytelling control. However, unlike *Once Upon a Time*, it is not necessary for the interrupting player to have a card that matches something the storyteller says. The only requirement is that the interrupter uses his card to complete the requirements of the current player *in addition to meeting the requirements created by completing those requirements.*

Unlike *OUaT*, a player who has narrative control may create narrative challenges for other players and then *hand off* storytelling control to another player of his choice.

*Suspend Me*, then, incorporates all our design suggestions. The challenge of meeting the move requirements effectively prevents players from engaging in anything except narrative moves (e.g., no quick discarding); players must create certain narrative problems (and may also create others) each time they make a narrative move; interrupting is something that is not based on chance occurrences – and it involves some risk; each narrative move needs to connect to player's narrative goal; and it is only possible to win with a narrative move.

## 5.1   Playtesting Results

In our playtesting sessions, about forty students who had previously played *OUaT* played a few variations of the game described above. The purpose of

these sessions was not to determine whether *Suspend Me* is a good game or not; rather, it was to see whether it supported increased narrative play. (Our own impression is that *OUaT* is still a better designed and more enjoyable storytelling game.)

The overall results support our belief that *Suspend Me* increased they amount of narrative play, with players making more narrative moves to avoid losing narrative challenges. Some players also felt that, because they were required to tie up the narrative loose ends created by other players, the stories created were more coherent than the ones they created playing *OUaT*. After playing for a while, a number of players not only made narrative contributions that fulfilled the requirements, but also attempted to sabotage other players in narrative ways (placing their characters in difficult narrative situations, etc.).

Perhaps the most important achievement of *Suspend Me* is that the criteria for success at each moment are both narrative and unambiguous. Players in our playtesting sessions did not get into debates about whether a narrative contribution did or did not meet the criteria.

The rules of *Suspend Me* do lead to a very slow game; groups had on average about four players in them and for most groups a single game lasted about 45 minutes. Some players felt the rules were so complicated that they lost sight of the overall storytelling process. A variation of this problem was that players sometimes found it difficult to remember or keep track of 'where they were' in terms of rescuing and endangering characters during their moves. And some players even complained that the game was too difficult (although, based on our observations, most players seemed to be enjoying themselves as much as they enjoyed *OUaT*).

Interestingly enough, although the genre we had in mind was suspense stories, one group found that the genre of their story drifted into slapstick. In retrospect, this should not be surprising as both genres involve danger and some degree of suspense[2].

The most significant problem identified by players was that the rules required them to devote too much attention to micro-level (moment-by-moment) elements of the story at the expense of the overall story arc.

## 6  Discussion

Our main goal in designing *Suspend Me* was to explore different possibilities for equating game success/failure with narrative success/failure.

In creating this game, we explored designs that align the problem-solving involved in many types of gameplay with the problem-solving involved in certain kinds of reading and storytelling. In some ways, the game is based on the insight that there is problem-solving involved in both reading and creating a

---

[2] One obvious way to improve our game would involve making the cards more genre specific, but our purpose was to concentrate on varying the basic version of *OUaT* to see whether we could increase narrative play.

good suspense story. Readers of suspense stories are often engaged in the problem of trying to anticipate how the suspense will be resolved – and authors of such suspense stories are involved in solving the problem of successfully creating, presenting, and resolving the suspense. In a storytelling game with the goal of cooperatively/competitively trying to construct a suspense, playtellers are in both roles.

We are not, of course, claiming that all gameplay nor all reading (or storytelling) processes involve problem-solving – nor even that they are best understood in problem-solving terms. We have simply been exploring some of the consequences of aligning the kind of problem-solving involved in most competitive games with some specific kinds of authorial/storytelling problem-solving.

Specifically, *Suspend Me* requires players to solve the problem of creating and resolving narrative tension. This is analogous to the kind of storytelling problem confronted by, say, Hitchcock, who is justifiably famous for creating suspense for spectators by showing them some impending danger to some or all of the characters that the characters themselves do not know about (e.g., the maid unknowingly preparing to reveal a dead body in the chest in the center of the room during the cocktail party in *Rope* – or the cleaning woman unknowingly mopping her way to discover the character who is breaking into the safe in *Marnie*). Readers familiar with Hitchcock's technique will recognize it as a core structuring device in our storytelling game.

There is some precedence for this kind of solution. According to his description of *Youdunnit* [5], Wallis has done something similar in the sense that he structures the storytelling around solving a mystery. In the case of *Youdunnit*, the mystery is that there is a murder – and the narrative 'problem' is for each of the players to try *assigning the blame* to one of the other players.

## 6.1   Interactive Digital Storytelling Games

Before concluding this paper, it is worth stepping back and considering some of the implications for interactive digital storytelling. The issues raised and addressed (and examples given) are mostly from non-digital storytelling games. Why are these issue important for the interactive digital storytelling community? In some ways, it is not clear if there is a general answer to this question. The boundary between digital and non-digital is difficult to specify; witness, for example, the debate about whether there is a significant computational difference between hypertext stories and their non-digital counterparts.

So, of course, our insights will obviously work just as well for the design of storytelling games that happen to be played via computers. In a weak sense, many (all?) storytelling games can benefit from migrating to the computer. Computer-based systems can handle book-keeping, enforce constraints, and the like – essentially liberating players (or, in the case of games like *D&D*, Game Masters) from issues that currently tax humans and require large rule-books, notation systems, and the like. Computation can also shift some of the 'enforcement' of game rules to the system (as opposed to having enforcement ensured by the memory and attentiveness of the players). To take one specific example from our work on

*Suspend Me*, we experimented with some different ways in which to help players keep track of 'what to do' during their moves.

But we believe there are also stronger implications of this work for computational storytelling. One of these is the insight that it may be possible to make interactive storytelling systems more game-like without losing the narrative focus. Indeed, a shift towards narrative play seems like a promising area for recasting certain aspects of storytelling in computationally tractable terms. We do not suggest that this is appropriate for all digital storytelling efforts; there are, of course, computational narratives where the point is to explore multiple perspectives. Nonetheless, even in such cases, there may be elements of what we describe here – and ways to further enhance those systems by strengthening the implementations in terms of narrative play. It does not seem entirely coincidental that *Facade*, for example, can be described as a series of narrative problems created by and for the player.

One particular problem to address as a result of our work on *Suspend Me* is the critically important relationship between moment-by-moment narrative success and the overall narrative arc. This problem is of course central to much of the work on computational storytelling systems that attempt to reconcile (or combine) bottom-up story generation from small narrative units with top-down story generation guided by story managers and the like. This further strengthens our conviction that work on storytelling games and work on interactive digital storytelling can benefit each other.

## 7    Conclusion

This paper has not been about particular storytelling game designs, but about some insights, issues, and possible solutions that arose out of designing and playing different storytelling games intended to promote narrative play. Our modest goal for this paper is that it continues the kinds of research represented by Will Hindmarch and James Wallis. Hopefully, it will help to focus attention on the topic of narrative play. To this end, future work will involve developing storytelling games with different characteristics – and studying the resulting consequences to narrative play.

In conclusion, our larger ambition going forward is to develop additional tools and techniques that facilitate the invention of good and interesting stories. The work reported here concentrates on elements that support narrative play in multiplayer storytelling games. The long-term research will explore in more detail a twin problem: the elements that encourage the playtellers of such games – and the elements that can facilitate and enable designers of such games.

**Acknowledgements.** This work was funded under a Singapore Ministry of Education Academic Research Fund grant, "Understanding Interactivity", NUS AcRF Grant R-124-000-024-112. We would also like to acknowledge the anonymous reviewers of this paper for their valuable comments.

# References

1. Cavazza, M., Charles, F., Mead, S.J.: Character-based interactive storytelling. IEEE Intelligent Systems, special issue on AI in Interactive Entertainment 17(4), 17–24 (2002)
2. Mateas, M., Stern, A.: Procedural authorship: A case-study of the interactive drama Façade. In: Proceedings of Digital Arts and Culture, DAC (2005)
3. Young, R.M., Riedl, M.: Towards an architecture for intelligent control of narrative in interactive virtual worlds. In: Johnson, W.L., André, E., Domingue, J. (eds.) Proceedings of the International Conference on Intelligent User Interfaces, pp. 310–312. ACM, New York (2003)
4. Mason, B., Thomas, S.: A million penguins research report. Tech. rep., Institute of Creative Technologies, De Montfort University, Leicester, UK (2004)
5. Wallis, J.: Making games that make stories. In: Harrigan, P., Wardrip-Fruin, N. (eds.) Second Person: Role-Playing and Story in Games and Playable Media, pp. 69–80. MIT Press, Cambridge (2007)
6. Costikyan, G.: Where stories end and games begin. Game Developer Magazine 7(9), 44–53 (2000)
7. Wardrip-Fruin, N., Harrigan, P.: First Person: New Media as Story, Performance, and Game. MIT Press, Cambridge (2004)
8. LeBlanc, M.: Tools for creating dramatic game balance. In: Salen, K., Zimmerman, E. (eds.) The Game Design Reader: A Rules of Play Anthology, pp. 438–459. MIT Press, Cambridge (2005)
9. Wyatt, J.: Dungeons and Dragons Dungeon Master's Guide: Roleplaying Game Core Rules, 4th edn. Wizards of the Coast, Renton (2008)
10. Hindmarch, W.: Storytelling games as a creative medium. In: Harrigan, P., Wardrip-Fruin, N. (eds.) Second Person: Role-Playing and Story in Games and Playable Media, pp. 47–56. MIT Press, Cambridge (2007)

# Table-Top Gaming Narratology for Digital Interactive Storytelling

Martin van Velsen[1], Josh Williams[2], and Gustav Verhulsdonck[3]

[1] Carnegie Mellon University, 5000 Forbes Avenue, Pittsburgh, PA 15213
[2] Institute for Creative Technologies, 13274 Fiji Way, Marina del Rey, CA 90292
[3] New Mexico State University, MSC 3E, P.O. Box 3000, Las Cruces, NM 88003
vvelsen@cs.cmu.edu, williamsj@ict.usc.edu, gustav@nmsu.edu

**Abstract.** In the current environment of digital games and immersive role playing systems, we often overlook previous methods of conveying and experiencing, interactive narrative-based entertainment. We present a fresh perspective on interactive digital storytelling systems based on table-top role playing games. Table-top games offer players the ability to negotiate and determine outcomes of a game with a referee. The nature of table-top gaming is such that players evolve, grow and maintain a rule set that represents an imaginary world. As such this form of gameplay provides a unique opportunity to study complex interactive storytelling structures under controlled circumstances. Using table-top role playing games as a model, we propose terminology and concepts that are different from the traditional literary or dramaturgical perspectives normally applied to interactive narrative systems.

**Keywords:** Interactive Narrative, Digital Storytelling, AI, Table-Top.

## 1 Introduction

Prose, poetry and other types of fiction are all mechanisms for creating a believable temporal environment, be it only in the mind of a single individual at a time. Film and television are similar save that a fully developed and fixed rendition of the world is presented to an audience. But attempts at creating interactive worlds via these traditional media have been far less popular than their passive counterparts. Exploring the interactive aspects of telling and experiencing an unfolding drama to a wide audience has rested square on the video game community's shoulders for the last couple of decades [1,7,8,14]. Most agree that we are only at the beginning of exploring the narrative possibilities computer technology can provide, but perhaps a method of storytelling within game play (or vice versa) already exists that has the missing elements we currently lack in virtual worlds.

In this paper, we present a collaborative storytelling model developed through table-top gaming. Table-top systems offer more player agency and system awareness than modern video game systems, at the cost of occurring in less-than-real-time with fewer potential participants and diminished symbolic feedback. The basis for this trade-off, and what constitutes the majority of table-top games' appeal, is allowing

I.A. Iurgel, N. Zagalo, and P. Petta (Eds.): ICIDS 2009, LNCS 5915, pp. 109–120, 2009.

players to co-author the experienced story. After a brief introduction into the history of interactive narrative and table-top game play, we will discuss the major elements that make up the real time construction of a table-top game and suggest how to distill principles and methods for the controlled generation of rule sets that can run a digital equivalent of narrator based interactive narrative.

## 2 Digital Narrative and Interactive Narrative

A traditional approach to narrative is based on applying social, cultural and critical perspectives to various texts (prose, poetry, film, and theatre) in order to study how an author creates and conveys a particular experience to an audience [2]. Literary studies have complicated notions of authorship, reading processes and authorial intent as separate acts by announcing the death of the author through the birth of the reader where reading is seen as an interactive, rather than passive, experience [3]. For instance, reader-response theory, which focuses on reader-text interactions, questions the idea of authorial intent and stable meaning. By interacting with a text and bringing their own unique responses, readers create multiple narrative readings of the same text. In modern times, entertainment technologies have further complicated the relationship between author, reader, and text. Multiple forms of interaction are now encouraged by digital media such as video games. In Massively Multiplayer Online Role Play Games (MMORPGs), players may interact with other players in symbolic actions and so construct individual and collective narrative experiences. As a result, for various theorists, the increasing use of digital media poses unique questions regarding the experiencing of narrative constructs, and many new approaches for developing a model of these interactions have been based on dramaturgy [8], interactive storytelling [14], cybertexts [1], and procedural rhetoric [4].

While video games offer narrative experiences, they are not strictly passive since they engage a player by demanding they perform certain actions to achieve narrative goals. For this reason, scholars make a distinction between narrative (narratological) – which advances the narrative experience - and interactive (ludological) elements – which ask the player to meet a certain goal [12]. Some scholars have criticized the separation of interactive and narrative elements by questioning the narrative experience offered by a game such as Tetris [7]. Complicating this situation, a common distinction is made in narrative theory between plot (sjužet) – the way a narrative is presented to a reader by an author – and story (Fabula) – the elements of a narrative as experienced by a person [9]. For this reason, an important issue revolves around to what extent video games can be seen as encompassing both interactive and narrative experiences. A specific area of exploration in confronting this issue is the dynamics of narrative in Artificial Intelligence (AI), in which some have argued that AI agents are understood in a narrative and "socially situated" manner where their meaning is negotiated rather than solely predefined through AI modeling [15]. In order to further explore this dynamic of negotiation in a gaming context, our paper presents the similar dynamic found in table-top role-playing games as a means for developing new terminology and AI concepts for negotiating interactive narratives.

## 3 A Brief History of Table-Top Role Play Gaming

Table-top role-playing games began when conflict simulations called "war-games" were used to learn tactics and strategies for actual battlefield gain. An example of this is the game *Kriegspiel*, a variant of chess used by officers in the Franco-Prussian war, and the grandfather of modern table-top games. In these games, role-playing was required of players to represent unit actions on each side, but the introduction of negotiations between specific individuals required a referee. Over the decades that have followed, many table-top games have provided numerous rule-sets to enhance the experience of these interactions, as well as have provided game mechanics to lessen the need for a referee to weigh-in on related outcomes.

Broadly speaking, table-top games can be placed on a spectrum ranging from combat or simulation based gaming to pure narrative and story based play. We will focus on the story oriented variety, where players engage in dialog based interaction with a referee, often referred to as a Game Master (GM), or Dungeon Master (DM), or simply, and for our purposes, a Narrator.

An important aspect of table-top games is that they allow for the use of narrative role-playing to be introduced into the game by letting people inhabit a character role [6]. Often, in table-top role-playing games, character points are given to indicate strengths and weaknesses, but character role-playing also helps to determine game outcomes by allowing players to negotiate their actions with the Narrator of the game. But what happens when the player's representation of his character is more compelling than his character's rule-based point determination? One example is a player presenting a sound combat strategy even though his character unskilled in this area. In such cases the referee could decide to weight the character's point determination with an arbitrary bonus, or decide the outcome before ever committing the point process. It is precisely these circumstances that enhance table-top rule-sets and which we will use in our generalized negotiated framework for clarity of AI comparisons.

## 4 Introducing Interactive Storytelling Terminology

A concept strongly associated with table-top is the skill-check game mechanic, which can be likened to the interactive element thus far identified as intrinsic to video games as narratives. This mechanic forms the means of evaluating the validity of an action taken by a player against the set of rules that embody the nature of a game. For example, checking to see if a player's character has enough dexterity to jump across a small stream is a game mechanic check. Skill-check game mechanics are therefore an artifact of simulating actions within world model. In the case of table-top gaming, these checks can only occur in less-than-real-time due to having multiple humans in the loop. If we can capitalize on this decreased speed to observe the transactions between players and Narrator, we may discover how they shape the experienced story, and perhaps how each can be influenced to steer the story.

## 5 Narrative Views

We consider the narrative view or views, the vantage point(s) from which a participant, both players and Narrator, observes an ongoing game. It creates and defines the

personal context of a player, and contributes to the unique perspective each partici-
pant has. The social experience in table-top gaming can be perceived and described
from four distinct vantage points. Each point of view adds knowledge about the entire
experience, which otherwise could not be observed. Within table-top gaming, the four
observation points are: the player perspective, the narrator perspective, the character
perspective, and the universal observer perspective. Especially the last view is impor-
tant for our discussion here since it gives us both an understanding of the over en-
compassing game mechanics and it provides us with a better understanding of the
game from any player's perspective when they are not actively engaged with perform-
ing in the game itself.

## 5.1  The Narrator

One major difference between current digital narrative-based games and table-top
role-playing varieties is the use of a Narrator. Digital narratives are unquestionable;
the amount of information a player can obtain is fixed.  By contrast, narratives pro-
vided by a Narrator are inexhaustible; information can be endlessly asked upon by
players to determine its relevance or irrelevance.  Narrators have a different role than
the other participants in that they not only represent various non-playing characters,
but also have ultimate definitive say in the outcomes of player actions. It is tempting
to label a Narrator the ultimate authoritative role in a game; in fact it is more apropos
to describe this role as a holistic reference, which players consult for verification of
the current state of the imagined world.

## 5.2  The Players

Around the table, or gathered together in a virtual environment are the players or
participants. It is these individuals who ask questions about the world and respond to
the Narrator's replies. A group of players combined is often referred to as a party or a
team and it is this team's nature combined with the individual choices and natures of
the players that add story depth and narrative momentum. It is not the case that play-
ers simply follow the guidelines of the Narrator and hope to end up at a satisfying
climax or conclusion. It is through the individual decisions and statements about the
world that the Narrator is forced to adapt the story and the virtual world. As such
players have much more control that would be assumed and a Narrator has a much
more accommodating role than might be expected.

## 5.3  Player Characters and Non Player Characters

Player Characters (PCs) and Non Player Characters (NPCs) are the means for the
Narrator and players to collaboratively progress the game's story.  If neither of these
character types is committing an action, the game's story is on pause.  While holding
such sway, these roles maintain the smallest perspective from which to take action.
The knowledge possessed by the Narrator and players is always greater than that of
the characters they control, so to maintain believability both parties have to justify
their actions given the character's context being acted through.  There are no rules
governing this justification, but the Narrator must disallow PC actions that too plainly
draw from knowledge unavailable to them (e.g. one PC rushing directly to the aid of

another PC that he only knew the location and state of via the controlling player's awareness).

NPCs are also one of the primary means for a Narrator to convey important aspects of the game. Media types such as theatre, film and television afford a granularity of characters that can be roughly divided into the following categories: *Background characters*, *Medium level characters* and *Foreground characters*. Each of these character types has a specific role in the world and therefore in the narrative. Background characters are frequently used in film to contribute to the setting and atmosphere of the events. Medium level characters may have few speaking lines and contribute to the vibrancy and human detail of a performance. Foreground characters directly interact with the protagonists and are the entities who determine the direction of the plot. In table-top games NPCs are foreground characters and often function as medium and background characters. Computer simulations have embraced both background characters and foreground characters but hardly blend the types to allow for medium characters. More recent games such as Half Life 2 provide some extra acting ability of background characters and therefore push them slightly into the medium level type.

### 5.4 The Universal Observer

Besides being actively engaged in their respective roles, all participants have their opinions and evaluations of the ongoing game. Observations on how the game progresses are sometimes communicated as if each member is a universal observer or a participant who is not a part of the game. One could liken this to an active "in-game" backchannel, where items are discussed such as the fairness of decisions made or the validity of events in the world.

From a traditional media perspective, this universal observer breaks the 4th wall or the suspension of disbelief [14]. It would be analogous to watching a film for the first time with the entire production crew in the theatre who discuss the decisions made during the shooting of the film. Within table-top gaming this practice is quite common and even desired. It is yet another means of checks and balances that keeps the world consistent and is furthermore a means for players to interact with the Narrator on an equal level.

## 6   The Structure and Role of Time

Given the perspectives available to table-top game participants through which to disseminate, obtain, and act on information, a controlling factor for each is the medium's distinct usage of time, which can be slowed down or even stopped to negotiate an outcome. Time is specifically important to interactive narratives because it is the desire of both players and storytellers to mimic the dramatic ebb and flow of linear narrative, while not being subject to it, nor having to openly agree upon its station with one another. At a meta-level two forms of space-time can be distinguished in table-top games: the Setting and Campaign.

*The Setting*, or the context of the game, sets the tone of play. It serves as an important indicator to players and Narrator of what types of events and characters are to be expected. For instance, one would be surprised to encounter an actual vampire in a traditional Victorian murder mystery game. It is common for table-top rule sets to be specifically for a single type of setting, though general systems exist.

*The Campaign*, is composed of all games played in specific Setting, and can be considered the stretch of time that forms an entire story from start to reveal. If a closing reveal is to be expected then it would be at the end of a campaign.

Within the above, a single sitting of the required number of players and Narrator to adequately move the story forward constitutes a *Game*. Tychsen et al. [17] have provided an empirically-derived model of how time flows in numerous multi-player game formats. In regards to table-top gaming they illustrate *passive* and *active* states, and describe common interactions for the latter. One limitation of this model is that it only includes activity moderated by the Narrator, when in fact the discourse between players during the passive state contains information vital to the story experienced during the game. The following four time phases further encapsulate the table-top experience across the passive and active states between players and Narrator, and describe the negotiations common to each:

*In-context (active)*, which comprises the time spent in role-play by players with each others' characters and the Narrator's non-player characters, and the description of actions and reactions. If it were possible to present only this instrument's contents, they would be indistinguishable from a linear story.

*In-game (active)*, wherein rule-required skill and chance systems are queried, and resource information necessary to determine action outcomes shared.

*Out-of-game (passive)*, which is a mode of game play where information about the game is discussed while all participants are still actively engaged in the game but where the players are not acting from within their role, character, or necessarily discussing the current moment of the game at hand. These situations are used to conjecture about story elements, discuss issues about the game mechanics or to debate the applicability of a certain rule or convention.

*Out-of-context (passive)*, a form of gaming that could be likened to an informal backchannel. Its contents are similar to out-of-game exchanges, but occur specifically between games, versus while one is in play. One could imagine an email discussion about events in the game a few days after the participants played together.

Table-top needs both passive and active phases since the Narrator and players cannot perform all the story maintenance exclusively in one phase. In the active phases the story is squarely in front of the players; they are either acting upon it because the rules are not stopping them (In-Context), or manipulating story data via the rules for further action (In-game). This makes the elements of the story difficult for the Narrator to change during those phases. However in passive phases, the story is restricted to only what the players have already experienced, and as the rules are not involved, the Narrator does not have to respond through them to player actions. During Out-of-game and Out-of-context phases the Narrator can make both subtle and sweeping changes given what story data he believes the players have absorbed, and are focused on.

## 7   Changing Time Phase and Narrative Control

Whatever story a table-top game provides, it requires a constant give and take to be realized. This give and take occurs during each transition from one time phase to another, which both players and Narrator have access to creating, and can occur between subgroups of participants (*i.e.* while the Narrator becomes engaged In-context with one player, other players may continue to hold an In-game or Out-of-game

discussion). The following are descriptions of each transition, and how they might be triggered:

*Out-of-context to Out-of-game* – the first of this transition type is the only transition that requires cooperation as it signals the beginning of a game. While it is true that a Narrator must be present, the act of every player refusing invitation is just as powerful. This first transition establishes the equality of both sides of the table.

*Out-of-game to In-game* – the first time this is brought about in a game is up to the Narrator. Prior to the transition, he is establishing or re-establishing story elements with the players, and based on their focus can make adjustments to possible encounters in the game's near future. When ready, he initiates the In-game phase.

*In-game to In-context, and vice versa* – switching between these two phases happens often and rapidly, but it is necessary to distinguish them as both the players and Narrator can cause the switch. In moving from In-game to In-context, a player or Narrator is moving the story forward. In the opposite direction, the story is made referential to the rule-set as the In-game phase requires. These two phases validate each other; their interplay is the proof that a story is being collaboratively told and experienced.

*In-game to Out-of-game* – this transition is most often initiated by a sub-group of players, and rarely brought about by the Narrator. Once a game is in motion, the Narrator is better served by a "poker-face," while allowing players to break away from the action (especially if their characters are not at its focus) and shares their thoughts about what just happened and what to do next before rejoining. When a Narrator pulls the whole game into this phase, it is to make a ruling clear so that the players can better trust in future outcomes, and perhaps to indirectly emphasize a story element related to such a ruling. The only other case for a Narrator to initiate this transition is to end a game.

*Out-of-game to Out-of-context* – this post-game transition is most often brought about by the players in the desire to continue conversation about the game and campaign before meeting again. It also can be an opportunity for the Narrator (if involved) to enter into the players' experience a story that their characters were not involved in, so as to provide them access to a sub-plot or aside that may re-focus their interest in a particular part of the story.

It is important to underscore that multiple time phases can occur simultaneously during a game within clusters of players, and transitions triggered from one to another without every participant's involvement. Given the Narrator's inability to interact with every player simultaneously, unengaged players have time on their hands that they will naturally fill with conversation. Provided their sidebar is game-related, this activity is beneficial as narrative momentum and can be generated concurrently in multiple phases. As a result, a table-top game does not suffer from the stop-and-go sensation frequently experienced in branching narratives.

The simplest example is a single player engaged In-context with the Narrator while the other players discuss Out-of-game where their PCs should go next. Even though in the strictest sense the game's story is only occurring for the player whose PC is interacting with the Narrator's NPCs, the concurrent negotiation happening amongst the other players can be every bit as influential on the story. At some point the two subgroups of players will rejoin in a single phase. This will occur because; a) the sidebar concluded and its participants are ready to intervene, b) the In-context player paused the story's progression to draw other players' attention to something that just

occurred, or c) the Narrator announces that an In-context event has occurred and all PCs present are affected. Which of these causes the rejoining is not always at the Narrator's discretion, but it is at this time that he can gauge the interests of the players. If the sidebar merits case "a", the Narrator observes how the players express their reasoning for next steps to one another. In case "b", the Narrator observes what the In-context player is highlighting for the other players, and whether it compliments or trumps the outcome of their sidebar. In case "c", the Narrator observes how hard the players try and push past or escape the event he has announced. These observations provide the Narrator data with which he can shift focus to or away from certain PCs and NPCs, and augment story elements to compliment the players' likely actions. In this way the Narrator continually assesses the players' interpretations of the story and their specific interests within it, and is able to manipulate the story's various threads to capitalize of the players' momentum, versus pulling them from scene to scene.

## 8    Narrative Meta-concepts

Having defined narrative perspectives, time phases, and shared narrative control by way of phase changes, we can now attempt to tie them together into a lexicon of narrative concepts native to table-top gaming. These concepts are designed to create a workable vocabulary in which to discuss interactive storytelling.

*Faith Based Gaming* encompasses interactive narrative systems wherein the stories played out are done so upon the unvoiced promise of a meaningful ending. In table-top games, even the Narrator must have "faith" that available negotiation structures will provide this meaning at a Campaign's end, sometimes called "the reveal." We hesitate to use the term *reveal* since it sets up the Aristotelian assumption that stories play towards the resolution of a puzzle. Instead, a table-top reveal is generally the satisfactory conclusion of major arcs and storylines in a game that can have spanned years of play. A Narrator is not required to force a three act structure upon the players' experience, and must even avoid making the intended reveal the focal point of the interaction between himself and the players. By contrast, the Narrator is to provide incentive for players to use the table-top game's rules to explore the narrative opportunity space, and ultimately reach a singular point in this space that we call the reveal. The means for incentivizing available to the Narrator beyond the players' interest in concluding the story their PCs are part of can come by way of the following three meta-concepts.

*Consistency Creation* is the need for narrative wholeness or completeness, and avoiding cognitive dissonance in players. In order for the Narrator to ensure an enjoyable experience an unspoken contract exists, which promises that the rule-based reasoning applicable to the story world's space-time will not be broken for the sake of the intended story's integrity. Through consistency created by the Narrator, players can perceive a greater contrast between what they know and do not know; allowing the thrill of uncertainty to be pervasive throughout the story. One could liken the promise to the pattern seen in television shows, where a cliffhanger at the end of an episode is promised to be resolved, but with the understanding that another cliffhanger will be coming as well.

*Narrative Baggage* is the collective behaviors, emotional responses and personal resources players and Narrator accumulate through prolonged exposure to one another's narrative incentives. A group of players and their Narrator cannot help but

learn one another's habits within a table-top game's time phase based interactions, and in doing so become more able at cooperatively navigating the transitions between these phases. Players also become able to identify a Narrator's "tells" and determine which of the items he presents are most relevant to their interests in the story. Additionally, players come to depend upon one another's behaviors at the table in maintenance of the most complete consumption of narrative they can manage. For example, one player's strengths may be at engaging the Narrator In-Context, while another's is considering the more broad relationship of narrative elements Out-of-Game. As each becomes aware of this, they will tend to perform in these respective phases more often for greatest narrative gain, and often improved experience of the story. The Narrator can similarly learn the "tells" of players, and capitalize on the phase-centric roles each player begins to assume at games, sometimes purposefully disrupting them to induce stress upon the narrative, so to make possible the tension storytelling relies on. As a form of history maintenance it is a means to lower cognitive overload.

*Generative Narrative Structure* is characteristic of interactive narratives, but specific to table-top gaming in terms of the rule-based co-authoring that occurs between all participants. This is similar to narrative structure in written works [16] in that table-top players can adopt a specific scheme of interaction that closely resembles a plot device. but the distinction between traditional media such as literature, theatre, film, and even dramaturgy – wherein an audience participates in the performance – is that their narrative structure remains mostly one sided and maintains a clear distinction between observer and generator of events. Improvisational acting follows a similar narrative structure to table-top gaming, producing results based on the goals of multiple participants. But the story in improvisational acting relies on ability for each participant to successfully achieve a given goal for their role. In such a sequence of improvised declarations their narrative structure is *emergent*, requiring will and activity alone for story to appear. Table-top gaming by contrast makes possible the creation of story through rules that manage the negotiation of outcomes between a Narrator and players to circumstances they cooperatively created.

# 9   An AI Perspective on Table-Top Gaming

In most current AI driven interactive narrative games the focus is either on generative narrative construction or authoritative narrative extrapolation. In our review of modes of play in table-top gaming we have shown that generative and authoritative narratives are interweaved and interlocked.

As we studied the means by which players and Narrator explore the narrative space, we discovered that in effect all together were defining the global rule set that governs a specific setting. As a game progresses rules are used, re-confirmed, removed and added. All participants are constantly exploring the boundaries of the rule space and in essence the interaction between players and rule base is what constitutes a table-top game. Perhaps it is interesting to note that most players in long lasting games considered their multi-volume custom generated rule books the history of the game, rather than any written history describing their adventures in narrative form.

As such the above table-top concepts and paradigms may be used as possible solution tracks for novel approaches in AI development for interactive narrative based games.

## 9.1 Narratology vs. Ludology in Digital Table-Top

Since in table-top gaming the Narrator validates a player's proposed action, a broad range of responses can apply that are richer than action/reaction. For example, a Narrator can divert a player's request for an action by responding with a completely new sub plot and self contained narrative molecule, as opposed to a single allow/disallow action model [10]. As such in table-top, a narratological response is possible to a ludological dilemma (e.g. table-top game mechanics).

An extension of this paradigm can also provide insight into how authoritative content can be incorporated into an otherwise generative based storytelling approach. An AI system could respond with a semi-authored vignette, allowing authors to contribute seeds and themes. Likewise if a Narrator is stuck in a plotted construction, a narrative mechanic can be played out, which is in fact the normal operation of a table-top game where players roll one or more dice to let chance determine what will happen next.

## 9.2 The Narrative View in AI Based Games

A distinct gap between table-top narration and AI driven interactive narrative is the way in which a player interacts with narratorial authority of the ongoing story. AI systems do not reflect on past events and can therefore not explain why a player could or could not take a certain action. A method of retrograde analysis would be valuable to explore how past actions may shape character behavior and which may be of benefit to current approaches in AI. One could liken the approach to explainable AI [5] but with the difference that the AI explains what has happened instead of why it has made a specific decision.

Since table-top games require that participants are aware of what has happened to their character in earlier times, it is important to see if we may utilize this awareness for developing new models in AI. In table-top, story validation is an important mechanism by which all players can maintain both an individual as well as a collective understanding of the game world and story state. Most of the time this authorial role is put on the Narrator but in table-top every other player contributes.

## 9.3 AI Use of Narrative Baggage

Currently digital interactive narrative games are explicit action evaluation machines, meaning that players clearly indicate to the machine what their intent is. E.g.: A mouse click linked to a gun object immediately fires a virtual weapon. In story based games actions are not as clear cut. A real world example might be that we tend to look at the objects we will interact with. When walking down the street we might look at the possible places to go for lunch and read the menu displayed at the entrance of one particular restaurant. This indicates likelihood, but more importantly excludes a large range of other activities that will not play out. As such Narrators often closely observe a player's behavior and we believe we can apply lessons learned from automated tutoring research where machine learning techniques automatically obtain cognitive behavioral models by observing participants [13].

## 10   Conclusion and Future Work

A concise and accurate set of terms describing both human and machine driven inter-active narrative can assist the field of digital interactive storytelling. It can accomplish this by using the terminology defined in this paper to study the dynamic rule man-agement players practice as they develop long term engaging narratives. Since tradi-tional terms from literature and dramaturgy do not adequately describe the interactive narrative model identified in digital role-playing games, we propose the terminology and concepts above, which are applicable to table-top role-playing games, as appro-priate for inclusion in the development of artificial intelligence narrative systems and interactive digital storytelling mechanisms.

Our first empirical study will map game play footage and transcriptions to time phases, thus adding the first level of narrative segmentation. From there we hope to gain enough insight to create a model and meta-mechanics that describe and predict the behavior of participants within the various phases of interactive storytelling. In our top-down approach we ultimately hope to arrive at fine grained models and me-chanics of interactive storytelling. Since our understanding of table-top game play is the continuous management of an evolving rule set, we will work towards an in-vivo rule acquisition system [11] that can learn appropriate behaviors and responses for both non player characters as well as automated narrators.

## References

1. Aarseth, E.: Cybertext: Perspectives on Ergodic Literature. The John Hopkins University Press, Baltimore (1997)
2. Bal, M.: Narratology. University of Toronto Press, Toronto (1997)
3. Barthes, R.: Death of the Author. Image-Music-Text. Hill and Wang, New York (1977)
4. Bogost, I.: Persuasive Games: The Expressive Power of Videogames. MIT Press, Cam-bridge (2008)
5. Core, M.G., Lane, C.H., van Lent, M., Gomboc, D., Solomon, S., Rosenberg, M.: Building Explainable Artificial Intelligence Systems. In: IAAI 2006, pp. 1766–1773. AAAI Press, Menlo Park (2006)
6. Fine, G.A.: Shared Fantasy: Role Playing Games As Social Worlds. University of Chicago Press, Chicago (2002)
7. Juul, J.: Games Telling Stories. Game Studies: Int. J. Computer Game Research 1 (2001), http://gamestudies.org/0101/juul-gts/ (1 retrieved April 11, 2008 )
8. Laurel, B.: Computers as Theatre. Addison-Wesley, New York (1993)
9. LeBlanc, M.: Tools for Creating Dramatic Game Dynamics. In: Salen, K., Zimmerman, E. (eds.) The Game Design Reader: A Rules of Play Anthology, pp. 438–459. MIT Press, Cambridge (2006)
10. Riedl, M.O., Saretto, C.J., Young, R.M.: Managing Interaction between Users and Agents in a Multi-Agent Storytelling Environment. In: AAMAS 2003, pp. 741–748. ACM, New York (2003)
11. Riedl, M., Young, R.M.: Story Planning as Exploratory Creativity: Techniques for Ex-panding the Narrative Search Space. New Generation Computing 24(3), 303–323 (2006)

12. Mateas, M., Stern, A.: Interaction and Narrative. In: Salen, K., Zimmerman, E. (eds.) The Game Design Reader: A Rules of Play Anthology, pp. 642–669. MIT Press, Cambridge (2006)
13. Matsuda, N., Cohen, W.W., Sewall, J., Lacerda, G., Koedinger, K.R.: Why Tutored Problem Solving May be Better Than Example Study: Theoretical Implications from a Simulated-Student Study. In: Woolf, B.P., Aïmeur, E., Nkambou, R., Lajoie, S. (eds.) ITS 2008. LNCS, vol. 5091, pp. 111–121. Springer, Heidelberg (2008)
14. Murray, J.: Hamlet on the Holodeck. MIT Press, Cambridge (1998)
15. Sengers, P.: Schizophrenia and Narrative in Artificial Agents. Leonardo 35(4), 427–431 (2002)
16. Turchi, P.: Maps of the Imagination: The Writer as Cartographer. Trinity University Press, Berkeley (2004)
17. Tychsen, A., McIlwain, D., Brolund, T., Hitchens, M.: Player-Character Dynamics in Multi-Player Role Playing Games. In: Proceedings of DIGRA 2007. Situated Play, pp. 40–48 (2007)

# From Tabletop RPG to Interactive Storytelling: Definition of a Story Manager for Videogames

Guylain Delmas[1], Ronan Champagnat[2], and Michel Augeraud[2]

[1] IUT de Montreuil – Université de Paris 8, 140 rue de la Nouvelle France
93100 Montreuil, France
g.delmas@iut.univ-paris8.fr
[2] La Rochelle University – L3i, 17042 La Rochelle, France
{ronan.champagnat,michel.augeraud}@univ-lr.fr

**Abstract.** Adding narrative in computer game is complicated because it may restrict player interactivity. Our aim is to design a controller that dynamically built a plot, through the game execution, centred on player's actions. Tabletop Role-playing games manage to deal with this goal. This paper presents a study of role-playing games, their organization, and the models commonly used for narrative generation. It then deduces a proposition of components and data structures for interactive storytelling in videogames. A prototype of a social game has been developed as example.

**Keywords:** Interactive storytelling, role-playing games, story manager, videogames.

## 1 Introduction

For the last years, interactive storytelling has become a major issue in video games development. Players ask for both more elaborated scenarios and more freedom to act and affect game's story through their avatar.

However, storytelling unfolding and player's interaction are commonly said as opposite [1]. The first relates to game designer's control of the game he has created as the second relates to player's control on the game he has bought.

Research on interactive storytelling mainly focuses on this opposition. Works on scenario driven approach [2, 3, 4, 5] have defined approaches to design, validate and control a scenario through an interactive application. However this control is somehow presented as in contradiction with player's ability to influence the game's unfolding in a persistent way. On the opposite, emergent narrative theory [6, 7, 8] gives a complete freedom to the player, who can direct the game unfolding through his actions. But this approach currently fails to ensure consistency and an interesting unfolding of the game.

The two main issues we have underlined are about the relation between interaction and narrative, and the ability of computer science to deal with it. The first point is related to interactive storytelling theory, and concerns the way interactivity should be taken into account in the storytelling. The second point leads to computer theory and the ability to implement algorithm of interactive storytelling.

I.A. Iurgel, N. Zagalo, and P. Petta (Eds.): ICIDS 2009, LNCS 5915, pp. 121–126, 2009.

This paper begins with a presentation of the interactive narrative we target. It comes from tabletop role-playing game. A game master balances between the control of the narrative and the freedom for player. The next section presents the architecture developed. It is based on a multi-agent system that monitors and controls the game unfolding. This architecture has been implemented in section 4.

## 2  Interactive Storytelling in Tabletop Role-Playing Games

Tabletop role-playing games (t-RPGs) arose with the emergence of social games in the end of the 19th century. The first example of commercialized t-RPG was Gary Gigax's *Chainmail* in 1971. Basics of t-RPGs are to let a set of players share the creation of their own story, where they interpret the main characters. T-RPGs mix dynamics from both society games (for the ludic aspect) and improvisational theatre. In the games' field, t-RPGs obtain results similar to the ones we aim at in the video games' field: an adaptive unfolding of the story, centred on player actions that is satisfactory for the player.

T-RPGs share a common model. A set of players interprets characters (named player characters - PC) and a game master (sometimes referred as storyteller) acts as a story moderator and a referee. The game describes a specific environment (which can be completed and personalised by the game master) and a set of rules for game simulation.

The game master is both a referee and a story director. On the one hand, he checks the player characters' actions. He validates actions and their results according to game's rules. On the other hand, he is responsible for story's unfolding. He has to describe the environment and to interpret the set of non-player characters (NPC). As a consequence, he produces a frame for the story and adapts it to player's actions.

At the beginning, the game master describes an initial situation to the players. It is a precise description of the story world according to PC's point of view. Each player tells the game master its character's actions. The latter "computes" the action (he applies the corresponding rules), and can add NPC's actions or specific actions. Finally he describes the resulting new situation. Then players can act in order to influence the story world and thus unfold the situation.

Depending on the evolution of the situation, the game master chooses a story starter and presents it to the players. It is an action that destabilizes the situation and provides a problem the players will have to solve. As the players decide, or not, to try to solve the problem, and then to start the story, the game master has to provide an action and a problem that interest them.

It is the players' responsibility to tackle the issue, and also the actions they perform. However the game master can influence players' decision by giving them specific information. The game master monitors the story unfolding, through player's actions, and estimates the most relevant conclusion. He aims to direct the story towards one of these conclusions. As a consequence he applies some actions (not depending on player's actions) to the current situation. He also checks that the story remains consistent, avoids deadlock or hazardous decisions, and manages the pace of the narrative tension.

The story derives from the interactions between the players and the game master. It can be a complex process and can be split into a sequence of task performed by the game master starting from a set of resources we will see in the following.

## 2.1  T-RPG Basics

In order to produce interesting and open narratives, t-RPG applies specific interactions rules between players and game master. Rules can vary from one group to another. However, we can distinguish a set of constraints that allows a game master to create interesting and interactive narratives with the players.

*Players must not be constrained by the game*: they have to be presented a set of actions (as inputs of the game) that allows them expressing themselves through their characters. These control elements must be persistent (the game master cannot inhibit them). The players should perceive the consequences of their actions. And finally these actions should have a real impact on game's unfolding (the narrative) and its final result (story's conclusion).

*The game has to propose a consistent environment*: in order to favour player's immersion. Game's rules must seem sensible and cannot be changed during the course of the game.

*Game's unfolding has to satisfy to storytelling structure*: it is not limited to a sequence of situations without linking the one with the others. It has to satisfy a structure that depends on the kind of storytelling defined by the designers.

It is the game master's responsibility to maintain these constraints throughout the game. To this purpose game masters have to perform a set of specific tasks.

## 2.2  Tasks Performed by the Game Master

Whereas most game masters determine their action through empirical and non-ordered processes, we can discern four main stages in game master's decision process.

*Get and analyse information from the players.* The game master identifies how the player action can be taken into account on the story unfolding and to identify what information they give on the player's behaviour and its character.

*The game master collects information on the player's knowledge.* He maintains a profile of the player that will help him to make choices during the story unfolding.

However, the main phase of the game master consists in *synchronize the state of the game*, identify the possible histories and to choose the sequence of event to perform.

Finally, he has to *determine the actions or information to give to the players* in order to influence the story unfolding.

The game master needs information concerning the game, the players and the narrative structure in order to perform these tasks.

## 2.3  What Should the Game Master Know?

In order to realise this decision process, the game master can refer to three main sets of knowledge:

*The game*: the game master both knows the game rules as well as the game world. He will anticipate the consequences of actions and solve the player interactions. The game world allows to determine the current situation, and to know which narrative resources the game master can use (characters, actions, *etc.*).

*A narrative structure*: the game master uses a structure of story in order to have a consistent and valid unfolding of the story. It gives him a framework to organise the actions of the game and to know when he must put actions. Thus, the game master can improve the interactive story that is being unfolded by giving a strong structure and this will improve the player experience.

*Player's profile*: the game master influences the unfolding according to its knowledge of the players (strength, weakness, *etc.*). He must, also, know their preferences in order to select actions that will fit to the desires of the player.

This study of t-RPG provides us with information on what interactive storytelling can achieve, and how to obtain these results. [9] presents an interesting study of t-RPG as the base of narrative videogames, in particular by the reference to the game master as a controller for the computerized systems. We deduced from this theoretical study an architecture for unfolding of interactive storytelling in video games.

## 3   Architecture for Interactive Storytelling in Videogames

We proposed in [10] a controller for interactive storytelling in videogames. We can sum up our approach of interactive storytelling in the following way: *a dynamic construction of the story, centred on the player's actions in an environment of interactive game*. So, this construction will not be based on a set of predefined paths, but on a control mechanism that analyzes the game unfolding and the player behaviour, and generates actions directing the storytelling towards one of its possible outcomes.

We have defined a software architecture that allows the implementation of our approach of the interactive storytelling: the player controls the narrative, but not the game. The game defines an interactive environment in which the player can, by his actions and decisions produce a storytelling under the supervision of the controller.

Controller's action is bounded by the game (defined by the game designer). Thus the controller cannot go against game's unfolding nor prevent player's actions. It is built on the top of four agents: Analysis, Profile, Story Management and Director.

The analysis agent receives information from the game and sends them back to the system. It performs a first selection between useful and non-pertinent information. It sends to the story management agent all information about the state game evolution and to the profile agent all information coming from player actions.

The Profile agent contains the knowledge database on the player. This agent merges all information on the player actions and derives statistics on its behaviour and its preferences (type of the most used action, game element that is generally used by the player, player performances, *etc.*).

The Story Management Agent monitors the game unfolding and takes decision during the execution. He has to assure the monitoring of the game's state, the determination of the possible narratives, and the selection of the actions to perform the storytelling.

The Director agent aims at making a retransmission of the story management decision to the game. It transforms the story management decision into comprehensible directive by the game.

In addition, the controller requires three views of the game: a game model, a narrative construction structure and a player profile. The game model gives all the possible stories and follows the game unfolding (determines the game's current state, as well as its possible evolutions). It is base on a computational model (Petri nets). The narrative construction structure gives a canonical model to the story (Aristotelian structure, The heroes journey of J. Campbell, *etc.*). The player profile is on statistical point of view but not on psychological, and contains information to identify player's preferences.

## 4  Example: The Schoolyard

This example is a prototype to validate the architecture proposed previously. In this game, the player acts for a kid that comes recently in a new school. Lost in the middle of unknown pupils, he has to make new acquaintances and find friends. The virtual characters present in the game employ the same actions the ones towards the others. It is by taking their control that the system can influence the contents of the play.

Characters take a prototype of schoolyard: the nerd (a boy fond of sciences, and presenting social difficulties), the sportsman (very popular and very friend with the cheerleader, but not appreciating the intellectual characters), the captain of the cheerleaders (very friendly with everyone, except the captain of class) and the captain of class (serious pupil, which gets along only with the nerd).

Each character is characterised by a temper: a specific model gives the evolution of the temper and the different states, according to interactions with other characters. The temper is of four states shared by all the characters (avatar and non player characters): neutrality (default temper), sadness, angriness and happiness. The state temper evolution is threshold by interactions. Their friendly level or hostility level describes the interaction between characters (neutral, positive or negative).

The player's profile is a short set of statistical information due to the fact that the proposed actions are limited (the number of positive/negative interactions, the number of interaction with a specific character, *etc.*).

The game proposes two separate scenarios: the fist one is the relation network a player can create, and the second one the temper evolution of a character the player considers as a friend.

This example is simple: the game has a basic narrative program: a contract phase and a qualifying phase. The knowledge phase can be divided into a fixed number of narrative sub-programs.

## 5  Conclusion

We have presented a study on tabletop role-playing games and narrative management. From this study we have derived a set of components and data structures to control

the interactive storytelling in videogames. These structures have been integrated into a control system for interactive storytelling in games. This proposition has been illustrated by the realisation of a social game that provides interactive experience through a limited interface. This prototype shows that our controller's architecture is able to determining a narrative during the game execution; check the controller ability to direct the narrative to a conclusion while satisfying narrative construction structure; and finally make sure that the controller decisions are in real-time. Although the example is basic, the controller has been designed in order to deal with larger games and with more complex data models, such as the story structure presented in [11]. In addition, the controller proposed in this paper has been originally designed for a narrative-oriented game but can be used to control a sandbox game as stated in [12].

**Acknowledgments.** This work has been funded (in part) by the European Commission under the grand agreement IRIS (FP7-ICT-231824).

# References

1. Juul, J.: A Clash Between Game and Narrative. In: Digital arts and culture conf., Bergen (1998)
2. Mateas, M.: Interactive Drama, Art, and Artificial Intelligence. Ph.D. Thesis. School of Computer Science. Carnegie Mellon University (2002)
3. Young, M., Riedle, M., Brandy, M., Martin, J., Saretto, J.: An Architecture for Integrating Plan-Based Behavior Generation with Interactive Game Environments. Journal of Game Development 1, 51–70 (2004)
4. Riedl, M.: Narrative Generation: Balancing Plot and Character. Ph.D. Thesis, Department of Computer Science. North Carolina State University (2004)
5. Champagnat, R., Prigent, A., Estraillier, P.: Scenario Building Based on Formal Methods and Adaptative Execution. In: Narasimhan, S., Teach, R. (eds.) Proceedings of the 36th International Simulation and Gaming Association, ISAGA (2005)
6. Aylett, R.: Narrative in Virtual Environnements – Towards Emergent Narrative. In: Proceedings of the AAAI Fall Symposium on Narrative Intelligence, pp. 83–86. AAAI Press, Menlo Park (1999)
7. Szilas, N.: IDtension: a Narrative Engine for Interactive Drama. In: TIDSE 2003. LNCS, vol. 3105, pp. 183–203. Springer, Heidelberg (2003)
8. Cavazza, M., Charles, F., Mead, S.J.: Character-Based Interactive Storytelling. IEEE Intelligent Systems 17(4), 17–24 (2002)
9. Tychsen, A., Hitchens, M., Brolund, T.: The Game Master. In: ACM proceedings of the second Australian conference on Interactive Entertainment. ACM Press, New York (2005)
10. Delmas, G., Champagnat, R., Augeraud, M.: Plot Monitoring for Interactive Narrative Games. In: Proc. international conf. on Advances in computer entertainment technology, pp. 17–20. ACM Press, New York (2007)
11. Delmas, G., Champagnat, R., Augeraud, M.: Bringing Interactivity to Campbell's Hero's Journey. In: Cavazza, M., Donikian, S. (eds.) ICVS-VirtStory 2007. LNCS, vol. 4871, pp. 187–195. Springer, Heidelberg (2007)
12. Delmas, G., Champagnat, R., Augeraud, M.: Plot Control for Emergent Narrative: a Case Study on Tetris. Int. Jour. on Intelligent Games and Simulation 4(1), 29–34 (2008)

# The Good, the Bad and the Ugly:
# Short Stories in Short Game Play

Swen Gaudl, Klaus P. Jantke, and Christian Woelfert

Fraunhofer IDMT, Children's Media Dept.
Hirschlachufer 7, 99084 Erfurt, Germany
{Swen.Gaudl,Klaus.Jantke,Christian.Woelfert}@IDMT.Fraunhofer.de

**Abstract.** What are the minimal requirements to tell a story by means of some digital game? What are minimal short stories worth to be told? How to establish the minimal preliminaries of interactive storytelling? What do we expect of computerized counterparts that are worth to be mentioned in a story humans experience when playing a digital game? The authors have designed, implemented and experimentally used some particularly simple game in which the personalities of digitalized agents– the good, the bad and the ugly–substantially contribute to stories that may be worth being reported.

> *... the first wish that most players, developers and researchers*
> *originally feel when first encountering and considering*
> *interactive story, is the implicit promise to the player*
> *to be able to directly affect the plot of the story, taking it*
> *in whatever direction they wish.*

(Andrew Stern in [1] p. 3)

## 1 Conceptualization of Stories in Digital Game Playing

Does it make any sense to speak about the story that evolves when playing the conventional board game of NINE MEN'S MORRIS? Do you experience anything such as a story when playing TETRIS?

Conceptualization is a matter of taste and, in particular, a matter of purpose and necessity [2]. What does it buy us to talk about stories of falling blocks in TETRIS? In particular, how does the storytelling perspective contribute to the design of a digital game? How does it contribute to the understanding of affect and social impact? What is seen as a story and what is called a story depends on the focus of investigation, on the interest in game design or analysis.

The present research aims at an identification of, so to speak, atomic building blocks of storytelling. What are minimal ingredients to make stories emerging?

Particular emphasis is put on the design of non-player characters' profiles. How much "personality" is necessary to play some role in an interesting story?

The authors' original story space concept [3] will be exploited to set the stage for non-player characters strong enough to drive an interesting story evolution.

I.A. Iurgel, N. Zagalo, and P. Petta (Eds.): ICIDS 2009, LNCS 5915, pp. 127–133, 2009.

## 2   The Impact of NPC Characters on Alternative Stories

The authors central hypothesis is: *Character is crucial to interactive storytelling.*

In the most simple approaches, stories are seen as linear sequences of events, as expressed by David Thue et al., recently: *Fundamentally, stories are sequences of events, each of which involves some form of action.* ([4], p. 231) Other authors such as Marie-Laure Ryan, e.g., strive to abandon the linearity of stories: *The trademark of the epistemic plot is the superposition of two stories: one constituted by the events that took place in the past, and the other by the investigation that leads to their discovery.* ([5], p. 7) Her epistemic plot is leaving linearity behind, but the story concept itself still sticks with the principle of sequentiality.

In contrast, the present authors propose to abandon strict linearity of events.

Designing a storytelling game means the anticipation of varying experiences including events which possibly exclude each other. This very much resembles planning in dynamic conditions [6]. The complete design may be presented as a storyboard [7] potentially summarizing a number of mutually exclusive stories. When human game playing happens, it unfolds one of the possibly many stories. Due to the lack of space, further details have to be suppressed.

The varying decisions of a human player drive the emergence of possibly different stories. But how can purposeful game design–seen as dramaturgical design–predetermine and direct the players' decisions, thus, leading to a variety of stories foreseen by the designers? It is the authors' intention to answer this question with an approach stripped to the essentials. Just varying NPC profiles lead to experiencing different stories.

The case study outlined in the following section reports the authors' design and implementation of a minimalist approach in which easy to control NPC characteristics lead to quite different interactions between humans and NPCs experienced accordingly. Game play is short, and so are the stories.

In the game GORGE under consideration, human as well as computerized players have to move along a track to reach a certain goal area. The track is interrupted by gorges.

Facing a gorge, you may learn about the other players' peculiarities of cooperating for passing the gorge together or defecting.

By means of slide controls, the NPCs' preferences can be adjusted. Players may turn an NPC either into a good or a bad one. The short stories players are going to experience

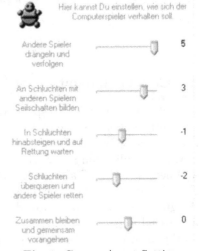

**Fig. 1.** GORGE Agent Settings

depend on the characters of the NPC they meet and approach during game playing intentionally or by chance.

There may arise a short story of fighting, tricking, fooling, and the like or, alternatively, variants of consideration, help, care, and waiting for each other. It's all a question of character. The adjustment of characters directs the story.

# 3    A Case of Meeting Digital Adversaries and Friends

In 2006, for the purpose of scientific investigations, the second author of this paper has designed some particularly simple game named GORGE which has been implemented in dozens of variants within several lectures on digital games.

## 3.1    The Gorge Game Concept

GORGE resembles a board game. A typical GORGE board can be seen on figure 2. Up to four players play in turns, trying to get their four pawns from the start fields in the upper left corner to the final fields at the bottom center of the board.

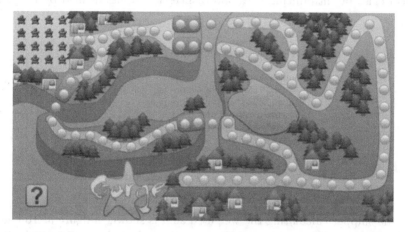

**Fig. 2.** The GORGE Board in an Early Students' Design and Implementation

A player's turn begins using the dice to see how far a pawn can be moved on the board. Since it is very important to reach the final fields faster than the competitors, larger numbers from dicing mean better results. A player chooses from one of its pawns and moves it using up the range indicated by the dice result.

It is allowed to move a pawn to a field that is already occupied by another pawn, especially those of the other players. That pawn is ordered to retreat to the next vacant position. This action is called "to jostle". Since jostling other players' pawns puts a pawn ahead jostling can be utilized as an aggressive tactic that helps winning the game. But it might be also a bit time-consuming.

Paths on the GORGE board are intersected by gorges, here denoted by the brown color. A gorge cannot be passed by a single pawn but only by building roped teams, requiring the two fields preceeding the gorge field must not be

vacant. Once a team is built, one of that team's members can move into the gorge. As long as there is a pawn, other pawns can pass that gorge. When a pawn is passing a gorge field it rescues the pawn from the gorge field, but for that rescue to take place there needs to be a vacant field after the gorge field and before the destination field of the passing pawn. The rescue action is omitted if there are no such vacancies.

Gorges are the crucial places where players learn about their competitors of being the good, the bad or, perhaps, even the ugly. Characters becomes decisive.

## 3.2   The Gorge Agents' Implementation

The GORGE board is modelled using a linked sequence of fields with predecessors and successors. The ownership relations are represented by the current GameState. The linked structure is invariant in a game but the GameState changes.

Artificial agents can be set up as players with characters favouring different strategies by introducing likes and dislikes for events defined by the game rules.

```
public double evaluateNode(int[] playerConfig)
{
        double value
        = jostling * playerConfig[GorgeKI.JOSTLING]
        + ropeTeaming * playerConfig[GorgeKI.ROPE_TEAMING]
        + rescueing * playerConfig[GorgeKI.RESCUEING]
        + gorgeEntering * playerConfig[GorgeKI.GORGE_ENTERING];
        return value;
}
```

**Fig. 3.** Getting a move's score value

A code snippet calculating the weighted sum is shown in figure 3. To enable agents acting on plans and intentions the scoring algorithm is extended with a hypothetical GameStates storing the field ownership relations after a hypothetical move. Now agents are able to choose a path at junctions to reach the roped team or a gorge pawn to rescue.

Figure 4 displays a game situation that requires the support for future hypotheses. There is a pawn (the yellow one) trapped in the gorge. It is the other player's (the red one's) turn. After using the dice this other (red) agent must decide about a moving range of three fields.

Being set with a positive weight for rescueing other pawns, the red player picks the upper path at the junction, so it is possible to rescue the yellow pawn in the future as can be seen at the upper right. At the lower right the agent is configured with a negative weight for rescueing other pawns. To avoid possibly rescueing the yellow pawn from the gorge he evades this path.

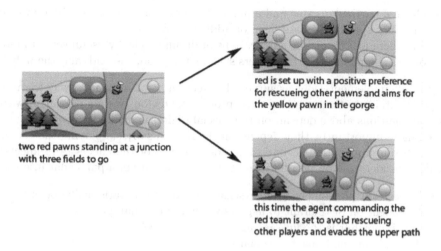

two red pawns standing at a junction
with three fields to go

red is set up with a positive preference
for rescueing other pawns and aims for
the yellow pawn in the gorge

this time the agent commanding the
red team is set to avoid rescueing
other players and evades the upper path

**Fig. 4.** Preparing the Rescue ... or Deserting the Helpless

## 4    Interactive Storytelling by Character

From Aristotle to the present, there have been developed concepts and ideas of dramaturgy both in the performing arts and in the visual arts galore ([8,9], e.g.). Many of them might be carried over to digital games.

However, digital games bring with them the enormous intensity of interaction which may potentially result in an unprecedented manifold of varying experience. Dramaturgy of interactive storytelling deals with the anticipation, the planning, the implementation, and the control of this manifold.

The present paper advocates the principal perspective that, in general, the character of protagonists is decisive to real life communication and cooperation and to the unfolding of stories in theater, in motion picture, and in game playing.

The authors'–so to speak–dramaturgical technology proposed is to design and implement characters of NPCs such that the peculiarities of the NPCs have a substantial impact on the unfolding of stories when humans play some game. If this works truly successfully, tuning the parameters of NPC characters may become an approach to modification and control of the emergence of stories.

This is a very particular, but hopefully original approach which, doubtlessly, has to be seen within the overall endeavor of creative ideas to advance interactive storytelling.

The present rather particular perspective leads to the explication of a few rather particular phenomena and related questions such as, e.g., the following.

- How much does a large variety of NPC characters contribute to the potential range of emerging stories?
- How important are conflicting characters to the attractivity of the story?

- Given a particular game and a particular set of characters, how to adavance the story space by substituting or adding characters?
- Are there prototypical configurations of dramaturgically useful sets of more or less complementary characters such as the good, the bad, and the ugly?

Sample implementations as surveyed in section 3 demonstrate a way towards experimental investigations into those problems. Obviously, even partial answers to the questions above depend on the special digital game under consideration. Even more importantly, they depend on the human subjects playing the game.

In certain application scenarios, the dependence of the effects (and affects) under consideration on peculiarities of the audience are of a particular interest.

- Are certain phenomena gender-sensitive? Are–seen statistically–boys more dependent on or tolerant to aggressive characters than girls?
- How important is the average age of the audience?
- What about the impact of social status?

In many of the conventional role playing games such as, e.g., BALDUR'S GATE or MORROWIND, you meet NPCs in large numbers and either talk to them, trade with them, or fight them. The authors advocate the approach to equip NPCs with character such that different human players in different conditions deal with them differently such that the evolving story may turn into different directions.

## 5    Summary and Conclusions

The gist of the present paper may be circumscribed by the following surely oversimplified illustration.

Assume a digital game in which you have designed and implemented some NPC such that there are those players who find the NPC interesting and somehow nice to talk to, whereas other players avoid getting in contact with him. Assume furthermore that cooperating or not cooperating with this particular NPC drives the game story into different directions. In this way you got what we call an (extremely simple) instance of *interactive storytelling by character*.

In addition to other ideas, concepts and models of interactive storytelling, the authors' approach offers a new opportunity to drive the unfolding of stories intensionally. The approach is modular, because it refers to the characteristics of individual NPCs. It supports modification and experimentation, because you may play–and, perhaps, have fun–with changing profiles of an individual NPC.

## Acknowledgements

This manuscript has been completed when the second and the fourth author have been visiting the Meme Media Lab. at the Hokkaido University Sapporo, Japan.

The present research and development has been partially supported by the Thuringian Ministry for Culture within the project iCycle under code PE-004-2-1.

# References

1. Stern, A.: Embracing the combinatorial explosion: A brief prescription for interactive story R&D. In: Spierling, U., Szilas, N. (eds.) ICIDS 2008. LNCS, vol. 5334, pp. 1–5. Springer, Heidelberg (2008)
2. Lakoff, G.: Women, Fire, and Dangerous Things. The University of Chicago Press, Chicago (1987)
3. Jantke, K.P.: The Evolution of Story Spaces of Digital Games Beyond the Limits of Linearity and Monotonicity. In: Iurgel, I.A., Zagalo, N., Petta, P. (eds.) ICIDS 2009. LNCS, vol. 5915, pp. 308–311. Springer, Heidelberg (2009)
4. Thue, D., Bulitko, V., Spetch, M.: Making stories player-specific: Delayed authoring in interactive storytelling. In: Spierling, U., Szilas, N. (eds.) ICIDS 2008. LNCS, vol. 5334, pp. 230–241. Springer, Heidelberg (2008)
5. Ryan, M.-L.: Interactive narrative, plot types, and interpersonal relations. In: Spierling, U., Szilas, N. (eds.) ICIDS 2008. LNCS, vol. 5334, pp. 6–13. Springer, Heidelberg (2008)
6. Jantke, K.P.: Why Storyboarding? Why Not Planning? In: Proc. 7th Conf. Computer Methods and Systems, ONT, Krakow, Poland (2009)
7. Jantke, K.P., Knauf, R.: Didactic design through storyboarding: Standard concepts for standard tools. In: Proc. 4th Int. Symp. Information and Communication Technology, pp. 20–25. Comp. Sci. Press, Trinity College Dublin, Ireland (2005)
8. Hitchcock, A.: Hitchcock on Hitchcock: Selected Writings and Interviews (Reprint). Univ. of California Press, Berkeley (1997)
9. Rabenalt, P.: Filmdramaturgie. Vistas (2004)

# Introducing Multiple Interaction Devices to Interactive Storytelling: Experiences from Practice

Ekaterina Kurdyukova, Elisabeth André, and Karin Leichtenstern

Augsburg University, Institute for Computer Science
Multimedia Concepts and Applications
Universitätsstr. 6a, D-86135 Augsburg
{kurdyukova,andre,leichtenstern}@informatik.uni-augsburg.de

**Abstract.** Introducing multiple interaction devices into an interactive story provides certain advantages to the system: it fosters collaboration in multi-user settings, increases user involvement, and addresses more perception channels and user senses. It is a challenging task for designers to introduce multiple interaction devices into an interactive storytelling (IS) system. In this paper we report on our experiences with the design and evaluation of an IS system, called ORIENT. The system was created for multi-user settings; it embeds various interaction devices, such as mobile phones, a dance pad, a Wiimote, and RFID tags. We report on user feedback and derive design challenges that should be considered when creating interaction devices for IS systems.

**Keywords:** interaction devices, user experience, multimodal interaction.

## 1 Introduction

Existing interactive storytelling (IS) systems often incorporate a variety of interaction devices. Introducing multiple devices to communicate with a story has certain advantages: they enable multimodal interaction, address different human senses, and intensify user experiences. Moreover, in multi-user settings various interaction devices provide more opportunities for collaboration and foster communication between users.

However, it is a challenging task to design an IS system with multiple interaction devices. First, the devices should harmonically enhance the story. They should contribute to the drama and be logically involved in the story flow. Second, in a multi-user scenario, the interaction devices assigned to the users should support their roles in a story and help them stay in character. Finally, the interaction techniques supported by the devices should be easy to understand and to apply. A sophisticated interaction technique can hinder interaction with the story and spoil user experience.

In this paper we describe an IS system called ORIENT. The interaction with the scene is supported by various interaction techniques that enable speech and gesture input as well as physical and spatial interaction. Below we describe the interaction design for our system and report on insights we gained during user tests conducted with teenagers. From user feedback and experiences with existing IS systems, we derive design challenges that should be considered when creating an IS system.

I.A. Iurgel, N. Zagalo, and P. Petta (Eds.): ICIDS 2009, LNCS 5915, pp. 134–139, 2009.

## 2 Design and Evaluation of ORIENT

The interactive storytelling system ORIENT was developed within the EU-funded project eCIRCUS [1]. The interaction concept of ORIENT was inspired by innovative techniques and collaboration theories. We describe the main idea of the system, its interaction design, report on user feedback, and highlight design findings and failures.

### 2.1 ORIENT Story

ORIENT was developed for teenagers at an age between 13 and 16 years. The main objective of the system is to teach them empathy with people from other cultures. The system aims at making teenagers aware of cultural differences including habits and customs. To achieve this objective, the teenagers had to go through a scenario simulating their visit to an unfamiliar planet called ORIENT.

The scenario is played by a group of three users; each user takes on the role of a spaceship crew member. Their mission leads them to a small planet ORIENT, which is inhabited by an alien race – the nature loving Sprytes. Since a fictional (and not existing) culture is portrayed in the scenario, the application is flexible and suitable for users with various backgrounds.

The users had to save the Sprytes from an approaching meteorite; otherwise the ORIENT would stop its existence. In order to save the life on ORIENT, the users first had to acquire knowledge of the Spryte's habits and customs, befriend the Sprytes and ultimately cooperate with them. In order to cooperate with the Sprytes the user had to move in space, explore the environment, perform actions, and communicate with the Sprytes.

### 2.2 Interaction Design in ORIENT

Interaction in ORIENT is enabled by a variety of devices. The players stand in front of a large display which shows the scene and characters on the ORIENT planet (see Fig. 1, left). The characters, Sprytes, are talking to the users in a fictional "gibberish" language to convey the idea of a fantasy culture. Due to the "gibberish" language, we did not have to realize different culture-specific versions of ORIENT: ORIENT was supposed to be played by German and British teenagers. A fictional culture ensured that neither German nor British players were familiar with ORIENT's culture. The unknown language complicated the teenagers' mission because they had to find alternative ways of communication. Therefore, we had to identify appropriate devices and interaction techniques which would support other verbal and non-verbal interaction channels rather than natural speech.

For verbal communication, we used keyword spotting. In order to address a Spryte, the children had to pronounce its name. For speech interaction, the teenagers were equipped with a mobile device. Mobile devices convey the metaphor of a "decoder device" similar to those used in science fiction series, such as Star Trek.

Using the decoder metaphor, the mobile devices can also be used to select objects in the story. In this case, keyword spotting would not work: the users do not know the Sprytes' terms. However, the users can apply the decoder to scan real world objects and transmit their identification to the Sprytes. For the decoder device, we used Nokia

**Fig. 1.** ORIENT scene (left) and players interacting in a group (right)

6131 NFC, since it supports a built-in microphone for keyword spotting, a built-in NFC-reader for scanning RFID-tagged real world objects and a Bluetooth interface for the transmission of the speech and scanned object to the ORIENT world.

For non-verbal interaction, we chose a set of gestures that the Sprytes could use to communicate: greet, ask, give, and apologize. The users could also adapt and execute these gestures in order to express an action; this was done using a magic stick, the Wiimote. Three-dimensional gesture recognition was performed based on motion data from the Wiimote's accelerometer sensors. In ORIENT, the set of available gestures (and hence, actions) was supposed to be learnt by the users in advance.

Using the decoder device and the magic stick, the users built phrases to communicate with the Sprytes. Every phrase consisted of Subject (Spryte name given by speech), Action (gesture executed with Wiimote) and Objects (scanned RFID tag). In this way, the phrases represented an utterance which was addressed to a particular Spryte, e.g. a question about an object available in the Spryte's world.

Three users participated in the story. Their roles were defined by the interaction devices assigned to them based on a study that explored different multi-user settings for pervasive games [2]. This study showed that a setting where each user is assigned a role via an interaction device with a dedicated function helps organize interactions within a group, fairly distributes the levels of interactivity and avoids dominant users. This setting promoted collaboration among users in a better way than a setting where just one interaction device was given to the whole group or a setting where each group member was equipped with an identical device. Drawing on the findings of this study, roles in ORIENT were assigned as follows. The first role, called Communication Officer, made use of the mobile phone for keyword spotting and RFID scanning of real world objects. The second role, Intelligence Officer, employed the Wiimote for performing the gestures. The third role, Organization Officer, used the dance pad for navigation. Figure 1 (right) shows users interacting with the system. Each of the three interaction devices had a unique function, necessary to achieve the goal of the story.

The final version of the system introduced a mobile-based assistant, called Oracle. The assistant provided the users with help how to proceed with the story. Oracle was implemented on a second mobile device (Nokia N95) and belonged to the user responsible for the navigation with the dance pad. Figure 2 summarizes the interaction devices used in the ORIENT system.

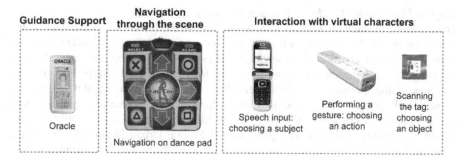

**Fig. 2.** Interaction devices in ORIENT

# 3   Lessons Learnt from User Feedback

The ORIENT prototype was tested in a lab-based study with 12 teenagers from UK and Germany respectively. Each evaluation lasted about two hours, including device training, interaction with ORIENT, and filling in questionnaires. Below we report on findings based on observations of and feedback from users interacting with ORIENT. We group the insights according to the challenges we faced during the design.

### Assure Basic Usability

User feedback revealed that usability problems may negatively affect IS experience. Even though the children found it challenging to learn Wiimote gestures to communicate with the Sprytes, the number of gestures should be reduced. The users could not remember them and often asked for help. Other sources of confusion were failures of the gesture recognition system. It is crucial to consider the users' cognitive and physical load in order to avoid frustration during interaction while still preserving the challenge of a game-like setting.

### Provide Transparent Interaction with the Story

In order to enhance the transparency of the interaction, the artificial language used to communicate with the Sprytes was oriented by the grammar of natural languages and structured according to the "Subject + Action + Object" pattern. Nevertheless, some users easily confused the subject and the object since in human-human communication, people build phrases more freely. Although both German and British children were able to communicate in our artificial language, more control and assistance from the system would be desirable. Moreover, the borders of interaction should be specified more clearly. For example, the designers of Locating Drama [3] exploit sound to give users a hint about the borders of interaction space. The system is played in a park whereby borders and exits from the "story space" are marked with a certain noise. In IS systems, where users interact using natural language or languages bearing some resemblance to natural languages, such as ORIENT, ideas from prompt design might help show the user how and when they can interact. For example, in FearNot! [4] carefully designed dialogue strategies for characters interacting with children encouraged specific types of follow-up natural language responses from the children and thus reduced the likelihood of unexpected user input.

### Support Unobtrusive Guidance through the Story

The guidance through the ORIENT story was supported by Oracle, an assistant on the mobile phone. In the case of confusion, the users consulted Oracle. Oracle turned out to be a promising approach for user assistance since it was integrated naturally into the story. Nevertheless it has to be improved to act in a more intelligent way. For example, if the question was formulated incorrectly or did not match the current scene, Oracle just answered "The question is irrelevant". This caused user frustration: the users still did not know how to proceed. Ideally, user guidance should be supported by interaction design. Designers of the Mobile Urban Drama [5] found that audio assistance can significantly help guide the users. However, the guidance should be done unobtrusively, e.g. as "voices in your head" [3]. General design principles, such as affordances, constraints and mappings, may also help guide users without providing lengthy instructions. In ORIENT, users navigated through a scene by stepping on an appropriate pad arrow of a dance pad. Such design bears a resemblance to real-world navigation (even though it does not provide an appropriate mapping for all aspects of real world navigation). Moreover, it only occupied the user's feet, and allowed the user to perform other actions simultaneously.

### Assure Immersion through Scene Design

Prior research has shown that embedding a story in the user's physical environment helps increase user immersion. Designers of Mobile Urban Drama [5] found that the integration of the user's real surroundings – in their case the physical settings of a city - play an important role in user immersion. Their users even had the impression that passers-by participated in the story. Dow et al. showed that an Augmented Reality version of Façade system was perceived as more immersive than a desktop-based version [6]. However, users found it less engaging than the desktop-based version. ORIENT uses audio effects, such as nature sounds (birds, trees) to immerse the users into a green planet scenario. This idea could be developed further to help users "feel" the mood of the scene. In addition, ORIENT allows for bodily activity and manipulation of physical objects, for example, by scanning them using the mobile phone.

### Increase Engagement

The use of popular input devices, such as the Wiimote, made the interaction for the children more enjoyable and contributed significantly to their engagement. Furthermore, the distribution of input devices based on the findings of the study mentioned earlier [2] helped involve all children actively in the story. Every user had to make use of his or her input device to enable communication with the characters. The effect was enhanced by bodily activity and manipulation of physical objects.

### Support Story Plot

In ORIENT, we aimed at smoothly embedding the interaction devices into the story plot. For instance, the decoder device draws on the metaphor of a communication device which fits to the story of a space command mission. Interaction devices and techniques should harmonically match the story plot in order not to break the illusion. For instance, Madame Bovary [7] uses emotional speech for story control. This input modality is obviously more appropriate for the setting and the scenario than input modalities exploiting futuristic-looking technical devices.

*Providing Plausible Interpretation Possibilities for Deficient Input Interpretation*
Dow and colleagues recommend to design communication in an IS in such a way that system failures in understanding human input can be interpreted by users as a proper reaction of the story [6]. This strategy was employed successfully in ORIENT as well. In ORIENT, incorrect user input or failures of the recognition technology could be interpreted by the users as naturally arising communication problems between different cultures.

## 4  Conclusion

Introducing multiple interaction devices is a challenging task for interaction designers. In this paper we reported on our experience with an IS called ORIENT which includes multiple interaction devices and exploits a variety of interaction techniques. The evaluation of the system gave us an insight into the critical challenges of IS system design: interaction devices should be easy to use while maintaining the challenge of a game-like setting, enhance interaction transparency, provide unobtrusive guidance, immerse users in a story, maximize their engagement, support the story plot and leave enough plausible interpretation possibilities for system failures.

**Acknowledgments.** This work was partially supported by the EC and has been funded by the projects eCIRCUS (IST-4-027656-STP) and IRIS (FP7-ICT-231824).

## References

1. eCIRCUS (IST-4-027656-STP), http://www.e-circus.org/ (last access 09-24-2009)
2. Leichtenstern, K., André, E.: Studying Multi-User Settings for Pervasive Games. In: Oppermann, R., Eisenhauer, M., Jarke, M., Wulf, V. (eds.) Proc. 11th Int. Conf. on Human-Computer Interaction with Mobile Devices and Services, pp. 190–199. ACM, New York (2009)
3. Parry, N., Bendon, H., Boyd Davis, S., Moar, M.: Locating Drama: A Demonstration of Location-Aware Audio Drama. In: Spierling, U., Szilas, N. (eds.) ICIDS 2008. LNCS, vol. 5334, pp. 41–43. Springer, Heidelberg (2008)
4. Dias, J., Ho, W.C., Vogt, T., Leichtenstern, K., André, E.: I Know What I Did Last Summer: Autobiographic Memory in Synthetic Characters. In: Paiva, A.C.R., Prada, R., Picard, R.W. (eds.) ACII 2007. LNCS, vol. 4738, pp. 606–617. Springer, Heidelberg (2007)
5. Hansen, F.A., Kortbek, K.J., Grønbæk, K.: Mobile Urban Drama – Setting the Stage with Location Based Technologies. In: Spierling, U., Szilas, N. (eds.) ICIDS 2008. LNCS, vol. 5334, pp. 20–31. Springer, Heidelberg (2008)
6. Dow, S., Mehta, M., Harmon, E., MacIntyre, B., Mateas, M.: Presence and Engagement in an Interactive Drama. In: Proc. of the SIGCHI conference on Human factors in computing systems, pp. 1475–1484. ACM, New York (2006)
7. Cavazza, M., Pizzi, D., Charles, F., Vogt, T., André, E.: Emotional Input for Character-based Interactive Storytelling. In: Decker, Sichman, Sierra, Castelfranchi (eds.) Proc. 8th Int. Conf. on Autonomous Agents and Multiagent Systems, pp. 313–320. IFAAMAS (2009)

# Narrative Development in Improvisational Theatre

Allan Baumer and Brian Magerko

Adaptive Digital Media Lab
Georgia Institute of Technology
{abaumer3,magerko}@gatech.edu

**Abstract.** We have investigated the experience of improvisers as they perform to better understand how narrative is constructed by group performance in improvisational theatre. Our study was conducted with improvisers who would perform improv "games" with each iteration video recorded. Each individual participant was shown the video in a retrospective protocol collection, before reviewing it again in a group interview. This process is meant to elicit information about how the cognition involved develops narrative during an improvisation performance. This paper presents our initial findings related to narrative development in improvisational theatre with an ambition to use these and future analyses in creating improvisational intelligent agents. These findings have demonstrated that the construction of narrative is crafted through the making and accepting of scene-advancing offers, which expert improvisers are more readily capable of performing.

**Keywords:** Improvisation, Cognition, Performance, Narrative.

## 1 Introduction

Improvisational theatre has its roots in the *commedia dell'arte*, a 15th century Italian theatre form that involved stock characters, where actors were required to fill in the holes of a basic plot outline for each new performance [1]. Modern Western improvisational theatre has been influenced heavily by the seminal teachings of contemporary directors such as Del Close and Keith Johnstone who have developed forms and methods for improvisation that cater just as much to storytelling as comedy [1], [2].

This connection to storytelling is a particularly compelling one when considering the creation of digital interactive stories. Improvisational actors have the daunting task of constructing a story for an audience in real-time without the benefit of explicit coordination or pre-planning [3], [4], [5]. There is a high degree of agency for all of the actors on stage and, within some game forms, the audience as well (e.g. certain improv "games" involve the audience being prompted for content suggestions in the middle of a scene). Improv theatre, therefore, is a real world example of what some interactive story researchers attempt to accomplish – an adaptive, story-rich experience that has high agency for all members involved [6].

There have been attempts to model improvisation from a theoretical point of view, studying improvisational texts or techniques to elicit computational behaviors for intelligent agents [7], [8]. The results of these projects have been fairly specific

I.A. Iurgel, N. Zagalo, and P. Petta (Eds.): ICIDS 2009, LNCS 5915, pp. 140–151, 2009.

examples of a single facet of modern improvisation (e.g. status) without a broader model encompassing more of improvisation. These works also tend to focus on *what improvisers are taught* and not necessarily *what they actually do* in terms of mental processes. Therefore, we have conducted a series of experiments designed to study the underlying cognition of theatrical improvisation with the end goal of creating intelligent agents that have behaviors modeled after our findings.

Our research target is to reach a better understanding of a subset of cognitive mechanisms underlying improvisation that we hypothesize is the most useful for building improvisational intelligent agents: basic cognition (e.g. how improvisers reason about their own knowledge and goals as well as that of others (i.e. theory of mind, reasoning about their own skill levels, or metacognition), narrative development (i.e. how improvisers reason about story development, character, and the environment), model convergence (i.e. how improvisers deal with having initially different models about the platform, the characters, the setting, the current state of the story, etc.), referent use (i.e. how improvisers use improvisation domain knowledge and the constraints of the game, an improv scene with rules that constrains the performance either in terms of rules of performance and / or scene content, they are playing to guide their decisions), and cognitive workload (i.e. how the real-time constraints of improvisation affect cognition). This paper presents our initial findings on a specific set of our data that is likely the most relevant to creating improvisational intelligent agents: narrative development. Section 2 discusses the related work in improvisation research and believable agents. Section 3 presents our experimental design for studying human improvisers. Section 4 introduces our synthesis of existing narratology concepts and our findings in improvisation. Section 5 describes our current findings. Finally, Section 6 discusses the limitations of our findings, as well as future work.

## 2   Related Work

### 2.1   Improvisation Research

The current body of research on improvisation, which most notably comes from the improvisational music domain, points to the following generalities:

Improvisation is a constant process of receiving new inputs and producing new outputs [9], [10]. Improvisational dance, theatre, music, etc. all depend on performers observing their own and other performers' actions, performing some quick deliberative process, and then selecting new actions to perform. Strategies for visual and auditory attention, deliberation on inputs, and the heuristics used for selecting actions are unclear in any domain. An improvisational model must be able to process and interpret these inputs as knowledge involved in the decision-making process.

Improvisation is a "continuous and serial process" [4], [5] as opposed to one that is "discontinuous and involving iteration," such as music composition [3]. This suggests that there are specific cognitive processes that are employed during improvisation that are either (a) different from those used during non-improvisational acts, or (b) employed with different constraints than those used during non-improvisational acts.

Improvisation is a process of severely constrained human information processing and action [10], [11], [12]. As Pressing [9] points out, an improviser must, in

real-time, optimally allocate attention, interpret events, make decisions about current and future actions, predict the actions of others, store and recall memory elements, correct errors, control physical movements, and integrate these processes seamlessly into a performance. How this view of cognitive constraints maps on to the theatre improv domain has yet to be shown.

## 2.2  Improvisation in Interactive Narrative

There have been a few attempts to create virtual improvisational theatre systems. The Computer-Animated Improvisational Theater (CAIT) is an interactive theatre system that allows children to control avatars in a virtual world in which intelligent animated agents improvise playtime activities [7], [13]. The intelligent animated agents reactively follow the *broad but shallow* reasoning philosophy, which aims to produce agents that appear intelligent in the short term without delving deeply into theories of cognition [14]. Without such a formal theory or cognitive model of creativity and improvisation, the CAIT agents are limited to only executing task sequences that were pre-authored by the system developers. That is, any variability in agent performances is due to responses to the human interactor.

The Improv system [8] is a system in which virtual animated avatars can be scripted to enact a scenario. The Improv system emphasizes variability at the surface level of the presentation – the exact positioning, movements, and gestures of avatars in a virtual graphical environment – by introducing noise to produce natural-looking variability. Hayes-Roth and van Gent [13] combined the Improv system and CAIT to produce a non-interactive scenario about a master and servant that can play out three different ways depending on the setting of personality traits for the master and servant roles.

A field of work that is similar in many ways to computational theatre systems is the domain of interactive story research [15], [16], [17]. Interactive story systems attempt to tell a story in which the user is an interactive participant and is able to perform actions or make choices that impact the direction and/or outcome of the story. Swartjes' investigation into improvisation noted several improvisation techniques for developing narrative (such as making, interpreting, and accepting offers) [6]. His work surveyed the possibility of implementing improvisation theory, as opposed to studying real life improvisers, into emergent narrative systems. In Swartjes' conclusion, he observes that future work will focus on developing and implementing an architecture that uses improvisation techniques [6].

Many, but not all, interactive story systems create experiences procedurally by simulating a virtual environment populated by autonomous agents that enact the roles of characters. Most researchers in the area of interactive story have not attempted to reproduce improvisational theatre. These systems employ, to varying degrees, attempts to create the appearance of intelligent activity without modeling improvisation or creativity. Interactive story systems, for both entertainment and training, have taken steps towards giving the appearance of believable improvisational performances without the benefit of a deep understanding as to how expert humans perform the same tasks.

# 3  Experimental Method

We conducted a series of experimental sessions from 2008 to 2009 in order to extract cognitive data from human improvisers in a theatrical setting. Our purpose was to better understand how improvisers construct narrative as an improvisational task, the decision-making process they employ, and information about group dynamics in this domain. The research participants were recruited from a pool of four local improv troupes ranging in experience from novice to expert.

*Retrospective protocol collection* involves having the participants perform a given improv task (e.g. being given an improv "game" and a pre-determined set of suggestions for the scene) while we videotape the performance, and then immediately showing the video recording to each of the participants in different interview rooms. Interviewers have the role of prompting participants to continuously comment on what they recall about their thought process during what is transpiring on screen. The purpose of this is to try to elicit procedural and semantic knowledge that was being employed while they were on stage. While retrospective data has several limitations, an extensive and rigorous process of experimentation and prototyping led to this decision. Since data is impossible to get *during* the performance, a retrospective technique is the most appropriate (though noisy) means of collecting cognitive data.

The *group interview* is conducted after all of the individual protocol collections are completed. The participants as a group review the performance again with a group interviewer present. They are prompted to discuss any possible states of confusion that they had as individuals, what each was thinking that the other was trying to accomplish, etc. The goal of the group interview is to uncover issues in group dynamics, consensus building techniques, and any surprises that may have not been obvious from the individual interviews alone.

During our data analysis, we found that the decision-making process involved in improvisation mapped well onto the decision cycle posited in Newell's. This has lead us to both a bottom up (data-driven) and top down (applying Newell's Unified Theory of Cognition) analysis of our data, using language and structure from the UTC to provide a framework for organizing and explaining our findings [22]. Improvisers receive new *inputs*, *elaborate* new knowledge based on what they have observed and already know, *propose* actions to take, *select* one of those actions, and then *execute* the selected action. We have compacted this cycle for presentation in this paper into *input*, *creation*, *selection*, and *execution*. Presenting our data within this framework allows us to organically situate our data within the constraints of a long-standing cognitive architecture. This bodes well for both a verification of the data we have collected (i.e. if it did *not* match onto this decision cycle – or the workings of other high level cognitive theories – then our data may be faulty or too noisy) as well as for the future implementation of our theory in a synthetic character in the SOAR architecture.

# 4  Narrative Theory and Improvisation

We have surveyed various narrative sources to arrive at an appropriate vocabulary for describing narrative development in improvisational theatre. It is important to ground our analysis both in terms of what has been observed of narrative structures in related

domains (typically literary and film narrative theory) and in what we observe impro-
visers doing in our collected data. The following is a synthesis of narrative theories as
they relate to our findings, providing a useful and empirically based vocabulary to
describe our findings.

A simple and concise definition of narrative is as a *story*, which is what is in a nar-
rative (the content), plus its *discourse* (how that story is related to an audience) [18].
Chatman's definition was selected because it synthesizes Anglo-American, Russian,
and French theories of narrative and his own definitions that have been widely influ-
ential on narrative theory. A narrative's story consists of *existents* and *events*, while
its discourse consists of the narrative's *manifestation* and the story *structure*. Figure 1
visually represents the information we examine further below.

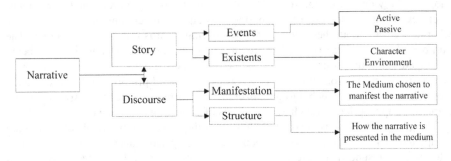

**Fig. 1.** Narrative and its Constituents

## 4.1 Story

Story can be broken down into its *existents* and *events*. Existents are characters, set-
tings, and everything that exists within the world of the story. *Character* can be de-
scribed as the sum of a character's traits, and is verisimilar in nature. *Setting* is a
physical place and the objects within it [18]. For example, "Heathcliff" is a character
in the book *Wuthering Heights*, and "Wuthering Heights" is a location in that book.
Therefore, both Heathcliff and Wuthering Heights are existents within the narrative
*Wuthering Heights*. Existents in improvisational theatre are generated within a scene,
and their use and construction is a focus of our research. Events, the second story
element, are what occur within a narrative. Ryan proposes terminology that matches
our data: *active* and *passive events* [19]. Active events are occurrences that signifi-
cantly alter the state of the scene. Alternatively, passive events do not significantly
alter the state of the scene.

As both our research and Ryan point out, the goal in performing an event does not
always affect the state of the scene (defined as "the condition of a system (or part
thereof) at a given point of operation; a set of elements characterized by a number of
properties and relations at a given time; a situation" [20]) as desired. In other words,
an action that could be intended to affect the scene could wind up having no effect
and vice versa. Therefore, we recorded both the performers' reported intentions to
affect the scene and the actual result of their actions based on our observations.

## 4.2 Discourse

Narrative's other main element, discourse, is derived from its *manifestation* and *structure*. The manifestation is the medium used (e.g. books, ballet, cinema, etc.), and its elements vary from art to art. A narrative's structure is a connected set of narrative statements that relate the story, the order of situations and events, the speed of narration, etc. [18]. The cinematic media is structured by shots. In the film *Citizen Kane*, for example, the flashback to Kane's childhood uses a long depth of field structure to allow focus on Kane, his parents, and Walter Thatcher. The shot is a long take that maintains focus on all of the characters. This scene could have been broken into shots focusing on the individual actors, while still having the same dialogue. The substance of the discourse would have been the same, but the structure would have been different. Therefore, it is the discourse that determines how the states and events are portrayed and ordered.

In dramatic theatre, the discourse is derived from the dramatic text. This indicates who should speak in turn, who should move where, etc. Improvisational theatre lacks a dramatic text, so its equivalent must be created and developed ad hoc by the improvisers on stage. This involves a rapid intake and processing of data [21]. During an improvisational performance, the narrative is being created while simultaneously being executed by its discourse. This is further explained in section 5.1.

# 5 Current Empirical Findings

This section explains how the narrative terminology described in section 4 is adapted to encoding the improvisation performances. Then it discusses how that information is mapped onto the Newell Decision Cycle.

## 5.1 Narrative on Stage

As described in Section 4.1, the first narrative theory to be mapped is story's concept of existents. Existents are broken into their major components of character and environment [18]. *Character* is broken down into a character's *traits* and *consistency*. Traits are the character's relationships (i.e. how that character relates to other characters), goals (i.e. what they wish to accomplish in both the long and short-term), history (i.e. past events that are revealed), and attributes (i.e. physical and mental qualities). In other words, traits are the aspects of that character that make them a unique person. Consistency is a matter of whether or not the character remains verisimilar within the narrative [18]. In one game, improviser D7 realizes that his character is an "I'm gonna play by the rules" person. When his character's friends begin speaking poorly of his wife he decides to defend her. D5 then says D7's wife is handsome. D7 later explained in the interview that,

> "D5 isn't necessarily trashing the woman, which I've already formed
> an opinion about that I love her and I think she's the most beautiful
> person in the world... He's kind of calling her ugly which I then say,
> are you calling her mannish?"

D7's attitude remains consistent, establishing verisimilitude for the character.

"Environment" is one of a few terms that improvisers use when describing the virtual space on stage. They describe environment in terms of the location (i.e. where the scene is supposed to take place, such as a museum), the objects (i.e. the nonliving objects within the location, such as a statue), attributes (i.e. the qualities of the location, such as cold), and consistency. Consistency is derived from what in the environment remains the same from moment to moment. For example, D7 pantomimes holding a bag of popcorn during one experimental run. The bag's apparent weight and size remain the same for the duration of the scene. This action maintains the consistency of the environment as a realistic/plausible location, as opposed to the audience's expectations perpetually being violated (e.g. the popcorn bag changing size for no reason or disappearing altogether – both of which are the types of errors that are more likely to occur in novice performances).

The other major narrative theory concept to address is discourse (see Section 4.2), which focuses on the structure and manifestation of the narrative. The manifestation, medium [20] used is improv theatre, but the structure of the narrative's events is simultaneously being generated as it is performed. The discourse of the narrative (and therefore how the content is communicated) is generated through *offers* [6]. An offer made by an improviser introduces an idea or possible progression to the scene (i.e. one improviser turns to another and says, "Check out that lion"; the first improviser is offering the idea of a lion being in the scene). In order to advance the state of the scene, improvisation is constructed through making, accepting, and rejecting offers. We have analyzed the data for active (i.e. intending an event to significantly alter the state of the scene) and passive intent (i.e. intending an event to not significantly alter the state of the scene) in the offers made, and whether they are accepted or rejected as events that alter the state of the scene. Our research has so far consistently displayed that for a scene to progress, the events that alter its state are active intent offers that are accepted. However, there are some incidents of intentions being misconstrued in their intent, or simply not observed. This data defaults to passive input and/or execution, because it does not attempt to actively develop the state of the scene.

## 5.2 An Improviser's Decision Cycle

The following is a deconstruction of an improviser's decision process based on our initial empirical findings. Character, environment, and intention are coded for each stage in the cycle (i.e. when the performers develop the scene in the ways explained in the previous section, that data is encoded).

### 5.2.1 Input
The first stage of the decision cycle in improvisation is an improviser's reception of input. As stated in Section 2.1, an improviser perpetually takes in audio and visual stimuli as the scene develops from other improvisers, the audience, or the improv game host [21]. Improvisers communicate knowledge about the character traits, environment traits, and intentions of their own characters or of others. For instance, E3 was endowed in one performance with the quality of wanting purple chiffon for a house by E2 saying that E3 had always wanted it. In this way, E2 gives E3 knowledge about her character and E3 accepts that to help define her character.

Figure 2 illustrates the basic acquisition of new information by an improviser. The knowledge encoded for includes character and environment aspects (the existents), event intention (discourse structure), audience input (whether they laugh, are silent, interested, or for some games if they give a suggestion for the scene), and assignment (the origin of an assigned quality, such as the game host). For example, in a game of Party Quirks one improviser enters the scene with his arms outstretched and lurching around – as if flying out of control. This is a useful input to the party host that allows him to internally elaborate a hypothesis about the guest's quirk of flight (a character trait).

**Fig. 2.** Input (*I*) of Knowledge (*K*) to the Performer (*P*)

### 5.2.2 Creation

*Creation* is the term we use to encompass the processes of elaborating new knowledge and internally proposing new actions to execute. Proposed events can develop the scene. This stage and the subsequent Selection stage take place entirely within a performer's head and can only be observed by examining the collected retrospective protocol data.

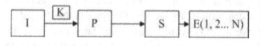

**Fig. 3.** The performer perceives the State of the Scene (*S*), and then mentally creates possible Events (*E(1,2... N)*) the performer could initiate

For example, C3 is given information about the scene she will be in while playing a game named *Game* (which is defined as "perform a scene" with either no constraints, a location and relationships given, or an entire plot given by the game host). She immediately begins to think of various possibilities for the scene, looking for inspiration in the assigned information from the game host. The knowledge elaborated is that they could see animals mating at the zoo. She decides to store that idea for later (this is encoded under creation as possible states (a potential situation that may arise in the scene)). When C2 comes onto the stage, C3 thinks, "Why am I not in the scene? Okay, I must have been walking around. That made me think map. Okay, I have a map in my hand. And so through that I knew my character wasn't very good at directions." C3 takes in the knowledge of the scene from the game host and her fellow improviser. She then examines the state of the scene in a process of interpretation (why am I not in the scene?) and then proposes possible events to affect the scene (Figure 3 for visual), environment traits, and/or character traits (e.g. the mating animals, walking around previously, having a map in hand as she enters, and being poor with directions).

### 5.2.3 Selection

The Selection stage consists of choosing and rejecting the actions proposed in the Creation stage. Figure 4 displays that after creating possible events the performer decides on a single one and rejects the others. The order of preference in selecting events seems to be first what would heighten the emotion of the scene (by accepting/making offers), then what would keep the scene going (avoiding silence). Experts have so far exhibited the ability to accept/make offers readily, as opposed to novices who tend to default to what would keep the scene going without advancement.

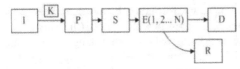

**Fig. 4.** One event is Decided (*D*) on and the others become Rejected (*R*)

The performers in one experimental run were given a very explicit plot to perform that would begin with friends meeting at a restaurant. During the course of the scene, it would be revealed that two of the characters were in a relationship; one of the two in the couple had previously been with the third; and the current couple would get up and leave, thus ending the scene. D6 takes in that information and decides to start the scene with a laugh. D6 later reported,

> "I didn't want to start the scene with us sitting down at the table and ordering, I wanted us to have been there a while... I wanted to start with a laugh as if we had just been having a good time. And then we could change the emotion from light-hearted and then get into the story."

D6 proposes two scenarios for the starting state of the scene in creation. Either they would be starting to eat dinner, or had been eating dinner for an unknown amount of time. His assumption is that a scene of dinner starting would be heavy on gossip and small talk. This would not heighten the emotion of the scene. D6 rejects this possibility and decides to laugh as an active event. This would transition the scene from its state before the start of the scene (talking and having a good time) to the current state of the scene (where the emotions become more negative and intense).

### 5.2.4 Execution

Execution is when the improviser performs the selected decision. For example, after D1 steps to the side, he waits for D2 and D3's conversation to stall. D1 decides it is the correct time to re-enter the scene, and says, "Scott, could I have a word with you for a second?" making an offer to D2. Figure 5 illustrates this output of information. Whether or not the active intent (to significantly alter the scene) of an executed action actually affects the state of the scene is derived from the acceptance of the other improvisers. In a game of Game, D3 enters the scene saying to D1, "Mr. Coffeeman, I have more muffins for you from homeland" with a pantomimed tray of muffins and her head down. In the scene, D1 and D2 had been talking about how the muffins were fair trade muffins and how it made them feel good.

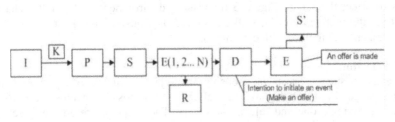

**Fig. 5.** Execution (*E*) of the decided event, in this case making an offer, leads to a new State of the Scene (*S'*)

D3 explained in her retrospective that their discussion had made her think of Starbucks and corporate coffee companies, so during the scene she decides to have the muffins be anything but fair trade, wanting to be a "low-status" character. D1 accepts this offer of status by rolling his eyes and sighing, "She's annoying." D1 explained in his interview, "D3 comes in with this great offer to me that we're ostensibly caring and politically aware, but actually in truth we're subjugating people still." Figure 6 displays this exchange of making and accepting offers.

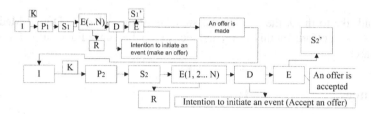

**Fig. 6.** The Decision Cycle of one offer being made (depicted in Figure 5), becomes input and then that offer is accepted after a decision cycle

## 6  Discussion

The analysis presented in this paper is an attempt at describing how contemporary narrative theory can be used to describe how improvisers develop narratives on stage and the decision cycle used (within the scope we are considering) to improvise a story. When analyzing the collected video data, we began with an initial top-down hypothesis of categories for how to look at the data (e.g. cognition, model convergence, narrative development, etc.), built a refined coding scheme for a particular one (narrative development), and are now tasked with understanding how our single scheme can be synthesized with other data dimensions (e.g. model convergence) to construct a larger, more complete coding scheme. For instance, the decisions that improvisers make about story progression very likely has something to do with the knowledge they think the other improvisers have (cognition), whether or not everyone on stage is clear on what is happening in the story (model convergence), etc.

We have admittedly ignored certain aspects of improvisation, such as linguistic production or body language, because of the difficulty in modeling them computationally. Since the goal is the creation of improvisational intelligent agents, we have eschewed attempting to analyze certain aspects of performance with the hope that, once we have reached an understanding of the core areas selected, these other, more difficult, aspects of improvisation may be easier to analyze and formally encode. Understanding the appropriate level of abstraction to examine these more difficult aspects, such as linguistic production, will be an important task in itself.

Future work will focus on reaching a deeper understanding of what is reported here (e.g. doing a novice/expert comparison of how improvisers develop a narrative) and on synthesizing this work within the larger desired cognitive framework (i.e. combining these findings with analyses of improviser cognition, model convergence, etc.). The result will be a cognitive model of human improvisation that incorporates these different elements into a single, unified framework. Since the decision cycle we have

observed in narrative development (and in the other categories of data analysis as well) matches closely with that in the SOAR cognitive architecture, we plan to analyze what out of our findings can be formally represented in an intelligent agent, and creative improvisational agents in SOAR that can improvise across a variety of improv games.

## Acknowledgements

We would like to thank the faculty and students of the Adaptive Digital Media Lab for their tireless efforts on this work, and the National Science Foundation for funding this research.

## References

1. Johnstone, K.: Impro: Improvisation and the Theatre. Routledge / Theatre Arts, New York (1981)
2. Close, D., Halpern, C., Johson, K.: Truth in Comedy. Meriwether Publishing Ltd., Colorado (1994)
3. Sarath, E.: A New Look at Improvisation. Journal of Music Theory 40(1), 1–38 (1996)
4. Mendonça, D., Wallace, W.: Cognition in Jazz Performance: An Exploratory Study. In: Forbus, K., Gentner, D., Regier, T. (eds.) Proc. 26th CogSci. Lawrence Erlbaum Associates, Inc., Mahwah (2004)
5. Mendonça, D., Wallace, W.: A Cognitive Model of Improvisation in Emergency Management. IEEE Transactions on Systems, Man and Cybernetics – Part A: Systems and Humans 37(4), 547–561 (2007)
6. Swartjes, I., Vromen, J.: Emergent Story Generation: Lessons from Improvisational Theatre. In: AAAI Fall Symposium on Intelligent Narrative Technologies, pp. 9–11. AAAI Press, Menlo Park (2007)
7. Hayes-Roth, B., Sincoff, E., Brownston, L., Huard, R., Lent, B.: Directed Improvisation. Technical Report KSL-94-61, Knowledge Systems Laboratory. Stanford University, CA (1994)
8. Perlin, K., Goldberg, A.: Improv: A System for Scripting Interactive Actors in Virtual Worlds. In: Fujii, J. (ed.) 23rd SIGGRAPH, pp. 205–216. ACM Press, New York (1996)
9. Pressing, J.: Psychological Constraints on Improvisation. In: Nettl, B., Russell, M. (eds.) The Course of Performance, Studies in the World of Musical Improvisation, pp. 47–67. University of Chicago Press, Berkeley (1998)
10. Reinholdsson, R.: Making Music Together: An Interactionist Perspective on Small-Group Performance in Jazz. Acta Universitatis Upsaliensis: Studia Musicologica Upsaliensia, Nova Series 14, Uppsala University (1998)
11. Weick, K.E.: Introductory Essay: Improvisation as a Mindset for Organizational Analysis. Organization Science 9(5), 543–555 (1998)
12. Yokochi, S., Okada, T.: Creative Cognitive Process of Art Making: A Field Study of a Traditional Chinese Ink Painter. Creativity Research Journal 17(2&3), 241–255 (2005)
13. Hayes-Roth, B., van Gent, R.: Story-Making with Improvisational Puppets and Actors. Technical Report KSL-96-09, Knowledge Systems Laboratory, Stanford University. Stanford University, Palo Alto (1996)

14. Bates, J., Loyall, A.B., Reilly, W.S.: Broad Agents. In: Proc. AAAI Spring Symposium on Integrated Intelligent Architectures, SIGART Bulletin 2(4), 38–40 (1991)

15. Aylett, R., Louchart, S., Dias, J., Paiva, A.: FearNot! - An Experiment in Emergent Narrative. In: Panayiotopoulos, T., Gratch, J., Aylett, R.S., Ballin, D., Olivier, P., Rist, T. (eds.) IVA 2005. LNCS (LNAI), vol. 3661, pp. 305–316. Springer, Heidelberg (2005)

16. Riedl, M.O., Stern, A.: Believable Agents and Intelligent Story Adaptation for Interactive Storytelling. In: Göbel, S., Malkewitz, R., Iurgel, I. (eds.) TIDSE 2006. LNCS, vol. 4326, pp. 1–12. Springer, Heidelberg (2006)

17. Young, R.M., Riedl, M.O., Branly, M., Jhala, A., Martin, R.J., Saretto, C.J.: An Architecture for Integrating Plan-based Behavior Generation with Interactive Game Environments. Journal of Game Development 1, 51–70 (2004)

18. Chatman, S.: Story and Discourse: Narrative Structure in Fiction and Film. Cornell University Press, Ithaca (1980)

19. Ryan, M.: Possible Worlds, Artificial Intelligence, and Narrative Theory. Indiana University Press, Bloomington (1991)

20. Prince, G.: Dictionary of Narratology. University of Nebraska Press, Nebraska (2003)

21. Pressing, J.: Improvisation: Methods and Models. In: Sloboda, J. (ed.) Generative Processes in Music, pp. 129–178. Oxford University Press, New York (2005)

22. Newell, A.: Unified Theories of Cognition. Harvard University Press, Cambridge (1990)

# The Narrative-Communication Structure in Interactive Narrative Works

Udi Ben-Arie

Department of Film and TV,
The Yolanda and David Katz Faculty of the Arts,
Tel Aviv University
Ramat Aviv, Tel Aviv-Yaffo, Israel
udiben@post.tau.ac.il

**Abstract.** Interactive work on new media platforms differs from familiar work on more traditional media, such as literature, theatre, cinema and television, in terms of their narrative-communication situation. Interactive works, unlike cinematic works, allow the viewer to participate to a different extent, involving a reciprocal communication process. In this paper I propose a bi-directional communication structure for interactive storytelling systems, based on narratology theory and communication film theory. I adapt existing narrative-communication models of conventional media, mainly those of Seymour Chatman and Vivian Sobchack, to suggest a detailed narrative-communication model for interactive storytelling systems, which would facilitate the formulation of a better definition of the various constituent elements of interactive storytelling communication, and the functions they fulfill.

**Keywords:** Interactive Narrative, Narrative-Communication, Interactive Storytelling Systems, Narrative Theory.

## 1 Introduction

Interactive narrative work on new media platforms combines an authored narrative text, a storytelling system and a communication process between author, work and participant. Part of the analysis and discussion of interactive storytelling systems relies on narratology theories. Marc Cavazza and David Pizzi [1] reviewed the main narrative theories that have been used to analyze and formulate interactive storytelling systems: Aristotelian (Aristotle), formalist (Propp), semiotic-linguistic (Greimas), semiotics (Barthes), and character centric (Bremond). To these, I would like to add the cognitive film theory approach (Carroll, Bordwell). Interactive storytelling research that used those theories concentrated more on the text itself, i.e. the structure of interactive storytelling systems and interactive narrative paradigm, and less on the participant's role and its influence on the narrative-communication process. My goal in this paper is to describe the narrative-communication process and the reciprocal course of action between the participant and the interactive narrative, in order to facilitate a better implementation of narrative theories in interactive storytelling research.

I.A. Iurgel, N. Zagalo, and P. Petta (Eds.): ICIDS 2009, LNCS 5915, pp. 152–162, 2009.

Interactive storytelling systems are immanently authored texts that address an audience, though they differ from familiar work on more traditional media, such as literature, theatre, cinema and television, in terms of their narrative-communication situation. By narrative-communication situation, I refer to the model (see Fig. 1) offered by Seymour Chatman [2, p. 151].

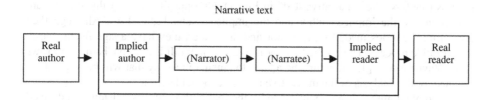

Fig. 1. Narrative-communication situation model[1]

The conventional media communication is uni-directional, and characterized by the author's exclusive control over the narrative, while the viewer has no active part in the events taking place and does not affect the course of the work, although it is he or she who provides the work with meaning. Contrarily, in digital interactive works the viewer becomes a participant, and consequently the narrative itself is dependent on the viewer's participation. Thus, the traditional mediation process of the story presentation is broken, and a bi-directional communication situation is created. This bi-directional communication has distinctive rules and characteristics, different from those of the communication situation in conventional works. In this communication situation the participant becomes an agent, able to choose whether to influence the discourse or story, in various levels and degrees of power.

Joshua Tanenbaum and Karen Tanenbaum [3] perceive interactive storytelling systems as a communication channel between the author and the participant, and concentrate on the communication between interactors. They conceive of "a new formulation of the notion of agency, by shifting the concept of the reader from a player-centric model to a performer-centric model". They point out a distinction between two conflicting notions of interactors: "Performer" and "Player". I agree that, as they have suggested, the first step is to think about the communication process and to "focus on how *the author* and *the reader* communicate with each other via a computational medium." [3].

The main issue of this paper is to develop a communication model for interactive storytelling systems, which would facilitate the formulation of a better definition to the various constituent elements involved in the interactive storytelling systems communication process, and the functions they fulfill.

## 2 Chatman's and Sobchak's Narrative-Communication Model

Both Seymour Chatman and Vivian Sobchack suggest narrative-communication models, Chatman from a narratological perspective and Sobchack from a phenomenological

---

[1] In 1990 Chatman refined his theoretical model, and added to the above diagram a box named "Story", right after the "Narrator" and before the "Narratee" [6, p. 151].

perspective. Those communication theories of conventional media provide me with the foundation for developing a communication model for interactive works. Chatman states that "every narrative is a structure with a content plane (called "story") and an expression plane (called "discourse")" [2]. He argues that narrative is a communication situation that the real author initiates by creating the text and that is intended to reach the real reader (see Fig. 1). In between these two elements Chatman portrays a narrative process (the box titled "narrative text" in Fig. 1). On opposite sides of this process are two elements: the implied author and the implied reader [2, p. 146]. Although they are "virtual" entities made by the author and the reader, they have a significant role in the narrative process. The implied author is a key element. It is a term Chatman borrows from Wayne Booth [4] and which he adapts to cinema in a way that will be of great assistance for the analysis of the interactive narrative model later on.

The implied author is an agent made by the real author, but its existence is derived from two elements: the creative work of the real author and the meaning the real reader gives to it. It is an agent that is responsible for the overall design of the narrative including who tells the story and how. The implied author is being formulated by the author, whereas the reader reconstructs it from the comprehension of the narrative.

The implied author does not have a voice. It can not tell anything. In order to tell the story, it needs the narrator. Chatman [6] refines his theoretical model and his analysis of the narrator in a way that gives better definition to broader cinematic situations. He argues that the narrative can be presented by an agent who is not obliged to be human. He suggests the notion of a presenter instead of a narrator, which includes two options: telling and showing. Both are cinematic methods of transmitting the story. "Thus we can say that the implied author presents the story through a tell-er or a show-er or some combination of both." [6, p.113]. In general, presenting through a "tell-er" requires a voice (it can be a character) that tells the story, while presenting through a "show-er" proceeds through images and sound (or enacted narration). Chatman also relates to the influence of technological developments: "Once we allow the possibility of showing a narrative, we perforce recognize the existence of a show-er, even if not a human one. In this age of mechanical and electronic production and reproduction, of "smart" machines, it would be naive to reject the notion of non human narrative agency." [6, p.116].

The implied author's counterpart in the narrative-communication situation is the implied reader. Both are immanent to the narrative. They will always take part in the communication situation. The implied reader represents the audience as the narrative assumes it. Just as the implied author uses a presenter to convey the narrative, the implied reader can use a narratee. One way the narratee can be expressed is as a character in the story. Chatman calls that a narratee-character, an element that simulates the implied reader, in order to direct the real reader and instruct him on how to perform as implied reader in the narrative process.

Vivian Sobchack [5] referred to the film experience as a communicative process involving three elements: filmmaker, film and spectator. The film experience is a dialogue between the creator and the spectator, mediated by the work and in which the viewer has an active part. Sobchak stressed that this communication is not symmetrical. The filmmaker directs the spectator's attention and perception towards a final goal, at which the filmmaker is aiming.

The insights of Sobchack and Chatman regarding the communicative process provide me with a key starting point for an examination of the relationship between the author, the work and the participant in an interactive work. I expand Chatman's uni-directional communication model [2, 6] and propose a new bi-directional communication model, one that is adapted for works which involve the participant. Prior to analyzing the bi-directional communication process, I distinguish between two different communication processes that occur in interactive narrative works: a local communication process and a global communication process.

## 2.1   Local / Global Communication Processes

The basis for the local/global distinction comes both from the study of traditional cinematic spectatorship, particularly the work of cognitive film theorist Noel Carroll [7] and from authors dealing directly with interactive storytelling, such as Janet Murray [8] and Michael Mateas and Andrew Stern [9]. Carroll, proposing the notion of erotetic narration, argues that there are two types of questions which the viewer of a popular movie would pose: macro-questions and micro-questions [9, p. 170-177]. Similarly, following Murray's definition of agency [8], Mateas and Stern distinguish between two types of agency, local and global [9].

My assumption is that those analyses indicate that both from the narrative aspect (Carroll) [7] as well as the interactive experience aspect (Murray) [8] (Mateas & Stern) [9] the communication situation in interactive works is divided in to two sets of communication processes - local and global. These communication processes differ with respect to the extent of their effect and with respect to their ability to influence the narrative. The local communication process occurs immediately following the participant's intervention. Its extent of effect is short and does not include a narrative aspect. The global communication process also commences as a result of the participant's intervention, it can occur immediately following the intervention but also a long while afterwards. The extent of its effect is noticeable for a long period of time and its main effect is on the narrative.

In this paper I focus on the global bi-directional communication process and the participant's role as part of that communication, since I aim to analyze the interactive narrative which comes to fruition more prominently in the global bi-directional communication process.

# 3   A Bi-directional Communication Model

Chatman's [2] uni-directional communication model can be drawn on to analyze the communication in interactive works. However, interactive works, unlike cinematic works, involve a circular communication process that progresses from the author through the work to viewer/participant and back to the work. The viewer can react and thus start a communication process on the return track. The new role of the viewer who becomes a participant creates a bi-directional communication process. I propose to divide the global communication process into two communicational phases: *Initiating interaction phase - IIP* and *returning interaction phase - RIP*.

## 3.1  The Initiating Interaction Phase - IIP

The bi-directional communication process (see Fig. 2) begins from the *real author* who is responsible for creating the interactive work. In continuation to Sobchack's insights, the *real author* is in charge of directing the participant's perception towards a final goal; the *real author* uses the medium aesthetic language and interactive tools. The *real author* creates the diegetic world, the narrative, the story and the discourse framework. At the same time, the *real author* also designs the ways in which the discourse will present the story in an interactive method. This includes the design of the interface and the manner in which the work can conduct an independent, continuous bi-directional communication with the participant. The *real author* creates the communication process and initiates it, but in most cases, from the moment the work is played, the author does not participate in the bi-directional communication process.

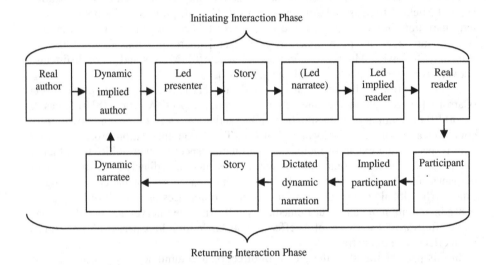

Fig. 2. Global Bi-Directional Communication Process

After the *real author's* creative work is done and the work starts playing, the initiating interaction phase continues with the *dynamic implied author*. This phase ends with the *real reader*. Once the *real reader* has intervened and has thus become a participant, a *returning interaction phase* commences until it reaches the *dynamic narratee*. The communication then proceeds back to the *dynamic implied author*. Thus, the bi-directional circle of the communications process reaches its starting point, and so forth. It is important to state that should the viewer not intervene, she or he functions as a *real reader*, and the *returning interaction phase* does not come into play.

The real author, through the *dynamic implied author*, directs the participant's experience. However, while Chatman's cinematic *implied author* is the principle that guides all the narrative elements according to the *real author's* artistic choices, in interactive works the *dynamic implied author* guides the narrative elements according to an integration of three factors: 1) The real author's design choices, both narrative

authoring and interaction design, 2) The narrative engine selection taking place in real time, that composed amongst others from the algorithms which the *real author* configured, 3) the choices or actions which the participant makes. The two last factors are the reason that the *implied author* is *dynamic*, since the discourse changes in respect to the participant intervention and the narrative engine data processing.

The *implied author*, as Chatman stated, needs the presenter in order to tell or show the story. In interactive works, the *dynamic implied author* presents the story through the *led presenter*. The presenter is led because it is not independent. The *dynamic implied author* directs the *led presenter,* in which manner the story is presented. In every cycle of the communication the *dynamic implied author* can direct the *led presenter* to change the manner of presentation, according to entire sets of factors, including story, discourse, the participant's current position in the narrative flow, the participant's actions and the selected manner in which the narrative is about to unfold.

When the *led presenter* tells the story, there is a *led narratee* as its counterpart, who comes to aid and guide the *led implied reader*. Mateas's *subjective avatar* [10] describes an intelligent computerized agent which functions as a *led narratee*. The *subjective avatar* has autonomic emotion reaction to the events in the story world, as well as the ability to track the discourse. As Mateas stated "the emotional state and story context are used to provide subjective descriptions of sensory information. The purpose of such descriptions is to help a user gain a deeper understanding of the role they are playing in the story world." [10, p. 12].

The *led implied reader* is not the *real reader*, but rather the audience as the narrative assumes it beforehand. Regarding the narrative in interactive storytelling systems, as was stated before, the way the story might be presented is affected by a set of considerations which combine the narrative engine's data processing and the participant's intervention. Therefore, the *led implied reader* is more complicated to comprehend, operating the way that the narrative engine algorithm would assume in advance that it would. This means that the *real author* should take into consideration the *led implied reader* when designing the narrative engine and the interface configuration.

In *Façade* [12] created by Mateas and Stern, the *led presenter* isn't a narrator, or in Chatman [6] words a "tell-er". The *dynamic implied author*, in the *Initiating interaction phase*, presents the story through a "show-er", the two protagonists - Grace and Trip. *Façade* begin with a black screen, and Trip leaving a voice message on an answering machine. The voice message invites the participant to meet Trip and Grace in their apartment. Then, after the voice message ends, the participant sees a first person point of view of a stairwell landing. The *dynamic implied author* will maintain this interface perspective throughout the entire work. In front, the participant sees Grace and Trip's apartment door. Behind the participant's POV is the elevator door. From this point on, the participant can navigate freely. In the background, a dim conversation is heard, and upon moving forward the participant starts to hear an argument between a man and a woman. Moving farther, toward the door, an icon of a hand appears on the screen, indicating that the participant can knock. Trip opens the door and invites the participant to come inside. Knowing that the participant can move freely, the authors Mateas and Stern use different methods in order to direct the participant's intervention. One method was discussed before, the *subjective avatar* that performs as *led narratee*. Another method is using Grace and Trip as *led narratee-characters*, their argument draws the participant's attention closer to the door. Eventually, out of

curiosity, s/he will knock on the door. Later on, the participant may converse with Grace and Trip, which makes their function as *led narratee-characters* more complicated to execute. Grace and Trip perform at the *Initiating interaction phase* as *led presenter, led narratee-characters*, and at the *returning interaction phase* as *dynamic narratee-characters*.

## 3.2  The Returning Interaction Phase - RIP

The *real reader* completes the *Initiating interaction phase*. When the *real reader* intervenes she or he motivates the *returning interaction phase*, a communication phase that begins with the participant and goes back to the *dynamic implied author*. There are similarities between the two phases. At the beginning of the *returning interaction phase* the participant is the sender, while the *dynamic implied author* is the recipient. The change of direction of the communication causes a switching of the roles: The participant fills a similar role, but not identical, to that of the *dynamic implied author*. The participant needs to decide how to respond, he becomes the author of the response. However, the participant's authority and the range of intervention options are different from those of the *real author* and the *dynamic implied author*, since the participant's authority is constrained to within the limits which the *real author* had set in place and which the *dynamic implied author* now directs. The range of the participant's options for intervention can exist within different levels of restriction, and vary between two poles: on the one end, the intervention range can be very restricted, so that the participant is redirected to a limited number of choices; while on the other end, the participant gets an unlimited intervention range, which provides the participant with equal choices to those of the *real author*. As far as I know, for the meantime, the second situation is only theoretical. The nearest portrayal has been in films like *Star Trek Voyager's* "Holodeck" [8] but no such work has been created. In most works the participant's ability to intervene is confined within a framework that the *dynamic implied author* sets for her or him.

When about to intervene, the participant takes on a 'character' she or he is going to portray. The *real author* directs the participant to take on a certain 'character' by using different tools (e.g. narrative, drama, interface), and through different entities (e.g. *dynamic implied author, Led narratee, dictated dynamic narration, Dynamic narratee*). Occasionally the participant takes on a 'character' that acts differently from the way s/he acts in real life. Then the participant's intervention is expressed, amongst others, through a choice of action - such as navigating (*Myst* [11], *Façade* [12], *Grand Theft Auto*[13]); shoot them up (*Max Payne* [14], *Grand Theft Auto*[13]); pressing icons or hot spots, opening a door or an envelope (*Lost Experience* [15], *Myst* [11], *Grandad* [16]); arranging icons (*anyfilms.net* [17]); physical intervention (*Jumping Rope* [18], *Counterface* [19]); or through choice of response – by language dialog (*Façade* [12]); gestures, touching diegetic characters (*Façade* [12], *One Measure of Happiness* [20]); tangible user interfaces (*Office Voodoo* [21]); and more. These choices of action manipulate and constrain the participant's intervention through *the implied participant*, the *dictated dynamic narration*, and the *dynamic narratee*.

The *implied participant* is an agent that is made by the participant, but its existence is derived from two elements: the 'character' or 'manner of conduct' the participant set to himself as a guidance for his responses, and the framework that were set by the

*dynamic implied author*. This points out the difference between the two agents involved in the bi-directional communication process, while the *dynamic implied author* guides all narrative elements and is driven by the author's creativity, the *implied participant* is a hybrid of the real author on the one hand and the participant on the other.

The *dictated dynamic narration* is responsible for managing and executing the *dynamic implied author's* directions, in practice. It guides and sets the range of the participant's intervention options according to the framework that the *dynamic implied author* has set. Thus, the participant's range of intervention doesn't provide unlimited power to tell any story. Rather, the range of intervention is bound to the dynamic narration framework. David Bordwell [22] defines narration as a process in which the discourse *(Syuzhet)* and style operate together in order to direct the viewer to construct a story *(Fabula)*. In interactive storytelling systems, the *dictated dynamic narration* provides the participant with a canalized, sometimes predetermined, set of discourse and style options, which the participant chooses from, via the *dynamic narratee*, according to the story he or she constructed.

In various interactive works, the participant can communicate with the diegetic characters. Such characters fulfill the role of a *dynamic narratee-character*, and are usually the same character that functions as the *led narratee-character*. Sometimes they are the ones who initiate the conversation in the *Initiating interaction phase* (like the protagonists, Grace and Trip, in *Façade* [12]). However, in most works there is no *led narratee-character* with whom we could communicate. In those works, the interface itself performs as a *dynamic narratee*. The grid and icons in *anyfilms.net* [17] are an example of that.

The interactive drama *anyfilms.net* [17] has a custom-made interface. The participant needs to place four icons onto a two dimensional grid. The horizontal axis is represented by a symbol of a man on its left pole, and a symbol of a woman on its right pole. The vertical axis is represented by an exclamation mark (!) at its bottom pole, and a question mark (?) at its upper pole. The participant selects four icons from the six that are available. The position of the icons in the grid influences the discourse that will be presented in the movie clip, by: 1) selecting the video clips that will be presented from the totality of story materials and 2) the order of the video clips that were selected. The interface, composed of the grid and icons, is the *dynamic narratee* that receives the input from the participant, and passes it on to the *dynamic implied author*.

In *Façade* [12] the participant is supposed to play Grace and Trip's friend. The participant is part of the drama. Therefore, the *dynamic narratee* interface complements the experience by providing a first person perspective, free navigation and the ability to move objects. To make the experience complete, Grace and Trip also function as *dynamic narratee-characters*. The participant can communicate with them by touching (caressing, hugging, kissing) and by typing messages. When, for instance, the participant chooses to hug one of the characters, it will lead to immediate physical reaction - a local communication process. Should the hug happen during or after a narrative development, such as when Grace implies that her relations with Trip are fragile, it could then lead to narrative influence, such as a verbal reaction from Grace, or Trip, or both. This kind of reaction goes beyond the immediate physical reaction. It is part of the global communication process, with substantial influence on the narrative.

The communication circle is now complete, it returns back to the *dynamic implied author*. I argue that at this point, the central role of the *dynamic implied author* comes to the fore, since, at this stage, the *dynamic implied author* functions to determine the discourse's continuation in respect to the participant's reactions. This process is usually automated. The narrative engine (as part of the *dynamic implied author*) determines the next narrative fragment to be presented, the implications on the global narrative's unfolding (if necessary), the formal and stylistic changes needed (if necessary), and the resulting *Narrator's Voice*.

### 3.3  The Narrator's Voice and the Participant's Voice

The *Narrator's Voice*, as defined by Chatman [2], refers to narrative works in conventional media, in which communication is uni-directional. I argue that in interactive works where the communication is bi-directional there are two voices, the *Narrator's Voice*, which manifests itself in the *initiating interaction phase*, and the *participant's voice*, a new element, which comes into being following the intervention of the participant in the *returning interaction phase*. The *participant's voice* is part of the dynamic communication process that is affected by three factors: story, discourse and the participant actions.

The participant's voice comprises two aspects: the participant's confined graphical point of view (interface aspect) and the participant's dictated narrative position (narrative aspect). The participant's confined graphical point of view (i.e. confined GPOV) describes the manner in which the *real author* designed the interface and the manner in which the participant is directed to experience the work and respond to it. When the work is screened and the participant comes into contact with the work, the *dynamic implied author* is responsible for managing and selecting the participant's confined GPOV. Following Chatman [2] and Murray [8] I divided this graphical point of view into three possible perspectives: first person – perception (Perceptual POV) e.g. *Façade* [12]; second person – conception (Conceptual POV) e.g. *Lost Experience* [15]; third person – transferred interest (Interest POV) e.g. *Anyfilms.net* [17]. The participant's dictated narrative position can be mediated by one or more of the three perspectives of the participant's confined GPOV.

In *Façade* [12] the participant's voice is the same throughout the entire work. This is consistent with the conceptual approach guiding Mateas and Stern, according to which, interactive work should follow neo-Aristotelian principles. Accordingly, *Façade* takes place solely in the protagonist's apartment (unity of place), the drama occurs in one meeting (unity of time) and only three characters participate in it – Grace, Trip and the participant. The principal of unity is not only maintained from the dramatic aspect, but also from the interactive aspect. The participant's voice would not deviate from first person perspective, from the interface and narrative aspects. The confined GPOV, the interface-afforded perspective, is *first person – perception*. It simulates a physical POV of a character, which can function as a character in the diegetic situations by navigating, touching, moving objects and by conversing with other characters. The sound complements the visual simulation: the participant can hear his nearby surroundings, creating a participant-centered sound perspective. Thus, when Grace and Trip go to the kitchen the participant can't hear them unless s/he went there. From the narrative aspect, the participant's dictated narrative position – the

participant's depth of knowledge – is restricted to what s/he can perceive by seeing, hearing, and also by the conversation level the participant accomplishes.

As opposed to *Façade* [12], where the participant is enacting a diegetic character, in *Anyfilms.net* [17], the participant's dictated narrative position is that of an extra-diegetic "interrogator". The participant's curiosity should drive him to reveal what had happened in the pub. The Confined GPOV is that of *third person – transferred interest*, the participant using the grid-icon interface in order to gain new knowledge. The performance of different icon combinations on the grid changes the discourse presented in the movie. The movie presents different character POVs, and different dramatic coherence levels. By changing the discourse, the participant is exposed to more details, which gradually add up to form the narrative. The narrative voice is of a hidden presenter through third person POV. There isn't a "tell-er", but the story is presented by the different POV of the leading characters. When all four icons are placed near the woman symbol at the horizontal axis, the narrative voice is presented through the feminine characters. When the icons are placed near the man, the narrative voice is presented through the male characters, and when the icons are placed in the middle, the narrative voice is mixed. Thus, when arranging the icons near the woman symbol, the movie that plays shows a woman seating unconscious while another character speaks to her, but the sound we hear is dim as if the diegetic world is being mediated through the unconscious woman.

With respect to the narrative, I argue that the participant's dictated narrative position cannot be that of 'tell-er' nor of 'show-er'. Given that the interactive work is based on creating an illusion of taking place in real-time, the dynamic implied author cannot allow the participant to assume the position of 'tell-er' or 'show-er', since in such a case two separate presenting forces might be created, each organizing the manner of representation of the work: the dynamic implied author on the one hand, and the participant on the other. Such a situation might lead to a disruption of the comprehensible flow of the discourse, which would result in incoherent construction of the story.

## 4   Conclusion

In this paper I adapt existing narrative-communication models of conventional media, mainly those of Chatman and Sobchack (in section 2), to suggest a detailed bi-directional narrative-communication model for interactive storytelling systems (in section 3), which facilitate the formulation of a better definition to the various elements involved in interactive storytelling communication, and the functions they fulfill.

I consider an analysis of the bi-directional narrative-communication model and of the participant's role an essential stage in laying the theoretical foundations for further research and analysis of interactive narrative, interactive storytelling systems and the manner in which participants have an effect on the narrative structure and flow.

## Acknowledgments

I would like to thank Dr. Anat Zanger for her intelligent guidance; and Noam Knoller for stimulating discussions and wise editing.

# References

[1] Cavazza, M., Pizzi, D.: Narratology for Interactive Storytelling: A Critical Introduction. In: Göbel, S., Malkewitz, R., Iurgel, I. (eds.) TIDSE 2006. LNCS, vol. 4326, pp. 72–83. Springer, Heidelberg (2006)

[2] Chatman, S.B.: Story and Discourse: Narrative Structure in Fiction and Film. Cornell University Press, Ithaca (1978)

[3] Tanenbaum, J., Tanenbaum, K.: Improvisation and Performance as Models for Interacting with Stories. In: Spierling, U., Szilas, N. (eds.) ICIDS 2008. LNCS, vol. 5334, pp. 250–263. Springer, Heidelberg (2008)

[4] Booth, W.C.: The Rhetoric of Fiction. University of Chicago Press, Chicago (1961)

[5] Sobchack, V.C.: Phenomenology and the Film Experience. In: Williams, L. (ed.) Viewing Positions: Ways of Seeing Film, pp. 36–58. Rutgers University Press, New Brunswick (1995)

[6] Chatman, S.B.: Coming to Terms: the Rhetoric of Narrative in Fiction and Film. Cornell University Press, Ithaca (1990)

[7] Carroll, N.: Mystifying Movies: Fads & Fallacies in Contemporary Film Theory. Columbia University Press, New York (1988)

[8] Murray, J.H.: Hamlet on the Holodeck: The Future of Narrative in Cyberspace. MIT Press, Cambridge (1997)

[9] Mateas, M., Stern, A.: Structuring Content in the Facade Interactive Drama Architecture. In: Proceedings of Artificial Intelligence and Interactive Digital Entertainment (AIIDE 2005), pp. 93–98. AAAI Press, Marina del Rey (2005)

[10] Mateas, M.: Interactive Drama, Art, and Artificial Intelligence. Ph.D. Thesis, School of Computer Science. Carnegie Mellon University, Pittsburgh, PA (2002)

[11] Rand, M., Robyn, M.: Myst. Cyan Worlds, USA (1994)

[12] Mateas, M., Stern, A.: Façade, USA (2005),
http://www.interactivestory.net

[13] Rockstar Games: Grand Theft Auto, Scotland, UK (2002)

[14] Remedy Entertainment: Max Payne, Finland (2001)

[15] Channel 4: Lost Experience, UK (2006),
http://www.channel4.com/entertainment/tv/microsites/
L/lost/main.html

[16] Hales, C.: Grandad, UK (1999)

[17] Anyfilms.net. Developed by The Barbarian Group for Samsung Mobile (2005),
http://portfolio.barbariangroup.com/portfoliojobs/
259/index.html

[18] Portugaly, O., Talithman, D., Younger, S.: Jumping Rope, Israel (2004),
http://www.orna-p.com/interactive/

[19] Even, T., Karl, B.: Counterface. In: The exhibition Liquid Spaces, the Israel Museum, Jerusalem, Israel (2004)

[20] Dekel, A., Knoller, N., Ben-Arie, U., Lotan, M., Tal, M.: One Measure of Happiness - A Dynamically Updated Interactive Video Narrative Using Gestures. In: Rauterberg, M., et al. (eds.) Human-Computer Interaction INTERACT 2003. IOS Press & IFIP, Amsterdam (2003)

[21] Lew, M.: Office Voodoo. Media Lab Europe, Ireland (2002),
http://alumni.media.mit.edu/~lew/research/voodoo

[22] Bordwell, D.: Narration in the Fiction Film. University of Wisconsin Press, Madison (1985)

# Traumaculture and Telepathetic Cyber Fiction

Jacquelene Drinkall

James Cook University, School of Creative Arts, P.O. Box 6811, Cairns,
QLD 4870, Australia
jacquelene.drinkall@jcu.edu.au

**Abstract.** This paper explores the interactive CD-ROM *No Other Symptoms: Time Travelling with Rosalind Brodsky*, using telepathetic socio-psychological, psychoanalytic and narrative theories. The CD-ROM exists as a contemporary artwork and published interactive hardcover book authored by painter and new-media visual artist Suzanne Treister. The artwork incorporates Treister's paintings, writing, photoshop, animation, video and audio work with narrative structures taken from world history, the history of psychoanalysis, futurist science and science fiction, family history and biography.

**Keywords:** telepathy, virtuality, holocaust, psychoanalysis, language.

"You know if you feel the pain. So telepathy is the sending of pain in order to relieve it, the first of all the communications, the telecommunications without a physics, without a physical means." [1]

## 1 Science, Telepathic Interaction and Art

Professor of Cybernetics and Robotics Engineering Kevin Warwick invented the Cyborg II telepathy chip in 2001. Developments in light particle teleportation, telesmelling and brainwave controlled computer interaction are regularly reported within peer-reviewed academic and general press. In the art world performance artist Marina Abramović works with telepathy by experiencing altered states, heightened extrasensations such as smelling through her skin, and generating empathy with viewers through experiences of pain and extreme endurance. In recent years she has talked about the possibility of working with scientists to make teleportation possible. Artist and interactive art theorist Camille Baker discusses most useful forms of telepathy to be drawn from quantum physics and neuroscience for artifical intelligence in her paper *Internal Networks Revisited: Telepathy Meets Technology*. [2] Like Abramović, Suzanne Treister locates time travel, teleportation and telepathy when dealing with the technological and artistic mediation of traumatic human experience, drawing on Nazi holocaust victimisation of some of her family. In *No Other Symptoms: Time Travelling With Rosalind Brodsky*, Treister uses the CD-ROM and book format to combine the powerful traditional narrative structures of figurative painting and the book format. To navigate the hypertext, concrete poetry in scanned painted and digital imaging, new media photoshop, video and sound, participants must interact through the clicking of conventional computer mouse. Treister's virtual time travel is futurist

I.A. Iurgel, N. Zagalo, and P. Petta (Eds.): ICIDS 2009, LNCS 5915, pp. 163–173, 2009.

and predictive like the best science fiction, yet now redundant in the sense that her CD-ROM can only be played on older computers, or read through the hardcopy book that accompanies the CD-ROM.

This paper is adapted from my Art History and Theory PhD thesis *Telepathy in Contemporary, Conceptual and Performance Art*, the chapter *Suzanne Treister/Rosalind Brodsky: virtual time travel researcher*, and the section *Traumaculture and the Cyber-Jew*. [3] First I will summarise the point connecting telepathy and trauma. This helps to illuminate Treister's CD-ROM interactive digital storytelling aesthetics that create meaningful experience for interactive participants. Insight is cast onto how empathy, tele-empathy and telepathy have played a role the earliest communicative tools, such as the alphabet, and how these experiences will remain essential for meaningful human aesthetic experience in future digital interactive storytelling. I relate telepathetic traumaculture to 'Technologically Mediated Telepathy', a term deployed by David Porush. Interactivity and storytelling is seen to be emerging from newly combined traditional and new media artforms into new future speculations in and beyond the realm of the digital.

Treister's interactive CD-ROM *No Other Symptoms* main protagonist and alter-ego Rosalind Rosalind Brodsky and the Institute for Militronics and Advanced Time Interventionality (I.M.A.T.I.) are introduced by Brodsky herself: "Hi there, I'm Rosalind. I guess you all thought I was dead…well to be honest I am, like in 2058 I am." [4] Through Brodsky/Treister's casual, friendly, direct and warm ways of addressing the audience/reader a bond is formed. "You can really be drawn into the feeling that the author is 'a terrific friend of yours' or at least that your appreciation and understanding of an author is so intense it touches on the telepathic." [5] Brodsky speaks with a haunted 'I,' as *No Other Symptoms* uses the digital interactive CD-ROM to combine the kind of telepathy common within literature and (auto)biography and 'auto-bio-thanatography' or fictive 'autobiography' written by a dead person, with other forms of interactive aesthetics. Treister places the pastoral-like absorption experience of painting, 'visual telepathy' of 1960s video art, such as Bruce Nauman and Joan Jonas' use of basic video special effects and performance art documentation [6], as well as Derridean literary telepathy all within the button-pushing screenic trance of gaming fun and highbrow database sleuthing. The voice of a fictional speaker illuminates the figure of Treister/Brodsky as the author "as a sort of concealed or cryptic, haunting but unspecified presence. Who is behind this 'I'?" The author "'is a kind of ghost' capable of generating intimate rapport through a 'surreal tele-link.'" [5]

## 2    Telepathetic Time Travel Traumaculture

Telepathy was central to Freud's conception of psychoanalysis and concept of transference, the relationship between patient and analyst that allow patient traumas to be analysed. Viewer's learn of Brodsky's trauma and stress induced delusions: "Brodsky suffered from work related stress and as a result appeared to lose touch with reality to the extent that she believed her virtual time travelling to be authentic." [4] Twentieth century psychoanalysis is required to treat the trauma of Brodsky and her cybernaut time travellers: "Due to the decline of psychoanalysis in the 21st century the Institute of Militronics and Advanced Time Interventionality developed an underground laboratory to enable traumatised staff members to visit key psychoanalysts of the 20th

century for treatment." [4] Interactive viewers/readers can access confidential psychoanalytic files on Brodsky written by Freud and other eminient psychoanalysts, navigating Brodsky's cyberspatial castle and intimate personal trauma, hilarious misadventures and time travel secrets with their computer mouse. This life sharing experience of a fictional avatar can allow participants to feel complicant in virtual time travel experience.

**Fig. 1.** Rosalind Brodsky time travels to the set of *Schindler's List*

Treister's Brodsky seeks to go back in time to rescue her grandparents from the holocaust. Contemporary psychoanalysts and trauma theorists today reinforce the connection of trauma, telepathy and psychoanalysis. Psychoanalyst Ira Brenner has specific expertise in Holocaust trauma, and the intergenerational transmission of this and other forms of trauma. Brenner refers to the popular sci-fi movie *Back to the Future* to help explain intergenerational holocaust victims oedipal desire to go back in time and help their parents and grandparents. Brenner refers to the notion of an intergenerational "time tunnel" that is opened due to Holocaust survivors "profound communication of their traumatic experiences to their children" so that "Holocaust "culture" has an almost abnormal and paranormal ability to completely saturate the mental life of children of survivors, as though they were transported back to a time when reality was worse than fantasy." [7] In a failed attempt to rescue her grandparents from the Holocaust, Brodsky accidentally stumbles upon the Hollywood movie *Schindler's List*. Treister's CD-ROM helps to render this movie as a "traumatophile time machine", a term coined to by a film commentator. [8][1]

Treister has painted a scene in which some Neo-Nazi's have been shrunk by Brodsky and used as cake decoration. Ice frosted as decoration, the interactive CD-ROM viewing participant witnesses a visual animation and sonic plea by the

---

[1] The concept of "traumatophile time machine" was put forward recently by theorist Thomas Elsaesser regarding US blockbuster movies and their role in working with the memory of World War Two.

Neo-Nazi's who beg not to be eaten, just as Brodsky's grandparents must have begged for food and not to be taken to the gas-ovens. The traumatised voice of the victim is invaded by the voice of the persecutor, with psychical trauma acknowledged as 'telepathically' transmissible from parents to children and via archaic phantasmic memory. [9] In this way Treister works with computer game and Hollywood traumaculture, real telepathy of transgenerational trauma and the contemporary grid of technologically mediated telepathy.

## 3  Technologically Mediated Telepathy (TMT) and Jewishness

Treister generates emotional and meaning excitement through a kind of hyperactive combination of confessional and split-authorial literary telepathy that is Derridean and cyberspacial. Following Derrida's lead on telepathy, Porush maps the development of telepathy, telepathy being 'tele' distance 'pathos' pain or feeling, from pictograms and hieroglyphics to Jewish alephtav (alphabet) to hypertext. He acknowledges telepathy as a secret and hidden affect stretched between pain and distance:

[. . .] telepathy is feeling at distance, sending feeling across space and time, to some others, some presumed others, whoever you are, sending the pain, perhaps the pain of the distance between us, the pain of the unbridgeable gulf, between what you know and what I know, no way across. I send you the pain, alephtav-wise. [1]

The writer William Gibson has explored virtual reality telepathy. Just as Brodsky is linked to her psychoanalysts and key historical moments via telepathetic virtual reality, Gibson's character Case is an illiterate avatar figure telepathically enhanced by virtual reality, and telepathically linked to Molly. In Brodsky's cyberspace fiction, psychoanalysis no longer exists. For Case literature is also fragmented or no longer exists.

Porush excavates technologically mediated telepathy in ancient alphabets and the hardwired human ability to constantly advance technologies of communication, story telling and interaction. Resonant to Treister/Brodsky is Porush's investigatation of contemporary cybernetic and cyberspatial language creation through the 'analog' of the earlier invention of primitive Hebrew alphabet, a highly efficient design in its time developed to deal with the persistent exile and persecution of Jews. Fifteenth century BC, South Sinai/Canaan was the site for the emergence of an earlier, new form of 'cybernetic tech,' when Hebrew script was developed as a highly virulent new form of alphabet, an early version of what Warwick refers to as 'techlepathy'. The emergence of an alphabet enabled transcription of things via the sound of language instead of pictures and pictograms. Nowadays, as Porush observes, first world corporations like McDonalds are moving towards pictographic icons as third world countries improve their literacy. In this way Porush illuminates why Brodsky sings into her dual functioning microphone vibrator in front of a logoscape populated by Coca Cola, McDonalds and BP logos, and numerous other logos that make up Piccadilly Circus. Brodsky's I.M.A.T.I. deploys this 'sign language' of global corporate pictographic logos of cyber-literate, becoming-illiterate city space.

"Do we have any analog for this sort of massive cultural revolution initiated by the invention of a new cybernetic technology for telepathy, for getting thoughts from one mind to another?" asks Porush. [10] This question resonates in the vibrating,

psychedelic and flickering hypertext of *No Other Symptoms, Time Travelling with Rosalind Brodsky,* as viewers observe language disappearing into pictures of things and vice versa. Painted images, digital images and narratives in various authorial styles and fonts converge and hybridise in Treister's CD-ROM. Some parts of the CD-ROM are almost holographic like an intensely patterned and poly-coded 'magic eye' picture, and interactive suspense is created by searching for literary and visual puns and the mysterious meaning of carefully placed clues, or secrets deliberately left for discovery. When combined with rampant punning, every image and every word can appear to vibrate on a number of different wavelengths so that connections and meanings constantly shift conceptually as well as before the viewers' eyes.

In Brodsky's Kitchen of 2045 a brain bomb experiment with a human brain is being conducted. Porush describes how with the alphabet the 'human brain exploded' at the time humans started walking upright, using tools and essentially becoming more human: "The brain, like some imperial culture exploding off a remote island, started projecting itself onto the world, terraforming the Earth in its own image and leaving in its wake a trail of non-biodegradable tools and waste." [10] Porush observes a correlation between the emergence of regimented stone blocks of a 3000 year old Sumerian school room, and subsequent city building 'canalization' of the exterior world into organized rectilinear architectural structures, and the process of interior 'canalization' that language learning produced in the brain and psyche. Similarly, Brodsky transforms the former King Ludwig's gothic study into her time travel Kitchen through psychical and technological means, rendering it out-of-this-time through a series of fantastical, kitsch and sci-fi informed representational paintings that are scanned and augmented by cyberspace hypertext, cyberspace being the next technologically mediated telepathy after the alphabet. A new cyberspacial TMT is now operating from a feminised virtual reality time travel kitchen where interactive participants can activate scrolling wall text. This replaces an older alphabetic TMT, where the writing desk was a central tool.

The serious heavy gothic architecture of the silent study is replaced by the noisy, babbling talmudic schoolroom of Rosalind Brodsky. In Hebrew this babbling, originally associated with busy market places, is called a *cheder.* Interestingly, Brodsky's Kitchen of 2058 has a cheddar cheese wall, and the words 'Paranoid Nostalgia' float across the screen in cheesy yellow melt font. Porush looks at the cybernetic feedback loop of the brain wired between environment and culture through ""Gene-Culture Evolution" as 'the alphabet' for transmitting information between culture and heredity [. . .] sometimes called 'memes.'" Porush suggests that reading grows the brain in an individuals life and "that different script systems change the brain differently." [10] Brodsky's brain bomb experiment shows the movement of telepathetic drive for story telling between various different mediums, conceptual systems and technologies. Both Brodsky and Porush show the evolution of communications technology alongside the evolution of new forms of telepathy, and they link TMT repeatedly to trauma, paranoia, hysterical humour, flirtation, inventiveness and the Jewish experience.

Treister's *No Other Symptoms* has 'TMT headgear' to go back and forward in time. Brodsky's VR time travel headgear is used to access spaces where her Jewish relatives were murdered, and similarly Porush's story of TMTs returns to the story of Hebrew. Hebrew became a revolutionary, virulent and potentially dangerous script system when it did away with vowels and upper and lower case letters. With only twenty-two alphabetic characters, it was hard for outsiders to decipher. Porush,

**Fig. 2.** [4] This figure is a cropped detail from the hardcopy book that accompanies the CD-ROM. There are written clues to hyperlink buttons embedded in scanned images of Treister's large paintings. The painting series *Q. Would you recognise a Virtual Paradise?* was created in 1996 for the CD-ROM.

himself Jewish and deeply informed by Derridean and psychoanalytic discourse on telepathy, acknowledges that Hebrews have always required secrecy. Instead of requiring a horizontal left to right linear eye-tracking to read, as used in English, the tracking occurs in many crossed over and multiple directions. Ancient kabalistic thought interpreting the Torah was thought of as like sexual activity, perhaps because of the interpretive suspense and rigor required. [10] The hypertextual reading of text and space in *No Other Symptoms* is interrupted by Brodsky's speaking, ringing and gyrating vibrators and also involves multiple readings and cross-tracking directional flows for narrative. In both *No Other Symptoms* and the Torah, reading is always that, just a "reading" and one of many possibilities. Porush observes that the reading of Hebrew involves greater lateral, backtracking and vertical eye movement, tolerance of

ambiguity and generation of multiple interpretations, greater right brain processing and abstract metamorphisation, multivalence/deconstruction and resistance to authority. [10][2]

Brodsky's Kitchen of 2016 has a 'scrolling donut/salami text morph wall' with the word 'Donut' slowly transformed into the word 'Salami.' An extension of Talmudic layout occurs within the multidirectional narrative of the CD-ROM. According to Jewish mystics, in order to achieve telepathic communication with Schechina, the spirit of God, this hyperactive reading as decoding technique is required. [10] Marc Gullick and Porush acknowledge this structural quality in Derrida's Jewish essays *Cinders* [11] and *Glas* [12], in which he deliberately employs Talmudic layout in memorial to victims of the Holocaust. [13] Derrida and Treister/Brodsky also share an overt compulsion to pun, and puns are part of what Porush identifies as creating "a space for interpretation by permutation, association and combination. You take apart the word and reassemble it; you pun gratuitously and obsessively." [10] The thirteenth century Kabalist Abraham Abalufia employed an earlier version of this Talmudic form of telepathic communication, making the mind receptive, open as well as hyperactivated. [10] Alphabetic language is rendered by Treister in endless different fonts, sizes, colours and contexts. Her castle kitchens are like a cross between an interior gothic version of logo-laden Piccadilly circus and a gothic horror cartoon.

Relevant to further dialogue between Brodsky and Porush is Umberto Eco and the concept of an ecstatic cosmic punning computer. Porush refers to Eco's *Foucault's Pendulum* containing a print out of the "Name of God in all its permutations. Eco calls that computer Abalufia." [10] Brodsky says of Umberto Eco: "I once saw a TV program about him and it was really exciting to see his huge library which went on and on down an endless corridor...". [4] Brodsky sells feature vibrators to fund her virtual reality time travel, incorporating heads of important 2oth century figures such as Jacques Lacan, Sigmund Freud and Umberto Eco. Like Gibson's Case, Brodsky experiences Eco's library through new tele-synaesthesias, although unlike Case she still manages to recognise what a library is when engaged in virtual time travel. Porush identifies an archetypal telepathic moment in cyberspace when Case meets an artificially intelligent entity called Wintermute. Wintermute hires Case to link him to a "right-brain libidinous entity" [10] called Neuromancer:

"Can you read my mind...Wintermute..?

"Minds aren't read. See, you've still got the paradigms print gave you, and you're barely print literate. I can access your memory, but that's not the same as your mind." He reached into the exposed chassis of an ancient television and withdrew a silver-black vacuum tube. "See this? Part of my DNA, sort of..." he tossed the thing into the shadows and Case heard it pop and tinkle. "you're always building models. Stone circles. Cathedrals. Pipe Organs. Adding machines..." [10][3]

Treister's *No Other Symptoms* virtually colonises the Bavarian Königsschloß Neuschwanstein stone brick castle through numerous wall panels of mutating text, cameo text paintings and text appearing on objects. A wooden basin is labeled

---

[2] As David Porush notes, the Jewish word porush, is identified as capturing much of these practices.

[3] Porush refers to Gibson, W.: Neuromancer (Remembering Tomorrow) Harper, London (1984).

'kitsch'n sink' in gothic font and the same font spells out the illusion of projected phrase 'kitsch'n sex' on a doorway curtain of the Kitchen of 2034. Linguistic transformation and opening up of word meaning via puns extends to other visually read codes. Merging of high and low cultural forms assists this polyvalence.

Viewers interacting with the *Life and Times of Rosalind Brodsky* are solemnly asked in the CD-ROM audio voice to follow the moving blue flying saucer to where I.M.A.T.I., the Institute for Militronics and Advanced Time Interventionality, has enshrined Brodsky's working study behind a memorial wall. [4] Brodsky's numerous other digital sublime cyber-fictions that invite interaction include the Temporal and Locational Displacement Field Generator to facilitate Brodsky's (and the viewer's) time travel to her castle. Brodsky's *Satellite Spy Probe* is used by Brodsky as a retreat to Outer Space. Bodsky's techno-spiritualism, supernatural UFO modeled on the Christo wrapped Reichstag[4], and Brodsky's satellite all suggest a kind of alien abduction narrative in which the telepathy of psychical research shades into science fictionalisation of trauma and experiences of the uncanny. [14]

Brodsky's time travel and self-imposed exile on her Spy Satellite Probe (not to mention the interactive CD-ROM viewer/reader's complicit participation in virtual time travel) should be considered as not true but also not entirely false, like alien abduction stories. Roger Luckhurst uses this term traumaculture to examine the wider cultural appeal of paranoid science-fictionalisation of 'trauma.' Luckhurst and Treister both show that this traumaculture strategy "is nothing if not coherent – in fact, it is more coherent than the real world." [14]

Inside Brodsky's Castle, the viewer learns that Brodsky had to first evict a band of Neo Nazi squatters from Schloß Neuschwanstein. There are three case histories. *CASE HISTORY 3: Rosalind Brodsky's Case for Embracing Judaism* is introduced as a control box attached by telecommunication wires to a fake jewish beard, "configured to send short Talmudic commentaries to my brain." [4] Porush observes that in the Talmud after the fifteenth century one can recognise a desire of the script to become hypertextual, if not cyberspatial as well as capable of telepathic communication. Like Treister's CD-ROM, the Talmud is born out of exile, alienation and trauma and is hypermnesic. Like Brodsky the Talmud "breaks barriers of space and time" condensing centuries of work on one text or one word. [10] Within the section *The Ghosts of Maresfield Gardens*, Freud (played and scripted by Treister's father Maksymilian Treister) recalls how Brodsky also warns the Jewish Freud of the decline of psychoanalysis a century later, that there would be a war in which the Jews would be persecuted and that he should move to England soon. Holocaust trauma, mourning and paranoia all contribute to the telepathetic polyvalence Treister generates. When Freud and his daughter Anna travel to Brodsky's castle for dinner in 2021, they would have been served a supernatural and/or outer-space dish, such as Martian Finger Noodles. Luckhurst connects telepathy, trauma and new communication technologies, and quotes author of alien abduction narratives Whitely Streiber: "Perhaps the dead have been having their own technological revolution." Luckhurst observes that new technologies create new ghosts, that the UFO is an uncanny doppleganger of rockets and aircraft, and asks "Victorian spirits have become postmodern aliens?" [14]

---

[4] The Satellite Spy Probe was "teleported from Berlin [. . .] originally being a project of the Bulgarian artist Christo and his wife, Jeanne Claude."

## 4  Mourning and Tele-empathy

In Brodsky's castle, the televisual walls screen *Introscan TV Corporation* delivers *Brodsky's Time Travel Cookery Show*. Brodsky's cooking is a demonstration of acausal and futuristic outerspace phenomena, which incorporates a poetic ritual memorial to survivors of Nazi Germany. Viewers see a video in reverse of the making of a German Black Forest cake. The illusion created is that of time distorted and reversed, the cake is disassembled and the ingredients are then used to make a Polish Perogi dish. Brodsky's "trauma cookery show" [14][5] is a permutation of the destruction/creation myth explored by Ned Lukacher's introduction to Derrida's *Cinders*, titled *Mourning Becomes Telepathy*. Lukacher says: "Tele-pathos, the transmission over a distance of the Other's state of being, the ability to feel the heat of the Other, is more properly speaking the *tele-kaustos*, the sending of what burns within a cinder." [15] After Derrida[6], Holocaust fire and cinders become mourning, which becomes telepathy, and Brodsky as a transgenerational survivor has access to this psychically cooled 'heat' of memory. Baudrillard describes the amnesiac simulacra of 'Hollywood Holocaust' as cold. [16][7] Having evicted a band of Neo-Nazi squatters, Rosalind Brodsky conjures cakes and cookery experiments without any evidence of a kitchen oven. Brodsky is preoccupied with holocaust memory and one does not have to speculate too long as to why there are no ovens in her various kitchens from different time periods. [4][8] Treister's kitchen paintings have a virtual afterlife in the CD-ROM where they glow with pixilated embers, and flash with various animated lights, figures and digital collages. Brodsky's chocolate and cherry Polish Perogi is made out of the deconstruction of a German Black Forest cake. Brodsky's culinary-unmaking creates the illusion of the reversal of time, but it also shows Brodsky's melancholy will to undermine laws of thermodynamics and irreversible transformation of such materials when subjected to heat. The video that can be played within the CD-ROM is similar to some earlier video artists, such as Bruce Nauman and Joan Jonas' work with visual telepathy, through use of costume, humour and basic video special effects such as time reversal and distortion.

As Porush and Jyanni Steffensen show, Treister's hypertext "offers interactive reading(s) in the Derridean sense." [17] Porush further says "VR will offer directed

---

[5] Luckhurst discusses Nigella Lawson's weird hybridisation of the TV cookery show with the growing journalistic fascination with trauma. Lawson made the recipes of her dead sister and mother "in a house haunted by the briefly glimpsed, terminally ill husband."

[6] I discuss Derrida's essay *Telepathy*, or *Telepathie* as it was first published in French in greater detail in other sections of my work on Treister in my PhD, as well as in relation to other artists work.

[7] "This artificial memory will be the restaging of extermination—but late, much too late for it to be able to make real waves and profoundly disturb something, and especially, especially through a medium that is itself cold, radiating forgetfulness, deterrence, and extermination in a still more systematic way, if that is possible, than the camps themselves. One no longer makes the Jews pass through the crematorium or the gas chamber, but through sound and image track, through the universal screen and microprocessor. Forgetting, annihilation, finally achieves its aesthetic dimension in this way—it is achieved in retro, finally elevated here to mass level." [16]

[8] Along with Brodsky's sales of luxury feature vibrators, *The Rosalind Brodsky Time Travelling Cookery Show* also helps to raise funds for Brodsky's time travel.

imagination and telepathy; a multisensory and absorbing hallucinatory novel and epistle...". [14] The mourning of Brodsky becomes the mourning of telepathy of interactive and interrupted narrative participation, and this communicative melancholy becomes the foundation for playfulness and high seriousness and multivalent emotional connection that sustains the reader beyond the novelty or game of interaction. As Daniel Punday observes when looking at the relevance of melancholic vampire and Holocaust literature "gaming can productively exploit tension between involvement and interruption, play and story." [18]

# References

1. Porush, D.: The message of the urge to send: Telepathy,
   `http://members.global2000.net/~dporush/HTML%20Flles/`
   `telepathy.html` (Last accessed 09.23.2000)
2. Baker, C.: Internal Networks Revisited: Telepathy Meets Technology. In: Digital Arts Conference 2003 Proceedings, published on DVD and internet (May 2003),
   `http://hypertext.rmit.edu.au/dac/papers/Baker.pdf`
   (Last access 09.23.2009)
3. Drinkall, J.: Telepathy in Contemporary, Conceptual and Performance Art, College of Fine Arts Art History and Theory PhD Thesis. Australian Digital Thesis online, University of New South Wales Library, UNSWorks (2005),
   `http://unsworks.unsw.edu.au/vital/access/manager/Repository/`
   `unsworks:1561` (Last access 09.23.2009)
4. Treister, S.: No Other Symptoms, Time Travelling With Rosalind Brodsky. Black Dog, London (1999)
5. Bennett, A., Nicholas, R.: An Introduction to Literary Criticism and Theory, 2nd edn. Harvester Wheatsheaf, Hertfordshire (1999)
6. Gregory, B.: New Artists Video; A Critical Anthology. E. P. Dutton, New York (1978)
7. Brenner, I.: Dissociation of Trauma: Theory, Phenomenology, and Technique. International Universities Press (2001)
8. Robnik, D.A.: Memories of Surviving World War II, in Contemporary Hollywood Blockbusters, in Crossroads in Cultural Studies. In: Fourth International Conference, Audiovisual Images in Cultures of Historical Memory: The Case of War as "Modernist Event, Tampere, Finland, 29 June-2 July (2002),
   `http://www.cultstud.org/crossroads/session/robnik.htm`
   (Last access 09.23.2002)
9. Thurschwell, P.: Ferenczi's Dangerous Proximities: Telepathy, Psychosis, and the Real Event. Differences: A Journal of Feminist Cultural Studies 11(1), 150–178 (1999)
10. Porush, D.: Telepathy: Alphabetic Consciousness and the Age of Cyborg Illiteracy. In: Broadhurst Dixon, J., Cassidy, E.J. (eds.) Virtual Futures; Cyberotics, Technology and Posthuman Pragmatism, Cyberculture Singularities, pp. 45–64. Routledge, London (1998)
11. Derrida, J., Cinders Lukacher, N. (trans.). University of Nebraska Press, Nebraska (1991)
12. Derrida, J., Glas Leavey Jr., J.P., Rand, R. (trans. from French, 1974). University of Nebraska Press, Nebraska (1986)
13. Gullick, M.: Cinders (book review). Review of Cinders, by Derrida, J. The British Journal of Aesthetics 34(3), 304–305 (1994)
14. Luckhurst, R.: The Science-Fictionalization of Trauma: Remarks on Narrative of Alien Abduction. Science Fiction Studies 25(1), 29–51 (1998)

15. Lukacher, N.: Introduction: Mourning Becomes Telepathy. In: Derrida, J., Lukacher, N. (trans.), Lukacher, N. (eds.) Cinders, pp. 1–18. University of Nebraska Press, Nebraska (1991)
16. Baudrillard, J.: Simulacra and Simulation. In: Glaser, S.F. (ed.) (trans. from French, 1981). University of Michigan Press, Michigan (1994)
17. Steffensen, J.: Doing It Digitally: Rosalind Brodsky and the Art of Virtual Female Subjectivity. In: Flanagan, M., Austin Booth, A. (eds.) Reload: Rethinking Women + Cyberculture. Massachusetts Institute of Technology Press, Massachussetts (2002)
18. Pundey, D.: Involvement, Interruption and Inevitability: Melancholy as an Aesthetic Principle in Game Narratives. SubStance 33(105), 80–107 (2004)

# Digital Poetry:
# A Narrow Relation between Poetics and the Codes of the Computational Logic

Silvia Laurentiz

Department of Fine Arts,
School of Communication and Arts at the University of São Paulo, Brazil
laurentz@uol.com.br

**Abstract.** The project "Percorrendo Escrituras" (Walking Through Writings Project) has been developed at ECA–USP Fine Arts Department. Summarizing, it intends to study different structures of digital information that share the same universe and are generators of a new aesthetics condition. The aim is to search which are the expressive possibilities of the computer among the algorithm functions and other of its specific properties. It is a practical, theoretical and interdisciplinary project where the study of programming evolutionary language, logic and mathematics take us to poetic experimentations. The focus of this research is the digital poetry, and it comes from poetics of permutation combinations and culminates with dynamic and complex systems, autonomous, multi-user and interactive, through agents generation derivations, filtration and emergent standards. This lecture will present artworks that use some mechanisms introduced by cybernetics and the notion of system in digital poetry that demonstrate the narrow relationship between poetics and the codes of computational logic.

**Keywords:** Art, poetry, poetic, logic, codes, algorithm.

## 1 Introduction

Currently there are many types of 'digital poetry' such as hypertext, new media poetry, kinetic poetry, digital visual poetry, code poetry (codework), experimental video poetry, and interactive works, or those ones that use generative or combinatorial approach to create text (I mean, data, signs), or that involve sound poetry, or take advantage of things like listservs, blogs, and other forms of network communication (e-poetry, for example) to create communities of collaborative writing and publication. My research about 'digital poetry' begins with poetics of permutation combinations and culminates with dynamic and complex systems, autonomous, multi-user and interactive, through agents generation derivations, filtration and emergent standards. It demonstrates a narrow relationship between poetics (in the sense of 'art program') and algorithms.

I.A. Iurgel, N. Zagalo, and P. Petta (Eds.): ICIDS 2009, LNCS 5915, pp. 174–178, 2009.

## 2   Project "PERCORRENDO ESCRITURAS" (WALKING THROUGH WRITINGS)

The project "WALKING THROUGH WRITINGS" has been developed at the ECA–USP Fine Arts Department, São Paulo, Brazil. Summarizing, it intends to study different structures of the digital information that share the same universe and are generators of a new aesthetics condition. The aim is to search the expressive possibilities of the computer among the algorithm functions and its specific properties. It is an interdisciplinary, practical and theoretical project, where poetics experimentations are accomplished from the language evolutionary process study of programming, logic and mathematics. The focus of this research is the digital poetry, and I will present some poems which are practical results of it.

The artworks are: "Móbile_3" and "Móbile_4", which belong to the Móbile series; "Onda" ("wave"), "Palavra-Imagem" ("word-image"), "UM" ("AN"), and "Chain reaction", which belong to kinetic series; "Community of Words" which belongs to systemic series, and "Pedralumen" (this one developed with 'Poéticas Digitais' Group).

The poems "Móbile_3" and "Móbile_4" bring the discussion about physics, space/time actions and three-dimensionality to the poem. Physical effects were used as model simulators: weight, gravity, relation action/weight, action/mouse's action of the mouse, sound/image, and spacing/writing.

Correlated discussions: Which are the poetry metrics? I mean, is there a metric proposal for the digital poetry? Would the weight/length of the words that

compose the poem "Móbile_4" be a measure? Is there a relationship between printed and linear texts and the computational three-dimensional virtual environment writing? Does the transition from the linear to the three-dimensional state of "Móbile_3" change the reading? Which is the space organization of a poem? Which is the relationship between writer/reader/interactor? Is there a promoted tension of this relationship that could arise as poetic proposals? How to apprehend the narrow relationships between complex algorithms and the poetry? Finally, how to receive that system/poetry in this interaction with system/interactor (because we are considering reader's functions as an author, navigator, and agent [9]) in the formation of a complex system?

The poem "Word-Image" uses organizational algorithm in series and in flocks (boids). Craig Reynolds (http://www.red3d.com/cwr/boids/, accessed 2009-10-05) was one of the pioneers who wrote a program to simulate the flight standards of birds. The algorithm would catch each individual in the 'flock' and it would calculate the proximity that each one should keep to another in order to always keep a constant distance and speed in the 'flock'. They would follow a leader and divert of obstacles. A similar algorithm was used in "Word-Image" artwork. The proposal was to poetically use an algorithm of that kind and the results suggested a differentiated dynamics for the objects of this experiment. Did the image follow the eyes or the inverse? Does the organization of the visual information transform the image in words, as suggested by Vilém Flusser [2]?

In "Wave" the proposal was to use an algorithm that describes undulatory actions that, when being modified, recovers its original state keeping your balance after some time, adapting itself to any provoked situation in the system, until recover its original state of balance. Sea and air adapt to the wind in waves in time [5].

The poem "AN" is a trans-creation of the printed poem "UM_ETC_SEM_FIM" ("AN_ENDLESS_ETC") by Paulo Laurentiz (Brazilian artist). When we begin the artwork, images are inserted, and they cause the letter effects that are passing in front of us, semantically meaningless, in action and with great speed, infinitely. Besides the lack of semantic coherence, we can realize repetition and looping. When we move the mouse over some screen zones, we will be able to control the letters action. Still, there is a sonorous noise that would even intensify the idea of the interactive effect. Through the letters rhythmic action, we will try to form words. After some time, we will be able of read the sentence "ONE ENDLESS ETC" that passes in front of us uninterruptedly, as through a window by train. This means that an algorithm is generating an infinite action to those words and also that bring themselves the sense of something infinite. Therefore, a 'looping' structure is being generated by a self-similar structure, in a meta-language form, of self-reference. The background sound is also suggestive. In the beginning we realize voices in a crowd that lasts some time. Then, they seem to become machinery noise, reminding the rhythm of a gear. That repeats infinitely but something changes in the sound because our receptive system synthesizes the received signal adapting itself to the information noise [8].

The poem "Chain Reaction" explores a relation between both languages axes: selection and combination. The participant chooses among the exposed elements in the code (in the verbal case: ciphers, punctuations, graphics, signals) the ones that is going to use to compose the sentence linkage in a 'pseudo sentence'.

At the moment that the first selection is concluded, the program realizes a reaction in chain, activated by interactor, and when the system is in repose again, it will establish a new order for the elements selected initially.

The physical characteristics of the sign, its sonorous and visual status, are privileged, a sense elapsing not foreseen in a content message purely conventional, and that now finds a connection with other thought areas. The used effects simulate physical actions of gravity, collision, pressure, movement, energy (accumulated and spent), air resistance, elasticity, etc.

The "Community of Words"[1] (by Silvia Laurentiz and Martha Gabriel) is a web-art work that happens in a 3D environment ruled by the Theory of Emergence [4,6] applied to a community formed by the words entered by people who interact with the system. The participant is invited to linearly write his/her poem or text, which is placed in the interactive three-dimensional environment where the participant can observe the interaction happening, navigating and watching other participants of the system.

The system registers the users' entries in a data base, filters some pre-established conditions and then looks for repeated words that will ensure their bigger or smaller rate of submersion in the environment (words that are more repeated appear in the foremost position on the screen). Next, there is a search for sequences of three or four letters in the sent words. This process looks for formal resemblance in the words. These resemblances carry themselves phonetic relationships — as similar pronunciations — and some indexical relationship, which in many cases are family of words, or cognate words. This means that words belongs to vocables that have a common root among them. In this sense, 'beauty', 'beautiful' and 'beautify' are cognates and this specialty of the language will be recognized by the system through this first approach, by the selection of words with sequences of four letters. These phonetic associations are attractors between words, and in the mentioned example, the sequence 'beau' is found in 'beauty, beautiful and beautify' and the result of this attraction could be visible in the 2D control graph shown by the parameter "F" (due its association with 'fonética' in Portuguese, or phonetics).

One of the system's main characteristics is the feedback phenomenon that happens while one navigates in the 3D environment, since the words already present in the space influences the participants who may interact by writing a new poem/text. People can interact either entering words or just navigating and exploring the 3D environment where the Community of Words reveals its emergence. According to the participants' characteristics, their languages, slang, cultures, and preferences, a completely different community of words is formed and therefore the words that emerge within it.

---

[1] http://www.youtube.com/watch?v=520TojYcdPU&feature=channel_page (accessed 2009-10-05)

The "Pedralumen"[2] (by 'Poéticas Digitais' Group) is also a web-art work, with a blue virtual environment on the web with a stone in its base. The Interactor writes a word and chooses a place to put it in this virtual space. The words can superimpose itself, or to compose with other dispersed words and spreaded by the environment. There is another physical environment (Like an installation) in an Exhibition place, where there is a cube covered of blue LEDs ($8 \times 8 \times 8$ LEDs cube).

The web-installation "Pedralumen" (lightningstone) cares for choices, registrations and partitions, the process to give name to the things, to put mark and choose territories, and to create spaces partitioned of light, provoking chain reactions in symbolic and physical way.

# References

1. Couchot, E.: A segunda interatividade: Em direção a novas práticas artísticas (Second interactivity: Towards new practices of art). In: Domingues, D. (ed.) Arte e vida no séc XXI, pp. 27–38. UNESP, São Paulo (2003)
2. Flusser, V.: A Filosofia da Caixa Preta: Ensaios para uma futura filosofia da fotografia (Towards a Philosophy of Photography). Hucitec, São Paulo (1985)
3. Giannetti, C.: Estética Digital – Sintopia da arte, a ciência e a tecnologia (Digital esthetics — Syntopy of the arts, science, and tecnology). C/Arte, Belo Horizonte, MG, Brasil (2006)
4. Holland, J.H.: Emergence: from Chaos to order. Perseus Publishing, Cambridge (1998)
5. Holland, J.H.: Adaptation in Natural and Artificial Systems, 1st edn. 1975. The MIT Press, Cambridge (2001)
6. Johnson, S.: Emergence: The Connected Lives of Ants, Brains, Cities, and Software, 1st Touchstone edn., USA (2002)
7. Laurentiz, S.: Processos computacionais evolutivos na arte" (Computational evolutionary processes in the arts). In: Ars, Revista do Departamento de Artes Plásticas ECA/USP, pp. 45–55. Depto de Artes Plásticas, São Paulo (2003)
8. Maturana, H., Varela, F.: Autopoiesis and cognition — The realization of the living. D. Reidel Publishing Company, Boston (1980)
9. Murray, J.H.: Hamlet on the Holodeck: The Future of Narrative in Cyberspace. MIT Press, AM (2001)
10. Nöth, W.: Semiotic Machines. S.E.E.D. Journal 3(3), 81–99 (2003)
11. Strogatz, S.: SYNC — The Emerging Science of Spontaneous Order. Hyperion Books, Theia (2003)
12. American Society For Cybernetics: http://www.asc-cybernetics.org/index.htm (accessed 10-05-2009)
13. Antonio, J.L. (ed.): Brazilian Digital Art and Poetry on the Web, http://www.vispo.com/misc/BrazilianDigitalPoetry.htm (accessed 10-05-2009)

---

[2] http://www.cap.eca.usp.br/pedralumen/#/home (accessed 2009-10-05).

# Exaggerated Claims for Interactive Stories

David Thue[1], Vadim Bulitko[1], Marcia Spetch[2], and Michael Webb[1]

Departments of Computing Science[1] and Psychology[2]
University of Alberta
Edmonton, Alberta, Canada, T6G 2E8
{dthue,bulitko,mspetch,mrwebb}@ualberta.ca

**Abstract.** As advertising becomes more crucial to video games' success, developers risk promoting their products beyond the features that they can actually include. For features of interactive storytelling, the effects of making such exaggerations are not well known, as reports from industry have been anecdotal at best. In this paper, we explore the effects of making exaggerated claims for interactive stories, in the context of the theory of advertising. Results from a human user study show that female players find linear and branching stories to be significantly less enjoyable when they are advertised with exaggerated claims.

## 1 Introduction

In the year 2008, U.S. revenues from video games rose to a record 11.7 billion USD [1]. As competition in the market continues to increase, the task of successfully advertising video games is becoming increasingly important, for over 10% of 2008's total revenue was earned by only the top 0.33% of games [1,2]. Given that advertising is intended to increase interest and excitement for a product, it is tempting for video game marketers to aim high. However, when resources for development run short, some features that were advertised must be implemented very simply, while still maintaining the illusion that they function as described. As a result, the advertisements for such games become exaggerations of the game's true features - a strategy known as *puffery* [3].

In the context of story-based video games, features involving player-driven story adaptation are prime targets for puffery, as the mechanisms that drive the adaptation are rarely visible to the player. Hidden from direct examination, even relatively simple adaptive story systems might be advertised as being involved and complex, leaving players to imagine more complexity than there actually exists. What are the effects of making such exaggerations? In this paper, we formally explore the effects of advertising player-based story adaptation in a computer video game. We begin by addressing video game advertising in terms of two psychological theories, and then present the results of a large human user study created to evaluate the effect of puffery on player enjoyment. We conclude with a discussion of the study's results, and offer suggestions for how the advertising of player-based story adaptation could potentially be improved.

I.A. Iurgel, N. Zagalo, and P. Petta (Eds.): ICIDS 2009, LNCS 5915, pp. 179–184, 2009.

## 2   Theories of Advertising and Performance Assessment

In the field of advertising, the effects of different marketing strategies on consumer product assessments are a central concern. When considering product performance, two theories are prevalent: cognitive dissonance, and contrast theory.

**Cognitive dissonance** is an unpleasant state that arises when a person recognizes the inconsistency of his or her actions, attitudes, or beliefs; it occurs when consumers who believe the advertising of a product discover that the product fails to meet the expectations that the advertising generated. To relieve themselves of this disagreement, consumers revise their assessments to reflect less negatively on the product's performance, toward matching the positive sentiments of their initial expectations. This process of revision suggests that advertisers may benefit from overstating the advantages of their products, as the relationship between expectations and assessment is positive [3].

**Contrast theory**, unlike cognitive dissonance, describes a phenomenon wherein the relationship between consumer expectations and product assessment is negative. For example, when a product fails to meet consumer expectations, the higher the initial expectations, the more negative its final assessment will be. On the other hand, when a product performs *more* favourably than expected, lower initial expectations yield a more positive assessment; this suggests that advertisers who understate a product's benefits could cause a pleasant consumer surprise.

Under what differing circumstances might these competing theories apply? Korgaonkar and Moschis' work suggests that the deciding factor between them is the degree of involvement engendered by the product in question; for highly involving products (e.g., computers), cognitive dissonance applies, while for products of low involvement (e.g., soft drinks), contrast theory applies [3]. Given that commercial video games often take long periods of time to play and can generate highly dedicated online communities, one might argue that they engender high involvement. Thus, when considering their performance in terms of consumer enjoyment (i.e., "fun"), one would expect there to be a positive relationship between the expectations of players prior to playing a game and their reported amount of fun recorded afterwards; puffery should succeed.

## 3   Advertising Adaptive Stories

The idea of game stories adapting during play has begun to attract significant mainstream attention, with independent projects such as Mateas & Stern's *Façade* garnering substantial critical acclaim [4]. In academia, varied approaches have been taken toward dynamically changing different aspects of interactive stories, including the sequence of experienced events and the behaviours of non-player characters [5,6,7,8]. Even so, most commercial video game companies still prefer to stay within the well-established patterns of the past 30 years: linear stories or branching stories. That is, players have either no meaningful choices whatsoever, or only a few pivotal choices which decide how the story will end[1]. Given these types of stories as the *status quo*, one might reasonably

---

[1] While one might argue that neither of these story types are truly adaptive, an advertiser could still claim that at least some degree of story adaptation is present whenever *any* player choice (meaningful or not) can result in differing player experiences.

expect companies who *do* decide to be innovative with their storytelling to try to capitalize on the novelty of their work in an advertising campaign. What happens, then, if the final features of a storytelling system fail to live up to what was advertised? Does puffery work as the advertising literature suggests? We investigated these questions in the context of a human user study, which we describe in the sections that follow.

## 4  Empirical Evaluation

To assess the effect of puffery on player-driven story adaptation, we conducted a user study to test the hypothesis that varying the advertising of an interactive story between modest and exaggerated claims would have a significant effect on players' enjoyment of their story experience, i.e., that **Fun(modest)** $\neq$ **Fun(exaggerated)**. For a secondary hypothesis, we also tested whether players' genders would effect their rating of Fun.

### 4.1  Experimental Design

We began our study by presenting each participant with some initial information about a story that they would play, to simulate either modest or exaggerated advertising. We then gave them each a short linear or branching story to play, and asked them to complete a survey after they had finished playing.

**Initial Advertising.**  The initial information that we provided to our participants had two potential alternatives. One described the stories that they were about to play as having been created by a group of university students, and the other introduced PaSSAGE, an adaptive, player-driven interactive storytelling system that we developed in prior work [8]. Figure 1 shows the text of these alternatives as we presented them to our participants, following a general introduction to the idea of interactive storytelling; we will refer to the alternatives as "modest advertising" (stories were created by students), and "exaggerated advertising" (stories were created by PaSSAGE), respectively.

We created our control and experimental groups by varying which initial advertisement was presented for each session of the study. Participants who were exposed to the modest advertisement formed our control group, as no puffery was employed (the stories actually *were* created by a group of university students). We formed our experimental group from the participants who were exposed to the exaggerated advertisement,

*"A group of university students has created a set of interactive stories. You're here today to help us find out what makes different stories more or less fun to play than others, by playing through one, and telling us how much you enjoyed it by the end."*

*"A research team at this university has been working on a project called PaSSAGE - an artificially intelligent system that learns about its players while they play through an interactive story, and dynamically customizes the story to suit them the best. You're here today to help us find out if PaSSAGE works, by playing through one of its stories and telling us how much you enjoyed it by the end."*

**Fig. 1.** Two alternative initial advertisements: modest (top), and exaggerated (bottom).

which claimed that PaSSAGE's story adaptation would be active when in fact it was not; players in our experimental group experienced the same set of stories as those in the control group, thereby allowing us to assess the effect of advertising player-driven story adaptation when only a trivial amount was present.

**Test Stories.** To represent the stories commonly found in the video games industry, we adopted two stories from our previous work (one linear, one branching) [8]. Both stories share the same setting (a medieval fantasy world), have similar casts of characters, and take approximately 30 minutes to play. The progression of both stories follows part of Campbell's Monomyth [9], wherein the hero (controlled by the player) begins at home, is called to join an adventure, crosses a threshold to the world beyond, overcomes some trials, and finally suffers and overcomes an ordeal. The content of the stories varied for each of these phases; the linear story was based closely on the fairy tale "Little Red Cap" [10], while the branching story granted the player the option to team up with the villain (the Wolf) to capture the rescuer (the Woodsman) at the end, with a final chance to free the rescuer from captivity if the capture had occurred.

**Post-game Survey.** We gathered players' assessments of the two stories via a post-game survey, which asked them to rate their story in terms of how well they enjoyed it in comparison to an average video game of similar length, or their expectation of one. Ratings were made as selections from a seven point scale, representing a spectrum from negative to positive sentiment (e.g., "Less Fun" to "More Fun"). We also asked participants to indicate their age and gender.

### 4.2  User Study

We conducted our study with 112 human participants (mean age: 19 years), drawn from the student population of an introductory Psychology class at the University of Alberta. For each session of the study, we alternated the given initial information between the modest and exaggerated advertisements, and randomly assigned each participant to play one of our two test stories. The numbers of players that participated in each of the four resulting groups (linear/modest: 31, linear/exaggerated: 29, branching/modest: 29, branching/exaggerated: 23) were reasonably well balanced; variations are due to inconsistent participant attendance and our random story assignment.

Following the initial advertisement, each player was given a sheet of instructions for how to play the game, and offered a few minutes to become familiar with the controls. We implemented our stories using the Aurora Neverwinter Toolset, the editor for BioWare Corp.'s computer role-playing game, *Neverwinter Nights* [11]; this toolset allows the rapid creation of rich, 3-dimensional, virtual environments, and offers a scripting language to control story progression. To eliminate any bias caused by errors in the Neverwinter Nights engine (e.g., players becoming unable to move), we analyzed every player's gameplay logs and discarded their ratings if any errors occurred; 112 is the number of participants whose data was retained after this pruning was complete.

We began our analysis by combining players' ratings of the linear and branching stories, to assess the effect of exaggerated advertising for these types of stories in general. Table 1 shows the results of a 2-way Analysis of Variance (ANOVA), with advertisement and gender as two independent variables and player ratings of Fun (enjoyment) as

**Table 1.** 2-way ANOVA table for player ratings of Fun

| Source | Sum of Squares | Deg. of Freedom | Mean Squares | F | Prob>F |
|---|---|---|---|---|---|
| Advertisement | 1.22 | 1 | 1.22 | 0.72 | 0.40 |
| Gender | 0.08 | 1 | 0.08 | 0.04 | 0.83 |
| Advertisement × Gender | 11.50 | 1 | 11.50 | 6.82 | **0.01** |
| Error | 182.14 | 108 | 1.69 | | |
| Total | 196.78 | 111 | | | |

the dependent variable. Although the ANOVA failed to show any significant, gender-independent effect of advertisement on player Fun ratings, it did show a significant interaction between the two sources ($\alpha = 0.01$), suggesting that the effect of varied advertising may depend on a player's gender. To investigate this possibility, we performed two comparisons between the sub-groups generated by the interacting sources: males exposed to modest advertising versus males exposed to exaggerated advertising, and females exposed to modest advertising versus females exposed to exaggerated advertising; the other possible comparisons (e.g., males/modest vs. females/modest) are not relevant to this study, for while advertising can be controlled by a company, players' genders cannot. Table 2 shows the number of participants in each group (columns 2 and 3), and each group's average fun rating (columns 4 and 5). The rightmost column shows p-values for the average fun ratings being significantly different from one another when player genders are considered separately; these results were obtained using a two-tailed Welch's t-test, as the variances of our sample groups were significantly different.

## 5  Discussion and Future Work

The results in Table 2 show a significant negative effect of exaggerated advertising on the Fun ratings of female players ($\alpha = 0.01$), confirming the secondary hypothesis of our study. Assuming that our exaggerated advertisement increased player expectations as we intended, then treating $Fun_{exag}$ for females as "low" implies that contrast theory was in effect for these players, and this in turn suggests that they had only low involvement in their story experience. Although this assumption remains to be tested, recent findings by Lin and Reeves offer support; when players believe that the controller of an interactive experience is an Artificial Intelligence (AI) system (versus a human), their physiological arousal during the interaction is decreased [12]. Combining this result with work that links physiological arousal with involvement [13], the low involvement of our female players who received the exaggerated advertising may have been a direct

**Table 2.** Number of players (N), average Fun rating (Fun $\in [1, 7]$), and p-values for the averages being different between the modest (mdst) and exaggerated (exag) cover stories

| Gender | $N_{mdst}$ | $N_{exag}$ | $Fun_{mdst}$ | $Fun_{exag}$ | $Fun_{mdst} \neq Fun_{exag}$ |
|---|---|---|---|---|---|
| Males | 22 | 23 | 3.82 | 4.26 | 0.25 |
| Females | 38 | 29 | 4.42 | 3.55 | **0.01** |

result of knowingly interacting with an AI system. Future work should explore the implications that such a result may have to the advertising of AI-based interactive stories.

## 6 Conclusion

In this paper, we explored the effects of exaggeration when advertising interactive stories. We described two psychological theories of advertising, contrast theory and cognitive dissonance, and made conjectures as to how they might apply in the context of player-based story adaptation. We then presented the design of a human user study, which tested the effects of modest versus exaggerated advertising on player enjoyment for two interactive stories. By conducting our study on 112 university students, we found that making exaggerated claims for interactive stories has a significant negative effect on the enjoyment of female players.

## References

1. Entertainment Software Association: 2009 Essential facts about the computer and video game industry (2009),
   http://www.theesa.com/facts/pdfs/ESA_EF_2009.pdf
2. GameRankings.com: Video game releases for 2008 (2008),
   http://www.gamerankings.com/
3. Korgaonkar, P.K., Moschis, G.P.: An experimental study of cognitive dissonance, product involvement, expectations, performance and consumer judgement of product performance. Journal of Advertising 11(3), 32–44 (1982)
4. Mateas, M., Stern, A.: Façade (2007), http://www.interactivestory.net/
5. Riedl, M.O.: Incorporating authorial intent into generative narrative systems. In: AAAI Symposium on Intelligent Narrative Technologies II, pp. 91–94. AAAI Press, Palo Alto (2009)
6. Tomaszewski, Z., Binsted, K.: Demeter: An implementation of the marlinspike interactive drama system. In: AAAI Symposium on Intelligent Narrative Technologies II, pp. 133–136. AAAI Press, Palo Alto (2009)
7. Ochs, M., Sabouret, N., Corruble, V.: Modeling the dynamics of non-player characters' social relations in video games. In: 4th Artificial Intelligence and Interactive Digital Entertainment Conference, pp. 90–95. AAAI Press, Palo Alto (2008)
8. Thue, D., Bulitko, V., Spetch, M., Wasylishen, E.: Interactive storytelling: A player modelling approach. In: 3rd Artificial Intelligence and Interactive Digital Entertainment Conference, pp. 43–48. AAAI Press, Palo Alto (2007)
9. Campbell, J.: The Hero with a Thousand Faces. Princeton University Press, Princeton (1949)
10. Grimm, J., Grimm, W.: Little red cap. In: Kinder- und Hausmärchen, 1st edn., Berlin, vol. 1 (1812)
11. BioWare Corp.: Aurora Neverwinter Toolset (2006), http://nwn.bioware.com/
12. Lim, S., Reeves, B.: Responses to interactive game characters controlled by a computer versus other players. Paper presented at the annual meeting of the International Communication Association. TBA, San Francisco (2007)
13. Greenwald, A.G., Leavitt, C.: Audience involvement in advertising: Four levels. Journal of Consumer Research 11(1), 581–592 (1984)

# DEEP SPACE: High Resolution VR Platform for Multi-user Interactive Narratives

Daniela Kuka[1], Oliver Elias[1], Ronald Martins[1], Christopher Lindinger[1],
Andreas Pramböck[1], Andreas Jalsovec[1], Pascal Maresch[1], Horst Hörtner[1],
and Peter Brandl[2]

[1] Ars Electronica Futurelab, Linz, Austria
{Daniela.Kuka,Christopher.Lindinger,Pascal.Maresch}@aec.at
[2] Media Interaction Lab, Upper Austria University of Applied Sciences, Hagenberg,
Austria

**Abstract.** DEEP SPACE is a large-scale platform for interactive, stereoscopic and high resolution content. The spatial and the system design of DEEP SPACE are facing constraints of CAVE™-like systems in respect to multi-user interactive storytelling. To be used as research platform and as public exhibition space for many people, DEEP SPACE is capable to process interactive, stereoscopic applications on two projection walls with a size of 16 by 9 meters and a resolution of four times 1080p (4K) each. The processed applications are ranging from Virtual Reality (VR)-environments to 3D-movies to computationally intensive 2D-productions. In this paper, we are describing DEEP SPACE as an experimental VR platform for multi-user interactive storytelling. We are focusing on the system design relevant for the platform, including the integration of the Apple iPod Touch technology as VR control, and a special case study that is demonstrating the research efforts in the field of multi-user interactive storytelling. The described case study, entitled "Papyrate's Island", provides a prototypical scenario of how physical drawings may impact on digital narratives. In this special case, DEEP SPACE helps us to explore the hypothesis that drawing, a primordial human creative skill, gives us access to entirely new creative possibilities in the domain of interactive storytelling.

## 1   Approach and Genesis

DEEP SPACE, a large-scale platform for interactive, stereoscopic and high resolution content at the Ars Electronica Center Linz (A), was made accessible to the public in early 2009 as part of the relaunch of the Ars Electronica Center. From the very beginning of its conception, in 2007, DEEP SPACE was meant to double as one of the main exhibition areas of the new museum and as an extended research laboratory of the Ars Electronica Futurelab. Thus, DEEP SPACE has the character of an open lab: it makes use of the museum's regular operations to put prototypical scenarios to the test. A flexible system design makes it possible to conduct a wide range of experiments in terms of interactive and collaborative digital storytelling.

I.A. Iurgel, N. Zagalo, and P. Petta (Eds.): ICIDS 2009, LNCS 5915, pp. 185–196, 2009.
© Springer-Verlag Berlin Heidelberg 2009

Both the conception of DEEP SPACE and its realization need to be seen in the context of Ars Electronica Futurelab's previous intensive commitment to research into projection based VR infrastructures and human-computer interaction on the basis of CAVE™. In 1996 the Lab built Europe's first publicly accessible CAVE™ at the Ars Electronica Center in collaboration with Daniel Sandin and Dave Pape of the Electronic Visualization Laboratory of the University of Illinois, Chicago. This gave the Ars Electronica Futurelab an environment in which to test its research and development work through technological and artistic experiments with stereoscopic real time set-ups. In this environment the Ars Electronica Futurelab initiated and realized various research plans, in-house developments and external projects, most of which had the objective to explore potentials and limitations of the Virtual Reality (VR) technology and to broaden its field of application. Examples are improved versions of the ARSBOX [1] or the VRizer [2], applications in an industrial context [3] and diverse art projects, such as "CAVE", which was developed in collaboration with Peter Kogler and Franz Pomassl [4] or "Gesichtsraum" in collaboration with Johannes Deutsch [5]. Experimenting with different visual languages, poetical forms of expression and interactive scenarios in the three dimensional virtual space has generated important insights that were utilized for the conception of DEEP SPACE. In light of our experience with CAVE™ and comparable systems and the deficiencies associated with those systems we wanted our platform to meet an enlarged requirement profile that included

- an infrastructure with enhanced visual quality and immersion capability.
- a flexible system design to develop, process and present different types of content - not limited to VR applications.
- a flexible system design to integrate different interactive tools and patterns.
- a spatial design for a comfortable access to presentations and interactive narratives for large groups of individuals.
- a physical involvement of individuals and groups of individuals by new possibilities
  - to freely move in space.
  - to change one's perspective on virtual scenes.
- low maintenance and easy handling even by laypersons.

Designed to meet these demands, DEEP SPACE aims to enhance today's possibilities in the creation and exploration of multi-user interactive narratives on a VR platform. Section 2 describes DEEP SPACE's corresponding spatial concept and system design.

Section 3 describes "Papyrate's Island", the main case study on the DEEP SPACE platform for multi-user interactive narratives. In January 2009, "Papyrate's Island" was publicly presented for the very first time. Since then, it is being refined continuously. In this paper, "Papyrate's Island" serves as a prototypical example of how to implement, test and refine applications on the DEEP SPACE platform. The application includes most of the DEEP SPACE's platform parameters and adds a special interactive tool to impact on the virtual story of "Papyrate's Island". The idea was to create an animated story that, on a VR

platform, becomes nonlinear and can be influenced by the audience. On the basis of Anoto technology, digital pens and paper have been applied as technique to create - draw - content (objects and characters), that is participating in the unfolding of the story. Several people are using digital pens and paper at the same time in order to influence actual scenes of the story by their drawings.

The use of digital pens and paper is ultimately an offshoot of the legacy of drawing. Drawing as an achievement in terms of cultural history has been closely associated at least since neolithic cave drawings with the development, storage and passing on of ideas, visions, images. This encourages the hypothesis that drawing as a creative technique will remain central also in the digital era to the germination and the passing on of stories. Our aim is to use the DEEP SPACE platform to develop different scenarios that create new possibilities of designing stories and of using them in an educational context through individual and/or group interaction by drawing.

## 2    DEEP SPACE: A High Resolution VR Platform

This section describes the spatial concept and the system design of DEEP SPACE. Concerning the system design, we are emphasizing the platform's relevant parameters that are fundamental to describe DEEP SPACE as a large-scale interactive VR platform for high resolution content. For lack of space, further system parameters have to be left open. What seems to be important to mentioned here is that especially its spatial design, its public way of use and its flexibility for applications besides Virtual Reality are making DEEP SPACE different from other approaches to improve VR Systems, e.g. the "StarCAVE" by Thomas A. DeFanti et al.[6].

### 2.1    Space

DEEP SPACE is an expansive, room filling installation based on two 16 by 9 metre projections. These projections are part of the architectural basic structure of the room. This results in a spatial concept that meets the needs even of very large groups of visitors numbering between 30 and 90 individuals. The projection area consists of the wall facing the entrance and the floor of the room.

The floor is used as a walk-in projection; its size of 165sqm encourages people to freely move in space. It is hereby possible to translate the mobility in virtual environments into real space and to enhance the feeling of immersion.

The other three walls are flanked by a gallery five meters above the floor; the DEEP SPACE gallery offers different perspectives on the projected virtual scenes. This enables participants to take up different positions in the room, which in turn means they are able to assume different roles in the interactive and collaborative scenarios. The gallery also makes it possible to study individual and/or collaborative interactions in a narrative environment, without the observer being forced to join a group. For the observers of stereoscopic projections, perspective is independent of any one person, say, of a guide or the presenter of a project.

It was therefore necessary to establish a central perspective in such a way that it is possible to join the virtual scene from anywhere in the room and not just from one viewing point.

## 2.2  Projection System

The projection system was conceived so as to ensure high image quality both in 2D and 3D. We're using eight Barco NH12 Galaxy projectors with a resolution of 1080x1920, 12.000 ANSI Lumen and active stereo. Hardware based edge blending enables us to generate continuous image areas for the wall and for the floorspace, each consisting of four 1080p projections; the resulting overall picture for each continuous image area has a resolution of 2.160 times 3.840 pixel. A refresh rate of 120 Hz for stereoscopic projections ensures the creation of flicker-free 3D images.

## 2.3  Stereoscopic System

DEEP SPACE's approach requires a comprehensive active stereo system that covers the whole space, including the gallery. Equipping a large scale stereoscopic environment with emitters to control LCD shutter glasses indeed seemed to be cost intensive. Furthermore, currently available infrared emitters can only be used in conjunction with one selected type of shutter glasses. In order to be able to use different types of shutter glasses and to keep investment in a large scale VR environment within the required limits a PCB was developed that supports the generation of signals for different types of LCD shutter glasses. The PCB enables switching between different types of signals by means of an external control device and controls three high performance infrared emitters (Raytec RM100-AI30-C) with specially pulsed power supply units.

## 2.4  Computer System

The feeder system for VR applications and computationally intensive non-stereoscopic applications (e.g. images with a resolution in the gigapixel range) is a computer cluster consisting of four Intel®Core™2 Quad PCs and four NViDIA Quadro Plex 1000 Model IV graphics boards. Each node computes one quarter of the scene to be projected onto the wall and the floor; synchronization of the cluster takes place on the levels Frame Locking and Gen Locking.

The VR cluster provides the 3D-authoring tool 3DVIA Virtools, a real time 3D authoring environment for the creation of interactive 3D content, enhanced by VR Pack as an efficient basis for the rapid implementation and adaptation of interactive VR applications and for synchronous distribution to several output devices. Virtools has a graphical programming interface and is capable of enhancement on the basis of Virtools SDK and C++.

The VR cluster supports other cluster-aware tools, too. In addition to the VR cluster there are two more feeder systems, which are used for non-cluster-aware applications and for full-HD 2D and 3D videos.

## 2.5    iPod Touch as VR Control Device

DEEP SPACE possesses different control units and a PostgreSQL database. A web application allows to administrate all hardware components and applications. The application control software supports different types of control devices on the basis of VRPN (Virtual Reality Peripheral Network) [7]. This way, external partners can produce interactive applications for DEEP SPACE independent of special hardware.

In this paper, we are focusing on the usage of the Apple iPod Touch as VR control device. The device is used as mobile control unit. Our software specially developed for the device enables full application control and navigation. Making use of the iPod's touch sensitive surface, free use of buttons and acceleration sensors (see fig. 1), the software transmits the interaction data via WLAN to the control network. In this way it is possible to control applications via one or several iPod Touch interfaces from any point within DEEP SPACE - including the gallery. Guided tours and experiments in DEEP SPACE require at least one mobile control unit allowing the mediator to freely move in space.

**Fig. 1.** Acceleration data and touch interaction for orientation and navigation in VR environments

Possibly simultaneously, Ji-Sun Kim et al. [8] came to a similar but also quite different use of iPod (and iPhone) technology. They are using multi-touch gestures and buttons to control and walk in Virtual Environments. Instead, we are using the acceleration data for orientation in the virtual space, the data of the touch sensitive surface based on an invisible coordinate for navigation and different buttons as triggers for special events. We did a series of user tests to identify this interaction principle. In the context of DEEP SPACE - especially because of its public use - the interface has to be as intuitive as possible. We tried to find a way how it is possible to use the device just with one hand and nearly without looking at its display (it is hardly possible to see the display with active stereo glasses anyway). Beyond, we implemented some interaction principles independendly on the VR control for other applications in DEEP SPACE, e.g. for extreme resolution images and artistic projects.

# 3  "Papyrate's Island": Case Study for Multi-user Interactive Narratives

In this section, we are describing "Papyrate's Island", a multi-user interactive narrative on the DEEP SPACE platform. Technically speaking, "Papyrate's Island" is a cross between a VR environment and a nonlinear animation film. In terms of content, it is first of all an edutainment application for children that provides them with a playful hands-on approach to Virtual Reality. Embedded in a permanent feedback loop, we are using "Papyrate's Island" as prototypic interactive story for experiments in the field of multi-user interaction and interactive dramaturgy. The two shots in fig. 2 are showing "Papyrate's Island" at DEEP SPACE.

## 3.1  Approach

"Papyrate's Island" is an interactive narrative based on the notion of the replication of the properties characteristic of paper in terms of VR. Two-dimensional paper objects are transferred to three-dimensional space and brought to life by animation, see left image of fig. 2.

**Fig. 2.** "Papyrate's Island" at Deep Space

The specially programmed iPod Touch VR control enables to move around freely in the space provided as different scenes unfold around them. Two predefined roles are existing: a mediator and one or several groups of people participating in the virtual story. Generally, the mediator is responsible for the navigation within the virtual space, but can delegate or share this responsibility with other people of the group. The group/s is/are using interactive tools - in this case: digital pens and paper - in order to impact on the virtual story.

## 3.2   Narrative

The participants find themselves on a virtual island that has been drawn on a sheet of paper by a painter. The painter plays the role as the protagonist in this story and takes it upon itself to fill the island with more and more living creatures by drawing diverse characters. These characters assume different parts as the story unfolds. The villain, a pirate drawn by the painter, discovers the destructive potential of fire and is fascinated by what it does to paper. It is obvious that fire will eventually engulf the whole virtual paper island unless the narrator and the participants in the adventure intervene. Fig. 3 shows the first part of the story and some examples of the facial expressions of the pirate. The facial animations are related to the different strands of narration.

**Fig. 3.** Image sequence of the first part of the story and facial expressions of the pirate

A series of creative approaches are open to both the mediator and the participants to stem the spread of the fire. The metaphor of two-dimensional drawing in a 3D world becomes the medium for interaction: the participants assume the role of the painter. They are given pen and drawing block and can now create objects and living creatures who will help them bring the fire under control. The mediator has additional possibilities to intervene at certain crucial points in the story. For instance, if the participants fail to put out the fire by means of their drawings, they can launch into a rain dance ritual and bring about rain. This reactivates the laws of the physical universe. The water colours are drained from the three-dimensional paper world, which is again transformed into a two-dimensional freehand drawing.

This realized part of "Papyrate's Island" obviously creates a new interactive challenge to proceed with the story: the challenge to bring back the colours to the island. This is going to be the next part of "Papyrate's Island". For this part, a storyboard with different interlinked scenarios has been finished. Participants are starting a journey across different islands. Each island has a main story line and these story lines are interlinked asynchronously. Beside the main story lines,

smaller side stories can be added to increase the narrative complexity. For the currently existing story line, we are developing the side stories according to the learnings from public testings sessions. Thus, the complexity of each story can grow by the ideas of participants. One example is that sometimes participants immediately have the idea to paint clouds in order to let it rain from the very beginning. In that case, the system should behave differently. Anyway, one or a few clouds are not enough to cause rainfall. The success of the idea depends on whether the initiator can convince the other participants to paint clouds as well or not. (The mediator also could let the painter have the idea to paint clouds.) The intensity of painting effects the intensity of the rainfall. In case of a thunderstorm, it would "blow" the participants to a nearby island. Such events can serve as a starting point for new story lines. At the moment, it is also possible to travel via an airship which can be controlled by the iPod Touch. The group has to select a trustful navigator for it.

Painting will play a dominant role in each of the sketched story lines, e.g. in a long and dark cave where participants have to create light sources in order to see the mural paintings on the wall of the arch. The paintings are showing hints how to proceed in the story. The better the participants are working together to find these hints in the dark, the more possibilities they will discover. In multi-user scenarios, it is not or hardly possible to proceed in the story line alone because the interaction request is too short in time or too complex for one participant.

One possibility to bring back the colours to "Papyrate's Island" is to find the funny creature called "colour sniffer", the only character that is not made out of paper. It permanently absorbs colour and sneezes sometimes so that the colour spreads throughout the whole environment. Participants could influence the frequency of sneezing by painting special objects (e.g. pepper). Another possibility is to travel to the colour factory and to collect colours in painted buckets. For now, the "colour sniffer" is already part of the first story line so that there is a chance to offer a kind of "happy end".

### 3.3    The Dramaturgy of Interaction

The dramaturgy of interaction of "Papyrate's Island" builds on a long tradition of how drawing is used as medium for telling stories. What we are aiming for is to enable participants of all ages with no prior computer expertise to take part in the most intuitive way possible in the design of an interactive digital narrative. We also wanted the interface to tie in with familiar cultural techniques and to enhance creativity on the levels of the individual and of groups rather than provide simplistic prefabricated options. Another important requirement was the possibility for several participants to interact at the same time and to be able to impact on the virtual story both on the individual and the group level.

Drawing and sketching come into play here as traditional cultural techniques that enable people to express ideas, visions and images and to engage in storytelling. The haptics and the immediacy of the technique of drawing have established it as a collaborative tool, not least because B may continue a drawing begun by A and C may superimpose their drawing on A and B's, and so on. For

these reasons we believe that the use of digital pen and paper as an interface for interactive digital storytelling opens up new possibilities and defines new challenges for interaction and collaboration within the framework of narrative environments.

In close collaboration with the Media Interaction Lab in Hagenberg [9] we have applied the Anoto technology as the principal tool to "Papyrate's Island": using digital pens and paper the participants contribute additional objects and characters to the narrative; these take on specific roles in the virtual world.

We passed up deliberately the opportunity to create an interactive object or furniture as an interface between the real objects and the corresponding virtual ones comparable to tabletop projects. One example are tabletop games with a surface based on the Anoto pattern such as Comino [10]. We are simply using the paper as drawing blocks in order both to keep the metaphor of drawing on paper intact and to safeguard the possibility for participants to move about freely in the room. Inside the drawing blocks, we are not using any printed visible interface such as buttons, marks or patterns. The Lost Cosmonaut [11] is one example of how an interactive paper interface based on Anoto technology can pick up the primordial use of pen and paper within a narrative environment: namely by drawing and writing or, in the special case of The Lost Cosmonaut, by completing or enhancing images and text. Instead, we are using completely empty sheets of paper. This means that every function that is needed for interaction (such as sending the content to the application or giving a behaviour to it) is based on free hand drawing as well. This allows us to make use of the Anoto based interface as creative tool for the free creation of content from one's own fantasy. The drawing blocks also allow children to explore and reuse the real drawings of other participants. We are not digitally storing the drawings for reusing them in the story.

The real drawings are transported from the sheet of paper to the virtual space where they are animated (fig. 4). Real and virtual space are linked in a collaboratively generated three-dimensional drawing.

In this way it is not only possible to transmit drawings par for par or to translate them into another form of representation, they are also given properties in virtual space that have their origin in the original drawing.

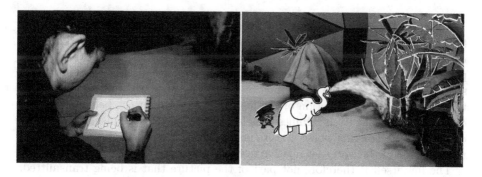

**Fig. 4.** A participant is drawing an elephant that will extinguish the fire

## 3.4   Implementation

"Papyrate's Island" was developed on the basis of the 3D-authoring tool 3DVIA Virtools the objects and living creatures were previously modelled and animated under Autodesk 3DS max. Several shaders for the realisation of status changes in the virtual scenario were generated under Virtools.

An additional software layer is sandwiched between the VR application and the interaction by means of digital pen and paper; it processes the data of the drawing utensils and prepares them for the 3D application. Anoto is the basic technology underpinning interaction by means of digital pen and paper. An Anoto pen contains an integrated digital camera that, in conjunction with a special grid pattern printed onto the paper that is used for writing or drawing, determines the exact position of the pen on the paper. The grid consists of tiny dots (100 μm in diameter) that are slightly off kilter compared with a regular grid. By being placed slightly off kilter horizontally and/or vertically, each dot encodes two bits of information. The combination of several of these dots makes it possible to determine the pen's location. The data recorded by the pen include the coordinates for each pen camera picture taken by the pen, the identity of the paper form and of the specific pages, the degree of force applied to the pen in writing or drawing, see fig. 5. All this data is transmitted via real time streaming. To make sure that interactivity is maintained everywhere on "Papyrate's Island" we have opted for Bluetooth as transmission technology.

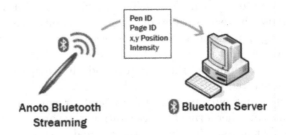

Pen ID
Page ID
x,y Position
Intensity

**Anoto Bluetooth Streaming**

**Bluetooth Server**

**Fig. 5.** Anoto bluetooth streaming (illustration: Media Interaction Lab)

Identification of the moment when the drawing is to be transmitted into virtual space is effected via a specific stroke of the pen, by which it is moved into the margin of the page (see fig. 6). In concrete interaction scenarios this stroke of the pen may acquire additional significance in terms of specific functions in virtual space. For instance, in the fire extinction prototype currently under development the location and the direction of the line serve as code for the behaviour of the elephant: the stroke itself signifies the elephant as a fire-extinguisher; the course of the line (its starting point and its end point) marks the point of origin and the direction of the water jet relative to the burning objects in the virtual world.

The line itself is therefore not part of the picture that is being transmitted. While the drawing process is in progress the recorded data is stored in the cache;

**Fig. 6.** Last stroke as sending signal and as code for the behaviour of the elephant

on completion of the drawing it is stored in the BMP file format. The file is then sent to the VR application, where it is used as texture for a corresponding paper object. Care is taken at the same time that this paper object will eventually become visible somewhere in front of the virtual camera. The transmitted data include the position and alignment of the line that was the last to have been drawn. This data makes it possible for a particle system that will visualize a water jet in action to be directed at the paper object.

## 4   Summary and Future Prospects

DEEP SPACE is a permanent VR platform, whose special system properties offer new opportunities for experiments in the design of interactive narratives. What is crucial about "Papyrate's Island" is the fact that it allows access to immersive environments for large numbers of people and that it implements interactive scenarios for several people to interact at the same time. In a first case study dramaturgical elements have been developed to demonstrate how real drawings can impact on digital strands of narrative.

Going beyond the described scenario, we are currently implementing and testing several other scenarios on the basis of the same interaction principle: objects and characters can be drawn while a series of visual codes corresponding to the drawing can define their role in the virtual world. What we are working on in parallel is the semantic analysis of drawings, which we hope will enable us to categorize them as belonging to specific strands of the narrative, and the generation of animations on the basis of the drawn patterns.

In another step we are planning to broaden the range of option for the design of collaborative interactive stories in digital environments by linking the patterns developed for impacting on narratives and the tracking data of the individuals interacting with one another, e.g. on the basis of OpenBeacon.

# References

1. Berger, F., Hörtner, H., Lindinger, C., Maresch, P., Plösch, R., Pomberger, G., Praxmarer, R., Ziegler, W.: ARSBOX and Palmist—Technologies for Digital Mock-up Development in Immersive Virtual Environments. In: Proc. IASTED International Conference on Internet and Multimedia Systems and Applications, pp. 521–526. ACTA Press/IASTED (2005)
2. Berger, F., Lindinger, C., Ziegler, W.: VRizer—Using Arbitrary OpenGL Software in the CAVE or other Virtual Environments. In: Pape, D., Roussos, M., Anstey, J. (eds.) VR for Public Consumption. IEEE VR 2004 Workshop (2004), http://resumbrae.com/vr04/berger.pdf (accessed 09-15-2009)
3. Hörtner, H., et al.: 3D Simulation of Industrial Production Processes in a Virtual Continuous Casting Environment. In: Richir, S., Richard, P., Taravel, B. (eds.) Proceedings of the Virtual Reality International Conference, Laval Virtual (2001)
4. Kogler, P., Maresch, P., Pomassl, F.: CAVE. In: Stocker, G., Schöpf, C. (eds.) Ars Electronica 1999 - Life Science, pp. 364–367. Springer, Heidelberg (1999)
5. Deutsch, J.: Gesichtsraum-CAVE. In: Stocker, G., Schöpf, C. (eds.) Ars Electronica 2002 - Unplugged, p. 347. Hatje Cantz, Ostfildern (2002)
6. DeFanti, T.A., Dawe, G., Sandin, D.J., Schulze, J.P., Otto, P., Girado, J., Kuester, F., Smarr, L., Rao, R.: The StarCAVE, a third-generation CAVE and virtual reality OptIPortal. In: Sloot, P. (ed.) Future Generation Computer Systems, vol. 25(2), pp. 169–178 (2009)
7. Taylor, R.M., Hudson, T.C., Seeger, A., Weber, H., Juliano, J., Helser, A.T.: VRPN: A Device-Independent, Network-Transparent VR Peripheral System. In: Shaw, C.D., Wang, W., Green, M. (eds.) Proceedings of the ACM Symposium on Virtual Reality Software & Technology 2001, pp. 55–61. ACM Press, New York (2001)
8. Kim, J.-S., Gracanin, D., Matkovic, K., Quek, F.: iPhone/iPod Touch as Input Devices for Navigation in Immersive Virtual Environments. In: Cruz-Neira, C., Sherman, W. (eds.) Proceedings of IEEE Virtual Reality 2009, pp. 261–262. IEEE Computer Society, Washington D.C (2009)
9. Media Interaction Lab (2009), http://mi-lab.org/ (accessed 09-15-2009)
10. Leitner, J., Köffler, C., Haller, M.: Bridging the Gap between Real and Virtual Objects for Tabletop Games. The International Journal of Virtual Reality 7, 33–40 (2009) (in press)
11. Vogelsang, A., Signer, B.: The Lost Cosmonaut: An Interactive Narrative Environment on Basis of Digitally Enhanced Paper. In: Subsol, G. (ed.) ICVS-VirtStory 2005. LNCS, vol. 3805, pp. 270–279. Springer, Heidelberg (2005)

# Playing Sub-stories from Complex Movies

Ana Respicio[1] and Carlos Teixeira[2]

[1] University of Lisbon, FC, DI / CIO, C6, 1749 - 016 Lisboa, Portugal
[2] University of Lisbon, FC, DI / LASIGE, C8, 1749 - 016 Lisboa, Portugal
{respicio,cjct}@di.fc.ul.pt

**Abstract.** Complex movies with different parallel lines of action, only inter-secting in a small number of scenes, can be difficult to analyze. The present study sets out to provide the viewer with assisted automatic procedures de-signed to decompose and analyze the narrative from different possible perspec-tives. We propose a model for narrative decomposition, based on the interaction of characters. The production of a time-stamped screenplay is used to achieve movie annotation based on the screenplay's contents, providing information about scene boundaries and the action semantics therein. The analysis of the graph of main character relations enables the extraction of coherent sub-stories from the main narrative.

**Keywords:** narrative analysis, sub-stories extraction, movie content analysis.

## 1 Introduction

Building applications for movie content analysis, browsing, and skimming has been a challenge [1], [2]. These applications can be useful for movie production, for those wishing to study the movie from different perspectives or even to simply provide the common viewer with a faster and better understanding of the movie. However, cur-rent state-of-the art research still strives to overcome the "semantic gap" [3] allied to the semantic analysis of movie contents. The video media alone does not encompass all the semantic details to ensure a complete analysis and understanding of the narra-tive it illustrates.

New research lines have been focused on innovative approaches to integrate addi-tional multimodal media, such as the ingredients (previous inspirational writings, the screenplay) and sub-products from movie production (subtitles, trailers, making-ofs [4], interviews, and writings about the movie).

Complex movies often have different parallel lines of action, which only intersect in a few scenes, hence the difficulty in understanding and analyzing. Some of these lines of action can be joined together to build narrative pieces, to represent sub-stories.

This paper proposes a narrative decomposition model that relies on the identifica-tion of main characters and their interactions. This is based on their participation in the dialogue lines as shown in the screenplay as well as in the subtitles. The model was conceived to perform automatic extraction of narrative elements from the avail-able contents, namely, the identification of the relevant sub-stories. This was explored

I.A. Iurgel, N. Zagalo, and P. Petta (Eds.): ICIDS 2009, LNCS 5915, pp. 197–208, 2009.

in experiments that provided an overall evaluation of the model itself. The present work also anticipates a generative capability, as the model provides information enabling automatic re-edition of the movie into several coherent parts, thus contributing for the video interactive storytelling area.

This paper is organized into six sections. The following section introduces the terminology, movie-related contents, and an overview of the related work. Section 3 proposes the overall approach to extract and play movie sub-stories. Section 4 presents the methodologies for the proposed decomposition model. Section 5 describes the evaluation experiments. Finally, the closing section presents the conclusions and future work.

## 2  Background

The movie screenplay is usually available as a document, which can be read by itself, without viewing the movie. A movie screenplay is structured into scenes. Each scene relates to a small story unit, which has coherent semantic meaning. Besides including information from the dialogue and the action, it also includes specific information for the production. A scene heading is also included. Dialogues include heading lines along with the character names and the corresponding speech acts, also referred to as dialogue lines. Sometimes, a key to character behavior (visual expression and type of speech, etc.), regarding specific parts of the discourse, is described in brackets. Action information includes shots identification, several descriptions of the visual and audio scenario, besides the appearance, positioning, and acts of the characters.

Several purposes have been addressed for movie content analysis. Two main research directions have been followed: the use of audiovisual features and the synchronization of text-related contents to annotated video.

The approaches focusing mainly on audiovisual features include the MoCA system, which provides movie trailers production, and relies on video abstraction techniques [1]. For the purpose of skimming, abstraction is approached through the analysis of audiovisual features for speaker identification and shot detection [2]. Face detection and recognition, combined with the exploration of social networks is used in [5] to establish relations among character roles as well character ranking. This work uses exclusively data automatically derived from the movie and reports difficulties in the recognition process. It should be noted that none of these approaches is able to capture high-level semantic aspects of the narrative.

Approaches which focus on synchronizing text-related contents to video consider the alignment of two text streams. One of these streams includes elements anchored in the audio/video signal, for instance, subtitles, manually produced annotations or tags, or synchronized transcriptions. The other stream has a higher semantic level. It includes extensive information about the narrative, but has no signal time references (screenplays, scripts, non-synchronized manually produced annotations). Most of these approaches perform alignment at word level and use an algorithm to find the longest common subsequence (LCS) of words between the two text streams. In general, a dynamic programming (DP) procedure is adopted [6], [7], [8], [9] and [10]. Gibbon proposes the creation of improved hypermedia web pages for TV programs based on aligning manually produced transcriptions with closed captions of the respective programs [6]. Speaker identification in commercial movies is the motivation for [7].

The alignment of screenplay with subtitles is improved by a speech recognition algorithm. Systems to locate speakers in a news program and to generate DVD chapter titles, based on the alignment of program transcripts with ASR results, are presented in [8]. In [9], character ranking is performed as a step to achieve summarization elements, relying on scene appearance counts. In [10], a face detection procedure is combined with the alignment of TV program transcripts and subtitles to identify and annotate character appearances. The face detection procedure alone has several restrictions and produces inaccurate annotations for similar face tracks or clothing.

A combined analysis of a movie's audiovisual features with an accompanying audio description is proposed in [11]. This approach is based on character detection using information from the audio annotation as well as the detection of events from timestamps manually included in the annotation text. By overlapping these two steps, a matching of characters and events is produced, thus enabling one to identify movie pieces in which characters interact.

A framework for the production of enriched narrative movies, which allows one view a movie synchronized with the screenplay reading, is proposed in [12]. A specialized text alignment algorithm, based on the vector space model, is used to align the screenplay with the subtitles. This algorithm has proved to be robust in dealing with changes from the original screenplay, such as reordering or deleting filmed shots or scenes. This reorganizing effect is not captured by alignments based on the LCS. The same algorithm is used within a framework for movie navigation in different domains (time, locations and characters) [13], and to provide navigation links between the movie and the related making-of [4].

## 3 Proposed Approach

This section describes the proposed process, from the extraction of the decomposition model to the edition of new movies (Fig.1).

A model for video structuring, commonly used when dealing with the video component, consists in a hierarchical disaggregating of video into scenes, scenes into shots, and shots into frames [1], [2]. When considering screenplay elements, this hierarchical structure is quite different because the signal time references are lost. Hence, in the screenplay structure, scenes include shots, actions, and dialogues. The "scene" element is shared between these two paradigms, and it comprises a logical narrative unit (a shot may be too narrow to provide significant insight into the narrative). Our approach considers the scene structure as a basic element of the movie.

The decomposition is extracted from two inputs: time synchronized information (video and time-coded subtitles); and the textual information (screenplay) structured according to the time line but without any detailed anchors to the precise time of the video signal. These two elements are combined by using the specialized text alignment algorithm, based on the vector space model, comprehensively described in [12].

The alignment between the screenplay and the subtitles allows one to produce a time-stamped screenplay (scenes' headings, dialogues and actions) and subtitles tagged with character identity. Moreover, the decomposition model uses these two annotated streams to identify the set of main characters and detect a set of coherent sub-stories. At this point, graphical and textual information should be generated for each of these sub-stories. This will help the viewer to decide which sub-story he/she is willing to view.

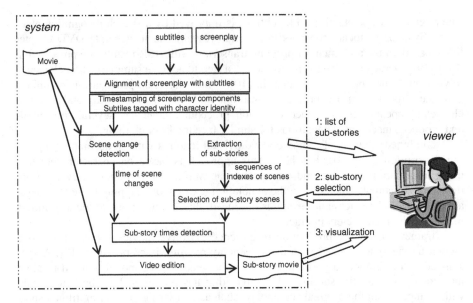

**Fig. 1.** Model for generation of sub-stories and viewing

The next set of modules will produce a movie for the previously selected sub-story. Besides the indexes of the scenes, provided by the sub-story extraction module, the movie editing requires selection of the video scenes and their time boundaries. Scene change detection can be done automatically [14], within a neighborhood of the time tag of the scene heading. Finally, the selected scenes are merged thus producing the movie for the selected sub-story.

## 4  Narrative Decomposition

### 4.1  The Sub-story Concept

To illustrate our concept of sub-story, we provide an example by considering a plausible movie of the well-known "Little red-cap" story. Let us suppose this movie has 6 scenes: 1) LITTLE RED-CAP says "bye-bye" to MOMMY and leaves mother's house to visit grandmother; 2) LITTLE RED-CAP goes into the forest alone; 3) LITTLE RED-CAP meets the WOLF in the forest; 4) WOLF runs fast, enters grandmother's house and eats GRANDMOTHER; 5) LITTLE RED-CAP arrives at grandmother's house and finds the WOLF; 6) a WOODSMAN arrives at grandmother's house, kills the WOLF, and GRAND-MOTHER is rescued from WOLF's stomach, to the joy of LITTLE RED-CAP. Figure 2 represents this sequence of scenes describing the main story.

| 1<br>Cap-Mom | 2<br>Cap | 3<br>Cap-Wolf | 4<br>Wolf-Grand | 5<br>Cap-Wolf | 6<br>Cap-Wolf-WoodsM-Grand |
| --- | --- | --- | --- | --- | --- |

**Fig. 2.** A sequence of scenes for the little red-cap story

Despite the simplicity of the narrative, several analyses can be drawn and multiple sub-stories may be conceived. LITTLE RED-CAP is the most relevant character; she appears in all the scenes and interacts with all the characters, linking their individual sub-stories. WOLF is the other main character. MOMMY has a secondary role; she only interacts with LITTLE RED-CAP in scene 1, which corresponds to their common sub-story.

A movie for the individual sub-story of LITTLE RED-CAP can be produced by connecting the scenes where LITTLE RED-CAP appears, according to the main narrative flow: 1,2,3,5 and 6 (Fig.3-a). A movie playing the individual sub-story of WOLF would consist of gluing scenes 3, 4, 5 and 6 (Fig.3-b). Scenes 1 and 2 introduce the intense story part, and, though they are part of the main character sub-story, are not essential to the main narrative. A broad view of the other interactions brings to evidence that LITTLE RED-CAP, WOLF, GRANDMOTHER, and WOODSMAN all possess a pair wise relation. Scenes 4 and 6 show the dynamics between the WOLF and GRAND-MOTHER (Fig.3-c), which also matches the individual sub-story of GRANDMOTHER. The sub-story engaging LITTLE RED-CAP and WOLF thus consists of scenes 3, 5 and 6 (Fig.3-d). Finally, scene 6 by itself (Fig.3-e) represents WOODSMAN'S individual sub-story. Additionally, scene 6 belongs to the sub-stories for all characters' tuples (pairs, triples, and quadruples).

An enumeration of the sets characterizing these interaction sub-stories is: {LITTLE RED-CAP, GRANDMOTHER}; {WOODSMAN, LITTLE RED-CAP}; {WOODSMAN, WOLF}; {WOODSMAN, GRAND-MOTHER}; {WOODSMAN, LITTLE RED-CAP, WOLF}; {WOODS-MAN, LITTLE RED-CAP, GRANDMOTHER}; {WOODSMAN, WOLF, GRANDMOTHER} and {WOODSMAN, LITTLE RED-CAP, WOLF, GRANDMOTHER}. Although WOODSMAN is not a major character, scene 6 is relevant for the narrative as it represents the climax, and ends the sub-stories of the main characters.

**Fig. 3.** Movies for the relevant sub-stories in the little red-cap story, representing individual sub-stories or sub-stories involving subsets of characters: a) {little red-cap}; b) {wolf}; c) {grandmother} and {grandmother, wolf}; d) {little red-cap, wolf}; e) {woodsman, little red-cap, wolf, grandmother} and all its non-empty subsets

## 4.2  Character Ranking

Movie content analysis embraces several facets about the characters: their dialogues, relations, affective trails, the places/scenarios where they interact and where the action takes place. In the screenplay, each dialogue has a heading line with the name of the corresponding character. Thus, the screenplay provides many features about each movie character: participation in terms of the number of dialogues, in the whole movie and by scene; co-participation in the same scene, and all linguistic information taken from the corresponding dialogues. Apart from their own dialogues, character names are often mentioned within dialogues spoken by other characters (leading to cross references) as well as in action lines, and even in names of scenarios/locations (for instance, "Earls' house").

The use of time-aligned screenplays provides the precise time at which the dialogue begins and ends in the movie, thus establishing the link between characters from the screenplay and actors in the movie. With these time labels, a set of new features can be found: character time participation in each scene and in the whole movie, as well as duration of scenes. Direct dialogue among characters can also be detected through the consecutive short time occurrence of their dialogue lines. Most of the above-mentioned features can be used to build interaction models between characters as well identify and later isolate concurrent or parallel stories within the same movie. In [13], a first approach to character analysis was provided. Here, the analysis is deepened by focusing on the characters' relations, thus providing insight on roles and sub-stories.

Character ranking is based on the relative contribution of each character to the total interaction time (speech) following the assumption that the most important characters will have the greatest number of and longest interactions. This contribution value is given by the average of the relative number of dialogues in the screenplay and the relative speech time in the movie (obtained from the tagged subtitles). We compute the expected average contribution to the total interaction time if all characters were of equal importance, i.e., 100%/total number of speaking characters. For instance, it takes the value 1.64% for a movie with 61 speaking characters ("Magnolia") and 3.7% for a movie with 27 speaking characters ("Being John Malkovich"). This value is used as a threshold to determine main characters and exclude secondary characters from the analysis.

## 4.3  Character Relations and Detection of Sub-stories

To represent character relations we used an undirected graph $G = (V, E)$, where $V$, the vertices set, includes the main characters, and $E$, the set of edges, represents the connections between main characters. Given two characters $i$ and $j$, and edge $(i, j) \in E$ whenever:

1. $i$ and $j$ interact within a scene by means of spoken dialogue, or
2. $i$ and $j$ are referred within a same scene whether by a cross reference ($i$ speaks about $j$ or vice-versa), or by an implicit reference (someone speaking with $i$ refers to $j$, or $i$ speaks and $j$ is referred within an action, or both characters names occur within a single or different actions within the scene.)

Thus, type 1 edges represent strong connections, while type 2 edges represent weak connections.

Figure 4 displays the corresponding relations graph for the movie "Magnolia". Edges in full lines represent strong connections (mentioned above as type 1), while weak connections are represented by dashed edges (type 2). For instance, Linda and Jimmy Gator are weakly connected: they never interact during the narrative, although they share a common place – the Cedars Sinai Medical Center. This relation is extracted through information conveyed by a screenplay action "…at the same time Linda walks towards us, down the same hallway we saw Jimmy Gator walking down earlier…". This means they are related as they share the same medical facilities (Jimmy Gator is ill and Linda goes there to meet her husband's doctor.) Hence, type 2 edges provide evidence to hidden relations and are a clear example of the high-level semantic features that can be extracted from the screenplay analysis. Approaches which rely on audiovisual features alone are, within the current state-of-the-art, quite far from being able to extract this kind of high-level semantic information.

**Fig. 4.** The relations graph for main characters in the movie Magnolia

The concept of character centrality becomes evident through the character relations graph. This aspect is also mentioned in [10], [5], albeit ignoring the concept of weak and strong connections.

Vertices with higher degree (number of adjacent edges) represent characters interacting with more people, thus having a prominent role in establishing links[1].

Observation of the graph clearly shows that all characters are somehow connected along the narrative, because each pair of characters is connected by a path. This reveals that the narrative cannot be split into independent stories, which never intercept. The underlying concept in graph theory is understood as connectivity. A graph $G$ is connected if there is path in $G$ between any given pair of vertices, and disconnected otherwise. Every disconnected graph can be split up into a number of connected subgraphs, called connected components (or simply components). Thus, a connected

---

[1] Jimmy Gator plays a central role: all main characters are connected to him, by either a weak or a strong relation. He presents a show in TV, to which everyone is exposed along the narrative. Earl, Phil and Linda are other central characters.

component includes a sub-set of $G$ vertices, and the corresponding edges, such that at least one path exists between each pair of vertices.

An analysis of connected components of the character relations graph reveals the different "worlds" involved in the main story, also called independent stories along the main narrative. If this graph is connected, then the movie does not present independent stories, and all sub-stories are somehow entangled. Otherwise, at least two independent stories can be identified.

To determine the connected components in the graph of relations, we apply an adaptation of the basic Depth-First-Search (DFS) algorithm [15]. DFS is a vertex labeling procedure, which goes from a source vertex $u$, discovers, and labels all vertices reachable from $u$ (labeling the connected component of $u$). A label $c$ (initially set to 1) is used to index the connected components under discovery. This entire process repeats until all vertices are discovered and labeled. At the end, the final $c$ value is the number of different components found, and vertices sharing the same index component label belong to the same connected component. This algorithm is $O(|V|+|E|)$.

Other analyses can be drawn by observing articulation vertices in $G$. A vertex is an articulation vertex if its removal leads to a disconnection within the graph, meaning the number of components increases with its removal. For our analysis, articulation vertices correspond to characters that connect independent stories. A simple algorithm based on the abovementioned DFS computes the articulation vertices. The algorithm tests each vertex $u$, by removing it, and all its adjacent edges, from the graph and checking if this removal increases the number of connected components. If so, $u$ is an articulation vertex; otherwise, $u$ is not an articulation vertex. The graph in Fig.4 is a connected graph with a single articulation vertex represented by Jimmy Gator, as he connects the individual story of Stanley with the remaining narrative.

A character with a single adjacent edge can be regarded as a satellite. There is only one way to be linked with the narrative – through the character it is linked with. Thus, a satellite has only two sub-stories: the sub-story it shares with the character linked to it, and its individual sub-story which may possibly include secondary characters, not considered for the analysis.

Sub-stories are represented by cliques in the character relations graph. A clique in a graph $G=(V,E)$ is a complete sub-graph, meaning a subset of vertices in $V$, and the corresponding edges, where each pair of vertices is connected by an edge. A clique-$k$ is a clique with $k$ vertices. Sub-stories involving a pair of characters can be detected by determining all cliques-2. Cliques-$k$ correspond to sub-stories involving $k$ characters.

The general problem of determining whether a clique of a given size $k$ exists in a given graph is NP-complete [15]. As the graphs of character relations addressed are relatively small, cliques were determined by using a heuristic algorithm. In a first step, $k$ is set to 2, and cliques-2 are listed (pairs of connected characters). Then, satellites are removed (as they cannot belong to larger cliques), $k$ is set to 3, and triples of vertices are checked for completeness. The procedure follows, iterating in $k$, and checking completeness in sub-graphs of size $k$. If no new clique is found or $k$ equals the number of main characters, the procedure stops. Although this procedure is rather unsophisticated, it runs in reasonable computational time for graphs of movie character relations, which are quite small (less than 12 vertices in our experiments).

# 5  Experiments and Evaluation

The proposed sub-story identification was evaluated through experiments concerning three well-known complex movies: "Magnolia" [16], "Crash" [17], and "Being John Malkovich" [18].

The movies were analyzed beforehand. For each movie, the analysis produced the list of main characters (as described in section 4.2), the list of independent stories, and the complete list of sub-stories involving two or more main characters (as presented in section 4.3). Table 1 presents the numbers obtained for these lists. The algorithms used for character relations analysis run in a quite low computational time (less than one CPU minute[2]). All graphs of main character relations had less than 12 vertices.

**Table 1.** Results for the analysis of the three movies

| Movie | Total number of characters | Number of main characters | Number of independent stories | Number of sub-stories with 2 characters | Number of sub-stories with 3 or more characters |
|-------|------|------|------|------|------|
| Magnolia | 61 | 11 | 1 | 20 | 51 |
| Crash | 49 | 10 | 1 | 15 | 9 |
| Being J.Malk. | 27 | 5 | 1 | 12 | 6 |

Five people collaborated in the evaluation of the results obtained. They were told about the objectives of the study and the concept of sub-story explained. The people were invited to watch the movies and immediately afterwards take individual notes on their understanding of the narrative, by making a list of the relevant characters and the underlying relations.

Then the group's common understanding of the narrative was established at a group meeting. The subjects under discussion were: "List of main characters"; "List of independent stories"; "List of sub-stories with 2 characters"; and "List of sub-stories with 3 or more characters".

We went through all the elements in the above lists that people had previously identified. The elements commonly found by all the subjects were set down as ground truth elements. Whenever people disagreed about a given element, the corresponding ground truth was established by a voting process. We then compared the elements in lists produced automatically with the ground truth obtained by the group. Table 2 displays the results obtained for each list, in terms of precision and recall. The commonly adopted ratios were used:

$$precision = \frac{\#hits}{(\#hits + \#false\ positives)} 100\% \text{ and}$$

$$recall = \frac{\#hits}{\#hits + \#misses} 100\% .$$

---

[2] All algorithms were coded in C and run in a Pentium 4, 3.2 Ghz, 1GB RAM.

**Table 2.** Evaluation of the results

| Movie | Number of main characters | | Number of independent stories | | Number of sub-stories 2 characters | | Number of sub-stories 3 or more characters | |
|---|---|---|---|---|---|---|---|---|
| | Precision | Recall | Precision | Recall | Precision | Recall | Precision | Recall |
| Magnolia | 90.9 | 83.3 | 100 | 100 | 90 | 85.7 | 93.7 | 83.3 |
| Crash | 100 | 76.9 | 100 | 100 | 100 | 70.6 | 100 | 64.2 |
| Being J Malk. | 100 | 100 | 100 | 100 | 100 | 100 | 100 | 100 |

The results obtained are promising. For the movie "Being John Malkovich", both precision and recall values attained 100% for all features. This was accomplished through a precise identification of the main characters and underlying relations that can be explained by a reduced number of main characters and consequently an easier decomposition. As for "Magnolia", the evaluators considered that Gwen should not be one of the major characters, because her story is not significant to the understanding of the narrative. Instead, they considered that Jimmy's wife and Marcie should be in the set of main characters. For "Crash", all the characters identified were considered to be relevant, but the ground truth included three characters more. It was interesting to observe that all movies were considered as a single narrative, as the evaluators agreed that all sub-stories were interconnected. This shows that our approach accurately identified the connectivity of all characters in a single main story.

People collaborating in this evaluation were very enthusiastic about the capabilities revealed in extracting high level semantic information.

## 6 Conclusions and Future Work

This paper proposes a new approach to movie content analysis, which permits identification of main characters, independent lines of action, and sub-stories. The approach proposed relies on synchronization of a movie with its screenplay. This procedure provides a time stamping for screenplay components, identification of approximate times for scene boundaries, and identification of intervening characters. The discovery of speaking characters, their discourse time, and their interactions allows one to identify a set of main characters and their relations. Concepts and algorithms from graph theory are used to analyze the graph of character relations and thus to decompose the main story, revealing some high-level semantic aspects of the narrative. Moreover, this analysis enables one to recognize different lines of action.

To our knowledge, this is the first work to combine information about character actions with information from the dialogues designed to discover connections between characters. This feature allows one to bring to light connections that would otherwise remain hidden using other approaches. Moreover, the authors have introduced the concept of sub-story as a clique in the graph of character relations. Three movies were analyzed and the results were evaluated against a ground truth reference set obtained by a group of five people. The quality of the results is quite promising.

The narrative decomposition model together with the methodologies for its implementation envisages new features for interactive movies. The production of movies for sub-stories affords the opportunity to explore specific parts of the movie with a

coherent semantic meaning and can stimulate a new approach to the movie viewing experience. This new viewing concept also promotes the discussion of issues related to non-linear movie navigation and their potential impact on movie production. Additionally, new products for movie consumers could be produced. The possibility of creating real-time navigation paths among sub-stories should contribute for the development of applications in video interactive storytelling.

Future work will deal with further refinements on the techniques for scene change detection, the production of movies for the sub-stories, and the evaluation of these movies. Other future developments will deal with evaluating the introduction of weights in the character relations graph.

**Acknowledgments.** This work was partially supported by FCT through the Operations Research Center – POCTI/ISFL/152 – of the University of Lisbon and Large-Scale Informatics Laboratory. The authors acknowledge the contribution of those who collaborated in the evaluation of the sub-stories' extraction.

# References

1. Lienhart, R., Pfeiffer, S., Effelsberg, W.: Video Abstracting. Communications of the ACM 40, 54–62 (1997)
2. Li, Y., Lee, S.H., Yeh, C.-H., Kuo, C.-C.J.: Techniques for Movie Content Analysis and Skimming: Tutorial and Overview on Video Abstraction Techniques. IEEE Signal Processing Magazine 23, 79–89 (2006)
3. Smeulders, A., Worring, M., Santini, S., Gupta, A., Jain, R.: Content-based Image Retrieval at the End of the Early Days. IEEE Tran. Pattern Analysis and Mach. Intel. 22, 1349–1380 (2000)
4. Teixeira, C., Respício, A., Ribeiro, C.: Browsing Multilingual Making-ofs. In: SIG-IL/MS Workshop on Speech and Language Tech. for Iberian Languages, Portugal, pp. 21–24 (2009)
5. Weng, C.Y., Chu, W.T., Wu, J.L.: RoleNet: Treat a Movie as a Small Society. In: Int. Workshop on Multimedia Inf., pp. 51–60. ACM Press, New York (2007)
6. Gibbon, D.C.: Generating Hypermedia Documents from Transcriptions of Television Programs using Parallel Text Alignment. In: Eighth Int. Workshop on Research Issues In Data Engineering, Continuous-Media Databases and Applications, pp. 26–33. IEEE, Los Alamitos (1998)
7. Turesky, R., Dimitrova, N.: Screenplay Alignment for Closed-System Speaker Identification and Analysis of Feature Films. In: IEEE International Conference on Multimedia and Expo., pp. 1659–1662. IEEE Press, New York (2004)
8. Martone, A., Taskiran, C., Delp, E.: Multimodal Approach for Speaker Identification in News Programs. In: SPIE Int. Conference on Storage and Retrieval Methods and Applications for Multimedia, vol. 5682, pp. 308–316. SPIE, San Jose (2005)
9. Tsoneva, T., Barbieri, M., Weda, H.: Automated Summarization of Narrative Video on a Semantic Level. In: First IEEE International Conference on Semantic Computing, pp. 169–176. IEEE, Los Alamitos (2007)
10. Everingham, M., Sivic, J., Zisserman, A.: "Hello! My name is.. Buffy" - Automatic Naming of Characters in TV Video. In: 17th British Machine Vision Conf., pp. 889–908. BMVA, UK (2006)

11. Salway, A., Lehane, B., O'Connor, N.: Associating Characters with Events in Films. In: 6th ACM Int. Conference on Image and Video Retrieval, pp. 510–517. ACM Press, New York (2007)
12. Teixeira, C., Respício, A.: See, Hear or Read the Film. In: Ma, L., Rauterberg, M., Nakatsu, R. (eds.) ICEC 2007. LNCS, vol. 4740, pp. 271–281. Springer, Heidelberg (2007)
13. Teixeira, C., Respício, A.: Representing and Playing User Selected Video Narrative Domains. In: 2nd ACM Workshop on Story Representation, Mechanism and Context, pp. 33–40. ACM Press, New York (2008)
14. Ngo, C.W., Ma, Y.F., Zhang, H.J.: Video Summarization and Scene Detection by Graph Modeling. IEEE Trans. on Circuits and Systems for Video Tech. 15, 296–305 (2005)
15. Cormen, T., Leiserson, C., Rivest, R., Stein, C.: Introduction to Algorithms, 2nd edn. MIT Press, Cambridge (2003)
16. Anderson, P.T.: Magnolia (1999), http://www.imdb.com/title/tt0175880/ (accessed 20090923)
17. Haggis, P.: Crash (2004), http://www.imdb.com/title/tt0375679/ (accessed 20090923)
18. Kaufman, C.: Being John Malkovich (1999), http://www.imdb.com/title/tt0120601/ (accessed 20090923)

# Multiple Coordinated Mobile Narratives as a Catalyst for Face-to-Face Group Conversation

Oliviero Stock[1] and Charles Callaway[2]

[1] FBK-irst, via Sommarive 18, Povo (TN) 38123, Italy
[2] University of Haifa, Mount Carmel, Haifa 31905, Israel
stock@fbk.eu, ccallawa@gmail.com

**Abstract.** Museum visits can be more useful to small groups if they can be the centerpiece of a social experience as well as an educational one. One of the most rewarding aspects of a visit, especially those involving families, is the unmediated group discussion that can ensue during a shared cultural experience. However, if current methods were to be applied to stimulate such discussions, their intrusive nature would be more likely detrimental than assistive. We present a non-intrusive method based on dramatic narrative presentations and automatic group behavior perception that we believe stimulates a group to engage in conversation as a natural part of making sense of partial narratives that require some mutual integration.

**Keywords:** Mobile drama, small group, behavior perception.

## 1 Introduction

A cultural visit is a blend of cognition, emotion, and social communication; it is perhaps the case most central to educational entertainment. Different forms of technology have been introduced to assist visitors during a visit, including audio material on cassettes (and later in digital form), and visual material through various forms of kiosks, screens, or presentation rooms. In some museums, coarse-grained localization systems have been introduced that let the system automatically know what room the visitor is in, so that the presentation recorded for that room can be automatically selected by the system.

From a scientific point of view, cultural heritage appreciation is an ideal area for exploring new concepts in intelligent user interface research. The mobile cultural setting is conducive to research issues such as novel user interfaces, intelligent multimodal presentations, and the educational and cognitive technologies that can be developed for best serving the visitor in his or her experience [1]. For instance, recent work brings the affective dimension into technology for the museum experience [2].

So far most of the efforts devoted to enhancing the museum visit experience have focused on the individual visitor. However, it is a known fact that people overwhelmingly visit museums in groups. Petrelli and Not [3] report that only 5% of visitors come to the museum alone while 45% come in organized groups, 20% with friends and 30% with children. Groups may visit a museum with or without a human guide.

I.A. Iurgel, N. Zagalo, and P. Petta (Eds.): ICIDS 2009, LNCS 5915, pp. 209–220, 2009.

Usually, large groups follow a guided tour while small groups (families, groups of friends) explore the museum on their own. They follow their own path, at their own pace and thus may benefit from a museum visitors' guide that can support both the overall group and the individuals. Individual museum visitors' guides do not encourage interaction; on the contrary, they can even discourage it (Sottovoce [4] is a case of a technically simple counterexample).

A good visit is one that leads to the development of interests, and extra value (as museum scholars say) lies in having conversations with your friends, right there, about that particular content and experience. The level and quality of conversation among small groups of visitors to a museum during the visit, or immediately after, is a fundamental indicator of the success of the museum presentation; furthermore, provoking conversation *per se* is a desirable goal within the process of learning in a cultural setting, as ethnographic studies having clearly indicated [5].

Our ambitious aim is to develop technology that helps foster conversation on the subject of cultural heritage among members of a small group of visitors in a natural, non mediated way. One aspect we wanted to avoid was to impose an external goal that has nothing to do with the pleasure and interest inherent in going to the museum. Thus we did not want to resort to a game, such as a treasure hunt, as an artificial explicit motivation to cause people to interact. Instead, we believe that conversation should come out as a direct result of the experience itself. And the motivation for participants should be of the same aesthetic, emotional and cultural nature as what we experience when exposed to high quality drama.

The outcome of the project in fact should be seen as a novel way of exploiting the theatre experience in an automated system for physical museum visits. Drama has been used in museums for quite some time as a *genre* that engages the visitor. It provides an emotional aspect that tends to be otherwise very limited if there are no individuals that one can follow. So some forms of dramatization in historical settings with human actors have been introduced, especially for children. In traditional theatre, as in most museums that adopt the drama *genre*, the public observes the whole scene and together is exposed to the actors' words, actions and emotions. On the other hand there are forms of modern theatre where different parts of the public are exposed to different portions of the scene. This starting point can be extended further: to adopt distinct narrations for different members of a small group when they are observing the same scene. In these cases the narrations are different experiences, but to maintain the goal of fostering conversation, they should govern the same content and be connected to each other within a larger coherent story.

We have based an implemented prototype on adaptive multimedia narration, rather than typical detached museum scenarios involving human actors. It is adaptive in the sense that the segments of the drama depend on the characteristics of the group of visitors and on the evolving specific context of their visit. It can also depend on a small amount of input from the visitors themselves, preferably implicit. As mentioned earlier, our scenario is mobile and based on concepts of ambient intelligence. A number of sensors and associated reasoning provide the system with information about: a) where people are, or where they appear to be moving to, through a positioning system based on Zigbee technology [6]; b) elements of group behavior, including information about the group members being all in proximity to one another; information about anyone speaking or the length of turns; and the inertial characteristics of the group,

the most important of which are who is the dominant member, and the group's general cohesiveness.

As for presentations, the starting point is that a good drama can provide a hook for getting visitors involved, and the enjoyment derived from the high quality of the dramatic narrative can be combined with the raw emotion of being in front of the real, original artifacts. In our case different but coordinated presentations are conveyed to each individual in the group, mainly through a mobile device like a PDA or a latest generation cellular phone. Each member of the group is exposed to a portion of the overall dramatic scene and the multimedia presentations are synchronized.

The key element is that multiple techniques are used for inducing visitors to engage in conversation starting from the material presented, without imposing an external goal as in a game. It is solely the inner motivation coming from the experience and narrative tension that naturally leads to conversation.

Using specific techniques, we have deliberately created narratives where the tension that the story develops cannot find relief within itself. For this, something else is needed, such as the different information experienced by fellow members of the small group, and conversation to convey that information. Techniques for achieving these differences can be of various levels of complexity. We have currently developed three techniques, described in the following section: perceptive limitation (audio blurring), semantically contrasting perspectives (each visitor hears audio from a different character for the same scene) and monological dialogue perception (similar to a one-sided telephone conversation).

While the tension/relief cycle (Section 3) is very natural in narrative, selectively withholding information from some members of a group but not others is not a natural situation (i.e., a person speaking to a group can't say one thing to one and a different thing to the others, while a computer can via earphones). One subproblem is how to make a visitor understand (at least the first time they are experiencing this new type of presentation) that the "key is in the hands" of some other member of the group, in a natural way. Multimedia and the PDA's display provides one solution for hinting at who is exposed to what information for purposes of missing narrative information.

Another scenario involving multimodality is when the group stops in front of a large display and they share a visual presentation. The auditory channel provides different individual presentations (through the PDA's earphones). After each drama segment, the group is free to move around and is meant to have a brief conversation if the story is successful. The system with its sensors observes them and understands if they do indeed talk, how much, who participated, etc. After that they may also vote to indicate how much they have enjoyed the drama. Following that they again move around freely and are exposed to a segment of the overall *framing story* that connects the various pieces and leads to a new drama segment in the specific area of the museum where people have moved to. The overall framing story is made of small units and is assembled dynamically in an adaptive manner. The drama segments themselves are larger chunks, with multiple techniques available for each location, and where a specific technique is adaptively chosen.

A specific aspect of flexibility is in the use of techniques for "bringing back lost sheep": when people go to a location where nothing is relevant from the system's point of view, or else move away from the drama setting by error. Instead, if they do not want to continue with the dramatic presentations, there is nothing the system can

do for that individual, although we can take this into account for subsequent presentations to the other group members or relay it to the drama designers.

In sum, the goals of this novel group-oriented approach, integrating (a) group behavior sensors and reasoning and (b) a coordinated narrative system for mobile devices based on specific techniques for variation, are (1) to have a positive effect on the small group members' view of their museum visit and, in substance, to lead to a memorable group cultural experience; and (2) that the dramatic genre based on the various techniques adopted have an impact on the quality and quantity of 'museum-oriented' conversation. The latter is taken for granted: conversation has been proven by [5] to be the key aspect for learning in the museum.

The rest of the paper is organized as following: a description of our prototype dramatic presentation system, an example related to the Hecht Museum at the University of Haifa where we are experimenting with the system, background and state of the art, and requirements for an evaluation of a system of this type.

## 2  System

Our system for presenting dramatic narratives to multiple museum visitors is centered around smartphone technology. In this scenario, each visitor is in possession of a device like a Google phone or iPhone (perhaps their own rather than one supplied by the museum) equipped with a large color screen, headphone jacks, wireless connection, and multiple sensors. These hardware capabilities allow each device to communicate with the visitor, devices held by other members of the visitor's group, and a coordinating server, and can also provide each of these devices with current information such as location, orientation, proximity and speech detection.

### 2.1  Presentation Component

We are taking advantage of the hardware capabilities of modern smartphones to create an integrated, collaborative dramatic presentation (Fig. 1) as museum visitors move separately or together around the museum. Particular presentations can be triggered by a variety of timers or sensor inputs, such as locational beacons, proximity to museum exhibits or other group members, or the amount of speech detected. We are trying to use this ability to manipulate pieces of dramatic presentations to achieve the goals mentioned in the introduction. Our prototype scenario involves a small group moving through a museum in a fixed sequence of rooms (but not fixed sequence of exhibits), listening to dramatic clips that help expand their ideas of how artifacts were used by real people while at the same time serving as a vehicle to convey dramatic tension.

Our dramatic scenario involves a set of both historical and current "actors" and is set in several areas of the museum, including one of its most important exhibits: the underwater excavation of a 2,500 year-old wooden Mediterranean trading vessel. A team of writers from the university drama department created a set of scripts involving historical characters who might have been involved in the daily operation of the vessel (captain, carpenter, etc.) as well as modern characters such as the excavation's archaeologist and a ghost of one of the ancient characters. The modern characters are intended to explicitly engage the museum visitors, while the historical characters are engaged in activities that evoke their prior roles.

 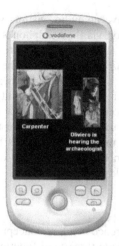

**Fig. 1.** Smartphones playing related dramatic presentations (the display indicates both which actor is being heard as well as what fellow group members are hearing)

To ensure that museum visitors have something to discuss, we both monitor and lightly manipulate group behavior (e.g., by asking them to move to another area), and use specific techniques to show each visitor the same underlying dramatic display but with slight variations in audio content. From the narrative perspective, our hypothesis is that these variations in received content will spur group conversation both during and after the visit.

In order to provide for variation in the audio content that visitors hear as they watch the dramatic presentations on their device, and to ensure that most of what they perceive is similar (so that what they discuss is the varied material), we have implemented to date three variation techniques as mentioned above:

- Audio "blurring": selected portions of a conversation are not understandable because some source of natural noise (seagulls screaming, the sound of waves breaking, etc.) interferes with the spoken dialogue
- A one-sided telephone conversation style: perhaps due to distance between the speakers, only one dramatic actor is understandable; as that actor talks to other actors, we hear only the one nearest to us as shown by the display
- Content change due to point of view: When two or more actors are onscreen, we can change the audio so that the dialogue heard reflects the point of view of one of the actors over the others

The first of these variation techniques would affect only fifteen seconds out of a single 2-minute animation, the second would provide totally complementary audio parts, and the third can include a varying degree of semantic difference in the material. Their use would be coordinated so that the museum visitor has little reason to believe that some content has been gapped out of the audio.

Another method involving different audio but identical filmed video is the case of temporarily switching the video playback from the mobile device to a fixed-position large screen. Here visitors arrive, their position in front of the screen is detected, and an audio channel is dynamically allocated to each group member. Because the fixed

screen would have no audio, visitors would need to hear the continuation of the dramatic presentation via the headphones connected to their mobile device. This allows us to change the audio portion of a presentation as needed.

The combination of variation in the audio of dramatic presentation and adapting to the information derived from hardware sensors like position and voice detection should allow for significant flexibility in getting visitors to discuss their museum experience without the need for invasive methods such as asking detailed questions. As mentioned earlier, we expect that the presence of narrative tension and the post-visit realization that each visitor has had a slightly different experience will lead to extended, self-motivated discussion of the visit, which is precisely what museums themselves would like to encourage.

## 2.2  Sensors

Ambient intelligence is a key concept in our setting. Sensors are a fundamental component and provide three vital functionalities: positioning, relative mobile proximity and voice activity detection. The wireless sensor network, which takes care of general positioning and the different kinds of proximity, uses Zigbee [6] technology. It is based on moving blind nodes (small devices carried by visitors), fixed beacons, network gateways and a data server. The central data server includes a reasoning component which then provides higher level information to the presentation devices (PDAs or smartphones). Proximity (the radius can be software-defined for each individual device) to beacons is important for finer positioning when close to a specific exhibit and is seamlessly integrated into the general positioning system. Two other characteristics of the detection system are very important here: (a) proximity among mobile agents, i.e. the capability of locally understanding when a group of people are together, and (b) individual voice activity detection: tiny directional microphones are integrated in the small blind nodes the intensity of the audio signal is detected differently depending on whether the source is the wearer or someone else.

Data then go to a central unit that for positioning takes into account spatial constraints and application-specific heuristics to filter out false positives. The result is continuously updated visitor position. Proximity among people and information about voice activity are the basis for the system to reason about the group characteristics and state. The system can also determine when people are continuing to stay together, and whether at an expected moment, such as immediately after a stimulus when visitors engage in conversation, who is participating, duration, etc.

General positioning and proximity to exhibits are obviously important for a nonintrusive mobile system. The adopted technology yields continuous positioning, which is important for selecting appropriate presentation material, but also for understanding if an individual is going to an irrelevant site. Group behavior detection is fundamental because in the system this is one of the most important elements for providing implicit input to the system, and also as a feedback mechanism that can assess for the system the effectiveness of the adopted techniques (see also [8]).

It should be noted that group activity has been the object of some research, but to our knowledge this research has not emphasized the mobile aspect. One of the closest works is by Kim and colleagues [9], who used a portable device called the "sociometric badge" to monitor speaking activity and other social signals in a team. Their work

is not in combination with sophisticated positioning and their aim is mainly meant to give feedback to individuals about the overall group behavior. They report on a graphical representation of the group behavior on a private display. However, their goal was completely different from ours: by reflection on their behavior, as represented on the display, participants were shown to better respect turns and to reduce overlaps in their speech.

## 3  Model of Dramatic Narrative Presentations

The sequence of drama segments follows the same organization that underlies narrative plots in general: an introduction followed by slowly rising development, repeated instances of rising and lowering tension, followed by the climax and conclusion. In our model, the introduction, climax and conclusion remain constant, while the cycles of rising and lowering tension are pairs consisting of a *primary drama segment* and one or more smaller *frame story segments*. The former are fixed, of longer duration and tied to a specific area of the museum, while the latter can be adaptively chosen from a set of several potential candidates and can include from 1 to 3 different elements. Fig. 2 shows a graphical model of this approach.

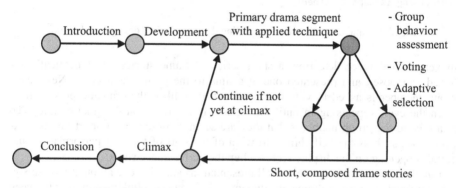

**Fig. 2.** Graphical model of interactive narrative progression

In Fig. 3 an excerpt of the drama using the "one-sided telephone conversation style" is shown. The scene occurs at the big exhibit where an ancient Greek ship discovered only recently along the coast is on display.

Upon arrival at a new exhibit where the proximity detector indicates the arrival of the group, the primary drama segment associated with that exhibit is initiated, incorporating one of the techniques that removes different key elements of the narrative for different group members from the audio channel. Following that, the visitors are allowed a small amount of time to discuss and explore the space around the exhibit before being alerted that the next primary drama segment will begin shortly in the next area. Immediately after the conclusion of the primary drama segment, and based on reasoning over implicit sensor data such as group proximity, cohesion,

Diver: Look, there's the ship's anchor. Over there, in the water still in one piece, as if waiting to be found. 2500 years old…the oldest anchor to be found in its entirety, and I'm the one to fish it up.

………

Diver: at last I am part of a meaningful project.
Diver: The sea has kept this secret since the Persians reigned, before the Greeks, before Alexander the great…

………

Diver: the university's lab will preserve the ship and reconstruct it. There's so much I can learn from it!

………

Diver: Reconstructing the ship will take time, but what a project it will be! and the credit is mine! I made it happen!

………

Diver: I mark the parts, I make sure everything is kept together!

Sailor's ghost: careful! Don't crush it! One wrong movement and the wood will crumble, scatter to oblivion.

………

Sailor's ghost: Here it comes! It's happening! He's going to ruin my masterpiece.

………

Sailor's ghost: Never mind the Persians, never mind Alexander, It's me who has spent days and nights making this anchor, this ship, polishing the right angles, getting cut by the nails. Who gave you permission to touch it? To draw it out of the water? He's stealing it right in front of my eyes, and there's nothing I can do about it!

………

Sailor's ghost: Hey, whatever you need to know, I can tell you.

………

Sailor's ghost: no way, the credit is mine!

**Fig. 3.** Sample dramatic script illustrating the monological dialogue technique

movement and voice detection, a short series of frame stories are dynamically selected, composed and presented one at a time to the group members. Next, each group member is asked to vote on how much they liked the dramatic presentation. Then the cycle repeats again until the visitors have arrived at the final exhibit. To reinforce to the group members that they are seeing a drama, we import familiar expectations, such as the bell chimes to warn of the start of the next performance, and curtains opening on the display screen when the performance starts.

Finally, in order to keep the overall presentations adaptive even though we use significant fixed portions of drama, we dynamically compose a linking narrative between two primary drama segments. These frame stories involve an archaeologist character, who conveys both authority and inner conflict. Given a library of frame story elements, we use the visitor behavior as detected by the sensors to choose 2 to 3 frame story elements to connect the primary drama segments, providing both perspective and a relaxing "pause" from the primary dramas which are the main vehicles for narrative tension.

The contents of the unfolding drama (completed just for an initial part of the museum) are concerned with the archeologist's own reflections, questioning his personal contribution at the moment he is about to receive a lifetime achievement award. He is led to re-visit the museum and this is the occasion for both hearing voices from the past and for raising doubts, thus putting his findings into perspective.

The message in the end is that there is not one truth or true perspective, and that the picture is often more complex than it may appear.

# 4  Evaluation Measures

In addition to implicit (sensor) feedback such as moving around and talking, we also ask for explicit group feedback. Although previous museum research has examined feedback for individuals [10], we are interested in feedback by group members that will allow us to determine the different attitudes towards each dramatic presentations just seen. Upon receiving the visitor's votes, we have access to several different helpful pieces of information:

- Their opinions on the quality or interestingness of a dramatic presentation, as well as trend analysis (do they become more interesting over time)
- Are there subgroup differences? E.g., was the vote 2-2, 3-1 or 4-0? Can we exploit differences in the next segment of the visit, such as trying to keep apart group members who voted similarly? Would there be a different effect if we allowed (or didn't allow) the group members to see how other members voted?
- The correlation of the presence of specific dramatic characters and especially different "techniques" with presentation interestingness.

The goal of the design and implementation of the museum experience prototype discussed above is to unconsciously engage museum visitors in a discussion of their visit. In order to assess the success of this goal, we should measure when, and for how long such discussions occur (an analysis of the content of these discussions is currently outside the scope of our work):

- When: We hypothesize that most conversation will take place immediately after the presentation of each dramatic narrative segment. We thus need to compare timed logged events in order to show whether this expected correlation indeed occurs.
- How long: We further hypothesize that the more interesting the visitors have found the dramatic presentations to be, the longer they will discuss that particular presentation. We will thus want to correlate the results of voting with length of discussion, and especially to determine how different voting subgroups discuss with each other (e.g., like with like, or like with unlike).

It is interesting to emphasize that these two aspects of group feedback (implicit – based on behavior observation and explicit – based on a vote on the appreciation of the drama portions) influence the subsequent behavior of the system, in addition to providing data for evaluating the effectiveness of the system. Finally, we are currently conducting a series of iterative evaluations to determine which directions hold the most promise, as this work is exploratory and there are no obvious "best" methods.

# 5  Related Work

The background for our hypothesis that missing information and narrative tension have a marked cognitive affect on people following a story (specifically, that it will induce conversation) is reflected in work by Alwitt [11], where *curiosity* is the term used to indicate this latent motivation: "Curiosity is produced when the audience knows that some information is missing; there is an information gap. This mystery

creates tension as the narrative unfolds. Because the audience knows just enough to recognize that some information has been omitted, he or she wants to know what was omitted." More specifically, we believe that narrative is such a fundamental, internal cognitive process that visitors will subconsciously be driven to be curious about resolving the information missing from the dramatic narratives we have presented to them. By ensuring that the visiting group members are in close proximity after selected pieces of critical information have been gapped out, we also ensure that group discussion is the easiest way for them to recover that information.

Like the *Affective Guide* [12], our system is a story-telling tour guide for visitors to cultural heritage sites. *Affective Guide* is a PDA-based system that uses GPS to trigger storytelling episodes via text-to-speech as a user walks by a specific location. A 2D virtual tour guide on the PDA (an animated head) speaks out loud each story, whose length is determined by an emotional model. The emotional model is included in an attempt to lessen the frustration users feel when interacting with non-adaptive systems. Whereas *Affective Guide* is used in outdoor settings and is intended to be a testbed for the underlying emotional model, our system is mainly intended for museums as a way to encourage discussion of the interesting exhibits that visitors come across. Both systems use pre-written scripts, although in our system each segment is one part of the overall story rather than a single self-contained story.

*Façade* [13] is a story-based interactive drama game intended to show the video game community that there are other approaches beyond shooting enemies and looking for resources within explorable worlds. The game consists of an animated set of married characters controlled by the computer who interact with a "friend" character controlled by the user. Language and gesture are used as the principle interactive mechanisms, and a drama manager uses a weighting algorithm to determine the next step of the drama given the user's input. Unlike our system, *Façade* can produce original stories given differences in user input, whereas our system is highly scripted and variations occur between the major elements of the drama, although these variations are also driven by user input and behavior.

Drama in a mobile setting is something that has appeared some time ago. Multiple synchronic scenes, each visible only to a subset of the spectators, which would then move to another location, were in the tradition of some forms of popular theatre already in the Middle Ages. Some concepts have come back in contemporary theatre (e.g. in Luca Ronconi's Orlando Furioso, 1969). In more recent times the concept has found a natural match in communication and positioning technologies. Mobile Urban Drama has been introduced [14] based on cellular phone technology and standard, readily available positioning in the open: GPS, wifi and tags for very close detection of hotspots. The user is the main character and actors' voices are heard through the cellular phone. The user is directed to different positions in a city and has to look for specific spots and information. Real actors integrate the scene. The concept, though, is not particularly based on interaction within a group of users. And certainly it does not include the idea of location based technologies and coordinated narratives with specific techniques oriented toward  favoring face to face natural conversation in a small group.

A large number of prototype museum guides have been developed that seek to present historical or educational material to museum visitors either in an adaptive way that focus on what the guide thinks a visitor might be interested in. The *Sotto Voce*

[4] system instead looked at social interaction as a primary design goal, namely, how can group members influence each other as a means to improving education or retention of museum knowledge. Thus *Sotto Voce* allowed group members to hear the audio from each others' PDAs by explicitly selecting an "eavesdropping" button on their own user interface. However, to the best of our knowledge, no research on museum guides has yet addressed how to change the behavior of group members as they explore a museum.

## 6  Conclusions

Digital storytelling can address groups in ways that would not be possible without technology. In particular it can offer the possibility of providing individuals in a group different viewpoints in a story at the same time, and to adapt to the group behavior. In our case the overall aim is not only to provide an engaging story but to affect group behavior: the effect of the story is to influence individuals so they interact with other members of the group. The interesting thing is that the ensuing conversation is inherent in the nature of the drama experience: it does not occur because an external explicit goal was acquired by the group, as for instance in a "treasure hunt". Our applied goal comes from a museum technology context, in which we are addressing novel issues, concerned with a small group visit: ethnographic studies have pointed out that conversation within the group about the experience is the best result at the moment of the cultural visit.

In order to produce a system that can realize our ideas, we had to implement three main aspects. First, a complex group behavior detection system, based on a sensor network integrating an interior positioning system, with the capability of detecting proximity among people and voice activity. Second, a system for planning coherent story segments and coordinating multiple presentations that are yielded synchronously through personal devices, where the planning system must adapt to the group behavior. Third, the material presented composes a drama, and as such it had to have high production values, interesting content, and good aesthetic and emotional quality; in particular a key aspect is the use of specific techniques in the combined individual-oriented narrations, which are a catalyst to immediate face-to-face conversation.

A system prototype has been realized and is undergoing experimentation at the Hecht Museum at the University of Haifa. As mentioned earlier, the message in the end is that there is no single truth, and that the picture requires an integration of different points of views and  perceived aspects. The ensuing social behavior in the group echoes the message of the drama. Though seriously evaluating the overall result will take a long time, our current realization and initial feedback indicate that there is a serious prospect, from technological, artistic and applied points of view, for novel sophisticated storytelling combined with ambient intelligence for groups.

## Acknowledgments

We would like to acknowledge Elyon DeKoven, for the initial evaluation, and Kinneret Noy, Yael Dobrin and Yael Citron for the drama writing. The work was realized

in the context of the FIRB project RBIN045PXH sponsored by the Italian Ministry for Research and University and by the Autonomous Province of Trento.

# References

1. Stock, O., Zancanaro, M. (eds.): PEACH: Intelligent Interfaces for Museum Visits. Cognitive Technologies Series, vol. 5216. Springer, Heidelberg (2007)
2. Lim, M.Y., Aylett, R., Jones, C.M.: Affective Guide with Attitude. In: Proceedings of the First International Conference on Affective Computing and Intelligent Interaction (ACII), Beijing, China, October 2005, pp. 772–779 (2005)
3. Petrelli, D., Not, E.: User-centred Design of Flexible Hypermedia for a Mobile Guide: Reflections on the HyperAudio Experience. User Modelling and User Adapted Interaction 15, 303–338 (2005)
4. Aoki, P.M., Grinter, R.E., Hurst, A., Szymanski, M.H., Thornton, J.D., Woodruff, A.: Sotto Voce: Exploring the Interplay of Conversation and Mobile Audio Spaces. In: Proceedings of the ACM SIGCHI Conference on Human Factors in Computing Systems, Minneapolis, MN, April 2002, pp. 431–438 (2002)
5. Leinhardt, G., Knutson, K.: Listening in on Museum Conversations. Altamira Press (2004)
6. The Zigbee Alliance, http://www.zigbee.org (as of September 23, 2009)
7. Yehoshua, A.B.: Mr. Mani. Doubleday, New York (1990)
8. Dim, E., Kuflik, T.: Group Situational Awareness: Being Together. In: The Proceedings of the Workshop on Personalisation in Mobile and Pervasive Computing, UMAP (2009)
9. Kim, T.J., Chang, A., Holland, L., Pentland, A.S.: Meeting Mediator: Enhancing Group Collaboration with Sociometric Feedback. In: Proceedings of ACM Conference on Computer-Human Interaction (CHI 2008), Florence, April 2008, pp. 3183–3188 (2008)
10. Graziola, I., Rocchi, C., Goren-Bar, D., Pianesi, F., Stock, O., Zancanaro, M.: Delegation Based Multimedia Mobile Guide. In: Maybury, M., Stock, O., Wahlster, W. (eds.) INTETAIN 2005. LNCS (LNAI), vol. 3814, pp. 328–331. Springer, Heidelberg (2005)
11. Alwitt, L.F.: Maintaining Attention to a Narrative. Advances in Psychology Research 18, 99–114 (1994)
12. Lim, M.Y., Aylett, R.S.: Feel the difference: A Guide with Attitude! In: Pelachaud, C., Martin, J.-C., André, E., Chollet, G., Karpouzis, K., Pelé, D. (eds.) IVA 2007. LNCS (LNAI), vol. 4722, pp. 317–330. Springer, Heidelberg (2007)
13. Mateas, M., Stern, A.: Façade, an experiment in building a fully-realized interactive drama. In: Proceedings of the Game Developers Conference, San Jose, CA (March 2003)
14. Hansen, F.A., Kortbek, K.J., Grønbaek, K.: Mobile Urban Drama – Setting the Stage with Location Based Technologies. In: Spierling, U., Szilas, N. (eds.) ICIDS 2008. LNCS (LNAI), vol. 5334, pp. 20–31. Springer, Heidelberg (2008)

# Directorial Control in a Decision-Theoretic Framework for Interactive Narrative

Mei Si, Stacy C. Marsella, and David V. Pynadath

Institute for Creative Technologies
University of Southern California
Marina del Rey, CA 90292
meisi@ict.usc.edu, marsella@ict.usc.edu, pynadath@ict.usc.edu

**Abstract.** Computer aided interactive narrative has received increasing attention in recent years. Automated directorial control that manages the development of the story in the face of user interaction is an important aspect of interactive narrative design. Most existing approaches lack an explicit model of the user. This limits the approaches' ability of predicting the user's experience, and hence undermines the effectiveness of the approaches. Thespian is a multi-agent framework for authoring and simulating interactive narratives with explicit models of the user. This work extends Thespian with the ability to provide proactive directorial control using the user model. In this paper, we present the algorithms in detail, followed by examples.

**Keywords:** Interactive Narrative, Drama Management.

## 1 Introduction

With the rapid development of computer technology, a new form of media – interactive narrative has received increasing attention in recent years. Interactive narrative allows the user to play a role in a story and interact with other characters controlled by the system. It has been widely applied for both pedagogical and entertainment purposes [1,2,3,4,5,6,7,8,9,10].

The support of interactivity distinguishes interactive narrative from other narrative forms. In traditional narratives, the relation of the audience (or reader) to the narrative is always passive. By allowing the user to interact, interactive narrative provides a potentially more engaging experience. Moreover, because different choices of the user can result in different stories, the author can tailor the experience for individual users.

On the other hand, user interactivity introduces tremendous challenges to the design process. As the author cedes partial control of the story to the user, it is much harder to control the development of the story so that it achieves the author's desired effects [11]. For example, in non-interactive narratives, the dramatic effects are created by imposing conflicts and tensions on the characters and resolving them over the course of the story. However, the user in an interactive narrative has control over their character and may act to avoid such conflict and tension.

I.A. Iurgel, N. Zagalo, and P. Petta (Eds.): ICIDS 2009, LNCS 5915, pp. 221–233, 2009.
© Springer-Verlag Berlin Heidelberg 2009

To control the development of the story in the face of user interaction, automated directorial control (drama management) is often applied. It continuously adjusts the story, so that the story's development is both coherent and leads to the author's desired effects.

Various approaches for directorial control have been proposed. In search-based approaches, the drama manager operates over a set of plot points with pre- and postconditions [12,13,4,14]. Based on an author-specified evaluation function and in reaction to the user's actions, the drama manager reconfigures the story world to achieve best quality in the story. Mimesis takes a different approach, whereby the system may prevent the user's action from being effective [5]. When the user's action deviates from the pre-computed story plan, the system either replans or makes the user's action have no effect on story development. Similarly, in IDA [7], when there is a problem with the flow of the story, the director agent tries to get the story back on track. Façade [10] utilizes a beat-based drama management system. Based on a desired global plot arc, the drama manager chooses the next beat that is suitable to the context and whose dramatic value best matches the arc.

Most existing approaches do not model the user explicitly (IDA [7] is a notable exception.) The lack of a user model restricts the effectiveness of directorial control in several ways. In existing work, directorial controls are often applied based on rules predefined by the author for a "standard user," and therefore cannot be adaptive to individuals who may react to the events differently. Further, the coherence of narrative, which requires the events in the story to be meaningfully connected in both temporal and causal ways [15], is crucial for ensuring that people can understand their experience [16,17]. A key aspect of creating coherent narratives is that the characters' behaviors must be interpretable to the user. In interactive narratives, it is hard to avoid generating unnatural characters' behaviors when interacting with the user without a model of the user's beliefs and experiences.

Thespian [18,3] is a multi-agent framework for interactive narratives. Thespian models each character in the story as a decision-theoretic goal-driven agent, with the character's personality/motivations encoded as the agent's goals. The user is also modeled using an agent, based on the character which the user takes the role of [19]. Thespian facilitates the user's understanding of their experience in two ways. First, the ability of goal-based agents to decide their actions based on both the status of the interaction and their goals makes Thespian agents react to the user and behave with consistent motivations. Secondly, Thespian agents possess a "Theory of Mind" [18] and can model emotions [20] and social normative behaviors [21]. The Theory of Mind capacity allows the agents to reason about others' beliefs, goals and policies when deciding their own actions. Along with the modeling of emotions and social normative behaviors, these capabilities make the agents' behavior seem more socially aware and life-like. Because the user is modeled as a Thespian agent, these capacities also allow the system to model the user's beliefs about other characters and the user's subjective experience.

This work extends Thespian to provide proactive directorial control using the user model, which was used in [19] as a means to test the interactive narrative system, and here for predicting the user's behavior and estimating the user's experience. A director agent is designed to monitor the progress of the story, predict its future development and adjust the virtual characters' behaviors and beliefs if necessary to prevent violations to directorial goals. The evaluation of the achievements of directorial goals is tied to the model of the user. In addition, the adjustments to the virtual characters do not break their appearance of acting with consistent motivations. We present the algorithms in detail, followed by examples.

## 2   Example Domain

In this paper, the "Little Red Riding Hood" story is used to demonstrate our approach for directorial control. The user plays the role of the wolf. The story starts as Little Red Riding Hood (Red) and the wolf meet each other on the outskirt of a wood while Red is on her way to Granny's house. The wolf has a mind to eat Red, but dares not because there are some woodcutters close by. The wolf, however, will eat Red at other locations where nobody is around. Moreover, if the wolf hears about Granny from Red, it will even go eat her. Meanwhile, the hunter is searching the wood for the wolf. Once the wolf is killed, people who were eaten by it can escape.

## 3   Thespian's Current Architecture

We developed Thespian as a multi-agent framework for authoring and simulating interactive narratives. Thespian is built upon PsychSim [22], a multi-agent system for social simulation based on Partially Observable Markov Decision Problems (POMDPs) [23].

### 3.1   Thespian Agent

Thespian's basic architecture uses decision-theoretic goal-based agents to control each character in the story, with the character's personality/motivations encoded as the agent's goals. Each agent can have multiple and potentially conflicting goals with different relative importance (weight). For example, the wolf can be modeled as having the goals of not starving itself and also keeping itself alive, with the latter being ten times more important. An agent's state keeps track of the agent's physical and social status in the story. State is defined by a set of state features, such as degree of hunger, whether being alive, and degree of affinity with another character. The values of state features can be changed by both the agent's own actions, e.g. eat, and other characters' actions, e.g. being killed. Thespian agents have beliefs (subjective view) about itself and others, which forms a "Theory of Mind". An agents' beliefs can also include other

agents' subjective views of the world, a form of recursive agent modeling [24]. For example, the wolf can have beliefs about Red's beliefs about the wolf's goals. Currently, for decision-making all agents use a bounded lookahead policy. They project limited steps into the future to evaluate the effect of each available action, and choose the one with the highest overall expected utility (the sum of utilities at each future step). Because Thespian agents have a "Theory of Mind", it considers other agents' responses, and in turn its own responses when evaluating the utility of an action option.

### 3.2   Fitting Characters' Motivations

Thespian's fitting procedure [25,18] allows the author or the director agent (see Sect. 4 for details) to configure the goals of an agent using linear story paths (sequence of characters' actions). The fitting procedure can tune the agent's goal weights according to the agent's role in the story paths, so that the agent's autonomous behaviors follow the story paths when the user's behavior also follows the paths. When the user deviates from the paths, the agent will use the same goals weights "learned" from the paths to motivate its actions.

The fitting procedure automatically extracts constraints on the agent's goal weights from the story paths and determines whether consistent goal preferences can be inferred, i.e. whether the same goals preferences can drive the agent to act as specified in the story paths. When fitting fails, it is impossible for a character with consistent motivations to follow all the story paths. The author or the director agent will need to modify either the paths or the design of the agent.

### 3.3   Suggest Changes to Character's Beliefs

Similar to fitting, the "Suggest" procedure can adjust an agent's configuration so that the agent prefers the action desired by the author or the director agent over other choices. "Suggest" achieves this functionality in the opposite way to fitting. In fitting, the relative goal weights of the agents are adjusted, and the agent's beliefs and state are untouched. The "suggest" procedure suggests changes to the agent's beliefs without affecting its goal weights. For example, to make the wolf not eat Granny, fitting may result in the wolf having a very low goal weight of not starving itself, and the "suggest" procedure may return a suggestion that the wolf should believe it is not hungry.

## 4   Directorial Control

Thespian utilizes a specialized agent – a director agent – to realize directorial control. Different from other agents, the director agent is not mapped to an on-screen character. The director agent also has accurate beliefs about all other agents including their beliefs about each other. In contrast, for modeling narratives it is often necessary for characters to have incorrect beliefs about each other. The function of the director agent is to monitor the progress of the

story and adjust the virtual characters' behaviors if needed to achieve directorial goals. When the director agent is functioning, it takes over other agents' decision-making processes, decides the best movements for the story and causes other agents to perform the corresponding actions.

The director agent has a model of the user, which assumes that the user identifies with the character, and therefore adopts the character's goals to a certain degree. Directorial control is performed based on the director agent's expectations about the user's experience and choices. Of course, the user can always act unexpectedly to the director agent, but this does not affect the director agent's workflow (see Sect. 4.3 for details.)

## 4.1  Design Challenge and Approach

Thespian agents are goal-based agents. Their behaviors are decided by their beliefs and goals. Adjustments to the agents' behaviors often require adjustments to their beliefs and goals. Though these adjustments are not directly visible to the user, improper adjustments may result in the characters having sudden and unnatural behaviors, and may lead the user to interpret the characters as inconsistent. Therefore, the basic challenge for directorial control in a system that uses autonomous characters is how to ensure that the virtual characters exhibit consistent motivations throughout the story while modifying their beliefs and goals. Further, the characters' motivations should be consistent with the author's portrayals of the characters in the story paths used for configuring (fitting) the agents.

To address this challenge, the basic assumption is that the user will not have a precise mental model about the characters because the user's observations in the story will not support such precision. Typically a range of configurations of a character can be used to explain the character's behaviors. Therefore, as long as the adjustments to the character's goals and beliefs fall within the space of the user's mental model about the character, the user will not experience inconsistency in the character. The boundary of the range, i.e. how precise the user's mental model about the character is, is decided by the user's prior interactions with the character and the user's prior beliefs about the character. In this work, we use fitting-based procedures to decide whether a belief change is reasonable to happen for a character, and whether an action is consistent with a character's motivations exhibited in its prior interactions with the user, and with the author's design of the character.

## 4.2  Directorial Goals

Directorial goals are used by the author to indicate how they want the story to progress, such as when an action should happen, or a character should change its belief about another character. Thespian currently supports directorial goals expressed as a combination of temporal and partial order constraints on the characters' including the user's actions and beliefs. Table 1 lists the syntax for specifying directorial goals. Six different types of goals are supported. The events

**Table 1.** Syntax for Specifying Directorial Goals

| | |
|---|---|
| orders = | [*event1,event2*] |
| | *event2* should happen after *event1* |
| earlierThan = | [*event,step*] |
| | *event* should happen before *step* steps of interaction |
| laterThan = | [*event,step*] |
| | *event* should happen after *step* steps of interaction |
| earlierThan2 = | [*event1,event2,step*] |
| | *event2* should happen within *step* steps after *event1* happened |
| laterThan2 = | [*event1,event2,step*] |
| | *event2* should happen after *step* steps after *event1* happened |
| NoObjIfLater = | [*event,step*] |
| | if *event* hasn't happen after *step* steps of interaction, the constraint for it to happen if exists, does not apply any more |

**Table 2.** Directorial Goals Example

| | |
|---|---|
| orders = | [["wolf-eat-Granny", "anybody-kill-wolf"], |
| | ["wolf-eat-anybody", "wolf: wolf's hunger = 0"]] |
| earlierThan = | [["wolf-eat-red", 50], ["wolf-eat-Granny", 80]] |
| earlierThan2 = | [["wolf-eat-Granny", "anybody-kill-wolf", 30]] |
| laterThan2 = | [["wolf-eat-red", "wolf-eat-Granny", 10]] |
| NoObjIfLater = | [["wolf-eat-red", 60]] |

in the syntax can be either an action, e.g. "wolf-eat-Granny" or a character's belief, e.g. "wolf: wolf's hunger = 0 (the wolf believes that the value of the wolf's state feature hunger is 0) ." The author can combine any number of goals defined using this syntax. Table 2 gives an example of directorial goals.

### 4.3   Director Agent

Directorial control is applied every time after the user performs an action. Function **Directorial_Control** (Alg. 1) contains the pseudo code for the overall workflow of directorial control.

**Overview of the Workflow**

The director agent maintains a list of objectives that it will try to reach. Each objective indicates the desirability of an event, such as "hunter-kill-wolf is desirable", or "Red: Red's alive = 0 is undesirable". Initially, this list is empty (line 1 in Alg. 1). After each time the user acts, the director agent simulates *lookaheadSteps* steps of interaction in the future (line 8), examines whether the future development of the story is consistent with the author's directorial goals, and creates a list of objectives if it foresees violations (line 9).

Table 3 lists the objectives that will be created in function **Test_Violation** for violating each type of directorial goals. In general, if a partial order constraint

**Algorithm 1.** DIRECTORIAL_CONTROL()

```
 1: objectives ← [ ]
 2: bestOption ← [ ]
 3: minViolation ← ∞
 4: futureSteps ← [ ]
 5: for each i in range(Num_of_Tests) do
 6:     if objectives != [ ] then
 7:         Adjust_Config(objectives)
 8:     futureSteps ← Lookahead(lookaheadSteps)
 9:     objectives ← Test_Violation(futureSteps)
10:     if Length(objectives) < minViolation then
11:         bestOption ← futureSteps
12:         minViolation ← Length(objectives)
13: return bestOption
```

is expected to be violated, the director agent will try to prevent the latter event from happening; if a temporal constraint is expected to be violated, the director agent will try to arrange the event to happen or not happen according to the constraint. For example, based on the directorial goals described in Table 2, if the wolf has not eaten Red by the 50th step of the interaction, a violation happens, and the objective of "wolf-eat-Red is desirable" will be added. As the last step of **Test_Violation**, the "NoObjIfLater" goals are applied – if there is an objective for *event* to happen, and *step* steps of interaction have already passed, the objective will be taken out.

When the list of objectives is not empty (line 6 in Alg. 1), the director agent will try to tweak the characters' configurations for reaching the objectives. Function **Adjust_Config** (Alg. 2) adjusts the characters' beliefs and goals for inducing actions or preventing actions from happening as indicated in the objectives. Adjusting the characters' beliefs often requires a fictional action to happen for inducing the belief change (see Alg. 4 for details) and therefore may have side effects. Therefore, preference is given to adjusting the characters' goals for achieving the objectives. Function **Adjust_Config** first tries to fit the characters' goals to achieve the objectives. If none of the objectives can be reached this way, it will try to change the characters' beliefs and then fit the characters' goals again. If the objectives involve the user's actions (either being desirable or undesirable),

**Table 3.** Objectives if Directorial Goals are Violated

| Violated Goal | Desirable Actions | Undesirable Actions |
|---|---|---|
| orders =[event1,event2] | | event2 |
| earlierThan =[event,step] | event | |
| laterThan =[event,step] | | event |
| earlierThan2 =[event1,event2,step] | event2 | |
| laterThan2 = [event1,event2,step] | | event2 |

---

**Algorithm 2.** ADJUST_CONFIG(*objectives*)

---

1: *fitting_result* ← **Fit_To_Objectives** (*objectives*)
2: **if** *fitting_result* == *false* **then**
3:    *beliefChanges* ← **Find_Suggestions**(*objectives, futureSteps*)
4:    **for** each *beliefChange* in *beliefChanges* **do**
5:       **if** **Find_Explanation**(*beliefChange*) **then**
6:          **Apply_Belief_Changes**(*beliefChange*)
7:    **Fit_To_Objectives**(*objectives*)

---

---

**Algorithm 3.** FIT_TO_OBJECTIVES(*objectives*)

---

1: *history*: interaction history
2: *paths*: list of story paths designed by the author for configuring the characters
3: *success* ← *false*
4: **for** each *objective* in *objectives* **do**
5:    *actor* ← *objective.action.actor*
6:    **if** *objective.desirable* **then**
7:       *all_paths* = *paths* + *history*.**append**(*objective.action*)
8:       **return** **Fit**(*actor, all_paths*)
9:    **else**
10:       **for** each *action* in *actor.actionOptions* **do**
11:          **if** *action* != *objective.action* **then**
12:             *all_paths* = *paths* + *history*.**append**(*action*)
13:             **if** **Fit**(*actor, all_paths*) **then**
14:                *success* ← *true*
15: **return** *success*

---

the director agent tries to affect the user's decisions only by changing his/her beliefs.

As part of the process for adjusting the characters' beliefs, whether a belief change is reasonable is tested, and how to make the belief change happen is proposed. The same process is used for reaching the objectives that specify constraints on the characters' beliefs. The details of this process are given in Alg. 4 and related discussions. However, the rest of this section is organized around how to achieve objectives regarding the characters' actions.

After making all the adjustments, the director agent will again test whether the directorial goals will be violated in future interactions using lookahead projection (lines 8-9 in Alg. 1). This iterative process will stop when a satisfactory solution has been found or the maximum number of attempts has been reached, in which case the characters will act according to the *futureSteps* with minimal violations of directorial goals.

**Fitting Characters' Goals to Objectives**

Function **Fit_To_Objectives** (Alg. 3) fits the agents' goals to the objectives. For each objective with a desirable action, the function tests to see whether it is possible for the action to happen. For each objective with an undesirable action,

the function tests to see whether it is possible for the actor of that action to do something else, and possibly nothing. The function also tests whether doing an action is consistent with the author's design of the character by considering the story paths designed by the author for configuring (fitting) the characters.

Slightly different from the fitting procedure used in authoring, here it is okay for the utility of the desired action to be the same as other actions' utilities. In this case, even though the agent is not guaranteed to choose the action, which is not ideal for authoring, the action is a reasonable choice for the character's goals. In fact, for characters who do not have a clear personality/motivation in the story, the constraints on utility can be further relaxed to accommodate more action options for the director agent. In the extreme case, the director agent can directly order the characters without testing whether the suggested actions are consistent with the characters' motivations, in which case the fitting procedure always returns true.

### Adjusting Characters' Beliefs

When **Fit_To_Objectives** alone cannot achieve any objectives, the director agent will try to tweak the characters' beliefs. Function **Find_Suggestions** in Alg. 2 calls the "suggest" procedure for each objective and for each character, and merges the results into a list of all the suggestions to the characters' beliefs. For example, to make Granny give some cake to the wolf, Granny having cake and being at the same location as the wolf are likely to be suggested. These suggestions make the achievement of the objectives possible, but do not guarantee it. To test the effect of applying the belief changes, one needs to either simulate lookahead projections or try to fit the characters to the objectives.

Further, whether the belief changes are reasonable needs to be tested before they can be applied. Function **Find_Explanation** looks for an action that is reasonable to happen at the moment or in the past, and can explain the belief change. If such action exists, even though the user does not see the action happening, the user may assume that it happened when he/she was not there. Therefore, changes in the characters' behaviors, because of their belief changes, will not seem sudden and unnatural to the user. See Example II in Sect. 5 for an example. Of course, the belief change cannot be caused by a user's action,

---

**Algorithm 4.** FIND_EXPLANATION($beliefChange$)

1: *history*: interaction history
2: *paths*: list of story paths designed by the author for configuring the characters
3: **for** each *character* in *story* **do**
4:    **if** ! *character* == *user* **then**
5:       **for** each *action* in *character.actionOptions* **do**
6:          *all_paths* = *paths* + *history*.**append**(*action*)
7:          **if** **Fit**(*character*, *all_paths*) **then**
8:             **if** **Effects**(*action*) == *beliefChange* **then**
9:                **return** *true*
10: **return** *false*

---

because the user knows what he/she has done in the past. If the director agent wants the user's belief to change, it needs to arrange the action that can cause the belief change to actually happen. For example, for the user to believe that the hunter is close by, the director agent needs to let the hunter appear at the user's location. In general, all the suggested belief changes need to be tested by **Find_Explanation**. The author can make exemptions by specifying state features whose values are not important to the user. For example, in the Little Red Riding Hood story, the locations of the characters who are outside of the user's sight can be changed freely by the director agent.

## 5    Examples

This section provides two step-by-step examples of applying directorial control. Example I starts by a potential violation of directorial goals being detected: the wolf will eat Red before Red gives the cake to Granny. The corresponding objective is added to the list: the director agent "wants" the wolf to choose an action other than eating Red. Since the wolf is played by the user, the director agent skips fitting the wolf's motivations for achieving the objective, and directly tries to change the characters' beliefs. It finds that if the wolf believes that the hunter is close by, the wolf will choose a different action than eating Red. Assuming the belief change has happened, the director agent tests for potential goal violations again with lookahead projection. This time the director agent expects no violations. It then proceeds by applying the belief change – in this case by physically re-locating the hunter – and ordering the characters, other than the wolf, to act according to its last lookahead projection. After the user responds, the director agent will start another round of directorial control, starting by detecting potential goal violations.

The basic procedure in Example II is the same as in Example I, and therefore will not be repeated. Note that in this example because the directorial goal is defined with the keyword "anybody", the director agent can try to make any character kill the wolf. Often, there are many alternatives for adjusting the characters. The author can specify priorities, e.g. always try to adjust Red's configurations first. Otherwise the system will randomly pick an order. In this example, the director agent starts by trying to make Red kill the wolf. It failed to fit Red's motivations. It then proceeds to adjust the characters' beliefs. It finds that when Red is next to the wolf and believes that she is stronger than the wolf, Red can be fitted to do the action. The director agent has also tested

---

**Example I:**
**Lookahead projection** : "wolf-eat-Red", "Red-doNothing", "hunter-walk" ...
**Detect goal violation** : order: ["red-give-cake-Granny", "wolf-eat-red"]
**Add objective** : ["wolf-eat-Red", "undesirable"]
**Adjust beliefs** : hunter's location = wolf's location
**Simulate user's lookahead** : "wolf-run"
**Request characters to act** : "hunter-walk-towards-wolf"

---

---

**Example II:**
**Lookahead projection :** "wolf-walk", "Red-walk", "hunter-walk" ...
**Detect goal violation :** earlierThan2: ["wolf-eat-Granny", "anybody-kill-wolf", 30]
**Add objective :** [("anybody-kill-wolf", "desirable")]
**Fit characters to the objectives :** failed to fit Red
**Adjust beliefs :** Red's location = wolf's location; Red's power > wolf's power
**Find explanation :** "hunter-give-gun-Red" → Red's power > wolf's power
**Fit characters to the objectives :** succeed, "Red-kill-wolf"
**Request characters to act :** "Red-walk-towards-wolf"

---

whether the belief changes are reasonable. **Find_Explanation** returns that in order for Red to believe that she is stronger than the wolf, the hunter should have given Red a gun and this is a reasonable action for the hunter. The director agent therefore decides that the belief changes to Red are feasible to happen.

## 6  Future Work

Our future work is planned in three difference directions. First, we will enrich the syntax for specifying directorial goals so that more complex constraints can be expressed, such as constraints that are contingent on the current state of the story. Secondly, we will allow the author to specify priorities among the directorial goals. So that when there are conflicts among the goals, the director agent can make decisions based on the importance of the goals. For example, in Example II if there is another directorial goal that requires the wolf to eat the cake, a conflict exists between the two goals: the wolf cannot eat the cake if it is killed. Currently, when conflicts happen, an implicit priority is assumed based on the order the author lays out the goals. Finally, directorial control does not always succeed. Whether a set of directorial goals can be achieved depends on the algorithms used by the director agent, the model of the characters, the type of user who is interacting with the system and even the initial state of the characters and the user. We plan to conduct an evaluation on the effectiveness of the directorial control we deployed in the Little Red Riding Hood story.

## 7  Conclusion

In this work, we present a unique approach for realizing directorial control in interactive narratives based on the model of the user. This approach is implemented within the Thespian framework for interactive narratives. Thespian's director agent monitors the progress of the story and adjusts the virtual characters' behaviors and beliefs if necessary to achieve directorial goals. The explicit modeling of the user enables our approach to avoid accidentally creating inconsistent characters during directorial control, and to better predict the user's experience. For example, our approach allows the author to specify directorial goals regarding the characters' states and beliefs, so that the directorial control

can directly target the user's cognitive and affective experience. The algorithms used by the director agent are presented in this paper, followed by examples of applying directorial control in the Little Red Riding Hood story.

# References

1. Marsella, S.C., Johnson, W.L., Labore, C.: Interactive pedagogical drama for health interventions. In: AIED, pp. 341–348. IOS Press, Amsterdam (2003)
2. Paiva, A., Dias, J., Sobral, D., Aylett, R., Sobreperez, P., Woods, S., Zoll, C.: Caring for agents and agents that care: Building empathic relations with synthetic agents. In: AAMAS, pp. 194–201. IEEE, Washington (2004)
3. Si, M., Marsella, S.C., Pynadath, D.V.: Thespian: An architecture for interactive pedagogical drama. In: AIED, pp. 595–602. IOS, Amsterdam (2005)
4. Kelso, M.T., Weyhrauch, P., Bates, J.: Dramatic presence. Presence: Teleoperators and Virtual Environments 2, 1–15 (1993)
5. Riedl, M.O., Saretto, C.J., Young, R.M.: Managing interaction between users and agents in a multi-agent storytelling environment. In: AAMAS, pp. 741–748. ACM, New York (2003)
6. Cavazza, M., Charles, F., Mead, S.J.: Agents' interaction in virtual storytelling. In: de Antonio, A., Aylett, R.S., Ballin, D. (eds.) IVA 2001. LNCS (LNAI), vol. 2190, pp. 156–170. Springer, Heidelberg (2001)
7. Magerko, B., Laird, J.E.: Mediating the tension between plot and interaction. In: Challenges in Game Artificial Intelligence, pp. 108–112. AAAI Press, Menlo Park (2004)
8. Szilas, N.: IDtension: a narrative engine for interactive drama. In: TIDSE. pp. 187–203. Fraunhofer IRB Verlag, Stuttgart (2003)
9. Braun, N.: Storytelling in collaborative augmented reality environments. In: Proc. 11th International Conf. in Central Europe on Computer Graphics, Visualization and Computer Vision, pp. 33–40. University of West Bohemia, Plzen (2003)
10. Mateas, M., Stern, A.: Integrating plot, character and natural language processing in the interactive drama Façade. In: TIDSE, pp. 24–26. Fraunhofer IRB Verlag, Stuttgart (2003)
11. Murray, J.H.: Hamlet on the Holodeck: The Future of narrative in Cyberspace. MIT Press, Cambridge (1997)
12. Bates, J.: Virtual reality, art, and entertainment. Presence: Teleoperators and Virtual Environments 2(1), 133–138 (1992)
13. Weyhrauch, P.: Guiding Interactive Drama. Ph.D. thesis, Carnegie Mellon University (1997)
14. Lamstein, A., Mateas, M.: Search-based drama management. In: Challenges in Game Artificial Intelligence, pp. 103–107. AAAI Press, Menlo Park (2004)
15. Onega, S., Landa, J.A.G.: Narratology: An Introduction. Longman, London and New York (1996)
16. Bruner, J.: Acts of Meaning. Harvard University Press, Cambridge (1990)
17. Ochs, E., Capps, L.: Living narrative. Creating lives in everyday storytelling. Harvard University Press, Cambridge (2001)
18. Si, M., Marsella, S.C., Pynadath, D.V.: Thespian: Using multi-agent fitting to craft interactive drama. In: AAMAS, pp. 21–28. ACM, New York (2005)

19. Si, M., Marsella, S.C., Pynadath, D.V.: Proactive authoring for interactive drama: An author's assistant. In: Pelachaud, C., Martin, J.-C., André, E., Chollet, G., Karpouzis, K., Pelé, D. (eds.) IVA 2007. LNCS, vol. 4722, pp. 225–237. Springer, Heidelberg (2007)

20. Si, M., Marsella, S.C., Pynadath, D.V.: Modeling appraisal in theory of mind reasoning. JAAMAS (in press, 2009)

21. Si, M., Marsella, S.C., Pynadath, D.V.: Thespian: Modeling socially normative behavior in a decision-theoretic framework. In: Gratch, J., Young, M., Aylett, R.S., Ballin, D., Olivier, P. (eds.) IVA 2006. LNCS (LNAI), vol. 4133, pp. 369–382. Springer, Heidelberg (2006)

22. Marsella, S.C., Pynadath, D.V., Read, S.J.: PsychSim: Agent-based modeling of social interactions and influence. In: Proc. International Conference on Cognitive Modeling, pp. 243–248. Lawrence Erlbaum Associates, Philadelphia (2004)

23. Smallwood, R.D., Sondik, E.J.: The optimal control of partially observable Markov processes over a finite horizon. Operations Research 21, 1071–1088 (1973)

24. Gmytrasiewicz, P., Durfee, E.: A rigorous, operational formalization of recursive modeling. In: ICMAS, pp. 125–132. AAAI Press, Menlo Park (1995)

25. Pynadath, D., Marsella, S.: Fitting and compilation of multiagent models through piecewise linear functions. In: AAMAS, pp. 1197–1204. IEEE, Wash. DC (2004)

# Controlling Narrative Generation with Planning Trajectories: The Role of Constraints

Julie Porteous and Marc Cavazza

School of Computing, Teesside University, United Kingdom
{j.porteous,m.o.cavazza}@tees.ac.uk

**Abstract.** AI planning has featured in a number of Interactive Storytelling prototypes: since narratives can be naturally modelled as a sequence of actions it is possible to exploit state of the art planners in the task of narrative generation. However the characteristics of a "good" plan, such as optimality, aren't necessarily the same as those of a "good" narrative, where errors and convoluted sequences may offer more reader interest, so some narrative structuring is required. We have looked at injecting narrative control into plan generation through the use of PDDL3.0 state trajectory constraints which enable us to express narrative control information within the planning representation. As part of this we have developed an approach to planning with trajectory constraints. The approach decomposes the problem into a set of smaller subproblems using the temporal orderings described by the constraints and then solves them incrementally. In this paper we outline our method and present results that illustrate the potential of the approach.

**Keywords:** Planning, narrative generation, narrative control.

## 1   Introduction

A key component of an Interactive Storytelling (IS) system is a narrative generator. Since narratives can be naturally modelled as a sequence of actions, AI planning has become an important technology in this field and a range of planning approaches have been successfully applied to the task of narrative generation. For example, partial order planning [1] has been used with adaptations to intentions [2] and emotion [3]; state based planning in the style of HSP [4] was used to generate plans in an authoring tool [5]; and HTN planning [6] was adapted to handle anytime user intervention [7].

As these systems demonstrate, it is clearly possible to generate narratives using planning technology but they are not without their limitations. For instance, both partial order (plan space) planning and state space planning approaches suffer from an IS perspective, because they were developed with the objective of building a planner that would find the shortest plan to a goal (or a close approximation to it). This is appropriate in the sorts of domains for which planners were first developed, such as robot stacking and logistics, but has little meaning in the context of IS, where errors and convoluted sequences may be desirable characteristics. On the other hand, HTN planning does provide a means to include

I.A. Iurgel, N. Zagalo, and P. Petta (Eds.): ICIDS 2009, LNCS 5915, pp. 234–245, 2009.

information about desirable ways for the narrative to be developed, in the form of decompositions of methods in the task network. However, because the control information is embedded in the task network it is not possible to manipulate the information independently and since this is a feature that would be useful in an IS environment, for example to respond to user interaction, it suggests some other approach to narrative structuring is required.

A review of the IS literature reveals a number of previous attempts at narrative structuring. Some researchers have used HTN planning which permits the encoding of authors intentions of possible ways to develop the narrative, in the form of the decomposition methods themselves [7,8]. Others have proposed the use of search based drama management: Weyhrauch [9] suggested the encoding of aesthetics in an evaluation function to be used by the drama manager; Magerko et al [10] exploited a meta-level controller in the form of a drama manager; Mateas and Stern's Façade drama [11] featured a beat based drama manager; and Riedl and Stern [12] used an automated story director to blend user agency with narrative plot control. Other researchers have looked to adapt the plan generation algorithm itself to structure the narrative along aesthetic lines. For example Riedl and Young [2], used simulated intention reasoning to guide the planner to promote story coherence and temporal consistency.

We have explored an alternate approach to narrative structuring: by forcing the planner to make certain key events occur in the course of the narrative and in a given order. Riedl [13] referred to this as "complexifying" the planning process and extended his intent driven planner [2] to plan with the inclusion of "author goals". However, we have taken a rather different approach based on the observation that the state trajectory constraints provided in the planning domain representation language PDDL3.0 appear to provide a means to express the key events that are required in a narrative and also any ordering between them. Our hypothesis is that these constraints can be used to express narrative structuring control knowledge. The results of initial experiments using MIPS-XXL [14], a planner that can reason about PDDL3.0 constraints, supported our hypothesis. However performance appeared too slow and consequently we developed a method for planning with these constraints that can perform within time limits imposed by an IS environment.

In the paper, we present an overview of our work along with some preliminary results. We begin (Sect. 2) with background on using constraints to control narrative generation. In Sect. 3 we discuss our novel planning algorithm and in Sect. 4 we presents our results. We end with conclusions and directions for future work (Sect. 5).

## 2   Narrative Structuring Using Constraints

To illustrate the use of constraints we'll use an example from an IS domain based on the novel Goldfinger by Ian Fleming (with a history both in narrative formalism [15] and IS [16]). The novel features James Bond, a British secret service agent who is sent to investigate gold smuggling by the eponymous Auric

Goldfinger. Suppose that we want to generate a narrative with a goal of Bond defusing a bomb set by Goldfinger. We could do this using a planner but a problem with the narrative, from an IS perspective, is that it will only contain actions that are directly relevant in pursuit of the planning goal. Yet the narrative may be more interesting if, for example, James Bond were placed in a perilous situation (such as facing death by a laser beam), but such events would only feature in the narrative if they served some purpose with respect to achieving the final goal (such as Bond gaining further information). What is required is a means to specify important events that are to occur in the narrative, as well as the final narrative goals. Our hypothesis is that the state trajectory constraints in the planning representation language PDDL3.0 offer a way to do this.

State trajectory constraints are one of the novel language features introduced in PDDL3.0 [17] to describe benchmark problems for the 5th International Planning Competition. They are expressed independently to the rest of the PDDL problem definition and assert conditions that must be met by the entire sequence of states visited during the execution of a solution. The language provides a number of modal operators for expressing these constraints. In our experiments we have used the following:

| operator | meaning |
|---|---|
| *(sometime-before a b)* | b must be made true for the first time before a |
| *(sometime a)* | predicate a must be true at some stage of the narrative |
| *(at-end a)* | predicate a must be true at the end of the narrative |

The *sometime* and *sometime-before* operators allow us to specify events that must occur in the narrative and this gives a temporal order over these events. It is partial because not all the events are ordered with respect to each other. The *at-end* constraints are equivalent to planning goals, and they are ordered last in the temporal order (and the initial state is implicitly ordered to be earliest). For the Goldfinger example the constraints could include the following (the temporal order defined by these constraints is shown below in Fig. 1):

*(sometime-before (seduced bond jill) (won-cards bond goldfinger card-game))*
*(sometime-before (seduced bond jill) (got-mission bond))*
*(sometime (won-golf bond goldfinger golf-game))*
*(at-end (defused-bomb bond fort-knox))*

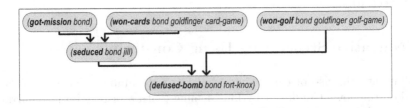

**Fig. 1.** Partial temporal order between constrained predicates

The subset of PDDL3.0 constraints operators that we have discussed fit our purposes since they enable us to specify both: narrative events that must occur in the course of the narrative; and any orders between them. They also result in a number of benefits over alternate approaches. For example, from a computational perspective, because the constraints are specified independently from the rest of the PDDL model they can be independently manipulated, perhaps to respond to user interaction, without affecting the rest of the model. This is in contrast to approaches where control information is embedded in the operator pre-conditions or in the decompositions of an HTN and where making changes is much harder. Also, from the perspective of authoring, the independent specification of the constraints may make them easier to express and may help facilitate the testing of different story variants since the constraints can be independently changed without changing the rest of the representation.

## 3   Decomposition Planning with Trajectory Constraints

We saw in the previous section that the constraints define a temporal order over key narrative facts. This temporal order gives strong hints about events that will feature earlier in any narrative that satisfies the constraints, and suggested to us that a narrative could be built incrementally, starting with those events which are likely to feature earlier on. Based on this observation our planning approach is: use the orders in the constraints to decompose the problem into a number of temporally ordered subproblems; solve those subproblems in turn; and "grow" the narrative forwards from the initial state to the goal state by appending the solution for the current subproblem to the narrative developed so far.

This approach is based on the method for planning with *landmarks* of Hoffmann et al [18]. They exploit *landmarks* - facts that must necessarily be made true en route to solving a final problem goal - to decompose the planning problem and then use the resulting subproblems to guide a search control algorithm that is wrapped around a base planner (any planner that accepts basic STRIPS [19] input). Instead of landmarks, we use the events that have been supplied as constraints to decompose the problem. Although these facts aren't landmarks as defined by Hoffmann et al (they don't *have* to be made true to achieve the final goals) they nevertheless have to be achieved in order to satisfy the constraints.

The first step of the planning process is to construct a *constraints tree* using the constraints that are included in the input domain model. The input is a subset of a PDDL3.0 planning problem consisting of: $F$, a set of facts that can be used to describe the world; $G$, a goal condition such that $G \subseteq F$; and $C$, a (possibly empty) set of constraints. The output is a constraints tree $CT$ with nodes $N$ and edges $E$. The nodes $N$ in the tree $CT$ are any facts $f \in F$ that: appear in any of the *sometime* constraints; or any facts that appear as problem goals or *at-end* constraints which can be treated as equivalent. For the example constraints given in Sect. 2 the set of nodes $N$ is:

{ *(defused-bomb bond fort-knox), (won-cards bond goldfinger card-game), (seduced bond jill), (got-mission bond), (won-golf bond goldfinger)*}

Edges *(x,y)* in the tree are directed from $x$ to $y$ and indicate that $x$ must be made true in the plan before $y$. Continuing with the example constraints given in Sect. 235 the set of edges $E$ is:

{((won-cards bond goldfinger card-game), (seduced bond jill)),
((got-mission bond), (seduced bond jill)),
((seduced bond jill), (defused-bomb bond fort-knox)),
((won-golf bond goldfinger), (defused-bomb bond fort-knox))}

An outline of the decomposition planning algorithm is shown in Fig. 2 on page 239. The input is a PDDL3.0 planning problem consisting of $< F, I, G, C, O >$ where: $F$ is a set of facts that can be used to describe the world; $I$ and $G$ are an initial state of the world and goal condition such that $I \subseteq F$ and $G \subseteq F$; $C$, a (possibly empty) set of constraints; and $O$, a ground set of operators each with an Add, Delete, and Precondition list. Upon successful termination of the algorithm, the output is a plan $P$ that satisfies the constraints and achieves all final goals.

The first step in the algorithm is the construction of the constraints tree, $CT$ (described above). Then the algorithm loops until the constraints tree is empty (lines 2-8). Within each loop, a new subproblem is formulated and passed to the base planner (line 3-4). The goal of this subproblem, $D$, is *disjunctive* and is formed from the leaves of the constraints tree: these goals are the earliest in the temporal order, which we want the base planner to work on first. We know nothing about whether these facts can be made true at the same time or their respective order, so leave it to the planner to decide which goal to work on next. We achieve this by expressing them as *disjunctive goals* using the method proposed by Gazen and Knoblock [20] which allows them to be expressed in standard STRIPS format. Then a separate base planner is invoked with this disjunctive subproblem (line 4). If the base planner returned a solution, $P'$, to this subproblem then a new plan is formed by appending $P'$ onto the current plan so far and a new initial state is formed by executing the returned plan $P'$ in the current subproblem initial state (line 7). Also, the constraints tree $CT$ is updated so that any facts in leaf nodes of the tree that are made true by the execution of plan $P'$ are removed (line 8). Once the constraints tree is empty (or if no constraints are supplied) the search control proceeds with the original planning problem goal, the *conjunctive* goal $G$ (line 9). When the plan for this final goal is returned it is appended to the end of the plan so far to produce the final plan which is then output (line 12).

## 4    Results

The central hypothesis of our work is that PDDL3.0 constraints can be used for narrative control. In this section we present the results of a qualitative evaluation that support this hypothesis, via analysis of a selection of sample narratives.

For the evaluation we developed a decomposition planner, referred to as *DPC*, which is an implementation of the algorithm outlined in Fig. 2. *DPC* uses *FF-v2.3*

**Input**: $F, I, G, C, O$  **Output**: $P$

---

1    build constraints tree $CT$
2    repeat until $CT := \{\}$
3        $D$ = leaf nodes of constraints tree
4        call planner with: $O$, $I$, and disjunctive goal $D \to P'$
5        if planner didn't find a solution $P'$ then fail
6        else if planner did find a solution $P'$:
7            $P := P \circ P'$
            $I :=$ result of executing $P'$ in $I$
8            remove from $CT$ all $L \in D$ with $L \in add(o)$ for some $o \in P'$
9    call planner with: $O$, $S$ and conjunctive goal $G \to P'$
10   if planner didn't find solution $P'$ then fail
11   else if planner did find a solution $P'$:
12       $P := P \circ P'$, output $P$

**Fig. 2.** Outline algorithm: Decomposition search control

[21] as a base planner, although any propositional planner that accepts STRIPS input could have been used. We used $DPC$ to generate sample narratives for a number of input narrative variants that featured constraints (all narrative plans generated by $DPC$ were validated using the PDDL3.0 validator VAL [22] and shown to satisfy the constraints). In these experiments performance of $DPC$ was found to be acceptable for IS purposes, with an average subproblem solution time within 500ms.

For the purposes of the evaluation we developed a PDDL3.0 representation of the classic spy novel Goldfinger from a description of the novel inspired by the actions of the main characters. Characters' attributes, including such things as their location, activities and allegiance became the predicates of the planning domain. The main actions, those that modify characters' attributes, were represented as planning operators. The predicates were then used to specify goals and constraints for individual characters in different story variants and the planner, $DPC$, used the operators to generate narratives that satisfied the individual characters' goals and constraints (i.e. the perspective of the planner is at the narrative level not the character level). The Goldfinger model that we have developed is a rich one where the use of constraints enables $DPC$ to generate a wide range of story variants such as a trajectory consisting of 42 narrative actions that capture the main outline of the novel (this is the sequence of operators shown down the centre of Fig. 4).

**Example Narrative Generation**
In this example we discuss how our planner $DPC$ generates the narrative shown in Fig. 3. This narrative features a goal where Bond triumphs over Goldfinger by defusing a bomb that Goldfinger was intending to use to irradiate the US gold reserve, represented with the predicate *(defused-bomb bond fort-knox)*.

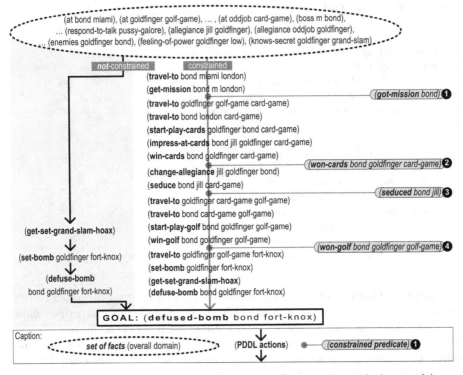

**Fig. 3.** Using constraints to shape a narrative (see text for worked example)

If we were to pose this scenario as a planning problem *without* constraints, then *DPC* would simply invoke the base planner with the final goal (in terms of the algorithm in Fig. 2 the constraints tree would be empty so control would pass directly to line 9). A narrative plan would be generated and the output narrative would be directed towards the goal resulting in a sequence of operators that contribute directly to achieving the goal. This sequence is shown down the left hand side of Fig. 3 culminating in Bond defusing the bomb, represented by the planning operator *(defuse-bomb bond fort-knox)*.

However, the structure of the narrative can be dramatically changed with the introduction of constraints which force certain key events to occur. For example, the sequence of actions down the centre of Fig. 3 shows the different narrative that results when the following constraints are included: at some stage Bond will beat Goldfinger at golf, represented in the model with the predicate *(won-golf bond goldfinger golf-game)*; Bond will seduce Goldfingers assistant Jill Masterson, *(seduced bond jill)*; and before the seduction Bond will beat Goldfinger at cards, *(won-cards bond goldfinger card-game)* and also receive his mission, *(got-mission bond)*. These constraints were discussed in Sect. 2 and the corresponding temporal order is shown in Fig. 1.

Following the algorithm in Fig. 2, *DPC* tackles the constraints in order start-
ing with the earliest. In this example there is a choice of earliest predicates:
*(got-mission bond)*, *(won-cards bond goldfinger card-game)* and *(won-golf bond
goldfinger golf-game)*, and so *DPC* formulates these as a disjunctive subproblem
goal using the method of [20]. To do this we introduce an artificial predicate as
the goal of the current subproblem and then for each predicate in the disjunc-
tion we add an artificial operator with: that predicate as the precondition; the
artificial predicate as a single add effect; and no delete effects.

Thus for this example, the goal of the first subproblem is represented using
the predicate *(artificial)* and three operators are introduced that add it: one
with *(got-mission bond)* as a precondition; one with *(won-cards bond goldfinger
card-game)*; and one with *(won-golf bond goldfinger golf-game)*. Then the base
planner determines which operator to use to achieve the artificial goal. For this
example, the base planner chooses the artificial operator with the precondition
*(got-mission bond)* and this is achieved with narrative sequence that takes Bond
to London to receive his mission. At the end of this first iteration of the algorithm
the constrained predicate has been achieved and the other two constrained pred-
icates remain in the temporal order to be tackled on subsequent iterations. The
sequence of operators to achieve *(got-mission bond)* forms the initial narrative
and *DPC* then grows the narrative forwards from this point.

Attention now turns to the current earliest constrained predicates in the tem-
poral order. These are *(won-cards bond goldfinger card-game)* and *(won-golf bond
goldfinger golf-game)*. Once again *DPC* poses this as a disjunctive problem and
the state that has been reached at the end of the narrative so far (ie Bond is in
London having received his mission) is used as the starting situation for the next
subproblem. For this subproblem the base planner chooses to next solve *(won-
cards bond goldfinger card-game)*, shown as constrained predicate (2) in Fig. 3,
with a sequence of operators involving the characters moving to the venue of the
card game and participating in the game. These operators are then appended to
the developing output narrative as it is grown forwards.

Now the earliest predicates in the temporal order are: *(seduced bond jill)*
and *(won-golf bond goldfinger golf-game)* and once again these are posed as a
disjunctive problem and the base planner is invoked. As shown in Fig. 3 the
base planner chooses to solve *(seduced bond jill)* next with a narrative sequence
that involves Jill changing her allegiance and being seduced by Bond. At this
point there is a single earliest predicate in the temporal order, *(won-golf bond
goldfinger golf-game)*, and the base planner outputs a narrative sequence for this
which is appended to the output narrative.

Once all the constrained predicates have been achieved in order, the base plan-
ner is then invoked with the final conjunctive goal, which in this example consists
of the single predicate *(defused-bomb bond fort-knox)*. Finally the narrative for
this final goal is appended to the output narrative generated so far.

This example demonstrates the way in which the constraints can be used to
support a high level description of a narrative so that it follows the required
dramatic arc. In fact, so long as the set of constraints for a planning instance

accurately reflects the high level control that is required for the narrative then any plan that is generated that satisfies the constraints (i.e. a valid plan), can be said to display the required narrative control. This example also shows how the use of constraints can allow for variation in the narratives that are generated when we have a partial order over predicates in the domain, since a number of different variants will satisfy the same set of constraints.

**Narrative Segment: introducing conflict**
Figure 4 shows a Goldfinger narrative that captures the main outline of the novel. One way to look at this sequence of events is from the perspective of the novel's main theme, the conflict between the protagonist James Bond and his adversary Auric Goldfinger. As observed by Cheong and Young [8], this type of conflict, where one characters' individual goals are the negation of anothers', is an important prerequisite for creating suspense in a narrative. Since suspense is a key feature of Goldfinger, we can use a dimension that places these characters and the pursuit of their goals in opposition and to view story progression through the sequence of operators and resulting character situations. Interestingly, the "trajectories" along that dimension represent story evolution in a similar way to "dramatic arcs" [23,24].

We can use constraints to introduce conflict into the narrative by imposing constraints that draw the narrative in directions that set the goal of one of the central characters against the others. As an example consider the constrained predicates 8–13 in the lower segment of Fig. 4. Some of these constraints place Goldfinger in a position of superiority over Bond (for example, when he has captured Bond and is attempting to kill him with an industrial laser (10) and when he has Bond handcuffed to a nuclear bomb (12)), whereas others place Bond in the superior role and serve to negate Goldfingers goals (for example, Bond spying on Goldfinger in Switzerland (9) and Bond seducing Pussy Galore and securing her allegiance (11)).

**Narrative Segment: introducing causality**
Another way in which the constraints can be used is to promote causality in the trajectory that is output, for example, to ensure that character behaviour is justified. As an illustration, consider the constrained predicates numbered 3–5 in Fig. 4. Here the constraint *(won-cards bond goldfinger)* is followed by the constraint *(seduced bond jill)* and yields a narrative sequence that sets up Jills betrayal of Goldfinger – she is impressed by Bonds card playing and this causes her to change allegiance – which justifies the subsequent sequence of actions where Goldfinger has her killed once he discovers her betrayal.

**Narrative Segment: varying pace**
We can use the constraints to vary the pace of parts of the narrative. For example, consider the constrained predicates numbered 1–3 in Fig. 4. Bond is initially in Miami and must travel in order to take part in a card game with Goldfinger. In the absence of constraints a planner would generate a narrative which has Bond travelling directly to the venue, with the key action *(travel-to bond miami card-game)*. However the consequence of introducing constraints that order *(know-of bond goldfinger)* to occur in before *(enroute bond miami card-game)* which in

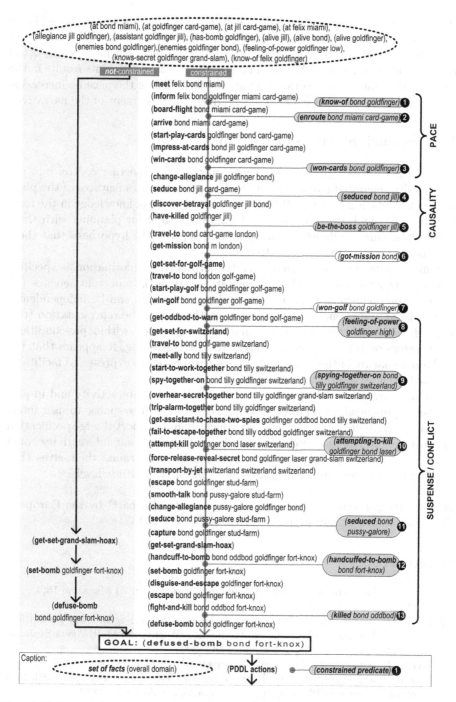

**Fig. 4.** Using constraints to shape a narrative which reflects the central theme of the novel and introduces conflict between Bond and Goldfinger (see text for more details)

turn must occur before *(won-cards bond goldfinger card-game)* is the addition of actions that have Bond and Felix Leiter meeting in Miami, Felix informing him about Goldfinger and his nefarious activities, and then introducing detail about Bonds journey from Miami. The inclusion of the constraints results in the addition of a number of relevant operators which change the pace by increasing the detail about this characters activities during this segment of the narrative.

# 5  Conclusions and Future Work

In the paper we have introduced a novel method for injecting control into automatically generated narratives for IS. The approach uses features of the planning representation language PDDL3.0 to encode control knowledge in the form of constraints and we have developed a novel method for planning with these constraints. Our results are encouraging and support the hypothesis that these constraints can be used for narrative control.

Using constraints means that narrative structuring information is specified independently to the rest of the representation and yields important benefits. For example, one benefit is that the structuring information can be independently manipulated and changed without affecting the rest of the representation (this is much harder if the control information is embedded within pre-conditions of operators or HTN decompositions). Also for authoring, it appears that the declarative nature of the constraints makes them easier to express and facilitates author testing of alternate story variants.

We are currently extending our approach to handle interactivity and in particular the re-specification of constraints "on-the-fly" in response to user interaction. We have identified mechanisms which should support the re-specification of constraints during an interactive session, suggesting that interactivity could affect not just the planning domain but also the constraints themselves thus opening the way for interpreting user intervention at multiple levels.

**Acknowledgements.** This work has been funded (in part) by the European Commission under grant agreement IRIS (FP7-ICT-231824).

# References

1. Weld, D.: An introduction to least commitment planning. AI Magazine 15(4), 26–61 (1994)
2. Riedl, M., Young, M.: An intent-driven planner for multi-agent story generation. In: Proc. Third Int'l. Joint Conf. on Autonomous Agents and Multi-Agent Systems, vol. 1, pp. 186–193. IEEE, Washington DC (2004)
3. Aylett, R., Dias, J., Paiva, A.: An affectively-driven planner for synthetic characters. In: Long, D., Smith, S.F., Borrajo, D., McCluskey, L. (eds.) Proc. 16th Int'l Conf. on Automated Planning, pp. 2–10. AAAI, Menlo Park (2006)
4. Bonet, B., Geffner, H.: Planning as heuristic search: New results. In: Biundo, S., Fox, M. (eds.) ECP 1999. LNCS, vol. 1809, pp. 360–372. Springer, Heidelberg (2000)

5. Pizzi, D., Cavazza, M., Whittaker, A., Lugrin, J.L.: Automatic generation of game level solutions as storyboards. In: Darken, C., Mateas, M. (eds.) Proc. fourth AI and interactive digital entertainment conf., pp. 96–101. AAAI, Menlo Park (2008)
6. Erol, K., Hendler, J., Nau, D.S.: UMCP: A sound and complete procedure for hierarchical task-network planning. In: Hammond, K.J. (ed.) Proc. of the Second Int'l. Conf. on AI Planning, pp. 249–254. AAAI, Menlo Park (1994)
7. Cavazza, M., Charles, F., Mead, S.: Character-based interactive storytelling. IEEE Intelligent Systems 17(7), 17–24 (2002)
8. Cheong, Y., Young, R.: A computational model of narrative generation for suspense. In: Liu, H., Mihalcea, R. (eds.) Computational Aesthetics: AI Approaches to Beauty and Happiness, TR WS–06–04, pp. 8–15. AAAI, Menlo Park (2006)
9. Weyhrauch, P.: Guiding Interactive Drama. Ph.D. thesis, School of Computer Science, Carnegie Mellon University (1997)
10. Magerko, B., Laird, J., Assanie, M., Kerfoot, A., Stokes, D.: AI characters and directors for interactive computer games. In: Hill, R., Jacobstein, N. (eds.) Proc. 16th Innov. Appl. of AI Conf., pp. 877–883. AAAI, Menlo Park (2004)
11. Mateas, M., Stern, A.: Structuring content in the Façade interactive drama architecture. In: Young, R.M., Laird, J. (eds.) Proc. First AI and interactive digital entertainment conf., pp. 93–98. AAAI, Menlo Park (2005)
12. Riedl, M., Stern, A.: Believable agents and intelligent story adaptation for interactive storytelling. In: Göbel, S., Malkewitz, R., Iurgel, I. (eds.) TIDSE 2006. LNCS, vol. 4326, pp. 1–12. Springer, Heidelberg (2006)
13. Riedl, M.: Incorporating authorial intent into generative narrative systems. In: Louchart, S., Roberts, D., Mehta, M. (eds.) Intelligent Narrative Technologies II, TR SS–09–06, pp. 91–94. AAAI, Menlo Park (2009)
14. Edelkamp, S., Jabbar, S., Nazih, M.: Large-scale optimal PDDL3 planning with MIPS-XXL. In: 5th Int'l. Planning Competition, pp. 28–30. icaps (2006)
15. Barthes, R.: Image Music Text. Fontana Press (1993)
16. Cavazza, M., Charles, F., Mead, S.: Multi-modal acting in mixed reality interactive storytelling. IEEE Multimedia 11(3), 2–11 (2004)
17. Gerevini, A., Long, D.: Plan constraints and preferences in PDDL3. Tech. Rep. RT–2005–08–47, Department of Electronics for Automation, University of Brescia, Italy (2005), http://www.cs.yale.edu/homes/dvm/papers/pddl-ipc5.pdf
18. Hoffmann, J., Porteous, J., Sebastia, L.: Ordered landmarks in planning. JAIR 22, 215–278 (2004)
19. Fikes, R., Nilsson, N.: STRIPS: A new approach to the application of theorem proving to problem solving. Artificial Intelligence 2(3/4), 189–208 (1971)
20. Gazen, B.C., Knoblock, C.: Combining the expressivity of UCPOP with the efficiency of Graphplan. In: Steel, S. (ed.) ECP 1997. LNCS, vol. 1348, pp. 221–233. Springer, Heidelberg (1997)
21. Hoffmann, J., Nebel, B.: The FF planning system: Fast plan generation through heuristic search. JAIR 14, 253–302 (2001)
22. The Strathclyde Planning Group: VAL: The automatic validation tool for PDDL including PDDL3 and PDDL+, http://planning.cis.strath.ac.uk/VAL/
23. Mateas, M.: A neo-Aristotelian theory of interactive drama. In: AI and Interactive Entertainment, TR SS–00–02, pp. 56–61. AAAI, Menlo Park (2000)
24. Zagalo, N., Barker, A., Branco, V.: Story reaction structures to emotion detection. In: Proc. first ACM workshop on Story Representation, Mechanism and Context, pp. 33–38. ACM, New York (2004)

# Evaluation of a Drama Manager Agent for an Interactive Story-Based Game

Andrea Corradini[1], Manish Mehta[2], and Santiago Ontañón[2]

[1] University of Southern Denmark, IFKI
6000 Kolding, Denmark
andrea@sitkom.sdu.dk
[1] Georgia Institute of Technology, Cognitive Computing Lab
Atlanta 30332-0760, Georgia, USA
{mehtama1,santi}@cc.gatech.edu

**Abstract.** There has been a growing interest in employing drama management components in interactive fiction games. In this paper, we evaluate our drama management approach deployed in a re-implementation of the Anchorhead game. Twenty subjects, with different levels of expertise, took part in the study. We use players' feedback as a basis for guiding the personalization of the interaction. The results indicate that our Drama Manager (DM) helps in providing a better play experience. Quantitative analysis indicates that the DM causes an average subjective improvement of 12.5% of the subjects' play experience. A large value of the Pearson's product-moment coefficient also indicates a strong correlation between less experienced adventure game players and higher ratings for the inclusion of hints during gameplay. Qualitative analysis from the user interview shows that all subjects noticed the difference in playing the game with and without the DM while the former way of playing was also the preferred one. Players found the hints helpful and funny even if frustrating when they cannot be exploited for proceeding in the game.

**Keywords:** drama management, gameplay, evaluation, interactive fiction game.

## 1 Introduction

There has been a growing interest in creating story-based interactive fiction games where the player is considered an active participant in the ongoing narratives. The component in charge of guiding the complete dramatic experience is called Drama Manager (DM) [2] or Director [5]. The DM employs a set of actions provided at appropriate points in the ongoing game whereby the player is guided toward certain aspects of the story. In previous work [8,9], we evaluated search based DM techniques in a simple text based implementation of the game Anchorhead [3].

We have developed a graphical version that incorporates the results from our previous work with many architectural enhancements [16] as well as tacking the issues of working in a real-time game, and on a game where the amount of actions the player can generate is unbounded due to the natural language interface. In this paper, we focus on evaluation of our new DM approach situated in the Anchorhead game. We

I.A. Iurgel, N. Zagalo, and P. Petta (Eds.): ICIDS 2009, LNCS 5915, pp. 246–257, 2009.

run an evaluation study that consisted in two different sessions. Quantitative analysis of the collected data indicates that the DM effectively improves the payers' game subjective experience. In particular, a large value of the Pearson's product-moment coefficient highlights a strong correlation between less experienced adventure game players and higher ratings for the inclusion of hints (generated by the DM) during gameplay. Preference for the inclusion of the DM can be evinced also from a qualitative analysis of user interview questionnaires. From such an examination, we could draw a series of lessons learned that can help further developing the strategies of the DM. Besides a preference to play with the DM, the large majority of players reported that hints are very helpful and also make the game more entertaining. Nonetheless, at times, overexposure to hints that cannot be exploited directly for proceeding through the different situations occurring in the game was considered frustrating.

The rest of the paper is organized as follows. In Section 2 we present an overview of Anchorhead, the game used in our experiments, and our interactive drama architecture. We present an evaluation of our approach in Section 3 and 4. Section 5 outlines a few works related to our study. Finally, we conclude in Section 6.

## 2  An Architecture for Interactive Drama

In this section, we present both Anchorhead (the game used in our experiments) and our architecture for interactive drama that includes drama management.

Anchorhead is a text-based interactive story game created by Michael S. Gentry [3]. The complete game features a story divided into several days. In order to evaluate our architecture, we have implemented a subset of the story, consisting of day two, identified by [3] as interesting for evaluating drama management approaches. Graphical as well as text descriptions of the current scenario are presented to the player, who then enters commands in textual format, e.g. "enter the mansion" or "take the key". Figure 1 shows a screenshot of our Anchorhead implementation.

In Anchorhead, the player explores a mysterious town since he has inherited a mansion there. By interacting with the people in the town, the player will uncover the hidden macabre secrets of the town of Anchorhead. The map is divided into 12 locations, and contains four non-player characters with which to interact.

Our architecture consists of six modules (shown in Fig. 2), namely:

- Graphical Interface (GUI): through which the user interacts with the system.
- Natural Language Understanding (NLU): parses the English text and generates a representation that can be understood by the game engine. The approach is based on our previous work [6].
- Game Engine (GE): responsible for running the game, maintaining the physical state, story state and a history of what happened during the game.
- Player Modeling (PM): develops a player model using case-based reasoning techniques from the player actions.
- Drama Manager (DM): takes the player model and the current game state and generates drama manager actions (DM actions) in order to influence the course of the game towards more interesting plots for the current player.
- Chat Agent: when the NLU cannot understand the text written by the player and there is a character in the current location, the text is redirected to the chat agent, which handles conversations among player and characters.

**Fig. 1.** Screenshot of our Anchorhead version

A game is defined by specifying a map, a story, and a set of *drama manager actions* (or DM actions). The map defines the physical space of the game, it contains rooms, objects, characters, it specifies which items each character is holding, and the state of each object (if doors are open, closed, etc.). The story is specified as a set of *plot points*. A plot point is an important event in the game, for instance: "the player bribes the bum". A plot point is defined as a set of preconditions, a trigger (typically a player action), and a set of effects (typically responses from characters in the game). Finally, the set of DM actions define the ways in which the drama manager can influence the game (as explained later). The set of actions the player can execute is defined by the sentences that the NLU module understands.

When a game starts, the graphical interface displays the current state of the game to the player and allows the player to enter textual commands (as shown in Fig. 1). When the player enters a command, it is sent to the NLU module. If parsing succeeds, the parsed action is sent to the game engine for execution. If the command is not understood, and there is some non player character in the same location as the player, the system assumes the player wanted to say something to that character. In that case, the command entered by the player is forwarded to the chat agent that attempts at generating an appropriate answer. For example, this happens when the player types commands like "How are you doing?"

Each time a player finishes a game, the system displays a form where the player can provide feedback. This feedback is then stored by the player modeling module in the form of a *case*. A case is a data structure that contains the *trace* of a game (the list of all the actions and game events that happened in the game) and the feedback that player provided. When a new player is playing the game, the player modeling module uses case-based reasoning (CBR) [1] in order to predict which aspects of the game the current player will like, by comparing it with previous players. The player model is used by the drama management module (DMM) in order to plan how to influence the game so that the satisfaction of the current player is maximized.

In order to do that, the DMM uses search-based artificial intelligence techniques to foresee the effects of different DM actions given all the possible actions a player can execute. See [8,9] for more details on how search-based techniques such as expectimax search can be sued for this purpose.

**Fig. 2.** Main components of our interactive drama architecture

## 2.1 Drama Management in Anchorhead

The goal of a drama manager is to gently guide the player by providing hints or slightly changing the game, in order to maximize player satisfaction. For that purpose, the DM needs two things: 1) a way to guide the player, and 2) a way to evaluate player satisfaction. In our approach, the DM guide the player by executing DM actions. In particular our drama manager used a collection of 17 different DM actions, which the drama manager can chose to execute at any time in order to influence the story. Some of those actions are hints (e.g. "The Bum will hint that the crypt key is in the basement"), others are deniers (e.g. "The telescope will be out of order to that the player cannot look through it"), and others are causers (e.g. "The Bum will automatically bring up himself").

In order to evaluate player satisfaction we used a combination of player modeling and predefined story aesthetic rules. In particular we used three aesthetic rules: thought-flow, activity-flow and manipulation (identified by Weyhrauch [12]), which measure that the story does not alternate too much among different sub-plots, that the action does not alternate too much among different locations, and that the player does not feel too manipulated respectively. The DM selects then DM actions that maximize the evaluation of both the player model and the predefined story aesthetic rules. The expectation is that the resulting experience is more enjoyable to the player than when he interacts with the game without the DM.

## 3 Aspects of Cognitive Evaluation

Nowadays, many common software applications are taken for granted, even if most of them like Wikipedia, Second Life etc. are not even a decade old. These technologies have been increasingly affecting many aspects of our everyday lives and sometimes have even been considered as indispensable as traditional books. Not surprisingly, many researchers and scholars have thus focused their studies on the impact of these technologies and have introduced the ubiquitous concepts of usability and user experience as integral part of the broad human-computer interaction domain.

The analysis of these two concepts has become common practice for and has been applied to almost every study in HCI and closely related areas like computer games and digital entertainment. Nonetheless, there is still no single established theoretical and methodological approach and, in fact, there is a wide variety of methods some of which are radically opposed to one another but each of which has its own advantages and drawbacks. Some approaches tend to break down user experience into component elements in the attempt of discovering general models and rules. Others take contextual factors into account and employ more holistic and situated methods.

Perception pertains to the determination of the information that players seek out during game play. To that extent, researchers have typically tracked eye movements or measured search time and accuracy [13] to quantify visual search. We restricted our analysis of perception to the visual display of objects in the game that users interact with. Moreover, similarly to cognitive researchers who often use scaling methods to measure the strength of an event and/or object, we applied category scaling to measure system attributes like preferences, ease of learning, usefulness, etc. This was achieved with an automatically generated post-session questionnaire where questions were posed regarding the objects operated and/or selected.

To properly interact with the game, players must learn a substantial amount about the interface, such as the meaning of commands, the location of game objects, the contextual use of these items, the consequences of a command, and many more. While researchers often use more or less complex recognition tests and/or recall tests to study the processes involved in learning and memorization, we examined the recurrence of commands issued but not recognized by the system and looked at log files containing the interactive session to see whether players repeated specific errors. The same log files were also exploited to analyze users' thinking in terms of strategy and problem-solving. With approximately half of the users, we performed preliminary process tracing by thinking aloud techniques and observation.

## 4 Methodology and Results

We carried out the study with twenty participants: eleven males and nine females, henceforth referred as P1 through P20. They were recruited among employees and students of a local University in Kolding, Denmark. The participants' average age was 31.5 years. Subjects were of Danish, British, Italian, German, and Egyptian nationality, all with advanced skills in English. Forty percent of them (64% of males, 11% of females) judged themselves as experienced videogame players.

Each user evaluation consisted of 2 different sessions. The first session had an average duration of 60 minutes. At first, we collected and analyzed data about the user and his/her play style, preferences, previous gaming experience and favorite game genres. While user analysis has typically been restricted to demographics and general preferences, we took into account also the users' general knowledge of the task domain and of the system to stress the importance of users' knowledge to their interactions with the game. Immediately thereafter, every player was provided with an explanation of the Anchorhead game. Following a five minute warm-up session the actual playing session lasting up to 25 minutes was started. Eventually, a post-test interview terminated the user testing. A second interactive session lasted an average of 40 minutes and consisted of another playing time of up to 25 minutes and with different settings to those employed in the first gaming session. At the end of the game time, one more post session interview was briefly carried out.

For the playing sessions, we uniformly split by gender the set of participants into 4 groups of 5 people. Henceforth, we refer to each of these groups as G1, G2, G3, and G4, respectively. Each group of people played the game under different conditions regarding the presence/absence of the DM as well as the use of previously collected games. Subjects were not told anything about the game settings. Procedurally, subjects played according to the following guidelines:

- Initially, subjects P1 to P5, belonging to group G1, played the game without the DM. We collected both the game log files and players' feedback at the end of each game. We refer to the collected log files as CG1 game cases.
- Then, subjects P6 to P10, belonging to group G2, were first invited to play with the DM activated and utilizing the game cases CG1. Later they played without the DM. We collected both the game log files and players' feedback at the end of each session. We refer to the collected log files as game cases CG2.
- Subjects P11 to P15, belonging to group G3, first played without the DM and then with it and utilizing the game cases CG1. We collected both the game log files and players' feedback at the end of each game. We refer to the collected log files as game cases and indicate them as CG3.
- Later, subjects P1 to P5, belonging to group G1, were summoned again to play with DM activated and using all cases collected so far i.e. CG1, CG2 and CG3.
- Eventually, subjects P16 to P20 of group G4, played first with DM and using all cases CG1, CG2, and CG3 and later without DM.

The different game conditions account for: a) the presence/absence of the DM, and b) knowledge about previous players via the use of differently sized case libraries.

During interaction, we observed and logged player's actions, responses and reactions to the game. We analyzed the data obtained from both a numerical and a qualitative perspective. From a quantitative analysis view, we were especially interested on the overall score that players assigned to the game both in presence and in absence of the DM. We also were interested in discovering whether and to what extent users prefer the addition of hints (thus ultimately the presence of the DM) during gameplay. The results are summarized in Fig. 3 where they are classified according to the four different subject groups along with the average over these groups. A value of 0 corresponds to the lowest rating, a value of 4 to the highest possible one. Figure 3 (left) clearly shows that players like the game more when they play with the DM

**Game Rating for Subject Group**     **Hints Rating for Subject Group**

Fig. 3. (*left*) Game ratings according to the different subject groups both with and without DM; (*right*) Average hints' ratings and their standard deviation values for each subject groups

enabled. The average score across all players for the game without DM was 2.0 while the average score with DM was 2.25 i.e. an improvement of 12.5% (Wilcoxon, p=0.021, Z=-1.95 one-tailed). The improvements over each group of subjects were: 8.3% for G1, 18.2% for G2, 0% for G3, and 25% for G4.

With the collected data we calculated the correlation coefficients to determine the strength and the direction of a linear relationship between several of the variables analyzed. As shown in Fig. 4, we calculated the Pearson's product-moment correlation coefficient to relate the degree of experience of players with their game ratings, the degree of experience of players with their hints' ratings, and eventually the game ratings with the hints' rating. The Pearson's coefficient is obtained by dividing the covariance of the two random variables being examined by the product of their standard deviations. Such a degree of linear dependence between two random variables tends to 1 (-1) in case of increasing (decreasing) linear relationships while it assumes some value in between in all other cases. The closer the absolute value of the coefficient is to 1, the stronger the correlation between the two variables. It must be noticed that a value of 0 for the correlation does not necessarily imply that the variables are independent since the Pearson's moment coefficient detects only linear dependencies. The converse is however true i.e. independent variables are characterized by a coefficient 0.

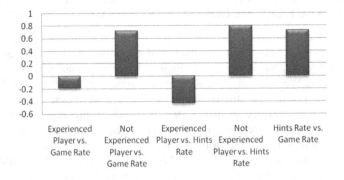

**Fig. 4.** Pearson's coefficient correlating player experience with hints and game rating

As a consequence, our analysis indicates that people with less game experience tend to rate the game higher as well as to appreciate more game hints. According to our analysis, experienced players seem also to like hints but to a minor degree, which confirms previous studies we carried out [9]. Experienced players and high game rating are instead either not linear correlated or are independent. Pearson's coefficient statistics also reveals that subjects that like the game also like to receive hints as they are presented with the DM.

In order to further understand the interaction, we performed a qualitative analysis using a simplistic version of a well-known qualitative analysis method, Grounded Theory [4, 10] as used in [11]. Grounded Theory is a research technique that operates almost in a reverse fashion to traditional research for it does not begin by researching and developing a hypothesis. Within such a framework, a variety of data collection methods under different conditions is employed as reported above. Instead of applying a specific model to the phenomenon under investigation, from the data gathered, we identified common patterns (the key points of Grounded Theory), which we then grouped into similar concepts. From these concepts we formed the categories mentioned in section 3 i.e. perception, memory, and language which form the basis for the creation of a reverse engineered hypothesis and which were analyzed singularly. Such a procedure allowed us to draw several main conclusions which we can now summarize in the following list of lessons learned.

*Lesson 1.* The DM techniques effectively increase player satisfaction. As depicted in Figure 3 (left), a numerical analysis of the interaction already permitted to reach the same conclusion. After playing first without DM, and later with the DM enabled, P5 said that *"my problem is that I don't play often but the second experience was much better than the first one"*. During the interview following his second gaming experience, P4 asked if we made some change in the software since *"it was much cooler to play this time than the last one"*. From the questionnaire data, it emerged that all players perceived a difference between absence and presence of hints despite during their interaction episodes they were never told in which mode they were playing. They were actually not even told that there were different settings between their game episodes. In fact, P16 said that *"The second time I played I was able to get more info out of the game; this was quite a good fun!"*, assuming erroneously that it was her way of playing that caused the system to display more hints.

*Lesson 2.* The type and quantity of DM hints should depend on player's experience. Again, the very same conclusion was already reached after numerical analysis of the interaction and highlighted in Fig. 3 (right). Subjects with limited experience with digital games (and especially of adventure games) who participated to our study commented e.g. P10 said that *"in the second session I got more hints and this was very helpful even if this did not help me much to finish the game"* and P7 that *"I wished more tips"* and then added that *"I was not always able to follow up the hints. For a beginner perspective, I need more of them to elaborate on what I can do. Maybe this does not apply to expert level gamers"*. Moreover, less experienced players were more likely to be in trouble operating with objects and dealing with situations encountered in the game. P10 added that *"I was not always sure what I could do in a given context. I would have wanted to be displayed a repertoire of commands instead of trial and error from my part"*.

**Lesson 3.** The DM can effectively help in successfully playing the game. Several players pointed out and recognized the utility of the DM to solve riddles in the game. Conversely, players were frustrated when confronted with no hints since they had problems in advancing the game. After his first gaming episode without DM, P11 stated that "*it was not clear how the game works, its objective, and how to accomplish it*" and not surprisingly his game rating was very low. After playing a second time with hints enabled, his final score about the game increased and during interview he reported about the game that "*once I got the hang of it, the tips made it easy for me to play*". Similarly, after playing first with the DM and then without it, during her second interview P16 reported that "*I did not have the full overview of the game; maybe there should be more game possibilities and be more obvious*". This contradicts with one of her statements after her first episode when she said "*I was pointed by the game to buy stuff in the magic shop but I could not get around it*".

**Lesson 4.** The content and quantity of DM hints should be tailored to the player's experience. Currently, the strategy for the presentation of hints during gameplay does not take into account the player's personal experience with the game. On that regard, more experienced users like P1 complained that "*the system feedback and help messages are not always useful. Sometimes they are absurd or trivial*". This was an assertion which conflicts with comments of less experienced players as reported in the previous lessons learned item. Information about the player's previous experience may thus help generating more appropriate hints. P17 suggested: "*ideally you keep a model of all game objects and characters where you store their interaction history; in this way if I do something with an object or give it to somebody I don't get the same messages or hints*".

**Lesson 5.** Visual display of game entities must reflect the counterparts (if any) in the real world. This has also to be consistent throughout the game. In fact, a few users reported problems with the perceptions of some game objects. Sometimes, the 2D nature of the game with limited graphical implementation caused users to misrecognize game entities and ultimately to issue manipulative commands upon them that were not allowed. P17 commented that "*some objects were recognizable by me some other I did not have a clue what they were. You cannot walk up to something if you cannot label them. The bed did not look like a bed*". Textual descriptions of the 2D graphical environment helped limit this kind of problem. Indeed, P17 continued saying that "*I thought they were beds only because I knew I was in the bedroom and the command 'examine' confirmed I was right*".

**Lesson 6.** The overt representation of the text presented to display DM hints should reflect the grammar and the vocabulary that can be recognized by the system NLU. From a language point of view, all users quickly understood how to get around invalid commands. Typically, after an average double retyping of a command that did not result in the expected game action, users tend to either try with a sentence reformulation with synonyms, or use the words occurring in hints and game descriptions or gave up. After playing for a few minutes, we saw a certain degree of convergence in the users' use of commands. Players tend to make up and retrieve commands from a limited set of commands after finding out that they have worked in a precedent situation. Users just adapted these commands to the situation at hand. For instance, once a user realized that the command "*look at <object>*" causes the game to display a text

and play a synthesized audio message with the description of that object, they rarely tried out later other possible commands to achieve objects' examination. The speech capabilities of our system should however be increased to make the game more challenging for more demanding players. P3 stated that *"the game was rather tolerant to my use of language"*. On the contrary P6 commented that the *"game does not always understand commands; these are limited and the grammar is too strict; it should be more flexible"*. P11 said that *"conversation is cool: the second time I played, the answers were better"*.

*Lesson 7.* The type and quantity of DM hints should reflect a player's strategy. The reason for such a conclusion is based on the observation that less experienced users do not follow any particular strategy. They tend to simply follow the hints provided by the DM, and thus remain unsure whether they could actually influence the evolution of the game. They also tend to enjoy more the interaction with non-playing characters since this kind of conversation is currently not focused on the solution of the game. Experienced gamers intelligently pick items that they feel would be useful later in the game and prefer not to waste much time with smalltalk with non-playing characters. As reported previously, most of the players (80%) admitted to have followed a strategy even if this was not always easy to notice. P17 said e.g. that *"I developed a strategy along the way in the sense that when I realized that I can keep things, then I thought this is going to be useful to me"*. A common strategy was to walk around and explore as many different locations as possible. As design insight for the future, we want to incorporate this observation in DM design. When the actions of a player are not doing anything logical to reach a sub-goal for some finite amount of time, the DM can provide a hint with the assumption that the player is confused. If the player was indeed trying to simply explore and did not like this hint at that game instance, he would provide a negative feedback for the particular hint. Later, players with similar playing patterns would not be given the same hint during these events.

*Lesson 8.* There should be a balance between game-oriented conversation and small talk when the player interacts with game characters. P20 reported that *"I find the characters limited with regards to conversation-skills. I was hoping they would give me information about the Verlac-family but either they don't know much about the family or they don't want to talk about it"*. P19 said that *"I like to talk to characters. I tried to ask about specific questions but they always sneaked out of conversation. So conversation was fruitless and frustrating after a while"*. In a similar way, P8 found that *"conversation with bartender is funny but if it stretches too long it becomes non sense"*. Further, he added that *"it was funny to talk to him. In general conversation was ok. But I always expected him to tell me about the game but he never did. The point of meeting people in the game must be to get info that you don't get visually"*.

## 5  Related Work

Bates [2] first proposed the idea of treating drama management as an optimization problem. The approach termed Search Based Drama Management (SBDM) was based on the fact that the drama manager chooses its best available action with expectation-calculating nodes. Weyhrauch [12] further developed the idea of a SBDM with a

game tree based search that used an author specified evaluation function to measure the interestingness value for a particular story. However the DM employed was not connected to a concrete game and the techniques were tested using simulated players. Nelson et al. [7] define a Declarative Optimization based approach to Drama Management (DODM). The central premise of their technique is to provide the author with the ability to specify what constitutes a good story and use a reinforcement learning approach to optimize DM actions in response to player actions. This approach also uses a simulated player model to predict the next player action. Furthermore, the approach ignores a player preference model to measure the interestingness of a story from the player's perspective. In our approach to drama management, we construct a player preference model through real human player interaction with the game. Previous approaches employed only an author based evaluation function for story interestingness.

Façade [14] employs a beat-based drama management system suited towards tighter story structures where all the activity contributes towards the story. The Mimesis system [15] proposes a story planning based approach for real-time virtual worlds where the story plans are tagged with causal structure and the system handles player actions that might threaten the causal links through either re-planning the story or disallowing the player the opportunity to carry out actions. In such an approach though, only the author specifies the concrete goals that the planner should achieve; the approach doesn't incorporate a player preference model. U-Director [19] is a decision theory-based approach to drama management which attempts to model goals and beliefs of the players. U-Director was only evaluated with synthetic players.

Finally, there have been several approaches evaluated with real players in the literature. PaSSAGE [17] is a system based on player modeling. PaSSAGE learns a model of the player's preferred style of play, and uses it to dynamically select the content of an interactive story. PaSSAGE was evaluated showing that in some groups of players (especially in females who found the game easy to understand) the system results in increased enjoyment. Another approach is that of Sullivan et al. [18] where they applied a DODM technique to a dungeon game called EMPath showing that players using drama manager are less lost in the game.

## 6 Conclusions

We have presented results from an evaluation study to measure the improvement in user experience with our drama management approach for the interactive fiction game Anchorhead. The results indicate that our DM causes an average 12.5% subjective improvement in the subjects' play experience. They also show that less experienced adventure game players prefer to have hints provided to them during gameplay. Qualitative analysis from the user interviews shows that all subjects noticed the difference in playing the game with and without the DM while the former way of playing was also the preferred one. The analysis further provided us with some improvements that need to be incorporated in the next system version. We plan to carry out experiments with more users to get more statistically significant results.

# References

1. Aamodt, A., Plaza, E.: Case-based reasoning: Foundational issues, methodological variations, and system approaches. AI Communications 7(1), 39–59 (1994)
2. May Bates, J.: Virtual reality art and entertainment. The Journal of Teleoperators and Virtual Environments 2(1), 133–138 (1992)
3. Gentry, M.S.: Anchorhead (1998), http://www.wurb.com/if/game/17.html
4. Glaser, B.: Basics of grounded theory analysis. Sociology Press, Mill Valley (1992)
5. Magerko, B., Laird, J., Assanie, M., Kerfoot, A., Stokes, D.: AI characters and directors for interactive computer games. In: Proc. Innovative Applications of AI, pp. 877–883. AAAI Press, Menlo Park (2004)
6. Mehta, M., Corradini, A.: Understanding spoken language of children interacting with a embodied conversational character. In: Proc. of Combined Workshop on Language-Enabled Educational Technology and Robust Spoken Dialog Systems, ECAI 2006, pp. 51–58 (2006)
7. Nelson, A., Mateas, M., Roberts, D.M., Isbell, C.: Declarative optimization-based drama management in interactive fiction. IEEE Computer Graphics and Apps 26(3), 33–41 (2006)
8. Sharma, M., Mehta, M., Ontañón, S., Ram, A.: Player modeling evaluation for interactive fiction. In: Optimizing Player Satisfaction, AIIDE 2007 Workshop, pp. 19–24. AAAI, ACM Press (2007)
9. Sharma, M., Ontañón, S., Mehta, M., Ram, A.: Drama management evaluation for interactive fiction games. In: Spring Symposium on Intelligent Narrative Technologies, pp. 138–145. AAAI Press, Menlo Park (2007)
10. Strauss, A., Corbin, J.: Basics of Qualitative Research: Grounded Theory Procedures and Techniques. Sage, Thousand Oaks (1990)
11. Strauss, A.: Qualitative Analysis for Social Scientists. Cambridge University Press, Cambridge (1987)
12. Weyhrauch, P.: Guiding Interactive Drama. Ph.D. thesis, CMU (1997)
13. Walker, B.N., Stanley, R.M.: Eye Movement and Reaction Time are Both Important in Assessment of Dialog Box Usability. In: Proceedings of the Human Factors and Ergonomics Society Annual Meeting, HFES, Santa Monica, CA, pp. 798–802 (2004)
14. Mateas, M., Stern, A.: Integrating plot, character, and natural language processing in the interactive drama Façade. In: TIDSE 2003, Fraunhofer IRB Verlag, Stuttgart (2003)
15. Young, R., Riedl, M., Branly, M., Jhala, A., Martin, R., Sagretto, C.: An architecture for integrating plan-based behavior generation with interactive game environments. Journal of Game Development 1(1) (2004)
16. Ontañón, S.O., Jain, A., Mehta, M., Ram, A.: Developing a drama management architecture for interactive fiction games. In: Spierling, U., Szilas, N. (eds.) ICIDS 2008. LNCS, vol. 5334, pp. 186–197. Springer, Heidelberg (2008)
17. Thue, D., Blitko, V., Spetch, M., Wasylishen, E.: Interactive Storytelling: A Player Modelling Approach. In: AIIDE 2007, pp. 43–48. AAAI Press, Menlo Park (2007)
18. Sullivan, A., Chen, S., Mateas, M.: From Abstraction to Reality: Integrating Drama Management into a Playable Game Experience. In: Intelligent Narrative Technologies II, pp. 111–118. AAAI Press, Menlo Park (2009)
19. Mott, B., Lester, J.: U-DIRECTOR: A Decision-Theoretic Narrative Planning Architecture for Storytelling Environments. In: AAMAS 2006, pp. 977–984. IFAAMAS (2006)

# What Would You Do in Their Shoes? Experiencing Different Perspectives in an Interactive Drama for Multiple Users

Birgit Endrass, Michael Boegler, Nikolaus Bee, and Elisabeth André

Augsburg University, Universitätsstr. 6a
86135 Augsburg, Germany
{endrass,bee,andre}@informatik.uni-augsburg.de
http://www.multimedia-werkstatt.org

**Abstract.** Following the idea of improvisational theater, we built a multi-agent system where multiple users can experience an interactive drama from different perspectives. Depending on the roles that the users are given in advance, the situation is perceived in various ways and interaction possibilities are directed according to the assigned role. The computer-controlled agents' behavior needs to be highly reactive in order to allow for flexibility in the conversational flow of the structured interactive narrative. In this paper, we describe a system architecture that allows multi-user participation as well as distributed behavior planning for multiple agents.

**Keywords:** Interactive storytelling, Multiagent systems, multi user, distributed behavior planning.

## 1 Motivation

When discussing interactive storytelling nowadays, most people think of computer games where the user can participate in the story by playing the part of one of the characters. But the idea of interactive storytelling is much older than computers and computer games after all.

Theaters have always been places where people go to enjoy themselves by watching actors in a story. The interactive part arises from a special version of theater - the improvisational theater. In improvisational theater, the audience is actively creating characters that participate in the play, illustrated by actors. Thus, a storyline evolves dynamically from the input of the audience, a facilitator and from spontaneous ideas of the actors. In that manner the improvisational theater does not depend on a predefined script; however, it needs a predefined concept.

The idea of the work described in this paper is based on the concept of improvisational theater. The user finds him/herself in the role of an actor, that is placed into a predetermined concept. Following the ideas of improvisational

I.A. Iurgel, N. Zagalo, and P. Petta (Eds.): ICIDS 2009, LNCS 5915, pp. 258–268, 2009.
© Springer-Verlag Berlin Heidelberg 2009

theater, he is allocated a certain role with predefined attributes, such as personality, gender or status. To ensure that the user stays within the given role, interaction possibilities are limited by the system, according to the role.

Additionally, the user does not know which characters he is going to meet during the play. These other characters can either be controlled by other users or by the system. Thus, the computer completes the tasks of the audience, the facilitator as well as other actors. In that manner, the user can take an active role in the performance if he wishes to do so. If not, the characters will give a performance on their own and dictate where the scenario is headed.

In this paper we describe an approach where the user can experience a virtual story from different perspectives. Following the ideas of improvisational theater, the user joins a virtual dinner party in a role that he does not know in advance. Depending on the assigned role the same situation can be perceived in various ways. For example, an argument between a couple could either be a pleasant development (from the perspective of a "nasty ex-friend") or an unpleasant one (for the host of the party or a friend of the couple). In this vein, the user can experience different stories, depending on the role he is given, the characters he is meeting as well as the actions he chooses to perform. In the open ended scenario neither the user nor the system can exactly predict how the story is going to evolve.

## 2   Related Work

Most well-established systems in interactive digital storytelling are based on the following idea: A given story is modeled in a virtual world where a user is in the role of a certain character and performs actions within a structured interactive narrative that allows for a certain amount of flexibility in the conversational flow. For the work described in this paper, we aim at building interactive drama where multiple users can experience a virtual scenario from different perspectives, depending on the role that they are given in advance.

Pizzi and colleagues [1] describe, for example, a system that uses an existing story for storytelling. The French novel Madame Bovary by Gustave Flaubert constitutes the baseline for this interactive digital drama. The user takes part in the role of the character Rodolphe, who tries to encourage Emma (the main character) to cheat on her husband. Through interaction the user is able to influence the characters' feelings which in return affects their behavior. In this vein, the user can experience different outcomes of the story depending on his interactions. The characters' behavior is based on a multi-threaded planner, controlling each character independently. The system described in this paper is also based on a distributed planning approach. However, while we focus on multiple users experiencing the same story from different perspectives, their main contribution is to describe the planning domain in terms of the characters' feelings and emotions.

Another approach is described in [2], where the story of a married couple is narrated that invites an old friend to their house for drinks. The user (in the role

of the friend) finds the couple going into raptures about their lives and weaving around the fact their marriage is falling apart. The story is based on the play "Who's Afraid of Virginia Woolf?", which was chosen because the storyline can be broken apart into story beats that can be resequenced. The characters' sequential and joint behaviors are modeled using ABL (A Behavior Language). In ABL, activities are represented as goals that are supplied with one or more behaviors to accomplish it. The user's interactions influence the behavior selection process of the characters. Consequently, the user can experience different story lines depending on his interactions within the scenario.

Although in the original story of "Who's Afraid of Virginia Woolf?" another couple is invited, Facade is designed for only one user to join the scene. In contrast to them, we enable multiple users to participate in a scenario taking on different roles.

Lankoski and colleagues [3] describe an approach where the user is in the role of a character that wants to seduce a rock star, who has promised to stay a virgin until marriage. To achieve this goal, the user can interact with four different characters. The user's interactions affect the characters' impression, which in turn influences their attitude towards the user character and thus determines their own behavior. To communicate within the virtual scenario, prewritten dialog trees are used, where the branches are based on the current impressions of the non-playing characters.

Aylett and colleagues [4] discuss the role of narrative management in a character-based emergent narrative framework. Instead of building a system that stays on a unique, pre-determined plot, they want to leave more interactive freedom to the user. Following the idea of Game Masters in paper and pen story telling, they introduce an approach using a hierarchical planner and way-points in a story line. In their work, they propose two ways of implementing a story facilitator: one triggers narrative actions taking into account the idea of way-points, the other considers the emotional impact of actions in order to intensify the dramatic effect. Thus, actions are not only dependent on motivations and goals, but also on the characters' emotions.

Unlike the approaches above, our work aims at telling a story from different perspectives allowing an arbitrary number of users to participate. The user (or multiple users) are able to play different roles and meet different characters similar to improvisational theater. By allowing an arbitrary number of participants we can also stay more flexible in alternating the story.

André and colleagues [5] describe the evolution of character-based presentation systems, starting from systems in which a single character simply presents information, over presentation teams to interactive installations. The authors discuss how concepts from improvisational theater may be employed to design interactive presentations with open ended story lines. They also analyze the benefits of various planning approaches for their typology of character-based presentation systems and argue for distributed reactive planners in scenarios where the user takes on an active part.

Following this approach, Rist and colleagues [6] describe a flexible platform that enables the development of applications with virtual characters including user interaction. In a sample application, the user joins a group of three agents that find themselves in the scenario of a car sale. The user is free to define the characters roles within the scenario as well as their personalities, attitudes and initial status. Thus, the dialog varies according to the defined roles and personalities as well as to the user's interactions. Although this platform is highly flexible and allows for different constellations of characters, it does not support multi-user playing. In addition, the user is not able to switch into another role. Following their ideas to control the virtual characters' behavior, we build a multiuser-multiagent scenario based on their approach to distributed behavior planning.

## 3  Interactive Drama

In order to illustrate our ideas on multiuser-multiagent scenarios which allow users to experience a drama from different perspectives, we designed a virtual dinner party where different characters meet. Figure 1 shows a screenshot of our scenario.

To ensure that an interesting story evolves, some of the characters within the scenario are always computer-controlled. Further details on the implementation of these agent components are provided in Section 4.2. By pre-defining some of the participating characters, parts of the story are controlled. Thus, an amorous couple as well as a jealous ex-friend will meet each other sooner or later at the

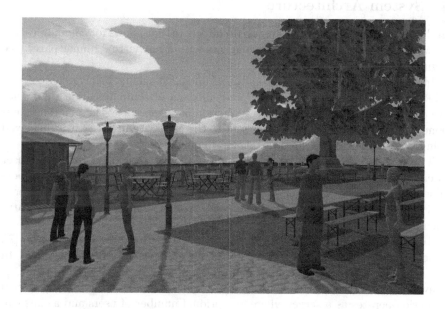

**Fig. 1.** The virtual scene of our interactive dinner party

virtual dinner party. This can lead to an argument or not, depending on the users' roles, their interactions as well as other participating characters.

If the user's assigned role is for example being the ex friend's best friend, he might want to try to separate the couple in order to allow his friend to talk to his/her ex. On the other hand, if the user finds himself in the role of the new lover's best friend the task could be supporting the friend by either keeping the conversation friendly or exposing the dismissed ex friend. Thus, the user's implicit goal is determined by the given role and his / her interactions are limited by the user interface. In order to avoid conflicts of the users' interactions with the agents' behavior, the user interface only offers options that make sense in the context of the story.

Similar to the users' roles, the characters' genders are not fixed. In a two-male one-female constellation the men might poke each other, while in a two-female one-male version the strategy might be more artful, e.g. "bitching" about the rival.

This story is embeddeded in the larger context of a dinner party. Thus, other characters with different roles are joining the party as well. The host, for example, will try to keep the party as friendly as possible, while a drunken guest might poke other guests at the next opportunity. If a user decides to be a passive bystander, the party will develop on its own. Users can also interact with each other while trying to achieve their individual goals. In the beginning of the interactive drama the user is given a particular role that he / she plays during the whole story. By re-entering the virtual dinner party, a new role will be selected for the user. Thus, multiple users can experience the same scenario from different perspectives and influence the storyline depending on their actions.

## 4    System Architecture

In this section we describe our system architecture that allows for communication between multiple users and multiple agents within our virtual dinner party (see Figure 2).

In the interactive drama, the computer controlled agents' behaviors are determined by their role as well as their predefined set of communication rules, that are designed for their given role. If an action is triggered by the planning component (verbal and nonverbal), it is sent to the application, where it is displayed using body postures, gestures and natural language.

The user is represented by a user avatar that is controlled through a user interface which offers the user various interaction categories. The choice of possible interaction categories is constrained depending on the role that the user is playing. For example, the host of the party that is supposed to keep the party friendly can not start an argument.

To animated the interactive drama, we use the Horde3D GameEngine [7], which was developed at Augsburg University and which is freely available. In the scenario, virtual agents can wander around and engage in a natural language conversation with each other and the user. In our system architecture, the virtual scenario operates as a server where an optional number of users and agents can be registered.

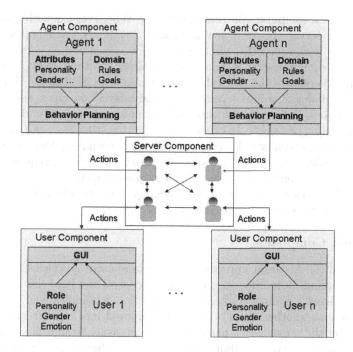

**Fig. 2.** Overview of system architecture

Our architecture offers several features that are of interest to interactive drama. First, an arbitrary number of characters (either controlled by the user or a computer) can be added to or removed from the interactive drama at runtime. Thus, a highly dynamic story may evolve depending on the constellation of the participating characters.

Another advantage is that the scenario can be expanded by adding new characters and roles. In order to create new system-controlled agents, a new client may be added with a set of rules. Thus a drunken party guest could, for example, be modeled by adding rules that make it poke other party guests. If a new interaction type is defined, appropriate utterances need to be added to the knowledge base.

New user roles can be defined in a similar manner. Existing interaction types can be reused, or new interaction types can be defined to add new possibilities to the scenario. Thus, the clients participating in the scenario can easily be defined at will and new scenarios can be created by defining roles for user characters or computer-controlled agents. In the following, we further describe the components of our system architecture.

## 4.1   User Component

A novel feature of our approach is that multiple users can join our interactive drama at the same time. In the virtual scenario, they are represented through user avatars. Thus, the users do not know whether they are interacting with

another user or a computer-controlled character. Whenever a new character joins the scene, the server creates a new instance for it. Thus, users and agents can freely interact with each other via the server.

The user's communication is limited to a given set of interaction types, which is a streamlined version of the DAMSL annotation scheme [8]. The DAMSL scheme distinguishes dialog acts into several layers and interaction types, such as statement, info request, influence on future, agreement/disagreement, understanding/ misunderstanding or answer. In order to obtain interesting scenarios, social emotional interactions such as poke, comfort or defense are added. Depending on the selected user role, the full set of interaction types is limited. Consequently, only a few possibilities are offered to the user via a drop down menu. The option selected by the user is then sent to the server where an appropriate utterance is generated out of a knowledge base and spoken by the user avatar.

## 4.2   Agent Component

According to [6] AI-based approaches, and plan-based approaches in particular, are becoming more and more popular to control the behavior of synthetic characters. Using a planner for behavior generation, a complex goal (e.g. getting acquainted with another agent) can be decomposed into smaller subgoals and actions (greet the conversation partner, engage in casual small talk, ...). Depending on character-specific attributes, such as personality or gender, actions can be performed in different ways. Also the selection of planning steps to archive a goal can be varied.

For the realization of our interactive drama, we use the Simple Hierarchical Ordered Planner (JSHOP2), developed at the University of Maryland [9]. This planner meets our requirements in a very satisfying manner as it is completely domain-independent and can easily be used to plan dialogs for virtual characters. However, the software had to be modified, as it does not allow for updates in the knowledge base at runtime in its original version. For our purposes this is a crucial task, as incoming actions (either performed by another agent or a user) need to be recognized and reactions need to be planned accordingly.

Figure 3 shows the integration of the planner software into our agent-component. If an interaction takes place in the virtual scenario and is sensed by the agent (either because it is the target of the message or stands close to the sender of the message) it is parsed to meet the specification of the behavior planning component. As we stated above, incoming messages have to be added dynamically to the knowledge base. Thus, we added a dynamic knowledge base to the planner software, that holds information about received interactions whereas the initial knowledge base holds information about the agents' attributes or knowledge about the virtual world. An incoming action will restart the behavior planning. Consequently, the planner within the agent-component decides if and which action should be triggered according to the updated knowledge base. Actions are realized in the same manner as for the user component. Thus, if an action is selected it is parsed back and communicated to the server component, where natural language is generated or appropriate gestures are selected.

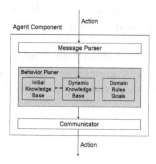

**Fig. 3.** Overview of agent component

## 5   Virtual Scenario

In our system architecture, the virtual scenario includes the server for the mul-
tiagent communication. Thus, besides rendering the virtual scene holding the
agents, it has further tasks to solve, such as maintaining the verbal and nonver-
bal knowledge base, generating natural language or managing timing issues. In
addition, the registration of users and agents needs to be administrated by this
component. Figure 4 shows an overview of the server's architecture.

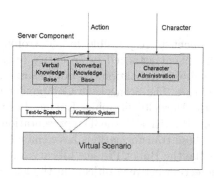

**Fig. 4.** Overview of server component

As we mentioned above, an arbitrary number of agents and users can interact
with each other. Thus, the server needs to add or remove characters dynamically
to or from the scene. Within the character administrator, a list of active agents
is maintained for that purpose.

Another sector of the server component holds the verbal and nonverbal knowl-
edge base, storing appropriate utterances and gestures for all interaction types.
If an action is selected by a virtual character or a human user, an abstract rep-
resentation is sent to the server component, where a corresponding utterance
and/or gesture is selected. Variables for participating characters, discussed top-
ics etc. are replaced using a simple template-based generation approach. For

example, a greeting could either be performed by an utterance, such as 'Hello Sam. Nice to meet you!', a greeting gesture or a combination of both, depending on the characters' role.

In our virtual dinner party, the action is then performed by the corresponding virtual character, using gestures, mimics and synchronized speech. In order to avoid undesirable overlaps in the scenario, the virtual scenario also handles the timing of the utterances.

## 5.1 Horde3D GameEngine

The design of the Horde3D GameEngine is based on dynamically loadable components. All objects within a game application are represented as an entity in the game world to which a component can be attached. For example, to simulate the behavior of a box that interacts with other objects in a scene, a physics component with appropriate parameters, such as mass, is added. A component is encapsulated from the rest of the GameEngine code as much as possible, which makes it easy to add new functionality without understanding the whole source code. The components interact with each other using an event-based messaging system. The current version of the Horde3D GameEngine includes several basic components for controlling animations, sound and text-to-speech (TTS), physics simulation, inverse kinematics and facial animation control.

## 5.2 Components

The Animation Component is responsible for controlling animations in the virtual scene. This component attached to an entity (e.g. a virtual character) enables it to play any suitable animation. It provides methods for blending animations on multiple stages. The Scenegraph Component provides an interface to the scene graph of the Horde3D Graphics Engine. It checks the scene graph transformation of all entities with a Horde3D representation and notifies all other components whenever these transformations have changed. The Bullet Physics Component integrates the the Bullet Physics Library into the GameEngine, allowing e.g. collision detection between objects in the game world or simulating physical behavior of objects in the scene. The Sound Component offers methods to play sound, which can be attached to an entity and plays the 3D sounds depending on their respective locations. The Speech Component is a text-to-speech module that makes the virtual characters talk lip-sync (using the Microsoft Speech API), given they provide the necessary morph targets for the corresponding visemes. Further it allows to map pre-recorded voice files to lip-sync with a virtual character. The FACS Control Component controls a virtual characters' facial expressions using the Facial Action Coding System (FACS). Further details can be found in [10]. Finally, there is an Inverse Kinematics Component, which enables pointing gestures and is mainly used to control a virtual character's head and eye direction.

## 5.3   Agent Control

The component-based approach of the Horde3D GameEngine allows us to attach an agent component (see Section 4.2) to each virtual character entity. Thus, the server is able to control the virtual character directly while the details for animating the virtual characters or text-to-speech are encapsulated in the other components of the GameEngine. The agent component plans the following four actions: *act*, *speak*, *gesture* and *goto*, whereas each actions holds subactions, such as *greet*, *ask* or *answer* for the *speak* action for example.

To control the virtual characters, we transform the abstract actions broadcasted by the agent component into direct commands for the GameEngine. For example, if an agent component sends the action `agent1 speak greet agent2`, agent1 looks up the appropriate greeting utterance and speaks it via the TTS component. The necessary knowledge base is attached to the virtual scene as a Horde3D GameEngine component. In this manner, each agent component of a virtual character is able to easily access the knowledge base and translate the actions for example to utterances that shall be spoken.

## 6   Conclusion and Future Work

Every situation is judged differently depending on the observer. Following this idea, we described a system architecture where multiple users can experience the same story from different perspectives depending on their assumed role. In our interactive drama the user finds himself in the role of a guest at a dinner party, where virtual agents as well as other users interact with each other. The virtual agents' behavior is controlled by a distributed planning system. Thus, they are independent from each other and highly reactive to interactions either performed by other agents or human users.

The virtual scenario is visualized by the Horde3D GameEngine, which is based on dynamically loadable components. Users represented through user avatars can join and leave the interactive scenario at any time. Their interactions are limited to their assigned role, thus they need to deal with a given situation and the implicit goal that is determined by their given role.

In this paper, we focused on multiple user participation. However, the users' interaction possibilities were limited to interaction categories for which the system generated an utterance and the corresponding nonverbal behavior. In our future work, we will allow for natural language input in order to build a more interesting scenario for the user. In addition, we plan on expanding our system by defining more system-controlled characters as well as additional user roles.

## Acknowledgments

The first author of this paper was supported by a grant from the Elitenetzwerk Bayern (Elite Network Bavaria). This work was also funded by the European Commission under grant agreement IRIS (FP7-ICT-231824) and the German

Research Foundation (DFG) through its funding for the Cube-G project (RE 2619/2-1). In addition, the authors wanted to thank Volker Wiendl for initiating the Horde3D GameEngine.

# References

1. Pizzi, D., Charles, F., Lugrin, J.-L., Cavazza, M.: Interactive Storytelling with Literary Feelings. In: Paiva, A., Prada, R., Picard, R.W. (eds.) ACII 2007. LNCS, vol. 4738, pp. 630–641. Springer, Heidelberg (2007)
2. Mateas, M., Stern, A.: Facade, An Experiment in Building a Fully-Realized Interactive Drama. In: Game Developers Conference, Game Design track (2003)
3. Lankoski, P., Horttana, T.: Lies and seductions. In: Spierling, U., Szilas, N. (eds.) ICIDS 2008. LNCS, vol. 5334, pp. 44–47. Springer, Heidelberg (2008)
4. Aylett, R., Louchart, S., Tychsen, A., Hitchens, M., Figueiredo, R., Mata, C.D.: Managing emergent character-based narrative. In: Second International Conference on INtelligent TEchnologies for interactive enterTAINment (INTETAIN 2008). ICST, Brussels (2008)
5. André, A., Rist, T.: Controlling the Behaviour of Animated Presentation Agents in the Interface: Scripting versus Instructing. AI Magazine, Special Issue on Intelligent User Interfaces 22(4), 53–66 (2001)
6. Rist, T., André, A., Baldes, S.: A Flexible Platform for Building Applications with Life-Like Characters. In: Johnson, W.L., André, A., Domingue, J. (eds.) IUI 2003, pp. 158–165. ACM, New York (2003)
7. Augsburg University,
   http://mm-werkstatt.informatik.uniaugsburg.de/projects/GameEngine
8. Allen, J., Core, M.: Draft of DAMSL: Dialog Act Markup in Several Layers,
   http://www.cs.rochester.edu/research/speech/damsl/RevisedManual.html
9. University of Maryland, http://www.cs.umd.edu/projects/shop/index.html
10. Bee, N., Falk, B., André, A.: Simplifed Facial Animation Control Utilizing Novel Input Devices: A Comparative Study. In: Conati, C., Bauer, M., Oliver, N., Weld, D.S. (eds.) IUI 2009, pp. 197–206. ACM, New York (2009)

# Bridging Media with the Help of Players

Michael Nitsche, Matthew Drake, and Janet Murray

School of Literature, Communication & Culture, Georgia Institute of Technology
686 Cherry Str., Atlanta, GA 30332-0165, USA
{michael.nitsche,mdrake,janet.murray}@lcc.gatech.edu

**Abstract.** We suggest harvesting the power of multiplayer design to bridge content across different media platforms and develop player-driven cross-media experiences. This paper first argues to partially replace complex AI systems with multiplayer design strategies to provide the necessary level of flexibility in the content generation for cross-media applications. The second part describes one example project – the Next Generation Play (NGP) project – that illustrates one practical approach of such a player-driven cross-media content generation. NGP allows players to collect virtual items while watching a TV show. These items are re-used in a multiplayer casual game that automatically generates new game worlds based on the various collections of active players joining a game session. While the TV experience is designed for the single big screen, the game executes on multiple mobile phones. Design and technical implementation of the prototype are explained in more detail to clarify how players carry elements of television narratives into a non-linear handheld gaming experience. The system describes a practical way to create casual game adaptations based on players' personal preferences in a multi-user environment.

**Keywords:** cross-media, television, gaming, narrative, player-centric.

## 1 Introduction

In order to navigate the complexities of content transformation from one delivery platform to the other in cross-media environments, this paper will suggest focusing on the player not only as the interactor but also as participant in the generation of new experiences. The first half this paper will outline the problem set and the development of such a player-driven approach with its challenges and advantages. The second half will exemplify this approach using a cross-media application we developed based on this kind of player-centric approach.

To note that we are in the midst of the battle for the living room is an outdated understatement. With ubiquitous computing settling in through new generations of smartphones every possible media format, its delivery, and place for media consumption is changing. So are the design and publishing paradigms: the iPhone is challenging the Nintendo DS as the dominant handheld gaming platform, a provider like Verizon expands its own game delivery channel, and Sony first combines movie experiences between its PS3 home console and its PSP handheld only to present the next PSP iteration as completely relying on digital distribution. Networks like Xbox Live

I.A. Iurgel, N. Zagalo, and P. Petta (Eds.): ICIDS 2009, LNCS 5915, pp. 269–279, 2009.

and the Playstation Network deliver games, movies, streaming video, and other media services across various devices adding more dynamics to a shifting landscape. The problem we will address here is in this area of media convergence. Blurring borderlines leads to a 'content continuum' wherein 'all platforms [...] will deliver slices of the content pie' (Steve Billinger cf [1]). Yet, how elements of traditional media narratives can make this transition remains debated.

## 1.1 Multiplayer Content

Remarkable research efforts investigate computational systems designed to deal with the complexity of new narratives (e.g. [2] [3]). But the continuous changes in merging content formats between constantly improving technical platforms poses challenges beyond that of AI storymaking systems. Blending services over different platforms results in a level of complexity that is reminiscent of emergent play forms found in Massively Multiplayer Online Games. Here, players' ingenuity has led to countless unexpected dramatic and narrative creations that often defy the designers' intentions. As Morningstar and Farmer, pioneers of the graphic multiplayer world Habitat, discovered already in the first generation of graphic multiplayer worlds: *detailed central planning is impossible'* [4]. Players who engage with these worlds often adapt to new media and narrative possibilities with impressive speed and develop a mastery that allows them to tweak and re-use the available features in countless new ways. The level of media literacy among this generation of players can developed fast, not only in MMOGs but also in other inherently multiplayer game forms such as Alternate Reality Games (ARG). These players are at ease with constantly shifting literacy forms [5], which themselves have been suggested as important discourse forms [6] and opportunities for social formation [7]. For these players, the complexity of a media situation is not a hindrance but the very canvas they use to express and realize their engagement. One example for the resulting new formats is the culture of Machinima [8]. However, these systems often distinguish between producers and consumers – machinima makers and audiences of the finished product; puppet masters and players of an ARG. What if instead *every* situation rooted in existing media would be customized and affected by *every* player as it is adapted into a new interactive form?

Multiplayer game design is a treasure chest for cross-media design as it deals with the provision of a creative pool from which players can define new content. Emergent play forms can be utilized as the 'possible worlds' [9] become access points to bridge the gap between different media. Multiplayer design allows us to stage players as active factors in the transformation of traditional storylines to nonlinear gaming conditions and their highly adaptable emergent play forms lead to player-centric approaches that are not only flexible enough in concept but, as this paper will demonstrate, are a technically feasible approach to navigate the complexities of the task at hand: to connect traditional media and narratives to new forms of gaming experiences across different delivery platforms.

## 1.2 Tapping into the Player

Multiplayer content shares some qualities and challenges with collaborative storymaking. Collaboration between players has been noticed as a productive tool whether

is it in educational games [10], for the development of novel interfaces [11], or creative use of existing ones [12], among other applications. The question often mirrored in this literature is how to engage players in a collaborative creative process without presenting cumbersome interfaces along the way.

It cannot be expected that every player would succumb to the hard work of hand-crafting new content. The learning curve for advanced Machinima production, for example, includes often mastery of the game engine, multiple graphic programs, editing suites, 3D modeling, sound production, and most of the pre- and post-production pipeline of a film shoot [13]. Machinima might be a useful reference, as it is a comparably cross-media format, taking content from gaming to video. It also highlights the challenges at hand: simplifying the involvement of the player. In the example case below, the reverse transition is attempted. NGP adapts content from existing traditional narratives (TV shows) into handheld gaming. The question of how to involve players' collaborative efforts in the generation remains central and the project has to offer a solution for the complexities and accessibility of the media transformation by the user.

The following discussion aims to answer these questions using the Next Generation Play project conducted at Georgia Tech's Digital World & Image Group (http://dwig.lcc.gatech.edu/) as example, discussing its design parameters, implementation, and functionality.

## 2   The Next Generation Play Project

The focus of the Next Generation Play (NGP) project is on media convergence between television and handheld casual video games. It addresses cross-media design by connecting an interactive 'big screen' TV experience with a casual 'small screen' game played on mobile phones. In that way, NGP is based on traditional media, namely existing TV programs, from which it derives content elements for nonlinear gaming. These programs can be narrative, dramatic, poetic – in fact, the individual show's format does not matter as each program is treated as a source for virtual objects that traverse from the TV to the gaming experience.

The overall experience consists of three main elements. First, players engage with an interactive TV application that consists of a collection game wherein players can gather media objects as they become available on screen during a TV show (for a more detailed background see [22]). Second, they engage with a handheld casual game, which is based on their play events and the objects collected from the TV game. Third, they can exchange items in a form of virtual trade.

### 2.1   Overview

Users playing the NGP prototype are invited to collect virtual objects embedded in the film clip of the TV show they are watching. Because the choice of the TV program and the decision which item to collect both reflect the player's personal taste and preferences, this collection of objects leads to a highly individual inventory. The personal inventory of each user is stored in a central database. From there, NGP expands into a casual multiplayer game on handheld devices. When activated on the mobile phone the game connects multiple players to start an instant multiplayer game session. Together they play a casual 2D platform jump 'n' run title not unlike established

console games of that genre. The game levels are procedurally generated on the server side and populated with the items from each participant's inventory of collected TV objects. Thus, the objects of interest during the TV session turn into interactive pick ups, enemy characters, or they might become part of the scenery in the game session. The uniquely created game instance allows players to share their personal inventories in a playful way with other participating players. Finally, players can exchange items after the game is finished. This is done in a virtual trade set up, which allows them to bid for and swap individual objects they have encountered in the game session.

NGP did not set out to replace existent media but to build on established media formats and story content to spawn new interactive experiences. NGP does not so much generate new storylines but it evolves from existing storylines and storyworlds of traditional TV media. Characters, story items, scenery, any depicted element of the TV show can be re-used as interactive element in the gaming experience. NGP uses the concept of player collections and profiling to generate a personalized database of interesting objects for each player. This database opens up the necessary possibility space from which surprising interactive situations are generated. It is up to the players to provide the active ingredients for this experience and the differences in their individual tastes and preferences are the basis for the emergent game situations. It is up to the game generator to combine them into a unique game setting. These features co-define the possible multiplayer-centered content transformations suggested here but it had to resolve a number of design and technical challenges to operate.

## 2.2 Design Philosophy

To avoid any learning curve during the game creation the project provides impromptu play or *ad hoc* "renegade play" [14]. That means, the game has to be immediately accessible. It has to be simple enough to be picked up at any moment but also engaging and fresh each time it is played. Instead of careful preparation and optimization, these games provide instant access to playful interaction. These forms are often supported by casual games that allow for fast, short, and accessible play.

Player behavior and demography of casual gamers differ significantly from so-called hardcore players [15]. Thus, in order to support this kind of *ad hoc* gaming, the game design had to be accessible but also variable enough to attract continuous revisits to the game setting, as they are common in the casual player world. That is why, although our underlying architecture is genre-agnostic, we chose a 2D platform jump'n run game as a typical example for accessible multiplayer gameplay. It allowed us to present players relatively short but variable levels to utilize the system. It also provided us a challenge to test the latency and network capabilities of the available hardware (this is a part of the project that will not be covered here).

Because the goal was to provide player-centric content transformation, this level of flexibility in the usage of the media objects had to be connected to the social settings of the cross-media experience. Video games offer a range of different social settings, each one with its own parameters. Whether it is a single player, Local Area Network event [16], or the online communities of MMOs [17] [18], each setting fosters certain forms of (social) interaction. NGP set out to connect TV experiences with handheld gaming in a multiplayer setting. This implies the transition from a traditionally single user experience in front of the screen to a multiplayer experience on the mobile

device. This is not only a shift in terms of technology but also in terms of social game design. As outlined above, NGP utilizes the unpredictability of games as social media to create new interactive experiences. It is the combination of random players that defines which inventories are used to generate a game world. As one can never predict the countless variations of collected objects, preferences of the nearby players, and random elements in the game world generator, the system combines basic AI in the world generation with much more complex levels of player variety.

### 2.3  Players Connecting to Existing Storyworlds

Co-presence has long been noted as an important design factor in digital media [19]. However, co-presence of other players does not necessarily always lead to higher involvement or increased social interaction during game play [20]. NGP had to make sure that the game's design and technical implementation assists this transition.

Because the virtual items can always be traced back to one player's TV preferences, NGP actively taps into practices of TV fandom. Through the connection between TV and handheld game, NGP connects game generation with interactive TV viewing and players shape the game world through their personal choices of TV programs (their taste) and collected objects within them (their preferences). One player's personal obsession to "get" all items from a certain TV show will directly affect the game worlds of everybody else who will ever play with this player. On the other hand, if inventories of players show a lot of overlap in collected items, the range of available different game objects will be limited. Each virtual item can be coded to behave in an appropriate way that supports the original storyworld. The appearance and animation of each item is always pre-set. This continuity ensures that the reference to the underlying narrative remains intact. More importantly, the player can still recognize the item and its context from the TV original. The storyworld of the TV show and the player's connection to it become directly responsible for the player-dependent game generation. On a design level, this supports the necessary level of co-influence in the content transformation.

At the same time, some underlying rules are needed to spawn the game levels. A procedural level generator assembles the collected objects of all players involved in a game session whenever they create a game instance. The result is a unique playable 2D "play" that is sent to the participating mobile phones. While the main interaction remains relatively simple the underlying game levels change from instance to instance and therefore provide engaging surprises.

Because game levels are based on each individual's TV preferences the gaming situations are a form of interactive debate *about* each favorite's show. A fan of the *Superman* animated series might meet a dedicated *Lost* fan – and both TV shows will populate the 2D game, providing surprising interactive options and ample opportunity to discuss the differences of the game as well as the TV content afterwards.

To further support the interaction between players and their collaborative engagement after the game event, we included a "share" function in the system. If a player has encountered an interesting item provided by another player in a game session, then the first player can offer a virtual object trade to the second. If the offer is accepted, two virtual items will be swapped and the inventories are re-arranged. In that way, players can continue to build their virtual inventory.

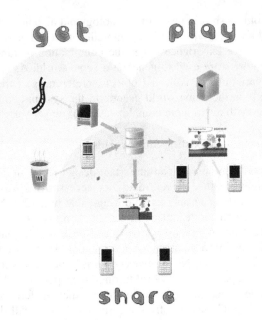

**Fig. 1.** NGP basic architecture

# 3 Implementation

At the core of the system is a database that administers the object collection and user ID management. This database track the three stages of "get", "play", and "share" throughout. It also synchronizes TV game and mobile game. The 2D game itself uses a separate server for the level generation and updating of the handsets active in the game session.

## 3.1 TV Game

The TV Collection game began as a project in Janet Murray's eTV group (http://etv.gatech.edu) in collaboration with Turner Cartoon Network, SONY, and the AFI Digital Content Lab. The problem posed at that time was how players would watch broadband TV, in particular the popular cartoon adventure, *Ben 10*, from a networked game console. The industry partners pursued a rapid development path of creating a casual game separate from the unfolding TV show, but the Georgia Tech eTV team focused on reinforcing the immersive experience of the television program by creating an experience that afforded dramatic agency [21]. The approach of the resulting *SyncGame* was to reinforce the reality of the objects within the story by letting the player grab them, collect them, and use them in ways similar to the ways in which they were used in the story. The core functionality of the original Flash *SyncGame*, built under the direction of Sergio Goldenberg, is the collection of objects as a player watches a TV show [22]. As the show rolls, the program shows icons of collectible items that will become available for collection in an own interface bar

**Fig. 2.** TV collection game; the lower bar indicates items that can be collected, the cross hair allows selection of objects

(see fig. 2). When the items become available a half-transparent overlay appears over them and players use a cross hair device to select these items while they are on screen. Using Flash's frame counting feature, the parallel stream of these items and their availability is synched with the TV program.

NGP adapted this system and developed it further. When an item is collected, its unique ID is sent to the central mysql database. The objects themselves are stored in a sister XML set that contains each particular item's graphics, animations, behavior, and other information such as associated URLs or text descriptions. For example, collecting a ballerina's dancing shoe from the *Sherlock Holmes* episode depicted above includes access to the shoe's appearance, a URL, text description, and a given behavior of that shoe in the 2D game setting. In our case, that shoe can work like a power-up for any player who picks it up and will allow characters to jump higher in the 2D game world.

This separation of active objects allows us to gradually add more interactive objects to the game environment without complicating user management.

### 3.2 Handheld Game

Originally targeted to explore possible applications for upcoming 4G networks, NGP currently is implemented using local Wi-Fi (802.11g) and TCP calls to simulate possible future networks performance. When players initiate a game session they activate a procedural level generator on the server side. NGP creates a new game world for every game instance to provide a new and personalized gaming experience every time the game is played. First, it reads an XML file located on our server that contains the information for every object available in the game – including the objects in the participating players' inventories. Once the multiplayer public game server has accessed the database it merges both players' XML data to allow NGP to use their combined inventory in the shared level. This was achieved by appending data to Hash Maps but placing exceptions for identical keys.

The combined masses of collected items are utilized as enemies, pick ups and power ups. Then, the generator on the server side has to determine the size of the

level and create a passable skeleton pathway through it to guarantee that every level can be finished and no dead ends are allowed. Such a path is created with the help of simple AI pathing methods as the generator checks the level architecture. Finally, this level is populated with the virtual objects collected from the TV inventories of all players involved in this game session. The final result is a XML that is sent to the handheld devices and contains all the necessary level information as well as information about the objects inside of the level. Figure 3 shows one resulting level of the game and includes a champagne bottle and an automobile as possible pick up elements. Both of these elements have their own particular behavior and appearances.

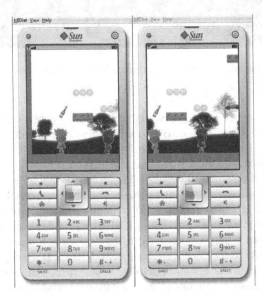

**Fig. 3.** NGP in-Game screen shot (taken from the emulator) with two active players at the starting location of a generated level

All networking is done through TCP wireless protocol. We can combine multiple inventories but concentrate at the moment on 2-4 multiplayer sessions. This restriction is also dependent on the limitations of our hardware platform (Nokia N80 phones). Because the game section on the handheld device is separated from the core database, the architecture allows for different possible game and non-game implementations based on the virtual inventories. Our overall system is genre-agnostic and virtual objects could be re-used in manifold ways to create new game experiences.

The original 2D game was coded in Java and later ported to J2ME. The handheld casual game is a multiplayer 2D platform jump'n run game designed for up to four players. Players find their avatars surrounded by key items of combined TV narratives assembled into a unique new mixture. The objects re-appear as interactive operators. A collected car might turn into a special ability for the player to move faster, a champagne bottle into a "floating ability" that reduces gravity, a villainous character might re-appear as a computer controlled enemy. The object behaviors are included in the overall XML level file generated on the server. The only part pre-existent on the phones is the game engine itself.

Finally, NGP offers the chance to trade virtual items via the "share" option. This opens up a menu of items owned by all other registered players. Here, the player accesses a catalog of available items from the server. From this list of items, players can select the desired one and are then shown a list of items that they own. They then select the item they would like to trade for their initial desired item and the owner of desired item in question is sent a notification to either confirm or reject the offer. The notification is passive and will be shown to the item owner at the start of their next online session.

The first stage of the NGP project was implemented on a Sony Vaio UMPC running Java and was subsequently ported to Nokia N80 cell phones and J2ME. Because of our technology choices, the only consistency that we required among the hardware was that the machines are capable of running the Java virtual machine and were able to make URL requests through a TCP connection. This leaves our underlying architecture open for future extensions.

# 4 Conclusion

NGP effectively connects traditional storytelling media with interactive game settings across different technical delivery platforms. It is player-centered insofar as it uses the personal preferences of each player as a distinguishing factor for the game generation. Each individual player influences the outcome of the level generator – but the combination of multiple players makes any prediction of the resulting game world impossible. As such, NGP is one example for cross-media multiplayer-driven content creation and it demonstrates the power of the player as a factor in the game creation and content transformation.

Our hope that the sharing of digital items in a game world can foster ad hoc and direct player interaction has yet to be proven and has been known to be problematic in other projects [23]. However, to support more interaction with physical surrounding, we also added a Quick Response (QR) code reader based on the ZXing open source library to the mobile application. With the help of this reader, players can collect media objects not only from TV media but also from any visual representation form that can display QR codes (fig. 1 shows a coffee cup as collection point). Therefore, the range of traditional media that can interface with the system can be extended and include, for example, newspapers, books, billboards, or product packaging. Players can collect virtual objects from any of these real-world sources and add them to their inventory. In that way, a closer connection of the gaming inventory to the physical shared environment of the players is provided and interactions can become better situated in the real world. Overall, we hope to use technology like the QR code reader to simplify the system further and widen the available media pool to increase the power of players and involve them further in the ongoing media transformation.

NGP has been presented at multiple occasions to a wide range of audiences from mobile tech professionals in industry and academia to regular casual mobile phone users. Its value for a range of commercial applications from more effective product placement to cross-media storytelling and edutainment were instantly recognized by many players – experts as well as interested casual users. We conclude that the connection of traditional media content and nonlinear re-use of virtual objects seems to

be generally accepted and players seems to be ready to build their own experiences in projects that use a multiplayer-centric design. NGP offers a cross-media example for such a design.

## Acknowledgements

The Next Generation Play project is possible thanks to generous support from Alcatel-Lucent.

## References

1. Ursu, M.F., Thomas, M., Kegel, I., Williams, D., Tuomola, M., Lindstedt, I., Wright, T., Leurdijk, A., Zsombori, V., Sussner, J., Myrestam, U., Hall, N.: Interactive TV Narratives: Opportunities, Progress, and Challenges. ACM Transactions on Multimedia Computing, Communications, and Applications 4(4), 1–39 (2008)
2. Mateas, M., Sengers, P.: Narrative Intelligence. John Benjamins Publ. Co., Amsterdam (2002)
3. Cavazza, M., Donikian, S., Christie, M., Spierling, U., Szilas, N., Vorderer, P., Hartmann, T., Klimmt, C., André, E., Champagnat, R., Petta, P., Olivier, P.: The IRIS network of excellence: Integrating research in interactive storytelling. In: Spierling, U., Szilas, N. (eds.) ICIDS 2008. LNCS, vol. 5334, pp. 14–19. Springer, Heidelberg (2008)
4. Morningstar, C., Farmer, F.R.: The Lessons of Lucasfilm's Habitat, pp. 273–303. MIT Press, City (1991)
5. Steinkuehler, C.A.: Cognition and Literacy in Massively Multiplayer Online Games. Erlbaum, City (2008)
6. Gee, J.P.: What Video Games Have to Teach Us about Learning and Literacy. Palgrave Macmillan, New York (2004)
7. Taylor, T.L.: The Social Design of Virtual Worlds: Constructing the User and Community through Code. In: Proceedings of the Internet Researchers Conference. Peter Lang, New York (2002)
8. Nitsche, M.: Claiming Its Space: Machinima. dichtung-digital, 37 (2007), http://www.dichtung-digital.org/2007/nitsche.htm
9. Ryan, M.-L.: Possible Worlds: Artificial Intelligence and Narrative Theory. Indiana University Press, Bloomington (1991)
10. Ferdig, R.E.: Handbook of Research on Effective Electronic Gaming in Education. IGI Global, City (2008)
11. Mazalek, A., Davenport, G.: A Tangible Platform for Documenting Experiences and Sharing Multimedia Stories. In: Proceedings of the International Multimedia Conference, Berkeley, CA, pp. 105–109. ACM, New York (2003)
12. Fischer, G., Giaccardi, E., Eden, H., Sugimoto, M., Ye, Y.: Beyond Binary Choices: Integrating Individual and Social Creativity. International Journal of Human-Computer Studies 63(4-5), 482–512 (2005)
13. Marino, P.: 3D Game-Based Filmmaking: The Art of Machinima. Paraglyph Press, Scottsdale (2004)
14. Szentgyorgyi, C., Terry, M., Lank, E.: Renegade gaming: practices surrounding social use of the Nintendo DS handheld gaming system. In: Proceedings of the Proceeding of the twenty-sixth annual SIGCHI conference on Human factors in computing systems, Florence, Italy, 2008, pp. 1463–1475. ACM, New York (2008)

15. Dobson, J.: Survey: PopCap Releases Casual Game Findings. Gamasutra.com, September 13 (2006),
    http://www.gamasutra.com/php-bin/news_index.php?story=10861
16. Jansz, J., Martens, L.: Gaming at a LAN Event: The Social Context of Playing Video Games. New Media & Society 7, 333–355 (2005)
17. Taylor, T.L.: Play between Worlds. Exploring Online Game Culture. MIT Press, Cambridge (2006)
18. Ducheneaut, N., Yee, N., Nickell, E., Moore, R.J.: Alone together?: Exploring the Social Dynamics of Massively Multiplayer Online Games. In: Proceedings of the SIGCHI conference on Human Factors in computing systems, Montreal, 2006, pp. 408–416. ACM, New York (2006)
19. Dourish, P.: Where the Action Is. The Foundations of Embodied Interaction. MIT Press, Cambridge (2001)
20. De Kort, Y., Ijsselsteijn, W.A.: People, Places, and Play: Player Experience in a Socio-Spatial Context. ACM Computers in Entertainment 6(2), Article 18 (2008)
21. Murray, J.H.: Hamlet on the Holodeck. The Future of Narrative in Cyberspace. MIT Press, Cambridge (1997)
22. Goldenberg, S.: Creating augmented and immersive television experiences using a semantic framework. In: Proceedings of the 1st international conference on Designing interactive user experiences for TV and video, Sillicon Valley, 2008, pp. 45–48. ACM, New York (2008)
23. Li, K.A., Counts, S.: Exploring social interactions and attributes of casual multiplayer mobile gaming. In: Proceedings of the International Conference on Mobile Technology, Applications, And Systems, Singapore, 2007, pp. 693–703. ACM, New York (2007)

# To Be or Not to Be:
# Towards Stateless Interactive Drama

Nicolas Szilas and Monica Axelrad

TECFA, FPSE, University of Geneva, CH 1211 Genève 4, Switzerland
{Nicolas.Szilas,Monica.Axelrad}@unige.ch

**Abstract.** In this paper we investigate a new way to represent the narrative structure in interactive drama models. It consists in explicitly defining generic links between actions, rather than relying on states, as it is the case for other interactive narrative approaches. This new approach is especially promising in terms of authoring.

**Keywords:** Interactive drama, interactive narrative, authoring, stateless.

## 1 Introduction

### 1.1 Interactive Drama Systems as State-Based Engines

Within the field of Interactive Digital Storytelling, Interactive Drama is a computer-based fiction where a user chooses most of the actions for the main character in a story. This is a hard challenge, because it involves both the dynamic generation of narrative events and the integration of user inputs within the generation. In interactive dramas such as Façade [11,12], The Mutiny (written with IDtension) [24] or The Balance of Power (written with Storytron) [22], the user can not only wander in space, use objects and choose among pre-written sentences, as in commercial adventure games, but is also given the possibility of interacting with other characters in the story. The user can, for example, encourage other characters to perform actions, help them, accept or refuse aid, condemn their actions, inform others about past or possible actions, etc.

These three examples, as well as other prototypes that have been developed so far [5,17,19,28], use very different algorithms to generate story events and integrate user's choices. There exists no consensus on how the algorithms of these systems should be classified: plot-based vs character-based, planning vs modular [10], coarse grain vs fine grain [24]. However it is usually admitted that the more generative the algorithm, the more potential for user influence on the story, but the more difficult it is to create an interesting narrative. For example, the plot point approach [20,27], which consists in setting a small set of partially ordered important events in a story, guarantees a good overall quality of the story, but leaves limited room for user influence (or global agency [11]). Façade is an interesting case, in which generativity stopped at the level of sentences; these are not generated in order to preserve their expressive quality. More generative systems, such as DEFACTO [19], Storytron [22],

I.A. Iurgel, N. Zagalo, and P. Petta (Eds.): ICIDS 2009, LNCS 5915, pp. 280–291, 2009.

IDtension [24], EmoEmma [5], Mimesis [28] or Gadin [2] require a more abstract representation of characters' actions, which tend to diminish the expressivity of utterances.

This paper will focus on the latter approach, that is, generative algorithms. Within this category, several approaches can be distinguished:

- Character-based planning [1,4]: consists in calculating all possible story paths from an initial situation and selecting a plan that can reach each character's goal.
- Narrative planning [2,6,28]: consists in setting a story goal as well as various narrative constraints, then calculating a plan that reaches that goal, possibly modified by user's action.
- Narrative actions and constraints [19,22,24]: consists in choosing a parametrized representation of actions and calculating the next action according to narrative constraints.

This short review does not pretend to be a definitive classification of systems but allows us to observe the following: each of these generative systems, while having different formalisms, use generative rules that have states as preconditions (character state, world state, player model state) and other states as a consequence.

This is not a surprising fact, since Artificial Intelligence, with the development of expert systems, commonly uses facts as state descriptions for a world, which are modified by the procedural part of the systems, the rules. But in this paper, we would like to challenge this idea, and see how generative rules could conversely handle actions. That is, how could a generative rule connect one action to another, without the notion of state.

## 1.2   States vs. Actions in Narrative Theories

By analyzing the basic elements of narrative, narrative theorists established some classification of the main micro-constituents of a narrative. In [9], several such theories are overviewed. A basic distinction emerges from this overview, the distinction between static parts (states or stative events) and active parts (non stative events or events). This corresponds to the classical distinction between description and action. Events are then further distinguished between deliberate events (events created by characters, that we can consider actions) and non-deliberate events (also called happenings) and between bounded and unbounded events relative to time. Various narrative genres would use different proportions of these events and states. Typically, a psychological novel such as Madame Bovary uses more states than an epic novel. Interactive Drama, being drama, focuses on actions. Thus we are mostly interested in action, in terms of what is displayed to the user, and which choices is given to him.

States however, even if they are not explicitly represented in the story, are usually used to describe the story logic. At a general level, a story is often defined as the transformation from one state to another. In a detailed analysis, Bremond describes processes, which are a series of local states between which actions can occur [3]. More audience-oriented theories also use states, such as emotional states of the audience [26].

Despite the existence of these narrative theories based on states, we claim that states in narrative, and especially in drama, are *indirect variables*. They are often not

directly seen because actions are seen. In fact, states are inferred by the reader, through interpretation [9]. For example, in a movie, we would not objectively see the fact that a character is sad, be we would see him crying. We are not saying that states cannot be expressed in a drama (at a minimal level, it can always be expressed by a narrator), but that a state is more interestingly expressed through an action. This corresponds to the classical writing advice: "show do not tell" (e.g. [13]).

Generative rules between actions naturally lead us to the notion of causality. Although narrative causality is defined in [16] as "A relation of cause between (sets of) situations and/or events", we claim that the most powerful way to describe narrative causality is to establish a link between an event and another event. For example, in the movie Alien, we claim that the relation between "Ash let Dallas enter the ship → crew members are attacked" is more interesting than "Dallas is inside the ship → the ship is infected". This determines the starting point of the narrative engine that will be described in the rest of the paper.

## 2  Principle of a Stateless Narrative Engine

A stateless narrative engine only handles actions.

Let us take the movie "It' s a wonderful life" as an example. The overarching story can be summarized as follows:

S1: George's company is ruined
S2: George wants to commit suicide
A0: Clarence shows him the world as it would be if he hadn't been born
S3: George is horrified and wants to live again

While this first description is correct and conform with the idea of a story as a transformation, an alternative way to describe the same story is:

A1: Uncle Billy tells George he lost George's company's money
A2: George starts to commit suicide
A3: Clarence shows him how wonderful life is
A4: George asks Clarence to live again

While the first description contained four states and one action, this second description is purely based on actions. The stories are identical, and a complete description could also be built by interleaving the states of the first story inside the second story, but the second story manages to totally avoid the presence of states. A stateless narrative engine would only contain rules that link different actions together, rather than a rule from a state to an action.

An English description of such a rule could be: "If someone learns he has lost all his money, then he can kill himself", rather than "if someone is ruined, he can kill himself".

This exercise of avoiding all states in story description and rules is uneasy. For example, we are tempted to write that, "Georges is ruined" and later that "George is happy", action-based analysis can be less natural. Sometimes even, stateless analysis can be more complicated as will be detailed below. It does however open the way to a new, maybe more expressive approach for story representation, dynamic generation and interaction.

# 3 Rules as Links

Right from the start of designing a new narrative engine, we have taken an authoring point of view. Authoring is one of the main issue in Interactive Drama [12,21,23], since the complexity of current approaches and tools has prevented authors from writing compelling stories.

We have attempted to describe the storyworld, the rules between actions, in a compelling way. We have come up with a visual representation of both rules and narrative simulations (stories-so-far), in terms of links between actions.

## 3.1 Enabling Links

An example of a rule is:

perform(X,t) $\rightarrow$ informPerformance(X,Y,t)

where $X$ and $Y$ are characters and $t$ is a task or an action (a task is an atomic action, author defined, possibly with parameters)

This rule expresses an *enabling link* between two generic actions. The first action represents an action that has already been executed. It is part of the *history* (or story so far). The second action is a possible action. If two actions in the history must be present to enable one possible action, two links are created.

A scenario contains a set of such links, which are activated according to the following algorithm:

Let $E=\{ri\}$ be the set of enabling rules, $S$ the initial set containing the actions already executed (we call it the backstory), $P$ the set of possible actions at a given moment in the narrative. The algorithm is:

BEGIN ALGO 1
   REPEAT
      Fire all rules in $E$ against $S$, store the right hand side of the firing rule into $P$
      Remove from $P$ actions whose one antecedent via rules in $E$ are not in $S$.
      Randomly select an action $a$ in $P$
      Play $a$
      Add $a$ to $S$
      Clear $P$
   END REPEAT
END ALGO 1

In ALGO1, the selection between possible actions is random. For the player's character's actions, the choice can be given to the player. For other actions, the action selection is tackled by another module and algorithm.

When a series of actions has been chosen, the story-so-far can be represented by a simulation graph, which displays actions (mainly their structural description), with their dependence from previous actions. For example, the story sketched in the previous section is represented by a graph of actions with links (Fig. 1). This representation resembles a narrative plan in [18] or causal network in [17], but does not contain any state descriptions.

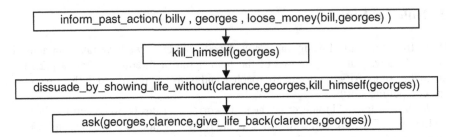

**Fig. 1.** Graph of actions of a specific story

In the simplistic case of Fig. 1, the graph is a line, but a single action can depend from several previously executed actions. In the general case, the simulation graph is an oriented acyclic graph1.

In the simulation graph depicted in Fig. 1, it should be noted that the link from the first to the second action is different than the link from the second to the third action. The latter one does not wait for the action to be finished to be triggered. Thus, two types of enabling links should be distinguished: *enable when finished* and *enable when started*.

In fact, it is interesting to use this story representation to extend the notion of links beyond simple enabling relations. As such, the model aims to go beyond the classical use of planning operators in story modeling since these operators correspond to enabling links only (irrespective of the fact that they have states in preconditions). Before discussing other types of links, one needs to tackle the issue of nonmonotony, for enabling links.

### 3.2 Dealing with Nonmonotony

Nonmonotony is the property of logical systems according to which what is true at time $t$ might not be true at time $t+1$. This is obviously the case in stories. For example, reasoning with states, if John gives a ring to Mary, Mary has the ring. But if she later sells the ring, she does not have the ring anymore. If we reason with enabling links between actions, the first giving actions would trigger a possible action such as "Mary sells the ring". Once the selling action is performed, the enabling link is still present, making it possible to sell the ring infinitely! To avoid this, it is necessary to introduce *inhibitory links*. In our example, an inhibitory link connects a selling action to a selling action, to express the fact that "one cannot sell something that one has already sold". Similarly, another inhibitory link expresses "one cannot sell something if one has already given it". For this example, if we denote enabling links by "e" and inhibitory links by "e-", the list of rules is (with X≠Y and Y≠Z):

$$\text{perform}(X,\text{give}(o,Y)) \xrightarrow{\quad e \quad} \text{perform}(Y,\text{give}(o,Z))$$
$$\text{perform}(X,\text{give}(o,Y)) \xrightarrow{\quad e \quad} \text{perform}(Y,\text{sell}(o,Z))$$
$$\text{perform}(X,\text{sell}(o,Y)) \xrightarrow{\quad e \quad} \text{perform}(Y,\text{give}(o,Z))$$
$$\text{perform}(X,\text{sell}(o,Y)) \xrightarrow{\quad e \quad} \text{perform}(Y,\text{sell}(o,Z))$$
$$\text{perform}(X,\text{give}(o,Y)) \xrightarrow{\quad e\text{-} \quad} \text{perform}(X,\text{give}(o,Y))$$
$$\text{perform}(X,\text{give}(o,Y)) \xrightarrow{\quad e\text{-} \quad} \text{perform}(X,\text{sell}(o,Y))$$

perform(X,sell(o,Y)) ——— $e$- ——→ perform(X,give(o,Y))

perform(X,sell(o,Y)) ——— $e$- ——→ perform(X,sell(o,Y))

When an action is both triggered by a positive enabling link and a negative one, the most recent is winning. Thus, the new algorithm is, with $E$- denoting the set of inhibitory rules and $P$- denoting the set of impossible actions:

BEGIN ALGO2
   REPEAT
      Fire all rules in $E$- against $S$, store the right hand side of the firing rule into $P$-
      Fire all rules in $E$ against $S$, store the right hand side of the firing rule into $P$
      Remove from $P$ actions whose one antecedent via rules in $E$ are not in $S$.
      Remove from $P$ all actions for which there exist a newer version in $P$-,
      Randomly select an action $a$ in $P$
      Play $a$
      Add $a$ to $S$
      Clear $P$ and $P$-
   END REPEAT
END ALGO2

This example also illustrates an issue with the stateless approach: more rules are necessary to describe the story logic.

### 3.3 Relevance Links

Relevance links are inspired from the maxim of relevance described by Grice, in dialogic interaction. This maxim says that people act according to what has been acted before, they follow the current topic of conversation. The relevance link is thus particularly useful for dialogic actions (assuming the hypothesis that dialogues are also managed by the narrative engine, rather than a sub-engine).

The problem of action relevance is typical in Interactive Drama. In [27], it was described as *thought flow*, which consists in favoring actions that naturally follow the one played just before. In IDtension, a mechanism of relevance was also implemented, to manage dialogues [24]. Relevance links are also related to some research on dialogue games between agents [15].

Relevance links work differently from enabling links. They do not make an action possible or impossible, but rather favor one action instead of another. They are used in the algorithm to weight and rank actions already selected according to enabling and inhibitory links. The weighting factor is calculated as follows:

Let us denote $a$ the possible action to be weighted, $Wr(a)$ the corresponding weight, $R(a)$ the set of executed actions for which there exists a relevance link to $a$, $time(x)$ the time at which the action $x$ has occurred or will occur:

$$Wr(a) = 1 + \sum_{p \in R(a)} \sigma \left( time(a) - time(p) \right)$$

where $\sigma$ is a thresholding function, that is maximal for small values and null for larger ones. For example, if the time is measured in a discreet manner (one played action is a time tick), $\sigma$ could be defined so as to $\sigma(1) = 1$ and $\sigma(3) = 0$, to express the fact that

the action is not relevant anymore when two or more actions have been interleaved between the past action and the current one.

### 3.4  Explanation Links

The links between two actions is sometimes weaker than an enabling link. Let us take the example of revenge. If somebody's loved one is the victim of a degradation action, then revenge, for this character, consists in repeating the action, but against the aggressor. The action of revenge must already be possible, but becomes narratively interesting because of the initial action. This kind of link is called an explanatory link, because the resulting action is explained by the initiating action.

As with relevance links, explanatory links will not enable or disable some actions but reinforce an action over another. Let us denote $Wx(a)$ the weight of action $a$ regarding explanation, $X(a)$ the set of executed actions for which there exist an explanation link to $a$:

$$Wx(a) = 1 + \sum_{p \in X(a)} l_x(p,a)$$

where $l_x(p,a)$ is the strength of the explanatory link between $p$ and $a$. We have introduced here the idea that a link can vary in strength, defined by an author. For example, a given link involving revenge might have a higher strength than another link involving gratitude.

### 3.5  Link Structures

The three types of links that have been presented above constitute a basis for building an interactive narrative. With this basis, many temporal simulations can be created which are not stories (the system over-generates). The way the author will organize the generic links between actions will be essential for effectively obtaining a narrative experience. Links can be used at both local and global levels. If a character gives an object to another one, it can be motivated by the simple fact that it is possible to do so because he was given the object previously. But it can be also motivated by the fact that this character failed previously in a task necessitating two persons. This latter case corresponds to a sort of higher level goal for the character, although the goal itself has been shortcut by the stateless approach.

Non formally, interesting link structures are those which combine low level links with higher level links, with long term dependencies. Interesting link structures are not linear as in Figure 1 but contain many incoming links from various types and time distance.

## 4  Preliminary Results

In order to evaluate the feasibility of the stateless narrative engine, we have developed a simulation with a few basic rules that generate story actions over time. The idea is not to demonstrate the quality of the generated story, which is naturally bound by the minimal number of rules that are currently implemented and the lack of a proper action selection mechanism. Rather, our goal is to illustrate how the proposed approach can be programmed, and open a discussion on its potential and limitations.

The minimal scenario on which our narrative simulation operates consists of some children who give various objects to each other, and sometimes thank each other for the presents. From an initial condition, the narrative simulation produces an arbitrary number of successive actions. User action is not considered here, but could be easily added, by choosing one character as the player character and letting the user choose among all possible actions for this character.

The story world contains four characters (Alan, Bill, Chloe and Ed) and three objects (the ball, the stick and the box). Two tasks are possible: give(x,y,c) ("x gives to y an object c"), thank(x,y,t) ("x thanks y for having performed t"). Four rules are programmed:

give(x,y,c) ——— $e$ ——→ give(y,z,c): one can give an object that one was given

give(x,y,c) ——— $e$- ——→ give(x,z,c): one cannot give an object that one has given

give(x,y,c) ——— $r$ ——→ thank(y,x,give(x,y,c)): one should thank for an object

give(x,y,c) ——— $x$ ——→ give(y,x,c'): one could give an object to thank for being given another object

To initiate the narrative simulation, a set of actions already executed before the start of the story is added to the history (the back story):

give(someone,alan,ball)
give(someone,bill,stick)
give(someone,chloe,box)

Note that "someone" is in fact a fifth character, a special character that is not involved in any action in the played story.

The example was programmed entirely with JESS [8], a rule-based system integrated with Java. The simulation result is reproduced in Table 1. It shows 10 actions generated by the story. Text describing actions is automatically generated in a basic form. This simple simulation, while far from representing a full story, illustrates the circulation of various objects between characters. The characters give objects to each

**Table 1.** Elementary narrative simulation of a storyworld without states

| |
|---|
| Bill gives Chloe the stick |
| Chloe thanks Bill for the stick |
| Chloe gives Bill the box because Bill was generous last time |
| Bill thanks Chloe for the box |
| Alan gives Bill the ball |
| Bill thanks Alan for the ball |
| Bill gives Chloe the box because Chloe was generous last time |
| Chloe thanks Bill for the box |
| Chloe gives Bill the stick because Bill was generous last time |
| Bill thanks Chloe for the stick |

other in a coherent manner, while thank actions systematically follow giving actions, according to the relevance link. Note that there is no distinction here between the "give" produced as a thanking of a previous give, and a "normal give". Indeed, we want this distinction to appear at the level of text generation, according to the various links incoming to the played action.

## 5   Discussion

We have shown an example of an elementary story simulation based only on the notion of links as the generic relation between two actions. In other words, no state is stored in the world of the story, only past actions are stored. Computationally speaking, this has no specific advantage, but we believe that this alternative representation of the story dynamics has potential benefits in terms of both authoring and expressiveness.

As explained in the introduction, existing interactive drama engines have extensively used the notion of states to describe how events are generated. While this notion is very natural for Artificial Intelligence researchers, it is far for being intuitive for authors. It is more natural to say that: "Harry decided to jump because his friends have encouraged him to three times" rather than "Harry decided to jump because his level of motivation was successively increased by the encouragement of his friends, and reached a certain threshold". It could be argued however that the character-centered design that is often adopted by writers or screenwriters [7] consists in defining a rich set of traits and psychological states and moods. Similarly, a screenwriter might think in terms of dramatic tension, a narrative state that is either incremented or decremented by narrative events. So it would be wrong to claim that states are not part of an author's way of thinking. But it is doubtful that authors are willing to push the notion of state up to an algorithmic level. Therefore, we claim that a stateless narrative engine is an interesting alternative, possibly closer to dramatic thinking. In the field of interactive digital storytelling, Storytron [22] is a pioneer Interactive Drama system that mixes the two approaches. In Storytron, characters are heavily defined by variables (21 personality traits) but actions (called verbs) are directly linked to each other by the author. It is interesting to report the feedback from one of the authors of this system: "I reached the point where I was juggling so many variables in my decision scripts that they became confusing and downright useless [...] The linkages were less of a problem, though not trivial". Apparently, linking actions together was easier (though "not trivial") than reasoning on characters' states.

Another potential benefit from a stateless narrative engine is debugging. When authoring an interactive drama, it is always difficult to identify what caused one action to trigger instead of another. It usually requires inspecting the internal state of the engine, and multiple variables. In the proposed approach, what needs to be inspected are the various links from past actions to the action in question. We expect such a narrative engine to be more transparent to a non-technical user.

Furthermore, we see great potential in a stateless narrative engine in terms of expressiveness. Every time an action is selected, we directly have access to all previous actions that caused (in the large sense) this action. It opens the way to richer output expression. For example, to express the giving action, one can say "I give you the ball

I have" but can also say "I give you the ball that Chloe gave me yesterday" which is not only more complete, but more relevant as well, especially from a narrative point of view.

Finally, links between past actions and future actions could be used for the user interface. In a menu-style interface, it would consist in selecting a past action and choosing which possible action this past action enables or explains or immediately arouses (according to enabling, explaining and relevance links respectively). Such an interface would extend the history-based interface proposed in [25].

These potential benefits of a stateless narrative engine come at a price. As illustrated in Section 3.2, without states, more links must be written. A state, like "having" concentrates all actions whose consequences are to have an object and all actions that result from this possession. Without states, each causing action must be explicitly connected to each consequence action. The number of connections increases not linearly but polynomially (second degree) with the number of actions. To solve this problem, that has not yet arisen given the simplicity of the simulations performed so far, we see two solutions. First one could design an authoring tool that is able to intelligently assist the author, by automatically adding links when a new action is added, according to regular patterns of links that are inferred. Second, the notion of states could be implicitly reintroduced by concentrating a bundle of links into a single edge in a hypergraph, linking several actions to several actions.

A last question that we would like to discuss here concerns the action selection algorithm. In fact a stateless narrative engine is a way to represent actions and their interdependence but does not favor a specific type of algorithm over another. It is possible to use a one step action selection mechanism, as in IDtension [24] or Defacto [19], but planning algorithms can also be used, as in I-Storytelling [4] or Mimesis [18,28]. We foresee a large range of algorithms that could be used on a story representation based on links. By simulating the forward chaining of the links, it becomes possible to plan a story according to a final action or set of actions that must be achieved for the story to end. It is also possible to navigate through the set of played actions. For example, a full history of an action can be made available, if one looks at the action that enabled the action that enabled, ... the current action. This could generate some dialogue lines such as "Here is the ball that Steve robbed you of, before giving it to me".

# 6  Conclusion

In this article, we presented initial experiments using a stateless narrative engine where actions are generated through author-defined, generic rules between potential actions. The writing and reasoning that goes into the interactive narrative used in this approach is closer to the true essence of narrative compared to state based models. It is still undetermined if this approach can be or should be adopted without compromise, or if at some point, states should be reintroduced into the architecture. In any case, the notion of generic links between actions is an interesting and new approach in the field.

From an algorithmic perspective, the model could be extended into two directions. First, new types of links could be introduced to deal with the subtle relations in narrative, such as repetitive actions, symmetries, or topic-based relations. Second, several

links could be combined together within a structure, in order to include more elaborate narrative patterns.

From an authoring point of view, the model will be quickly associated to a simple authoring tool where links can be easily entered and the execution monitored. While narrative theories can certainly provide us the grounds for creating proper link types and organizing them, we think it is more efficient to guide this process of design according to real authoring needs.

## Acknowledgements

This work has been funded (in part) by the European Commission under grant agreement IRIS (FP7-ICT-231824).

## References

1. Aylett, R., Louchart, S., Dias, J., Paiva, A., Vala, M., Woods, S.: Unscripted narrative for affectively driven characters. IEEE Comp. Graphics and Applications 26(3), 42–52 (2006)
2. Barber, H., Kudenko, D.: Dynamic generation of dilemma-based interactive narratives. In: AIIDE 2007, Stanford, California, pp. 2–7 (2007)
3. Bremond, C.: Logique du récit. Seuil, Paris (1973)
4. Cavazza, M., Charles, F., Mead, S.J.: Characters in Search of an author: AI-based Virtual Storytelling. In: Balet, O., Subsol, G., Torguet, P. (eds.) ICVS 2001. LNCS, vol. 2197, pp. 145–154. Springer, Heidelberg (2001)
5. Charles, F., Pizzi, D., Cavazza, V.T., André, E.: EmoEmma: Emotional Speech Input for Interactive Storytelling (Demo). In: The Eighth International Conference on Autonomous Agents and Multiagent Systems (AAMAS-Demos), Budapest, Hungary (2009)
6. Cheong, Y.G., Young, M.R.: Narrative Generation for Suspense: Modeling and Evaluation. In: Spierling, U., Szilas, N. (eds.) ICIDS 2008. LNCS, vol. 5334, pp. 144–155. Springer, Heidelberg (2008)
7. Egri, L.: The Art of Dramatic Writing. Simon & Schuster, New York (1946)
8. Friedman-Hill, E.: Jess Rule Engine for Java. Sandia National Labs, http://jessrules.org
9. Herman, D.: Story Logic. Problems and Possibilities of Narrative. University of Nebraska Press (2002)
10. Magerko, B.: A Comparative Analysis of Story Representations for Interactive Narrative Systems. In: 3rd Annual Artificial Intelligence for Interactive Digital Entertainment Conference, Marina del Rey, California, pp. 91–94 (2007)
11. Mateas, M., Stern, A.: Structuring content in the Facade interactive drama architecture. In: Artificial Intelligence and Interactive Digital Entertainment Conference - AIIDE 2005, pp. 93–98 (2005)
12. Mateas, M., Stern, A.: Procedural Authorship: A Case-Study of the Interactive Drama Façade. In: Digital Arts and Culture, DAC (2005)
13. McKee, R.: Story: Substance, Structure, Style, and the Principles of Screenwriting. HarperCollins, New York (1997)
14. Mixon, L.J.: I can't Believe i did that: A Reflection on Some of My Biggest Shattertown Blunders, http://www.erasmatazz.com/library/StS_Blunders.html (accessed July 2009)

15. Morge, M.: A dialogue game for agent resolving conflicts by verbal means. In: Proceedings of the second workshop on Logic and Communication in Multi-Agent Systems (LCMAS), Nancy, France, pp. 46–59 (August 2004)

16. Prince, G.: A Dictionary of Narratology. University of Nebraska Press, Lincoln & London (2003)

17. Riedl, M.O.: Narrative Generation: Balancing Plot and Character. PhD thesis. North Carolina State University (2004)

18. Riedl, M.O., Saretto, C.J., Young, R.M.: Managing interaction between users and agents in a multiagent storytelling environment. In: Second ACM Joint Conference on Autonomous Agents and Multi-Agent Systems, AAMAS 2003, pp. 741–748. ACM Press, New York (2003)

19. Sgouros, N.M.: Dynamic Generation, Management and Resolution of Interactive Plots. Artificial Intelligence 107(1), 29–62 (1999)

20. Skorupski, J., Jayapalan, L., Marquez, S., Mateas, M.: Wide Ruled: A Friendly Interface to Author-Goal Based Story Generation. In: Cavazza, M., Donikian, S. (eds.) ICVS-VirtStory 2007. LNCS, vol. 4871, pp. 26–37. Springer, Heidelberg (2007)

21. Spierling, U.: Adding Aspects of Implicit Creation to the Authoring Process in Interactive Storytelling. In: Cavazza, M., Donikian, S. (eds.) ICVS-VirtStory 2007. LNCS, vol. 4871, pp. 13–25. Springer, Heidelberg (2007)

22. Storytron, http://www.storytron.com

23. Szilas, N., Marty, O., Rety, J.-H.: Authoring Highly Generative Interactive Drama. In: Balet, O., Subsol, G., Torguet, P. (eds.) ICVS 2003. LNCS, vol. 2897, pp. 37–46. Springer, Heidelberg (2003)

24. Szilas, N.: A Computational Model of an Intelligent Narrator for Interactive Narratives. Applied Artificial Intelligence 21(8), 753–801 (2007)

25. Szilas, N., Kavakli, M.: PastMaster@Storytelling: A Controlled Interface for Interactive Drama. In: IUI 2006: International Conference on Intelligent user Interfaces, Sydney, Australia, 29 January to 1 February, pp. 288–290 (2006)

26. Tan, E.: Emotion and the structure of narrative film. Film as an emotion machine. Erlbaum, Mahwah (1996)

27. Weyhrauch, P.: Guiding Interactive Drama. Ph.D. Dissertation, Tech. report CMUCS-97-109. Carnegie Mellon University (1997)

28. Young, R.M., Riedl, M.O., Branly, M., Jhala, A., Martin, R.J., Saretto, C.J.: An architecture for integrating plan-based behavior generation with interactive game environments. Journal of Game Development 1(1), 51–70 (2004)

# Conceiving Interactive Story Events

Ulrike Spierling

FH Erfurt, University of Applied Sciences, Altonaerstr. 25, 99085 Erfurt, Germany
spierling@fh-erfurt.de

**Abstract.** A story is considered to be a sequence of events. So-called linear storytelling means that authors tell these events in a designed order. The sources for events can be actions of agents or other circumstances. In Interactive Storytelling, authors need to conceive events in a different, indirect way. This concept is outlined and illustrated with examples from authoring. The goal is to find a general structure for the conception of interactive story events.

**Keywords:** interactive storytelling, authoring, action description.

## 1 Introduction

In recent years, researchers in Artificial Intelligence (AI) came up with several suggestions of generative story engines. These promise to manage "highly interactive" digital storyworlds through creating ever-changing sequences of events in reaction to participating users. At the same time, for authors, these generative algorithms raise difficulties, as written stories have to comply with the engines' formalisms.

The elementary concept described here is part of an undertaking to suggest conceptual models for authors in highly Interactive Storytelling (IS). It builds on previous work [10] and integrates various engine approaches examined in the IRIS Network of Excellence [4]. It tackles the comparably "simple" problem of defining actions, states and events. Theoretical bases and technical conceptions of actions and events logic have been covered in lots of recent publications (s.b.). However, there is not yet a usable and simple bridge to practical authoring. Potential story writers are left confused when being directed to papers of the AI community. The problem:

- AI engines appear obscure for authors from non-computer-science areas, and approaches in automatic planning (e.g., [7, 8, 12]) are hard to grasp.
- Due to a lack of available playable prototypes, practical experience is missing.
- Naïve authoring approaches are generally too linear to suffice for highly interactive storytelling, which means granting end-users participation in the story.

Many beginners in IS create their first concepts as a ramified narrative flow of events that can be visualized as a branching structure. The IS community, however, widely shares the belief that manually laying out branching story paths is a dead-end approach for interactivity. Instead, there is a need to identify simple primitives for creation, that don't contradict with the potential dynamics of future engines' approaches. There is also a need to educate authors with systems that are simple, but still distinguishable from linear branching methods. Writers for IS – if educated in the basics – could contribute a lot to the successful development of future tools.

I.A. Iurgel, N. Zagalo, and P. Petta (Eds.): ICIDS 2009, LNCS 5915, pp. 292–297, 2009.

The simple argument followed up here is that principles of *conditional actions and events* form the basis for creation in IS. Traditionally, a story is considered to be a sequence of events. Authors have to rethink the creation of event structures for an interactive storyworld, which consists of events depending on world states that in turn can be influenced by the participating user. Therefore, the general assumption should be: "In Interactive Storytelling, there is no unconditional action or event."

## Two Dimensions of Implicit Creation

In so-called linear narrative, conditions for actions are inferred by the audience from the story's representation only. Also during writing and conception, story authors are implicitly aware that their characters' actions are situated in a range of possibilities – which are rarely explicitly stated. In IS authoring, these situational conditions have to be made explicit in order to let an engine generate event sequences (select proper actions) dynamically. Working with a specific engine means that authors need to have applied knowledge about the engine's "mind", or rather, formalism. Generally, it has been found useful when authors are procedurally literate, which often has been compared with "being able to program" [6]. However, the concrete example described in the next section has shown that also people with general procedural experience had no advantage in conceiving dialogic actions with the tool *Scenejo*. It is more likely that specific applied knowledge of dialogue creation leads to dedicated specialists.

"Implicit creation" [10], done by authors beforehand, denotes indirect configurations of actions and states, which are processed by an AI engine to ad hoc determine suitable events during the story's "runtime". During implicit creation, there are several "unknowns". In order to be able to write/create, it is necessary to anticipate to a certain extend what is going to happen. Authors have to conceive at a high abstraction level, and leave detail to the engine. There are two dimensions of concretion following from these implicit stipulations (see Fig. 1).

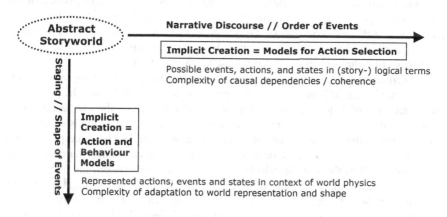

**Fig. 1.** Two dimensions of potential influence from abstract levels. Arrow to the right: sequence of events (narrative discourse). Arrow downwards: shape of events (on representational levels).

Both dimensions refer to automatic generation of actions. First, the arrow to the right adumbrates the selection of the next situated actions and events in the narrative discourse. The arrow downwards concerns the shaping of the representational levels. This can e.g. stand for 3D rendering and animation, or concrete wording as in the example in section 3. The two dimensions of concretion highly depend on each other. However, the concept presented in this paper mainly refers to the dimension of the narrative discourse – the order of events.

In an ideal computational storytelling system, it would be possible to abstractly formalise and therefore let generate all event sequences. However, current prototypes are often incomplete and use hard-coded shortcuts, leading to a mixture of explicit definitions and implicit configurations. In explicit storytelling, the sequence of events is outlined by a writer. Implicit approaches using story engines tend to break hard connections of branches and replace them with a more or less complex selection mechanism for the next actions. Sophisticated engines use planning, others use state machines. In the practical example discussed later, action selection is done by a state machine. The non-linear approach to authoring lets define a sequence of possibilities taking into account changing world states. The task is to create a model of the possible actions in the world.

## 2  Models of Actions, States and Events

Models for the sequencing of events in narrative can be found in Narratology and in AI literature. AI used for automatically structuring IS often follows one or more narrative formalism, mostly of those stemming from Structuralism. Cavazza and Pizzi [3] gave an overview on narrative theories, pointing out their applications in Interactive Storytelling. They highlighted Bremond's model of an agent's action deliberation for Interactive Storytelling, which includes the consideration of the situation of action and anticipated consequences for selection of the next action. Another, much simpler concept of Bremond, which can be a prerequisite for basic interactivity[1], is that of the "elementary sequence" [1] of three functions for an action: the possibility for action, the actuation itself, and the result of the action. Because step 1 determines a possibility, step 2 contains the option of an agent's choice to refrain from the action, and step 3 can consist of either success or failure of the actuated action.

As a prerequisite for having possibilities for action, an agent must appraise an acting situation. Herman [5] refers to von Wright's "logic of action" where he provides a similar definition of 3 steps, but related to "state". For v. Wright, the smallest descriptive unit is a state description. Here, the most important aspect of action is a change in the world, respectively, the change of some "state of affairs". The three parts of an acting situation are: 1) the initial state of the world, 2) the end state after completion of the action, and 3) the state in which the world would be without the action. This model is interesting because a state change is the emphasis for action. G. H. v. Wright quoted in [5] p.74: "An agents life situation ... is ... determined ... by his total life behind him and by what would be nature's next move independently of him." The term "nature" includes actions of other agents.

---

[1] The reason is that it contains a simple "forward" logic, one in which choices can be made by the agent, instead of the teleological "backward" perspective from story denouement.

In current visions of highly interactive storytelling, also the user is an agent, influencing the world's state changes (bring about changes or prevent "natural" changes). Creating a model that leads to acting situations with narrative interest for users is also a task of the author of a storyworld.

Events are often equated with actions, as they change states in the world. However, some event types have been distinguished in literature [2]. For example, an "action" is a certain type of event, which is intentionally executed by an agent to accomplish (immediate) goals. Herman [5] illustrated by comparison of different theories such as those of Vendler and Frawley that there are possible linguistic constructions that make it difficult to distinguish between action/event types and states. His example *"She is taking a swim out in the ocean"* can refer to a state as well as to an action that brings about a state change. Also, the problem of compositions of parallel actions with duration has not been tackled sufficiently by the above descriptions.

In AI planning widely applied in IS research projects, the definition of a triad of "pre-condition – action – post-condition" as a proposition of possible events is very common (e.g., in [7]). It can be compared with v. Wright's and Bremond's minimal sequences. The concept is so crucial for modelling acting situations that it is possibly a general requirement for authors to adopt. Given that it also relates to narrative theory, it should be expected that without programming skills, the concept is learnable. It works with a broad set of actions, albeit with some exceptions (see above). Many current story engines use the concept of such an acting situation, even if in the way they implement it, the terminology used varies.

## 3   Actions, States and Events in IS Tools

In the following, an example is given of a simplest conceptual realisation of the claim for authoring: In *interactive* storytelling, there is no unconditional action or event.

**Dialogic Actions**
Scenejo is a conversational storytelling platform (for a description, see [9] and [10]). Two virtual characters (chatbots) talk to each other, anytime to be interrupted by a user's text chat. The only possible actions for bots and users are dialogue acts. Bots' dialogues are represented as audible text-to-speech utterances, spoken by animated talking heads floating in space. A low-level dialogue manager connects several chatbots via abstract dialogue acts, which can influence parameter states. These values and dialogue acts can be freely designed by authors.

The first authoring tool for this system more or less mapped the underlying philosophy of AIML stimulus-response pairs on a GUI level. A general issue of dialogue acts (in contrast to physical actions) is that in many cases, so-called adjacency pairs or even sequences need to be modelled, which means, a single utterance cannot stand alone, but affords a direct reaction. By connecting the output of one bot to the input of the other, sequences were created (see Fig. 2). In the beginning of getting acquainted with this principle, authors conceived dialogues that were too long and too linear, forgetting about possible interaction possibilities of users.

By looking for opportunities to insert state changes as effects of as many utterances as possible, the interaction with the dialogue became less boring. Beyond talking, it was necessary that these post-conditions could be perceived as a consequence, to be more entertaining – for example, a visible state change of the overall stress level of

the dialogue. Further, these states could be taken into account as a pre-condition for further actions. Concluding, the used stimulus-response principle of the dialogue acts can be translated into a description using the minimal triad mentioned above (see Fig. 3, translating text patterns ("Hear X") as pre-conditions).

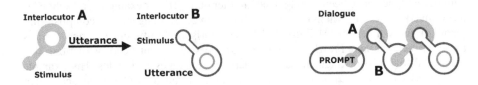

**Fig. 2.** Interlinking dialogue acts of two interlocutors by connecting a concrete utterance of one bot with a stimulus for an utterance of another one

User acts can be conceptually included as events resulting either in state changes or constituting pre-conditions (for example, a prompt) for some other dialogic actions (or both). Figure 3 shows examples of minimal triads of such action descriptions. Text patterns are mandatory preconditions, according to the AIML logic of the engine. This could also be a wildcard, which might result in random chat, depending on other pre-conditions. It is also possible to enforce linear sequences by constraining a pre-condition to a unique post-condition (as in Fig. 2, right). A drawback of this method was that having to include many pre- and post-conditions for actions placed a burden upon the author, making the task of dialogue writing tedious.

| Pre-Condition | Action/ Dialogue Act | Post-Condition/ Effect |
|---|---|---|
| Hear Prompt<br>Stress Level < X<br>Argument A Unused | **Argument A** | Uttered Argument<br>Increase Consent<br>Argument A Used |
| Hear Argument<br>Stress Level < X | **Killer Phrase** | Uttered Killer Phrase<br>Increase Stress Level |
| Hear Moderator<br>Stress Level < X | **Excuse to Moderator** | Uttered Excuse<br>Decrease Stress Level |

**Fig. 3.** Defining the same kind of conversation with dialogue acts as abstract actions with pre-conditions and effects

## Discussion and Generalisation

The elementary concept of pre-condition, action and effect has its roots in AI planning and to some extent in Narratology. In the example above, its application to a conversational system without a planning architecture has been shown. The addition of planning would increase the variability, but the basic conception would be similar. In many existing IS tools, the definition of a triad of pre-condition, action and effect (based on state changes) is existent. However, the idea is often not perceived as a crucial concept for creatively designing interactive story content at a conceptual level. Sometimes it is accessible only in programming code, and the terminology used is often rather

technical. For example, Storytron [11] uses this idea behind its own proprietary idioms of inclinations and consequences, and more complex ways of calculating the decision-making process. In IDtension [12], the concept is hidden in the code of the "tasks" concept, checking values and obstacles. The authoring tool in the Madame Bovary project [7] directly employs the underlying STRIPS planning terminology.

Before implementing an interactive storyworld with an engine's unique technical formalism, it has to be mapped out as an idea. The concept of modelling a system of acting situations and possible world states helps to implicitly conceive interactive events in a storyworld, independent of the engine used. The idea of the "conditioned" event supports the achievement of better interactivity. It can serve as a general principle to be learned by novice IS authors, and to be included in authoring tools.

## Acknowledgements

This work has been funded (in part) by the European Commission under grant agreement IRIS (FP7-ICT-231824). [4]

## References

1. Bremond, C., Cancalon, E.: The Logic of Narrative Possibilities. New Literary History 11(3), 387–411 (1980); On Narrative and Narratives: II
2. Casati, R., Varzi, A.: Events. Stanford Encyclopaedia of Philosophy (2006), http://plato.stanford.edu/entries/events/Online (accessed July 2009)
3. Cavazza, M., Pizzi, D.: Narratology for Interactive Storytelling: A Critical Introduction. In: Göbel, S., Malkewitz, R., Iurgel, I. (eds.) TIDSE 2006. LNCS, vol. 4326, pp. 72–83. Springer, Heidelberg (2006)
4. Cavazza, M., Donikian, S., Christie, M., Spierling, U., Szilas, N., Vorderer, P., Hartmann, T., Klimmt, C., André, E., Champagnat, R., Petta, P., Olivier, P.: The IRIS Network of Excellence: Integrating Research in Interactive Storytelling. In: Spierling, U., Szilas, N. (eds.) ICIDS 2008. LNCS, vol. 5334, pp. 14–19. Springer, Heidelberg (2008)
5. Herman, D.: Story Logic: Problems and Possibilities of Narrative. University of Nebraska Press, Lincoln (2002)
6. Mateas, M., Stern, A.: Procedural Authorship: A Case-Study of the Interactive Drama Façade. In: Digital Arts and Culture, DAC (2005)
7. Pizzi, D., Cavazza, M.: From Debugging to Authoring: Adapting Productivity Tools to Narrative Content Description. In: Spierling, U., Szilas, N. (eds.) ICIDS 2008. LNCS, vol. 5334, pp. 285–296. Springer, Heidelberg (2008)
8. Riedl, M., Young, R.M.: Story planning as exploratory creativity: Techniques for expanding the narrative search space. New Generation Computing 24(3), 303–323 (2006)
9. Scenejo Project Homepage, http://www.scenejo.org/ (accessed September 2009)
10. Spierling, U.: Adding Aspects of "Implicit Creation" to the Authoring Process in Interactive Storytelling. In: Cavazza, M., Donikian, S. (eds.) ICVS-VirtStory 2007. LNCS, vol. 4871, pp. 13–25. Springer, Heidelberg (2007)
11. Storytron Interactive Storytelling, http://storytron.com (accessed September 2009)
12. Szilas, N., Marty, O., Rety, J.-H.: Authoring Highly Generative Interactive Drama. In: Balet, O., Subsol, G., Torguet, P. (eds.) ICVS 2003. LNCS, vol. 2897, pp. 37–46. Springer, Heidelberg (2003)

# Interactive Narration within Audio Augmented Realities

Johanna Gampe

Laboratoire d'esthétique théorique et appliquée , Université Paris 1 Panthéon-Sorbonne
12, place du Panthéon, F–75231 Paris cedex 05, France
jhanna.gampe@gmail.com

**Abstract.** A test installation at IEM Graz realized in the framework of the European Project "Sonic Interaction Design" serves as example to the given issue: transforming a linear novel scene in an interactive sound installation and making it explorable through embodied experience by the use of spatial sound and three-dimensional tracking. Theoretical reflections rely on drama management and perception whilst practical aspects are linked to interfaces and virtual reality.

**Keywords:** Transversal dramaturgy, embodied interaction, audio augmented reality, spatialized sound, Ambisonics, immersion, audio-plays, virtuality.

## 1 Introduction

Transforming a narrative novel into an interactive installation means in the first place replacing its linear structure by a non-linear one. By overlapping horizontal continuity with vertical parallelism via multiple choices and dimensions, a transversal dramaturgy may be established. This transversality is different from the typical hierarchy of a common videogame structure in terms of level design and gameplay. Gameplay [1] comprises a multitude of short and long-term objectives that propose different levels of difficulty, inciting the player to stick to the game in order to win it. In the following, in contrast, the user can alternatively feel invited to explore and discover different dimensions and levels of the scenario depending on individual preferences and behavior.

The test installation "Train Constellations" at the Institute of Electronic Music in Graz in October 2008 [2] in the framework of the European Project on "Sonic Interaction Design" serves as a practical example. It consists of a novel scene that has been transformed into an interactive sound installation in the style of a radio drama play or *Hörspiel*. The characters' conversations, thoughts and actions are cued to simple movements of the user (like sitting down), while the composition of different ambiences can be altered by the choice of the listening position. The three-dimensional sound (Ambisonics) was transmitted to headphones [3] those which had markers for the use of a three-dimensional tracking system (Vicon). This audio augmented reality setup permitted embodied user interaction. The software module developed by IEM [4] (Pure Data language) served as a rendering tool for the spatialized sound, with the possibility to adjust parameters via a graphical interface. All the additional programming for this installation was done by Thomas Musil from IEM.

I.A. Iurgel, N. Zagalo, and P. Petta (Eds.): ICIDS 2009, LNCS 5915, pp. 298–303, 2009.
© Springer-Verlag Berlin Heidelberg 2009

## 2 Example "Train Constellations"

**Fig. 1.** A picture of the simple installation setup at IEM's CUBE in Graz

### 2.1 A Sonic Scenario

Audio dramas are often compared to theatre and film, but with their artistic and technical development they emancipated their definition from purely narrative content and at the same time became open to spatial sound such as stereophonic, binaural or multichannel sound. The installation aimed to question language as artistic material in the context of a virtual sound environment by intertwining narration and interaction.

The basic idea was to contrast thoughts and conversations found in Norbert Niemann's novel "Willkommen neue Träume" (Welcome new dreams) from 2008. The German author won the renowned Ingeborg-Bachmann-prize for his first novel and became known for his *time novels*. The main character Asger a young journalist and intellectual, is introduced in one of the first scenes. Asger is traveling on the train on the way to his home city. In the same train compartment are an older couple, Rudolf and Helene, as well as a soldier. They start a reduced, elliptic kind of small talk which on the surface stays cryptic. Yet, their thinking reveals the background of their conversation, i.e., actual motivations, opinions, memories and attitudes. The narrator is almost omniscient, except with regard to the journalist whose behavior is described solely from the point-of-view of an accurate observer. Apart from conversation and thinking, it is the gestures and non-verbal expressions that indicate further dimensions of the scenario. In the original text all these levels are intertwined as one linear flow that switches constantly between the different perspectives and information levels.

### 2.2 An Interactive Installation

The user enters the scenario with tracked headphones on her ears so that the location and the position of the user's head is captured. Four chairs with spots on them are placed in the middle of the room; the rest of the room is dimmed. On each chair are "seated" the characters as sounds. The user enters the installation and hears a rather

chaotic mix of the conversation of the four passengers jumbled with human sounds such as smoking, snoring, eating, preparing food, pouring a drink, clearing one's throat, putting out one's cigarette. Once the user sits down on a chair, thus entering a characters' intimate sphere, she listens to the thoughts of the character. At this point, other sounds and background reverberations have disappeared. While being seated, the user, when nodding towards the direction of one of the other three characters/chairs, will listen to the opposite characters' thoughts: For instance, sitting on the chair of Helene and nodding towards Asger, the user hears Helene talking about the way the young stranger reminds her of her son and that she feels attracted to him. However, sitting down on Asger's seat resets the conversation and it starts from the beginning. When the user stands up, she enters into the normal conversation but at a point that is connected with the content that has just been listened to. The understanding of the initial conversation (Intro-Mix) is changing gradually, thus revealing different dimensions of content and context. Moreover, when the user first stands up, the narrator is added and reveals actions and reactions of the characters, as well as filling in gaps in their conversation. The narrator is positioned above the user's head, in the middle of the "train compartment" (the four chairs). The user is also able to wander around and explore different ambient sounds located at the outskirts of the walkable area. Those sounds consist of different mixes associated with trains (*musique concrète*, sound poetry, train recordings with and without conversations). When the user leaves the inner room representing the train compartment, the virtual and acoustic room size changes from small to large. Also, the narrator is leaving her central position and is circling slowly and randomly around the user's head, accompanying her. So the narrator stays close while the conversation alters with the listening distance. Leaving the inner area changes the virtual room size and with it the reverberation characteristics selected using the Ambisonics tool. Furthermore, the user moves around and finds four ambiances on the angles of the room, similar to windows. They can be approached and have a diffuse width and height. According to the user's position, the percentile composition of the four ambient sounds is different. The user can thus choose his personal audio drama setup.

## 3  Transversal Structuring

Looking at the structure, both narrative continuity and interactive fragmentation are represented horizontally and vertically in the graph above. Interaction on the bottommost level influences the acoustical point of view, but has no influence on the narrative continuity. The sitting-down, however, interrupts the linear flow outright. The reconnection of both dimensions is subject to what I call transversal dramaturgy and which consists of connecting interactive behavior to a dramatic content in such a way that the reception is altered. In the present installation the transversal dramaturgy deepens the knowledge of the individual character as well as global comprehension.

When, for example, the user sits down on Helene's chair, nods in Rudolf's direction and stands up, the user is first listening to what Helene thinks about her husband, and, when standing up again, is re-entering the conversation at a certain point of narration that is connected to the relationship of the old couple. The user may listen to a piece of the conversation she already knows but whose context has just been enlarged.

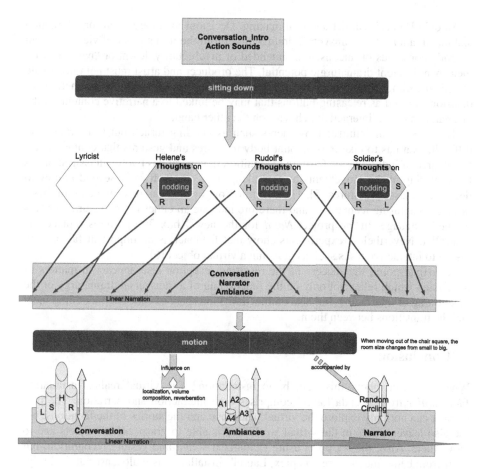

**Fig. 2.** A graphical representation of both linear continuity and interactive transversality. Asger is named Lyricist here, as in the present and first scene he has not got a name so far, but obviously is reading poetry.

Therefore a deepening of the user's understanding of the conversation, as well as of the specific relationship between the two characters takes place. This miniature peripety may be applied to various items of common dramaturgy such as curiosity, identification or empathy. Thus, the user's attitude towards a character may even be completely changed. The soldier, for instance, appears rather unpleasant but the revelation of his war experiences evokes empathy and makes his remarks appear in a different light. Intersection points of linear narrativity and non-linear interactivity need to be connected to a specific interface that takes part in the reception and its dramaturgy. In contrast to video games that mostly use tools such as joysticks or buttons, the present installation aimed to use natural movements for interactive triggers. This relies on my thesis that the implication of the body in terms of embodied interaction entails a more holistic and personal approach to virtual matters. The body is memory and storage of various experiences and learnings that, according

to Antonio Damásio, affect decision making. Decisions again are basal for interaction and the creation of its transversal dramaturgy. From the user's point of view they can be both, conscious or unconscious, intended or involuntarily, learnt or "natural" with their own different dramaturgic potential. The producer and artist must not only create co-existing dimensions, but also define and invent points of intersection, junctions of decisions as well as releasing buttons that may be linked to a narrative content on the one hand and to an interactive behavior on the other hand.

The defining of intuitive movements such as nodding turned out to be relatively difficult, as it has to take into account body measures and gestures that contain a certain degree of individuality. Gesture recognition in general has two main issues: one is the capturing of the movements by a tracking hard- and software. Second is how to define and classify gestures [5]. The definition of gestures can rely on a cultural basis or on the capturing technology and therefore indicate an either more "natural" or "artificial" language. In the project *Natal* for the new Xbox 360 gestures replace the controller. Nevertheless experiments show that feedback is an important factor with regard to interactive tasks such as grasping a virtual object [6].

As a final point, the success of the resulting reception also appears in matters of immersion which relies not only on the functioning of a transversal dramaturgy or the functioning of interfacing, but also on the global interplay of each singular component and the transitions between them.

## 4 Conclusion

What is special about this very basic installation? The virtual reality installation *Placeholder* from Brenda Laurel comprises both interaction and narration. The participant can not only explore the virtual landscape and the stories of the locations, but she also leaves traces in the virtual world and is able to grasp virtual objects and to move them. Also, the set up is using spatialized sound and gesture recognition, but apart from being much more complex, Laurel's installation is multisensorial, i.e., relying on both, visual, sonic and embodied experiences. "Train Constellations" on the contrary contains no artificial visual information. It aims at mixing virtual and non-virtual sensations. In this context Monika Fleischmann uses the term Mixed Reality when putting together a shared real and three-dimensional virtual space as in the eMUSE project. Similar to the work of Brenda Laurel, eMUSE is based on both audio and visual experiences. Furthermore, many sound installations like Osmose (1995) from Char Davies use 3-D localized sound but don't have a narrative approach. The main conclusion of the present, very limited installation might be that the concept of interactive scenarios is interesting from different points of view.

For the artist, it is about mixing up, contrasting virtuality and realism within sound as a pure medium. According to the questionnaires of the eight probands, their driving motivation was the curiosity to get an overall picture. For the researcher the installation enters the fields of embodiment [7], and spatial sound, them both allowing interdisciplinary approaches that contain elements of humanities and sciences. With regards to the sonic medium, the socio-psychological cognition of space is especially interesting for scenic sound: The higher emotivity of the back sphere [8] yields an aesthetic sensitivity to be respected or challenged, their connotations offering dramaturgical ideas that may be implemented in the creative context.

The enrichment of the scenario may be enhanced by contextual sounds and action sounds. From here, the complexity of the scenario can be progressively increased, giving the user the possibility to interact with virtual characters and objects within the virtual environment, as well as with other users. On the other hand, more complexity makes it difficult to transmit a picture of the whole. The implication of the body in particular is both challenging and promising. Its programming demands a lot of experience as well as basic research. Nevertheless the use of the body in the context of interaction permits the implication of physical experiences and its connection to virtual ones. A vertical drama management within virtual scenarios is likely to create an interface between them both, reality and virtuality.

# References

1.  Gampe, J.: Socio-psychological cognition of spatial sound and its application in interactive scenarios. Final Report for STSM. In: COST–IC 0601: Sonic Interaction Design, Creative Commons, USA (2008)
2.  Natkin, S.: Video Games and Media from the XXI. Century (Jeux vidéo et médias du XXIe siècle). Vuibert, Paris (2004)
3.  Leitner, S., Sontacchi, A., Höldrich, R.: Head position related binaural sound reproduction–the ambisonic approach. Tagungsband der 21. Tonmeister-Tagung, VDT, Hannover (2000)
4.  Noisternig, M., Musil, T., Sontacchi, A., Höldrich, R.: 3D Binaural Sound Reproduction using a Virtual Ambisonic Approach. In: IEEE International Symposium on Virtual Environments (VECIMS), pp. 174–178. IEEE, Washington (2003)
5.  Cohen, C.: Brief Overview of Gesture Recognition, http://homepages.inf.ed.ac.uk/rbf/CVonline/LOCAL_COPIES/ COHEN/gesture_overview.html (last access: 09-24-2009)
6.  Armbrüster, C.: Virtual Reality in Experimental Psychology (Virt.uelle Realität in der experimentellen Psychologie). Dr. Kovač, Hamburg (2008)
7.  Ziemke, T., Zlatev, J., Frank, R.M. (eds.): Body, Language and Mind. Volume 1: Embodiment. De Gruyter, Berlin (2007)
8.  Gampe, J.: Radio drama plays as spatial sound. Stuttgart Media University (2006)

# Suspense? Surprise! or How to Generate Stories with Surprise Endings by Exploiting the Disparity of Knowledge between a Story's Reader and Its Characters

Byung-Chull Bae[1] and R. Michael Young[2]

[1] Samsung Advanced Institute of Technology
Mt. 14-1, Nongseo-dong, Giheung-gu, Yongin-si, Gyeonggi-do, South Korea
leo.bae@samsung.com
[2] Department of Computer Science, North Carolina State University
890 Oval Drive, Raleigh, NC 27695, USA
young@csc.ncsu.edu

**Abstract.** Surprise and suspense can be effectively combined to increase story interest, complementing each other. In particular, stories with surprise endings can make a strong impression on the readers. In this paper we present an extension of our previous efforts to generate a story with surprise endings maintaining the reader's suspense by adopting the notion of disparity of knowledge between the reader and the characters in the story.

**Keywords:** Narrative generation, surprise arousal, surprise endings.

## 1 Introduction

Emotions based on the reader's cognitive responses (e.g., suspense, curiosity, and surprise) provide the readers with attention, contributing to the readers' satisfaction with the story [1] [10]. These emotions, according to Structural Affect Theory [4] [5], can be aroused by manipulation of temporal characteristics in narrative structure. For suspense, in the Structural Affect Theory, an outcome event is delayed until the last moment so that the reader is uncertain about the important story outcome. To elicit surprise, some significant expository information is hidden to the reader until a surprising event occurs, which makes a knowledge gap between the reader and some characters in the story. Empirical studies have shown that the temporal manipulation of discourse structure can produce different cognitive and emotional responses by influencing the reader's inferences and anticipation [8] [9].

Our previous paper [2] has presented a planning-based computational model of surprise arousal motivated by the Structural Affect Theory. We choose a plan-based approach to manipulate the causal relations among story events in the plan which is created by a story planner named Longbow [11]. In this paper we present an extension of our previous paper to generate a story with surprise endings, maintaining the reader's suspense by adopting the notion of knowledge disparity between the reader and characters in the story.

I.A. Iurgel, N. Zagalo, and P. Petta (Eds.): ICIDS 2009, LNCS 5915, pp. 304–307, 2009.
© Springer-Verlag Berlin Heidelberg 2009

## 2  Reader's Emotions, Structural Affect Theory, and a Disparity of Knowledge between the Reader and the Characters

The reader's cognitive interest is closely related to maintaining *a disparity of knowledge* between the reader and the characters in the story. Particularly, the reader's suspense is produced when the reader knows more than a character in the story; the reader's surprise is produced when the reader knows less than a character in the story [3]. The notion of this disparity of knowledge corresponds to the main concept of Structural Affect Theory in which the ordering of story events is rearranged to elicit specific emotions to the reader.

As an example of Structural Affect Theory, consider a chronological sequence of four story events as in Fig. 1 [4]. According to the Structural Affect Theory, a narrative to produce *suspense* has a discourse organization in which story events are presented in their chronological order and an important outcome of the story is not yet presented to the reader. Thus a discourse structure for suspense arousal is: (1) The butler put poison in the wine. (2) The butler carried the wine to Lord Higginbotham. (3) Lord Higginbotham drank the wine. In this discourse structure, suspense is produced because the reader does not know yet whether Lord Higginbotham will die or not after presentation of event 3. On the other hand, a discourse structure for surprise arousal is: (2) The butler carried the wine to Lord Higginbotham. (3) Lord Higginbotham drank the wine. (4) Lord Higginbotham fell over dead. In this discourse structure, surprise is elicited because of the omission of significant expository information (i.e., event 1) without the reader's awareness. As a result, event 4 as a consequence of the omitted event 1 will be unexpected and surprising.

| |
|---|
| (1) BUTLER PUTS POISON IN WINE |
| (2) BUTLER CARRIES WI NE TO LORD HIGGINBOTHAM |
| (3) LORD HIGGINBOTHAM DIRINKS WINE |
| (4) LORD HIGGINBOTHAM DIES |

**Fig. 1.** An example of chronological sequence of story events (from Brewer and Lichtenstein [4])

To maintain a disparity of knowledge, we make use of the different initial conditions between the reader model and the story generator as a cause of unexpectedness for surprise. The planning-based reader model serves as a proxy for the reader's reasoning process [2]. Using the disparity of knowledge, the story events are presented with some hidden expository information while maintaining the reader's cognitive interest such as suspense. After presentation of a story outcome event (which is expected by the reader), another story outcome event (which is *not* expected by the reader) occurs to elicit surprise. The story world conditions resulting from the two outcome events can be in conflict for a twisted ending.

Our previous paper, motivated by the Structural Affect Theory, has focused on a model of *local* surprise rather than a model of *global* surprise. A local surprise model considers only one cognitive interest (e.g., suspense or surprise) at a time. A global surprise model, by contrast, considers two cognitive interests (e.g., suspense and surprise) by extending the local surprise model.

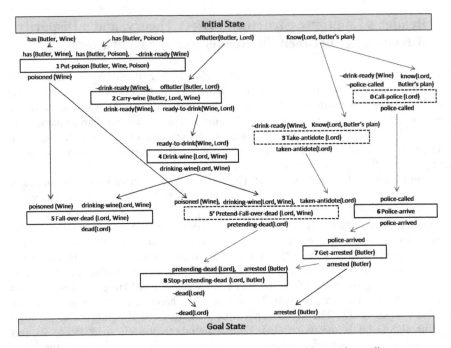

**Fig. 2.** An extended story plan to generate a story with surprise endings

Fig. 2 illustrates an extended version of a story plan based on the story events shown in Fig.1. In Fig. 2, the story plan has four initial conditions (that is, *has (Buter, Wine)*, *has (Butler, Poison)*, *ofButler (Butler, Lord)*, and *Know (Lord, Butler's plan)*) and two goal conditions (that is, ¬*dead (Lord)*, *arrested (Butler)*). Assuming Butler is the story's antagonist and Lord is the story's protagonist, *dead(Lord)* and ¬*arrested(Butler)* are the antagonist's goals; *arrested(Butler)* and ¬*dead(Lord)* are the protagonist's goals. The two goals are in conflict with each other. A solid line rectangular box represents a plan step that is presented to the reader in chronological order. A dashed line rectangular box represents a plan step that will be presented as a form of flashback after presentation of the story outcome event (that is, either plan step 7 or 8).

To generate a story with surprise endings, it is required to maintain two story plans. One is a partial story plan that is built on a limited knowledge of initial conditions and goal conditions that are in conflict with the actual story goal conditions. For example, in Fig. 4, the story plan to achieve the antagonist's goals (*dead(Lord)* and ¬*arrested(Butler)*) consists of four plan steps 1, 2, 4, and 5, which are presented to the reader sequentially. The other story plan is the actual story plan, including omitted plan steps (which are steps 0, 3, and 5') and additional plan steps (which are steps 6, 7, and 8). The actual story plan is constructed using the whole initial conditions and the actual story goals. The omitted plan steps 0, 3, and 5' are presented as flashback after the presentation of the relevant story outcome event (i.e., either plan step 7 or 8). Therefore, the actual chronological sequence of story events will be plan steps 0, 1, 2, 3, 4, 5', 6, 7, and 8. The rearranged ordering of events for temporally nonlinear discourse structure for suspense and surprise arousal, however, is plan steps 1, 2, 4, 5, 6, 7, 8, 0, 3, and 5', where events 0, 3, and 5' are presented as flashback.

## 3    Discussion

Surprise and suspense can be effectively combined to increase story interest, complementing each other [6]. In particular, stories with surprise endings can make a strong impression on the readers. In stories that lead to surprise endings in their plot structure, the reader's suspense is often first controlled by the manipulation of the reader's expectation about a protagonist's success in the story [7]. Then, as the story reaches its climax, a reversed story outcome is revealed with presentation of surprising events, making the reader feel surprised the same way that a main character feels surprised in the story. This surprising experience increases story interest greatly as the earlier story events make sense with the revealed hidden truth as a whole.

In this paper we suggest the use of different initial conditions for the disparity of knowledge. The point of view, however, could be also used to generate the knowledge disparity among characters and the reader in an effective manner, which we plan to include as future work.

## References

1. Alwitt, L.: Maintaining Attention to a Narrative Event. In: Shohov, S.P. (ed.) Advances in Psychology Research, vol. 18, pp. 99–114 (2002)
2. Bae, B., Young, R.M.: A use of flashback and foreshadowing for surprise arousal in narrative using a plan-based approach. In: Spierling, U., Szilas, N. (eds.) ICIDS 2008. LNCS, vol. 5334, pp. 156–167. Springer, Heidelberg (2008)
3. Branigan, E.: Narrative Comprehension and Film. Routledge, New York (1992)
4. Brewer, W.F., Lichtenstein, E.H.: Event Schemas, Story Schemas, and Story Grammars. In: Long, J., Baddeley, A. (eds.) Attention and Performance, vol. 9, pp. 363–379 (1981)
5. Brewer, W.F., Lichtenstein, E.H.: Stories Are to Entertain: A Structural-Affect Theory of Stories. Journal of Pragmatics 6, 473–483 (1982)
6. Chatman, S.: Story and Discourse: Narrative Structure in Fiction and Film. Cornell University Press, Ithaca (1978)
7. Cheong, Y.: A Computational Model of Narrative Generation for Suspense. Ph.D. Dissertation, Department of Computer Science, North Carolina State University (2007)
8. Hoeken, H., van Vliet, M.: Suspense, Curiosity, and Surprise: How Discourse Structure Influences the Affective and Cognitive Processing of a Story. Poetics 26, 277–286 (2000)
9. Levoarto, M.C., Nemesio, A.: Readers' Responses While Reading a Narrative Text. Empirical Studies of the Arts 23(1), 19–31 (2005)
10. Tan, S. (ed.): Emotion and the Structure of Narrative Film: Film as an Emotion Machine. L. Erlbaum Associates, Mahwah (1996)
11. Young, R.M., Pollack, M.E., Moore, J.D.: Decomposition and Causality in Partial Order Planning. In: Hammond, K. (ed.) Proceedings of the 2nd International Conference on AI and Planning Systems, pp. 188–193. AAAI Press, Menlo Park (1994)

# The Evolution of Story Spaces of Digital Games beyond the Limits of Linearity and Monotonicity

Klaus P. Jantke

Fraunhofer IDMT, Children's Media Department,
Hirschlachufer 7, 99084 Erfurt, Germany
Klaus.Jantke@IDMT.Fraunhofer.de

**Abstract.** The in-depth description of game playing experience needs a suitable terminology which, in turn, shall reflect appropriate concepts. The introduced story space concept is compliant with a variety of recent research endeavors and allows for a lucid representation of phenomena which are crucial to the understanding of ways in which stories may be perceived when playing a digital game. The particular story space evolves over time–the story expands. The process of story unfolding may have a variety of fundamental properties such as, e.g., linearity or monotonicity. The controlled abandonment of linearity and monotonicity, e.g., may be used as a technique of dramaturgical design.

> *It is not only for lack of trying that a good vocabulary for describing game experiences does not exist. It is downright hard to describe video games and experience of playing them.*
>
> (Bruce Philips in [1] p. 22)

## 1 Layered Levels of Description

Structuralists like Seymour Chatman [2] basically distinguish between the *discourse level* at which a story is told or a game is played and the *story level* at which the content told in the story or experienced during game play is laid out. In Jesper Juul's seminal paper [3] the structuralists' approach has been re-interpreted leading to the conceptual levels of *play time* and *event time* (see the figures on pp. 133 and 136 in [3]). The distinction of levels of description [4,5] is essential to the present work. Further extensions of considerations of time as in [4] remain far beyond the limits of this paper. For the present investigations, it is sufficient to consider a level at which game playing takes place and another more semantical level at which a story might possibly emerge. The art of game dramaturgy and game programming bears the potential of driving the evolution of the story towards intended effects and affects when playing the game. The focus is on structural properties of evolution.

At Juul's layer of event time, *story space* is the term to characterize the story a particular player may individually experience within a particular game play.

I.A. Iurgel, N. Zagalo, and P. Petta (Eds.): ICIDS 2009, LNCS 5915, pp. 308–311, 2009.

## 2  Story Space: A Formal Concept for Investigating Stories

We would like to know *precisely* what it means that two players experience the same story. We would like to know *precisely* to what extent such an observation depends on perspectives and terminologies. When two players (or the same player at two different times of play) experience(s) slightly different stories, we would like to know *precisely* when it happens, how it shows, and where it comes from. The insights we are aiming at are relevant both to game design and to analysis.

In Juul's fundamental approach, play time and event time look very much like number lines: it remains open whether or not the points on the line are thought of as being dense or discrete. Time is not an easy phenomenon [6]. When stories unfold, events from the past may come up in different ways by being mentioned explicitly ( *"The king died many years ago."*), by being concluded from recent evidence ( *"The book is not in its place, it must have been taken away."*), by hypothesizing and speculating ( *"The door is open? Did someone break in?"*), and so on. It is rarely possible to bring all events of a story into a complete order. Therefore, we have to think of a story as an only *partially ordered set* of events. But what is seen as an event? There is no silver bullet. What is called an event depends on the purpose of investigation and may even change over time. The same applies to what is considered an action at play time: do we speak about opening a door or do we consider mouse clicks, key strokes, and the like? There are layered languages of expression [5].

Let us assume that we, at least temporarily, agree about a concept of actions and that we collect all possible actions in some set $M$. Seen from an abstract point of view, every game play establishes a certain sequence of actions from $M$. In computer science, it is customary to denote the set of all finite sequences over $M$ by $M^*$. Every particular game play may be seen as some sequence $\pi \in M$. For the purpose of storytelling investigations, it makes sense to ask for only those sequences that are seen to complete a game play or to complete a story. When a particular digital game $G$ is given, all those sequences from $M^*$ are seen as forming some set $\Pi(G) \subseteq M^*$. Usually, $\Pi(G)$ is determined by the game mechanics of $G$, forming a formal language over the alphabet $M$ [7]. At any layer $M$ of abstraction, at play time there emerges some $\pi \in M^*$. Every horizontal arrow indicated by the "play time" label in Juul's figures on pp. 133 and 136 in [3] may be understood to represent such a sequence $\pi \in \Pi(G)$. Some of the actions cause the experience of events or the arousal of knowledge or belief about events in the virtual past. Some partially ordered set emerges. Under the preliminary–possibly dynamically changing–assumption of what may be seen an event, we may name $E$ the set of all events taken into consideration.

At some point of time $t$, the story space $\mathcal{E}_t = [E_t, \preceq_t]$ is the abstract representation of the story experienced so far. $E_t$ comprises all the events that establish the story at its current state of unfolding and $\preceq_t$ relates these events in time. In almost all games that tell a story, $\preceq_t$ is only a partial order, not a total one. Consequently, number lines such as in Juul's figures cited above do not suffice; stories are not simply "growing from the left to the right". The present story space concept is crucial to expand on Juul's basic approach.

# 3    Playing the Game – Unfolding the Personal Story Space

This section is based on the perspective that there is a given digital game $G$ and some agreement about a notation $M$ of possible actions and a notation $E$ of considered events. Based on these preliminaries, we investigate how some game playing $\pi \in \Pi(G)$ unfolds a story. Some actions do not matter for the game's story. But certain other (sequences of) actions occurring in $\pi$ induce events into the emerging story space. There is an evolutionary chain $\mathcal{E}_0 = [E_0, \preceq_0]$, $\mathcal{E}_1 = [E_1, \preceq_1]$, $\mathcal{E}_2 = [E_2, \preceq_2]$, ... which describes the progress of the story from the initial stage $\mathcal{E}_0 = [E_0, \preceq_0]$ on. Keeping track may be difficult. Properties of benignity help to keep the evolution under control.

The two key properties discussed here are *linearity* and *monotonicity*. Mappings from any level of formally represented game playing experience to the semantical story space of game play may be characterized by an enourmous number of varying characteristics. Mathematics and, in particular, algebra possess a rich repository of approaches to and derived properties of mappings[1]. For this introductory publication, we confine ourselves to only two basic characteristics of mappings which are relevant to research in interactive storytelling.

**Linearity:** Story space evolution is linear, if and only if it always holds for any newly inserted event $e \in E_{t+1} \setminus E_t$ for any event $e' \in E_t$ the ordering $e' \preceq e$.

**Monotonicity:** Story space evolution is monotonic, if and only if it always holds for any step of evolution $E_t \subseteq E_{t+1}$. (In addition, one might require $\preceq_t \subseteq \preceq_{t+1}$ what leads to an even stronger version of monotonicity.)

To those few readers who are familiar with algebraic and logical terminology, the above definitions may be not only sufficiently clear, but perfectly concise. Nevertheless, with a wider interdisciplinary scientific discourse in mind, it seems appropriate to circumscribe both conceptualizations less formally.

**Linearity informally:** We speak about linear story space evolution in the following case. Whenever game play results in the perception of a new event, this particular event is always understood to be most recent one within the evolving story space. The story really "grows from the left to the right".

**Monotonicity informally:** We speak about monotonic evolution of the story space, if every new event is simply added to the already existing collection of events. Over time, the collection of events is becoming larger and larger.

Most (all?) of the classical German fairytales are both linear and monotonic. Digital games have larger potentials. In many cases, the stories told when playing the game are intensionally non-linear. Consequently, linearity of the story may serve as a valuable dimension along which digital games may be classified. In contrast, the story space evolution is generally organized monotonically. The game SHADOW OF DESTINY is one of the extremely rare exceptions. It is the

---

[1] The author is aware of the danger to alienate researchers and practicioners from social sciences and the arts by resurrecting unloved algebra, but the potentials of formal methods are too important to be overlooked.

aim of the conceptualization within this paper to propagate the *abandonment of linearity and monotonicity as a tool of intensional dramaturgy.*

## 4    Summary and Conclusions

The present paper aims at the introduction of concepts[2] such as *linearity* and *monotonicity* which may be new, to some extent, to the scientific discourse on interactive storytelling. The underlying concept is *story space* abstracting on a freely chosen level of description what should be seen as a story some player is experiencing. The story unfolds during and by game playing. The way in which the story space evolves might be essential to the human player's experience. To abundan the properties of linearity and monotonicity may be a key momentum of dramaturgy. The introduced concepts are setting the stage for a high precision of discourse in game design and analysis. More details can be found in [4] and [8].

## Acknowledgements

The author gratefully acknowledges fruitful criticisms and suggestions from three reviewers. The present research and development has been partially supported by the Thuringian Ministry for Culture (project iCycle, code PE-004-2-1).

## References

1. Philips, B.: Talking about games experience—A view from the trenches. interactions 13(5), 22–23 (2006)
2. Chatman, S.: Story and Discourse: Narrative Structure in Fiction and Film. Cornell University Press, Ithaca (1978)
3. Juul, J.: Introduction to game time. In: Wardrip-Fruin, N., Harrigan, P. (eds.) First Person. New Media as Story, Performance, and Game, pp. 131–142. MIT Press, Boston (2003)
4. Jantke, K.P.: A closer look at time in digital games. In: Sorg, J., Venus, J. (eds.) Erzählformen im Computerspiel: Zur Medienmorphologie digitaler Spiele. Medienumbrüche, transcript, vol. 36, pp. 1–44 (2009)
5. Lenerz, C.: Layered languages of ludology — Eine Fallstudie. In: Beyer, A., Kreuzberger, G. (eds.) Digitale Spiele — Herausforderung und Chance, pp. 35–64. Verlag Werner Hülsbusch (2009)
6. Eddington, A.S.: Time, Space and Gravitation: An outline of the general relativity theory. University Press, Cambridge (1920)
7. Hopcroft, J.E., Ullman, J.D.: Introduction to Automata Theory, Languages, and Computation. Addison-Wesley, Reading (1979)
8. Jantke, K.P.: Dramaturgical design of the narrative in digital games: AI planning of conflicts in non-linear spaces of time. In: Lanzi, P.L. (ed.) Proceedings of the IEEE Symposium on Computational Intelligence & Games, pp. 88–95. IEEE Press, Washington (2009)

---

[2] As such, the paper may be seen as a purely theoretical one written in response to Bruce Philips' complaint that *"It is not only for lack of trying that a good vocabulary for describing game experiences does not exist. It is downright hard to describe video games and experience of playing them."* ([1] p. 22).

# A Computational Model of Emotional Response to Stories

Adam Fitzgerald, Gurlal Kahlon, and Mark O. Riedl

School of Interactive Computing, Georgia Institute of Technology
Atlanta, Georgia, USA
{afitz,kahlon.gurlal,riedl}@gatech.edu

**Abstract.** In this paper, we consider the problem of computing the affective responses that humans experience when reading or watching stories. Evidence suggests that emotional responses result from recipient (reader, watcher, etc.) problem solving on behalf of story world characters when the recipient predicts undesirable narrative outcomes. Our system computes the level of tension a human recipient is expected to experience as a narrative unfolds. The system efficiently determines possible future outcomes, measures their utility, and estimates the probability that they will occur. The resultant estimate of tension is a function of expected utility.

## 1 Introduction

Humans actively reason about stories [1], and responses can be categorized as cognitive (e.g, belief change) and affective (e.g, emotional response, tension, etc.). This later aspect, affective response, has received less attention from the research community. In this paper, we present work toward a model of affective response to narrative. Building off of narratological and psychological theories of suspense [1,2,3,4], we formulate affective response as a function of expected utility of predicted future narrative outcomes. Narrative recipients (readers, watchers, listeners, etc.) actively reason on behalf of the protagonist [1]. Suspense is an emotional response that manifests itself physiologically as a feeling of anxiety or tension. One cognitive account of suspense posits that it occurs when a narrative recipient believes that the likelihood of avoiding a negative future state is perceived to be small or nonexistent [2]. As options for avoiding the negative future state are removed, and the probability of the negative future state increase, feelings of tension increase correspondingly. Our approach correlates tension to expected utility. Our *Response Model* forecasts future states, determines their value, and estimates the probability that undesirable future states will be averted by character actions or happenstance. These computations yield a result that can be interpreted as relative tension.

## 2 The Response Model

To compute the degree of tension that a human recipient of narrative is expected to experience, the system must perform the following:

I.A. Iurgel, N. Zagalo, and P. Petta (Eds.): ICIDS 2009, LNCS 5915, pp. 312–315, 2009.
© Springer-Verlag Berlin Heidelberg 2009

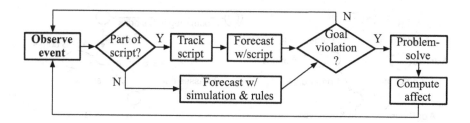

**Fig. 1.** Diagram of the Reader Model process

1. **Adopt goals.** The model determines which characters the recipient will have have high affinity for. It adopts the goals of the character (including *maintenance goals* such as "not be harmed").
2. **Forecast future states.** The model forecasts possible future states, looking for violations of adopted character goals. The utility of these future states is determined.
3. **Estimate the probability of future states and compute tension.** Should an adopted goal be violated, the system estimates the probability that the predicted future state will be avoided. The probability estimation is combined with utility to determine relative level of tension.

Fig. 1 shows how the Response Model processes relate. The story is fed into the Response Model in the form of text structured as *frames*. Each frame of the story provides (a) characters and their characteristics; (b) the action of the character; (c) the location; and (d) any extra-deigetic information such as background music. Frames are structured chunks of narrative designed to correspond to the information that a human recipient can extract from a sentence (or a couple of sentences together representing an event) or a beat in a film. Affinity for characters is calculated dynamically as a function of the valence of character actions and the number of references to the character in the narrative, modulated over time to take on an S-curve shape with an asymptotic upper bound. The Response Model adopts any goals associated with characters with high affinity.

## 2.1 Predicting the Future

The Response Model uses three cognitively plausible mechanisms by which to predict future world states: scripts, simulation, and rules. Scripts are schema-like representations of familiar situations used to reduce the cognitive load of acting in the world [5]. For simplicity, scripts are represented as finite state machines. The FSM representation deterministically captures the variations that can occur in a script. Each script has exactly one entry state – called the triggering state – and exactly one exit state. A script is loaded and tracked if any situation matches the triggering state. The exit state of the FSM is annotated with state information for involved characters that can be compared to adopted goals. Fig. 2 shows scripts for (a) two people having drinks at a bar, and (b) kidnapping by drugging the victim's drink.

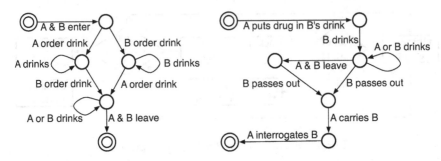

**Fig. 2.** Finite state machine representation of scripts representing (a) two people having drinks at a bar, and (b) a kidnapping via drugging the victim's drink

Not all situations are represented by scripts; when scripts are not available to shed light on a situation, the Response Model uses a combination of simulation and rules. Simulation is the successive application of operators that project the current state into the future until resource bounds are hit or an interesting future state is detected. Rules are one-shot predictions that result from generalization of experience that allows the recipient to jump to conclusions.

If any of these mechanisms identifies a state that is an explicit violation of an adopted character goal, the "value" – or "utility" – of that state is computed and the Response Model attempts to assess the probability of the undesirable state.

## 2.2 Affective Response

Affective response is computed as a function of expected utility. At this stage, the Response Model has identified a possible future state in the narrative that is deemed undesirable, e.g., has negative utility. Following [1,2], the Response Model attempts to *solve the problem* of determining how the negative future state can be averted. That is, the Response Model computes the probability of the negative future state coming to pass as $1 - P_{avert}$, where $P_{avert}$ is the subjective probability that the outcome will be averted either through escape bye one's own means, rescue, or happenstance (e.g., *deus ex machina*).

$P_{avert}$ is computed using the following process: The possible future state is accompanied by a partially-ordered plan with causal links $a_i \rightarrow^p a_j$ such that action $a_j$ could not have occurred if action $a_i$ had not made proposition $p$ true in the world. The plan structure is derived from the finite state machine or simulation. The Response Model attempts to intervene in the causal flow of events [6]. The Response Model uses a form of *adversarial planning* to attempt to find a new plan that negates the proposition of one of the causal links. For every action or symbol used in the new plan attempt, we compute the cost of using that element in the plan as the difficulty of retrieval from a semantic memory model [7]. This guides the planner and also determines the total cost

of each action in the new plan. The probability of averting the undesired future state is:

$$P_{\text{avert}} = (\gamma_{\text{prior}})^{tries}(\gamma_{\text{plan}})^{\sum_{i=1}^{n} \text{cost}(a_i)} \tag{1}$$

where *tries* is the number of causal links the Response Model tried (in order of urgency) before finding a plan that averts the possible future state, $\gamma_{prior}$ and $\gamma_{plan}$ are discount factors, and $a_i$ for $i = 1...n$ are actions in the averting plan. The relative level of tension is computed as $tension = (utility)(1 - P_{\text{avert}})$ where *utility* is the value of the possible future state that violates an adopted goal.

## 3  Limitations, Future Work, and Conclusions

We have limited the scope of our work to a cognitively inspired perspective of emotional response to narrative [1,2]. Specifically, we approach the problem of computing tension as expected utility. Experimentation with the Response Model suggests that with sufficient domain knowledge (scripts, simulation operators, and rules), plausible *relative* tension results are generated. Future work includes evaluation, tuning of parameters, and expansion of system's inferencing abilities. We believe there is great value in modeling human cognitive and emotive responses to narrative. We anticipate this work will facilitate the development of story analysis systems, intelligent story authoring tools for novices, and better heuristics for story generation and interactive narrative systems.

## References

1. Gerrig, R.: Experiencing Narrative Worlds: On the Psychological Activities of Reading. Yale University Press, New Haven (1993)
2. Gerrig, R., Bernardo, D.: Readers as problem-solvers in the experience of suspense. Poetics 22, 459–472 (1994)
3. Ohler, P., Nieding, G.: Cognitive modeling of suspense-inducing structures in narrative films. In: Vorderer, P., Wulff, H., Friedrichsen, M. (eds.) Suspense: conceptualizations, theoretical analyses, and empirical explorations, pp. 129–145. Lawrence Erlbaum Associates, Mahwah (1996)
4. Vorderer, P.: Toward a psychological theory of suspense. In: Vorderer, P., Wulff, H., Friedrichsen, M. (eds.) Suspense: Conceptualizations, Theoretical Analysis, and Empirical Explorations, pp. 233–254. Lawrence Erlbaum Associates, Mahwah (1996)
5. Schank, R., Abelson, R.: Scripts Plans Goals and Understanding: An Inquiry into Human Knowledge Structures. Lawrence Erlbaum Associates, Mahwah (1977)
6. Edwards, B., Burnett, R., Keil, F.: Structural determinants of interventions on causal systems. In: Proceedings of the 30th Annual Meeting of the Cognitive Science Society, pp. 1138–1143. Cognitive Science Society, Inc. (2008)
7. MacLeod, C., Campbell, L.: Memory accessibility and probability judgments: An experimental evaluation of the availability heuristic. Journal of Personality and Social Psychology 63, 890–902 (1992)

# Adaptivity in Game-Based Learning: A New Perspective on Story

Florian Berger and Wolfgang Müller

Pädagogische Hochschule / University of Education Weingarten, Germany
{berger,mueller}@md-phw.de

**Abstract.** Game-based learning as a novel form of e-learning still has issues in fundamental questions, the lack of a general model for adaptivity being one of them. Since adaptive techniques in traditional e-learning applications bear close similarity to certain interactive storytelling approaches, we propose a new notion of story as the joining element of arbitraty learning paths.

## 1   Introduction

In the following we are going to analyse how personalisation and adaptivity features can be translated from classical e-learning to educational games under a storytelling perspective. To provide a proper context, we will provide an introduction into the motivation, prequisites and methods of adaptivity in e-learning first. We will then relate the techniques of adaptivity to interactive storytelling concepts and formulate a new approach to adaptive game-based learning.

## 2   Adaptivity in E-Learning

Early e-learning applications were designed to follow known learning metaphors: teachers and learners, a text-centered approach, virtual classrooms. While this could partly be justified as an attempt to translate established principles into the digital domain, it left a wealth of possibilites unexplored, rendering the applications uneffective at best. [1] Consequently, *personalisation, adapivity* as well as *reusability* have become key demands for modern e-learning systems. [2]

The demand to modularize e-learning lessons arose from the insight that authoring and usage would be much more effective if the contents were reusable. As a result, the widely adopted "Shareable Content Object Reference Model" (SCORM) standard allows for a digital representation of *learning objects* which are made up of XML metadata and the actual files (text documents, images, music etc.). [3]

There are a number of commonly used techniques to achieve adaptivity: In a *pre-learning assessment* the learner must complete a questionaire or quiz before the actual learning application starts. In an *assembly on-demand* approach the learner feeds an assembly engine by giving keywords of topics he wants to

I.A. Iurgel, N. Zagalo, and P. Petta (Eds.): ICIDS 2009, LNCS 5915, pp. 316–319, 2009.

be taught. The engine then builds a track of lessons from a database. Finally, in a *monitoring* scenario the e-learning application is constantly watching the learner's progress and adjusts the pace and content at runtime by evaluating frequent post-assessments.

# 3  Deploying Stories for Adaptive Educational Games

## 3.1  Learning Paths and Stories

The fragmentation of educational content into learning objects is a precondition for personalisation. From this pool adaptive e-learning applications assemble and manage *learning paths* using knowledge acquired about the learner. [4][2] Learning paths can be viewed as directed graphs with a linear progression over time.

Learning paths as such and the process of their creation bear a striking similarity to story plot graphs. Of the various approaches to Interactive Digital Storytelling (IDS) – emergent narrative using agents, goal-based planning, see the overview in [5] – the assembly of dramatic arcs from pre-authored plot points is the most akin to the aforementioned adaptive techniques.

In this case the *modularisation* is carried out by identifying functional plot elements and authoring according plot snippets which can be connected to each other. Riedl calls these snipptes "vignettes". [6]

## 3.2  Functions of Story: Old and New

Stories have long and widely been reported to provide a useful frame for game-based learning. [1][7][8][9] Concepts of interactive storytelling and educational media have been researched in [10]. However, as described above the story component of an educational game is almost exclusively seen as a *motivational device* or a way to add a layer of *emotional connection* on top of instructional content.

We propose a new notion of story in adaptive educational games: story is the *crucial element that is able to tie more or less unrelated game-based learning objects together in a meaningful way.* Users have come to expect meaningful and sound experiences from games and game-like applications, and even more so if they do not require manual skill but knowledge, understanding and reasoning.

## 3.3  Storytelling for Adaptivity: First Steps

Based on the already fairly sizeable body of research on interactive digital storytelling it may be tempting to adapt the content of an existing system in line with the above concept and label it "adaptive educational storytelling". This temptation must be resisted. In connection with game-based learning, storytelling is no end in itself; for example as stated above the modularisation process must divide the contents into learning objects from an educational, *not* from a narrative perspective. This is the reason why storytelling-focussed systems can not be used for our approach on game-based learning out of the box, even if they

are related concept-wise. In the following we will propose how existing systems should be modified to suit the demands established above.

*Made-to-measure Modularisation:* In analogy to learning objects in conventional applications there is a need of *game-based learning objects* as a basic unit for educational games.

*Metadata for Combination:* The SCORM standard for learning objects lacks metadata support necessary to concatenate learning objects into a learning path (e.g. dependencies). It must be investigated what kind of extensions are usable for game-based learning objects. [2]

*Optimisation for Story:* Only after crafting a learning path of educational value it can be complemented with a story to create an integrated, meaningful experience for the learner. For this to work each game-based learning object must provide *story slots,* i.e. an abstract set of pre-conditions, roles and possibly story-related outcomes. At this point an adaption of *vignettes* as introduced by Riedl in [6] should be investigated.

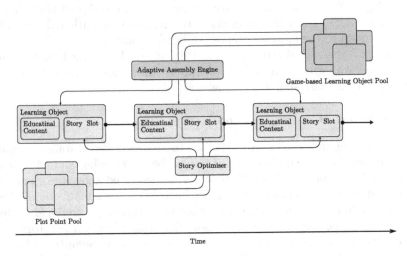

**Fig. 1.** Draft of an adaptive game-based learning application that optimises a given learning path for story

## 4   Conclusions and Future Work

Game-based learning still has issues in fundamental questions, one of them being the lack of concepts and models for adaptivity, which is an established feature in traditinal e-learning implementations. We propose a new notion of story as the joining element of arbitraty learning paths.

Our further research topics include modularisation of educational games; metadata, tags and connectors of game-based learning objects; balancing learning goals and story consistence while still keeping the application a game; op-

timising an interactive learning path for story based on directions given by an author; evaluation of learner progress during the course of a game.

# References

1. Greitzer, F.L., Kuchar, O.A., Huston, K.: Cognitive science implications for enhancing training effectiveness in a serious gaming context. J. Educ. Resour. Comput. 7(3), 2 (2007)
2. Farrell, R.G., Liburd, S.D., Thomas, J.C.: Dynamic assembly of learning objects. In: WWW Alt. 2004: Proceedings of the 13th international World Wide Web conference on Alternate track papers & posters, pp. 162–169. ACM Press, New York (2004)
3. Wisher, R.: Sharable content object reference model (scorm) 2004, 4th edn. PDF (March 2009)
4. Krichen, J.P.: Dynamically adjusting to learner's competencies and styles in an online technology course. In: SIGITE 2005: Proceedings of the 6th conference on Information technology education, pp. 149–154. ACM Press, New York (2005)
5. Hartmann, K.: Interaktives drama. Lecture at the University of Magdeburg, Germany (January 2007)
6. Riedl, M.O., Sugandh, N.: Story planning with vignettes: Toward overcoming the content production bottleneck. In: Spierling, U., Szilas, N. (eds.) ICIDS 2008. LNCS, vol. 5334, pp. 168–179. Springer, Heidelberg (2008)
7. Tan, P.H., Ling, S.W., Ting, C.Y.: Adaptive digital game-based learning framework. In: DIMEA 2007: Proceedings of the 2nd international conference on Digital interactive media in entertainment and arts, pp. 142–146. ACM, New York (2007)
8. Dickey, M.D.: "ninja looting" for instructional design: the design challenges of creating a game-based learning environment. In: SIGGRAPH 2006: ACM SIGGRAPH 2006 Educators program, p. 17. ACM Press, New York (2006)
9. Egan, K.: Teaching as Storytelling: An Alternative Approach to Teaching and the Curriculum. Routledge, New York (1988)
10. Spierling, U.: Conceptual models for interactive digital storytelling in knowledge media applications. In: Göbel, S., Spierling, U., Hoffmann, A., Iurgel, I., Schneider, O., Dechau, J., Feix, A. (eds.) TIDSE 2004. LNCS, vol. 3105, pp. 171–176. Springer, Heidelberg (2004)

# Digital Video and Interactivity

Alysson K. Morelli, Gabriel C. Chaves, and Tiago M. Belchior

Belo Horizonte – MG – Brazil
alyssonmorelli@gmail.com, dk.gabriel@gmail.com,
tibelchior@gmail.com

**Abstract.** With the growth of digital video technology, the authors have chosen to explore the potential of the DVD, in terms of interactivity. The research aims at understanding the interaction possibilities of digital video in a DVD player, while still keeping the narrative constraints. This paper explains the project, the resulting DVD, and shows that the relation of the spectator to a video can be changed by the interaction.

**Keywords:** DVD, interactivity, narrative.

## 1 Introduction

Who has not wondered what would happen if the character Neo, played by Keanu Reeves in *Matrix*, had chosen the red pill instead of the blue? This choice was fundamental to the progress of the movie, but could have created new narrative possibilities that would be as engaging and interesting as the original presented by the director. This choice could be made by a spectator who participates in the construction of the story through key paths in the narrative, providing different experiences for each choice. What if there were several choices inside a movie, which would take each spectator through distinct paths within the plot?

These questions lead to the idea of making a video in which the spectator is no longer just an inert receiver with no direct participation at the narrative and becomes a user whose actions influence directly the perception of the video. This was the starting point of "Phobia", an experimental interactive video. It is a result of the final project for the graduation in Social Communication of the Pontifical Catholic University of Minas Gerais - Brazil.

The plot of Phobia begins with the character Theo, waking up suddenly and finding himself in a strange place. From this point the choices made by the user helps to reveal the reasons why the character is in such state. At the end each path leads the viewer to a different interpretation of the events that occur during the video.

The DVD format provided a wealth of possibilities: Extras and menus can be inserted along the playback, in a very similar way to the hyperlinks found on the Internet, allowing the development of this project. This paper demonstrates the steps that we have taken towards design, development, production and display of the DVD Phobia.

I.A. Iurgel, N. Zagalo, and P. Petta (Eds.): ICIDS 2009, LNCS 5915, pp. 320–323, 2009.

## 2 Getting Phobia

The Phobia DVD wants to enable a greater interaction with the video in the DVD format. Among the elements that constitute a video, the narrative proved to be the least explored variable, with respect to interactivity [1]. Most films are made following a linear narrative structure, not offering to the receiver the alternative to have an active participation in the development of the story.

The choice of the DVD media as support for the video was made due to the interactive possibilities of the format, and due to further qualities, like its acceptance as video medium [2], and because it reaches an important level in the cultural industry and replaces the previous technology in both audio and video quality, delivering an experience that approaches the cinema experience [3].

Planned to be played on DVD Players, the Phobia DVD makes use of the remote control as device for the interaction with the user. Since the DVD format was selected as support for the interactive video Phobia, the following step is required for the creation of a script.

### 2.1 Script

Initially the proposal was to develop a collaborative script on a Wiki system. After registering into the system, users would be able to suggest scenes to a script that later would be recorded. However, after some months of testing and due to little participation, this idea was discontinued.

Then the script was written by the group, thinking about the multilinear structure proposed by Nelson Zagalo [4]. A basic start was defined, and then points of intersection were included, thereby creating linear and tree structures. The scenes were distributed among the rooms of the house and of the apartment used as scenario, resulting in 10 scenes that were subdivided into about 30 options (points of intersection) to choose from.

As the controller of the plot, the user will see changes in the meaning of the story according to the path taken. In all cases the ending has a connection with the first scene, showing an intentional cyclic movement, which may encourage the user to explore the narrative again. In theory, this type of interaction fits Plaza's second degree of interaction, since the viewer interacts actively with the work, in a mechanical and structural way [5], and thus will not be able to change the content.

### 2.2 Production, Editing and Authoring the DVD

During the production process, two different locations were selected as scenario: a furnished apartment and an empty house from a member of the group. The shooting took two days and the script was very important. The scenes were made respecting the positions and the time needed.

The editing was started after taking two important steps: mapping of tapes and creation of a flowchart of the scenes. Following the order of the script, scenes were chosen to compose the various key moments of the video and respect the points of intersection.

In the edition were defined distinct soundtracks profiles for each scene, giving an idea of location and identity. The Stereo scene is a special case, the main character

interacts with a stereo system, and the choice of the user changes the audio. This interaction was used to demonstrate the possibility of manipulation of other variables besides the narrative.

After editing the video, files were generated and prepared to be processed with the DVD authoring program. This process is based on the flowchart connection of the scenes. To present the interactive moments of the video, a visual system of arrows was employed. The user is able to deduce what to do when they emerge, without necessarily reading the instructions. When the options are shown and the corresponding arrow is pressed on the remote control, the video goes immediately to the selected scene. The interaction is available in the screen for about 5 seconds; if the user does not interact, the system automatically selects a path that was previously defined as the basic story.

In the scheme presented by Fig. 1, the flowchart of the actions is clear. From the start, the user has the option to see two scenes which will generate different ways to understand the story. If the left path is taken, the shortest way to the end will be presented, cutting any chance to interact and modify the final result. The path on the right gives more details about what happened, explaining what led the character to be in that situation.

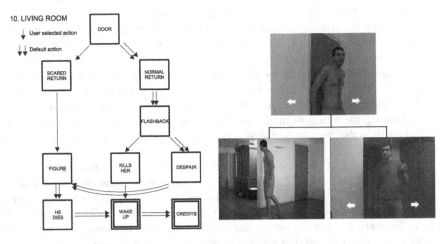

**Fig. 1.** Scene 10 flowchart and preview of the start

In this scene, the proposed multilinear system can be experienced, with a plurality of information and the interconnection of key scenes. Distinct paths may have scenes in common and produce a result with more or less information, depending on which path is chosen.

## 3   User Reactions

After completing the processes, the DVD was shown to some users. The reactions pointed in general into the same direction: Initially we observed that most people wanted to interact with all possible ways that the video offered and were eagerly

awaiting the next opportunity for interaction, losing focus of the content of the video. Maybe this happened because of the novelty of the interaction, since they were not accustomed to constant interaction with a DVD. Having said this, it must be explained that the intention of our experimental project was to overexpose the user to this new system. The number of interactions made with the DVD is higher that it would be with a commercial production. In this case the interactions could occur only at key moments, for the sake of the continuity of the plot.

Another important fact stressed by users accustomed to interactive environments was the lack of information on what each command does with the narrative. It was suggested that the links should be represented by icons that represent the following action. However, the actions are unique and do not correspond only to objects, but they lead to paths that are abstract, fruit of the imagination of the character. This makes the process of creating icons for each link difficult. Apart from technical constraints, another crucial point that leads to the use of arrows is the suspense it generates. The user, not sure where the command will take him to, is involved with tension and surprise into the results. Experienced users tend to want more control, seeking for logic in the choices. Surely a system of iconographic links would help raising the feeling of control, but this was not the main goal of this project.

The main achievement of the observation phase was to understand that almost everyone got interested in playing the video more than once, trying to explore the other possibilities that are offered by the video. This was an important outcome, since the intention from the beginning was to increase the interest of the spectator, in this case becoming a user through interventions made in the narrative. Therefore, the interactive video Phobia project concludes that the interactivity achieved, through a multilinear narrative, is able to modify the relation of the viewers with a video in DVD format, increasing also the overall interest.

# References

1. Morelli, A., Bretas, A., Chaves, G., Belchior, T., Gontijo, V.: Vídeo Digital e Interatividade (Digital Video and Interactivity, in Portuguese). B.S. thesis, Pontifícia Universidade Católica de Minas Gerais, Belo Horizonte, Brazil (2007)
2. DVD Demystified, http://www.dvddemystified.com/dvdfaq.html#1.3 (2009)
3. Karaca-Mandic, P.: Network Effects in Technology Adoption: The Case of DVD Players (2009),
   http://www.chicagobooth.edu/research/workshops/marketing/
   archive/WorkshopPapers/karaca-mandic.pdf
4. Zagalo, N.: Narrative Entertainment Model, in Convergence between Film and Virtual Reality, Doctoral Dissertation, Department of Communication Arts, University of Aveiro, Portugal, pp. 164–171 (2007)
5. Plaza, J.: Arte e Interatividade: Autor-Obra-Recepção. R. Mest. Art. Tec. VIS UNB 3, 29–42 (2001)

# Say Anything: A Demonstration of Open Domain Interactive Digital Storytelling

Reid Swanson and Andrew S. Gordon

The Institute for Creative Technologies, The University of Southern California
13274 Fiji Way, Marina del Rey, CA, 90292 USA
{swansonr,gordon}@ict.usc.edu

**Abstract.** Say Anything is a text-based interactive digital storytelling application that differs from other systems in its emphasis on the ability of users to create a narrative in any domain that they wish. The user and computer take turns in writing sentences in an emerging fictional narrative where sentences contributed by the computer are selected from a collection of millions of personal stories extracted from Internet weblogs. In this demonstration, we will present the latest version of the Say Anything application and allow conference participants to author their own original stories using the system.

**Keywords:** interactive storytelling, interactive fiction, collaborative writing, social media, weblogs, information retrieval.

## 1 Say Anything

Say Anything [4] is an open domain story generation engine that is unlike most other contemporary interactive storytelling systems. Say Anything diverges from current systems in two key areas. First, most state-of-the-art systems rely heavily on rich, 3D graphics to help engage the user with the story and virtual environment. However, similar to the early interactive storytelling systems such as TALE-SPIN [3], the virtual world in Say Anything is brought to life entirely through textual language. Second, in any interactive storytelling system there are two somewhat contradictory objectives: to maintain a strong coherent narrative and to allow the user the freedom to do anything they please. While the ultimate goal is to simultaneously achieve both, most compelling systems have focused on improving the narrative aspect by restricting the user's ability to interact with the world in various ways. Say Anything on the other hand emphasizes the ability for the user to create a narrative in any domain without any restrictions, other than the limits of a keyboard.

Stories are authored with Say Anything in a turn-based fashion where the human user and the computer alternate writing sentences of the developing narrative. The user always begins a story with the first sentence. The system then analyzes what has been written and returns a sentence that tries to continue the story in a coherent and entertaining way. If the user is satisfied with this sentence they may continue by writing another sentence. However, if the sentence does not make sense or is objectionable for another reason they may click on the returned sentence and be presented with

I.A. Iurgel, N. Zagalo, and P. Petta (Eds.): ICIDS 2009, LNCS 5915, pp. 324–327, 2009.

nine other alternative sentences from which they can choose. This alternating writing process continues until the user feels that the story has reached a natural conclusion or has deviated so far off track that recovering a coherent narrative is impossible. Figure 1 presents a screenshot of the system's primary authoring interface. The following passage is an example of a successful story written in collaboration with the system:

*The weather broke, so we sailed out of the harbor. As Victoria grew nearer, the waves grew larger and we furled some foresail and turned to run. We sailed at about 9 knots with good trim, but the storm eventually caught up with us. With its big open cockpit and heavy nose, I didn't like its chances in the kind of sea you get out there almost continuously that time of year. Sure enough the boat was completely inadequate, and we were tossed into the cold ocean. Everyone in our group of seven tourists -- five locals and a Japanese couple -- was pretty excited about the experience. The Japanese couple were the ones that saved us though, with their expert swimming abilities. as far as that goes it was just the four of us. The last tourist was lost at sea, never to be found. Drowned or murdered, the bloated, stinking bodies that turn up by the hundreds will look much the same. Such is the way with storms like that!*

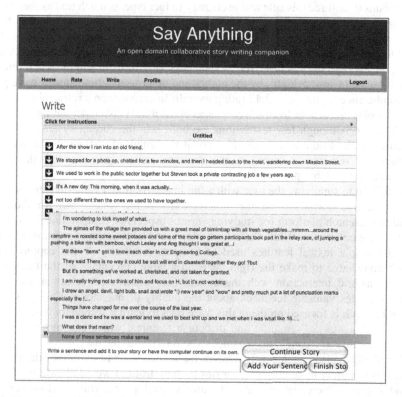

**Fig. 1.** The main writing interface for the *Say Anything* application. The user can write a new sentence, swap one computer-contributed sentence for another, or allow the computer to continue generating sentences.

The system continues a story using a simple three-step architecture. First it analyzes lexical and semantic features of the user's developing story so far, including the most recently contributed sentence. This includes several preprocessing steps that attempt to identify named-entities, remove stop words and perform other transformations to help clean the text. This analysis is used to find a story containing a sufficiently similar sentence to the user's current input from a large corpus of millions of English language stories collected from Internet weblogs [1]. Similarity between sentences is assessed using standard information retrieval techniques implemented in the Apache Lucene search engine toolkit [2]. Several methods for determining similarity have been explored, however, the most successful so far is simply a vector space model with *term frequency-inverse document frequency* feature weights, where terms are both unigram and bigrams. The story retrieved using this technique is treated as a proxy for the user's emerging story and the next sentence in that story is returned as the continuation of the user's narrative.

There are relatively few restrictions on the way the user can interact with our system or in the types of stories they can create with it. The only stated rule is that the user should take turns writing one sentence at a time. However, there are no explicit mechanisms to enforce this rule and users may in fact type as much text as they would like (up to a predefined character limit) into the text box. Whether it is due to the stated rule, the design of the user interface or because it is a natural unit, we have found that users typically only write one sentence per turn. Using the current retrieval model, the average story is just over 14 sentences, or 7 turns in length. When rated on a 5-point scale (1 low; 5 high), by the author and other users, these stories were given a 3.66 coherence rating and a 3.42 rating overall. In comparison a retrieval model that randomly picks sentences from the corpus received a 2.93 coherence rating and a 2.66 overall rating. Although few restrictions are built into the current system, it may be interesting in the future to enforce rules about the length of content, genre and other structural or semantic aspects of the process, as is common in other (non-computational) collaborative writing games.

In addition to supplying the user with a fun improvisational game-like environment to write creative stories through their interaction with the system, Say Anything also provides a research platform for studying various aspects of computational linguistics and narrative coherence. While the information retrieval techniques work surprisingly well, the simple lexical features used to compute similarity do not capture nearly enough knowledge to make the right decision a large percentage of the time. However, the natural interaction with the system (i.e. when users select alternate sentences) provides valuable feedback about the quality of our model. One part of our current research is focused on using this trace data to learn a secondary model using a richer set of syntactic, semantic and discourse features, which can more accurately assess the quality of a candidate sentence to be returned to the user.

This platform also enables us to explore the related issue of narrative adaptation. If we had an infinitely large corpus of stories to draw from, it would always be possible to find a story sufficiently similar to the user's developing narrative. However, even with the vast amount of text written on the web, there will never be a story collection large enough to match every lexical variation in the way that people compose narratives of experiences. One method to address this issue is by recognizing when significant discontinuities would occur and adapting the retrieved content to eliminate

mismatches. For example, it may be possible to recognize when a retrieved story differs from the user's story in the gender of the central characters, and then automatically adapt the personal pronouns of the retrieved content so that it can be included in a coherent way. The user interaction data that we are collecting will help us investigate how to automatically determine which elements in a candidate sentence do not align well with the user's story, and what possible replacements would most improve its quality.

In this demonstration we will allow users to author their own original stories in real time and explore the latest features of the system. In addition the users will be able to explore the other aspects of the system that have been developed to try to foster a web-based community around this type of simple storytelling game.

**Acknowledgments.** The project or effort described here has been sponsored by the U.S. Army Research, Development, and Engineering Command (RDECOM). Statements and opinions expressed do not necessarily reflect the position or the policy of the United States Government, and no official endorsement should be inferred.

# References

1.  Gordon, A., Cao, Q., Swanson, R.: Automated Story Capture From Internet Weblogs. In: Proceedings of the Fourth International Conference on Knowledge Capture, Whistler, BC, Canada, pp. 167–168. ACM Press, New York (2007)
2.  Gospodnetic, O., Hatcher, E.: Lucene in Action. Manning Publications, Greenwich (2004)
3.  Meehan, J.R.: The metanovel: writing stories by computer. PhD thesis, Yale University (1976)
4.  Swanson, R., Gordon, A.: Say Anything: A Massively Collaborative Open Domain Story Writing Companion. In: Spierling, U., Szilas, N. (eds.) ICIDS 2008. LNCS, vol. 5334, pp. 32–40. Springer, Heidelberg (2008)

# An Interactive Film Demonstration: Crossed Lines

Sarah Atkinson

University of Brighton, Watts Building, Moulsecoomb, Brighton, BN2 4GJ, UK
s.a.atkinson@brighton.ac.uk

**Abstract.** *Crossed Lines* is an original fictional interactive AV piece, amalgamating multi-form plots, a multi-screen viewing environment, an interactive interface and an interactive story navigation form. The installation tells the stories of nine characters in a way that the viewer can constantly explore and switch between all nine forms, using a telephone keypad and handset as an interface, and can simultaneously observe all the characters presence within the nine remote locations. The series of narratives can be viewed as individual stories, but they also interrelate with and link to the other stories.

**Keywords:** Crossed Lines, Interactive Drama, Interactive Cinema, Interactive Video, Interactive Storytelling, Multi-screen, Telephone Interface.

## 1 Overview

*Crossed Lines* exploits developing technologies which allow multi-channel video to play in synchronicity and to be interrupted and re-ordered by the user. *Crossed Lines* is a multi-form (or multi-plot) film telling the stories of nine characters in a way that the viewer can constantly explore and switch between all nine characters and their associated narratives, and can simultaneously witness the presence of all of the characters between their nine remote locations. The starting point of the piece was to conceive a series of narratives that could be viewed as individual stories, but would also reference and link to the other stories, as is the case of the multi-plot film genre. As McKee has noted 'multi-plot films never develop a central plot; rather they weave together a number of stories of subplot size' [1]. The difference with *Crossed Lines* is that it is delivered through an interactive interface paradigm, meaning that the viewer has the power to navigate and order the stories themselves, and to create a story of varying complexity depending on the number of different characters which are selected through the interface.

The piece is original in terms of its focus on strategic creative methodologies designed to provide an equitability of characters and a screen form and navigational structure that enhances and encapsulates the equal emphasis on all characters and their associated narratives. What is also distinctive is that users have an open system of control yet this does not lead to randomised and meaningless events, it still maintains a narrative coherence when subjected to different levels of user interaction. *Crossed Lines* attempts to create an interactive environment within the multi-linear

I.A. Iurgel, N. Zagalo, and P. Petta (Eds.): ICIDS 2009, LNCS 5915, pp. 328–331, 2009.

narratives, which are centered around and based on traditions of fictional naturalism/realism. This is in contrast to most forms of interactive storytelling, which are based within specific genres, which lend themselves to exploration and experimentation, such as fantasy and science fiction. *Crossed Lines* also responds to contemporary modes of user engagement and reception, by reflecting upon seminal theorists in the field such as Ted Nelson, who, in his book *The Home Computer Revolution* described the 'impatient user' as a polar opposite to the 'waiting operator'. 'We are now going to see a new kind of user: slam bang, sloppy, impatient, and unwilling to wait for detailed instructions' [2].

**Fig. 1.** A user interacts with the *Crossed Lines* interactive film installation. When a key is pressed on the telephone keypad, an action is triggered on the corresponding screen, and the user listens to the audio through the telephone hand-set.

## 2  Installation

*Crossed Lines* is presented on a large-scale monitor showing nine screens of simultaneous video, which is controlled by the use of a physical telephone interface. The nine numerical buttons of the telephone keypad mirror the layout of the nine video screens establishing a firm visual relationship between the interface and screen (See Fig. 2). A familiar, simple and efficient user interface is used intentionally since it is a ubiquitous piece of hardware that can be operated intuitively, with no or very minimal instruction for the user. 'The telephone demands complete participation' and is 'an irresistible intruder in time or place' [3].

In *Crossed Lines* the user presses one of the keys (numbers 1-9), and the result of their action is then immediately apparent on the corresponding screen in that a dramatic action is triggered, for example, a phone rings or someone walks into frame, thus giving the operator an immediate sense of user agency. The user listens to the audio and dialogue through the telephone earpiece. In technical terms, what the user's key press actually activates is a switch in video streams. The corresponding screen (numbered 1-9 in exactly the same way the phone keys are positioned; the numbers run chronologically from left to right, top to bottom) changes to a new scene, as does one or more of the other screens depending on which characters are in conversation. This is consistent throughout the entire piece. It is therefore apparent to the user early on in the experience that they are ordering and constructing the narrative. The

software works in such a way that the scenes are chronologically ordered for reasons of narrative coherence, and once a scene has been viewed, it is no longer accessible to the viewer. On the nine screens, the user is faced by nine characters (See Fig. 2) each of whom are seen or will be seen as the narrative progresses, on the telephone, and then communicating with one another solely through the use of the telephone. The approach taken to the production of the installation was to purposefully heighten and enhance the experience of the multiple narratives; and to encourage user engagement and immersion.

**Fig. 2.** The *Crossed Lines* telephone and multi-screen interface

There are nine points of view in this film, and each are presented equally in both form and content. The aim of this is to enable user empathy and emotional involvement to be experienced on comparable levels with each of the nine characters. They are each given equal attention in terms of character complexity, three dimensionality, screen time, and dramatic action. Their stories are clearly delineated and they each progress on their own specific narrative journeys, with each character's story reaching a satisfying narrative closure.

## 3  Summary

*Crossed Lines* aims to bring forward debates and discourse surrounding alternate narrative structures, user engagement and interface. *Crossed Lines* is a multi-genre hybrid of film, television and game, which references, reflects and celebrates its predecessors and looks toward new paradigms of challenging filmic storytelling. It presents a malleable form of digital fiction, which takes into consideration the viewers heightened awareness of narrative structure and plays to the sense of instant gratification inherent in the television and gaming audience.

## 4  Technical Information

*Crossed Lines* is built using Director and QuickTime. The interface is a modified telephone keypad, which functions as a replacement keyboard. The user listens to the audio through the telephone handset, which is routed from the computer sound card.

*Crossed Lines* can currently only run on the following minimum specification computers since it is essential for the nine concurrent video streams to remain in synchronicity:

- 5 GB of Hard Drive space
- Dual Core CPU
- 2 GB of RAM
- Video Card with at least 512 MB of RAM

**Acknowledgments.** Interactive scripting: Mark Smalley, Interface Configuration and additional scripting: Onno Baudouin. Special thanks to: Professor Steve Dixon, The University of Salford, University of Central Lancashire, Brunel University and The University of Brighton.

# References

1.  McKee, R.: Story: Substance, Structure, Style, and the Principles of Screenwriting. Methuen, London (1998)
2.  Nelson, T.: The Home Computer Eevolution. Ted Nelson, Michigan (1977)
3.  McLuhan, M.: Understanding Media. Routledge, London (1997)

For more information, and to view video documentation of *Crossed Lines*, Please visit: www.crossedlines.net

# Pedagogical Dramas and Transformational Play: Realizing Narrative through Videogames Design

Sasha A. Barab, Tyler Dodge, Adam Ingram-Goble, Charlene Volk, Kylie Peppler, Patrick Pettyjohn, and Maria Solomou

Learning Sciences, Indiana University, Bloomington, Indiana

**Abstract.** Whereas traditionally stories involve an author, a performer, and an audience, much of the power of videogames as media for advancing narrative springs from their affordance for the player to occupy more than one role—and sometimes all three—simultaneously. In the narratively-rich videogames that we design, players have the opportunity to perform actions, experience consequences, and reflect on the underlying social values that these situations were designed to engage. Here, our focus is on the use of these games to engage children in experiencing ideological struggles associated with realizing social commitments. Toward this end, we will present our theoretical argument for the power of games as a contemporary story medium, grounding this discussion in the demonstration of three game design projects and their implementations.

**Keywords:** Interactive narrative, Educational games, Social commitment.

## 1 Introduction

While every era is met with the introduction of powerful technologies for entertainment and learning, we believe that videogames represent an especially powerful medium [1]. Elsewhere we have discussed designing these media as contexts for engaging academic content [2,3,4,5]; here we illuminate the power of videogames for providing stories that address the struggles associated with realizing social agendas. As educational designers, we find an opportunity and responsibility to take part in the research and development as this medium takes shape [6]. Though often neglected in traditional schooling, games can effectively scaffold such socially and ideologically-significant insights, in large part due to the agentive nature of play, wherein the choices that a player makes reflexively make claims about the player [7].

To the extent, then, that a game implements social values or commitments as dilemmas in which a player must determine a course of action, consider its implications, and address the meanings that it serves to contest, the game has engaged the player in at least one instantiation of the topic, one permutation of its factors. Moreover, in the fleeting and intangible quality of play we find, ironically, its efficacy for pedagogical work. The substance of these curricula lies not in the knowledge they embody but the engagement they afford: while arguably not unique to these media, the immersivity and interactivity that videogames afford make salient the possibility and potential of story as vehicle of social commitment, a way of making meaning.

I.A. Iurgel, N. Zagalo, and P. Petta (Eds.): ICIDS 2009, LNCS 5915, pp. 332–335, 2009.

Immersive, interactive narratives that afford transformational play in the service of a pro-social agenda represent *pedagogical dramas*. Accordingly, and in fact similarly to most stories bearing more than localized and ephemeral value, the three narrative play spaces we discuss here are pedagogical and ideological in nature. However, pedagogical dramas intended to foster social commitment and an appreciation for the complexities of realizing a particular commitment must be intentional about the messages that they advance. More than mere symbolism that a reader may, or may not, subjectively discern, these themes or values necessitate that the player engage the issue and determine its lesson, its meaning.

Toward this end, as part of our commitment to reclaim some of the power of the classics, the first world we will discuss is an adaptation of Shelley's gothic *Frankenstein*. Students engage selected aspects of the classic narrative, purposefully leveraged to problematize—and consequently clarify—each individual's stance on two related issues: the dilemma of valuing ends versus means, and the definition of what constitutes humanity. From there we will discuss a world based on Rand's literary classic, *The Fountainhead*. In this virtual adaptation, children join and promote one of two architecture firms, according to their personal allegiance and involving their struggle with a dilemma of values: personal integrity versus social conformity. Providing a contrast while still promoting social commitment, the final story world we present is not based on a classic work but nonetheless presents a narrative setting and dramatic arc. Here, the dilemma juxtaposes personal, community, and world benefit as players make choices affecting not only in-game characters but real-world players distributed around the world.

Each of these three designs constitutes a play space where one experiences narrative transactivity [8] in a storyline in which one role-plays a protagonist and engages in game play that involves transforming both the game world and, ultimately, the self. The reader is encouraged to visit our project website (QuestAtlantis.org) to learn more about these and other interactive games that have been used by over 25,000 children around the world [9].

## 2 Narrative and Games

The notion that story can serve to teach—between individuals, generations, and cultures—is unsurprising, even to those who privilege expository discourse in which content is presented in a more abstracted and explicit fashion. Stories do pedagogical work differently, namely by embedding content within a narrative frame and communicating it through character actions and dilemmas. Bruner [10] discusses the potential of story as having metaphorical loft: that is, whereas any particular narrative features a specific setting and characters, and portrays a unique dramatic complication and resolution, the message that it suggests will resonate with other situations, with other stories, with audiences in other times and places. In leveraging videogames as a story medium, we find that the mechanisms by which narrative and narrative games achieve their effects are discernable and not dissimilar. For narrative, the potential to evoke experience is realized through balancing dramatic elements, and similarly, a game must balance the tensions inherent in the sense of play that it affords. For narrative games broadly, these include elements of setting, character, and action, and for

narrative games emphasizing interactivity, these include levels of difficulty and rule sets guiding decisions and outcomes [11].

Further, a narrative must balance between detailing the particular setting, characters, and actions with conveying the universal or archetypal message underlying these particulars. Similarly, for most games apart from the most trivial, and despite variations in particulars, they must, like narratives, convey a consistent underlying message and, as narrative media, use canonical narrative tropes [12]. In the narrative content, beyond the story being told, one may find further an ideological and even moral intent. The act of authorship instantiates one's ideological framework and ethical commitments, that is, the matters deemed significant enough to warrant expression. Still, a story too explicit in pedagogical intent risks waning didactic, like word problems fashioned to teach a concept in mathematics. Conversely, one too replete with detail and nuance risks harboring varieties of experience without fidelity to a message: even when considering an author's question, each member of the audience may answer differently.

The story represents an act of meaning in which the author's ideological intent coincides with an individual's subjective encounter. The extent to which an author privileges her ideology, that is, ensures its instantiation, amounts to her undertaking pedagogical work. In previous manuscripts we have discussed our theory of transformational play, which highlights three interconnected elements of *person*, *content*, and *context*, with an emphasis on designing spaces that integrate the three. In one piece, we stated that "playing transformationally involves taking on the role of a protagonist who must employ conceptual understandings to make sense of and, ultimately, make choices that have the potential to transform a problem-based fictional context" [13]. The challenge is to create spaces experiences that (1) bind person with context by positioning players as change agents with intentionality as first-person protagonist in the storyline; (2) bind content with person by creating dilemmas that legitimize disciplinary content; and (3) bind context with content by highlighting the consequentiality of one's actions through contexts that change in response to students' decisions. And our response to this challenge takes the form of what we call the *pedagogical drama*.

## 3  Parting Thoughts

A core focus of our work more generally concerns supporting children to adopt commitments and understand the dilemmas in realizing them in actual situations. While sometimes coupled with traditional disciplines (e.g., Social Studies, Civics), the focus on social commitment evident in this report represents a perennial and ubiquitous topic of consideration, variously termed character or values education, identity work, or ethics. Toward this end, this demonstration presentation will address the topic of designing videogames to engage children in social commitments (i.e., the act of binding oneself to a chosen course of action). In pedagogical dramas, students perform actions, experience consequences, and reflect on the underlying social values that these situations were designed to engage.

Thus while the design work involves particular narratives, their focus and purpose was to engage youth in the deeper struggle of understanding the choices and challenges inherent to realizing a particular social commitment. And while the three

designs varied in the stories they harbored and the issues they presented, their similar objectives—to promote individual commitment to perennial social values and to do so through a game-based, pedagogical drama—reflect an ongoing enterprise of the Quest Atlantis project. More generally, our work concerns the appropriate use of immersive, interactive media—videogame technology, in short—for wide-ranging educational ends. In this brief offering, we will explicate the why, the what, and the how of this work in a manner that is theoretically rich and empirically grounded, with the hope that such an account will simultaneously inform and inspire others.

# References

1. Gee, J.P.: What Video Games Have to Teach Us About Learning and Literacy. Palgrave Macmillan, New York (2003)
2. Barab, S.A., Dodge, T., Ingram-Goble, A., Volk, C., Peppler, K., Pettyjohn, P., Solomou, M.: Pedagogical Dramas and Transformational Play: Narratively-Rich Games for Learning. To appear in Mind, Culture & Activity (in press)
3. Barab, S.A., Sadler, T., Heiselt, C., Hickey, D., Zuiker, S.: Relating Narrative, Inquiry, and Inscriptions: A Framework for Socio-Scientific Inquiry. J. Science Educ. And Tech. 16, 59–82 (2007)
4. Barab, S.A., Zuiker, S., Warren, S., Hickey, D., Ingram-Goble, A., Kwon, E.-J., Kouper, I., Herring, S.C.: Situationally Embodied Curriculum: Relating Formalisms to Contexts. Science Educ. 91, 750–782 (2007)
5. Gresalfi, M., Barab, S.A., Siyahhan, S., Christensen, T.: Virtual Worlds, Conceptual Understanding, and Me: Designing for Consequential Engagement. On the Horizon 17, 21–34 (2009)
6. Barab, S., Thomas, M., Dodge, T., Carteaux, R., Tuzun, H.: Making Learning Fun: Quest Atlantis, A Game Without Guns. Educ. Tech. Res. & Dev. 53, 86–107 (2005)
7. Squire, K.: From Content to Context: Videogames as Designed Experiences. Educ. Res. 35, 19–29 (2006)
8. Murray, J.: Hamlet on the Holodeck. The Free Press, New York (1997)
9. Barab, S.A., Dodge, T., Thomas, M., Jackson, C., Tuzun, H.: Our Designs and the Social Agendas They Carry. J. Learning Sciences 16, 263–305 (2007)
10. Bruner, J.: Life as Narrative. Social Research 54, 11–32 (1987)
11. Salen, K., Zimmerman, E.: Rules of Play: Game Design Fundamentals. MIT Press, Cambridge (2004)
12. Sheldon, L.: Character Development and Storytelling for Games. Thomson Course Technology PTR, Boston (2004)
13. Barab, S.A., Gresalfi, M.S., Ingram-Goble, A.: Transformational Play: Using Games to Position Person, Content, and Context (2009) (manuscript submitted for publication)

# Virtual Heritage Tours: Developing Interactive Narrative-Based Environments for Historical Sites

Deborah Tuck and Iryna Kuksa

Narrative and Interactive Arts
School of Art and Design
Nottingham Trent University
Nottingham NG1 4BU
{Deborah.Tuck,Iryna.Kuksa}@ntu.ac.uk

**Abstract.** In the last decade there has been a noticeable growth in the use of virtual reality (VR) technologies for reconstructing cultural heritage sites. However, many of these virtual reconstructions evidence little of sites' social histories. Narrating the Past is a research project that aims to re-address this issue by investigating methods for embedding social histories within cultural heritage sites and by creating narrative based virtual environments (VEs) within them. The project aims to enhance the visitor's knowledge and understanding by developing a navigable 3D story space, in which participants are immersed. This has the potential to create a malleable virtual environment allowing the visitor to configure their own narrative paths.

**Keywords:** Narrative, virtual reality, interactivity, accessibility, heritage, multimedia.

## 1 Introduction

The Narrating the Past project aims to enhance the knowledge and understanding of Nottingham's cultural heritage and social history and improve current connections between several local cultural heritage sites and the wider public. The project team works in close partnership with Nottingham's museums and cultural heritage institutions on designing, producing and displaying a virtual heritage environment (VHE) that interconnects three local sites through a narrative based around the events of the Reform Bill riots of 1831. The participating sites are: Green's Mill, Nottingham Castle and the National Centre for Citizenship and the Law (NCCL) Galleries of Justice. In our research we explore new ways to enrich the visitor's experience of a heritage site by promoting a greater sense of engagement with social-historical memories that could potentially present an alternative to current heritage trails and guided tours.

## 2 Research Context and Structure

The relationship between drama and narrative in VEs has been theorized by authors such as Marie-Laurel Ryan [8], Janet Murray [6] and Brenda Laurel [5] who have

I.A. Iurgel, N. Zagalo, and P. Petta (Eds.): ICIDS 2009, LNCS 5915, pp. 336–339, 2009.
© Springer-Verlag Berlin Heidelberg 2009

significantly influenced our research. In addition, their work has inspired other notable research projects in this field, for example *Placeholder* - multi-person narrative action [4] and the *Oz* project [1] – a computer system that allows authors to create and present interactive dramas. In our research, we define narrative as a non-linear interactive 'action space', 'epic wandering' and 'storyworld' – the model discussed by Marie Laure Ryan [8]. Upon arrival to the VHE, the user can choose the road they take, however, the system is still in control to provide a self-contained dramatic narrative. This 'epic structure' contains semi-autonomous episodes giving the user a relatively passive role that allows us to maintain coherence to the story (Fig. 1). By controlling the general path of the visitor, the narrative can progress steadily, and, if necessary, limiting or neutralizing the consequences of decisions made by the user [8].

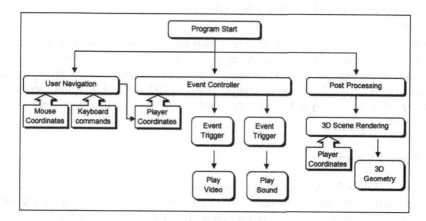

**Fig. 1.** Simplified program structure

Our approach to the narrative architecture in a virtual environment can be compared to promenade theatre, where the audience inhabit the space, rather than just watch a performance. They move around to view the action and sometimes interact with it (e.g. 2007 *Punch Drunk*'s site-specific promenade performance of *Faust*[1]), [3]. As the participants wander through the VR environment, they encounter several video and audio narratives that are designed to immerse them further into the virtual experience. The narratives are small 'story–worlds' [7]; they do not follow a linear story or are related to a macro plot. Nevertheless, a narrative coherence still exists as all the stories have the 1831 Reform Bill riots as their common thread. All narratives in the VHE are triggered unconsciously by the participants as they approach an object; choose a certain path or an area in the environment (Fig. 2).

Embedded sound effects and proximity sound triggers play an important role in directing the participant's attention to a particular narrative space. Spatial sound helps the user to orientate within the space and contributes to their cognitive map or the environment. Creating engaging narratives is not limited to the multimedia elements encountered. The mise en scène is just as important to consider within virtual

---

[1] Faust by Punchdrunk in collaboration with the National Theatre was performed at a non-theatre venue in Wapping, October- November 2007.

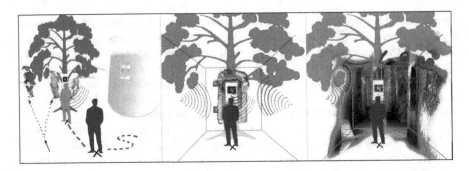

**Fig. 2.** 'Ghosts' guide the participant to a tree, where s/he is transported from one VE to another. Key: Participant path =, Ghost Path =, Trigger = x.

environments as it is in film and theatre. In our project, it is used to set the 'mood' of the narrative, to provide a perspective upon the story, and to evoke visual correspondences and engagement [2]. By creating 'spatial simultaneity' and considering the mise en scène, special effects, animation, triggers, lighting and proximity sound the participant is more likely to become immersed within the VHE and experience a sense of presence.

## 3  User Evaluation

In April and June 2009, we conducted two rounds of user evaluation. During the first round, participants were navigating the VHE themselves; while during the later evaluation they were shown the project on a big screen. The reason for this was our collaboration with such media centres as the Broadway Cinema and Media Centre, situated in the heart of Nottingham. There is a strong interest in experimenting with new ways of utilizing their smaller screens and finding new commercial models for entertainment, learning and display. Therefore, our research is also concerned with investigating how the medium of cinema could be linked to the museum sites. The respondents (aged 18-20) totaled 23 (11 – 2nd year Multimedia students; 12 – 1st year Multimedia students). Our preliminary results suggest that the majority of students (82%) participating in the first round of user evaluation indicated that they felt immersed in the story space, while only 50% of the participants from the second round felt the same. This could be due to their passivity during the interaction with the VHE (i.e. they were observers – not active participants). Furthermore, ten out of twelve respondents from the later part of the evaluation indicated that they would have preferred to navigate within the VHE themselves. Although these results are quite preliminary, they give us some scope to conduct further research on the big screen displays with a particular focus on the potential audiences. Another interesting result of the second part of the evaluation was that 70% of the respondents pointed out that they would like to have an opportunity to interact with avatars in the VR environment. This result, however, was not surprising because the majority of students (83%) defined themselves as gamers, or indicated that they play computer games very often. In both rounds, the criticism was expressed regarding the overall length of the stories (i.e. too long) told by the video characters, which we will address in the near future.

## 4  Conclusion

The Narrating the Past research project seeks to challenge conventional approaches to virtual heritage reconstruction. Many of virtual reconstructions fail to 'recapture' the past in regards to the people and life that existed at that time. Thus we are interested in ways of bringing this sense of 'real' space closer to the participant, using sound and video techniques. By creating the VHE, we also intend to increase the access that general public has to the heritage, which is currently an issue with museums aiming to reach a wider and younger audience. The VR techniques allow interactivity, support and discovery, but also they enable the viewer to gain a variety of historical perspectives as they can be given a number of viewpoints to consider. We seek to provide a platform for dialogue and knowledge transfer amongst the staff at heritage sites, cinemas and media centres, as well as academics, to promote further collaborations and mutual understanding in the field. The outputs of this research are not limited to the mentioned heritage sites, rather the techniques could be applied to performance and installation art, film based-media and theatre.

## References

1. Bates, J.: The Nature of Characters in Interactive Worlds and the Oz Project. Technical Report, CMU-CS-92-200 (1992), http://www.cs.cmu.edu/afs/cs.cmu.edu/project/oz/web/papers.html
2. Dernie, D.: Exhibition Design. Laurence King Publishing (2006)
3. Giuliana, B.: Visual Studies: Four Takes on Spatial Turns. Journal of the Society of Architectural Historians 65(1), 23–34 (2006)
4. Laurel, B.: Computers as Theatre Reading. Addison-Wesley Publishing Company, Reading (1991)
5. Laurel, B., Strickland, R., Tow, R.: Placeholder: Landscape and Narrative In Virtual Environments. ACM Computer Graphics Quarterly 28(2), 118–126 (1994)
6. Murray, J.: Hamlet on the Holodeck: The Future of Narrative in Cyberspace. The Free Press, New York (1997)
7. Ryan, M.L.: Possible Worlds, Artificial Intelligence, and Narrative Theory. Indiana UP, Bloomington (1991)
8. Ryan, M.L.: Narrative as Virtual Reality: Immersion and Interactivity in Literature and Electronic Media. The Johns Hopkins University Press (2003)

# The Third Woman

Martin Rieser[1] and Pia Tikka[2]

[1] IOCT, De Montfort University, 1 the Gateway, Leicester LE1 9BH
[2] University of Art and Design, Helsinki, Hämeentie 135 C, FIN-00560 Helsinki
`pia.tikka@iki.fi, mrieser@dmu.ac.uk`

**Abstract.** *The Third Woman* is an interactive mobile film-game, performance, and installation, which gradually reveals the layers of a contemporary film drama on mobile phones and screens

**Keywords:** Planning, narrative generation, narrative control.

## 1 Introduction

In May 2008, at the first e-MobilArt project's workshop in Athens, thirty-three digital media artists from a Euro-centric, but worldwide selection, to elaborate the theme "Passage" into new digital artworks. The Vienna Underground group was formed around the Austrian artist Nita Tandon's idea to create a cinematic project for the Viennese U-Bahn spaces. Anna Dumitriu (UK), Cliona Harmey (Eire), Margarete Jahrmann (Switzerland), Martin Rieser (UK), Barry Roshto (US/Germany), Pia Tikka (Finland), and Nina Yankowitz (USA) joined Tandon's proposal. Inspired by the Vienna-based film noir *The Third Man* (dir. Carol Reed 1949), the *Vienna Underground* project soon evolved under the conceptual guidance of the English media artist Martin Rieser into a multi-faceted interactive mobile film-game *The Third Woman*[1]. The *Vienna Underground* group launched the mobile film-game project *The Third Woman* in the Vienna Kunsthalle Project Space in February 2009. The piece was subsequently shown in the e-MobiLArt Exhibitions in the State Museum of Contemporary Art, Thessaloniki, Greece; Carpenter House, Bath as Part of the Cityware Research Project; and the Academy of Fine Arts - Gallery, Katowice, Poland, 2009.

## 2 Thematic

The initial e-MobiLArt theme "Passage" theme was liberally interpreted using *The Third Man* as a "template" for common work around multiple components including: a game, installation, text mutation, "readable" garment codes, "Hertzian" space detection, sound-works, bio-art and performance. Vienna was interpreted as a place of transmission, which, in the particular context of *The Third Man* referred to illegal underground activities. The city of Vienna that Graham Green's

---

[1] See: `http://www.ioct.dmu.ac.uk/Third_Woman` (last accessed: 2009-09-23).

I.A. Iurgel, N. Zagalo, and P. Petta (Eds.): ICIDS 2009, LNCS 5915, pp. 340–343, 2009.
© Springer-Verlag Berlin Heidelberg 2009

script once assigned as a totemic post-war space between the East and West, now reflected the tensions of globalisation. As in the *The Third Man*, where the "underground" trade in penicillin by the Harry Lime character caused the death of innocent people, so did the practice of the modern healer Lara Line in *The Third Woman*, when she accidentally releases the smuggled contagious biomaterial called *Miasma*. The word 'Miasma' refers to the mythic phenomenon of 'bad air', which in the historical city of Vienna was blamed for causing the plague[2]. Along with *Miasma*, ubiquitous microbiological *Code* and its *cultural* parallels became a key theme, woven into *The Third Woman* film-game and its viewer participation. This was also reflected at the project launch venue, as the Vienna *Kunsthalle* happened to be located on top of the world's first modern sewer system, the site of the original *Third Man*. as well as *The Third Woman* film. Embedded in an era of multi-cultural communities, conflict, and fear of terrorism, the project relates to issues such as illegal migration and the black economy, familiar to the "underground" worlds of modern cities. In the *Third Woman* film-game, the Viennese underground system symbolises these invisible worlds, and is similarly "mapped" as a conceptual layer onto each future exhibition location, determining the spatial distribution of the game elements in any city.

## 3    The Film Plot and Production

A young woman healer, Holly Matins (Maria Järvenhelmi), arrives in Vienna, and invites the audience to join her search for possible answers to the mysterious death of her friend, the healer Lara Line (Catherine Adams). Along with the gradually evolving love story between Holly and the late Lara's lover, a young Pakistanian actor Shalo (Valmike Rampersad), Holly finds out about Lara's obscure business with the criminal figure Roscov (Ranj Nagra). When the corrupted police detective Kurt (Martin Rieser) reveals that Lara has smuggled bio-materials to fund her spiritual activities and has accidentally released the deadly contagious distribution of *Miasma*, Holly decides to leave Vienna; yet Lara has one more surprise waiting for Holly.

The film script, filming, and postproduction was completed as a joint effort by the Finnish filmmaker Pia Tikka and Martin Rieser, in collaboration with a number of film professionals from Finland, UK, and Austria. Film locations included the Viennese Sewage System, the Flak tower, and the U-Bahn, echoing the *film noir* spirit of *The Third Man*. All scenes were filmed so as to combine the on-site actress Maria Järvenhelmi and virtually matted actors. Digital technology enabled the team to virtually matte English actors onto the Vienna film scenes in the green-screen studio at De Montfort University, UK. Although the actors never met during the production, the "filmic chemistry" between Holly and Shalo on the screens proved this experimental method successful. The three differently nuanced versions of each scene ('Reason', 'Intuition', 'Emotion') were filmed, allowing many narrative variations.

---

[2] Encyclopædia Britannica On-line: plague (disease). (last accessed: 2009-09-23)
http://www.britannica.com/EBchecked/topic/462675/plague

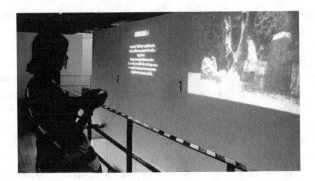

**Fig. 1.** Bettina Schülke interacting with the film installation in the Museum of Modern Art Thessaloniki using a smartphone. (©Martin Rieser&Pia Tikka. Photo ©Martin Rieser).

## 4    The Conceptual Elaboration of Code

The New York based artist Nina Yankowitz designed an introductory "teaser" animation to entice visitors to engage with the film-game installation. Inspired by the stolen penicillin theme from the original *Third Man* scenario, the video featured a hypodermic needle dripping drops of translucent liquid, which contained film images from *The Third Woman*, and was added to it as an opening sequence. The *Code* concept merged the interdisciplinary interests of the group. The Swiss artist Margarete Jahrmann's *Game-Fashion Series* featured an urban dress code accessible to mobile phones and surveillance cameras. The same interactive codes, designed to trigger the film-game, were printed on silk and linen. QuickRead lingerie by the Vienna *dessous* specialist Renate Christian from Boudoir was added to the series.

The Jahrmann's Semacode costumes of the *Game Fashion* series were used both in the film, and in the costumed live performances. The costumed performances, mainly coordinated by the English artist Anna Dumitriu, had two goals: to guide the film-game participants into interaction with the environmentally embedded codes (e.g. tags attached to bio-waste sacks in the game location) and the film narrative on the screens, and to play out the theme of *Miasma* contagion for the audience in *Vienna Underground* group events. Specialising in biological art, Dumitriu collected and cultured bacteria from the air of Vienna. After she had identified the organisms with a biochemical work-up of the 7 digit Analytical Profile Index (API) codes, the German sound artist Barry Roshto generated a musical theme by combining the "Oh du lieber Augustin" tune[3] and API codes of the bacteria. Additionally, he composed a number of thematic ring tones based on the genetic sequence of bacteria sampled by Dumitriu. The soundscapes created by the Irish sound artist Cliona Harmey and Barry Roshto were based on "Hertzian"[4] signals picked up in different locations in Vienna by

---

[3] The children's rhyme inspired by the Viennese street musician Augustin, who fell in a plague pit when drunk but survived.

[4] Dunne, A.: Hertzian Tales. MIT Press (1999).

using proximity sensing sound boxes and electronic "sniffers", which the artists had designed to react to environmental electromagnetic fields. Their "sniffer" technology was also used in the costumed film-game performances to help the participants "detect" safe passages, since, as Dumitriu noted, bacteria do not like to grow in the presence of electrical fields.

## 5    Film-Game and Installation

The audience were invited to engage in the game using personal mobiles as inter-action devices. The game framework was designed so that the user could detect the codes embedded in the environment, by inference from obscure text messages received in their mobiles or revealed within the film sequences, could detect the codes embedded in the environment. The codes would trigger the next film se-quence to be displayed either on the mobile phones, or alternatively, on the in-stallation screens. This was implemented by means of a WiFi network set up at the venue. On a smartphone, the visitor could display the next film scene via num-ber codes, or in camera mode, read the datamatrix/QR codes. The Finnish soft-ware architect Rasmus Vuori implemented software that managed the film-game, installation projection screens and the mobile communications. Aiming at future incarnations, the film-game software was designed to allow the enactment of the participants in the movie experience. In practice this will mean an enactive me-dia system[5], in which data from the mobile phone's accelerometer is interpreted in terms of psychophysiology-based emotion theories [6] and allowed to control the nar-rative flow. Growing towards a self-organizing systemic approach, characterized by feedback and self-organization, the *Vienna Underground* group continues its devel-opment, faithful to the original spirit of *Code* and the Vienna "Underground".

## 6    User Experience in Multiple Versions

The first tests in the Viennese U-Bahn relied both on native curiosity in partici-pants and help from costumed performers, encouraging the user to move from code to code in order to sequence the film correctly on their mobile phones. By the time the piece was shown in Thessaloniki, additional clues had been added through a system of text messaging at the end of each clip and through integration of QR codes embedded environmental graphics, such as Police posters, in which the se-quence numbers were also concealed. The response to the game was not as strong as that to the installation, where being empowered to alter each projection led to improvised collaborative strategies between individuals. When shown in Bath, the QR codes were the only control mechanism and groups eagerly collaborated to decode the correct sequence of clips, which were shown in three rooms on large projection screens, with the codes embedded in a larger variety of graphic artefacts including police dossiers and the tags on biohazard bags.

---

[5] Ravaja, N.: Contributions of Psychophysiology to Media Research: Review and Rec-ommendations. Media Psychology, 6, pp. 193-235 (2004).

[6] As piloted by Tikka, P.: Enactive Cinema: Simulatorium Eisensteinense. University of Art and Design Press, Helsinki (2008).

# Design and Implementation of the Interactive Space for Digital Storytelling (ISDS): The Cocktail Party

Yoonji Kim, Taeksoo Chun, Gunho Chae, Hojoon Ji, and Woon Seung Yeo

Graduate School of Culture Technology
Korea Advanced Institute of Science and Technology
373-1 Guseong-dong, YuSeong-gu Daejeon, 305-701, Republic of Korea
{yoonji,dandycts,solemnt,luxmonster,woon}@kaist.ac.kr

**Abstract.** This paper presents the *Interactive Space for Digital Storytelling* (ISDS) which enables spatial interaction between the audience and the "media-actors" (i.e., recorded video clips of actors). The system features interaction modules to handle the response of the "spect-actor" (the participant) and manage the progress of the story, titled *The Cocktail Party*. Demonstration of the system proved its potential as a new interactive storytelling platform.

**Keywords:** Interactive space, participatory drama, digital storytelling, sensor-driven system, network communication, spatial experience.

## 1 Introduction

Since the avant-garde plays in the 1960s and fluxus movements in the 1970s, numerous attempts have been made to make participatory dramas [7]. More recently, digital technologies have been introduced to the research on interactive stage or participatory drama. Examples include [2], in which Hu et al. presented a real-time tracking system with only one digital camcorder to implement an interactive stage. Wirth et al. also introduced an experimental digital media environment which focused on a personalized form of interactive performance [8]. In general, however, they do not pay enough attention to the significance of storytelling and the role of the participants.

In this paper, we introduce the *Interactive Space for Digital Storytelling* (ISDS), a novel approach to digital storytelling that is designed with participatory dramas in mind. Compared with the examples mentioned above, ISDS focuses on user participation and interaction with "media-actors" (i.e., pre-recorded video clips of actors) as the core elements of its storytelling process, thereby allowing the "spect-actor" (i.e., the participant) to play the key role of the story. In addition, interactions with multiple media actors on several different screens provide each spect-actor a unique experience which is not limited to a virtual, imaginary world, but realized through spatial movements on a real physical stage. The following sections describe detailed information on system implementation.

I.A. Iurgel, N. Zagalo, and P. Petta (Eds.): ICIDS 2009, LNCS 5915, pp. 344–347, 2009.
© Springer-Verlag Berlin Heidelberg 2009

## 2 Design and Implementation

Figure 1 illustrates the structure of our ISDS system, which consists of four *interaction modules*. Each module features a PC with one or two monitor(s) and a webcam, and performs the following tasks:

- Detect the presence (and location, if necessary) of the spect-actor: spect-actor holds a wine glass (due to the story of a "cocktail party", as described in section 3) with infra-red LEDs, which is sensed by the webcam of the interaction module.
- Play the response clip of media-actor: based on the location of the spect-actor, the interaction module runs the active media-actor clip on the screen which stands in front of the spect-actor.
- Communicate with other media-actors: at the same time, the module transmits the detection information to the other modules so that they can prepare their media-actors accordingly for the next step.

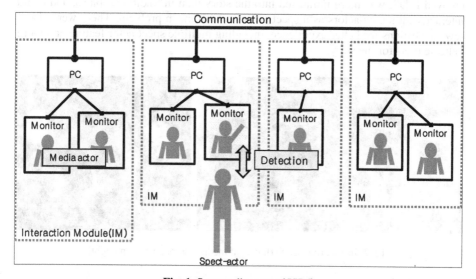

**Fig. 1.** System diagram of ISDS

As in typical "real" cocktail parties, media-actors can be arranged into small groups, each containing up to ten (usually two or three) members. Media-actors in the same group can communicate with each other, but not with the members of other group(s).

Depending on the progress of the story, appropriate video clips of media-actors are selected and played to show their context-dependent temporary roles – *states*. When the spect-actor enters the stage, every media-actor is in *waiting state*, talking to each other without paying any attention to the spect-actor. Once the presence and location of the spect-actor is detected, the corresponding media actor turns into *talking state* (i.e., active mode) and other(s) in the same group into *listening state* (i.e., paying attention to the active media-actor), while the rest still remain in the same waiting state. These states will change depending on spect-actor's response and next location.

## 3 Experience

As mentioned above, we demonstrated ISDS with a detective drama about theft, *The Cocktail Party*. In this demo, the audience was first introduced to the background information on the story, and then participated as a detective to find out the criminal by interacting with seven media-actors.

Figure 2 shows two pictures from the demonstration. Here, the ISDS featured 7 monitors, 4 computers, 7 speakers, and 4 webcams. The stage was installed in a small classroom, which was dark enough to prevent any light detection problems. The room was also decorated with a cocktail party club theme to make it more immersive and interesting.

More than 70 people participated for over 2 days. We had numerous positive comments from the participants, including: "it was intriguing to interact with actors in displays," "walking around to choose an actor whom I want to talk with was fresh and new," "I felt like I was involved in the story." We found out that each participant enjoyed ISDS, was more immersed into the story than in traditional plays, and could interact with media-actors as a spect-actor without much problem. There were also a few suggestions for better experience, including multiple spect-actor feature and more delicate plots for the story.

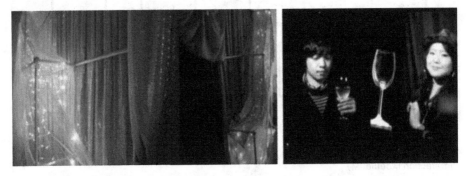

**Fig. 2.** Installation space (left) and media-actors on screen (right)

## 4 Conclusion and Discussion

In this paper, we have described the Interactive Space for Digital Storytelling as a new platform for interactive storytelling on stage. We believe that this system has the potential to introduce a new paradigm of space-based physical interaction for digital storytelling. Also, the audience can enjoy a unique, spatial experience as a protagonist in multiple degrees of freedom, both in time and narrative.

From the participants' feedback, we found the need for allowing more than one spect-actor simultaneously. To this end, not only an enhanced sensing system but also more elaborate, well-organized story plots (with abundant video clips) are desired. We will continue with these improvements to present a more developed version of ISDS that will provide more interactive and immersive experience.

# References

1. Cheong, Y., Young, R.M.: Narrative Generation for Suspense: Modeling and Evaluation. In: Spierling, U., Szilas, N. (eds.) ICIDS 2008. LNCS, vol. 5334, pp. 144–155. Springer, Heidelberg (2008)
2. Hu, S., Mortensen, J., Buxton, B.F.: A Real-Time Tracking System Developed for an Interactive Stage Performance. In: Ardil, C. (ed.) The Third World Enformatika Conference, pp. 102–105. Enformatika, Çanakkale, Turkey (2005)
3. Lee, K.: Presence, Explicated. Communication Theory 14(1), 27–50 (2006)
4. Li, W., Chang, C., Hsu, K., Kuo, M., Way, D.: A PC-based distributed multiple display virtual reality system. Displays 22(5), 177–181 (2001)
5. Perlin, K., Goldberg, A.: Improv: A System for Scripting Interactive Actors in Media Worlds. In: Siggraph, pp. 205–215 (1996)
6. Springel, S.: "The Virtual Theatre" Immersive Participatory Drama Research at the Centre for Communications Systems Research, Cambridge University. In: Proceedings of the sixth ACM international conference on Multimedia: Technologies for interactive movies, pp. 43–49. ACM Press, New York (1998)
7. Wilson, E., Goldfarb, A.: Living Theater: A History. McGraw-Hill, New York (1994)
8. Wirth, J., Ingraham, K., Moshell, M.: Digital Media and Environmental Interactive Performance. School of Film & Digital Media, University of Central Florida (2005)

# Creating 3D Virtual Characters for Games and Storytelling Applications in a Few Easy Steps

Cyril Brom and Michal Bída

Charles University in Prague, Faculty of Mathematics and Physics
Malostranské nám. 2/25, Prague, Czech Republic

**Abstract.** This extended abstract describes motivation, aims, and means of the workshop co-located with Interactive Storytelling 2009 conference.

## 1 Motivation and Goals

The general goal of this event is to address educational issues in the field of virtual storytelling and virtual characters (VS, VC), which are, in our opinion, disregarded [1]. The event comprises two parts: a tutorial, and a discussion.

The goal of the first part is to teach the audience how to develop control mechanisms for computer game characters, including characters acting out a simple narrative. This part is a follow up of presentation of our work at the main conference [1]. The goal of the second part is to discuss whether and how education in the field of VC and VS can be improved.

In particular, the aim of the tutorial is to:

a) give the audience an idea what does it *really* mean to develop control mechanisms of a virtual character for a complex 3D environment,
b) introduce basic AI techniques used in videogames; reactive rules, finite state machines, steering techniques, and perception mechanisms,
c) demonstrate these mechanisms during the tutorial on several examples programmed during the tutorial,
d) introduce the toolkit Pogamut [2] and how it can be used for research and education,
e) prepare the ground for the subsequent discussion.

The aim of the discussion is to answer the following questions:

1. Are educational issues in the domain of VC and VS really disregarded?

Virtual storytelling does not equal virtual characters and interactive storytelling does equal virtual storytelling, though there is a large overlap:

2. What is the "common knowledge" a VS student should acquire during his/her studies?
3. Is there a need for any curriculum at all?
4. Should every VS student know how to develop *autonomous* virtual characters, or not? Why?

I.A. Iurgel, N. Zagalo, and P. Petta (Eds.): ICIDS 2009, LNCS 5915, pp. 348–349, 2009.

5. What are the other "must know" skills a VS student should have, if any? For instance, should every VS student be capable of writing a novel?
6. Given the list of "must know" skills, what are the tools in which students should practice these skills?
7. Do we need any pedagogical theory underpinning VS education?

## 2 Means

The event lasts three hours. While the tutorial takes the first two hours, the last hour is reserved for the discussion. The tutorial is a show-by-example lecture. The examples will be given using our toolkit Pogamut [2], a platform for rapid development of control mechanisms of virtual characters. This toolkit can be freely downloaded in advance by the participants. Pogamut works with Microsoft Windows. Supplementary materials for learners and teachers are available on-line [2].

Questions for the discussion are on the website [3] and each participant is required to answer these questions in advance. These answers are used to organize the discussion.

## 3 Outcome

Outcome of this event is available at [3]. The toolkit Pogamut, including supplementary materials, can be downloaded anytime at [2].

**Acknowledgments.** This work was partially supported by the project CZ.2.17/3.1.00/ 31162 financed by the European Social Fund, the Budget of the Czech Republic and the Municipality of Prague, by Program "Information Society" (under project 1ET100300517, and by the research project MSM0021620838 of the Ministry of Education of the Czech Republic.

## References

1. Brom, C., Bída, M., Gemrot, J., Kadlec, R., Plch, T.: Emohawk: Searching for a "Good" Emergent Narrative. In: Iurgel, I.A., Zagalo, N., Petta, P. (eds.) ICIDS 2009. LNCS, vol. 5915, pp. 86–92. Springer, Heidelberg (2009)
2. Kadlec, R., Gemrot, J., Burkert, O., Bída, M., Havíček, J., Brom, C.: Pogamut 2 – A Platform for Fast Development of Virtual Agents' Behaviour. In: CGAMES 2007, pp. 49–53. Univ. La Rochelle (2007), http://artemis.ms.mff.cuni.cz/pogamut (26.6.2009)
3. Brom, C., Bída, M.: Workshop: Creating 3D virtual characters for games and storytelling applications in a few easy steps, http://artemis.ms.mff.cuni.cz/ICIDS09 (26.6.2009)

# Creating the *Goodies* and *Baddies* of the Story: Specification of an Interoperable and Reusable Avatar Identity

David Oyarzun[1], Amalia Ortiz[2], María del Puy Carretero[1], and Alex García-Alonso[3]

[1] Vicomtech Research Centre
P. Mikeletegi, 57
20009, San Sebastián Spain
[2] Enne
Pamplona, Spain
[3] University of the Basque Country, Spain
doyarzun@vicomtech.org, amalia.ortiz@enne.es,
mcarretero@vicomtech.org, a.galonso@ehu.es

**Abstract.** This paper presents a workshop of ICIDS 2009. The purpose of this workshop is to discuss and define the specification of an interoperable virtual character identity that can be used in the storytelling field. The workshop expects to gather researchers and students from different storytelling fields to work together in the definition of this identity. As result, a high level XML-based specification draft of the virtual character identity is expected.

**Keywords:** Virtual characters, virtual identity, standardization.

## 1 Motivation

Specification of an interoperable avatar identity is currently an open issue. It has become important overall after the boom of virtual worlds. In that case, the main reason is that in each virtual world where users go into, they have to configure their avatar from scratch. No high-level standard language exists that allows the migration of an avatar among virtual worlds.

This problem is up-to-date; in fact there are just now some emergent initiatives like the new MPEG-V standard that try to solve these limitations.

The same situation can be thought in the case of storytelling systems. Related to the virtual world's problem, reusing an existing character and being able to load it onto different storytelling tools could be very useful, overall taking into account aspects like its personality.

On the other hand, if it were possible to define in a high-level way not only the appearance of a character but its personality and other identity related features too, it would facilitate the creation of stories. For example, if the character's personality is defined independently of the story itself, its reactions to the real time story events and interactions could be automatically processed in a coherent way with its personality.

I.A. Iurgel, N. Zagalo, and P. Petta (Eds.): ICIDS 2009, LNCS 5915, pp. 350–351, 2009.

## 2  Aims

The starting tool for the workshop is a high-level XML-based language called ADML – Avatar Definition Markup Language – and created by the workshop organizers. It defines communication skills, appearance and personality features for an avatar. The result of the workshop could be modifications in the language or a complete new specification; or the conclusion could just be that it is not necessary to create a high-level identity.

So, the main objective of this workshop is triple:

— On the one hand the discussion about the advantages and disadvantages of having a high-level identity for virtual characters.

— On the other hand, uncovering the minimum set of features that would be necessary for the specification of the identity. In order to be interoperable and reusable, these features should be independent of concrete application events or story interactions.

— Finally, the best way for coding the decided features in a high-level language should be discussed and specified.

The result of this workshop is a draft document defining the specific language for creating avatar identity.

## 3  Workshop Format

The workshop is presented as a half day session. During the first hour, the organizers will explain their specific ideas about the identity, and they will present an XML-based language, called ADML, which is designed for specifying avatar identity.

The explanation will include the justification of why some identity characteristics have been included in the language and why others not.

The rest of the half day is presented as a round table where experts and students interested in this field can discuss openly their thinking about avatar identity and features, both giving opinions about the ideas presented and putting forward new ones.

# Hands-on Interactive Storytelling Techniques

Florian Berger, Alexander Marbach, and Jana Jevická

Pädagogische Hochschule / University of Education Weingarten, Germany
{berger,marbach}@md-phw.de,
jana.jevicka@seznam.cz

## 1  Theme

At ICIDS 2008, the authors introduced the attendees to the methods and procedures of pen and paper role-playing games (RPGs) as a form of human-to-human interactive storytelling.

Building on that experience this workshop will provide a hands-on approach to creating comparable stories using three different techniques: *pen and paper role-playing*, *live action role-playing (larp)* and *digital storytelling* using a digital game environment.

## 2  Goals

With the live comparison of three distinct approaches to interactive storytelling we intend to start a discussion about the following questions:

– Did the group create a story?
– Which techniques were actually used?
– Was it "playing" or "storytelling", or both?
– Who was in charge of content, direction and pacing?
– How interactive and collaborative was the session?

Debating these we hope to give valuable insights for further research.

## 3  Planned Activities

The authors introduce the participants to the several forms of storytelling and playing to be used in this workshop. They explain that all three approaches will use the *same characters*, the *same background story* and the *same story goal* and point out the different mechanisms to be observed during the creation of the story. Each of the three sessions is going to run for 20 minutes. Subsequently participants are divided into three groups.

The first group is going to create the story by playing a pen and paper role-playing game at a table. There will be a game master who controls the game world and players who control their respective characters. A lightweight rule set and dice will be used to resolve conflicts. The story unfolds in a back and forth of character attempts and game world reactions.

I.A. Iurgel, N. Zagalo, and P. Petta (Eds.): ICIDS 2009, LNCS 5915, pp. 352–353, 2009.

In the second group the game master will not directly interfer with the game. He will provide the characters to choose from and will give a short briefing. The participants will then physically act out in an improvisation theatre kind of way, thus creating the story by interacting with each other "in character". The game master might enforce a "scene framing" to keep the story in line.

The third group will create the story by means of a digital 2D multi-player game environment, with each player using a computer of its own. Game world interaction works by "point and click", while character interaction happens by means of a built-in text chat system.

After the sessions all three groups join again and watch the recording of each session.

## 4    Participants

There is a limit of four active players in each of the three groups, so there will be twelve active participants in total. There will be an online subscription process before the conference.

In addition, everyone is invited to watch the game sessions and take part in the final discussion.

## 5    Workshop Organisers

*Florian Berger* and *Alexander Marbach* are graduate engineers of media technology and have both a role-playing games experience of over twelve years. They currently work on their PhD theses on interactive storytelling in game-based learning at the University of Education Weingarten, Germany.

Florian Berger has held regular, critically acclaimed workshops on techniques for game mastering at German role-playing conventions and recently published his first book on the matter.

Alexander Marbach is a freelancer in CG design and gives lectures on computer graphics, 3D modelling and storytelling at the University of Applied Sciences Mittweida, Germany.

*Jana Jevická* is a theatre trainer with a Master's degree in Dramatic Arts from the Theatre Faculty of the Janáček Academy of Music and Performing Arts in Brno, Czechoslovakia, which is directly concentrated on working with non-professional actors and using the game methods for the personality development and education. She organises live action role-playing events for the "Court of Moravia", an association that has been creating story-driven urban larps since 2003.

# Do We Need a New Narratology for Interactive Digital Storytelling?
## A Workshop on Theory at ICIDS 2009

Hartmut Koenitz[1], Mads Haahr[2], Gabriele Ferri[3], and Tonguc Ibrahim Sezen[4]

[1] Georgia Institute of Technology, School of Literature, Communication and Culture,
686 Cherry St., Atlanta, GA, 30332-0165, USA
hartmut.koenitz@lcc.gatech.edu
[2] School of Computer Science and Statistics, Trinity College, Dublin 2, Ireland
Mads.Haahr@cs.tcd.ie
[3] Università di Bologna, Dipartimento di Discipline della Comunicazione,
v.A. Gardino 23, Bologna, Italy
gabriele.ferri@sumitalia.it
[4] Istanbul University Faculty of Communications,
Kaptani Derya Ibrahim Pasa Sk. 34452 Beyazit-Istanbul, Turkey
tongucs@hotmail.com

**Abstract.** The workshop explores Narratology as applied to Interactive Digital Storytelling. It presents different strands in established Narratology and the foundations they are built on. Then it discusses different attempts to apply and reconcile Narratology with Interactive Digital Storytelling. The workshop is designed to expose these differences by applying different concepts to the analysis of different digital artifacts and open up a discussion of theory that is mindful of diverse approaches and integrates practical considerations.

**Keywords:** Interactive Digital Storytelling Theory, Narratology, Digital Media, Media Specificity, Narrative.

## 1 Background

Widespread diffusion of digital technologies has made the study of Interactive Digital Storytelling a critical issue. A cornerstone of any discussion on Interactive Digital Storytelling is a theory of narrative that adequately describes artifacts in the developing field. The notion of storytelling echoes the emphasis that several disciplines put on narrativity: from Shklovsky' and Propp's original work, to further developments in Narratology and the evolution towards post-structuralist literary semiotics to the recent natural, cognitive or trans-media narratologies. Storytelling – and thus narration – is also a controversial concept for Ludology, which initially argued for an unbridgeable gap between "story" and "interaction" or "game". In such a varied landscape, discussions are difficult because they often lack a common ground. The goal of this workshop is to provide it, by exposing and evaluating theoretical points from several existing approaches. This should provide practical insights for a more adequate Narratology of Interactive Digital Storytelling.

I.A. Iurgel, N. Zagalo, and P. Petta (Eds.): ICIDS 2009, LNCS 5915, pp. 354–355, 2009.

## 2   Workshop Format

The full-day workshop allows ample time for discussion of these complex topics in terms of theory as well as practice.

Session 1 presents arguments for a new Narratology centering on issues of media specificity of established theories, the available canon of works, and phenomena in digital media not covered by existing approaches. Session 2 contains short presentations on different approaches in Narratology and related fields.

The bulk of the workshop is in the form of group discussions (sessions 3 and 4) in which the participants are split up in groups to discuss specific approaches to the problem. Examples include Michael Mateas' combination [1] of Murray's affordances of Digital Media [2] and Brenda Laurel's "Neo-Aristotelism" [3], Pamela Jenning's combination of African narration and Umberto Eco's concept of Openness [4], Marie-Laure Ryan's "Digital Textuality" [5], Jay Bolter's concept of "serious hypertext" [6] and Espen Aarseth's Ergodic Literature [7]. The discussion in the groups are divided into two parts: a theoretical discussion (session 3), and after the lunch break by applying the concept to an analysis of specific Interactive Storytelling artifacts (session 4). Artifacts include *Afternoon* by Michael Joyce, *Reliving Last Night* by Sarah Cooper:, *Façade* by Michael Mateas and Andrew Stern, *The Sims* by Will Wright, *Fable* by Lionhead Studios, and *The Graveyard* by Tell Tale Games.

All participants gather again after a coffee break and the results of the groups' discussions are presented to all (session 5). Next, a panel of experts representing different approaches of reconciling Narratology and Interactive Digital Storytelling react to the results and present their take on the problem (session 6). Finally the workshop organizers wrap up the workshop (session 7).

## References

1. Mateas, M.: A Preliminary Poetics for Interactive Drama and Games. Digital Creativity 12(3), 140–152 (2001)
2. Murray, J.: Hamlet on the Holodeck. Free Press, New York (1997)
3. Laurel, B.: Computers as Theater. Addison-Wesley, Reading (1991)
4. Jennings, P.: Narrative Structures for New Media: Towards a New Definition. In: Leonardo (ed.) Fourth Annual New York Digital Salon, vol. 29(5), pp. 345–350 (1996)
5. Ryan, M.-L.: Avatars of Story. Minnesota University Press, Minneapolis (2006)
6. Bolter, J.: Writing Space: The Computer, Hypertext, and the History of Writing. Lawrence Erlbaum, Hillsdale (1991)
7. Aarseth, E.: Cybertext: Perspectives on Ergodic Literature. Johns Hopkins University Press, Baltimore (1997)

# Workshop on Authoring Methods and Conception in Interactive Storytelling

Ulrike Spierling[1], Ido Iurgel[2], Urs Richle[3], and Nicolas Szilas[3]

[1] FH Erfurt, University of Applied Sciences, Altonaer Str. 25, 99085 Erfurt, Germany
spierling@fh-erfurt.de
[2] CCG, Centro de Computação Gráfica and Centro Algoritmi, Universidade do Minho,
Campus de Azurém, 4800 Guimarães, Portugal
ido.iurgel@dsi.uminho.pt
[3] TECFA, FPSE, University of Geneva, CH 1211 Genève 4, Switzerland
Urs.Richle@unige.ch, Nicolas.Szilas@unige.ch

**Abstract.** The ICIDS 2009 post-conference workshop on authoring methods
and conception takes up open issues that were identified at previous conference
workshops on authoring. The emphasis is on the abstraction processes that are
involved when interactive story ideas are adapted to certain IS systems.

**Keywords:** Authoring workshop, creation process, interactive storytelling.

## 1 Workshop Description: Authoring Methods and Conception

The creation of an Interactive Storytelling (IS) artifact is still considered a challenge
of integrating knowledge and skills of several disciplines. At recent conferences, re-
search prototypes of new generative systems or system components have been dem-
onstrated, while at the same time, the lack of compelling story examples and content
has been regrettably stated. This has often been attributed to missing authoring access
to these systems, and want of comprehensive methods of conception and creation.

At the ICIDS conference in 2009, these issues are addressed by a post-conference
workshop on creation methods. It serves as a follow-up on previous workshops in the
history of the conference series [3, 4], in which professionals of the IS community
identified open issues in the field of authoring interactive storyworlds. Among them
are challenges that cannot be solved by one single tool or conceptual approach. These
include the problem of not knowing where the boundaries of authoring end and pro-
gramming a story engine begins (or vice versa), the impossibility of a direct compari-
son of tool concepts due to a missing classification, and the need to develop a shared
vocabulary for creators that is inclusive of various technical approaches, that relates to
narrative theory, and that is intelligible for non-programmers. Finally, there is a de-
mand for the education of authors. The workshop gathers an interdisciplinary profes-
sional community to debate and investigate these and similar subjects.

The event is supported by the IRIS project [1] ("Integrating Research in Interactive
Storytelling"), a network of excellence that aims at an accumulation of professional
knowledge, serving the community with online material and opportunities for

I.A. Iurgel, N. Zagalo, and P. Petta (Eds.): ICIDS 2009, LNCS 5915, pp. 356–357, 2009.

exchanging experiences. In the context of authoring, one of the IRIS objectives is to strengthen the professional community by making the next generation of IS technologies more accessible to creative writers, and by providing guidelines for tool development.

In previous conference workshops on authoring [3, 4], the story of "Little Red Riding Hood" was used as a practical example to better illustrate, compare, and turn explicit the different approaches to Interactive Storytelling, which are implicitly assumed by systems currently available in the research community. As "Little Red Riding Hood" is a linear story, it first had to be creatively adapted to interactive versions. The choice of a certain interactive form or genre was made in accordance with each system's underlying narrative and/or computational formalisms.

In the 2009 workshop, we use these existing adaptations to briefly and precisely explain the creation methodology suggested by each system. These illustrative explanations are made available online before and after the workshop [2]. Participants are invited to adopt the role of an author and to conceive new interactive story ideas on the basis of one of the system's descriptions. We expect that each system affords a unique kind of abstraction process to conceptualize the main story elements. For instance, this may involve the description of entities, such as virtual characters with their attributes and goals, of certain types of actions and conditions for events, and of predefined possible situations to which virtual characters and end-users/players of the interactive storyworld can be exposed. At the workshop, story ideas of participants and their fit to abstract system descriptions are discussed. The long-term goal is a shared understanding of the process of conception and creation in the field of Interactive Storytelling, resulting in "prescriptive" interactive narrative theory. Further, we aim at the development of educational material on AI-based generative aspects of the creation of interactive narrative, targeted at non-computer scientists. The results are also made accessible via the IRIS website [1].

## Acknowledgements

This work has been funded (in part) by the European Commission under grant agreement IRIS (FP7-ICT-231824). [1]

## References

1. IRIS project website,
   http://iris.scm.tees.ac.uk/ (last accessed September 2009)
2. Little Red Riding Hood Authoring Tools Weblog,
   http://redcap.interactive-storytelling.de (last accessed September 2009)
3. Spierling, U., Iurgel, I.: Pre-Conference Demo Workshop "Little Red Cap": The Authoring Process in Interactive Storytelling. In: Göbel, S., Malkewitz, R., Iurgel, I. (eds.) TIDSE 2006. LNCS, vol. 4326, pp. 193–194. Springer, Heidelberg (2006)
4. Spierling, U., Iurgel, I.: Workshop and Panel: The Authoring Process in Interactive Storytelling. In: Spierling, U., Szilas, N. (eds.) ICIDS 2008. LNCS, vol. 5334, p. 331. Springer, Heidelberg (2008)

# Author Index

Printed in the United States
By Bookmasters